W9-CMP-347

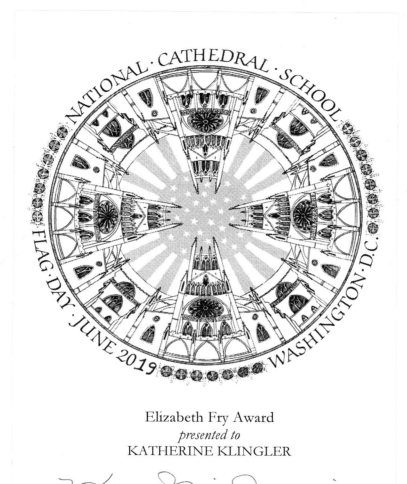

NATIONAL · CATHEDRAL · SCHOOL
FLAG · DAY · JUNE · 2019
WASHINGTON · D.C.

Elizabeth Fry Award
presented to
KATHERINE KLINGLER

Head of School

Meetings with
Remarkable Manuscripts

Twelve Journeys into the Medieval World

CHRISTOPHER
DE HAMEL

PENGUIN PRESS
New York
2017

PENGUIN PRESS

An imprint of Penguin Random House LLC
375 Hudson Street
New York, New York 10014
penguin.com

Copyright © 2016 by Christopher de Hamel
Penguin supports copyright. Copyright fuels creativity, encourages diverse voices,
promotes free speech, and creates a vibrant culture. Thank you for buying an authorized
edition of this book and for complying with copyright laws by not reproducing, scanning,
or distributing any part of it in any form without permission. You are supporting
writers and allowing Penguin to continue to publish books for every reader.

First published in Great Britain by Allen Lane,
an imprint of Penguin Random House UK.

ISBN: 9781594206115 (hardcover)
ISBN: 9780698163386 (e-book)

Printed in the United States of America
10 9 8 7 6 5 4 3 2 1

FRONTISPIECE: Saint Louis as a child being taught to read under the direction of his mother Blanche of
Castile, as depicted in the Hours of Jeanne de Navarre, Paris, *c.* 1334. (See p. 396)

Contents

Introduction

This is a book about visiting important medieval manuscripts and what they tell us and why they matter. As first envisaged, it was to be called 'Interviews With Manuscripts', and indeed the chapters are not unlike a series of celebrity interviews. Actual interviews – traditional published interviews with well-known people – usually set the scene and describe the circumstances of how the encounters came to happen at all. They generally attempt to evoke something of the experience of meeting and interacting with the interviewees. You will already have had information in advance, of course, but what are the people like in reality, when they finally come to the door, shake your hand and usher you to a seat? The accounts may say something of their physical presence and perhaps their clothes, demeanour and style of conversation. We may all pretend that a well-known person is really no different from any other human being, but there is an undeniable thrill in actually meeting and talking to someone of world stature. Is he or she, in fact, charismatically impressive, or (as sometimes) rather disappointing? You might seek to discover how people became famous and whether their reputations are deserved. Listen to them and let them speak. A good interviewer may be able to elicit secrets which were entirely unknown and which the famous person had meant to keep quiet. There is even a certain voyeurism for the reader in eavesdropping as these intimate confessions are teased out.

The most celebrated illuminated manuscripts in the world are, to most of us, as inaccessible in reality as very famous people. To a large extent, anyone with stamina and a travel budget can get to see many of the great paintings and architectural monuments, and may stand

today in the presence of the Great Wall of China or Botticelli's *Birth of Venus*. But try – just try – to have the Book of Kells removed from its glass case in Dublin so that you can turn the pages. It won't happen. The majority of the greatest medieval manuscripts are now almost never on public exhibition at all, even in darkened display cases, and if they are, you can see only a single opening. They are too fragile and too precious. It is easier to meet the Pope or the President of the United States than it is to touch the *Très Riches Heures* of the Duc de Berry. Access gets harder, year by year. The idea of this book, then, is to invite the reader to accompany the author on a private journey to see, handle and interview some of the finest illuminated manuscripts of the Middle Ages.

Palaeographers, the general term for those of us who study old manuscripts, become accustomed to working in the reading-rooms of rare-book libraries, but these are sanctuaries as out of bounds to the general public as the tomb of the Prophet in Medina would be to me. Modern national libraries are among the costliest public buildings ever constructed, but few people actually penetrate as far as the exclusive tables set aside for consultation of the most valuable books of all. Some settings for studying manuscripts are stately and intimidating, and others are endearingly informal. Access is a secret of initiates, and formulas for admission and the handling of manuscripts vary hugely from one repository to another. This is an aspect of the history of scholarship often entirely neglected. The supreme illuminated books of the Middle Ages are cornerstones of our culture, but hardly anyone bothers to document their habitat.

Some of these great manuscripts may be known from facsimiles or from digitized images available on-line, as accessible and as familiar as authorized biographies of well-known people, but no copy is the same as an original. The experience of encounter is entirely different. Facsimiles are rootless and untied to any place. No one can properly know or write about a manuscript without having seen it and held it in the hands. No photographic reproduction yet invented has the weight, texture, uneven surface, indented ruling, thickness, smell, the tactile quality and patina of time of an actual medieval book, and nothing

can compare with the thrill of excitement when a supremely famous manuscript itself is finally laid on the table in front of you. You do not merely see it, as under glass, but really get to touch it and peer into its crevices. There will always be details which no one has seen before. You will make discoveries every time. Unnoticed evidence may be wrested from signs of manufacture, erasures, scratches, overpainting, offsets, patches, sewing-holes, bindings, and nuances of colour and texture, all entirely invisible in any reproduction. The questions manuscripts can answer face-to-face are sometimes unexpected, both about themselves and about the times in which they were made. There are new observations and hypotheses in every chapter here, elicited by nothing cleverer than engaging the originals. Look closely. Use a magnifying glass, if you like. Sit back: turn the pages and listen quietly to what the books tell us. Let them talk. Apart from anything else, this is enormously enjoyable and interesting. Medieval manuscripts have biographies. They have all survived through the centuries, interacting with successive owners and ages, neglected or admired, right into our own times. We will disentangle provenances which were entirely unknown. Sometimes these histories are very dramatic, as books take their place in European affairs at the highest level, from the bed chambers of medieval saints and kings to the secret hiding-places of Nazi Germany. *Habent sua fata libelli*. Some manuscripts have hardly stirred from their original shelves since the day they were completed; there are others which have zig-zagged across the known world in wooden chests or saddle bags swaying on the backs of horses or over the oceans in little sailing ships or as aircraft freight, for books are very portable. Many have at some time passed through commerce and the auction rooms, and the prices attached to them as they transited are a part of the changing history of taste and fashion. The life of every manuscript, like that of every person, is different, and all have stories to divulge.

A dozen manuscripts have been selected for interview here. No one really knows how many medieval manuscripts survive throughout the world – maybe a million, perhaps more – and the choice was very wide indeed. They are all potentially fascinating and even the plainest and scruffiest of those manuscripts would have offered up enough

material to fill a chapter of this book, but it might have made a less glamorous experience for the reader. We are going to be moving in grand company. As you sit in the reading-room of a library turning the pages of some dazzlingly illuminated volume, you can sense a certain respect from your fellow students on neighbouring tables consulting more modest books or archives, and I hope to share a flavour of that quiet satisfaction of associating with celebrated manuscripts, which for a short while are to become our intimate companions. Join me in a bit of self-indulgent namedropping. Among these titans I have tried to choose a representative range of different kinds of medieval book, not all Gospels and Books of Hours but also texts of astronomy, biblical commentaries, music, literature and Renaissance politics. We could also have opted for liturgy, medicine, law, history, romance, heraldry, philosophy, travel, or many other subjects widely covered in manuscripts of the Middle Ages. I have singled out volumes which seemed to me characteristic of each century, from the sixth to the sixteenth. They all tell us something about their times and the societies which made them.

I have been to see every one of these manuscripts for the purpose of writing this book. I had handled some of them before, but I came now with no particular expectations of what I wanted them to tell us, and any new revelations – and there are certainly some – were offered up by the manuscripts during the course of the encounters described here. The narrative will show this happening.

Manuscripts are not all the same size. The miniature nature of the illuminator's craft is part of the fascination of medieval manuscripts, but some of these books are enormous. Those who study the history of art exclusively from reproductions, either reduced in textbooks or magnified onto lecture screens, lose all sense of the relative scale of one manuscript to another. Throughout the Middle Ages there was a strong feeling for the hierarchy of things, both in the natural and the human worlds, often expressed by size. The book with the largest dimensions here is the Codex Amiatinus, a pandect (as it is called) of the entire Scriptures, written for public display. The smallest is the dainty Book of Hours of Jeanne de Navarre, made for the hands of a queen. When a

manuscript is delivered to your desk in a library, even before you open it, there is often an unexpected realization of how big or small it is. As a trick of design therefore, each chapter begins with a picture of the particular manuscript shown closed. That for the Codex Amiatinus is illustrated as large as the dimensions of this book will allow: the bindings of all others in turn are then shown at the start of each chapter in scale relative to that largest reproduction.

Certain themes will become clear as we proceed. Chapter One on the Gospel Book of Saint Augustine takes us into the age when a new Christian literacy was emerging from the collapse of ancient Rome. The Codex Amiatinus in Chapter Two is the oldest surviving Latin Bible, sent to Italy from the ends of the earth, as its dedication declares, by those who prided themselves on their Roman learning. The incomparable Book of Kells, forming Chapter Three, is a very different kind of manuscript of the four Gospels and we are immersed in that distant Celtic world where magic and belief are inseparable and eventually have a part to play in the modern sense of Irish national identity. Chapter Four is about copying manuscripts and copying cultures. The headlong race to the millennium and the anticipated apocalypse preoccupied the tenth century and they fill Chapter Five. The far-reaching and sober effects of the Norman Conquest of 1066 can be experienced graphically and first-hand in the manuscripts examined in Chapter Six. The twelfth century marks a major shift from monastic to secular book production, a watershed in the history of literacy and art, and is one of the under-appreciated turning-points of our civilization. In Chapter Seven we will decipher the name of the king who personally owned one of the finest Psalters of the time. In Chapter Eight we pick up a little book in Munich and find the songs of love and lust of the students and wandering scholars of the early thirteenth century. Chapter Nine introduces a delicate Book of Hours made for a king's daughter, who, like her manuscript, became the pawn of politics, in a tale which then stretches in an unbroken thread of possession from the troubled dynasty of Saint Louis of France to Hermann Göring. Chapter Ten on the *Canterbury Tales* brings the beginning of recognizable English literature and book publishing, with a sub-text on the responsibilities

and dangers of literary scholarship. The *Semideus* of Chapter Eleven is on warfare and armaments, and modern Russia. We end with Chapter Twelve on luxury and money. Between them, the dozen interviews here tell a story of intellectual culture and art from the final moments of the Roman Empire right through to the high Renaissance and then on again, transmitting these manuscripts from their own times through into our contemporary world.

All these books have certain features in common, apart from fame. They are all manuscripts: the word simply means 'written by hand'. That was not out of choice. Until the invention of printing in the mid-fifteenth century, all books were necessarily copied by scribes. Nearly all medieval manuscripts are decorated in some way, at the very least with coloured initials and very often with gold and pictures. Most are undated and have no title-pages. Pages of books were rarely numbered in the Middle Ages. The modern convention, which I use here, is to count the leaves, not the pages, and to number each according to its front (*recto*) or back (*verso*), generally abbreviated to 'r' and 'v'. Most manuscripts from medieval Europe, including all those described here, were written on animal skin (for most purposes the words parchment and vellum are interchangeable). Oblong rectangles of parchment were folded in half and arranged one inside another to form clusters, commonly but not always of eight leaves or sixteen pages, which could eventually be sewn down their central folds. Each section is called a 'quire' or a 'gathering', like a signature in a modern hard-bound print-ed book. A whole series of quires bound in sequence would make up an entire manuscript. I am explaining this in some detail because it is important for what is known as the 'collation' of a manuscript, which forms a crucial part of every chapter here. Palaeographers express this in a formula which looks at first sight as impenetrable as a knitting pat-tern or a sequence of DNA, but which is quite precise and simple in reality. Each quire is imagined as being numbered in lower case Roman numerals, and the number of leaves in each is written in superscript Arabic numbers. Thus, to take an easy example, a manuscript of eighty-six leaves formed of ten quires of eight leaves, each followed by one of six leaves, would be expressed as: $i-x^8$, xi^6. Many medieval manuscripts

– probably most of them, in fact, one way or another – are now no longer complete. Say that same manuscript once had eighty-six leaves but is now reduced to eighty-three by the loss of single leaves at each end and one somewhere in the middle. The collation might be given as: i^7 [of 8, lacking i, a single leaf before folio i], ii–v^8, vi^7 [of 8, lacking iii, a single leaf after folio 41], vii–x^8, xi^5 [of 6, lacking vi, a single leaf after folio 83].

As will become apparent as we look at each manuscript, the collations prove to be extremely important. They will sometimes reveal gaps in the text or picture cycles where no one had ever expected them. To know a manuscript we need to have a sense of what was once there when it was new. More importantly, a collation takes us back to the separate units in which a manuscript was originally made. It is striking how collaborating scribes and illuminators evidently divided their labour according to assignments of loose quires, and a change of hand very often occurs between one quire and the next. We will see this from the Codex Amiatinus of the late seventh century right through to the Spinola Hours 800 years later. I confess that I love collating manuscripts. It is strangely satisfying to work it out quire by quire and to find that the total adds up reassuringly to the precise number of pages in the book. The answer should be absolute. You peer into the central folds, looking for the sewing threads, and you gradually build up a series of V-shaped diagrams of the structure throughout the volume. This would be entirely impossible from a facsimile or microfilm, and it often furnishes the magic key for the separation of hands and the units of text. I have sometimes thought that if I ever retire I should call my pensioner's cottage 'Duncollatin'.

Another feature which is recurrent through all the chapters here is that, unlike a printed book which mostly rolls off a press in a single process, any manuscript was written over time. It may even have been begun at one period and then have been adapted or completed in further phases of activity. A manuscript is a bit like a building or a piece of large hand-made furniture, which can be left unfinished for a while, or it can be partly taken apart again and reconfigured, with additions or removals, forever being adapted to the whims and needs of its successive

owners. Some of the apparent mysteries of manuscripts interviewed here are solved by the sudden realization of more than one moment of production.

If there is a single theme which I would try to convey if we were actually undertaking these journeys together, it is what pleasure you can have in looking at manuscripts. I hope that something of the enjoyment emerges from these encounters. Of course I am the most biased person in the world, but I think that medieval manuscripts are truly fascinating at so many levels. I want to know everything about them. I want to know who made them and when and why and where, and what they contain and where their texts came from, why a particular manuscript was thought to be needed, and how they were copied and under what conditions and how these affected the format and size, what materials were used, how long the manuscripts took to make, why and how they were decorated and by whom (if they were decorated, and why not, if they weren't), and what they cost, how they were bound, who used them and in what way, how or whether they were retransmitted onwards in further copies, what changes were made to them later, where they were kept, how they were shelved and catalogued, how they have survived often against all odds, who has owned them, how they were bought and sold and for how much (for they were always valuable), under what circumstances they reached the custody of their current owners – and, at every one of these questions, how we can tell. We can enjoy ourselves poking impertinently into the affairs of men and women of long ago, and sharing the same original artefacts which gave delight to those people too.

The idea for this book arose out of a conversation with Caroline Dawnay. I had urged her, as I often do urge people without expecting anything to happen, to come to see the Parker Library any time she was in Cambridge. One day she turned up without warning, with half an hour to spare. She had never particularly looked at medieval manuscripts. We got out a volume of the Bury Bible, one of the first English books made by a professional illuminator, written around 1130. The enchantment of that wide-eyed encounter, for me as much as for

her, suggested the challenge of trying to convey to a wider audience the thrill of bringing a well-informed but non-specialist reader into intimate contact with major medieval manuscripts.

I have tried to avoid using technical terms known only to specialized historians. If these were actual visits to libraries, I would encourage you to interrupt if anything seemed unclear or too complicated. This should be as near to a conversation as a published book can be. For that reason, I have resisted the temptation to scatter the text with footnotes. I, for one, am incapable of reading any footnoted book without holding fingers between multiple pages, which slows the narrative and bores the layman. For those who care, and many will not, there are separate and discursive bibliographies and notes for each chapter. These have had their own problems of composition. I have been on familiar terms with some of these manuscripts, or have known about them, for more than forty years and I do not necessarily recall the sources of everything I have read. Worse than this, I am afraid that people have told me things and have suggested ideas, and I may have forgotten. I have tried to make acknowledgements in the text itself or in the notes. I am indebted too to all the curators who received my visits with good grace and often with information. We who work in palaeography are conscious of whole international networks of like-minded historians and bibliographers, and we gladly help one another when we can. We talk in the vestibules of libraries and gossip at conferences. We ask advice by email. We sometimes stay in each other's houses. I hope that it will become apparent that a book like this is only made possible by a lifetime of friends and colleagues.

There are two people I would like to single out at the beginning. The first, of course, is my wife, Mette, who has endured the writing for several years and who graciously appears as the subject of several jokes in the text. (This is a trick by me: she will have to read the book to find them.) The other is my old friend Scott Schwartz of New York, who discussed the project with me at its outset and helped define its parameters. Through a period of ill-health, now thank goodness abated, he read the first draft of every chapter as it was finished, and I owe much to his wisdom and perception. It is to him I dedicate this book.

The Gospels of Saint Augustine

late sixth century
Cambridge, Corpus Christi College,
MS 286

At the end of this chapter I will recount how Pope Benedict XVI and the Archbishop of Canterbury both bowed down before me, on live television, in front of the high altar of Westminster Abbey. Before reaching that very unlikely moment, however, we must follow the footsteps of a manuscript as it weaves through a millennium and a half of English history, encountering several popes and other archbishops of Canterbury on its journey. One of these archbishops was Matthew Parker (1504–75), who owned the book itself. Parker had attended Cambridge University, and he had been ordained a priest shortly before the Reformation in England. By lucky chance, perhaps through a family connection in Norfolk, he became domestic chaplain to Anne Boleyn, second wife of Henry VIII and queen of England from 1533 until her execution for treason in 1536. It was in Anne's circle that the first intimations of Lutheran reform had infiltrated the English court, and Parker was evidently caught up in that heady intellectual excitement of the religious renaissance of the time. In 1544, on the recommendation of Henry VIII, he was appointed Master of Corpus Christi College in Cambridge. Parker got married (a radical step then for the clergy), was deprived of his position under the reactionary Queen Mary, 1553–8, and in 1559 was summoned to London by the new queen, Elizabeth, daughter of Anne Boleyn, who made him the first archbishop of Canterbury of her

reign, with instructions to make the English Reformation absolute and irrevocable.

The reformed Church of England, as confirmed by Parker in what is known as the Elizabethan Settlement, was at least initially very different from the Protestantism of continental Europe. Martin Luther had looked back to the apostolic times of early Christianity, rejecting the papacy and undermining the Roman Church from behind by fielding a translation of the Bible derived from texts which were older and apparently more authentic than the standard fourth-century Latin Vulgate edition of Saint Jerome. Matthew Parker, by contrast, embraced the very early popes and the traditional line of apostolic succession from Saint Peter. Gregory the Great, pope 590–604, was one of Parker's heroes, not least because he had sent the first organized Christian mission to England in 596, dispatching a party of Italian monks under the command of one Augustine, prior of the monastery of Sant'Andrea in Rome. Saint Augustine of Canterbury, as he is now called, had then landed in Kent in south-east England in 597 and had convinced Ethelbert, king of Kent *c.* 560–616, to adopt Christianity. The missionaries from Italy had established a cathedral in Canterbury nearby and they founded a monastery outside the town walls, initially as a burial church, originally dedicated to Saints Peter and Paul, patron saints of Rome. Augustine himself became the first archbishop of Canterbury. The monastery he had set up was later renamed St Augustine's Abbey in his honour. It survived on the outskirts of Canterbury for almost a thousand years until its suppression under Henry VIII in 1538, in Parker's lifetime.

Matthew Parker was the seventieth archbishop in what he saw as a line of unbroken continuity back to Augustine. He persuaded himself that those early missionaries had intended to establish an entirely independent English Church, unfettered by Rome. As far as Parker was concerned, the development of religion in Europe was irrelevant after 597. Only England, in his interpretation, had managed to preserve the Christian Church in its primeval purity, as Saints Gregory and Augustine had intended. This, as he saw it, had been corrupted and subverted with the Norman Conquest (1066) and the centraliza-

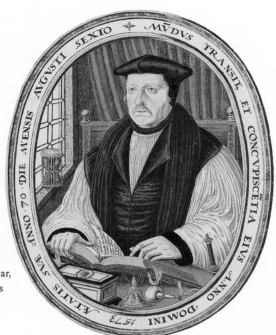

Matthew Parker (1504–74), engraved portrait by Remigius Hogenberg, 1573, showing the archbishop in his seventieth year, reading a Bible as the hourglass on the windowsill runs out of sand

tion of the Catholic Church under the initiatives of Gregory VII, pope 1073–85. The Elizabethan antiquaries all looked back with nostalgia to the Anglo-Saxon era as a golden age of English national identity and independence. Parker decided that the supposedly radical practices of sixteenth-century reform, including the use of vernacular language in the liturgy and the central role of the monarchy in the Church, had actually all been established traditions in Anglo-Saxon England. In 1568 he obtained licence from the Privy Council to take into his own custody any original manuscripts in England which would justify the Anglican Reformation in these terms and would provide tangible precedents for the Elizabethan agenda. Parker eventually commandeered about 600 early manuscripts, mostly from the libraries of recently restructured medieval cathedrals or from former monasteries, including many of the oldest books then in England. He was the first truly great collector of the Elizabethan period, well ahead of Sir Robert Cotton (1571–1631), whose manuscripts are now at the core of the British Library in London, and earlier too than Sir Thomas Bodley (1545–1613),

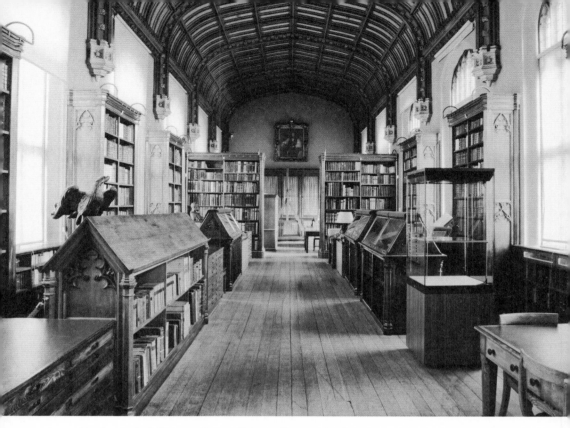

Matthew Parker's library at Corpus Christi College, Cambridge, in the upstairs room designed for it by the architect William Wilkins (1778–1839)

whose acquisitions furnished the new Bodleian Library in Oxford, which we will visit in Chapter Six. About thirty early manuscripts were requisitioned by Parker from the abandoned monastery of St Augustine in Canterbury. The oldest of these was the so-called Gospel Book of Saint Augustine himself, the earliest surviving book known to have been in medieval England. It is the subject of this chapter.

In 1574, towards the end of his life, Archbishop Parker made arrangements to send his collection from Lambeth Palace, his official residence in London, up to his old college of Corpus Christi in Cambridge. The indenture of the bequest outlined two principal conditions. One was an assumption of public access, which the college has largely ignored, and the other was that there should be an annual audit of the library every August, and that if even a few volumes were unaccounted for or lost through carelessness or neglect, the entire bequest would be for-

feit and would revert instead to Gonville and Caius College, further up the street in Cambridge, together with wonderful pieces of Tudor table silver given also by Parker, which are very desirable. It was largely from fear of this awful penalty clause that relatively few outsiders were ever allowed in to see the books. For more than 400 years the Parker Library was notoriously (even scandalously) inaccessible to scholars, or at best it was quixotically and inconsistently available. It is with a certain inverted pride that I report that when I myself first asked to see a manuscript there in the mid-1970s, I was refused permission, and this is still the only library in the world to which I have ever been declined admittance. Excluding readers has meant, however, that every one of Parker's books remains safely on the shelves, and many are in astonishingly fresh condition, almost exactly as they were at the Reformation. They have been in their current possession longer than any other principal manuscripts we will encounter in this book.

In the late 1990s, the governing body of Corpus Christi College resolved to reverse this isolationism and to open up and to exploit their greatest tangible asset. They raised money from various sources, principally the Donnelley Foundation in Chicago, to endow a full-time curator. That same man who had been refused entrance twenty-five years earlier then duly applied and he was appointed in 2000. The fact that the Parker Library has become one of the most accessible and widely used rare-book libraries in the world, both in reality and through comprehensive digitization, is not remotely to my credit, but simply because times have changed and that was an expectation of the new position.

Corpus Christi is one of twenty-nine independent colleges which make up the University of Cambridge. At any one time, it has about 260 undergraduate students. The oldest parts of the buildings date from its foundation in the mid-fourteenth century. Most readers with appointments to study manuscripts in the Parker Library now enter the college up several steps through the over-sized medieval-looking gatehouse in Trumpington Street, usually checking in first in the porters' lodge on the left, so that the library staff can be alerted. Ahead is what is known as New Court, a large quadrangle of manicured grass, striped

by constant mowing, enclosed on four sides by pale stone buildings in regency gothic style built in the 1820s by the architect William Wilkins (1778–1839). ('New' in England is always a relative term; the New Forest is eleventh century.) Tourists often gather around under the archway, photographing themselves and peeping in, curious for glimpses of undergraduates and employees of the college who live and work in rooms off staircases around the sides. Straight ahead is the entrance to the chapel, flanked by niches with statues of Nicholas Bacon, benefactor, dangling a purse of money, and Matthew Parker, with both hands on a book. The bursary is to the left of the chapel, Bacon's side, and the master's lodge on the right. The college dining hall is behind high lancet windows along the north side of the courtyard. The Parker Library fills most of the upstairs floor on the right-hand (southern) facade. Ring the buzzer at the tall gothic door in the far corner of New Court and you will be admitted into a dark lobby with a choice of a stone staircase rising up in front of you or an entrance immediately off to the right. Members of the public usually proceed in organized groups to the magnificent long high-ceilinged library at the top of the stairs, with walls lined with Elizabethan and later printed books and with bright-lit glass cases down the length of the room, displaying some of the library's finest manuscripts. Those who have come to study rare books will be let instead into the secure reading-room on the ground floor.

This room is not as large as upstairs. It was formerly the furthest extremity of the undergraduate library. It has pale green walls and a grey carpet. Mullioned windows on the south wall, generally shielded by blinds to reduce direct sunlight, look out over Saint Botolph's churchyard; those on the north face into New Court. The room is furnished with oak bookcases salvaged from the 1930s and with new purpose-built pale oak tables and fourteen matching chairs all inset with bright scarlet leather, a gift from the manuscript collector Gifford Combs. A glass plaque on the wall, designed by Lida Kindersley, records the opening of the reading-room by Prince Philip, Duke of Edinburgh, on 21 June 2010.

We are about to look at MS 286, the oldest and by far the most precious book in the library. This is a privilege of being escorted by

the librarian: the Gospel Book of Saint Augustine is not brought out easily for casual readers. It is immensely fragile and vulnerable and for many people it still has a sacred and spiritual significance. For Archbishop Parker it would have had a primary value in his search for the foundation of Christianity in England in 597. The manuscript is stored in a burglar-alarmed and air-conditioned vault, where it is shelved horizontally in a stout fitted oak box, made in 1993 at the expense of an architect and old member of the college, Roger Mears, whose name is recorded on a leather label. Wait in the reading-room for a moment while I fetch it, carrying the box in with both hands and placing it on the table. We unclip the brass clasps and lift off the heavy lid, relieving the subtle pressure which keeps the book tightly closed when it is not in use. The volume nestles inside in a bed of firm archival thermoplastic grey foam. Lift it carefully out and lay it on one of the orange-covered padded book-rests on the library tables.

Those who meet famous people often remark afterwards how unexpectedly small the celebrated personage was in reality. For all its stature in English history, this is not a large manuscript, and it is even

The Gospel Book of Saint Augustine, open at the portrait of the evangelist Saint Luke, displayed in the Parker Library

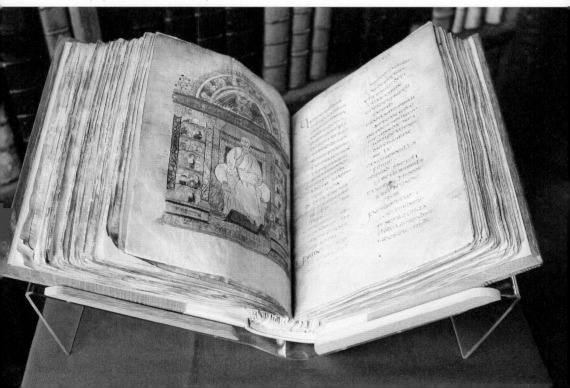

mildly disappointing to some visitors who see it for the first time. It is about 10½ by 8½ inches, about 3 inches thick, quite light, insubstantial, and easy to hold in one hand. It is bound in plain oak boards slightly bevelled on their inner edges, with a spine of creamy alum-tawed goatskin, in the style beloved of the Arts and Crafts movement in England, especially championed and promoted by the binder Douglas Cockerell (1870–1945). The spine, which is now shadowed from handling, is ruled into six rectangles, one stamped in gold "MS 286" and another with a Maltese cross; at the foot are the letters "C.C.C.C." (for Corpus Christi College Cambridge). There is no other title. The manuscript was rebound for the college at the British Museum bindery in 1948–9 (it was returned to Cambridge in July 1949). The loan to London had one consequence. Attached to an end flyleaf is a standard British Museum note about the number of leaves dated July 1948, in the distinctive handwriting of Eric Millar (1887–1966), then Keeper of Manuscripts. The Assistant Keeper was at that time Francis Wormald (1904–72), who took the opportunity of examining the Gospel Book seriously when it was in the temporary custody of his department. Wormald subsequently gave his Sandars Lecture about it in Cambridge beginning on 29 November that year, a major step in the book's road to fame in the twentieth century.

The British Museum binders stitched the gatherings onto the tips of separate and protruding paper guards, fanning them outwards, so that the manuscript can be opened safely at 90° without bending the original parchment. This was fashionable conservation practice at the time, now no longer recommended because it rather unnaturally alters the original integrity of a book and, as the pages are turned, it can result in friction between gatherings. The binding has modern paper endleaves and it responsibly preserves an earlier paper leaf at the back from the previous rebinding in the mid-eighteenth century, together with a number of medieval flyleaves on parchment. The first two of these are plain, perhaps from the late Middle Ages. One, at least, has clearly been transferred from the end, where it served as the last leaf of the book up against the original back cover. Both it and the present final leaf have matching rectangular indentations and small rust holes

at the extreme top imprinted from what was must have been a riveted chain-hasp once attached to the upper edge of the lower board of the medieval binding. At some time the manuscript was evidently secured by a chain, with the front cover upwards.

We will come back later to a more detailed description of MS 286, but no one could resist a preliminary look inside the book itself. This is a chance which will not recur often. The manuscript comprises the four Gospels from the New Testament, in the Latin translation of Saint Jerome, taken from the original Greek of its four authors and rendered by him into the spoken language of Western Europe. The term 'Vulgate', which since the Reformation has carried critical overtones of being arcane and inaccessible to the common people, originally simply meant that it was the normal vernacular of the period. When this manuscript was made, Latin was still generally spoken, and Jerome, who died in 420, was then no more distant in time than (say) Walter Scott or Emily Brontë are to us. The Roman Empire had recently imploded. Rome had been sacked by the Visigoths in 410 and again by the Ostrogoths in 546, within living memory. It saved its identity by reinventing itself as a Christian empire. Saint Augustine's mission to England was the first conscious imperial initiative of the Roman papacy.

The manuscript opens mid-word in the *capitula* list preceding the Gospel of Matthew. These lists are tabulated headings or chapter summaries (although the early-medieval chapter divisions are different from the modern numbering, which was not devised until the thirteenth century). The first surviving words in the book are "[nine-] vitarum signum pharisaesis tradit", referring to Christ giving the Pharisees a sign from the men of Nineveh (in our numeration this is told in Matthew 12:41). There is quite a bit more missing in the manuscript before this, as we will see. The full text of Matthew's Gospel begins on folio 3r, "*Liber generationis* ih[es]u xp[ist]i filii david ...", 'The book of the generation of Jesus Christ, son of David ...' (Matthew 1:1). Its first two words are written in red (which is why I have given them in italics), faded to pale orange which is almost brown, and the opening 'L' is slightly taller than the next letter. It is restrained and subdued, without any exceptional ornament or emphasis for the opening of the

Gospels, quite unlike the flamboyance of later manuscripts such as the Book of Kells.

The writing of the Gospels of Saint Augustine is in two columns of small and neat Latin uncial script. There is much uncertainty about the derivation of the word 'uncial', a term first used disapprovingly by Jerome who regarded it as a frivolous affectation. Ironically for him, it became a script most widely disseminated through its general use in manuscripts of his own translation of the Latin Scriptures. It is sometimes associated with the word '*uncia*', an inch (of which the adjective would be *uncialis*), large letters exaggeratedly thought to be an inch high, which they never were in reality. Uncials became the formal handwriting of early Christianity, as rustic capitals were for secular texts (see Chapter Four below). Uncials are curved capital letters, with a few forms like their modern lower-case equivalents, such as 'h' with a high ascender, 'f' extending down below the line, and a graceful round-backed 'd'. The script was written with a broad quill or possibly a reed, with clear contrast between thick and thin strokes. It is spacious and easy to read, especially given the extreme age of books which use it. In the Middle Ages, uncials were associated with antiquity and authority. The Corpus Glossary, a kind of alphabetical dictionary from around 800, also from St Augustine's Abbey and now too in the Parker Library, defines the word "antiquarius" as "qui grandes litteras scribit", one 'who writes large script': an antiquarian was one who used uncials.

In MS 286 the words are laid out in the pattern which was called '*per cola et commata*', meaning something like 'by clauses and pauses', in which the first line of each sentence fills the width of the column and any second or subsequent lines are written in shorter length. The format was almost certainly that of Jerome's original manuscript of the Vulgate and it is characteristic of the very earliest copies. Each unit is probably what a person would read and speak aloud in a single breath. Thus Matthew opens, 'The book of the generation of Jesus Christ, son of David, son of Abraham', pause, take a breath, glance down silently at the next phrase, 'Abraham begat Isaac', another intake of breath,

RIGHT: The first surviving page of the Gospels of Saint Augustine, opening in the list of chapter headings to Matthew's Gospel, with the earlier Parker Library shelfmark 'L.15' at the top

IN IERUSALEM SIUNM
PHARISAEIS TRADIT
MATRO MONETRA
TRES SPERNIT
XIII DE NAUICULIS TUR
BIS PARABOLAS SEX
PONIT PROPHETA
IN PATRIA MSUA
SINE HONORE ES
SE DICIT
.II. DE IOHANNIS CAPITE
IN DISCO DE QUINQ
PANIB ET DUOB
PISCIB INQUINQ
MILIA UIROS IHS
SUPRA MARE AM
BULANS PETRU
MERCENTE AM
LEUXIT
QUOD MANIBUS QUA
DE ORE EXEANT
INQUINANT
QUOD NEM FILIE
MULIERIS SYRO
PHENISSA EX DAEM

MONIO LIBERAT
ET MULTOS ALIOS
SANAT
XVI DE SEPTEM PANIB
IN QUATTUOR MILIB
UIRORUM A FER
MENTO PHARISA
RUM CAUE NDUM
XPM DM SUM IPSE FILIU
ESSE PETRUS CON
FITETUR QUEMQUE
POST PAULULU
PETRA DURE IN
CREPAT
XVII IN MONTE TRANSFI
CURATUR PUERU
LUNATICUM SAL
UAT DE SIXTERE
IN ORE PISCIS
XVIII HUMILITATEM DOCET
SICUT PUER ET
NE CONTEMNUM
FIDELIUM SCAN
DALIZANDUM
QUORUM ANGELI

look back again at the text, 'And Isaac begat Jacob, [and] Jacob begat Judah and his brothers', breathe again, and so on. Winston Churchill typed his great speeches like this, so that they could be read at a glance and his famous oratorical pauses were graphically preordained in the layout of his script. It is an arrangement prepared primarily for reading aloud, which itself tells us something about the Gospel Book of Saint Augustine, which comes from a time of oral culture when most of the audience for the Scriptures was illiterate.

The second gospel, that of Mark, begins on folio 75r with its prologue and *capitula* list, and the text itself six pages later. The prologue and *capitula* list for the third gospel, Luke, are preceded by a full-page painting showing twelve scenes from the Passion within a grid of square frames (folio 125r). The actual opening of Luke faces a full-page portrait of the evangelist himself seated below an arch with his symbol of an ox above his head and scenes from his gospel in columns down the sides (folio 129v). This is the page we usually exhibit when the manuscript is on public view, since it is the only opening with both picture and text facing each other. It is not difficult to locate, for the exhausted manuscript now naturally flops open at this point. The final Gospel of John begins on folio 208r, similarly preceded by prologue and *capitula* lists. The whole book ends with the words "D[E]O GRATIAS" (strictly, that first word could probably also be expanded as "D[OMIN]O") and, further down "SEMPER AMEN". This is probably based on the formula 'Thanks be to God' used in the Mass at the end of any Gospel reading, but it is also applicable to the sentiment of the scribe himself, grateful and relieved to have finished single-handedly writing 530 pages of text. The words here are written in rustic capitals rather than uncials, since they are not part of the Scriptures, rather as we might use italics to differentiate other kinds of text. Blank pages at the very end of the manuscript are filled with copies of later charters and monastic records, including an interesting twelfth-century relic list.

There is a rather shocking souvenir of a previous visitor on the paper flyleaf at the back. It is a patronizing statement in Latin, informing the

RIGHT: A picture page of the Gospels of Saint Augustine with multiple scenes from the Passion of Christ, from the Entry into Jerusalem through to the carrying of the Cross

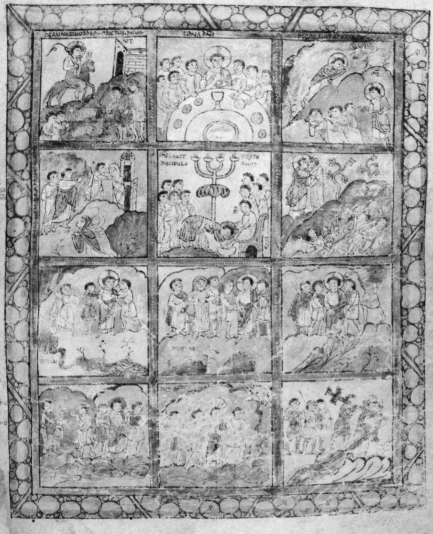

world that the manuscript so closely resembles the Codex Amiatinus that it can be confidently assigned to the sixth century. It is signed "Const. Tischendorf". The Codex Amiatinus, which is the subject of the next chapter here, actually dates from a hundred years later and is not very much like this at all, except for being also in Latin uncials. Constantin Tischendorf (1815–74), of Leipzig, discoverer in 1844 of the Codex Sinaiticus, the primary copy of the Greek Bible, struts boldly and immodestly through nineteenth-century biblical scholarship. On the day he signed and dated his attribution, Thursday, 9 March 1865, he was in Cambridge to accept an honorary LLD from the university. The first times I looked at the manuscript I had not paused to read this crabbed inscription at all: it was pointed out to me ruefully by Archimandrite Justin Sinaites, librarian of the monastery of Saint Catherine on Mount Sinai, where Tischendorf is remembered today not as a hero but as the double-crossing purloiner of their greatest treasure, the fourth-century Greek Codex Sinaiticus.

Many who see the manuscript exhibited now either venerate it piously, or laugh at its credentials, often with the Puritanical scorn still reserved for a supposed relic of any saint. (It is curious how people will accept that a medieval manuscript belonged to a secular celebrity – the Bible of Charles the Bald, for example – but the moment a saint is involved, they dutifully scoff at the credulity of others.) There are also those for whom the Gospel Book of Saint Augustine is still a religious relic of the highest spiritual value. There is a new book about it by the Episcopalian bishop of Arizona, written from the perspective of its religious significance to Christians today. When the manuscript was exhibited in the Fitzwilliam Museum in 2005, a visitor was seen by Stella Panayotova, curator of manuscripts there, weeping and kissing the ground in front of its glass case. These things matter to people, and we clearly need to weigh the evidence for Saint Augustine's ownership as objectively as we possibly can.

Humfrey Wanley (1672–1726), antiquary and early Anglo-Saxonist (and certainly no credulous Catholic), first made the post-Reformation case for identifying the volume in the Parker Library with Saint Augustine of Canterbury. He was one of the few early scholars allowed free

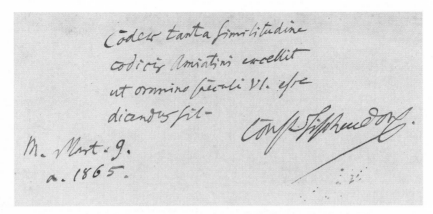

The note added by Constantin Tischendorf (1815–74) when he inspected the Gospels of Saint Augustine in 1865, comparing it with the Codex Amiatinus

access to Parker's bequest in Corpus Christi College, which he visited in 1699. He describes the Gospel Book succinctly but accurately in his account of the ancient literature of Northern Europe, published in Oxford in 1705. Wanley drew attention to Bede's account of Gregory the Great having sent Augustine from Rome, following this up with a gift in 601 of all the paraphernalia necessary for the use of the English Church, including "codices plurimos" ('very many books'). He cited the descriptions of two Gospel Books which an early fifteenth-century text from St Augustine's Abbey associated with Gregory's bequest, and he suggested that these two manuscripts must surely be this volume here in Cambridge, and another similar but undecorated Gospel Book in the Bodleian Library in Oxford. The identification of both books as having been brought to England by Saint Augustine was accepted unquestioned by other early antiquaries, including Thomas Astle (1735–1803), who published an engraving of our manuscript in 1784. It was already beginning its journey into the public eye.

The Bodleian manuscript was clearly owned in Anglo-Saxon England but it has no recognizable association with medieval Canterbury. Its previous history is unknown before its gift to the Bodleian in 1603 by Sir Robert Cotton. An early note in a lower margin suggests that a reading from the adjacent chapter 9 of John's Gospel was suitable for the feast of Saint Chad, which may indicate that the manuscript was used in Mercia,

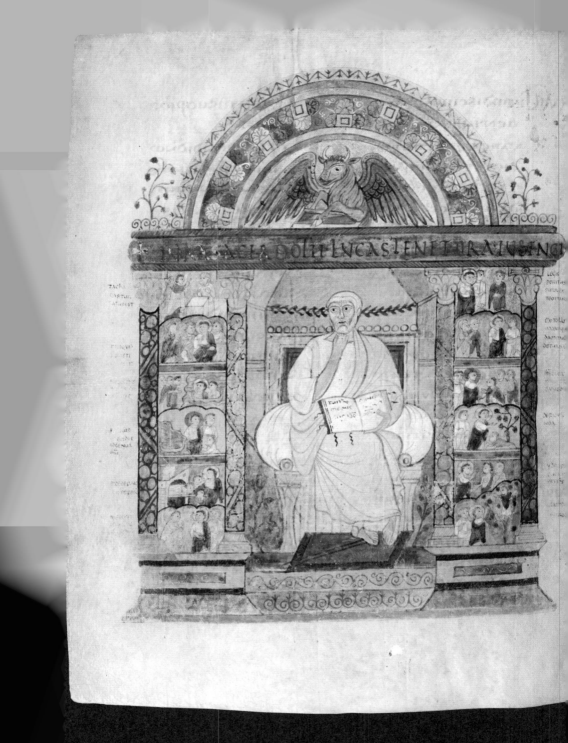

perhaps at Lichfield, where Chad is buried. Evolving scholarship since Wanley's time has slowly weakened the likelihood of its identification with one of Augustine's own books. The case for MS 286, however, has gone from strength to strength. It was undoubtedly at St Augustine's Abbey. It was provably in England by the late seventh century, for it has corrections to the text and captions to the pictures both inserted in a distinctively southern English script of that period. Blank pages were later used to record charters and possessions of St Augustine's Abbey itself. The earliest of these is copied in a tenth-century hand onto the page facing the opening of the prologue to Mark. It is the bequest in Old English of a woman called Ealhburg in the mid-ninth century granting to the abbey various pieces of produce from her property at Brabourne in Kent, including a bullock, four sheep, hens, bread, cheese and wood, in exchange for which the monks would sing psalm 20 daily on behalf of her and her husband, Ealdred. Another is in an upper margin opposite the beginning of Mark's Gospel itself: it is a land charter in the name of Wulfric, abbot of St Augustine's 989–1005. Further documents mentioning the abbey are on the flyleaves at the end, including a beautifully written grant of land in Plumstead, now in south-east London, datable to 1100, for it says it was transacted during Lent in the year when King Henry gave his daughter (Matilda) to the emperor (Henry V, to whom she was betrothed that year). It is by the same scribe as a Missal from St Augustine's Abbey also in the Parker Library, MS 270. At the top of the next page is a twelfth-century list of holy relics kept in a little black box in the abbey, including many crumbs of the True Cross, pieces of the cloak of the Virgin Mary and of the hair of Saint Cecilia, and a finger of Saint Gregory the Great. There is therefore no doubt whatsoever that the manuscript was in the possession of St Augustine's Abbey from Anglo-Saxon times and that it was probably in the custody of the keeper of the relics. The fourteenth-century Customary of St Augustine's Abbey describes the curatorship of relics as one of the duties of the sacristan.

LEFT: The portrait of Luke in the Gospels of Saint Augustine, set between scenes from the Gospel narrative and below the evangelist's symbol of a winged ox

OVERLEAF: The opening of the prologue to the Gospel of Mark, with a document in Old English added on the formerly blank page opposite, recording the bequest of Ealhburg to Saint Augustine's Abbey

In nomine dm̄ eulhbuph hafaþ geret mrðhype
freondæ þ alhtum ga þ man ælce gene agyfe þurh þy p
to sc̄a aguftine of þu lande æðþadan þ urnan xl.
ambur a mealtes ealdhyðen iiii pehenay. xlycc hlaf
rane pæg spices jcrsef. iiii forno pudes. þx henrugla;
spy lc man seþ landhebbe þayðinge agyfe forualdnedes
saule jforealhbunge. þ halnþan asingan ælce dæge æfter
hy ra feyre þæne scalm for hra exaudiut æd ñy. spæhpylc
man spahiy abneceꝺ sihe asccladen fru goðe jfru eallum
hallgū jfru þanhal ganpene. onþy sulife jonecnesse.
þon synt hey æf þ þara manna naman togepit nesse þise
geseted nesse þirþon ꝺpluht nobulb py. jos mund ppb
eþelred py. pyn hene ꝺu con. beuhmund. cenhaụnꝺ. hy se
aꝺꝺa. caꝺa. beuynfeph. beuynhelm. ealoped. eulhbuph. ealhþaru
hor. hene. leofe. paldhelm. ꝺudde. ofu. ofe. pighelm. pullar. eaꝺpal
gifhit þon spa ge gæþ spape nane py rcað þ hpy lc broc onbecume
þuph hæþen folc ofþe hpy lce oðre eurfobnesse þ hit man neme
þay geres gelæftun agife onoþru geare betþeo fealdum. gif
þon git nemæce sy lle onꝺuddu gla re beꝺpy fealou. gy fheþon
nemæge nenelle; agife land jbecþu hiþu to sc̄a agustine;

MARCUSEUANGELIS
TADETPETRIINBAP
TISMOXPIFILIUSXIQ
INDRITINOSERMONE
DISCIPULUSSACERDO
TIUMINISRLACENS
SECUNDUMCARNE
LEUITACONUERSUS
ADFIDEMXPIEUAN
CELIUMINITALIACON
SCRIBSITOSTENDENS
INEOQUODETGAENO
RISUODEBERETETXPO
NAMINITIUMPRIN
CIPIIINUOCEPROPHE
TICAEEXCLAMATIONIS
INSTITUENSORDINE
LEUITAEELECTIONIS
OSTENDITATPRAEDI
CANSPRAEDESTINA
IOHANNECIPFILIU
ZACHARIAEINUOCE
ANCELIENUNTIAN
TISEMISSUMNON
SOLUMUERBUMCAR

NEMFACTUMSEDCOR
PUSDNIPERUERBU
DIUINAEUOCISANIMAXLU
INITIUMEUANGELIEX
PRAEDICATIONISOSTEN
DERETATQUIHAECLE
CENSSCIRETEUMNIHIL
CARNISINDNOETBO
ADUENIENTISHABILA
CALUMCARODEBERET
AGNOSCEREXITQIN
SEUERBUMUOCIS
QUODINCONSONANTIB
PERDIDERATINUENIRE
DENIQETPERFECTI
EUANCELIIOPUSGINPAN
ETABXPISTICDNI
PRAEDICAMSDMINI
COAXISNONLABORA
UIT·NATIUITATEMCAR
NISQUAMINPRIORE
UIDERAIDICEREESC
TOTUSEXPRIMENS
EXPOSITIONEM
SERIIIEIUNIUM

Hęc sunt reliquie in uno paruo nigro sermo flore uno signato. De ligno dñi plures partí cule. De Sepulchro dñi. De Scapula Sci Nicomedis mart. De Capill' Scę Cecilie unŷ ŷ ñi. De S' Margareta. De S' Ianuario. De vest' S' Marie. De ossib; ꝫ uest' S' Clementis ñi. De uest' S' cecilie. De S' Antonio epo. De S' Laurentio ñi. De S' Iohe Bapt ofuii. De S' pancratio ñi. Costa d S' Marthia aplo. De S' Andregesilo. De Sco Martino. De S' Medardo atq; Gildardo. De S' Odulfo epo. De S' Audoeno. Deuf S' Gedaft. De S' Vilgaro. De S' paulino. De S' Affre. De S' Geruasio. De S' Abrosio. De cruce S' Andree apli. De S' Mildretha. De S' Vilfrido. De S' Cadgutha. De S' foldno. De Sca Walburga. De S' Amato epo. De S' petrocio. De S' Bartholomeo aplo. De S' Tecla. Digit' S' Gregorii. De S' Iacobo aplo ħr S' Iohis. De S' Nicholao. De S' leonardo. De S' Benedicto. ꝫ alię plu res reliquię sine scriptis. ꝫ de S' fide ꝫ.

hollord. Kenl. Ozor. Yun. Andreuf. Aclache.

A list of relics owned by Saint Augustine's Abbey, including pieces of the True Cross and a finger bone of Saint Gregory, added in the Gospels of Saint Augustine

There are two principal medieval sources for the treasures preserved by the monks of that monastery in the belief that they had been entrusted by Pope Gregory the Great to Augustine at the time of the conversion of England. The first of these witnesses is the chronicle of St Augustine's Abbey by Thomas Sprott from the late thirteenth or early fourteenth century. It is known in two copies. Sprott mentions the Bible of Saint Gregory together with his Gospel Book ("et evangelia euisdem") among other relics, which included vestments sent by Gregory from Rome. The second text is a much more rambling antiquarian survey of the abbey dated 1414, the *Speculum Augustinianum* of Thomas Elmham, monk of the abbey. His original manuscript now belongs to Trinity Hall in Cambridge. Elmham writes at length about the venerable books which he calls the 'first fruits' of the entire English Church. He provides a sketch of the high altar of the abbey with six closed books drawn in red shown propped up on display on either side of the reliquary of King Ethelbert, with a caption above *"libri missi a gregorio ad augustinum"* ('books sent by Gregory to Augustine'). He describes the individual volumes, not all of them on the altar. Their number has now increased to include two Gospel Books. This was the reference cited by Humfrey Wanley in 1705. One of these manuscripts was described as shelved in the library, where it was stored with the two-volume Bible of Saint Gregory (now lost). Elmham says that its companion Gospel Book opened with ten canon tables and a prologue

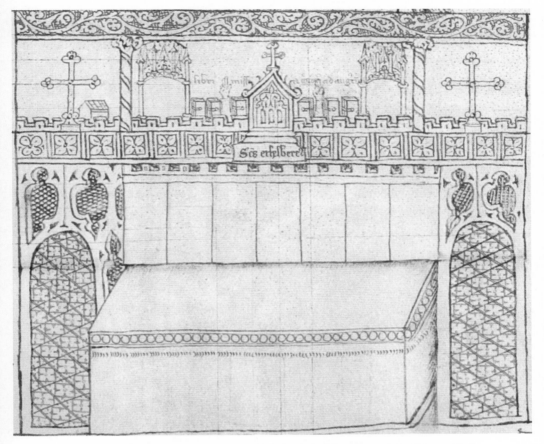

Drawing by Thomas Elmham in 1414 of the high altar of Saint Augustine's Abbey, with the books sent by Saint Gregory propped up on either side of the reliquary of King Ethelbert

beginning "Prologus canonum ...". These volumes, the Bible and Gospel Book in the abbey library, are clearly the same manuscripts as those mentioned by Sprott a century earlier. The second Gospel Book among the 'first fruits' listed by Elmham in 1414 was kept in the vestry, where it was known as the Gospels of Saint Mildred, on which (he says) a certain peasant in Thanet had sworn falsely and lost his eyes.

Mildred Budny (note her first name), who prepared a very long account of the decorated Anglo-Saxon manuscripts in the Parker Library published in 1997, suggested that MS 286 was probably to be identified with the Gospel Book of her saintly namesake. The earlier Mildred, who died around 700, was the daughter of a Kentish princess; she became abbess of the convent which her mother had founded at Minster-in-

Thanet in Kent, some twelve miles north-east of Canterbury. Saint Mildred was reputedly a great-great-granddaughter of Ethelbert, the king of Kent converted by Augustine, which might have provided a line of descent for an Italian manuscript brought to England in the Augustinian mission. The problem, however, is that if her Gospel Book was at Thanet (as it clearly was, since it took cruel vengeance on a perjuring peasant there), then it would have come to St Augustine's Abbey around 1030, when the all relics of Saint Mildred were translated across to Canterbury, whereas our manuscript was demonstrably already in St Augustine's by the tenth century at the latest. In short, if MS 286 is one of the two books described by Elmham, then it was surely the former, kept in the library. This may be consistent with the offset from a chain-hasp described above, since the library books were chained whereas liturgical books in the vestry were not. The Gospels of Saint Mildred, in turn, might then be a mutilated manuscript now divided between the British Library in London and the Parker Library, sometimes called the 'London–Cambridge Gospels', recorded independently on both portions as having been among the books sent from Gregory to Augustine but in reality made in England around 700, which makes it possible, just, that it could indeed have been owned by Saint Mildred.

In summary, then, the claim of MS 286 to be the Gospel Book of Saint Augustine depends on four facts. They are: (1) Bede records that Gregory sent books to England with Augustine, and it is extremely likely that he did, and these would necessarily have included a copy of the Gospels; (2) a Gospel Book purporting to be one of those books sent by Gregory was recorded twice at St Augustine's Abbey in the Middle Ages where it was preserved with a Bible, also believed to be a relic of their founder; (3) MS 286 in the Parker Library was certainly in England by the late seventh century and was demonstrably at St Augustine's Abbey by at least the tenth century; (4) it had to have reached the abbey somehow, and it is of the right date and origin to have been sent from Italy in the late sixth century. That is generally as far as the evidence has ever been taken – very likely, on balance, but ultimately unprovable. The devil's advocate would argue that it might have come to England second-hand from anywhere in Southern Europe up to a century after its manufacture.

There is, however, another piece of evidence. A very interesting analysis of the text of the manuscript was published in 1933 by Hans Hermann Glunz (1907–44), of Frankfurt. He reaches a conclusion which is so astonishingly relevant to this discussion that I cannot understand why it has for so long been overlooked. Although Jerome's Vulgate translation gradually became standard in the Middle Ages, it replaced an earlier and less fluent version known as the *Vetus Latina* or 'Old Latin' text, which had circulated among Christians in the Roman Empire. The more accurate Vulgate had a slow start, and for several centuries many conservative users in Europe still preferred the familiar and homely Old Latin, which for a time survived in tandem. MS 286 in the Parker Library is recognized as more or less the oldest substantially complete copy of Jerome's new translation of the four Gospels in existence, no small claim. It has the *siglum* 'X' as primary witness in the family tree of the text. However, even Wanley noticed that it has many unexpected discrepancies from the standard Vulgate. Glunz documented these systematically, tabulating approximately 700 variants. Most are exceedingly slight or insignificant, comprising negligible differences of word order or spelling. In others the scribe has opted for readings taken from the Old Latin and not from the text of Jerome at all. Listen carefully, because here is where this gets very important. Gregory the Great, reputed donor of the Gospel Book to Augustine (and one-time possessor of the finger in the relic box at St Augustine's), was also a notable author of biblical commentaries. In the *Moralia*, his exposition on the book of Job, Gregory explains that both the Vulgate and the Old Latin were simultaneously in use in the Apostolic palace in Rome in his time, and that in his commentary he himself will be using the Vulgate, except where the wording of the earlier text seems better suited to his particular line of argument. Medieval pictures of Saint Gregory often show him writing while the Holy Dove whispers in his ear: it is as if Gregory received supernatural authority to his sometimes arbitrary editorial decisions.

Gregory also compiled homilies on the four Gospels, issued in 593,

OVERLEAF: The narrative of the shepherds in the field in the Gospels of Saint Augustine, with the Old Latin variant 'a son is born to us' corrected later to the Vulgate version 'born to you'

usq·indiemosten
sionissuaexdisrl̄
factumestautem
indieb·illis
exiitedictumace
sareaugusto·
utdescriberetur
uniuersusorbis
haecdescriptio
primafactaest
praesidesyrie
cyrino
etibantomnesut
profiterentur
singuli·insua·
ciuitatem
ascenditautem
etioseph·agal̄
laexaduiciuitate
nazareth
iniudaeamciui
tatemdauidque
uocaturbethlee
eoquodesseide
domoetfami

liadauid
utprofiteretur
cummaria des
ponsatasibi
uxorepraecnt̄
factumestaute
cumessentibi
impletisuntdies
utpareret
etpeperitfiliu
suumprimo
genitum
etpanniseumin
uoluitetrecli
nauiteumin
praesepio
quianonerateis
locusindiuer
sorio
etpastoreserant
inregioneeade
uigilantes
etcustodientes
uigiliasnoctis
supracregemsui

e iecce angelus
dni stetit iux
ta illos·
et claritas dei cir
cumfulsit illos
et timuerunt ti
more macno
et dixit illis ance li
lus nolite ti
mere
ecce enim euan
celizo uobis cau
dium macnum
quod erit om
ni populo
quia natus est uo
bis hodie salua
tor quiest xps
dns in ciuita
te dauid
et hoc est uobis
signum
inuenietis infan
tem pannis in
uolutum et po

situm in prae
sepio·
et subito facta est
cum angelo mul
titudo militiae
caelestis
laudantium dm
et dicentium
gloria in altissimis do
et in terra pax
in hominibus bo
nae uoluntatis
et factum est ut
discesserunt
ab eis angeli
in caelum
pastores loque
bantur ad in
uicem
transeamus usq
in bethleem
et uideamus hoc
uerbum quod
factum est quod
et
cit dns ostendit no
bis

four years before the mission to England. One of the oldest manuscripts of that text is also in the Parker Library, MS 69, copied in the late eighth century. Here, then, is the crucial observation. Every time wording from the Old Latin appears in MS 286, it is also the reading substituted by Gregory in his homilies on the Gospels. The conclusion, although Glunz does not draw it explicitly, is that this is a text which can only have emanated from the household of Saint Gregory himself in Rome.

Let us look at some representative examples in the manuscript itself. On folio 134r is the famous account of the angel appearing to the shepherds in the field near Bethlehem. In column 1, line 16, the original scribe wrote, "natus est nobis hodie salvator" ('today a saviour is born to us"); a later hand corrects this in darker ink to the standard Vulgate reading "natus est *vobis* ..." ('a son is born to *you*', Luke 2:11). The manuscript originally used Gregory's variant, derived from the Old Latin, which he chose, he says, because it still applies at a theological level in our own time, to us now and not just to the shepherds in history. Here is another. In the second column of folio 235v is the passage from John 10:11 in which Christ declares himself to be the good shepherd who will lay down his life for his flock. The scribe uses the Old Latin verb "animam suam *ponit* pro ovibus suis" (this is lines 20–21; a corrector changes it back to the Vulgate 'animam suam *dat*'). Gregory in his homily on the Gospel retains the older 'ponit', *places* his life for his sheep, rather than 'dat', *gives*, because, he explains, it implies a more conscious sacrifice by Christ. A third example is in the last line of folio 262r running on to the very top of folio 262v. It is the story of the moment after the Resurrection when Mary Magdalene first encoun-

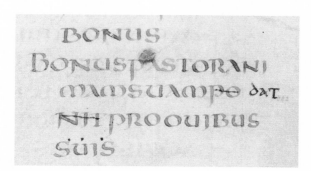

John 10:11 in the Gospels of Saint Augustine, with the old Latin variant whereby the Good Shepherd 'places' his life for his sheep, corrected later to the Vulgate reading 'gives'

ters the risen Christ and mistakes him for the gardener (John 20:15). Jerome's Vulgate wording reads, "illa estimans quia hortulanus *esset*", with the verb in the subjunctive, 'she, believing that he might be the gardener'. The manuscript in the Parker Library and Gregory's homily on the text both preserve the present tense, from the Old Latin, "quia hortulanus *est*", 'that he *is* the gardener', because Gregory interprets it in a spiritual sense as an actual reality and not as an abstract possibility.

Glunz hints that Gregory must have prepared a kind of edition of the Vulgate, salted with Old Latin variants in order to be read in parallel with his own commentaries. Even if it were not as deliberate as this, perhaps Gregory simply used a manuscript of mixed parentage then available to him in his household. In either case, the coincidence is too great. MS 286 can only have descended from Gregory's scriptorium in Rome. For that reason alone, I think we can drop the cautious 'so-called' and can identify the manuscript with some confidence as having been among those known to have been sent to England from Saint Gregory himself.

The manuscript is still lying on its bookrest on the long table in the Parker Library. Like many late-classical manuscripts, its parchment is very thin and sometimes almost weightless. Not every leaf is exactly the same size, which suggests that we have something not so different from the book's original dimensions. Because the book is usually kept tightly closed in a vault in conditions of optimum temperature and humidity, its release into a room warm enough to be comfortable to humans causes the parchment to absorb moisture rapidly from the air and, unless checked, the pages begin to curl up alarmingly under our eyes, as if they were alive, a bit like those paper fish one used to buy in joke shops, which you placed on the warmth of your open hand and which then curled to indicate whether you were in love (they always did, causing ribald merriment when we were ten). Curiously, the pages of the manuscript curl towards the darker, former hair-side of the skin, precisely the opposite of the natural curve of the skin when it was around the animal. That, I am told by conservators, is because the fibres on the outer surface of any pelt are denser and less flexible

whereas those on the softer pliable flesh side expand rapidly as they take in moisture. It is not a permanent curl; a page flattens out again quite harmlessly as we turn to another.

Jiří Vnouček, specialist in parchment from the Royal Library in Copenhagen, tells me that the manuscript is mostly or entirely made from sheepskin, which seems coincidentally appropriate for Gregory, whose chosen name is a pun on *greges*, 'flocks', and who wrote the *Pastoral Care* and constantly defined himself as a shepherd. The pages are scored with guide lines into two columns of 25 lines each. As with almost all manuscripts, the person preparing the ruling has pricked the measurements through several pages at once for ease of consistent duplication: in this manuscript, unusually, the vertical line of prickings runs down the centre of each page rather than in the margins. The fact that there is only a single line of holes indicates that the pages must have been ruled before they were folded, since the prickings had to be joined up across a double opening.

The collation of the book is given below, according to the formula explained in the Introduction.* The pairs of leaves were arranged into gatherings which are, or were, mostly of eight leaves each, although single leaves are now missing at various points, as shown in the collation. In the right-hand corners of the last leaves of gatherings ii–x are original marks by the scribe for assembling the book in the right order. These are written as a letter 'Q' (for "*quaternum*", usually meaning four pairs of leaves) followed by a Roman numeral between 'IIII' and 'XII'. Therefore most of three quires – numbered 'I' to 'III' – are now missing at the beginning, probably twenty-two leaves altogether, assuming that each was of eight leaves. This would be about right for the general prologues, the ten canon tables described by Elmham probably with their usual explanatory letter from Eusebius to Carpianus, together with the preface to Matthew and the first pages of the *capitula* list for Matthew. There was also clearly once a full-page picture of the evange-

* 4 flyleaves + i² [probably of 8, lacking i–v and viii, 5 leaves before folio 1 and one after folio 2], ii–x⁸, xi⁹ [of 10, lacking iv, a leaf after folio 77], xii–xvi⁸, xvii⁷ [of 8, lacking viii, a leaf after folio 130], xviii–xxvi⁸, xxvii³ [of 4, lacking iv, a leaf after folio 205], xxviii–xxxiv⁸, xxxv⁴ + 4 flyleaves (blank except for the addition of medieval documents).

list Matthew under an arch, like that of Luke still surviving, for it left unambiguous red offsets imprinted onto the leaf which once faced it. Whether there was also once a page of multiple narrative pictures for Matthew, as for Luke too, is unknowable, but it is very possible. There was certainly a portrait of Mark facing folio 78r, where there is a leaf missing and faint offsets also appear. A text leaf is missing after folio 130r, with Luke 1:17–33. The lost portrait of John, unexpectedly, was not apparently opposite the opening of his Gospel, where there are no marks and no gap in the collation, but instead it faced the prologue, leaving slight marks on the adjacent page. A further page of multiple pictures, however, was at the very end, leaving ghostly traces of its presence on folio 215v. Those apart, the collation shows the manuscript to be intact.

The inclusion of integral pictures, even if only two now survive, is of importance too in assigning the manuscript to an origin under the patronage of Gregory the Great, since Gregory himself made a famous defence of the value of religious illustrations, writing to Serenus, bishop of Marseilles. Pictures, he said, are useful for teaching the faith to the unconverted and for conveying sacred stories to the illiterate. That would be exactly what Augustine would have needed. According to Bede, Augustine made an initial appointment with King Ethelbert of Kent, and showed him a picture of Christ painted on a panel, and then proceeded to preach.

Let us now look more closely at the two remaining full-page pictures. The first is the series of twelve little square scenes, set within a trompe l'oeil frame of red-veined marble. This is on folio 125r. It comprises four rows of three square pictures each, showing incidents from the Passion of Christ. To describe it as resembling a comic strip would be banal, but this is indeed a succession of graphic images telling a story in pictures. The subjects are, briefly, the entry into Jerusalem, the Last Supper, the Agony in the Garden, the raising of Lazarus (oddly out of sequence, and if there is a reason for this I cannot think of it), Christ washing the feet of the disciples, the kiss of Judas, the arrest, Christ before Caiaphas, the mocking of Christ, Pilate washing his hands, Christ led out to be crucified, and the carrying of the Cross. You will notice

that the Crucifixion and Resurrection, the central events of the Passion, do not appear. I would guess that the subsequent sequence of pictures, now lost from later in the manuscript, would have completed the story. On the same principle, the earlier page of scenes attached to Matthew's Gospel probably showed the life of Christ from his nativity to adulthood.

The second picture is the large portrait of Saint Luke, nine pages later. The evangelist resembles a white-bearded Roman senator, seated on a throne with his legs crossed, resting his chin on his hand and holding an open book on his lap. He is not shown in the act of writing, as he might have been in a Greek Gospel Book, but is listening thoughtfully for divine inspiration. The composition here may reflect some late-antique prototype showing a philosopher rather than an author. On either side of Saint Luke are marble columns, alternately red and green, with white marble capitals supporting a lintel and a great arch, all as if straight from a stately throne room in imperial Rome. Within the tympanum at the top is a half-length figure of a winged bull, the symbol of Saint Luke in art. Across the lintel are words about the ox, quoted from the *Carmen Paschale* of the fifth-century poet Sedulius; echoes from the corresponding verses on the symbols of the other evangelists (a man for Matthew, a lion for Mark, and an eagle for John), or sketches of the symbols themselves, occur on folios 2v, 78r and 207v, and are part of the evidence for similar portraits once present in the book. This is very early usage of these pictorial symbols, which derive from Ezekiel's vision of the throne of God (Ezekiel 1:10 and Revelation 4:7). The man, lion, ox and eagle will reappear in the Book of Kells (Chapter Three) right through to pictures of the evangelists in the Spinola Hours (Chapter Twelve). Between the pillars on either side of Saint Luke here are vertical rows of tiny pictures, six on each side, showing incidents from Luke's Gospel, from the annunciation to Zacharias (Luke 1:11) to Zacchaeus up the sycamore tree (Luke 19:4). The scenes are all identified precisely in the margins in an eighth-century English hand. Given that the minute scenes have little to distinguish them, the caption writer either had access to some larger and less generic version, such as a panel or a

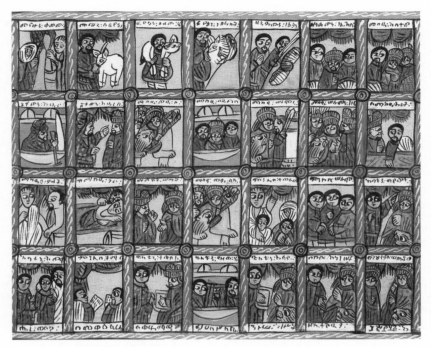

Modern Ethiopian religious paintings on panels are often curiously similar in format to the multiple images in the Gospels of Saint Augustine and may preserve an ancient tradition

fresco, or he was simply inventing likely identifications wherever the subjects were unclear.

There is a considerable literature on the iconography of the pictures in the Gospels of Saint Augustine, which need not detain us now. The style is entirely classical, almost three-dimensional, and painted in the soft Mediterranean colours familiar to us from fragments of Roman fresco, palest cornflower blue, creamy white, terracotta, and delicate orange. If there are almost no surviving decorated European manuscripts from the sixth century, there are certainly mosaics and wall-paintings in churches, with which satisfying parallels can be drawn. The manuscript's image of Saint Luke is itself placed in an architectural setting. The picture with multiple scenes may also be based on something once familiar in the context of churches. It is shown like a single great painting framed in classical marble. On my one visit to Ethiopia with a party from Corpus Christi College I was very struck by the similarities of this

composite design to the huge wooden panels of primitive-looking narrative cycles of religious scenes similarly arranged in repeated rows of consecutive rectangles, exactly as here, hanging today in Ethiopian churches. Very little has changed in religious practice in Ethiopia since about the date of the Gospels of Saint Augustine. As I looked at those multiple panels used there to convey Christian stories to the illiterate, I could not help wondering whether churches in Rome in the time of Gregory the Great might also have owned similar framed pictures, and whether the composition in the manuscript reflects wooden panels either familiar from Roman basilicas or even among the possessions brought to England by Augustine himself.

While I was writing this chapter, Professors Andrew Beeby and Richard Gameson, both of Durham University, came to the Parker Library with portable Raman spectroscopy equipment, which allows the chemical identification of pigments by analysing the wavelengths of laser beams bounced off spots of colour. I seized the chance and brought out the Gospel Book of Saint Augustine. They were able to tell me, for instance, that the three kinds of red used in the manuscript are reddish-brown haematite (or possibly red ochre), bright orange red lead, and vermilion, which is used for the red writing. These are naturally occurring minerals. The blue, they say, is indigo. That is made from the flowers of a plant, *Indigofera tinctoria*, grown commonly in Italy and elsewhere, but originally, as its name suggests, reputed to have come from India. The yellow they cannot identify by the Raman technique, except to say that it is not orpiment. Richard Gameson remarked too that the colours are applied in remarkably thin wash, unlike (say) early Greek manuscripts, where the paint is often so thick that it flakes off. The pigments here, as insubstantial as watercolour, remain secure in a manuscript which must have been subject to much handling and changes of climate.

The manuscript does not contain gold. Perhaps that also was deemed too vulnerable and fragile for a book which was to be carried across Europe. Strictly speaking, the word 'illuminated' as applied to manuscripts implies the use of gold, which sparkles and catches the light. About half the items described in this book are not technically il-

luminated manuscripts at all, including the Book of Kells. It is not that gold was an especially rare commodity in the sixth century, for there are many examples from this period of Mediterranean jewellery and mosaics which are rich with gold. However, this is mostly a very muted manuscript. The two picture pages are stupendous rarities, but the text pages are undecorated, not even with initials. Instead, any gold would probably have been on the manuscript's original binding. The ancient flyleaf at the front has two faint lozenge-shaped green stains offset from some brass or copper fitting once nailed through the thickness of the covers, presumably pins for securing fittings of some kind. There is an image of a jewelled bookbinding in the sixth-century mosaics in the church of San Vitale in Ravenna, showing the Emperor Justinian accompanied by priests, one of whom is holding what is surely a copy of the Gospels, bound in boards covered in gold which is inset with ornament in green and white. There also exists a detached jewelled bookbinding of the late sixth or early seventh century still in the treasury of the cathedral of San Giovanni Battista in Monza, near Milan, to which it was given by Theodelinda (*c.* 570–628), queen of the Lombards. We

The jewelled book cover in Monza, probably from the Gospels presented by Saint Gregory to Queen Theodelinda, possibly the kind of binding once on the Gospels of Saint Augustine

know from his epistles that Gregory the Great had sent her a Gospel Book. It does not survive, but, if this is its cover, as is usually assumed, it may be a clue as to the type of binding likely to have been on MS 286, also sent from Gregory. The binding in Monza is of wood covered with gold framed and decorated on both covers with cruciform designs of gold filigree set with coloured stones and pearls between classical cameos. It is even possible that parts of some such binding could have survived on the Gospels of Saint Augustine until the period of looting at Reformation, when it would have been ripped off for the value of its metalwork and jewellery, in which violent process the twenty-two lost leaves at the beginning were torn away too.

The manuscript in the Parker Library is probably the oldest non-archaeological artefact of any kind to have survived in England (it is hard to envisage anything else continuously owned and in use in the country since the late sixth century). It is by some margin the oldest surviving illustrated Latin Gospel Book anywhere in the world. It is matched in date by hardly a handful of other illustrated Gospel manuscripts of comparable date from the Christian orient, and I would not care to assign absolute precedence to any of them. The most mysterious of all are the two volumes recently thrust into prominence following their rediscovery in the monastery at Abba Garima in northern Ethiopia, written in the Ge'ez language. Anything seems possible, in that mysterious culture fossilized from late antiquity. Parts of the Abba Garima manuscripts are perhaps very ancient indeed, and carbon dating of the pages sampled is said to have indicated a secure origin around the fifth to seventh century, which might otherwise have seemed hard to credit. They too include full-face portraits of the evangelists, staring out at us from framed compartments. More certain in date and better documented, however, are the famous Rabbula Gospels, in Syriac translation, signed by the scribe Rabbula in the year 586. That manuscript is now in the Biblioteca Medicea Laurenziana in Florence. It is profusely and vigorously illustrated but is apparently overpainted (I have seen the original, where the colouring looks worryingly refreshed). There are also two marvellous Gospel Books in Greek with narrative pictures, utterly real, from around 600 or shortly before. Both are remains of

luxury codices written in gold or silver on purple-stained parchment, with delicate dancing illustrations. One is in the diocesan museum in Rossano, in Calabria, in south-east Italy, and the other is in the Bibliothèque nationale in Paris, known as the Codex Sinopensis from having been acquired in 1899 at Sinop on the Black Sea in northern Turkey. Those, with the Latin Gospels of Saint Augustine in the Parker Library, are the oldest illustrated copies of the Gospels known, and it is a rarefied gathering.

There is an extraordinary aside to this line-up of the sixth-century illustrated manuscripts. But for the merest chance, the Rossano Gospels might now also have been in the Parker Library. My energetic nineteenth-century predecessor as Fellow Librarian of Corpus was the black-bearded acquisitor and classicist, Samuel Savage Lewis (1836–91). His wife was Agnes Smith Lewis, one of the twin 'sisters of Sinai', extraordinary travellers and explorers of Levantine Christiandom in an age when such pursuits were almost exclusively male. In the biography she wrote of her husband after his death, Agnes Lewis tells of their visit together to Rossano in December 1889 to see the famous Gospel Book. No one could find it. Eventually it was tracked down to the house of an archdeacon, who kept it in a cardboard box in a drawer in his bedroom. The cleric and Lewis entered into whispered discussion over its value and the need for money to buy church furniture. The word "immediamente" was overheard. Back in Naples, these unexpected negotiations proceeded in earnest. The sum of £1000 was suggested. Mrs Lewis continues: "So after telegraphing home for funds, he formed a mad project of taking the train back to Rossano, arriving at mid-night, meeting the priests by appointment at the station, and returning with the purchased MS in his pocket by the next train." There was clearly a huge domestic row, as can happen on holiday, and Agnes Lewis, in a deplorable fit of Presbyterian righteousness, vetoed the deal. The rest of the Lewis private collection of books and antiquities is now still the property of Corpus Christi College.

When the Gospels of Saint Augustine arrived in England, it was probably initially a very practical book, not yet venerable enough to have become a relic. It would doubtless have been carried in processions

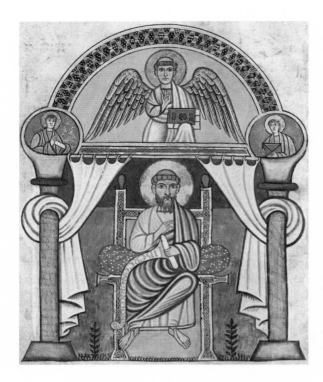

Saint Matthew, from
the eighth-century
Codex Aureus now
in Stockholm, copied
from a similar image
once in the Gospels of
Saint Augustine

and during the liturgy. It may have been used as an exemplar for copy-
ing other manuscripts. We would know this only if identical readings
could be found in other Gospel Books of English manufacture, but too
little survives to draw clear conclusions. According to Bede, a renewed
interest in biblical scholarship took place in St Augustine's Abbey (not
yet called that) in the time of Hadrian, abbot there 670–709. He was a
North African by birth, fluent in Latin and Greek, previously an abbot
in southern Italy. MS 286 is extensively corrected by English hands of
the late seventh century, exactly the time of Hadrian, bringing it into
line with the mainstream and conventional Vulgate, straightening out
the Old Latin variants cited above. Some words are erased and rewrit-
ten, or are expunged by crossing out or marking with rows of dots, and
alterations and more accurate phrases are inserted in darker ink. From
that time onwards, then, the manuscript would no longer have had a
text distinctive enough to tell us whether it was used again as an exem-
plar, but this is likely, given the authority conferred by its provenance.

Its pictures, however, undoubtedly had an enduring afterlife in Canterbury. Its evangelist portraits were copied into the Codex Aureus, a magnificent English Gospel Book of the mid-eighth century, now in the royal library in Stockholm. Frustratingly, the manuscript in Sweden is now missing its picture for Luke. Since the portrait of Luke is the only one which survives in MS 286, a direct comparison between the images of the two manuscripts is impossible. However, the Codex Aureus does furnish us with what are doubtless reliable reproductions of the lost miniatures of Matthew and John in the Gospels of Saint Augustine. Their compositions are almost identical to the surviving Luke picture, showing the authors seated under arches with their symbols in the tympana above. The Matthew miniature in Stockholm even has the little wispy plants which appear in the Gospels of Saint Augustine growing beside Luke's chair. It is not known where the Codex Aureus was made, except that it was stolen in the ninth century by a raiding party of Vikings and it was then ransomed back for gold by a couple in Canterbury, Aldorman Ælfred and his wife, Werberg, and so it is likely to have come from Canterbury originally. The symbol of the ox above Luke in MS 286 was also copied unambiguously into a Gospel Book now in the British Library, adapted from a whole Bible which was demonstrably made at St Augustine's Abbey in the later eighth century. The creature is exactly the same, lying with its limp-wristed hoof resting daintily across a book. This adds to the virtual certainty that MS 286 was indeed at St Augustine's long before the first charters were added in the tenth century.

The page with the rows of pictorial squares, like those in Ethiopian churches, had an even more long-lasting influence on English art. Most strikingly, the scene of the Last Supper at the top centre was copied in the late eleventh century, with negligible alteration, into the Bayeux Tapestry, no less, where the scene becomes Bishop Odo of Bayeux blessing a chalice at a round table, after the Normans had landed at Pevensey in September 1066. The Gospel Book of Saint Augustine therefore has a part to play in the argument that the Bayeux Tapestry was actually made in Canterbury. The design of multiple squares forming a narrative sequence is apparently echoed as late as the twelfth century in the prefatory cycle from the Eadwine Psalter, written in Christ Church

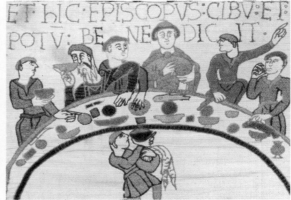

The picture of the Last Supper in the Gospels of Saint Augustine was copied nearly 500 years later into the Bayeux Tapestry, where it was adapted to become the scene of Odo of Bayeux feasting with his nobles

Cathedral Priory in Canterbury around 1160. Although the style and subjects are updated, the format is identical and it is unique to Canterbury. The final manifestation of the pictures is in the prefatory cycle of the so-called Anglo-Catalan Psalter, now in Paris, illuminated in Canterbury shortly before 1200, 600 years after the Gospels of Saint Augustine entered England. Some art historians see parallels too in the patterns of late twelfth-century stained glass surviving in Canterbury. There is even a possible link with the architecture of the Trinity Chapel in Canterbury Cathedral, beyond the high altar, built in 1179–84 and later adapted as the shrine of Saint Thomas Becket, one of the most visited pilgrim destinations in Europe. Around the chapel are pairs of columns surmounted by white capitals and supporting arches above: the pillars are twinned, with one each in red and green mottled marble, exactly like those shown flanking the classical evangelist of the Gospels of Saint Augustine.

Although the manuscript was at St Augustine's Abbey, not at the cathedral, it has a renewed modern association with Canterbury Cathedral. Those who live in that city sometimes call it the 'Canterbury Gospels'. It is the book used now for the swearing of the oaths of office at the enthronement of each new archbishop of Canterbury. The line of archbishops from Saint Augustine onwards has continued in direct succession since the sixth century, far longer than there have been kings of England or any other public office. Matthew Parker would have seen

divine approval in this continuity. The present incumbent is the 106th to hold the title. Eighteen of the archbishops have been canonized. Those same visitors to the Parker Library who doubt the manuscript's association with Saint Augustine often also scoff, "I suppose its use by the archbishops is only another of those spurious traditions invented in the nineteenth century." No it is not; it is not even so old. It started as recently as the installation of Geoffrey Fisher in 1945. There is an enchanting typescript account in Canterbury Cathedral Archives in which William Urry, archivist then, describes the arrival of the manuscript in a police car from Cambridge at 12.30 precisely on 27 June 1961, for the enthronement of Michael Ramsey, the second occasion of its use. It was a day like something from an old-fashioned comedy film in which the Gospels of Saint Augustine was chased around the cathedral precincts followed by Sir George Thompson, master of Corpus, Michael McCrum, senior tutor, and several hot-footed policemen, and ended up on the Urrys' piano when tea was served afterwards.

I myself have accompanied the manuscript to Canterbury twice, for the enthronement of Rowan Williams on 27 February 2003 and again for that of Justin Welby on 21 March 2013. I do not want to get too distracted by accounts of those memorable days (although I could, if you would like me to), for I have a related event to describe in a moment. I have, however, one experience from Archbishop Williams's enthronement which has a possible relevance in the study of early manuscripts. I had to enter the cathedral that day through the west door, joining the procession just as they began singing the first hymn, which was 'Immortal, invisible, God only wise', a Welsh tune in homage to the nationality of the new primate. I was holding the Gospels of Saint Augustine open on a cushion. It was secured by two ribbons of transparent conservation tape. Upwards of 2,500 people singing a familiar hymn very loudly in an enclosed stone building makes the air vibrate. This is the nature of sound waves. The parchment leaves of the manuscript, as we saw earlier, are extremely fine and of tissue thinness, and they picked up the vibration and they hummed and fluttered in time with the music. At that moment it was as if the sixth-century manuscript on its cushion had come to life and was taking part in the service. It occurred to me that

maybe ancient Christian manuscripts always did that, for their parchment is generally much finer than in later books, and perhaps one reason for carrying early Gospel Books open in processions at all was because this effect is astonishingly powerful and moving. I have to add, in the interests of scientific detachment, that it did not occur again in 2013.

Finally, I return to the incident with which I opened this chapter. It began with a tentative telephone call in June 2010 from Canon Jonathan Goodall, the archbishop of Canterbury's chaplain at Lambeth Palace, with what he called 'an interesting idea'. He explained to me that he and his colleagues were planning the visit of Pope Benedict XVI to England that September. This was only the second occasion when any reigning pope had been to Britain. The proposal, he said, was for the Pope and the Archbishop to preside jointly at an ecumenical service in Westminster Abbey. The reason for choosing the Abbey, rather than, say, the cathedrals of Canterbury (Anglican) or Westminster (Catholic), is because the Abbey is a 'royal peculiar', which means that it is subject directly to the Queen and is independent of the jurisdiction of Canterbury. Therefore the Pope and the Archbishop would be equal guests of the Dean, without the diplomatic delicacy of precedence. Westminster Abbey was also once, of course, a medieval Benedictine monastery, and (especially appropriately, in this context) one dedicated to Saint Peter. Would we, Canon Goodall wondered, consider allowing the Gospel Book of Saint Augustine to be carried into the Abbey in the procession and to be jointly reverenced by the Pope and the Archbishop after the reading of the Gospel text for the day?

The formal request trickled its way slowly through the bureaucracy of Corpus Christi College. Facilities for insurance and transport were put in place. On the morning of Friday, 17 September 2010, I was at the College well before six. The manuscript had been packed the previous night in a dark-blue bombproof case. We strapped it into its security van (not a police car) and I travelled with it down to London and along the Embankment to Westminster Abbey. By eight o'clock it was locked in the safe below the library in the east range of the cloister, in the care of Tony Trowles, Abbey librarian. The whole service was meticulously rehearsed from 11.30 onwards. We were all walked through our paces,

even the Archbishop, who was there (the Pope was not), and some last-minute modifications were made to enable appropriate but unobtrusive television coverage. For the rehearsals I used a modern book in place of the original.

By mid-afternoon the whole of Westminster was cordoned off by police. Security was very tight indeed. Re-entering the Abbey precincts shortly before four o'clock was difficult. A clergyman in the queue happened to recognize me, and I was hurried in, back to the cloisters, where we prepared the book onto a kind of modified red cushion, rather like an invalid's padded breakfast tray. We had been asked if the book could be opened at one of its picture pages but this seemed curatorially irresponsible. Instead we turned it to the Latin words of the designated Gospel reading for the service, Mark 10:35–45, so that the Pope would be able to venerate the actual text just read.

I was to be dressed in suitable academic regalia, the first time I had worn a Cambridge Ph.D. The manuscript and I were escorted to the Jerusalem Chamber by the west door of the Abbey (it was the room where Henry IV died). The affable Cardinal Archbishop of Armagh was already there. I sat in a corner with the manuscript on my lap. One by one, the heads of the various Christian churches of Britain arrived too, some already arrayed in underlayers of medieval finery, and others with trim little suitcases, from which mysterious apparel and ornaments were unfolded. Furtively watching them deck themselves, like walking Christmas trees, each after his or her own kind, was an unforgettable pleasure of the day. There were the moderators of the Presbyterian Church and of the Free Churches of England and Wales and of the United Reformed Church, chattering to bishops and archbishops; there were the presidents of the Methodist Conference and, in striking contrast, of the Council of Oriental Churches in the United Kingdom, with the Archbishop of Thyateira and Great Britain; and the Methodist and the Lutheran and the Salvation Army, and many others, gathering and robing.

By now the quiet anticipatory rumble of several thousand invited guests in the Abbey was eclipsed by singing and shouting from enormous and motley crowds in the street outside. The cardinal and I walked over and watched from the window. There was a swathe of

banners and flags and placards, protesting at and welcoming the Pope in equal measure. Probably Saint Augustine of Canterbury had encountered not dissimilar gatherings when he disembarked in 597. A canon switched on a television in the Jerusalem Chamber, so that we could watch the Pope's speech in Westminster Hall, which told us too when the papal entourage was about to cross the road towards the Abbey, which was the cue for our strange panoply to move out from the Chamber into places in the west end of the nave. Clutching the manuscript, I took up my appointed position at the memorial stone for David Lloyd George, beside a pillar. "Don't you sometimes think, What *am* I doing here?" I whispered to the polychrome verger beside me, holding the glittering processional Cross of Westminster. He looked puzzled. "No," he said; "not really. This is normal work for us."

The Pope's entrance through the west door was heralded by roars

Pope Benedict XVI in Westminster Abbey venerating the Gospels of Saint Augustine, held by Christopher de Hamel, watched by Rowan Williams, Archbishop of Canterbury

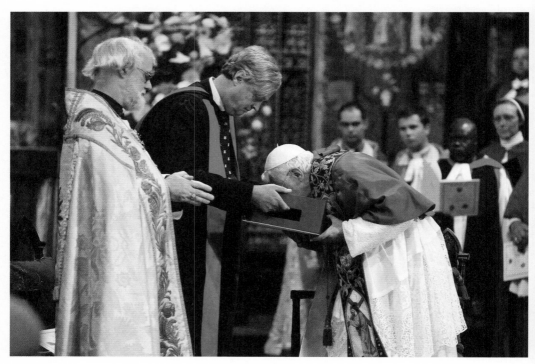

of the crowd in the street and the whirring of innumerable cameras, like the sound of thousands of birds taking flight. After the Pope was greeted and robed, we all set off in stately procession down the long gothic nave of the Abbey and up through the choir and across the mosaic pavement laid for Henry III in 1268. I placed the precious volume on the high altar, doubtless much as it would have been in Saint Augustine's Abbey in the early Middle Ages, and I bowed (a bit self-consciously) and moved to my seat in the adjacent sedilia. The long procession continued, culminating in the Dean, the Archbishop of Canterbury, and the Pope, with attendant chaplains. Later, after the reading of the Gospel (in English, by the Moderator of the Church of Scotland), my brief task was to bring the manuscript forward on its cushion to the Pope, who bowed in front of me and kissed the pages, and then to turn to the Archbishop, who did the same. My primary worry was not to slip over on the deceptively smooth medieval stone steps down from the high altar and back again. Tripping up, which I am capable of doing at the best of times, would have made spectacular television but would have been bad for the manuscript. Afterwards, during the singing of the Magnificat, the Dean censed the altar, endlessly waving the smoking thurible back and forth over the open manuscript, and I wondered what I would do if I saw a crumb of smoldering charcoal landing on the parchment.

In fact, all was well. Afterwards we could not even smell the incense on the pages. The Archbishop in his address recounted how the Church in England had ultimately been a papal foundation, represented by the Gospel Book sent here by Pope Gregory in Rome. At the scheduled moment, I carried the volume out again, back to my post on top of Lloyd George, and I watched the Pope pass by and out into applause in the dusk outside. When the congregation had dispersed and the streets of Westminster were reopened, the security van drove in through into Dean's Yard and we repacked the manuscript for its return journey. By the late evening it was safely home in Cambridge from its recaptured moment of medieval splendour, and, in the dark, back on its shelf in the vault, it reverted once again to being MS 286 in Matthew Parker's library.

The Codex Amiatinus

c. 700
Florence, Biblioteca Laurenziana,
Cod. Amiat. 1

Very little has survived above ground from seventh-century England. Traces of architecture of the period can still be seen in the west end of the parish church of St Peter at Monk Wearmouth, in the modern county of Tyne and Wear in the far north-east of England in what was ancient Northumbria. Despite being a designated World Heritage Site, however, the overall setting of the building there is disappointing today, in the suburbs of the modern industrial town and port of Sunderland, looking much like any Victorian parish church in a trim municipal park encircled by houses. There are neat notices on the lawn to the south of the church indicating outlines of recent archaeological excavations, but it takes more than my imagination to envisage this as a wild Dark Age landscape near where the great Wear river emerges into the North Sea (neither of which are now within sight of the church), given in 674 by Ecgfrith, king of Northumbria, for the foundation of a great monastery on the model of those in late-classical Rome.

The first abbot and founder of this new northern abbey was Benedict Biscop (*c.* 628–90), a local nobleman who visited Rome no fewer than five times in his life. These experiences clearly made a huge impact on his cultural outlook. He had decided to become a monk. On his third trip, in the year 669, he escorted back to England the seventh archbishop of Canterbury in succession to Saint Augustine, Theodore

of Tarsus (602–90), who is credited with bringing Greek learning to southern England. In return, Theodore appointed Benedict as acting abbot of the neighbouring monastery in Canterbury later known as St Augustine's Abbey. For a time Benedict Biscop therefore had custody (as I do now) of the Gospel Book of Saint Augustine, probably by then already treasured in memory of the abbey's founder. When several years later in 674 King Ecgfrith offered the land beside the Wear for a monastery, Benedict was the obvious candidate to send back up to Northumbria. We know the details of this from the incomparable histories of Bede (*c.* 672–735), towering genius among the Anglo-Saxon writers.

After establishing the new house at Wearmouth, Benedict set off again for Rome in 679 accompanied by a younger monk, Ceolfrith (*c.* 642–716). The two travellers bought or somehow obtained there 'an immeasurable quantity of books of all kinds', as Bede expressed it, which will figure prominently in the story which follows. Bede, who knew them both, implies that it was specifically Ceolfrith rather than Benedict who acquired in Rome the text of the new translation of the Bible (that is, Jerome's Vulgate) in three manuscripts, together with one vast pandect – or comprehensive volume – of the entire Bible in what was described as an 'old' version of the Scriptures. These and other books, as well as relics and sacred treasure, were all shipped with Benedict and Ceolfrith back to Wearmouth. The English monks also enticed personnel from Rome, including a cantor named John to teach the Roman practice of chanting, and probably practising craftsmen. The notices for visitors outside the church in Monk Wearmouth today record how excavations of the site have revealed traces of Roman glass and mortar, techniques otherwise unknown in northern Europe at that date. The books brought from Rome, highly treasured in Bede's time, have long since perished, except (perhaps) for a tiny sixth-century Italian fragment from Maccabees in the Latin translation of Jerome, which survives by chance through its reuse as a flyleaf in a medieval manuscript in the library of Durham Cathedral.

In 682, King Ecgfrith gave the monks further land at Jarrow, about seven miles to the north-west, near the mouth of that other great Northumbrian river, the Tyne. The monks decided to build a second

church. Abbot Benedict Biscop entrusted this task to Ceolfrith, who moved up to the new site with twenty members of the monastery, including Bede, who was then a young boy and a junior monk. The two foundations were conceived as one community, within manageable walking distance of each other. Modern historians commonly refer to the twin monasteries as 'Wearmouth–Jarrow', as if they were a single location, and it is customary to refer to 'the library' or 'the scriptorium' of Wearmouth–Jarrow as indistinguishable entities. Wearmouth was dedicated to Saint Peter and Jarrow to Saint Paul, the joint patrons of Christian Rome. It is likely that Ceolfrith transferred up to Jarrow the manuscripts that he had himself acquired in Rome, since Bede clearly had continued access to them, but they would nevertheless have remained the joint property of both churches. In 686, Ceolfrith was appointed abbot of both houses, and he remained living at Jarrow for a further thirty years.

The church of Saint Paul in Jarrow today is incomparably more evocative than its twin sibling further south. It is outside its modern town, in a beautiful grove of trees set with paths and benches, where I sat taking notes in the dappled sunlight. To the south side of the church are twelfth-century ruins of the monastery rebuilt on Ceolfrith's site, which, like that at Wearmouth, has now been fully excavated and is marked out clearly on the grass. The ground there, which was once terraced, slopes down steeply to the muddy banks of the slow-moving river Don, just before it joins the mightier Tyne as it flows out into the ocean. East of the church is the wasteland known as Jarrow Slake, and in the distance are the cranes and oil containers of the Port of Tyne dockyards. The proximity of the sea was a benefit to the builders and suppliers of the abbey, but also a danger, for the monastery was first sacked and looted by the Vikings in 794.

It was a Sunday morning when I was there. An old man joined me on my bench. I asked about the opening hours of the church. He said that the morning service would begin at eleven o'clock and I replied that I would be glad to attend it. He told me much more, not all of which I really understood, for the robust Geordie accent can still be impenetrable to southerners. Ceolfrith and the visiting Roman cantor

The church of Saint Paul in Jarrow, viewed from the north side: the tower and the east end are survivals from the Anglo-Saxon monastery

had doubtless conversed in Latin, which might have been easier. Inside the church itself we sat on wooden chairs in the nave, rather than in pews (my new companion disapproved of this recent innovation), and I could see up through the base of the tower into the tiny early chancel at the east end, which dates from the time of Ceolfrith himself. On its right wall, the southern side, are three tiny original seventh-century windows, one now set with recovered fragments of Anglo-Saxon coloured glass, the earliest known. Windows facing south were characteristic in early Irish churches too, for that was the direction of sunlight. The equivalent window on the north wall at Jarrow is modern, designed by John Piper and unveiled in 1985 by Diana, Princess of Wales. High above the chancel arch, inset into the wall and visible from the nave, are two tangent stone tablets with their famous contemporary inscription in Latin recording the dedication of this church of Saint Paul in 685, on IX Kal. May (23 April) in the fifteenth year of King Ecgfrith and in the fourth year of the founder Abbot Ceolfrith, who is mentioned here by

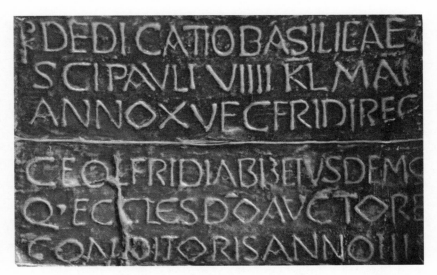

The stone recording the dedication of Jarrow Church in 685 in the fifteenth year of the reign of King Ecgfrith and the fourth of the abbacy of Ceolfrith

name. It was a moving experience to sit in prayer beneath words and names which would have been seen daily in that very same church by Ceolfrith and Bede so long ago. Whether the monks would have recognized much of the Anglican Sunday service is another matter. Large parts of both the choir and the sparse congregation were women. For the reading of the Gospel, however, the two priests, robed in green and white, processed out into the nave carrying the sacred book aloft with its elaborate covers closed: that would be imaginable with one of the manuscripts brought back from Rome in 680.

There are two related early eighth-century accounts of the copying of further biblical manuscripts here under the patronage of Ceolfrith. Given the rarity of any documentary references to Anglo-Saxon book production, these deserve to be looked at carefully. The first occurs in an anonymous life of Ceolfrith, evidently written by one of his monks. It records that Ceolfrith greatly enriched the furnishings of the church at Jarrow and that he added notably to the collection of books which he and Benedict Biscop had brought back from Rome. The author explains that Ceolfrith commissioned three further entire Bibles (or pandects – the word we encountered earlier), of which one was placed in

each of the churches of the twin monasteries, so that whoever wanted to read a passage from either testament could do so without difficulty. There is no certain date for this, except that it happened during Ceolfrith's abbacy, but these manuscripts are likely to have been begun in the last decades of the seventh century, and the work may well have continued into the beginning of the eighth century.

Bede, who was undoubtedly very familiar with the copy displayed in Jarrow church, supplements this account slightly in his *Historia abbatum*. He describes Ceolfrith as having brought a pandect of an 'old' translation of the Bible from Rome and having then increased the benefaction by making three further copies of it but according to the 'new' text instead. It is this last observation which is important. It is typical of Bede that he noticed and recorded which translation was being used. The scribes under Ceofrith's direction modelled their copies on the format of the great pandect they had received from Italy, but now they substituted its text to be that of Jerome's more modern Vulgate. That fact will become significant in the story.

One new Vulgate Bible for each of Wearmouth and Jarrow is understandable, although impressive, but a third copy? We can only speculate. Perhaps there were plans which never materialized for the foundation of a third Northumbrian house, as distinct but as indivisible as the Trinity (a conceit they would have liked); or perhaps – he would not be unique in this – Ceolfrith secretly wondered if his career would lead him yet further, perhaps as archbishop of Canterbury on Theodore's death or even as pope, and maybe he kept one volume in reserve for any new promotion he might be offered elsewhere. Both the anonymous *Vita Ceolfridi* and Bede tell us what happened eventually. At the advanced age of seventy-four, Ceolfrith decided to go back again to Rome and to take the spare third pandect with him as a gift for Saint Peter, prince of the apostles. (It was common medieval practice to refer to a church by the name of its patron saint, as if still alive: what is meant, of course, is the papal court.) The implication is that this announcement came as a surprise to the community of Wearmouth–Jarrow. We do not know his motive, any more than Bede did. Was Ceolfrith still privately hoping for an appointment in Rome, for which

he might need the Bible to ease the negotiations? Pope Constantine had died on 9 April 715, and Ceolfrith's decision to travel was probably made around the time that the news reached England. Or had there been some tacit understanding in 679 that he could take books from Rome to Northumbria in exchange for eventual transcripts? Both are possibilities. The *Vita Ceolfridi* records the exact words of an inscription which was inserted at the beginning of the volume, presenting it to Saint Peter from Ceolfrith, abbot of the English, from the furthest ends of the earth ("extremis de finibus"). In June 716, as the account tells us, this third pandect, already suitably inscribed, was therefore carried down that slope below Jarrow church into a ship in the river Don and into the Tyne and out to sea, accompanied by Ceolfrith and a retinue of monks. This is the first documented export of a work of art from England. Alas, Ceolfrith died on the journey in Langres in central France in September, and that, for over a thousand years, was the end of the story.

There is a famous early manuscript Bible in Italy known as the Codex Amiatinus. It was an ancient treasure of the monastery of San Salvatore on Monte Amiata, in southern Tuscany, from which it takes its name. It is recorded in a list of the abbey's relics dated 1036, describing it as being an Old and New Testament 'written in the hand of the blessed Pope Gregory'. An attribution to Saint Gregory the Great (*c.* 540–604) was a not unreasonable ascription, since it is written in Italianate uncials, very like the Gospel Book of Saint Augustine, and it was never doubted that it had been made in Italy. It opens with a full-page dedication which presents the book to the monastery of the Saviour (*Salvator*) from a Peter, abbot of the Lombards, 'from the furthest ends of the earth'. This is an echo of the wording of Deuteronomy 28:49. Even today, Tuscans regard all Lombards as people of an alien realm beyond the furthest frontiers of civilization (and vice versa), and the strangely worded inscription was contentedly accepted in San Salvatore at face value. The book is the oldest surviving entire manuscript of the Vulgate and it is still the principal witness for establishing the text of the Latin Bible.

Constantin Tischendorf, who made a brief and not very creditable appearance in the previous chapter, edited the text of the Latin New Testament from the Codex Amiatinus in 1854. He noticed that there had been minor alterations in the presentation inscription and that the names of Peter, abbot of the Lombards, and of the receiving monastery both appeared to have been written over erasures. Thirty years later, the epigrapher Giovanni Battista de Rossi (1822–94) finally deciphered the names underneath and revealed that the manuscript had originally been dedicated to Saint Peter from one Ceolfrith, 'abbot of the English'. Soon afterwards, the Cambridge professor of divinity, F. J. A. Hort (1828–92), recollected that these words matched the transcription in the *Vita Ceolfridi* and first realized that this must be the actual pandect from Wearmouth–Jarrow, untraced since it left Northumbria in 716. When the news broke in February 1887, it caused a sensation, especially in Britain. That was an exciting decade of biblical discoveries in the Near East and at Oxyrhynchus in Egypt, but few announcements have ever been so unexpected as the revelation that the oldest complete copy of the Latin Bible was actually made in England. In 1890, H. J. White, later dean of Christ Church, Oxford, called it, with a touch of patriotic exaggeration, "perhaps the finest book in the world".

Four days after my visit to Jarrow, I was in south-west Umbria, where I had arranged to meet Nicolas Barker, editor of *The Book Collector*, and his wife, Joanna, who have a holiday house near the Lago di Bolsena and who met me with their car at Orvieto station, from which I emerged, blinking in the bright summer glare. Our day's objective was to see where the Codex Amiatinus had been kept. Nicolas drove; Joanna directed him from the back seat. As we crossed into the southern corner of Tuscany, Monte Amiata came into sight, the biggest in a long range of volcanic mountains, dominating the horizon like an Italian Ararat. We motored up the E35, the former main A1 trunk road between north and south which partly still overlaps with the Via Francigena, the medieval pilgrim route to Rome, and then we branched off to the left up the very winding mountain road signposted to San Salvatore. It is a surprisingly bleak and untilled landscape, almost biblical, unlike the gentler domesticity of northern Tuscany.

The monastery of San Salvatore on Monte Amiata, southern Tuscany, shown from the west with the fountain and chestnut trees

The monastery is not at the summit, which is the site of a ski resort, but on a plateau on the eastern slope of the hillside. Around it is a medieval town, all known collectively as the Abbadia San Salvatore since it evolved as an adjunct to the life of the monastery, which it so surrounds and protects that initially we were unable to find the abbey building at all. We asked for directions in a town square. A man with kindness and perhaps nothing much else to do that day jumped into his car and instructed us to follow him through the little streets and up the Via Cavour and into the Piazzale Michelangelo, where the ancient basilica stood before us. He gestured towards it proudly. It is indeed spectacular. It has two medieval towers, one tall and one squat, on either side of a modest Romanesque doorway. The church inside is very high but dark, with tiny round-arched windows, not unlike those in the chancel at Jarrow. There is some modern reconstruction internally but, as configured now, the altar and a fine twelfth-century wooden crucifix are at the top of a central stairway. On either side of these stairs are steps leading down into a marvellous pillared crypt, said to date

from the eighth century. To the north side of the church is the cloister, which presumably at one time housed the library. There is a small monastery museum above the south range of the cloister. It was closed until four o'clock, despite our importuning a sleeping priest and several nuns, but, after an agreeably pleasant lunch and a stroll through the town, we obtained admission at the appointed hour and we saw wonderful medieval objects and textiles and many photographs of the famous Codex Amiatinus.

We learned from the museum displays that the documented history of the abbey goes back to 742. It joined the Cistercian Order in 1228. Charlemagne is reported to have stayed here in 800, on his way south to his imperial coronation in Rome. Pope Pius II – Enea Silvio Piccolomini, the humanist scholar – lived here during the summer months of 1462, as is commemorated by a Latin monument under the chestnut trees outside the church, which Nicolas declaimed for us into English. The emperor and surely the pope might very easily have been shown the precious codex. Because the manuscript was (and still is) the primary witness for the text of the Latin Vulgate, it assumed great importance during the Counter-Reformation. The beleaguered sixteenth-century Catholics felt threatened by Protestant translations of the Bible, which were newly taken directly from the original languages of the Scriptures, whereas they had only the Latin. The Codex Amiatinus, however, provided an apparently unassailable response to this. This reputedly sixth-century Latin 'Bible of Saint Gregory' was substantially older than any Hebrew manuscript known and at that time was matched by only one in Greek (in the Vatican). It was therefore a major piece of propaganda in the battle of textual precedence. In 1572, the general chapter of the Cistercians sent for it for consultation; so too did the advisors of Gregory XIII. The monastery refused to lend it. Eventually it was summarily demanded by Pope Sixtus V to be used as the principal source for preparing a new papal edition of the Bible, and the monastery had no choice. The book left for Rome on 12 July 1587 and was returned to San Salvatore on 19 January 1590. The Sistine Vulgate based on it was published in 1590 and then revised as the monumental Clementine edition of 1592, the Catholic response to Luther, which is still in print.

Like many Italian monasteries caught up by the modernizing secular politics of the Holy Roman Empire in the late eighteenth century, the Abbadia San Salvatore was summarily suppressed in June 1782. For several years the Codex Amiatinus might have been available to anyone enterprising enough to steal it. Its existence was reported in 1789 to the Grand Duke of Tuscany, Peter Leopold (1747–92, later emperor himself as Leopold II), as having been 'among the shadows and under dust, unknown as though lost'. He ordered it to be taken from Monte Amiata to Florence, first to the custody of a seminary and then soon afterwards to the Biblioteca Laurenziana, where it is now Cod. Amiat. 1, probably the library's most famous manuscript.

My first inquiry about seeing the Codex Amiatinus itself was met with refusal, that deep all-encompassing sigh of infinite regret which only the Italians have perfected: it is too fragile to be moved, I was informed, and it is too precious to be handled. In Italy, however, the word 'no' is not necessarily a negative. It is merely a preliminary stage of discussion. I am indebted to Laura Nuvoloni for advice and to Giovanna Rao for willingness to listen to my entreaty.

Half a century ago, the English archaeologist Rupert Bruce-Mitford described his experience of seeing the Codex Amiatinus for the first time:

Having put in one's slip, and waited a respectable interval, one watches with awe two attendants, with a third to open doors, staggering in under the load. Half a dozen fat volumes have to be placed on the table, to take the strain off the binding, before one can open its covers. It is with trepidation that one ventures to produce the bicycle lamp with which one had planned to supplement, for minute scrutiny of the decoration, the inadequate light in Michelangelo's octagonal reading room.

As a picture of antiquarianism from long ago, this image seems difficult to credit in the modern world. Actually, my own encounter with Amiatinus was to be not so different.

The Biblioteca Medicea Laurenziana is among the architectural and literary glories of Florence, one of the most achingly beautiful cities

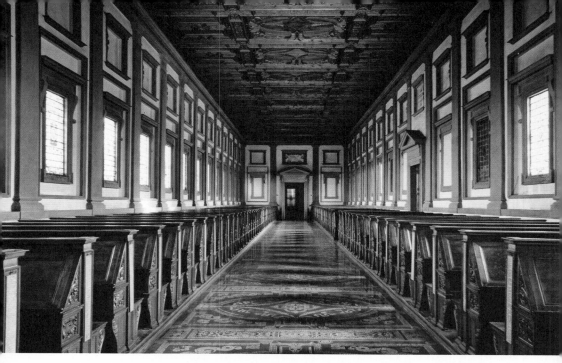

The old reading-room of the Biblioteca Medicea Laurenziana, designed by Michelangelo, above the cloisters of the Basilica di San Laurenzo in Florence

in the world. Its core is the humanist library originally assembled by Cosimo de' Medici '*il vecchio*' (1389–1464), supplemented especially by the acquisitions of his grandson Lorenzo 'the Magnificent' (1449–92). After Lorenzo's death the books were ransacked, sold, and reacquired by the Medicis by now living in Rome. Eventually the collections were returned to Florence by Clement VII (Giulio di Giuliano de' Medici, 1478–1534), who commissioned Michelangelo himself to design a noble library for them over the cloisters of the Basilica di San Lorenzo, the family church of the Medici since 1419. It was completed in 1571 by the pope's collateral kinsman Cosimo I de' Medici (1519–74), Grand Duke of Tuscany, then with about 3000 manuscripts. It still retained something of the character of a dynastic library when Grand Duke Peter Leopold commanded Amiatinus to be brought here from the *extremis finibus* of his dukedom in the 1780s.

You approach the library through a gateway in the south-west corner of the Piazza di San Lorenzo, the square in front of the unfinished brick façade of the church. There are Italian and European flags over the entrance, and banners for whatever exhibition is currently on view.

It leads you, via a ticket office, into the cloister built in 1462. There are Renaissance monuments around the walls. In the middle is a pretty garden. I am sure that the fruit trees are oranges but my guidebook asserts them to be pomegranates. The stairs to the library are straight ahead, beside the tomb of Paulo Giovio (1483–1552, notable manuscript collector: I was glad to see him). The steps lead up past faded frescoes onto the upper level above the eastern range of the cloister. The first door is the public entrance into the staircase to the library room built by Michelangelo and still with its ranks of sloping book presses. The second door, beside a terracotta pot, takes you into the library office.

Two women were chatting. I said that I had an appointment to see a medieval manuscript. They placed a telephone call. A man in jeans appeared and asked if I spoke Italian: I replied in English, then French and German – "necnon etiam Latinam", I ventured hopefully – but he shrugged and informed me in Italian anyway (I hadn't even said who I was) that I must have come to see the *Bibbia Amiatina*. I agreed, relieved. He led me along through a series of low rooms lined with framed prints, past staff lockers and what are presumably entrances into secure book vaults on the right, below Michelangelo's interior above. By the far corner of the cloister we came to a little room evidently used for photography, with camera stands, filing cabinets of microfilms and a photocopier. Another man appeared. They pointed to a trolley with a bulky shape under a blanket. "Amiatina!" they declared, and the two of them, reminiscent of Bruce-Mitford's experience, together heaved it bodily onto the photographer's high table, and made to depart. There were no facilities for propping the book open safely, and I begged for something to place under the cover when I lifted it. They came back with the four volumes of the library's set of Briquet's *Filigranes*, not the first time those century-old reference books have proven woefully inadequate. Then I was left alone, entirely unsupervised throughout my visit, except by the occasional person who wandered through to use the photocopier.

Just as Amiata is a great mountain, there is no denying that the Codex Amiatinus is a colossus. It is not so much tall, for many late-medieval choir books are of larger dimensions, but it is almost

unimaginably thick. Each page is about 20 inches high, but the spine –
try to envisage it – is about 11½ inches across. The width tapers slightly
towards the fore-edge. The manuscript is bound in very modern plain
tan-coloured calfskin over wood with leather straps dangling from the
lower board stitched with yellow thread and fitted with modern brass
clasps which reach up to metal pins set in the edge of the upper cover.
It looks, frankly, like a huge and expensive Italian leather suitcase. I
raised the front cover, far too high from the table for the pile of Bri-
quet volumes to support. There is a long shelf slip stamped 'Amiatino 1'
enclosed and a recent photocopied sheet loosely tucked in from the
Ministero per i beni e le attività culturali authorizing conservation,
including full rebinding in 2001, naming the conservators as Sabina
Magrini and Sergio Giovannoni. Although it is unmanageably bulky,
there is satisfaction in the fact that they retained it as a single pandect,
as so impressed Bede and the biographer of Ceolfrith, and the manu-
script is not now arbitrarily subdivided into modern volumes for its
librarians' convenience, like the Book of Kells (Chapter Three) or the
Morgan Beatus (Chapter Five). Offsets of rust on the outer edges of
the endleaves suggest that there were once metal fittings on the covers.

Out of interest, I attempted to pick the volume up. I can do so,
using both arms, but not when the manuscript is open, for it would
be simply impossible to hold without it sagging uncontrollably in the
middle. Bruce-Mitford weighed it at 75½ lb, or, with binding, fittings,
and travelling case, at an estimated 90 lb, comparable, as he unforget-
tably suggested, to the weight of a fully grown female Great Dane. A
twelve- to thirteen-year-old boy is about the same.

The first eight leaves, which we will examine closely in a second, are
fractionally smaller than the rest of the book, and are lavishly deco-
rated. There is the precious dedication inscription under an arch on
the verso of the first leaf, with the substituted names very apparent in
much browner ink and not nearly as neatly executed as the unaltered
writing. There on the facing page is the supremely famous Ezra por-
trait, the oldest English painting to which any absolute date can be
assigned (i.e. not after 716). Familiar works of art abound in Florence,
but there is still a thrill of recognition in encountering them in the

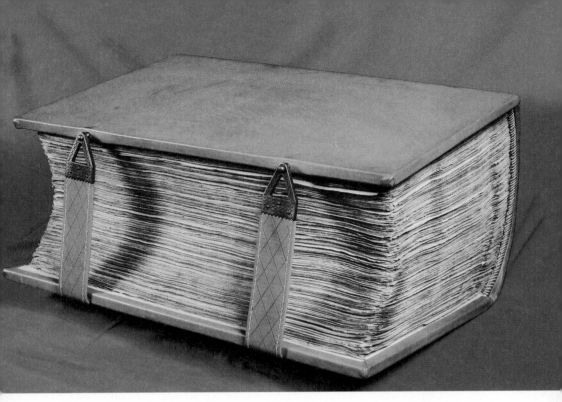

The enormous Codex Amiatinus, still in a single volume, rebound in tan-coloured calfskin in 2001, with brass clasps and catches

originals. What struck me immediately was the glittering brightness of the gold, around Ezra's halo, in the background to his bookcase, on the sides and upper surface of his stool, and in the rectangles in the corners. I knew from reproductions that the artist had used gold (generally more characteristic of early Greek manuscripts than of Latin ones), but I had not expected such vividness and sparkle. Perhaps the availability of gold should not be surprising in an English manuscript almost contemporary with the glittering Anglo-Saxon jewellery of Sutton Hoo and the Staffordshire Hoard.

In striking contrast, most of the rest of the huge manuscript, over 2000 pages, comprises austere but graceful text, in two columns, mostly with negligible ornament. Once again, my initial impression was of the astonishing freshness of condition. Most early manuscripts bear marks of usage at many different periods, readers' notes in various scripts,

OVERLEAF: The dedication inscription of the Codex Amiatinus, with its altered names, and the facing illustration of Ezra writing beside a book cupboard

✝ CENOBIUM AD EXIMII MERITO
UENERABILES ALUXTORIS
QUEM CAPUT ECCLESIAE
DEDICAT ALTA FIDES
PETRUS LANGOBARDORUM
EXTREMIS DEFINIB· ABBAS
DEUOTI AFFECTUS
PIGNORA MITTO MEI
MEQUE MEOSQ· OPTANS
TANTI INTER GAUDIA PATRIS
IN CAELIS MEMOREM
SEMPER HABERE LOCUM

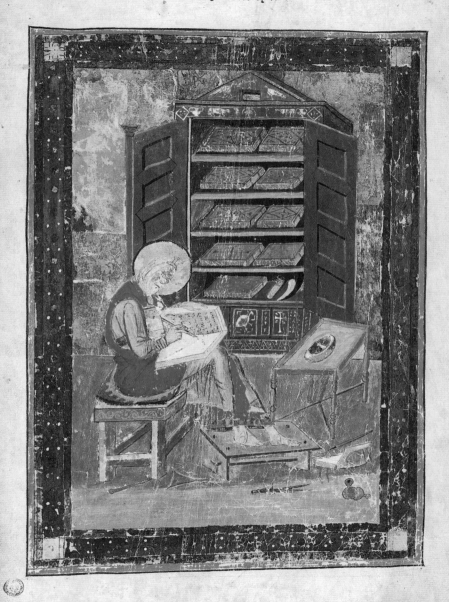

CODICIBVS SACRIS HOSTILI CLADE PERVSTIS
ESDRA DŌ FERVENS HOC REPARAVIT OPVS

emendations, and signs of consultation and reference over centuries. Apart from a few contemporary corrections and liturgical markings, probably from the original scriptorium in Northumbria, the manuscript shows almost no signs of use whatsoever. It is as if it were wrapped up and never opened. Perhaps that is precisely what did occur, if the monks of San Salvatore regarded it as a sacred relic of Saint Gregory rather than as a book with any practical use. The Psalms are now numbered in a post-medieval hand and there is discreet chapter numeration according to the modern system, which I could easily believe might date from the manuscript's exile in the Vulgate editors' offices in Rome in 1587–90. It is a sad truth that if you lend any precious possession reluctantly, it seldom comes back in precisely the condition in which it left.

The manuscript is mostly constructed in gatherings of eight leaves each.* At one time, scholars of Amiatinus speculated that its exotic preliminary quire might have been transferred from some other manuscript, perhaps of Italian origin, for it is so unlike the rest of the volume or anything known in any other extant medieval Bible. Two of the leaves are stained purple and one in yellow, entirely classical devices. However, it is now universally accepted that these pages are an integral if very unusual component of the volume, by the same English scribes and illuminators using the same pigments as the picture of Christ in Majesty for the New Testament on folio 796v, which is unquestionably an original part of the book, as the collation shows.

The presence of these opening pages leads us into another whole layer of extraordinary coincidence to that account of Benedict Biscop

* The collation is: i⁸ [a bifolium + 4 + 2 singles], ii–xxi⁸, xxii⁴⁺¹ [folio 173 is a single sheet], xxiii–xxiv⁸, xxv⁴, xxvi–xlvii⁸, xlviii⁸⁺¹ [folio 378 is a single sheet], xlix–lxvii⁸, lxviii⁴⁺¹ [folio 535 is a single sheet], lxix–lxxxix⁸, xc⁴⁺¹ [folio 708 is a single sheet], xci–cxviii⁸, cxix–cxx⁸⁺¹ [folio 941 and 950 are single sheets], cxxi–cxxx⁸. The manuscript has original numerical quire signatures in Roman numerals in most lower inner corners of the last leaves of the gatherings, sometimes preceded by the letter 'Q' (*quaternion*) and sometimes not. A complication is that the first quire is not numbered (folios 1–8, all preliminary leaves), and the scribe's quire signature 'XXIV' is carelessly repeated, appearing at the end of what is thus actually the twenty-fifth gathering (folio 193v) and also at the end of the twenty-sixth (folio 201v). What the scribe would have called quire CXXVIII, the last in the manuscript, is therefore in reality the 130th gathering.

LEFT: Christ in Majesty, between the four Evangelists with their symbols, the full-page illustration preceding the New Testament in the Codex Amiatinus. The curve on the left is from the neck of the animal's skin

and Ceolfrith obtaining an 'immeasurable quantity of books' on their visit to Italy in 679. It involves a library of books assembled by Cassiodorus (c. 485–580), consul in the late Roman Empire, philosopher and prolific author, a Christian convert and a giant figure in the history of biblical scholarship. In his retirement, Cassiodorus had set up a kind of monastic research foundation in Calabria in the extreme south-east of Italy, called the Vivarium – the name alludes to the fish ponds on the estate – and he bequeathed his personal library to it. Furthermore, in the *Institutiones*, his textbook on divine and secular learning, Cassiodorus not only explained his method of subdividing and interpreting the Bible but he also described in detail how he had had his unique biblical apparatus incorporated into some of his own manuscripts. The details given correspond so exactly to what is in those first leaves of the Codex Amiatinus that the inescapable explanation seems to be that these are direct copies, and that somehow that 'immeasurable quantity of books' secured in Rome must have included some of Cassiodorus's own manuscripts formerly at the Vivarium, then back on the market. As so often with small and poorly endowed libraries, the Vivarium had failed to survive for long after its founder's death and its books were evidently dispersed or sold. If some (at least) were then bought by Ceolfrith, they would in turn have become available as exemplars for the scribes of Wearmouth–Jarrow in Northumbria. Bede, whose knowledge of classical learning was so astonishingly wide, perhaps had the fortune of access to purchases made from one of the finest private book collections of the late Roman Empire, and he may not even have realized that the manuscripts at Jarrow had once been owned by the great Cassiodorus himself.

In his *Institutiones*, Cassiodorus describes owning a huge pandect of a Latin translation of the Bible, which he called his '*Codex Grandior*', 'the larger manuscript'. Its Old Testament text, he says, was taken from Jerome's first revision of the Greek, rather than from the later Vulgate version newly translated from the Hebrew. It apparently comprised 380 leaves. Considering the extreme rarity then of any comprehensive one-volume Bibles in Latin, this manuscript was in all probability none other than that very same pandect in an 'old' translation brought back

from Italy by Ceolfrith. Cassiodorus says that he had inserted into his *Codex Grandior* a diagram of the layout of the Temple of Jerusalem, as described in Exodus 26. Exactly such a detailed plan appears on a double-page spread among the opening leaves of the Codex Amiatinus (folios 6v–7r). It shows the inner temple, the Tabernacle itself. In the centre is the Holy of Holies, with the Ark of the Covenant. Furthermore, Cassiodorus reports (this is all in book I, chapter 14, of the *Institutiones*), that he also included in the *Codex Grandior* diagrams of the different ways of dividing the text of the Bible according to Saints Hilary, Jerome and Augustine respectively. That is precisely what we find on folios 3r, 4r and 8r of Amiatinus.

The most famous and strangest of the preliminary pages is the so-called Ezra portrait, already mentioned, now placed as a frontispiece. It shows a haloed man in Jewish priestly garments sitting hunched up on a stool almost in profile, writing in a book half open on his lap. He has his feet on a low pedestal. Scattered around him are the various instruments of a scribe's occupation – stylus, dividers, pen, ink pot and what is probably a dish of pigment on a separate table. Behind him is an open cupboard, with panelled doors hinged back to reveal five sloping shelves on which are arranged nine books bound in decorated dark red covers. A very similar bookcase enclosing the four Gospels on shelves is depicted in a mosaic of Saint Laurence in the Mausoleum of Galla Placidia in Ravenna, datable to the second half of the fifth century, almost within Cassiodorus's lifetime. The carpentry of the furniture and the ornament carved around the cupboard shown in the Codex Amiatinus are extraordinarily delicate and sophisticated. There is an enlightened attempt at perspective. The ink pot throws a shadow on the ground, worth noting if only because it is usually said that shadows do not appear in European art until the fifteenth century. Simply as an illustration of a scribe drawn in England in the late seventh century, the picture is full of interest, not least in that he has no writing desk and he is working directly into a book on his lap, as scribes still do in Ethiopia today. As I was jotting this down and thinking

OVERLEAF: The plan of the Temple in Jerusalem in the Codex Amiatinus, similar to that described by Cassiodorus who inserted a comparable illustration into his *Codex Grandior*

ASER N· XLI· D D

ARETOS·

FILII MERARI VI CC

BENIAMIN N· XXXV CCC

EFRAIM N· XL

DYSIS

FILII GERSON VII D

ARCA TEST

SCS SCORM

ALTAR

CAND

MENSA

MANASSE N· XXXII CC

FILII CATH VIII DC

MESEMBRIA

GAD· N· XLV· DCL RUBE

LXII DC NEPTHALIM·N̄ LIII CCCC.

ISSACHAR N̄ LIIII CCCC

ANATOL

IVDAS N̄ LXVIII DC

ZABVLON N̄ LVII CCCC

HOLOCAVSTI

ALTARE

MOSES ET AARON

LABRVM

XLVI D SYMION N̄ LVIIII CCC

how different it is from most images of a medieval scriptorium, I realized that I was at that moment taking my notes into a hard-bound exercise book on my own lap, because the Codex Amiatinus filled the entire table before me, leaving no room for anything else. For a moment, the scribe seated writing in front of a book cupboard might have been me beside the microfilm cabinets and reprographic equipment of the Laurenziana.

It is a strange subject, apparently showing an author drafting a text rather than a scribe copying one. The words in his book are indicated by disjointed scribbles: it is sometimes claimed that these are actual Tironian notes, a kind of early-medieval shorthand, but it is surely no more than the artist's representation of non-specific text. At the top of the page outside the frame of the picture is a couplet written in rustic capitals "Codicibus sacris hostili clade perustis / Esdra deo fervens hoc reparavit opus", meaning (more or less), 'The Holy Books having been destroyed by hostile disaster, Ezra, committed to God, restored this work.' This alludes to the occasion at the end of the captivity of the Jews in Babylon around 457 BC when the priest and scribe Ezra was sent back to Jerusalem and found that the Hebrew Scriptures had been forgotten and lost, and under divine guidance he reconstructed them from memory. It is this caption, as well as his Old Testament priestly costume, which identifies the man shown as Ezra.

Prefatory author portraits had probably been a feature of Greek texts since classical antiquity. We have looked at the Luke portrait in the Gospel Book of Saint Augustine (Chapter One). Ezra was not precisely an author. His contribution, if we take it at face value, was in preserving texts from the first part of the Old Testament – not of course the entirety of the Christian Scriptures, most of which dated from long after his lifetime. In many ways, a more appropriate frontispiece for a pandect of the whole Vulgate would have been an image of Saint Jerome writing, as does indeed often open many later medieval Bibles. The style here is so utterly Mediterranean that it must have been copied from the exemplar imported from Italy, presumably also in the *Codex Grandior*, although Cassiodorus does not mention the presence of such a picture there. It is commonly suggested that the painting in

Amiatinus is actually a misunderstood picture of Cassiodorus himself, who was, like Jerome (and Ezra, and Ceolfrith), a committed preserver and transmitter of the Bible after a period of chaos. Cassiodorus lived through the sack of Rome at the hands of the Ostrogoths in 546, and his little Christian oasis at the Vivarium was dedicated to keeping the Scriptures safe during the storms of barbarianism and apostasy. In his *Institutiones*, Cassiodorus not only describes his *Codex Grandior* but also what he calls the "novem codices", the nine separate volumes into which he had the text of the Bible divided and copied. The shelves in the cupboard behind Ezra in the picture show just that: nine biblical volumes with titles on their spines. In reproductions of the page these names are almost impossible to see but, by positioning the original manuscript so that it reflects the light, the nine titles become visible from their shine against a matt ground – the Octateuch, Kings and Chronicles with Job, eight books of history, the Psalms, the books of Solomon, the Prophets, the Gospels, the Epistles, and (lastly) Acts and Revelation. At best, only the first shelf could have applied to Ezra in historical reality, but all nine were in the library of the Vivarium. It would make better sense if the model for this picture had been a portrait of Cassiodorus. Whether Cassiodorus would commission a picture of himself is disputable, but his posthumous librarians and successors might easily have inserted such a hagiographic frontispiece into their late master's favourite *Codex Grandior*.

The use of this image of the scribe for different identities – Cassiodorus or Ezra – is perpetuated by a remarkable instance of pictorial transference further up the coast of Northumbria in the late seventh or first half of the eighth century: the portrait was exactly re-copied yet again, but this time its subject changes once more into the iconic frontispiece of the evangelist Saint Matthew in the famous Lindisfarne Gospels in the British Library. There the composition of the former 'Ezra' is precisely reutilized as a Gospel writer, to the exact composition of his posture, his hands on the open book, his sandals and two stools, one for himself and one for his feet.

From the scribe, let us turn to the script. The text of the Codex Amiatinus is written in uncials, the quintessential '*romana scriptura*',

Saint Matthew in the Lindisfarne
Gospels of the late seventh or
early eighth century, copied in
Northumbria from the same model
as the image of Ezra in the Codex
Amiatinus

laid out, like the Gospels of Saint Augustine brought from Rome, in
the double columns of long and short lines suitable for ease of reading
aloud, '*per cola et commata*'. The uncial is utterly unlike the native-born
majuscules and minuscules of Irish books, known to manuscript his-
torians as the 'insular' style, which encompasses all the Celtic sphere
of the British Isles. The contrast with Mediterranean uncials is further
graphic evidence that the communities of Wearmouth and Jarrow were
distancing themselves from Ireland and consciously imitated Roman
writing practices. A possibility has to be that Benedict Biscop and
Ceolfrith brought back trained scribes from Italy, to teach uncial to the
English. On folio 86v of the Codex Amiatinus, in the prefatory material
to Leviticus, are several clumsily written words in Greek, apparently
asserting that one Lord Servandos was the maker of the book. That is
not remotely an Anglo-Saxon name, and the sentence must have been
copied uncomprehendingly from the exemplar, by someone who knew
Latin but not Greek. Although the scribes closely modelled their work
on Italian prototypes, they themselves were indisputably English. They
are betrayed by distinctively insular marks of abbreviation and other

oddities found uniquely in uncial manuscripts which we know for certainty were copied in Northumbria.

It is frequently observed that in the use of script alone one can see the utter difference of cultural outlook between Wearmouth–Jarrow, modelled on Rome, and Lindisfarne, the Irish island foundation some fifty miles to the north, where manuscripts were routinely copied in the contrasting insular hands. In reality and in commonsense likelihood, the communities drew on each other. For all its Roman script, the Codex Amiatinus shows traces of a distinctively insular practice in the opening words of some texts, using what is known as 'diminuendo', beginning large and decreasing in size letter by letter. An example is at the opening of Genesis. The first words are "In principio", 'In the beginning …' (folio 11r). The 'I' is big, seven times the height of normal text, the 'n' is not so large, and the 'p' is smaller still, as the scale slowly reduces and merges with the size of the writing. That is a characteristic of Irish manuscripts, and there are extreme examples in the Book of Kells (Chapter Three). The scribes of the Codex Amiatinus must have encountered it at Lindisfarne. In exchange, as we saw, the Lindisfarne monks derived their pattern for Saint Matthew from the *Codex Grandior* at Jarrow, and tiny uncials were used in their lovely early eighth-century 'Saint Cuthbert Gospel', now in the British Library, as dainty and weightless as Amiatinus is vast and bulky, apparently interred at an early date with the body of Saint Cuthbert, who had been enshrined on Lindisfarne in 698.

Some sense of the scale of the scriptorium and the tightness of its organization is conveyed by the fact that no fewer than seven and maybe as many as nine different scribes seem to have worked on the Codex Amiatinus. Some hands are of larger size than others, and this is very noticeable in the breaks between different biblical books. Their stints were clearly apportioned in distinct clusters of texts. As the collation showed, several gatherings comprise unusual numbers of leaves, all corresponding to ends of books: xlviii (9 leaves, end of Chronicles, folio 378v), lxviii (5 leaves, end of Isaiah, folio 535v), and xc (5 leaves, end of Tobit, folio 708v). Each of these also represents a change of scribe. An odd-leafed gathering is only likely to have been necessary if

the following text had already been begun. Multiple scribes were thus working simultaneously.

Parchment for manuscripts as large and as extensive as entire pandects would have required skins of a huge number of animals. No more than a single pair of leaves could have been prepared from each pelt. The 1,030 leaves of the Codex Amiatinus would have utilized skins of 515 calves or young cattle. For all three pandects commissioned by Ceolfrith, this must be multiplied by three. It is sometimes asserted, without evidence, that a grant of land made to Wearmouth–Jarrow in 692 was in order to provide sufficient pasture for an increased herd necessary for making the bibles. In reality, farming a couple of thousand animals need not have been abnormal for a large and well-organized rural community over the thirty years of Ceolfrith's abbacy, especially as cattle furnished many necessary products in addition to their skin. These included meat for the daily dinners of many active monks, and also horn, glue, bone and probably blood fertilizer for agriculture. Although the quality of the parchment is generally good and beautifully soft to the touch, there is a certain home-made feel which one would not encounter in (say) the fifteenth-century Visconti manuscript in Chapter Eleven or the Spinola Hours in Chapter Twelve. Some pages of the Codex Amiatinus are spotted; others include original flaws and excised holes which the scribes have worked around; sometimes parchment is so fine that it is almost illegible through transparency (such as folio 810); some pages are shorter than others or lack corners, where the scribes have had to make do with skins which were slightly too small (such as folios 613, 735, and others). Many non-specialists in manuscripts may doubt what I am about to say (and perhaps some palaeographers will too), but if I had not known that the Codex Amiatinus was English, I might have suspected this simply from its feel and especially the smell of the pages. I have no vocabulary to define this, but there is a curious warm leathery smell to English parchment, unlike the sharper, cooler scent of Italian skins. It might simply be the result of English scribes using different kinds of animal – such as calf rather than sheep – or the use

RIGHT: The opening of Genesis in the Codex Amiatinus, showing the characteristically insular practice of the opening letters diminishing in size in the first words of the text

IN PRINCIPIO CREAUIT DS
CAELUM ETTERRAM
TERRA AUTEM ERAT INANIS ETUACUA
ETTENEBRAE ERANT SUPER
FACIEM ABISSI
SPS DI FEREBATUR SUPER AQUAS
DIXITQUE DS FIAT LUX ETFACTA EST LUX
ETUIDIT DS LUCEM QUOD ESSET BONA
ETDIUISIT LUCEM ACTENEBRAS
APPELLAUIT QUE LUCEM DIEM
ETTENEBRAS NOCTEM
FACTUM QUE EST UESPERE
ETMANE DIES UNUS
DIXITQUOQUE DS
FIAT FIRMAMENTUM INMEDIO AQUARU
ETDIUIDAT AQUAS ABAQUIS
ETFECIT DS FIRMAMENTUM
DIUISITQUE AQUAS QUAE ERANT SUB
FIRMAMENTO ABHIS QUAE ERANT
SUPER FIRMAMENTUM
ET FACTUM EST ITA
UOCAUITQUE DS FIRMAMENTUM
CAELUM
ETFACTUM EST UESPERE ETMANE
DIES SECUNDUS
DIXIT UERO DS
CONGREGENTUR AQUAE QUAE SUBCAELO
SUNT INLOCUM UNUM
ETAPPAREAT ARIDA
FACTUMQUE EST ITA
ETUOCAUIT DS ARIDAM TERRAM
CONGREGATIONES QUE AQUARUM
APPELLAUIT MARIA
ETUIDIT DS QUOD ESSET BONUM ETAIT
GERMINET TERRA HERBAM UIRENTEM
ETFACIENTEM SEMEN
ETLIGNUM POMIFERUM FACIENS
FRUCTUM IUXTA GENUS SUUM
CUIUS SEMEN INSEMET IPSO SIT SUPER
TERRAM. ETFACTUM EST ITA
ETPROTULIT TERRA HERBAM UIREN
TEM ETAFFERENTEM SEMEN
IUXTA GENUS SUUM
LIGNUM QUE FACIENS FRUCTUM

ET HABENS UNUM QUODQUE SEMENTEM
SECUNDUM SPECIEM SUAM
ETUIDIT DS QUOD ESSET BONUM
FACTUM QUE EST UESPERE ETMANE
DIES TERTIUS
DIXIT AUTEM DS
FIANT LUMINARIA INFIRMAMENTOCAELI
UTDIUIDANT DIEM ACNOCTEM
ETSINT INSIGNA ETTEMPORA
ETDIES ETANNOS
UTLUCEANT INFIRMAMENTOCAELI
ETINLUMINENT TERRAM
ETFACTUM EST ITA
FECITQUE DS DUOMAGNA LUMINARIA
LUMINARE MAIUS UTPRAEESSET DIEI
ETLUMINARE MINUS UTPRAEESSET
NOCTI ETSTELLAS
ETPOSUIT EAS INFIRMAMENTO CAELI
UTLUCERENT SUPERTERRAM
ETPRAEESSENT DIEI ACNOCTI
ETDIUIDERENT LUCEM ACTENEBRAS
ETUIDIT DS QUOD ESSET BONUM
ETFACTUM EST UESPERE ETMANE
DIES QUARTUS
DIXIT ETIAM DS
PRODUCANT AQUAE REPTILE
ANIMAE UIUENTIS
ETUOLATILE SUPERTERRAM
SUBFIRMAMENTO CAELI
CREAUITQUE DS COETA GRANDIA
ETOMNEM ANIMAM UIUENTEM
ATQUE MUTABILEM
QUAM PRODUXERANT AQUAE
INSPECIES SUAS
ETOMNE UOLATILE SECUNDUM
GENUS SUUM
ETUIDIT DS QUOD ESSET BONUM
BENEDIXITQUE EIS DICENS
CRESCITE ETMULTIPLICAMINI
ETREPLETE AQUAS MARIS
AUESQUE MULTIPLICENTUR
SUPERTERRAM
ETFACTUM EST UESPERE
ETMANE DIES QUINTUS

of animals grown in very different environments. Breeds of medieval domestic animals would have differed much more by region than they do now. This is an area where DNA studies may transform manuscript scholarship for future generations.

Considering the absolute rarity of any records and manuscripts from the seventh century to the eighth, this chapter has already benefited from some truly extraordinary coincidences of survival. In view of the negligible survival rate of manuscripts from that period at all, it almost defies belief that one of those actual volumes recorded by Bede should subsequently be found to be still in existence. That would be rare good fortune even for a fifteenth-century manuscript. It stretches happenstance nearly to the point of miraculous that the only known detailed account of any private library anywhere in Europe, a hundred years earlier and more than 1,500 miles from Northumbria, proves to have supplied the documented exemplars for making that surviving book. However, we are now about to take coincidence of survival to an even further level of unlikelihood.

It began in early September 1908 when the Oxford church historian Cuthbert Turner (1860–1930) was in Durham Cathedral Library inquiring about early manuscripts of the Bible. The canon librarian, William Greenwell (1820–1918), archaeologist and collector, invited him home for supper. Turner noticed a leaf from a large manuscript written in uncials framed in Greenwell's hall, and he remarked conversationally that it looked like a missing page from the famous Codex Amiatinus. This seems to have provoked an unexpected reaction from his host. Greenwell asserted that it was from one of the other two Bibles commissioned by Ceolfrith, and, before any further inquiries might be made and certainly before Turner could publish it, he promptly presented the leaf to the British Museum, where it was received at the beginning of 1909. It is generally known by the pleasantly arboreal name – like something from Robin Hood – of 'the Greenwell Leaf'. It has the Latin text for III Kings 9:29–12:18. In retrospect, Greenwell came up with an unverifiable story, which varied in detail, that he had acquired the leaf around 1890 in a Newcastle bookshop or, in another recollection, in an 'old curiosity shop'. As Newcastle is only half a dozen miles from

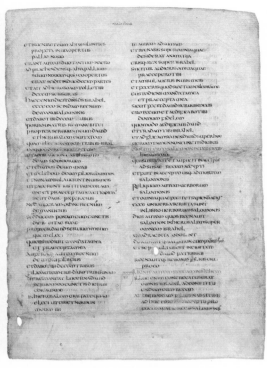

William Greenwell, collector of British antiquities and librarian of Durham Cathedral, together with the leaf of a late seventh-century manuscript Bible which Cuthbert Turner found framed in the hall of Greenwell's house in September 1908

Jarrow, the provenance sounded suitably plausible, although it is hard to believe that Greenwell, no modest antiquary (in either sense), could make such an astonishing find and forget to mention it to anyone for almost twenty years.

The likely source was revealed in 1911 when W. H. Stevenson (1858–1924), fellow and librarian of St John's College, Oxford, published his catalogue for the Historical Manuscripts Commission of the muniments of Lord Middleton at Wollaton Hall, Nottingham, one of the great English houses built in the 1580s. Stevenson reported having found ten more leaves and three tiny fragments from the same uncial manuscript, used in sixteenth-century bindings in the archives of the Willoughby family, later ennobled as Barons Middleton. They all comprised further pieces from III–IV Kings. By now there was no doubt that these twins of Amiatinus must indeed have been astonishingly lucky survivals from one or other of the pandects assigned by Ceolfrith to the

churches of Wearmouth or Jarrow. In 1938, the Willoughby pieces were sold for £1000 to the British Museum too. A further leaf from Ecclesiasticus was found by Nicholas Pickwood as recently as 1982 among the estate papers of the Bankes family at Kingston Lacy, a property owned by the National Trust. That fragment is now on indefinite deposit at the British Library. My chauffeur on our outing to Monte Amiata, Nicolas Barker, at that time head of conservation at the library, had a part in its identification, passing it on to his colleague in the department of manuscripts, Janet Backhouse. She noted that it too was connected with Wollaton Hall, in that it had been used as a wrapper around manorial deeds of an estate in Dorset which was bought from Sir Francis Willoughby of Wollaton in November 1585. Believe me, I have myself painstakingly trawled the shelves of the Willoughby archives in Nottingham, in the vain hope of finding more pieces. All I can report is having seen the various transcripts and cartularies there in which Stevenson found his fragments, some still with spectral mirror-image offsets of late seventh-century English uncial. If I had to guess, I would suspect that Greenwell's leaf was truthfully also from Lord Middleton's archive, and that maybe Stevenson sent him the discoveries for advice on the identification, with an improper invitation that he might retain one, highly unofficially, in gratitude for his help.

Very probably, the pieces are all remains from a Bible which was at one time owned by Worcester Cathedral. The evidence for this is that the Willoughby archives also disgorged similar pieces of a large manuscript of almost identical dimensions containing eleventh-century transcripts of Worcester charters. We know that Offa, king of Mercia 757–96, is reputed to have given a great Bible to Worcester, and that Wulfstan, bishop of Worcester 1062–95, ordered the cathedral's charters to be copied into the 'Bible of the holy church'. Offa's Bible was described in the twelfth century as having been written in Rome, which probably means that it was in uncial script. Since King Offa's daughter married the king of Northumbria in 792, there is a possibility that one of Ceolfrith's Bibles came to him during diplomatic exchanges between the realms in the late eighth century, perhaps when Jarrow was sacked by the Vikings in 794.

I took my set of photographs of the Greenwell and Willoughby leaves to Florence to compare with the Codex Amiatinus itself. Of course this has been done before, first by Cuthbert Turner in 1909, following his dinner with Canon Greenwell, and especially by Richard Marsden for his *Text of the Old Testament in Anglo-Saxon England*, 1995, which has been an important source for me throughout this chapter. However, there is a satisfaction in matching up the pandects word by word.

Mostly the text of the two manuscripts is absolutely identical, as one would expect (and hope) with copies made from the same exemplar in the same scriptorium, or one from the other. Occasionally there are tiny verbal variants, such as "oblectavit" (Eccelesiasticus 35:25) on the Kingston Lacy leaf, and "oblectabit" in Amiatinus, which make no difference whatsoever to the sense of the text. There are two points where they differ significantly. The Willoughby leaves in the British Library make no break between the end of III Kings and the opening of IV Kings, except for a tiny *chi-rho* monogram in the margin and a fractionally enlarged letter 'P' for "Praevaricatus" (in the numbering of a modern Bible this is 2 Kings 1:1). In the Codex Amiatinus the break between the two books is marked absolutely unambiguously. III Kings ends on folio 303v with the word "FINIT" and ten lines are left blank. IV Kings opens on the next page with a line in red ink and a big indented initial three lines high.

There is no textual reason why there needs to be an arbitrary break between the third and fourth books of Kings, for the narratives follow on seamlessly, and the two parts all form a single uninterrupted text in the Bible in Hebrew. A division into separate books, however, occurs in the Greek version of the Old Testament, known as the Septuagint. On the face of it, the exemplar available at Wearmouth–Jarrow presumably had no break either, for a scribe would have been unlikely to overlook it. By the time that Amiatinus was being copied soon afterwards, an editorial decision had been made to bring the Latin into line with the Greek custom and to separate the texts, an adaptation so convenient that all Latin Bibles since Amiatinus did the same, and indeed all modern

OVERLEAF: The end of III Kings and the opening of IV Kings in the Codex Amiatinus, showing the clear break between the two texts. The curve at the bottom is again from the animal's skin

ET UNIUERSA QUAE FECIT
ET DOMUS EBURNEAEQUAM
AEDIFICAUIT
CUNCTARUMQUE URBIUM
QUAS EXSTRUXIT
NONNE SCRIPTA SUNT HAEC
IN LIBRO UERBORUM DIERUM
REGUM ISRAHEL
DORMIUIT ERGO ABAB
CUM PATRIBUS SUIS
ET REGNAUIT OHOZIAS FILIUS
EIUS PRO EO
IOSAPHAT FILIUS ASA REGNARE
COEPERAT SUPER IUDAM
ANNO QUARTO ABAB REGIS ISRAHEL
TRIGINTA QUINQUE ANNORUM ERAT
CUM REGNARE COEPISSET
ET UIGINTI ET QUINQUE ANNOS
REGNAUIT IN HIERUSALEM
NOMEN MATRIS EIUS AZUBA
FILIA SALAI
ET AMBULAUIT IN OMNI UIA ASA
PATRIS SUI
ET NON DECLINAUIT EX EA
FECITQ· QUOD RECTUM EST
IN CONSPECTU DNI
UERUM TAMEN EXCELSA
NON ABSTULIT
ADHUC ENIM POPULUS SACRIFICABAT
ET ADOLEBAT INCENSUM
IN EXCELSIS
PACEMQ· HABUIT IOSAPHAT
CUM REGE ISRAHEL
RELIQUA AUTEM UERBORUM
IOSAPHAT
ET OPERA EIUS QUAE GESSIT
ET PROELIA
NONNE HAEC SCRIPTA SUNT
IN LIBRO UERBORUM DIERUM
REGUM IUDA
SED ET RELIQUIAS EFFEMINATORŨ
QUI REMANSERANT IN DIEBUS
ASA PATRIS EIUS ABSTULIT
DE TERRA

NEC ERAT TUNC REX CONSTITUTUS
IN EDOM
REX UERO IOSAPHAT FECERAT
CLASSES IN MARI QUAE NAUIGAREN·
IN OPHIR PROPTER AURUM
ET IRE NON POTUERUNT QUIA CON
FRACTAE SUNT IN ASIONGABER
TUNC AIT OHOZIAS FILIUS ABAB
AD IOSAPHAT
UADANT SERUI MEI CUM SERUIS
TUIS IN NAUIBUS
ET NOLUIT IOSAPHAT
DORMIUITQ· CUM PATRIBUS SUIS
ET SEPULTUS EST CUM EIS
IN CIUITATE DAUID PATRIS SUI
REGNAUITQUE IORAM FILIUS
EIUS PRO EO
OHOZIAS AUTEM FILIUS ABAB
REGNARE COEPERAT SUPER
ISRAHEL IN SAMARIA
ANNO SEPTIMO DECIMO
IOSAPHAT REGIS IUDA
REGNAUITQUE SUPER ISRAHEL
DUOBUS ANNIS
ET FECIT MALUM IN CONSPECTU DNI
ET AMBULAUIT IN UIA PATRIS SUI
ET MATRIS SUAE
ET IN UIA HIEROBOAM FILII NABAT
QUI PECCARE FECIT ISRAHEL
SERUIUIT QUOQUE BAHAL
ET ADORAUIT EUM
ET IN RITAUIT DNM DM ISRAHEL
IUXTA OMNIA QUAE FECERAT
PATER EIUS

FINIT

PRAEVARICATUS EST AUTEM
MOAB IN ISRAHEL POSTQUAM
MORTUUS EST ACHAB
CECIDITQUE OHOZIAS PER CANCELLOS
CENACULI SUI QUOD HABEBAT
IN SAMARIA
ET AEGROTAVIT MISITQ NUNTIOS
DICENS AD EOS
ITE CONSULITE BEELZEBUB
DEUM ACCARON
UTRUM VIVERE QUEAM DE IN
FIRMITATE MEA HAC
ANGELUS AUTEM DNI LOCUTUS EST
AD HELIAM THESBITEN
SURGE ASCENDE IN OCCURSUM
NUNTIORUM REGIS SAMARIAE
ET DICES AD EOS
NUMQUID NON EST DS IN ISRAHEL
UT EATIS AD CONSULENDUM
BEELZEBUB DEUM ACCARON
QUAM OBREM HAEC DICIT DNS
DE LECTULO SUPER QUEM
ASCENDISTI NON DESCENDES
SED MORTE MORIERIS
ETABIIT HELIAS REVERSIQ SUNT
NUNTII AD OHOZIAM
QUI DIXIT EIS QUARE REVERSI ESTIS
AT ILLI RESPONDERUNT EI
VIR OCCURRIT NOBIS ET DIXIT AD NOS
ITE ET REVERTIMINI AD REGEM
QUI MISIT VOS
ET DICETIS EI HAEC DICIT DNS
NUMQUID QUIA NON ERAT DS
IN ISRAHEL MITTIS UT CONSULA
TUR BEELZEBUB DEUM ACCARON
IDCIRCO DE LECTULO SUPER
QUEM ASCENDISTI NON DESCENDE
SED MORTE MORIERIS
QUI DIXIT EIS CUIUS FIGURAE
ET HABITU EST VIR QUI
OCCURRIT VOBIS
ET LOCUTUS EST VERBA HAEC
AD ILLI DIXERUNT VIR PILOSUS
ET ZONA PELLICIA ACCINCTIS RENIB

QUI AIT HELIAS THESBITES EST
MISITQUE AD EUM QUINQUAGENARIU
PRINCIPEM ET QUINQUAGINTA
QUI ERANT SUB EO
QUI ASCENDIT AD EUM SEDENTIQ
IN VERTICE MONTIS AIT
HOMO DI REX PRAECEPIT
UT DESCENDAS
RESPONDENSQ HELIAS DIXIT
QUINQUAGENARIO
SI HOMO DI SUM DESCENDAT IGNIS
E CAELO ET DEVORET TE
ET QUINQUAGINTA TUOS
DESCENDIT ITAQUE IGNIS E CAELO
ET DEVORAVIT EUM ET QUINQUA
GINTA QUI ERANT CUM EO
RURSUM MISIT AD EUM PRINCIPEM
QUINQUAGENARIUM ALTERUM
ET QUINQUAGINTA CUM EO
QUI LOCUTUS EST ILLI
HOMO DI HAEC DICIT REX
FESTINA DESCENDE
RESPONDENS HELIAS AIT
SI HOMO DI EGO SUM DESCENDAT
IGNIS E CAELO ET DEVORET TE
ET QUINQUAGINTA TUOS
DESCENDIT ERGO IGNIS DI E CAELO
ET DEVORAVIT ILLUM
ET QUINQUAGINTA EIUS
ITERUM MISIT PRINCIPEM
QUINQUAGENARIUM TERTIUM
ET QUINQUAGINTA QUI ERANT
CUM EO
QUI CUM VENISSET CURVAVIT
GENUA CONTRA HELIAM
ET PRAECATUS EST EUM ET AIT
HOMO DI NOLI DESPICERE
ANIMAM MEAM ET ANIMAM
SERVORUM TUORUM
QUI MECUM SUNT
ECCE DESCENDIT IGNIS E CAELO
ET DEVORAVIT DUOS PRINCIPES
QUINQUAGENARIOS PRIMOS
ET QUINQUAGENOS QUI CUM EIS ERANT.

Bibles still do too. It is one possible clue that the Codex Amiatinus was copied subsequent to the volume with the Willoughby leaves, and that decisions about textual policy were still ongoing in the scriptorium of Wearmouth–Jarrow during the production of the pandects.

The other difference occurs on folio IIv of the Willoughby leaves. To demonstrate the point, I need to quote the text in Latin (a translation will follow in the next paragraph). Here are lines 6–18 in the first column of the fragment:

Et constituerunt sibi regem Iosiam filium eius pro eo. *Reliqua autem sermonum Amon quae fecit, nonne haec scripta sunt in libro sermonum dierum regum Iuda. Sepelieruntque eum in sepulchro suo in horto Aza, et regnavit Iosias filius eius pro eo.* Octo annorum erat Iosias cum regnare coepisset et triginta et uno anno regnavit in Hierusalem.

This is IV Kings 21:24–22:1 (2 Kings 21:24–22:1 in the modern Bible). The surprise is that the words here printed in italics, present in the Willoughby leaf, are entirely omitted in the corresponding passage of the Codex Amiatinus (folio 325v). The simple explanation is a common scribal error known as '*homeoteleuton*', whereby the scribe copied the words "eius pro eo" in the first line, paused, looked back at his exemplar and his eye jumped instead to the second appearance of "eius pro eo" a few lines further down and he continued copying instead from "Octo annorum …" onwards. It is an easy kind of mistake to make. It resulted in two verses of the Bible being lost, and on the authority of their absence from Amiatinus they were deleted from the Catholic revisions during the Counter-Reformation and they still do not appear in my own working copy of the Vulgate (Madrid, 1965), based on the Clementine edition of 1592. That itself is interesting and goes back to a moment in Wearmouth–Jarrow.

However, everything about the lost verses looks suspect. They say, approximately, 'The rest of the acts of Amon that he did are surely written in the Book of the Annals of the Kings of Judah; he was buried in his tomb in the garden of Uzza, and then his son Josiah succeeded him.' Although the words are now regarded as authentically biblical, they sound in every way like a spurious interpolation, for they are an

The end of III Kings and the opening of IV Kings in the Middleton leaves, with the two texts run together as a continuous narrative

almost word-for-word repetition of III Kings 15:7–8, which similarly begins "Reliqua autem sermonum …" and ends "… filius eius pro eo". A textual editor of any critical experience would suspect them of having been casually reinserted here as an explanatory gloss, triggered by verbal repetition of "eius pro eo", a kind of backwards *homeoteleuton*. In other words, we do not know whether the verses – which must have been in the exemplar – were omitted from Amiatinus by accidental eye-skip or by intelligent intervention.

If it is the latter (and there is nothing else in Amiatinus which is careless), we must suppose that there was someone in Wearmouth–Jarrow with the confidence and critical ability to delete received words of the

Scriptures in the interests of textual plausibility and with sufficient knowledge to emend the Latin conflation of III–IV Kings to conform to the Greek. This person could only be that exceptional biblical scholar and commentator who was indeed resident in the monastery at Jarrow throughout the entire period that the pandects were being prepared: Bede himself. It is quite likely to have been Bede too who initially persuaded Ceolfrith that the new pandects should follow the new Vulgate of Jerome, but his reference source for improvements might have been the *Codex Grandior*, with its archaic text taken from the Greek.

Another interesting variant in the Codex Amiatinus occurs at Genesis 8:7. This is the passage where Noah is sending birds out from the Ark to test whether the floods have receded. In modern Bible translations he releases a raven which flies out and back until the waters have dried up. This is the reading of the original Hebrew. However, the Greek text adds a negative, which makes the raven fly out and not come back until the waters have dried up. Both variants make sense. Bede discusses the alternatives at some length in his commentary on Genesis, and he himself opts for the version found in the Greek. The editor who divided the third and fourth books of Kings in the Codex Amiatinus made the same choice, deferring to the Greek. In the passage about the raven, the scribe of Amiatinus wrote the received Latin version, "qui egrediebatur et revertebatur …" and then a contemporary but distinctly non-calligraphic hand has altered it, inserting the little word "non" in uncials before "revertebatur" to bring it into conformity with

Genesis 8:7 in the Codex Amiatinus, with the word 'NON' added in the third line, to bring the text into conformity with the Greek, as proposed by Bede

the Greek. This occurs in the manuscript on folio 15r, seventeen lines up from the bottom of the second column. Is this an autograph word in the hand of Bede? It is certainly quite possible. It is hard to convey that sudden shiver of excitement, here in the photocopy room of the Biblioteca Laurenziana, in realizing that one may be touching a page which was actually read and corrected in late seventh-century Northumbria by Bede himself.

Finally, let us go back to the abbey of San Salvatore on Monte Amiata. We do not know how or when the Codex Amiatinus arrived there. The doctored donation inscription from the supposed 'Peter, abbot of the Lombards' might represent an actual gift; it may also be a spurious invention to conceal the embarrassing fact that the manuscript was somewhere other than the destination intended by Ceolfrith. The monastery, as we saw before, looks out over the Via Francigena, the pilgrim route from the north of Italy down to Rome, and it was certainly a stopping place for travellers. Ultimately, this ancient road follows a longer line right down across Burgundy through Lausanne, over the pass of the Gran San Bernardo into Italy above Aosta, and down through Pavia, Lucca, Siena, Viterbo and into Rome. Anyone, even Charlemagne in theory, could have gathered up the manuscript on any part of that route after Ceolfrith's death in Langres and could have left it with the monks of San Salvatore on the journey south, or north again on return.

I mentioned the abbey's museum. Over lunch in London some months earlier, Nicolas Barker had told me about an item exhibited there which so caught my imagination that we originally planned our visit together to Monte Amiata in order to see it. It was found in San Salvatore in the 1960s. According to one account it was discovered concealed in a hollow beneath the high altar during the reconfiguration of the sanctuary, permitted by the Second Vatican Council. It was first published in 1974. The object is a tiny and exquisite portable insular reliquary box, shaped like a little house with a gabled roof, inset with dark red mosaic rectangles and ornamented with interlaced metalwork including bird-head finials, which are closely paralleled in manuscript decoration in the Book of Durrow and the Lindisfarne Gospels,

probably both of the late seventh century. One might assume that the reliquary was Irish, except that it incorporates garnets (recorded in Anglo-Saxon England but apparently not in Ireland itself) and it has pieces of coloured glass, examples of which, as we saw at the opening of this chapter, survive uniquely at Jarrow. The box has metal tags for suspension cords, so that it could be carried. A date approximately contemporary with Ceolfrith is entirely credible.

Once again, a monastery on a pilgrim road can receive exotic gifts from passing travellers and grateful guests at any time. There is absolutely no known connection between the reliquary and the Codex Amiatinus, except the noteworthy coincidence that San Salvatore should have owned two great works of art of the same date and same origin, so far from Northumbria, and one simple explanation would be that they arrived together. Nicolas and I became quite expansive on the subject, as we egged each other on in our speculations. It is easy to envisage. Ceolfrith's party would undoubtedly have carried portable altars,

The late seventh- or eighth-century insular relic box or chrismal, found in the 1960s concealed in the abbey of San Salvatore on Monte Amiata

chalices and relics from Wearmouth–Jarrow for the maintenance of religious life during their journey. According to the *Vita Ceolfridi*, some of the monks returned home after the death of Ceolfrith in September 716. Others continued their journey towards Rome, still carrying the Bible. The route would have been south along the Via Francigena. Northern Italy is cultivated and easy countryside for travelling. As one reaches the wilder region between Tuscany and Umbria it suddenly becomes dangerous, underpopulated and very mountainous. There would have been brigands and wolves and probably bears. One can imagine the leaderless delegation pausing, waiting perhaps for a safer season, and somehow never quite moving on. There may already have been some religious settlement there on the slopes of Monte Amiata. The English monks would have died off one by one. In 742, when the monastery of San Salvatore is first recorded, the youngest members of Ceolfrith's retinue were not necessarily older than their mid-forties, but old and few enough to opt gladly for a more sedentary life, with their Bible and their reliquary. This is no more than fanciful guesswork, but it would fill the gap in this astonishing manuscript's 1,300-year journey from Wearmouth or Jarrow to the photocopy room in Florence.

The Book of Kells

late eighth century
Dublin, Trinity College,
MS 58

The Book of Kells has been reported stolen twice. The second occasion was in 1874. The account in the *Birmingham Daily Post and Journal* for 5 November is typical of a large number of similar stories in the press across Britain and Ireland that week: "Trinity College, Dublin, is in despair. One of its chief treasures is missing – viz., the Book of Kells, written by Saint COLUMBKIL in 475 – the oldest book in the world, and the most perfect specimen of Irish art, with the richest illuminations, and valued at £12,000 ..." The valuation is interesting: the previous year, a Gutenberg Bible on vellum had sold in the Perkins sale at Hanworth Park near London for £3400, by far the highest price then ever paid for any book, and a second copy on paper had made £2690. In estimating the missing Book of Kells at almost four times more valuable than the world's most expensive known book, the College was probably not wrong. It was recounted that the loss was discovered when the Provost of Trinity College had wished to show the manuscript to some lady visitors, and he found that it had disappeared. No one could recall when it was last seen, and the librarian was absent and could not be consulted. Rumours and whispers flew around, as they can only in universities. The *Birmingham Daily Post* revelled in a further layer of mystery: "A receipt for the volume signed by a Mr. BOND, purporting to be from the British Museum, has been placed in the hands

of the Provost." Within a week the manuscript was located. The librarian of Trinity College, J. A. Malet, had himself taken it to the British Museum in London for advice on rebinding. The suspicious 'Mr Bond', whose name had been printed in the newspaper story in capitals, was Sir Edward Augustus Bond (1815–98), keeper of manuscripts from 1867 and principal librarian of the Museum from 1873. Bond had dissuaded Malet from meddling with the binding, on account of the supreme importance of the book, but he asked whether he might keep the volume in his custody for a few days to inspect it. By this time the College had sent its lawyer, Mr Moore, to London to demand its return, and the manuscript was hastened indignantly back to Ireland. Those were heady days for Irish nationalism. In 1874 the Home Rule League was founded. Gladstone's Irish Government Bill was narrowly defeated in 1886. In 1888, the executive committee of the politically charged Irish Exhibition at Olympia in London requested inclusion of the Book of Kells. "It is believed that a satisfactory arrangement may be come to in that respect," blandly reported the Dublin newspaper *Freeman's Journal and Daily Commercial Advertiser* on 25 April that year. It was widely announced in London that the manuscript would be exhibited. This was reckoning without politics. The Board of Trinity College soundly refused: "they do not consider it consistent with their duty to subject such a unique and invaluable national treasure" to exposure in England.

The previous occasion when the Book of Kells was stolen was a little over 850 years earlier, in 1007. We have only one source for this incident and some of its details are ambiguous. The account is in the so-called *Annals of Ulster*, an ever-updated chronicle partly in Old Irish from the earliest times to the beginning of the sixteenth century. The original manuscript is also in Trinity College, Dublin. One entry in the narrative for the year 1007 has been loosely rendered something like this: 'The great Gospel of Colum Cille was sacrilegiously stolen in the night from the western sacristy of the church of Cennanas. It was the most precious object of the Western world, on account of its covers with human forms. This Gospel was recovered after two months and twenty nights, its gold having been taken off it and with a sod over

it.' 'Colum Cille' is Saint Columba (it literally means 'Columba of the Church'). 'Cennanas' is the old name for the town of Kells, or Kenlis, in County Meath, about forty miles north-west of Dublin. The westerly storage place of the book – "*airdom iartharach*" in the original – may mean the western end of the church or it may have been some kind of free-standing treasury to the west of the church. The stated reason for the theft was because of a highly ornamented binding or fitted case, for Irish Gospel Books were commonly enclosed in portable shrines. The original word used in the Annals is "*comdaigh*"; in other contexts it is usually spelled '*cumdach*'. Evidently the *cumdach* at Kells was made of gold and was ornamented with anthropomorphic images, perhaps representing the Evangelists. The robbers were interested only in the value of the precious metal, and they may have been Vikings. There survive elsewhere records of other manuscripts stolen around this time, including a Psalter in a jewelled binding looted in 1012 from the abbey of Saint-Hubert in Luxembourg, and the Stockholm Codex Aureus, stolen by Vikings from Canterbury in south-east England and immediately ransomed back again, doubtless without its binding (see above, p. 47). The thieves of the Book of Kells presumably stripped it and discarded or buried the worthless text. The two months and twenty nights of its purgatory are exactly double the forty days and forty nights of the Gospel account of Christ in the wilderness, or twice the length of Lent. They ended with burial and resurrection.

This 'most precious object of the Western world' is now a national monument of Ireland at the very highest level. It is probably the most famous and perhaps the most emotively charged medieval book of any kind. It is the iconic symbol of Irish culture. It is included in the Memory of the World Register compiled by UNESCO. A design echoing the Book of Kells was used on the former penny coin of Ireland (1971 to 2000) and on a commemorative twenty-euro piece in 2012. One of its initials was shown on the reverse of the old Irish five-pound banknote. It has been illustrated on the country's postage stamps. Probably every Irish bar in the world has some reflexion of its script or decoration. It is reproduced on millions of tea towels of Irish linen, not to speak of patriotic or souvenir scarves, ties, brooches, beer bottles, cufflinks and

tablemats. The original is displayed in a special darkened shrine now called the Treasury, at the eastern end of the library at Trinity College in Dublin, and over 520,000 visitors queue to see it every year, buying coloured and numbered admission tickets to the Book of Kells exhibition. More than 10,000,000 people filed past the glass cases in the first two decades after the opening of the present display in 1992. The daily lines of visitors waiting to witness a mere Latin manuscript are almost incredible. There are signposts to the 'Book of Kells' across Dublin. The new tram stop outside the gates of Trinity College is named after the manuscript. No other medieval manuscript is such a household name, even if people are not always sure what it is. I have quite often been asked whether a 'Book of Kells' is similar to a 'Book of Hours', and, if so, what is a kell?

The Book of Kells, which simply takes its name from the town which once owned it (and from which it had been stolen in 1007), is a manuscript of the four Gospels – Matthew, Mark, Luke and John – in the Latin translation of Jerome, with variations, as we will see, supplemented with a number of traditional prefatory texts before the start of the Gospel of Matthew. In that, although in very little else, it resembles the Gospel Book of Saint Augustine (Chapter One), and it probably dates from the very end of the eighth century.

I arrived in Dublin to see it on an early-morning flight from London, for it is practically within commuting distance, connecting with the airport shuttle bus into the south centre of the town. It was a crisp autumnal day, with high clouds in the palest of blue skies. You come into Trinity College through an archway in a classical building called Regent House into what is virtually a miniature city of grand houses and elegant squares. For the Book of Kells you follow signs straight ahead and then to the right, round to the far (south) side of the long eighteenth-century library building. With slight embarrassment at my presumption, I threaded past the lines of tourists already queuing along the cobbles outside for admission to the Treasury exhibition. You

RIGHT: The Long Room in the library of Trinity College, Dublin, built in the early eighteenth century and expanded in the nineteenth

enter and leave the building through the bookshop, for Kells is serious business, like pilgrim shrines of the Middle Ages. There is no obvious inquiry desk other than the harassed cashiers. I espied a man in official clothing and I asked where I should go for an appointment with Bernard Meehan, the keeper of manuscripts. "Oh, I'll take you," he said, with that irresistible Irish lilt. I suspect now that he had actually been sent to wait for me. He led me straight up the main staircase marked 'Exit only' directly into the centre of the Long Room, as it is called, of Trinity College Library. This is the magnificent polished wooden cathedral of books, built by the architect Thomas Burgh in 1712–32 initially for 100,000 volumes but doubled in the mid-nineteenth century by an upper floor of multiple mezzanine galleries of gilt and leather-bound books from floor to firmament. It is breathtaking. Even my escort paused, to allow the effect to penetrate me properly. "You've been here before, I suppose?" he asked. I agreed that I had. If Jorge Luis Borges' Library of Babel could have existed in reality, it would have been something like the Long Room of Trinity College. We walked down the length of the room, past marble busts on pedestals and exhibition cases, through barriers of green ropes, to a steep wooden staircase, like something on a sailing ship, in the far left-hand corner. "Mind your head," said the man, whose name I learned later was Brian. He brought me upstairs into a balcony, where two conservators were working at a table, and through into the reading-room for rare books at the western end, like the sacristy of Kells. Several people were at desks, some of them (I could not help noticing) being made to wear gloves. We, however, turned right and then left again into the open-plan library offices, where Bernard Meehan emerged to welcome me most affably. He has a neatly cropped greying beard, a bit like a friendly Schnauzer dog with glasses. Everyone likes him. He is the kind of person who uses your first name constantly when addressing you.

The Book of Kells is so precious and so immediately recognizable that Bernard explained that it would be inappropriate to allow it into the reading-room. No other manuscript is comparable, not even the *Très Riches Heures* of the Duc de Berry, at Chantilly in France. The Book of Kells risks being mobbed, like a pop star or a head of state. The secu-

rity arrangements around it are necessarily as complex as presidential protection undertaken by the secret services of a great nation. When he read an early draft of this chapter, making a number of helpful observations, Bernard Meehan begged me not to describe too precisely where we had looked at the volumes of the precious manuscript. I have no wish to be mysterious but of course I defer to his caution. I must simply say that the three of us went out to a secure room in the library in which there could have been be no possibility of accidental interruption. Earlier that morning Bernard had had a large grumbling humidifier wheeled in to bring the centrally heated environment of the location up to the level for the optimum safety of the manuscript. It was clearly working, for the little window had already misted up with moisture. I was placed at a circular green-topped table, prepared in advance with foam pads, a digital thermometer, and white gloves. "We are ready," he nodded to Brian, and the two of them went off together to fetch the first volume. I cannot deny that I felt a certain excitement in sitting alone waiting for their return. It had been more than fifty years since I handled my first modest medieval manuscript, at the age of thirteen, in the Dunedin Public Library in New Zealand. I wondered what I would have thought then if I could have known that I would one day be in Dublin, about to meet the most famous book in the world.

Although the British Museum's advice in 1874 had been not to interfere with its binding, however inadequate, the Book of Kells was indeed rebound in 1953 by Roger Powell (1896–1990), the best-known British craft binder of his generation. Powell divided the Book of Kells into four volumes, in part so that different Gospels could be exhibited simultaneously, and in order that the displays might rotate and portions of the manuscript could be retired from exposure before returning to the public glare. I had agreed with Bernard Meehan in advance that I would be content to see whichever two volumes happened not to be on view the day I was there. When Bernard and Brian arrived back they were carrying a slim box with a leather handle, like a little wooden suitcase. It looked too small for the Book of Kells and it was a moment before I realized that it must actually contain the first of the separate volumes. The boxes were made by Edward Barnsley (1900–1987),

cabinet maker, and all four apparently stack one above the other into shelves of something like a dolls' house chest of drawers, which is the modern *cumdach* of the manuscript in Trinity College. The boxes resemble wooden trays, each with a snugly fitting lid held firmly in place by a long copper spring which is released by twisting. The pressure exerted by the tension of the spring holds the volumes tightly closed without the need for clasps.

Bernard Meehan lifted this first volume out onto the table before me. We gazed for a moment. Unopened, it measures about 13¾ by about 10½ inches. Already the binding of 1953 looks strangely old-fashioned, in the Arts and Crafts style not unlike that used on the Gospels of Saint Augustine, which was rebound at almost the same time. The sides of the Book of Kells are plain quarter-cut oak boards, now rather thumbed. The spine is wrapped around with alum-tawed white leather, secured to the boards by steel screws on the inside and out. Leaves that required repair were stitched with very visible white thread, on the principle that sewing, although obvious, is an honest and traditional craft. Flyleaves and essential repairs used clean white parchment, with no attempt to deceive. I suspect that a binder today would seek less obtrusive techniques. The major problem encountered by Roger Powell was that some 140 leaves were loose or needed urgent reinforcement on their inner folds. To achieve this, these sheets had to be attached to new stubs of modern parchment. That meant, in turn, that the extreme inside edges of those leaves were now of double thickness, twice the bulk of the book at its fore-edge. A binder's usual solution would have been to pare away the parchment at the folds to exceptional thinness, to compensate for the added mass. The Board of Trinity College absolutely refused permission for this to be done, insisting that nothing whatsoever (even dirt) should be taken from the pages. Powell and the College almost fell out over the issue. He called them "misguided to the point of absurdity". I think that we would now commend the College's caution. In the end, Powell's solution was to insert clusters of new blank parchment pages between the gatherings, peeled to extreme thinness at their inner edges and of robust thickness elsewhere. The result restored the volumes to regular shape, but it pads

The wooden cases by Edward Barnsley and Roger Powell for the four volumes of the Book of Kells, holding each Gospel tightly closed under the pressure of a copper spring

them out unnaturally and it utterly ruins the bibliophilic pleasure of turning the pages, for one is forever being interrupted by the shock of stark new leaves. It is a great pity. This is not visible to anyone viewing the manuscript in a glass case, or studying it in a facsimile or in digitized images on-line.

Bernard had outlined certain further house rules in advance, hoping that these were acceptable. I was welcome to spend as much time as I liked with each of the two available volumes as they were brought out, one at a time, but he himself would actually turn the pages for me. He had set aside the entire day and he was happy to let me see every page, which he did with infinite patience, sometimes making observations on what we were seeing, sometimes discreetly retreating as I scribbled notes. He turned the leaves carefully with the extreme tips of his fingers, usually from the top and bottom simultaneously.

An absolute first impression of the original manuscript is that it is very smooth, sometimes almost translucent, and the pages are completely flat, like a printed book, not cockled and undulating as in many large manuscripts. The flattening was carried out by Roger Powell, with the intention that compactness of the pages would prevent the ingress

of dust. It was achieved by dampening the leaves very carefully and then by suspending them tightly on all sides from rows of bulldog clips as the pages dried under tension. The edges of the leaves had already been crisply and cleanly cropped, the legacy of George Mullen, an enthusiastic improver, who rebound the manuscript in the mid-1820s. For better or worse, the Book of Kells is now very neat and tidy, which it can never have been in the Middle Ages.

The first page of the book is slightly disappointing. Stitched boldly within a frame of clean modern parchment is a brown and rubbed upright rectangle with irregular edges (it owes this shape to trimming to the edge of the design on the verso of that leaf, as I could see when I signalled to Bernard to turn the page). It was evidently once a crumpled fragment, now smoothed out by Powell and restored to its original position. It is divided vertically into two columns within ornamented frames. The text opens in big rounded script "Sadoc iustificatus, Sidon venatio, Thomas abysus …" This is the last column of a lost list which was presumably once the opening text in the manuscript. It is an abridged catalogue of Hebrew proper names which occur in the Gospels of Matthew and Luke, in alphabetical order (it may surprise you to find alphabetization already in use in the eighth century), originally compiled by Saint Jerome, giving a synonym for each of the names in Latin. Jerome had been anxious that names of people and places in the Bible also had meanings in Hebrew which would be lost to readers who knew Latin only and who might therefore miss some simultaneous layer of interpretation in the sacred text. It is strange that this should be considered useful in a grand display manuscript like the Book of Kells, surely never envisaged for consultation by an exegetical scholar. The first name here is 'Sadoc' (Zadock), explained as meaning 'justified'. As far as I can see, Zadock the priest is mentioned nowhere in the Gospels at all (he is a priest from the books of Kings and Chronicles and was last cited in Ezekiel). The next is the place name 'Sidon', interpreted as 'hunting': the city of Sidon is indeed in the Gospels, paired with Tyre (Matthew 11:21–2, etc.). The apostle Thomas, the third name, 'a pit'

RIGHT: The first surviving page of the Book of Kells, opening in the middle of a list of Hebrew names appearing in the Gospels

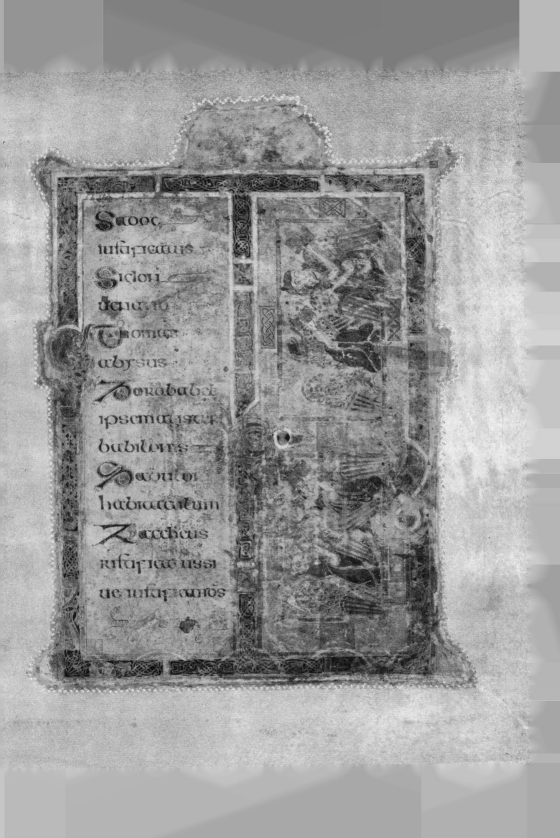

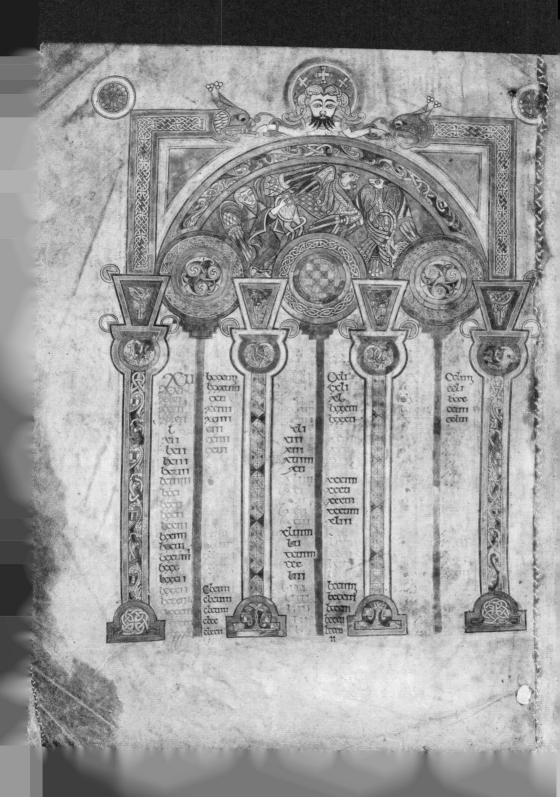

(or 'deep sea'), appears many times of course and is first mentioned in Matthew 10:3. The list ends with Zacchaeus, the tax collector from Luke 19. His name, like Sadoc's, is explained as meaning in Hebrew 'justified or justifiable'.

The second column of that first surviving fragmentary page brings our first encounter with pictures in the Book of Kells but they are now so brown and rubbed that they are hard to make out. They appear sideways, as if to be viewed from the right. These are the first of many small images in the manuscript which seem to face in the wrong direction. We can imagine people crowding round the book in the eighth century and gazing at it from all sides, or maybe we are meant to envisage God doing so. The faded pictures here are the symbols of the four evangelists, which were also found in the Gospels of Saint Augustine. Here they are again – an angel with a book for Matthew, a winged lion with a long tongue for Mark, what must be an ox for Luke (although it is difficult to discern detail), and an eagle for John. This is the most common imagery of the manuscript. Here they are doubtless a partial frontispiece to the Canon tables which follow.

The Canon tables are the concordances of parallel passages in the four Gospel narratives, devised by Eusebius of Caesarea (*c.* 260–*c.* 340). They would once have been in Saint Augustine's manuscript too, before its loss of leaves at the front. In many early Greek and Latin manuscripts the tables are laid out between pillars joined at the top by graceful round arches ranged across a double opening, resembling the arcade of a cloister. A reader would run his finger across the page, matching chapter numbers horizontally between the columns. In most manuscripts, the comparison with classical architecture is very striking. Looking at Canon tables in a Greek or even Carolingian Gospel Book is like standing in the sunlit courtyards or painted aisles of a Byzantine palace or a Mediterranean monastery. However, in the island beyond the furthest extremities of Western Europe, probably no one in late eighth-century Ireland had ever seen colonnades of soaring round arches at all. Churches there were doubtless mostly low and

LEFT: The Canon tables of the Book of Kells, derived ultimately from classical architecture, listing chapter numbers for parallel passages in the Gospels. Roger Powell's stitching is clearly visible on the right

dark structures with square lintels across tiny windows and doors. In the Book of Kells the original architectural ancestry of these Canon tables has become almost lost and drowned in Irish ornament. The pillars look insubstantial, crawling with interlace and writhing creatures. The feet of the columns are no longer structural. The arches over the top are crammed (they really are) with decoration and with faces and the symbols of the evangelists again, an innovation which seems to be unique to insular or Irish manuscripts. By the last two pages of the Canon tables in the Book of Kells, the designer gave up, or perhaps he was copying from a defective exemplar and had to improvise. He simply ruled the last pages of tables into rectangular grids instead. The pillars and arches have gone. It looks a bit like a design for a modern boardgame. (If the shop of Trinity College read this and decide to market it, please remember who suggested it first.)

Along the lower margins of the last of these pages and all over the once-blank leaves which follow them are transcripts of various contracts written in the medieval Irish language. There are more elsewhere in the manuscript too. They all relate to land around the monastery of Kells between the late eleventh century and 1161, and they were probably inserted into the manuscript at the time or soon afterwards. It is quite likely that the agreements had been sworn on the Gospel Book itself and that they were subsequently inserted where the sacredness of their context would ensure their perpetuity and appropriate reverence for what had been transacted with such solemnity. The addition of charters is a common feature in early Gospel Books, in all parts of Europe (we saw some in the Gospels of Saint Augustine). Those here record deals such as that Ua Breslén, priest of Kells, and his kinsmen have bought for 18 ounces of silver a piece of land known as Muine Choscáin, with its meadow and turbary (the right to cut turf, or peat), extending to the west as far as the mire of Donaghmore, as witnessed by very many people (try to imagine them all gathered noisily around the manuscript), including Oengus, grandson of Rancán, full chief of Síl Tuathail; Ferdomnach Ua Clucáin (d. 1114), successor of Colum Cille,

LEFT: Charters added in the Old Irish language to pages originally left blank in the Book of Kells, including a document in the name of Ua Breslén, priest of Kells

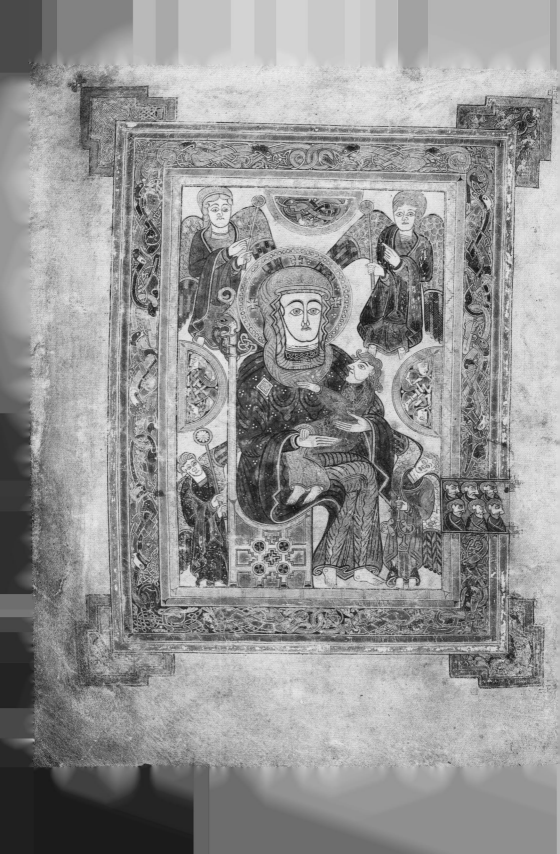

with all the community of Colum Cille; Ua Dúnán (d. 1117), senior cleric of the north of Ireland and of Domnall son of Flann Ua Maelsechnaill, king of Tara (1087–94); and Ossín, son of Echtgal, doorkeeper of Kells. This particular example is written at the bottom of folio 6v. The names sound magical and redolent of a very ancient world. They also localize absolutely where the book must have been at that time. These inscriptions are actually the only early evidence that this manuscript is indeed the great Gospel which belonged in the eleventh century to Kells, as described in the account of its theft from the church there in 1007, almost a hundred years earlier.

Bernard turned the leaf again, and there was the first full-page illustration in the Book of Kells. It is on folio 7v. It shows the Virgin and Child attended by four angels. It is one of the most recognizable images in Irish art. A detail from it was reproduced on a set of Irish postage stamps, designed by Patrick Scott, for Christmas in 1972. Apparently it is the earliest representation of the Virgin and Child in European art. As a result of what I am about to say, I shall probably have my permission to visit the Republic of Ireland revoked for ever, but the picture is dreadfully ugly. Mary's head is far too big for her body, and she has huge staring red-lined eyes and a long nose which looks as though it is dripping downwards, and a tiny mouth. Her pendulous breasts are visible through her purple tunic, and her little legs stick out sideways like a child's drawing. The baby, seen in profile, is grotesque and unadorable, with wild red hair like seaweed, protruding upturned nose and chin, and a worrying red line from his nose to his ear, perhaps a foreshadow of Christ's beard in later life. The child has two left feet. I am not qualified to say whether the four unpleasant-looking angels are lifelike, but they are certainly anatomically very improbable beneath their weighty garments. However, intrinsic beauty is a difficult concept in art history, especially across a divide of 1200 years. One need not doubt the artist's technical skill, given the extreme delicacy of the border ornament even on this page. Perhaps the central figures are derived from some ancient composition for which there was particular veneration or

LEFT: The Virgin and Child, said to be the earliest illustration of the subject in European art, shown between four angels

assumption of authenticity. The weirdness may be inherited tradition rather than simply being poor draughtsmanship. Saint Luke himself was said to have painted a portrait of the Virgin Mary and many Greek icons were (and still are) claimed to be descendants of that picture. There are early Syriac and Coptic manuscripts with similarly misshapen representations of the Virgin and Child. The undoubted journey of such iconography to the western isles is really beyond our comprehension, as inexplicable still as the migration of birds. Something very like the upper part of this composition occurs on the shaft of the eighth-century stone high cross of Saint Oran, from the island of Iona, recently restored and redisplayed in the museum there.

The image in the manuscript must allude to the Nativity of Christ, for it faces the opening of the chapter summaries for the Gospel of Matthew, which begin with the nativity. The page has lines in ornamental initials so dense that they are almost unreadable, and a seventeenth-century hand has helpfully transcribed the opening words into the lower margin for ease of comprehension, "Nativitas xpisti in bethlehem …", 'The birth of Christ in Bethlehem', the incident which does indeed open the Gospel text. When the page is turned again we encounter at last the lines of large graceful insular majuscule script for which the Book of Kells is so rightly famous. ('Majuscule', sometimes called 'half-uncial', is the big flourished horizontally oriented display script, characteristic of the islands of Britain and Ireland.) However, the actual Gospel texts do not begin for another twenty-one leaves. The amount of non-biblical prefatory material here is extraordinary. It is as if various early manuscripts opened with different aids to usage, and every one of these has been gathered up and comprehensively introduced here, although they no longer had much practical value to the first owners of such books. Rather like 'all the trimmings' customarily supplementing Christmas lunches, more elaborate year by year, the ever-growing apparatus added to Gospel Books was unquestioningly inherited and included with each manuscript made, even when its necessity was lost in tradition. The Canon tables and chapter summaries are more or less unusable, since there are no chapter divisions in the Gospel texts of the Book of Kells anyway.

The opening of the preface to Matthew's Gospel, "Matheus ex iudaeis sicut primus ponitur ... ",
'Matthew, [one] of the Jews, as he was placed first ...'

The supernumerary texts continue with the traditional preface
to Matthew, with a great square initial showing a startled man peer-
ing out from behind it, like a bather caught changing behind a towel
on the beach; the chapter summaries and preface to Mark; the pref-
aces to Luke and John; then it jumps back to the chapter summaries
of Luke and John, partly written in red and purple, very decoratively;
and finally prefatory illustrations to Matthew – the symbols of the four
evangelists again, dancing in space in a beautiful frame and a full-page
standing figure of Saint Matthew himself. This has brought us to folio
28v. The evangelist stands staring directly at us. His left hand holds a
book, and his right is tucked into his cloak, like Napoleon. The cloak
itself is purple, dotted in yellow. One might believe him to be a spectre,
conjured up among vibrant ornament and wild-eyed animal heads. His
feet face outwards and the hem of his cloak flutters, as if he were float-
ing in the air. The page is rather dark, for it must have been exhibited
and thumbed many times in the last thousand years.

OVERLEAF: The beginning of Matthew's Gospel, with a full-page portrait of the evangelist
facing the first words of the text, "Liber generationis ...", 'The book of the generation ...'

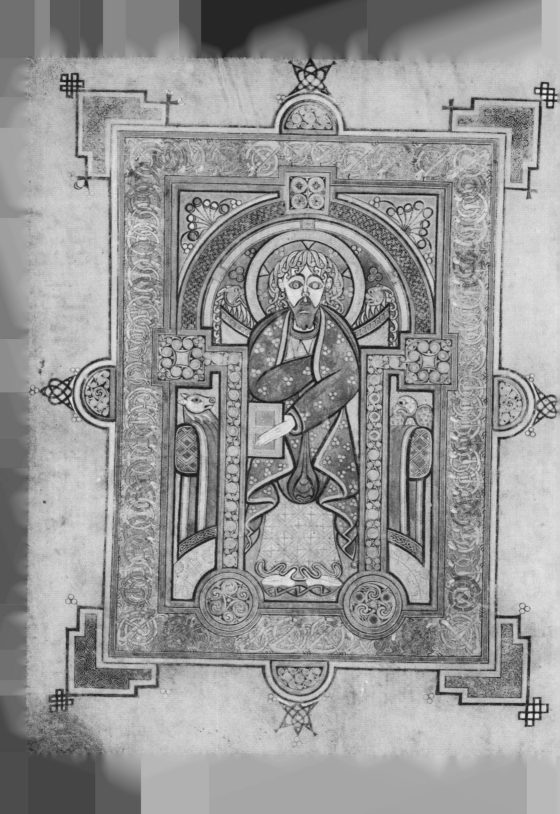

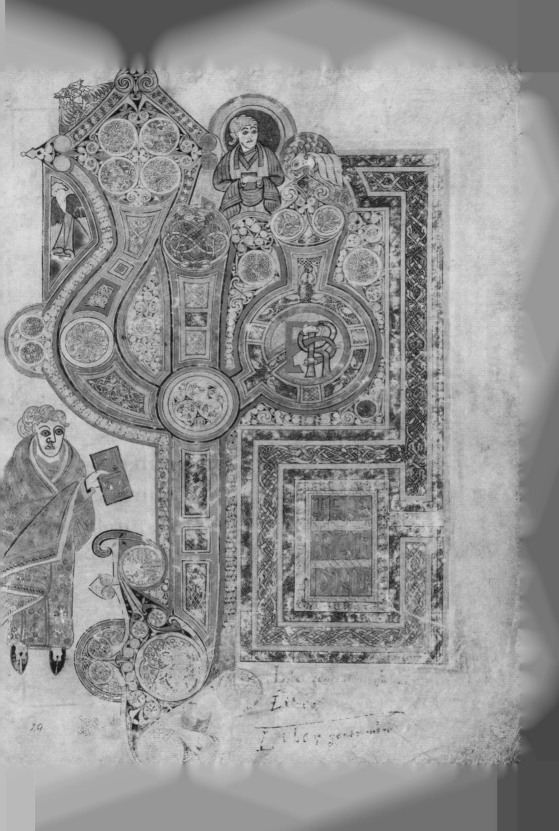

Eventually, almost a quarter of the way through what is now the first volume, the Gospel of Matthew finally begins on folio 29r, and its opening page is virtually unreadable. It is a mass of swirling curves and geometric circles and rectangles, infilled with ornament of the finest delicacy. Peeping out at the top is a little man looking like a building surveyor who has climbed up through the decoration and is now inspecting the chaos below. He is presumably Saint Matthew, for he has a halo and a book, and there is an angel, Matthew's symbol in art, in a corner of the upper margin. At the lower left is a free-standing figure of a man holding a closed book. It may be the author again, although there is no halo, or perhaps he is a priest or deacon bringing in the Gospel which is about to be unlocked to reveal the fulfilment of all the prophets. Although it is nearly impossible to find the word in the frenzy of ornament, Matthew's Gospel actually opens with the word 'book', "Liber generationis ...", as two doubtless despairing later readers have transcribed more legibly into the lower margin.

A few pages later is what amounts to a second multiple opening for the Gospel of Matthew. There is a full-page image of Christ, apparently on a throne (folio 32v), and, facing it, what is called a 'carpet page' of pure ornament. This graphic term used by art historians is entirely appropriate, for this does indeed look like a marvellously woven oriental carpet. Those who seek the origins of Irish Christianity in Coptic North Africa can quite rightly point to Coptic textiles which are extraordinarily similar. Folio 34r, the next opening, is for all practical purposes unreadable again. It is actually a word "Christi" – for the birth of Christ beginning at Matthew 1:18 – but in its traditional medieval abbreviation from its first letters in Greek, "XPI", shapes that lend themselves to kaleidoscopic patterns. These are designs so familiar from countless reproductions that it is difficult to imagine their impact to an eighth-century congregation seeing such pages for the first time.

There are great full-page paintings for each subsequent Gospel too, each preceded by the symbols of the four Evangelists again and each opening with complex pages so formalized that the text would be

RIGHT: The text for Matthew 1:18, "XPI autem generatio", 'Now the generation of Christ', ornamented with an almost unreadable 'Chi Rho' monogram for the name of Christ

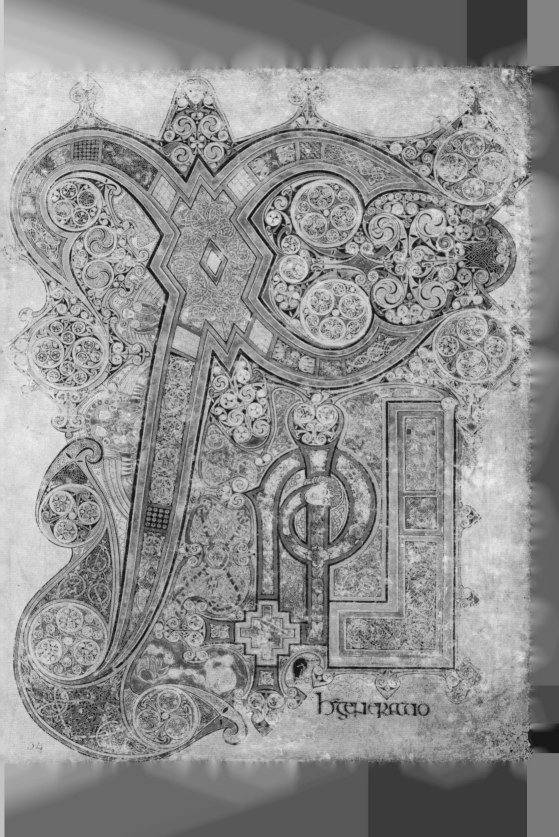

generatio

duo excuobis superterram decomttire q:
cumque peuerint apaaremeo quiin
caelis est fia cum illis · Ubi enim
sunt duo uettres congregtta innomi
ne meo ibi & cosum inmedio eoruz

Tunc accedens peurus adoeum djat
dne quoniam si peccauerit inm
frater meus quoaes dimittti mei us
que insepaes · Diat illi ihs non dico
tibi usque sepaes seclusque septua
gies & sepaes · ·

Ideo adsimilatum est regnum ce
lorum homini regi quiuoluitra
aonem ponere cumseruissuis
& cumcoepissa rationem po
nere oblatusest ei unus quidebe
bat decem milia talenta cumautez

indecipherable to anyone who did not know it by heart, with Mark (folio 130r), Luke (folio 188r) and John (folio 292r).

My private impression from having pages of the Book of Kells turned before my eyes, one after the other throughout the day, is that the picture pages interrupt the text and are hard to enjoy, despite all their fame. I am not even sure that we can regard them as beautiful. They are spectacularly important in the history of art and their commercial value is almost beyond estimation (I write as a former employee of Sotheby's), but they are confusing and difficult to decipher. Human forms are primitive, even crude. There is too much decoration. The eye has nowhere to settle. Furthermore, these pages are now dark and shiny, almost as if varnished, probably from overzealous handling and even pious kissing, and one can understand the misguided attempts by George Mullen, restorer of the manuscript in the 1820s, cleaning the margins and adding white paint to improve the definition. The difference of preservation between pages of pictures and those of text is something not obvious from facsimiles, where all finishes are rendered equal. The pictures probably seemed more impressive when they were in pristine condition.

The text pages of the Book of Kells, however, are far finer and more exquisite than I ever expected. The writing, in huge insular majuscule script, is flawless in its regularity and utter control. One can only marvel at the penmanship. It is calligraphic and as exact as printing, and yet it flows and shapes itself into the space available. It sometimes swells and seems to take breath at the ends of lines. The decoration is more extensive and more overwhelming than one could possibly imagine. Virtually every line is embellished with colour or ornament. Every sentence opens with a complex calligraphic initial filled with polychromic artistry, like enamel-encrusted jewellery. They often comprise or include forms of animals and strange creatures. Capitals within the text are lit up with bright paint. The dominant colour seems to vary, like a display of synchronized fireworks, so that on one page it may be the brilliant yellow which really stands out, and on others it may have become red, or an intense pale green, metallic in its finish. The whole

LEFT: A text page of the Book of Kells, with Matthew 18:19–24, including lions' heads in the decoration of the initials

effect is fluid and forever moving, like the sea, ebbing and flowing. I was reminded of tides rushing in among rocks, swirling and receding, leaving bubbles of foam, which become myriads of red dots and eddying circles (sometimes even fish and monsters of the deep). There are faces and lions and panthers and hares. Bernard Meehan pointed out the penwork lion on folio 40r which was on the Irish five-pound note. There are the famous images of cats (as I type this our own cat is in the armchair behind me, trying to remind me that Saint Jerome worked with a lion at his feet: in my experience that would not have happened,

The Irish five-pound banknote, issued in 1976, including a detail reproduced from the top of folio 40r of the Book of Kells

for the lion would have been installed comfortably in the chair before Jerome reached it). Above all, there are minute pen-work scrolls and Celtic interlace of the finest delicacy and complexity. Bernard offered me a magnifying glass, which I took reluctantly for this is a book on a big scale and I think I have reasonable eyesight, but it is extraordinary what it reveals in the tiniest of detail. *The Poetic Faculty*, a poem by Hugh MacDiarmid (1892–1978), includes the line that the Book of Kells can only be studied with a microscope. Modern scribes have experimented with how the whorls and interlace must have been designed, but even cutting a quill to such a fine point is an almost unimaginable technical achievement.

There is a medieval description of a manuscript resembling the Book of Kells which is endlessly cited in textbooks on insular art. Gerald of Wales (*c.* 1146– *c.* 1223), traveller and chronicler, saw a manuscript in Kildare in 1185, which was probably not the Book of Kells, for we know where that was in the twelfth century and it was not in Kildare,

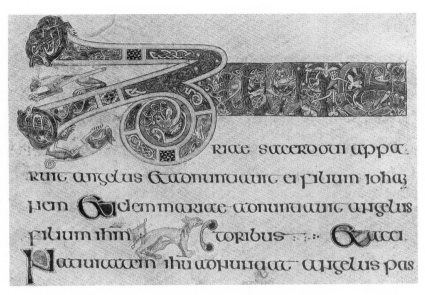

The summaries to Luke's Gospel, describing the angel appearing to Zechariah the priest, as reproduced in Sir Edward Sullivan's *The Book of Kells*, 1914

but it must have been something extremely similar. Gerald wrote that the precious manuscript he was shown was entirely filled with picture and ornament, so rich that it was overwhelming. 'But if you take the trouble to look very closely,' he wrote, 'and penetrate with your eyes to the secrets of the artistry, you will notice such intricacies, so delicate and subtle, so close together, and well-knitted, so involved and bound together, and so fresh still in their colourings that you will not hesitate to declare that all these things must have been the work, not of men, but of angels.'

The likelihood that Gerald of Wales had been examining a similar but now lost manuscript reminds us that the Book of Kells was once probably not unique. To say that the Book of Kells is one of a number of Irish Gospel Books may suggest that such manuscripts are common now. They are not. They are among the absolute rarest and most prized of all medieval works of art. However, the Book of Kells is so famous that it is easy to overlook that Trinity College in Dublin owns no fewer than five other early Irish Gospel Books which are even older. They may

have less decoration but they are nevertheless stupendously precious relics of insular civilization, and, in truth, these half-dozen manuscripts together make up almost the entire corpus of such survivals from early-medieval Ireland. The oldest of all is a very damaged fragment of about 180 leaves known inelegantly as the Codex Usserianus Primus, written probably in Ireland in the early seventh century. It has simple ornament, including the outlines in red dots which become so distinctive of insular manuscripts. Its companion Codex Usserianus Secundus, more poetically called the 'Garland of Howth', has two full-page decorations, but they are "exceptionally barbarous", in the words of the palaeographer E. A. Lowe, who dates it as eighth to ninth century. However, no one doubts the quality of the Book of Durrow. It is attributable to the second half of the seventh century. Like the Book of Kells, it carries the legend that it was copied by Saint Columba, and it belonged to the church of Durrow, about sixty-five miles south-west of Kells, founded by Saint Columba himself. It too has a set of Canon tables, six elaborate carpet pages, five full-page images of the symbols of the Evangelists (one on folio 2r showing all four, the others at the start of each Gospel), five very large initials up to full page in size, and very numerous smaller initials. The Book of Durrow is not as elaborate as the Book of Kells or as large, but it shows all those incipient features of swirling Celtic interlace and infill. Finally, the Book of Mulling and the Book of Dimma are both ascribed to the second half of the eighth century. They too include Evangelist portraits and symbols, and huge and wondrous initials. Any one of these would be a national celebrity of the highest grade, were they not eclipsed by their youngest and largest sibling from Kells.

Newcomers to manuscripts sometimes ask what such books tell us about the societies that created them. At one level, these Gospel Books describe nothing, for they are not local chronicles but standard Latin translations of religious texts from far away. At the same time, this is itself extraordinarily revealing about Ireland. No one knows how literacy and Christianity had first reached the islands of Ireland, possibly through North Africa. This was clearly no primitive backwater but a civilization which could now read Latin, although never occupied by

the Romans, and which was somehow familiar with texts and artistic designs which have unambiguous parallels in the Coptic and Greek churches, such as carpet pages and Canon tables. Although the Book of Kells itself is as uniquely Irish as anything imaginable, it is a Mediterranean text and the pigments used in making it include orpiment, a yellow made from arsenic sulphide, exported from Italy, where it is found in volcanoes. There are clearly lines of trade and communication unknown to us.

It went both ways. The monks from Ireland were restlessly itinerant. Missionaries crossed the Irish Sea into Scotland and England in the late sixth century, and they came into unanticipated contact with the Italian Christians sent up from Rome (see Chapter One). There are also a number of fine eighth-century Gospel Books made outside modern Ireland in the Irish or insular style, but contaminated by new exposure to Roman manuscripts encountered in England. As in genetics, questions of pure ethnicity are seldom simple. The finest, and the Book of Kells's only real competitor as a work of art, is the Lindisfarne Gospels, made in Northumbria probably in the early eighth century and one of the supreme possessions of the British Library in London. It looks entirely Irish in its script and ornament and yet, as we saw in the last chapter, its portrait of Saint Matthew is copied from the Ezra picture used also in the Codex Amiatinus, a manuscript of unimpeachably Italian ancestry. The same missionaries travelled outwards from England across the mainland of continental Europe, exporting and mingling their native traditions of book production with those of countries as distant from Ireland as Germany, Austria and northern Italy. Some insular Gospel Books, probably made in the British Isles, were taken to the continent, such as the Echternach Gospels in Paris or the Barberini Gospels in Rome; others were made by scribes on their travels, such as a manuscript in Vienna decorated in Salzburg by the scribe Cutbercht, who must have been Irish.

All of these, and others (all treasures), include some features of what makes the home-grown Book of Kells so famous – monumental insular majuscule script, elaborate carpet pages and images of the Evangelists and their symbols, initials decorated with complex interlace, and

astonishing artistry. The Book of Kells, however, is the last and the most elaborate of all in this dazzling chorus line of stars. It is the stately opera singer, who finally takes her bow when all the others have been applauded and have stepped back, and who at the end of the evening receives the standing ovation, the diva of insular manuscripts, who knows she simply has no equal. Then the lights go out on stage. Vikings, plague, famine, and the struggle for survival preoccupied the country. Almost no important manuscripts survive from Ireland later than the Book of Kells. When the rest of Europe began to wake up to the arts of manuscript illumination, Ireland had disappeared from sight.

When the Book of Kells first entered popular consciousness in the early nineteenth century, it was still assumed to date from the sixth century, since Saint Columba had died in 597. The press cuttings of 1874, quoted earlier, had called it confidently "the oldest book in the world". Ireland was believed to have been Christian from the very earliest times and then to have been cut off from the developments of mainstream Europe, like those tales of lost valleys where dinosaurs still roamed. As in Ethiopia, where Christianity does indeed still preserve many ancient customs largely unchanged as a result of its geographical isolation, it was initially hoped that the text of the Book of Kells would provide a version of the Gospels which was older and therefore more authentic than anywhere else. The earliest serious study of the manuscript was that by John Obadiah Westwood in his *Palaeographica Sacra Pictoria*, published in 1843–5. He wrote, "The various readings of this manuscript are as important as its ornamental initials." Westwood drew attention to a phrase included in the text of John 3:5–6. It is the passage where Nicodemus asks Jesus how a person may be born again spiritually, and Jesus replies that what is born of the flesh is flesh, but that what is born of the spirit is spirit. The Book of Kells adds 'for God is spirit and is born of God' ("quia deus spiritus est et ex deo natus est"). This is on folio 297v, lines 5–6. Those additional words were cited by Tertullian (*c.* 160–*c.* 225), one of the earliest Church fathers, but they are no longer in the modern Bible. Westwood noted that it was recorded by Saint Ambrose (*c.* 339–97) that the phrase was expunged from the Gospel

The additional clause "quia deus spiritus est et ex deo natus est", 'for God is spirit and is born of God', supplementing the text of John 3:5–6 in the Book of Kells

by the Arians, who did not accept belief in the Trinity. On that sample reading, therefore, the Book of Kells seemed to represent an authentic and unexpurgated text of extreme antiquity.

In reality, it is not as simple as that. Ireland was clearly not quite as remote as it sometimes seems even now. The Book of Kells, like the manuscripts of Chapters One and Two, is a text of the standard Vulgate translation by Saint Jerome, which was completed in 384. Like the Gospels of Saint Augustine in Chapter One, it is sometimes contaminated by readings from the earlier and faulty 'Old Latin' version, but this time the variants are not deliberate. The Old Latin was also known in Ireland: the Codex Usserianus Primus, the Garland of Howth and the Book of Dimma are all in versions of it. Many Irish scribes would have first learned the Scriptures from the Old Latin and would have known phrases by heart. The Book of Kells includes numerous words inserted probably quite unconsciously from childhood familiarity with its phrasing. The "quia deus spiritus est" is one of those, used in the Old Latin known to Tertullian, and it is not scripturally authentic at all. In so far as we have enough examples to see a pattern, the Book of Kells belongs to an Irish strand of the Vulgate, similar to the Book of Durrow, overlaid with multiple small eccentricities derived from memory or carelessness. A small example of the latter is at Luke 3:26, in the list of the ancestors of Christ from Joseph, husband of Mary, back to Adam. The biblical verse enumerates 'Maath, who was [son] of Mattathias, who was [son] of Semei', and so on, which correctly in Latin would be "Maath, qui fuit Matthathiae, qui fuit Semei". The long and unfamiliar name Mattathias may have been broken at the end of a line in the

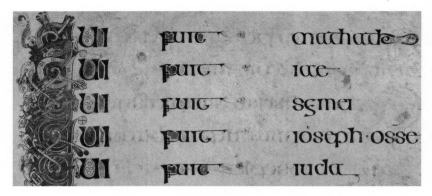

The ancestor of Christ, Matthathias, mistakenly written in the Book of Kells as being two different people, Mathath and Iaus

manuscript's exemplar. The scribe assumed it was two people, and he extemporized, "Maath qui fuit Mathath, qui fuit Iae, qui fuit Semei", mistakenly inventing an additional ancestor, Iaus. This is on folio 200v. It is no great doctrinal error, but it is wrong.

Truthfully, then, the Book of Kells is a poor and degraded witness to the Gospel text, often inconsistent and occasionally even scarcely intelligible. Like the preliminary matter at the beginning, it was presumably not really intended to be read with any scholarly or critical focus. That fact alone tells us much about the manuscript's original purpose. An insular Gospel was a work of art. It was a sacred object and a tangible symbol of divinity, enclosed in a *cumdach*, for sanctifying a church, for carrying in processions, for swearing oaths, and for veneration. It was a catalyst for religion and a central implement of the liturgy, but it was not primarily for textual study. Mere reading was secondary. To most of the modern public, queuing to see it in the Treasury in Trinity College today, it is not much different.

The manuscript is no longer complete. It begins, as we saw, at the very end of the list of Hebrew names, and it probably lacks up to about a dozen leaves at the beginning. The last leaves are very faded and repaired, and the final page is almost illegible. It breaks off at John 17:13. By my own sums (for calculations differ), a little over ten leaves are lacking at the end to take the text through to the end of that Gospel. Within the body of the book, it is relatively easy to collate, since Roger

Powell's insertions mark the separation of most gatherings very clearly.* The problem is with leaves made on single sheets, for we cannot be entirely sure that they are correctly identified and inserted into their original places. Similarly, the lack of a picture where one might expect one, such as a portrait of Mark after folio 129, does not necessarily mean it was ever there.

There are two observations to be made. One is that the full-page pictures are all on single sheets – these are those on folios 7, 27, 28, 32, 33, 34, 129, 188, 290 and 291 – whereas the great full-page initials, such as the openings of Matthew, Mark and John, are generally on leaves integral with text pages. In some way, therefore, producing the pictures must have been a distinct activity. In fact, the illustrated pages need not necessarily have been executed at exactly the same time and place as the text leaves, and they could (in theory) have been afterthoughts or even transferred into the Book of Kells from another manuscript. The second observation is that changes of scribe commonly occur between gatherings. The Codex Amiatinus was the same. The Book of Kells is generally accepted as being the work of four different scribes, sometimes with several stints each, almost all divided according to the different quires. The division of labour by the distribution of unbound gatherings is evidence of an organized scriptorium of some sophistication. That may be relevant when we come to speculate on where and under what conditions the manuscript was made.

* As the manuscript is currently bound, the collation is: i^3 [of unknown number, all single sheets], ii^{8+1} [folio 7 is a single sheet], iii^{10}, iv^{4+2} [perhaps of 4+3, lacking a leaf after folio 26, folios 27–8 are both single sheets], v^{10+3} [folios 32–4 are all single sheets], vi^{8+1} [folio 41 is a single sheet], vii–$viii^{10}$, ix^8, x^{10}, xi^{8+2} [folios 91 and 96 are single sheets], xii–$xiii^{10}$, xiv^{6+1} [folio 120 is a single sheet], xv^{4+1} [folio 129 is a single sheet], xvi^{10+1} [perhaps of 10+2, probably lacking a leaf before folio 130, folio 140 is a single sheet], $xvii^{8+2}$ [folios 143 and 149 are single sheets], $xviii^{10}$, xix^8, xx^{6+3} [folios 170, 172 and 175 are single sheets], xxi^{9+1} [of 10+1, lacking i, a leaf before folio 178, folio 180 is a single sheet], $xxii^{10+1}$ [perhaps of 10+2, probably lacking a leaf before folio 188, folio 188 is a single sheet], $xxiii^{10}$, $xxiv^{4+4}$ [folios 210 and 212–14 are all single sheets], xxv^{6+1} [folio 219 is a single sheet], $xxvi^{10}$, $xxvii^9$ [of 10, lacking vii, a leaf after folio 239], $xxviii^{2+6}$ [folios 243–5 and 248–50 are all single sheets], $xxix^{8+1}$ [folio 253 is a single sheet], xxx–$xxxi^8$, $xxxii^{2+9}$ [folios 277–85 are all single sheets], $xxxiii^4$ [all single sheets], $xxxiv^{10+1}$ [folio 291 is a single sheet], $xxxv^{10}$, $xxxvi^{12}$, $xxxvii^8$ [probably of 10+1, lacking viii–x after folio 330, folio 331 is a single sheet], $xxxviii^8$. Folio 36 is numbered twice, and so there are 340 leaves in total, not 339 as they are foliated.

Early notes in an upper margin recording the loss of a leaf and its subsequent rediscovery and insertion back into the manuscript in 1741

At various stages in its history there have been leaves loose in the Book of Kells. There is a seventeenth-century note at the top of folio 337r, "here lacketh a leafe, beinge yᵉ begini[n]ge of yᵉ xvi chapt[er] of St John", to which another hand adds, "This Leaf found 1741". When the leaves were carefully counted by James Ussher in August 1621, he reached the total of 344, as he noted in the lower margin of folio 334v. The manuscript now has 340 leaves. It is not at all impossible that four leaves have fallen out and have been lost or given away since the seventeenth century. It is tantalizing that they might have included full-page portraits for Mark and Luke, which may have preceded folios 130 and 188. There are also six text leaves certainly missing. Any fortunate readers of this book who find even one of these in their possession could probably, if they wished, retire on the sale proceeds into a life of unlimited luxury. It is even possible that some strips from the upper margins might still survive. When the manuscript was rebound in 1825–6, George Mullen trimmed the edges very dramatically, sometimes cutting away the extremities of the original decoration at the top and bottom of pages – "ignorant and mischievous bookbinder", Sir Edward Sullivan called him in 1914. The manuscript was already a famous relic in Mullen's time. When another national icon, the Domesday Book, was rebound in London in the nineteenth century, the binder cropped its edges but he was permitted to keep the offcuts as personal souvenirs. If your name is Mullen and you have an envelope at home with ribbons of parchment, please let me know and we will decide whether or not to inform Trinity College.

*

As we have seen, the Book of Kells was already at Kells by the early twelfth century. It was still there in the fifteenth century, when a rambling poem was added in a small and untidy cursive hand on the blank leaf at the end of Luke's Gospel. It seems to be a wish against taxation on church land in Meath, and it invokes the support of the famous book, above which word the name 'Columba' is added, 'which is venerated on the altars among the relics of the church', it says: "qui inter reliquias templi venerat[ur] ad aras". The manuscript was evidently still a sacred relic with semi-magical status. If it could still be invoked in Ireland to avoid tax today, undoubtedly it would be. It was seen by visitors to the church in Kells, some of whom wrote their names in it. Among these was a George Plunkett, of Dublin, who scribbled a number of facile remarks in a sixteenth-century hand, including a bad verse fitted into an arch of the Canon table on folio 4v: "This work doth pass all mens conyng / that now doth live in any place. / I doubt not therefore in anything / but that the writer hath obtayned god's grace." One of Plunkett's notes is dated 1568. It was his hand that made the reference on folio 337r to a missing leaf, cited above. The unidentified Plunkett, poor poet though he appears to have been, actually marks the first stage of the transit of the Book of Kells from ecclesiastical talisman into artistic treasure.

The manuscript was inspected in Kells also by James Ussher (1581–1656), outstanding biblical scholar and eventually archbishop of Armagh and primate of all Ireland. He is probably best known now (a trifle unfairly, in our modern world) for his calculation that the world had been created on the night of Saturday to Sunday, 22–23 October 4004 BC. Ussher too wrote in the Book of Kells, including his enumeration of the leaves in 1621, the year in which he was appointed bishop of Meath. He arranged for a copy to be made of the charters in the Irish language, now also in Trinity College, in which the name 'book of Kelles' was used for the first time. In his book on the antiquities of Britain, published in 1639, Ussher mentioned the manuscript, noting that the people of Kells in the county of Meath believed it had been made by Saint Columba and that they regarded it as sacred ("eidem … sacrum habent").

It is sometimes asserted that Ussher acquired the Book of Kells

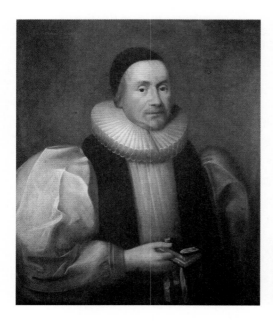

James Ussher (1581–1656),
archbishop of Armagh, who first
studied the manuscript and used
the term 'the Book of Kells' for
the first time

himself. He was a magnificent collector of manuscripts, but the Book of
Kells was not his. (It is probably just as well: it would have been a shame
if it had become known merely as Codex Usserianus Tertius.) The manu-
script remained in the town of Kells, which was very badly damaged
during the rebellion of 1641, and probably in 1653 the precious book
was sent by the Earl of Cavan, governor of Kells, to safety in Dublin.
When Ussher's nephew, Henry Jones, himself became bishop of Meath,
assuming jurisdiction over the church in Kells, he transferred it to Trin-
ity College, together with the Book of Durrow. The precise year of the
arrival of these two manuscripts at the College does not seem to be re-
corded, except that Jones was bishop from 1661 to 1682. Astonishingly,
they were initially available for loan, like any other books in the library.
In 1686–7, Richard Acton, the vice-provost, borrowed "a manuscript
commonly called St Columba's Gospels" against a security of £3 10s.,
very probably the Book of Kells itself, which was in the catalogue of
Trinity College in 1688, still ascribed to the hand of Saint Columba.

As we saw, the manuscript's rise to international stardom began in
the early nineteenth century and was partly political. The old attribu-
tion to Columba, who died in 597, conferred a supposed date within the

sixth century. That year was significant, because it was also in 597 that Saint Augustine arrived in Canterbury from Rome, as we saw in Chapter One, bringing literacy and Christianity to England. The date of Columba's death seemed to give the manuscript irrefutable precedence in the debate on the relative authority of the Irish and Roman churches, which (in the memories of the Irish, at least) had not been forgotten since the overruling of the Irish delegation at the Synod of Whitby in 664.

The Book of Kells is likely to have been shown to George IV on his visit to the Long Room in Trinity College in 1821. It was certainly exhibited to Queen Victoria and Prince Albert in 1849. The Queen recorded the occasion in her journal, recounting how the librarian, J. H. Todd, "showed us some most interesting ancient manuscripts and relics, including St. Columba's Book (in which we wrote our names)". The

Signatures of royal visitors on the former flyleaf of the Book of Kells, including Queen Victoria with Prince Albert, Edward VII with Queen Alexandra, and Prince Alfred

association with Saint Columba was clearly what had been pointedly emphasized to the royal visitors, demonstrating Christianity in Ireland to be older than that in England. It was the only detail Victoria remembered afterwards. Her son, Prince Alfred, was shown the manuscript in 1861. Edward VII and Queen Alexandra saw it, too, in 1903. The College invited all these royal visitors to sign the Book of Kells, although on a modern flyleaf, not within the ancient pages. Those autographed leaves are now bound separately. The manuscript had become a symbol of the cultural priority of Ireland, and it was as if, by signing it, the queen of England was made to subscribe to this. In the single year of 1877, shortly after its controversial trip to the British Museum and back, it was brought out to show to W. E. Gladstone, four times prime minister of Great Britain and tireless advocate for Irish independence (he was shown it in "the inner room"), and, separately that year, to the archbishop of Canterbury, Archibald Tait, to Pedro II, emperor of Brazil, and to the Chinese ambassador, who came in August with the lord mayor of Dublin: "the Book of Kells called forth his warmest admiration," reported the *Freeman's Journal and Daily Commercial Advertiser*. Two years later it was exhibited to General Ulysses S. Grant, president of the United States 1869–77.

The incomparable and distinctive artistry of the Book of Kells caught the imagination of the Celtic Revival. The Oxford professor and entomologist John Obadiah Westwood (1805–93), mentioned earlier in regard to the text, published his own coloured tracings of illuminated pages in his *Palaeographia Sacra Pictoria* in 1843–5. Shockingly, Westwood confidently wrote his monogram and date into an inner margin of the manuscript itself in 1853 (folio 339r). This is the last leaf of the manuscript, worn and faded. Is it possible that the leaf was loose and was actually given to Westwood, and was subsequently brought back? The Book of Kells is included in all the great nineteenth-century picture books of medieval illumination, such as H. N. Humphreys and Owen Jones, *The Illuminated Books of the Middle Ages*, 1849; Owen Jones, *The Grammar of Ornament*, 1856; Henry Shaw, *A Handbook of the Art of Illumination*, 1866; W. J. Loftie, *Lessons in the Art of Illuminating*, 1885; and others. These, in turn, were used as pattern

books for countless Victorian copies and adaptations. The Book of Kells became the source for fashionable illuminated addresses (such as, among many, one presented to Cardinal Newman in 1880), and for metalwork (including a commemorative box given to the viceroy, Lord Carlisle, by the ladies of Ireland in 1858), embroidery (an exhibition travelled around England and Scotland in 1886), furniture, vestments, bookbinding, sculpture, pottery, and so forth. In 1890, the Irish department store Robertson, Ledlie and Ferguson advertised a damask called the Columbkille, after the Book of Kells. The Dublin jewellers Hopkins & Hopkins promoted for Christmas in 1896 gold brooches copied from initials in the manuscript at 21 shillings each.

It seems extraordinary today that Victorian illuminators were permitted to make copies directly from the Book of Kells, with their paintboxes and jars of water on the table beside the original manuscript. Mrs Helen Campbell D'Olier (1829–87), of Dublin, spent many years copying its illuminated initials. In 1884 she captivated large audiences

Detailed copies of initials in the manuscript made in watercolour by Helen Campbell D'Olier and reproduced in Sullivan's *Book of Kells*, 1914

at Alexandra College with images of her exquisite paintings of the manuscript projected by magic lantern and oxy-hydrogen light. Some of her copies are preserved in the library at Trinity College. The Chicago illuminator and collector, C. Lindsay Ricketts (1859–1941), who was in Dublin in July 1908, recorded that he was the last person allowed to make watercolour facsimiles from the manuscript itself. By his time, of course, photography was a practical alternative. As early as 1888–9 the library had been selling sets of photographs of the Book of Kells, both in Dublin and through the South Kensington Museum in London.

A very popular picture book, *The Book of Kells*, by Sir Edward Sullivan (1852–1928), son of the Lord Chancellor of Ireland, was published in 1914, with twenty-four mounted plates in full colour. Curiously, five of these plates were photographed not from the actual manuscript but from those copies by Helen D'Olier. Sullivan's book became a required possession in Irish households, which by then also included vast numbers in the United States. A copy belonged to James Joyce (1882–1941), the most quintessentially Irish of all writers. Joyce described it to Arthur Power in the early 1920s: "In all the places I have been to, Rome, Zurich, Trieste, I have taken it about with me, and have pored over its workmanship for hours. It is the most purely Irish thing we have, and some of the big initial letters which swing right across a page have the essential quality of a chapter of *Ulysses*. Indeed, you can compare much of my work to the intricate illuminations."

In *Finnegans Wake*, published in 1939, Joyce mentions the Book of Kells by name. I cannot pretend to understand Joyce's text, which is to me as unreadable as some pages of the Book of Kells itself must have been, even when the manuscript was new. That has been a recurring theme of our inspection of the manuscript, and perhaps an unanticipated one. The Book of Kells is an artifice of the highest order, but it can never have been a text to be read as a sequential narrative. It is simply too rich and overloaded, and it carries too much with it. Words are run together strangely, or picked out and rendered unfindable in full-page labyrinths. *Finnegans Wake* has conscious parallels. In one passage, in a

RIGHT: Facsimile of folio 8r of the Book of Kells, copied probably from the original in 1908 by C. Lindsay Ricketts, illuminator and collector from Chicago

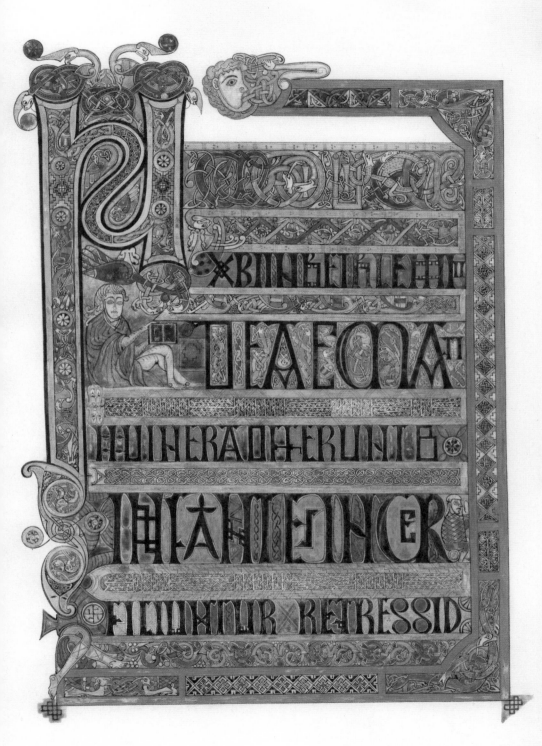

single vast and breathless sentence, Joyce echoes the text of Sullivan's somewhat overblown introduction and he mentions palaeographers, the interpolation of second-best buns (why not?) into families of manuscripts, hieroglyphs, the "tenebrous *Tunc* page of the Book of Kells" – he alludes here to Matthew 27:38, folio 124r of the manuscript, Sullivan's plate XI – and "the toomuchness, the fartoomanyness of all those fourlegged ems: and why spell dear god with a big thick dhee (why, O why, O why?): the cut and dry aks and wise form of the semifinal; and, eighteenthly or twentyfourthly, but at least, thank Maurice, lastly when all is zed and done, the penelopean patience of its last paraphe, a colophon of no fewer than seven hundred and thirtytwo strokes tailed by a leaping lasso …", and very much more.

Finally, then, where and when was this "most purely Irish thing" actually made? Politics and sense of national identity are so embodied in the Book of Kells that even the most experienced of medievalists have learned to tread very cautiously. No one now really accepts that the manuscript is actually in the hand of Saint Columba, although the fact that it carried this tradition from its first sighting in 1007 is important. Columba himself had brought a community of monks from Ireland to the little island of Iona in the western isles of Scotland, and he established a monastery there in 563. Even today this is a remote and awe-inspiring site, still with a strong religious atmosphere. In the seventh and eighth centuries Iona was the principal command post for the dissemination of Irish Christianity into the mainland of Britain and thence across into Europe, and it would necessarily have sustained a scriptorium. It was wealthy and productive for two centuries. However, the Vikings raided the island in 795. They burned the monastery in 802. They attacked again in 806 and sixty-eight of the monks were killed. According to the *Annals of Ulster*, most or all of the community then abandoned Iona and returned to Ireland. Probably in 807 they settled instead in a site at Kells in County Meath, which they called the 'new settlement of Colum Cille'. The church there was completed in 814. That the Book of Kells was owned by that church by the time of its theft in 1007 is not in doubt. By then it was regarded as the chief relic of Saint Columba's community and it was confidently ascribed to the founder's own hand.

James Joyce in 1934, and the "tenebrous *Tunc* page" of the manuscript as reproduced in Sullivan's *Book of Kells*, owned and cited by Joyce in *Finnegans Wake*

Whether the Book of Kells was made partly or all on Iona, or whether it was made or completed at Kells in Ireland, hinges entirely on the date assigned to it. Palaeographers have argued for different dates between the late seventh and the mid-ninth century. On balance, the current consensus puts it around the very end of the eighth century. The unmatched sophistication of the enterprise and the coordination of its craftsmen seem to point to production in a large and organized community, not in a party of migrant refugees. We even know the name of a master scribe on Iona, Abbot Connachtach, who died there in 802. Whether he was the designer we will never know, but he might have been. An origin on Iona does not undermine the absolute Irishness of the manuscript, for it was an exclusively Irish community on an island accessed from Ireland, not yet classified by modern political borders. It is, however, historically likely that the Book of Kells, the most Irish of all works of art, was actually made in what is now Scotland; and, after all, *Finnegans Wake* was written in Paris, and its Irishness is not in doubt either.

The Leiden *Aratea*

early ninth century
Leiden, Universiteitsbibliotheek,
Cod. Voss. Lat. Q 79

Let us look at the whole question of copying. Every medieval manuscript, unless it was the author's first autograph draft of the text, was necessarily a copy of something else. Scribes reproduced manuscripts which already existed, and they learned to copy as carefully and as conscientiously as they could. Illuminators would base their illustrations on those of their predecessors. The transcripts themselves could then become exemplars in turn, and the copying process went on indefinitely across the centuries. Not all manuscripts duplicate every aspect of their models precisely, for the skill of the craftsmen and the circumstances and requirements of the commission may vary greatly, and artistic styles constantly evolve from one generation to the next. Some manuscripts, however, are remarkably similar to their forebears. The volume which is the subject of our inquiry here, the Leiden *Aratea*, a poem on ancient astronomy, was, as far as we can tell, an almost exact facsimile of its exemplar, which was then many hundreds of years old. Why that should be, and what it tells us about the aspirations and taste of the Carolingians, are extraordinarily interesting questions.

In the modern world, simple copying is a pejorative concept, especially when applied to literature and art. Writers and artists now strive instead for originality. Plagiarism is anathema. In medieval Europe, however, copying was admired. Artists were trained to imitate each

other's work. Inherited patterns and formulas were dutifully repeated without reference to reality. Authority (*auctoritas*) was always respected and invoked. Authors deferred to earlier writers, often concealing actual originality in a pretence that it had all been said before. Even in creative fiction, authors such as Boccaccio and Chaucer opened tales by claiming to have found their narratives in older books. Scientific texts, such as medicine or natural history, were more respected if they reproduced knowledge transmitted from the distant past. The learning of the classical world was especially esteemed. Throughout the Middle Ages there was a lingering sense that the Greeks and Romans had been culturally superior and that the ancients had known things now forgotten or only hazily preserved. There was a wistful nostalgia for a vanished halcyon age of learning in classical antiquity.

The word 'renaissance', literally rebirth, is commonly applied to three periods of European history, and all involved copying. The ultimate love affair with the classics in *quattrocento* Italy will appear in Chapter Eleven below. The fascination with antiquity in the twelfth century and early thirteenth will enter into Chapters Eight and Nine, in the age known appropriately as 'Romanesque'. For the moment, let us concentrate on the earliest renaissance, a stage-managed imitation of classical civilization under the Carolingian rulers of Western Europe in the first half of the ninth century.

Charlemagne (*c.* 742–814), king of the Franks with wider ambitions, consciously set about seeking out and copying the administration and culture of ancient Rome. He invented the concept of a Holy Roman Empire, and in 800 he had himself crowned in Rome by the pope as the first of a new kind of Christian emperor. He was Augustus re-created for the new religion. He adopted customs of antiquity. He ordered Gospel Books made on purple parchment, in allusion to a supposed practice of the ancient emperors. His palace chapel in Aachen was modelled on that of the Emperor Justinian in Ravenna, before the old dynasty had emigrated eastwards. Both Charlemagne and his co-heir, Louis the Pious (778–840, joint emperor from 813), were buried in original Roman sarcophaguses. Charlemagne brought in the English scholar Alcuin (*c.* 735–804) to advise on a revival of classical learn-

A ninth-century bronze figure of an emperor, apparently representing Charlemagne or possibly his son, Charles the Bald, now in the Louvre

ing in his dominions. Alcuin, who came from York, was a link back to that period of Mediterranean scholarship in the far north of England which had produced the Codex Amiatinus a century earlier. Under his guidance, Charlemagne's advisors set up some kind of palace library. This probably came to include texts by authors such as Lucan, Statius, Terence, Juvenal, Tibullus, Horace, Claudian, Martial, Servius, Cicero, and Sallust. From time to time, Charlemagne and Louis the Pious seem to have come into possession of actual manuscripts then surviving from late antiquity. We can glimpse the details only opaquely, but it is the earliest hint of antiquarian book collecting in the Middle Ages. Two original manuscripts of this kind still exist, evidently brought to France for use in the Carolingian court, presumably from Italy. They are the famous fourth-century illustrated copies of Virgil, which were afterwards somehow alienated from the palace collections out into the custody of the abbeys of Tours and Saint-Denis respectively. Both are now in the Vatican. Other manuscripts from the classical period are known to us only because they were imitated within the Carolingian court, and their memory still exists, at one remove, in attempted

facsimiles made of them in the early ninth century. The precious origi-
nals are now lost. They clearly included the mid-fourth-century 'Cal-
endar of 354', an early Christian almanac with pictures (unseen since
the ninth century and known to us now only from much later drawings
taken from the Carolingian imitation); a fourth- or fifth-century vol-
ume of the comedies of Terence with 150 pictures, reflected now only
from the ninth-century copy re-created by the scribe Hrodgarius, now
also in the Vatican; a manuscript of the illustrated treatise on Roman
surveying known as the *Agrimensores*, perhaps sixth century (again,
attested only from a Carolingian facsimile); and two quite different
manuscripts of Aratus on ancient astronomy. One of these was the
model for a Carolingian copy which is now in the British Library. The
other is the superlative 'Leiden *Aratea*', one of the most important of

The Vatican Virgil, early fourth-century, a late classical manuscript probably brought to France
for the palace library of Charlemagne; this scene shows the sea snake strangling Laocoon

all Carolingian illustrated manuscripts. That, then, is the volume we are going to examine in the Netherlands.

My initial inquiry as to whether I might see the manuscript of the *Aratea* in the Universiteitsbibliotheek in Leiden was met with the reply that this would hardly be necessary, since there is a high-class published facsimile from 1989 and the complete book is in any case digitized and freely available on-line. It was a response entirely within the theme of copying. If you had applied to the palace librarians of Aachen in the early ninth century to see the late-antique Terence, they would almost certainly have assured you that you would be better off with their nice new copy by their scribe Hrodgarius. After a little more persistence, however, Dr André Bouwman, curator of Western manuscripts, courteously agreed to my request, partly because the Dutch are generally very obliging, and partly because I was to be in Leiden to give one of what are called the Lieftinck Lectures on manuscripts and so (I pleaded) the university owed me a small favour. They conceded gracefully. The French polymath Joseph Justus Scaliger (1540–1609) famously said of Leiden, "Est hic magna commoditas Bibliothecae, ut studiosi possint studere": 'The great benefit of the library here is that the studious may study', which remains true today.

Leiden is an enchanting Dutch mercantile city, south-west of Amsterdam, with quaint old streets and sixteenth-century canals. Its university was founded in 1575, the oldest in the Netherlands. It was raining heavily on my visit, and I was very wet by the time I arrived on foot out at Witte Singel, the avenue which follows the canal around the boundary of the medieval town. It was the kind of weather that makes you wonder how any manuscript can survive from the Middle Ages in northern Europe. The main university library is a vast modern building, designed between 1977 and 1983 by the architect Bart van Kasteel. It is not immediately obvious that it is a library at all and the entrance is hard to find among concrete pillars which flare upwards like inverted trumpets. There is a good deal of mottled concrete and shiny chrome. I finally stood dripping water at the red and white inquiry desk, thrusting my wet woolly hat into my coat pocket and attempting to look

The university library in Leiden, built in 1977–83, succeeding to a much earlier library originally founded here in 1575

like the kind of person who might be allowed to see the most valuable book in the country.

It is agreeably easy to get through the security of Leiden University Library. The staff are infinitely unflustered, switching seamlessly into colloquial English. There are students everywhere. There is still a touch of hippiedom about Dutch universities, as if they have all just tumbled out of bed, sadly lacking now in the more focused British or American youth. The library assistant takes a little photograph of you from a camera projecting from the admissions desk (mine looked like a bedraggled axe-murderer), and it converts at once into a pale-blue plastic library card which then lets you through the main electronic gates. Turn immediately right and walk through the length of the library, through a bright room with hundreds of computers and languid browsers, and continue on further among book stacks, where all the volumes on the shelves are enlivened by coloured paper slips projecting from the pages (I imagine it is a classification system but it looks very festive, like fields of Dutch flowers). Finally you take either the central spiral staircase or the lift up to the second floor. This is the rare-books level. There are lockers for people who have damp coats stuffed with soggy hats.

They were expecting my visit. "Normally we don't let it out," said the invigilator, rather impressed, as he handed me the mustard-yellow cloth box which encloses the *Aratea*. "You can sit anywhere," he added, waving across an entirely empty L-shaped reading-room. There are long black tables trimmed with silvery steel, with neat little grey or orange padded chairs on wheels. There are huge windows looking out across the town canal, and rain was pouring against the outside of the glass. There were no cradles for holding manuscripts, but some time later the invigilator brought me a big white cushion to support the book. I used a pencil, although I was not asked to do so, and they had actually given me a ball-point pen to sign the readers' register. There was no nonsense about wearing gloves. I can see why everyone likes the Dutch.

The *Aratea* is quite small, with ninety-five leaves, nearly 9 by 8 inches, almost square in shape (a point to which we will return). It is unexpectedly heavy, but as one lifts the cover it is evident that the weight lies in the thickness of the wooden binding. The manuscript was rebound in 1989 by a Benedictine nun of Oosterhout, Lucie Gimbrère, who did much work for the library in Leiden. Presumably the book had required disassembling for photography for the facsimile published that year (another aspect of copying manuscripts, with which conservators today become involved). It was also exhibited in America at that time, when the separated leaves allowed many pages to be seen at once. The new binding is now a quite passable imitation of the one the *Aratea* might have had in the ninth century. It has yellow-brown suede-like leather over thick wooden boards cut flush with the edges of the pages. The spine shows traces of undulations where it is traversed by four sewing-bands beneath the leather, and there are projecting laced tabs at the top and bottom. The covers are now wrapped around loosely in conservation paper, perhaps so that Sister Lucie's staining of the surface of the leather does not seep uninvited into the endleaves. The edges are untrimmed probably from the seventeenth century, mottled with red and stamped diagonally in black, "ACAD." and "LVGD.", '*Academiae Lugdunensis*', of Leiden University, mercifully untrimmed by Sister Lucie. I am told, however, that she could not be restrained from carefully cleaning the margins of manuscripts with an eraser, which is

why the pages of this and many Leiden books have a disconcertingly unweathered appearance.

The *Aratea* opens with a flyleaf, blank except for a purchase note by Jacob Susius (1520–96), which we will look at later. The flyleaf was formerly an original pastedown and it preserves shadowy offsets from the leather turn-ins of the medieval binding. Turn the page and we plunge straight into the text. The first line is written in red ink, and it opens with Jupiter, god of the sky, "*Ab iove Principiu*[m] *magno dedux*[it] *aratus* …" Here, in a manuscript made in the radically Christian court of Charlemagne, now a canonized saint, or of his son Louis, called the 'Pious', is a text which unashamedly invokes the ancient pagan deity. It just avoids blasphemy by ambiguity. 'Aratus', it says in Latin (Aratus was the original author), 'began with the Jupiter …', but the poet here addresses an unnamed 'you', greatest and most divine of all, presumably in the antique original a Roman emperor but tactfully applicable also to his Carolingian imitator. At last, under your benign rule, the poet says, we can lift our eyes to the heavens and study the position and movements of the celestial bodies and stars, which aid the sailor in navigation and the ploughman in the prediction of seasons.

The most immediately striking feature is that the text of the *Aratea* is written in convincing 'rustic capitals', *capitalis rustica*, the characteristic script of literary manuscripts in the Roman Empire. The adjective 'rusticus' means plain, for this was once an ordinary or everyday script. Political slogans, scrawled on the walls of Pompeii, were often written in rustic capitals. It is a very compressed upright hand, all in capital letters, as its name also suggests, with great contrast between its thick and thin strokes and distinctive little flicks, or serifs, at the top and bottom of vertical lines. Rustic capitals are beautifully graceful and calligraphic, still easy to read, and they were preferred by the later Romans for secular texts, as distinct from rounded uncial, which became the more sophisticated script of early Christian writings such as the Gospels of Saint Augustine and the Codex Amiatinus. When the Carolingians attempted ultimate authenticity in their re-creations of classical books, they

RIGHT: The opening page of the *Aratea*, written in rustic capitals, opening "Ab iove Principium deduxit aratus …", 'Aratus took his beginning from Jupiter …'

A B I O V E P R I N C I P I V M M A G N O D E D V X A R A T V S

C A R M I N I S A T N O B I S G E N I T O R T V M A X I M V S A V C T O R

T E V E N E R O R T I B I S A C R A F E R O D O C T I Q V E L A B O R I S

P R I M I T I A S P R O B A T I P S E D E V M R E C T O R Q : S A T O R Q V E

Q V A N T V M E T E N I M P O S S E N T A N N I C E R T I S S I M A S I G N A

Q V A S O L A R D E N T E M C A N C R V M R A P I D I S S I M V S A M B I T

D I V E R S A S Q : S E C A T M E T A S G E L I D I C A P R I C O R N I

Q V E V E A R I E S E T L I B R A E Q V A N T D I V O R T I A L V C I S

Ab ioue pncipiu magno deduxit aratus.
Carminis at nobis genitor tu maxim auctor
Te veneror tibi sacra fero doctiq; laboris
Primitias pbat ipse deu rectorq; satorq;
Quantu eteni possent anni certissima signa
Qua sol ardente cancru rapidissim ambit
Diuasq; secat metas gelidi capcorni
Queue aries 7 libra equant diuortia lucis.

Ex Bibliotheca Viri Illuſt. Iſaaci Voſſii. 296

ACAD.LVGD

preserved this distinction. They imitated uncial for biblical texts, such as the ninth-century Utrecht Psalter, but they reverted to rustic capitals in literature from the world of the old religion, which is what we have here.

This is primarily a picture book of the constellations, as known to the Greeks. The name '*Aratea*' – you have been desperate to ask but were too polite to interrupt – indicates a text derived from the lore of the astronomer Aratus of Soli (*c.* 315–240/39 BC), rendered into Latin. The manuscript currently comprises thirty-nine full-page illustrations, all on verso pages followed by passages of text describing the subject matter, laid out as poetry with each line opening with a red capital. In some cases the verses are so short that they are little more than captions. The pictures are mostly square, set against dark blue panels to represent night sky. They are framed in bright orange, which was clearly added last, since the colour overlaps the edges of the blue. It is as if these are reproductions of framed paintings, and conceivably they are, for the ultimate prototypes might actually have been pictures hanging on the walls of a Roman or Greek house. The blue grounds for the sky vary from almost black to a chalky turquoise. Against the light, the blue can be seen to have been applied in streaks, vertically and then horizontally.

The pictures in the *Aratea* are, to say the least, strange. To the Carolingians, they must have seemed to encapsulate knowledge which was not entirely clear to them either. The only way of preserving this arcane ancient wisdom would therefore have been to copy exactly, even details which had no immediately comprehensible relevance.

The first picture is on folio 3v. It shows a long pink and grey snake zigzagging down the page, with two little bears leaping and rolling between the coils of the snake. At seemingly random points across the composition (but not at all random in reality) the page is studded with tiny squares of gold leaf. These are the stars in the constellation depicted. The text, which runs for several pages, explains that the stars rotate ceaselessly between celestial poles, and that these are guarded by the bears of Crete, animals which had protected Jupiter as a baby from his cannibalistic father, Saturn, in return for which they had been set into the sky to mark the poles. They are known as Helice of the seven stars

and Cynosura, who has never deceived Phoenician sailors guided by her. Between them, the text continues, winds a monstrous snake, like a river, with stars along its body, around the bears. The Pole Star is in the smaller of the bears. These are the constellations which we still know as Ursa Major and Ursa Minor, with the Plough (or as the Great and Little Dipper in America).

The second picture shows a clean-shaven young man stepping to the right, looking back over his shoulder. He wears a short pink gold-trimmed tunic and elaborate sandals. In his right hand he holds a golden hooked staff, and a green spotted lion skin is draped over his left arm. The skin identifies him as Hercules. He is not named in the text opposite, which describes a man who is guardian of the bears, but although he has many stars, 'by no means faint', only one is named, Arcturus, at the point where his garment is knotted. Arcturus is actually the brightest star in the northern hemisphere.

The third is an image of a classical wreath of gold and brown leaves, tied with trailing red ribbons. The text calls it the '*Corona*', or 'Garland', worn at the wedding of Bacchus and Ariadne. After her premature death, Bacchus threw it into the sky, where it became a constellation. The next picture is the Snake-Bearer. It has a naked man, seen mostly from behind, wearing a tight-fitting black headdress rather like a bathing cap and holding a writhing snake while standing on a scorpion. The verses which follow tell that the Snake-Bearer has his back to the Garland, and has the brightest stars on his shoulders, which remain undiminished even during a full moon. Keep turning pages. The picture we encounter next looks like Hercules again. He is shown as a muscular young man with a staff holding up his left hand, as if to stop the traffic. The accompanying leaf with the explanatory text, however, is now missing. In the *Aratea* manuscript the modern pencil foliation takes account of these gaps, and so there is no folio numbered 13 at all, where

PAGES 152–163: Specimen double openings of the *Aratea*, showing Arcturus Major and Arcturus Minor, little bears rolling between the coils of a snake, marking the north pole; Hercules holding a lion skin; Boötes, the ox-driver or herdsman, followed by the text on Virgo, for a leaf is now missing at this point; Gemini, the twins, identified as Castor and Pollux; Leo, the lion; and the five planets, shown as the heads of Saturn, Jupiter, Mercury, Venus and Mars, whose motion is different from that of the stars

ismaela
cui seret

Cetera que toto fulgent uaga sidera mundo
Indefessa trahit pprio cum pondere celum.
Axis at immotus semp uestigia seruat
Libratasq; tenet tras. 7 cardine firmo:
Orbe agit. extremu geminus determinat axem.

CETERA QUAE TO TO FULGENT UACA SIDERA MUNDO

INDEFESSA TRAHIT PROPRIO CUM PONDERE CAELUM

AXIS AT IMMOTUS SEMPER UESTIGIA SERUAT

LIBRATASQ. TENET TERRAS ET CARDINE FIRMO

ORBE ACIT EXTREMU CEMINUS DETERMINAT AXEM

QUEM GRAI DIXERE POLUM QUO MERSA SUB UNDAS

OCEANI PARS CELSA SUB HORRIFERO AQUILONE

AXEM CRETAE DEXTRA LEUAQUE TUENTUR.

SIUE ARCTOAE SEU ROMANI COGNOMINIS URSAE

PLAUSTRA QUAEQ. FACIES STELLARU PROXIMA UERO

TRES TEMONE ROTISQ. MICANT SUBLIME QUATERNAE

Quem grai dixere polum quo mersa subundas
Oceani pars celsa sub horrifero aquilone
Axem crete dextra leuaq; tuentur.
Siue arctoe seu romani cognominis urse
plaustra q; que facies stellax proxima uero
tres temone rotisq; micant sublime quatine

IPSAM HELICEN SEQUITUR SENIOR IACULOQ MINATU[R]

SIUE ILLE ARTOPHYLAX SEU BACCHIO MUNERE CESUS

ICARUS EREPTAM PENSABIT SIDEREUITAM

Ipsam helicen sequit̃ senior iaculoꝗ minat̃

Siue ille artophylax seu bacchio munere cesus

Icarus ereptam pensabit sidere uitam

IRGINIS INDE SUBEST FACIES CUI PLENA SINISTRA

 FVLGET SPICA MANV, MTVRISQ. ARDE

AN

 E ARISTIS

QUAM TE DIVA VOCEM TANGUNT MORTALIA SITID

CARMINA NEC SURDAM PRAEBES VENERANTIBUS AUREM

EXO SA HEU MORTALE GENUS MEDIO MIHI CURRU

STABUNT QUADRIPEDES ET FLEXIS LAETUS HABENIS

TEQ. TUUMQ. CANAM TERRIS VENERABILE NUMEN

AUREA PACATI RECERET CUM SAECULA MUNDI

IUSTITIA INVIOLATA MALIS PLACIDISSIMA VIRGO

SIUE ILLA ASTREI GENUS EST QUEM FAMA PARENTEM

TRADIDIT ASTRORUM SEU VERA INTERCIDIT AEVO

ORTUS FAMA TUI MEDIIS TE LAETA FEREBAS

SUBLIMIS POPULIS NEC DEDIGNATA SUBIRET

TECTA HOMINUM ET PUROS SINE CRIMINE DIVA PENATIS

IURA DABAS CULTUQ. NOVO RUDE VULCUS IN OMNES

FORMABAS VITAE SINCEROS ARTIBUS USUS

A D CAPITISUBERUNT GEMINI PROLEMQ. TONANTIS

A EGRECIAM ET PROPRIO POSTREDDITA NUMINA CAELO

N ALACHEDEMONIIS CUM MARS CALUISSET APHIDNIS

C ASTOR ACECROPI TULIT INCREMENTIA BELLI

Ad capti suberunt gemini prolemq̃ tonantis
A egreciam et pprio post reddita numina celo
Il amiache demoniis cũ mars caluiss̃ aphidnis
C astor acecropi tulit incrementia belli

O RA HORRENTISQ. IUBAS ET FULUUM CERNE LEONEM

H UNCUBI CONTIGERIT PHOEBI UIOLENTIOR AXIS

A CCENSA INCANCRO IAMTUM GEMINABITUR AESTAS

H INCNYMFETENUES TUNCEST TRISTISSIMA TELLUS

O ra horrentisq; iubas 7 fuluũ cerne leonem
H unc ubi contigerit phebi uiolentior axis
A ccensa in cancro iantũ geminabit̃ estas
H inc nymfe tenues. tunc est tristissime tellus

A T QUINQ STELLAE DIVERSA LEGE FERUNTUR

E T PROPRIO MOTU MUNDO CONTRARIA VOLUUNT

C URRICULA EXCEDUNTQ LOCO ET UESTICIA MUTANT

H AUD EQUIDEM POSSIM ALIO CONTINGERE SIGNO

Q UE DIUISA DIES HINC ATQ HINC SAEPE UIDENTUR

At quincq; stelle diuersa lege ferunt
E t pprio motu mundo contraria uoluunt
C urricula excedunt q; loco et uestigia mutant.
H aud equide possim alio contingere signo
Q ue diuisa dies hunc atq; hinc sepe uident.

this would have been, with a now-lost miniature on its verso. The subsequent text reveals what the missing image had shown, evidently Virgo, the maiden. She is described as the serene goddess who once ruled the world in the golden age, when war was unknown and no one needed to sail to other men's regions. She rarely descended from Olympus in the silver age, except in sorrow, and in the corrupt bronze age of degradation, when people began eating meat and using iron, she abandoned the earth and instead also became a constellation in the sky, near the Plough. The picture survives for Gemini, the twins. By now we are up to folio 16v. Two bronzed young men wear little white caps, surmounted by gold crosses, naked except for cloaks over one shoulder and elaborate boots. One holds a club and spear, and the other a harp and a plectron for plucking it. The pictures and their accompanying verses continue like this, with Cancer, the crab, which lies below the middle of Helice and with Gemini beneath its head; Leo, the lion, below the back legs of Cancer, warning that when the sun's chariot touches the sign of Leo in the summer water is scarce for farming and sailors should not set forth on the azure sea; Auriga, the charioteer, shown with three blue goat kids, which are evil omens to sailors; Taurus, the bull; Cepheus; Cassiopeia, whose tunic has slipped from one breast, fortunately concealed by a gold star; her daughter, Andromeda, with her arms stretched out tied to columns of rock; and so on, all interspersed with verses describing the scenes or recounting their stories.

Following the thirty-six pictures of constellations are two composite illustrations. The first depicts the five known planets, shown as detached heads, four male and one female, with pale haloes, like saints. This is on folio 80v. The text opposite explains that the planets were known as 'wandering stars' and that they operate under a different law, 'and in their independent motion they choose opposite journeys over the earth and they move out of their place and change their courses'. They are not named here, but they are Saturn, Jupiter, Mercury, Venus and Mars. Venus is therefore the female one. We understand now why the movements of the planets in our solar system are different from those of stars visible from distant galaxies, but it must have greatly puzzled medieval astronomers, who knew nothing of planetary orbits around the sun.

A couple of leaves later a similar picture of four female heads in the sky represents the four seasons. Once again, because we know about the rotation of the earth around the sun, the different seasons are easily explicable to us, but it was not so obvious in the Middle Ages. The extensive verse which follows is complicated (at least to me), but the gist is that there are multiple orbiting wheels of stars which cut through the firmament, including the Milky Way (using that metaphor, describing it as the colour of milk – "lactis ei color" – and the largest to revolve in the sky), and, as the sun journeys through the orbits of these various circling stars, so its potency is affected and the year is thus divided into four seasons, and the lengths of the days are apportioned. One of these great revolving wheels is that of the zodiac, and the sun traverses across its twelve points annually, causing the changing effects of weather and climate. That is why the seasons are different. My Latin is reasonably competent, but my knowledge of the stars is not really good enough to comprehend all of what is being explained.

Ours is probably the first generation for tens of thousands of years not to recognize the constellations. Until far into the twentieth century, the skies were relatively unpolluted at night and more people still lived in the countryside than in cities. The astonishing and thrilling experience of gazing up at a million stars at night is no longer so common in our time, and most of us now feel pleased with ourselves if we can at least identify Orion's belt in the firmament (here is Orion, son of Poseidon, striding manfully on folio 58v of the *Aratea*: "sic balteus exit", says the verse a leaf later: 'his belt goes forth like this', with three bright stars in a row). From the beginning of human consciousness, however, people have gazed spellbound at the night sky, looking for patterns and meaning in the spectacle. It is difficult not to associate the heavens with infinite majesty and divinity. The arc of the sun, on a track which moves for six months to the left and six months to the right, taking exactly a year in its cycle, was for all civilizations the first measure of time and of seasons.

The earliest surviving Greek text on the names and relative positions of the stars and planets was the *Phaenomena* ('Appearances') by Aratus of Soli in the third century BC. It is a poem, derived almost

certainly – although not all scholars agree – from a lost work by Eudoxus of Cnidos, a student of Plato a hundred years earlier. The information given by Aratus and Eudoxus about the names and legends of the constellations doubtless went back infinitely further in oral traditions and campfire conversations far beyond any known literacy. The *Phaenomena* of Aratus became an immensely popular text in the ancient world, both as a teaching text about the universe and mythology, and as a practical aid to memorizing the stars for use in navigation. It has the unusual distinction for a classical Greek poem of being cited in the New Testament. When Saint Paul was preaching in Athens, he remarked to his audience that the one God had made all the world and that it is in him that we live and move and have our being, "as even some of your own poets have said, 'For we are also his offspring'" (Acts 17:28). That Greek quotation is from line 5 of the *Phaenomena*, and it actually refers to Jupiter, with whom, as we saw in the opening line of the Leiden manuscript, Aratus began. Perhaps the apostle had a text of Aratus on his travels for navigation in the Mediterranean.

The *Phaenomena* was translated or adapted into Latin at least three times in antiquity. The earliest version was made around 80 BC by Cicero (106–43 BC), the great statesman himself. An incomplete classical manuscript of that translation was evidently acquired by the Carolingian court library, where it was copied exactly, mostly also in rustic capitals. The new ninth-century copy reached Anglo-Saxon England by the tenth century and it is now bound up in a composite volume in the British Library, mentioned earlier. It has a wonderful feature that the lines of text are shaped to fit within outlines of the pictures of the constellations, so that massed writing rather than colour fills the design.

A second and much more popular Latin translation was made by Germanicus Caesar. We know the name only because of a couple of chance references, including the commentary by Saint Jerome on the Epistles of Saint Paul, for Jerome had recognized that quotation in Acts 17:28. It is assumed but is not actually known that the translator is to be identified with the Germanicus (15/16 BC–AD 19), who was the grandson of Mark Antony and adopted son of the emperor Tiberius. There are other candidates with the same name. That version is the principal

text used in the Leiden *Aratea*. Before it even began its long journey of textual transmission, it was thus an imitation by Germanicus of an imitation by Arateus of a text by Eudoxus.

A third Latin translation from Aratus's original Greek was made some time in the fourth century by Rufius Festus Avienus, about whom almost nothing is known for certain. It is the longest version of the three. Here and there in the Leiden manuscript there are short interpolations from the Avienus translation into that of Germanicus. The description of Gemini, for example, supplements the brief Germanicus text after four words, inserting seven lines from the longer edition by Avienus. The account of Cancer the crab in the manuscript is almost all taken from Avienus. Such contamination of a text with pieces from elsewhere is not unusual in manuscript transmission (we saw examples in both the Gospels of Saint Augustine and in the Book of Kells), but what it does indicate is that the late-classical manuscript, which they had acquired and were replicating in the Carolingian court, was not older than the lifetime of Avienus. In fact, it probably was late fourth or conceivably early fifth century.

At first sight, one might even believe that the volume in Leiden was actually an original manuscript from the late Roman Empire. The general style of painting in dabs of rich dark colour, at times blotchy and even verging on impressionistic, is a good imitation of Roman art: the frescoes in Pompeii and sarcophagus portraits from Egypt, for instance, are examples familiar to us. The script, in a beautiful rustic capital, looks entirely authentic. The almost square shape is utterly classical too. The manuscript was probably originally even squarer, if we can judge from the savage cropping of tiny captions in some of its outer margins.

The square format of ancient books merits a brief digression. Until the first century AD, all literary texts would have been written on scrolls, occasionally made from leather or parchment (as are most of the Dead Sea Scrolls), but usually from papyrus. The river god on folio 68v of the *Aratea* is shown holding what is probably a sprig of the papyrus plant. At about the time of the arrival of Christianity in the West, scribes first began using the codex format, by which is meant manuscripts in the shape of a modern book, with pages hinged on their inner edges so that

they can be turned one after the other, with writing on both sides. It was an invention which had many advantages in texts which required consultation back and forth, rather than being read from end to end, and it was especially useful in Christian liturgy and in manuscripts of law. (We still use the term 'to codify' a legal text, meaning originally that it was transferred to codex format.) By the third and fourth centuries the codex was becoming standard for most books in the late Roman Empire.

To make a quire for a very early codex, one would take a sheet of papyrus and fold it in half and in half again. It could then be cut open along one edge to form a cluster of four leaves, or two bifolia enclosed one inside the other. Because papyrus was made by compressing strips of reed laid one way and then the other, the original unfolded sheet was square, and so the resulting codex was square too. The Leiden *Aratea* is a descendant of a manuscript which was probably on papyrus. After the fall of the Roman Empire and the collapse of the papyrus trade from Egypt, however, scribes resorted instead to using animal skin (which is better for a codex anyway, since papyrus tends to snap when pages are turned). Most mammals are oblong. A rectangular sheet of parchment folded and then cut open will necessarily produce an oblong or upright book, which evolved into the standard shape of manuscripts in medieval Europe. When paper was eventually introduced in the late Middle Ages, scribes were by that time so accustomed to folding and cutting their sheets in this way that paper was artificially manufactured in the oblong proportions of an animal skin, and it still is. It is at least arguable that the reason why almost all modern books, including the one in your hands, are upright rather than square is because parchment replaced papyrus in the late-classical Mediterranean.

The collation of the Leiden *Aratea* not only shows how it was folded but also that five leaves are now missing.* We know their subjects, because all were copied from this manuscript into another, now in Bou-

* The collation is: i⁷ [of 8, lacking i (foliated '1')], ii⁷ [of 8, lacking v (foliated '13')], iii–viii⁸, ix²⁺⁶ [i.e., a pair of leaves (folios 69 and 71) + 6 single sheets], x⁷ [of 8, lacking ii (foliated '74')], xi¹⁰⁺¹ [folio '81', at the beginning, is a single sheet], xii⁸ [of 10, lacking iv (foliated '95') and vii (unfoliated)]. As noted above, the modern pencil foliation generally takes account of long-missing leaves, which is a bit confusing since the original frontispiece is lost and the manuscript begins on what is now called folio 2.

logne, which we will come to in a few minutes. The lost pages showed Jupiter with an eagle, Virgo, the centaur, Helios (the sun) in a chariot, and Luna (the moon). The leaves with pictures are sometimes on noticeably thicker parchment (and so too, sometimes unnecessarily, are their conjoint pairs). This was probably a practical matter: puddling a background of wet paint onto a relatively small parchment leaf would cause the surface to buckle if the sheet was too thin. It is another reason to wonder whether the classical exemplar they were using was on papyrus, where that would not have been a problem. I think that quire viii (folios 57–64) is by a different artist, using slightly different pigments.

One of the consequences of examining the original of a very famous manuscript is that the word rapidly flies around the library that the iconic object is out, like a rare bird spotted by an ornithologist on a social network. In the early afternoon, a group of Leiden Ph.D. students materialized in the reading-room and deferentially asked whether they might stand behind my chair while I continued to turn the pages. I found myself giving an unofficial tutorial about the Leiden *Aratea*.

As I commented on the truly extraordinary fidelity with which the Carolingian scribes had clearly copied the appearance and format of their classical exemplar, one student asked how we know that this really is a ninth-century copy, rather than the late-Roman original. It is actually a very difficult question. One answer is the thickness and texture of the parchment (as above), which is consistent with the ninth century. Classical parchment, when used, is usually very thin, almost weightless, with a tendency to curl in the slightest humidity, as we witnessed in Chapter One. Secondly, the miniatures, although plausibly ancient, have a distinctive look of Carolingian painting, especially in the faces. It is curious how the human brain is so instinctively trained in face recognition that it is usually the eyes that give away forgeries or anachronistic pastiches in art. The face of Cepheus in the *Aratea*, for example, is almost exactly paralleled in the portrait of King David in the Lothair Psalter in the British Library, made for a member of the imperial family in Aachen in the 840s. Finally, there is one integral page which is written in Carolingian minuscule, a script which would have been inconceivable before 800.

Here it is on folio 93v, towards the end of the manuscript. It is a delicate full-page planetarium, with a circular diagram of the planets and the sun and moon in precise positions of their orbits around the earth, within a wheel of constellations around the edge. The style of execution is very precise and different from that of the other pictures in the *Aratea*, but it shares its distinctive pink pigment with the work of the artist in quire viii (compare the dog on folio 60v). A planetarium is not part of the Aratean apparatus, although of course it is relevant to astronomy. The design is executed with extreme care, with the multiple orbits meticulously shown in red ink. If you hold the manuscript up to the light, you can see tiny pin holes where the points of compasses were used. The earth is in the centre. Saturn, Jupiter and Mars are in elliptical orbits round the earth. Remarkably, Venus and Mercury are shown on the left in orbits which are not around the earth (as everyone reputedly believed until Copernicus) but correctly around the sun, which is itself also in orbit. The paths of the planets are inscribed with quotations from the *Historia naturalis* of Pliny in lines of tiny and exquisite Carolingian minuscule, the script consciously invented during the cultural reforms of the early 800s. The *Historia naturalis* was a text which Alcuin had explicitly recommended to Charlemagne. Around the outer rim of the planetarium is a band of colour, enclosing roundels with the signs of the zodiac alternating with standing figures against gold grounds representing the twelve months. The importance of these little figures is that they are copied not from the exemplar of the *Aratea*, but from the antique 'Calendar of 354', the fourth-century manuscript also then in the possession of the Carolingian palace library, mentioned earlier. The original Calendar does not survive and nor, as far as is known, does the facsimile which was made from it in the ninth century (that has not been seen since the death of its last recorded owner, Nicolas-Claude Fabri de Peiresc, astronomer and antiquary, who died in 1637), but we do have very good sixteenth- and seventeenth-century drawings of it, the best of which are in the Vatican. The use of the Calendar as a pictorial source for the frame of the planetarium in the *Aratea* is the second

LEFT: The planetarium, showing the planets with the sun and the moon in orbit around the earth, within a ring with the twelve months and the signs of the zodiac

piece of evidence that the composition of this picture, uniquely in the manuscript, was a ninth-century invention of the Carolingian court.

The third reason for dating the diagram to the ninth century is the most tantalizing. Its apparent precision of detail has attracted much attention from modern astronomers. Let us suppose that the relative positions of the planets and the sun in this picture are not random, but were measured from actual observation of the skies, which we know that the Carolingians were capable of doing. There is an enthralling article by the brothers Richard and Marco Mostert published in 1999. It imagines dividing the outer ring of the planetarium of the Leiden *Aratea* into 360 degrees. By drawing lines from the planets as shown to the centre of the diagram and by locating them in relation to the fixed stars indicated here by the zodiac in the outer ring, the Mosterts were able to suggest an actual date when the planets seen from the earth would have been in precisely the positions shown in the design. It was Tuesday, 18 March 816. Of course, the planetarium here is hardly bigger than a saucer, and the measurements may not be absolute. To place it in context, however, the authors explain that if the positions of the planets are really indicated with scientific precision, that exact configuration of the planets occurs only once in 17,000,000,000,000 years. If we allow variation of up to 5 degrees (quite a lot), then, they say, the probability is limited to one day in 216,000,000 years. If a tolerance of up to 15 degrees is allowed, then the occurrence of the planets in the positions shown here is reduced to once every 98,000 years. In a supplementary article of 2007, Elly Dekker argues that the planets could also have been in almost exactly those same positions at the other end of that same lunar month, on Monday, 14 April 816. I am not capable of weighing the merits of variant astronomical calculations of slightly less than four weeks either way, but there is certainly nothing stylistically implausible about suggesting that the Leiden *Aratea* was made *c.* 816 or, at the most cautious, in the first third of the ninth century (but not earlier than 816).

Whether or not either date can be taken at face value, 18 March was a very important anniversary. According to the calculations in the *De temporibus* of Bede (*c.* 672–735), still the standard text on calendars in the ninth century, it was the date of the creation of the universe. God

had said, 'Let there be lights in the dome of the sky to separate the day from the night, and let them be for signs and for seasons and for years' (Genesis 1:14), and, as published by Bede, God completed this work on 18 March: 'thus the heavens and the earth were finished' (Genesis 2:1).

If this is a correct interpretation, it could explain a good deal about the purpose of the manuscript. The pictures transmit classical knowledge of astronomy from the ancient world, which the Carolingians admired, but (as far as they were concerned) the heavens were nonetheless originally devised and set in motion by God. The planetarium shows their configuration, as well as they understood it, on the anniversary of the day he created them, and therefore as close as possible to the moment when God pronounced his creation to be perfect. (They knew enough about planetary motion to know that 18 March 816 was not necessarily astronomically identical to 18 March 3952 BC, which was Bede's suggested year; but, in the way that each Easter and Christmas were annually, in some spiritual way, the actual days of Christ's resurrection and nativity, so every 18 March was effectively the day of creation, and the date is often recorded in medieval calendars.) The Leiden *Aratea* may open with Jupiter but it ends with Christ on its last page, "Vale, fidens in d[omi]no xp[ist]i vestitutus amore", 'Farewell, faithful in the Lord, clothed with the love of Christ.' The medieval assumption was that God made everything in the universe for a purpose, and for the use of mankind. It was the duty of the Christian to study and to decode that divine purpose. To know how the stars and planets were created in order to assist people in providing seasons and weather and navigation would have been a form of theology, or even a devotional exercise.

There is nothing explicit in the manuscript to identify the 'faithful in the Lord Christ' to whom it is dedicated, any more than we know for sure the imperial ruler addressed by Germanicus in the original preface. If the date of 816 or later is valid, this excludes Charlemagne, who died in 814. It is generally assumed that the patron of the *Aratea* was his son and successor, Louis the Pious, or a member of his immediate family. It is quite likely that it was made in Aachen, where the court library must have been. The male form *'vestitutus'* in the dedication ought to exclude Judith of Bavaria, whom Louis married in 819 and who is sometimes

also suggested as a possible owner of the manuscript. Louis himself was crowned emperor in 816 (in October, unfortunately, not March), and he is attested to have had interests in religion and astronomy. The standard contemporary life of Louis, the *Vita Hludowici*, seems to be nothing but a relentless succession of battles and skirmishes. When Louis won, it was evidence that God was on his side; when he lost, it was proof of treachery. The *Vita* was written by an intimate member of the imperial household known to posterity as the 'Astronomer', from his references to constellations. For example, he records a comet in the sign of Auriga, the charioteer, in 817, but, most famously, he describes what we now know as Halley's Comet seen in 837, appearing in Virgo below the Ser-

Louis the Pious, probable patron of the *Aratea*, shown seated between two imperial ambassadors in a late eleventh-century manuscript of the chronicle of Ademar of Chabannes

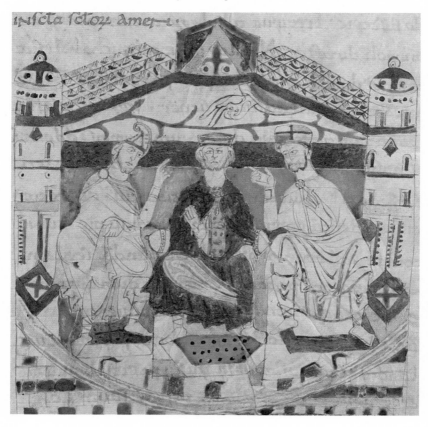

pent, and crossing eastwards through Leo, Cancer and Gemini, to the head of Taurus and below the feet of Auriga (this is a writer who knows his stars, or his *Aratea*). Its orbit was different, he says, to those of the wandering stars (the planets). He relates that Louis summoned the author, 'who is believed to have knowledge of these matters', as he writes of himself, and they went out onto a balcony adjoining the palace to discuss whether it was a divine portent or a natural phenomenon, and the emperor concluded that there was effectively no difference. Here the *Aratea* was undoubtedly very relevant indeed. Emperor and astronomer might have had the manuscript with them on that balcony. There is perhaps even a conscious echo of the tale of the Emperor Augustus watching portents in the skies with the Tiburtine Sibyl.

What is interesting about the imitations of ancient manuscripts made in the Carolingian court is that the late-Roman originals are never heard of again. The only surviving ancient codices which may well have passed through the court library, the two fourth-century Virgils now in the Vatican, were retained only because no copies had been made. As for the others, once a new manuscript was available, the old exemplars were evidently deemed to be of no value. Perhaps they were hard to read or were too fragile on crumbling papyrus and they were simply discarded. The new versions of the *Aratea*, the Terence and the *Agrimensores*, however, then themselves became exemplars. The reproductions begin to breed and the process takes on a life of its own, like the birth of grandchildren.

By the middle of the afternoon, the rain had stopped in Leiden and the sun came out. For a few minutes, before a librarian dutifully lowered the Venetian blinds, the manuscript was lying in direct and raking sunlight. At that moment I suddenly noticed something not visible in any reproduction. It was similar to the way that aerial photography at dawn or dusk can reveal archaeological indentations in a historical site invisible from the ground. In the bright light it was clear that the outlines of many pictures had been impressed unnaturally deeply into the parchment pages. Once you see this, it is a very obvious feature of a little over half of the miniatures of the *Aratea*. The outlines (only) of

the compositions have clearly been carefully and firmly redrawn with a blunt instrument or stylus, impressing the designs through the parchment and doubtless onto some other sheet inserted underneath. The versos of many of these pages preserve the same outlines in mirror image, in what looks like graphite. Similar marks have been observed on the reverse side of some illuminations of insular manuscripts, including the eighth-century Lindisfarne Gospels in the British Library. In the *Aratea* something like carbon paper was probably inserted beneath to transfer these compositions onto new pages. They are strictly outlines only, not including stars or faces. Note that detail, for we will return to it. Those transferred designs could then become pattern sheets for making further reproductions of the pictures.

It is well-known that the Leiden *Aratea* was copied around the year 1000 into two other manuscripts, perhaps both prepared in the abbey of Saint-Bertin in the Pas-de-Calais in north-western France. One of these is in the municipal library of Boulogne. It was made for the monastery of Saint-Bertin, about thirty miles east of Boulogne, during the time of Odbert, abbot in 986–*c*. 1007. It has not moved far in a thousand years. The second manuscript, possibly very slightly later, may have been made in Saint-Bertin but it was soon afterwards given to the cathedral in Strassburg by Werinhar, bishop there 1001–28. It has now migrated to the public library in Bern in Switzerland. It is generally assumed that the Leiden manuscript must by then have been owned in Saint-Bertin and that both copies were made from it in the abbey's scriptorium, in which Odbert himself participated.

To verify this, we need to take a short visit to Boulogne, easily accessible from London though the Channel Tunnel. On this occasion, my wife came too and we drove down from Calais on a mild and misty spring day. The central municipal library is now in the former seventeenth-century hospice for pilgrims who visited the shrine of the Virgin of Boulogne. It is in the cobbled Place de la Résistance in the centre of the old town. You enter and proceed diagonally across enclosed cloisters to the reading-room in the far corner for 'Patrimoine', principally local history, from where the assistant, Virginie Haudiquet, took me upstairs to an empty room with long tables, rather like a classroom (she

told me that this part of the building was basically thirteenth century), where a solitary table had been laid for me with a dark blue book-rest, and a pair of white gloves. She went to fetch ms 188. The manuscript is a large thin volume, about 14 by 12 inches, lettered "Calendrier" in ink on the upper cover. It is a collection of texts and tables on astronomical calendars, including instructions for calculating the date of Easter. The table on folio 10v is made out with examples for the coming quarter-century from the year 999 onwards, which is an entirely credible dating for the manuscript (the imminent millennium revived popular interest in cosmology, as we will see in the next chapter). The *Aratea* is copied closely onto folios 20v onwards of the manuscript in Boulogne.

The pictures are uncannily similar to those in Leiden, like one of those dreams where you recognize something absolutely and yet somehow it is all different. This time they are arranged two to a page, one above the other, with the Germanicus text copied beside them on the right. The script is no longer in *capitalis rustica*, but it is still in capitals, which may be a deferential nod to this unusual aspect of the exemplar. I had brought my own tracings (made from the facsimile, I reassure you) to check whether the designs had been transferred directly from the indented outlines in Leiden, and the answer is no. This was a bit disappointing. The scale is slightly smaller to fit two to a page, and some specific details and proportions have changed. They are close copies but they are not measured duplicates. Some of the pictures now missing from the manuscript in Leiden, such as the first, showing Jupiter on an eagle, are faithfully echoed in the copy in Boulogne and they were evidently still present in the original. Others are omitted here for no obvious reason, such as the hare and the four seasons, integral in the Leiden volume. The planetarium is transferred into the copy in Boulogne but it has been expanded to incorporate the latitudinal zones of the earth, movements of the sun, and a very simple world map, divided into Asia, Europe and Africa. It is no longer a facsimile, as the Leiden manuscript had been of its own antique exemplar, but it is a version updated and adapted for a different purpose, principally now monastic time-keeping.

Furthermore, the colours are often quite different. For example, the first of the Gemini here has a green cloak over his left shoulder, whereas

in Leiden it is red; his twin now holds a green harp outlined in orange, while in Leiden the harp is red and gold. Cepheus in the Boulogne manuscript has a brown cloak draped over a grey and white tunic, but in the Leiden *Aratea* it had been in red over a brown tunic. The lion skin of Hercules has changed from green to black; and so on. These differences do not affect the iconography but they do suggest that the images were copied from intermediary line drawings, rather than directly from the coloured exemplar. Remember also that the drawings traced through from the Leiden manuscript had outlines but no faces. This has an odd consequence. The pictures in Boulogne are by one artist, but all the facial features – eyes, noses and so on – were clearly inserted by different hands and probably afterwards. The first are in brown ink in typical Anglo-French style of around 1100; the face of Orion is left entirely blank (this is on folio 27v); and all faces thereafter are completed in rather scratchy black ink. That detail too suggests that they were using an exemplar which was not the actual manuscript now in Leiden, but the intermediary set of outline drawings without faces, and that initially the artist in Saint-Bertin had mistakenly understood that featureless heads were a requirement of the design.

The copy of the *Aratea* made in the time of Odbert, abbot of Saint-Bertin 986–*c.* 1007, now in the municipal library of Boulogne

This observation, if right, removes the necessity for the Leiden manuscript itself to have been in the possession of Saint-Bertin, and indeed it is not listed in the eleventh- to twelfth-century catalogue of the abbey's library. It could even have been in England for a time. The Carolingian court library does not appear to have survived beyond the ninth century. A number of its great manuscripts found their way to Anglo-Saxon England, including the Utrecht Psalter and that other translation of Aratus by Cicero, and there are various lines by which this might have happened, including through Judith, granddaughter of Louis the Pious, who in 856 married Aethelwolf, king of Wessex and father of King Alfred. Another avenue might have been through Grimbald of Saint-Bertin (d. c. 901), the scholar brought by Alfred to England, rather as Alcuin was to France by Charlemagne, to help with cultural reform. There was clearly some kind of intellectual trade route between the French and English courts, passing each time through Saint-Bertin near the crossing of the Channel. It is certainly true that Odbert, abbot when the copy was made, obtained manuscript exemplars and artists from England as well as from France.

We now return to the library in Leiden. A very obtrusive and indeed disfiguring feature of the *Aratea* manuscript is that around 1300 the text was re-copied out section by section into the same book in a crabbed gothic bookhand adjacent to the original rustic capitals. This ugly writing fills up many of the blank pages of the manuscript and the generous spaces once left between the verses. The transcription was poorly done, often with careless mistakes. On this occasion of copying, in effect, a late-medieval manuscript and its earlier exemplar appear in the same volume, even on the same pages. Evidently to most readers by the late thirteenth century the beautiful antique capitals were no longer easily legible. We saw something similar in the Book of Kells, where the impenetrable pages of textual monograms were rewritten much later in readable Latin in their lower margins. The *Aratea* clearly still had some function 400 years after it was made, even when familiarity with archaic script had been lost. The manuscript was by that date already older than the late fourth-century original had been

The ownership inscription of Jacob Susius, recording that he bought the *Aratea* manuscript from the school of a painter in Ghent in 1573

to the Carolingians. It was evidently still considered to be useful and it needed to be made readable.

The *Aratea* was perhaps not in a monastic or institutional library at all in the late Middle Ages. On the flyleaf at the very end is a faint price written in plummet probably of the fourteenth or fifteenth century, "xxii lb. xix s.", 22 *livres* and 19 *sous*. Whatever the currency, that was a lot of money. It was either a note for sale or a record of purchase, or it might be a valuation as security for a pledge or loan. Despite the rewritten script, the manuscript was probably principally of value for its pictures, which might have been used as exemplars for other works of art or even architecture. It was clearly in the hands of some kind of craftsman. There are a number of marginal sketches for decorated initials, such as a flourished letter 'A' on folio 63r, and a standing figure of a man on folio 82v scratched into the background of the miniature, invisible unless the page is held up to the light. Some symbols added in plummet look to me like typical late-medieval masons' marks.

The manuscript certainly belonged to an artist's workshop when its first provable owner acquired it. At the top of the flyleaf at the front is the sixteenth-century inscription, "*Sum Iacobi D[anielis] F[ilius] P[atris] N[icholai] Susii, E pictoris pergula emptus mihi*" – this last word inserted above the line – "*Gandavi Anno a Chr[ist]o corporato MDLXXIII, Mense Januario, Machlinia bis capta care[n]ti, καὶ παροικῷ*", 'I belong …' (this is the book talking) '… to Jacob son of his father Nicolaus Susius, bought by me …' (Susius speaking now) '… from the school of a painter in

Ghent, in the year of the incarnation of Christ 1573, in the month of January, [when I was] an exile, being far absent from twice-conquered Mechelen.' This was Jacob Susius, or Suys (1520–96), humanist and philologist, temporarily in Ghent following the sack of Mechelen by the Spanish in 1572. The manuscript was mentioned by Susius in a publication of 1590 addressed to his friend Janus Dousa (1545–1604), first librarian at Leiden. Susius there promises him that he will undertake an edition of the ancient *Aratea* when a suitable engraver can be found to copy the pictures.

This was finally accomplished ten years later by his precocious student, Hugo Grotius (1583–1645), later celebrated classicist and jurist. Grotius had written his first book at the age of sixteen, an edition of Martianus Capella published in 1599, soon followed by one of the *Aratea*, which he called the *Syntagma Arateorum, Opus poeticae et astronomiae utilissimum*, published in Leiden in 1600. Grotius does not exactly say that the manuscript then belonged to him personally, but it very clearly did, as is reported later by Andreas Cellarius (*c.* 1596–1665) in his *Atlas Coelestis*, 1661, noting that the original had been acquired by Grotius from the heirs of Jacob Susius through the help of Dousa. Grotius was a great collector and eventually formed a marvellous library. In 1618 his theological misalignment led to condemnation to life imprisonment in the castle of Loevestein in the central Netherlands. With help from his enterprising wife, he contrived a dramatic escape from prison in 1621 concealed inside a crate of books, and the couple fled to Paris with the library. Here they were contacted by Christina of Sweden (1626–89). Three years after the eventual death of Grotius, his widow agreed to sell her late husband's library *en bloc* to Christina for 24,000 guilders. The collection arrived in Stockholm by the middle of October 1648, and we must assume that the *Aratea* was included in the shipment.

Christina, like Jeanne de Navarre and Margaret of Austria, whom we will meet in later chapters, was one of that unexpected class of *reines bibliophiles*. She was the sole heiress of Gustavus Adolphus, king of Sweden 1611–32, she succeeded to the throne at the age of six, and she assumed control of her Scandinavian kingdom from her eighteenth birthday in 1644. She was fascinated by the extremities of religion, science,

Reine bibliophile: Christina, queen of Sweden 1632–54, depicted *c*. 1649–50 by the Flemish painter Erasmus Quellinus as the goddess Athena, patron of wisdom

and the occult, and the esoteric and enigmatic pictures in the by-then 850-year-old *Aratea* would have been well within her focus. Queen Christina gathered books and manuscripts as assiduously as she cultivated those who studied them. Her collections profited outstandingly from Swedish spoils of the Thirty Years' War, including some of the finest of Ottonian manuscripts. Eventually Christina abdicated in 1654, became a Catholic in 1655, and transported herself and about 2,000 immensely important manuscripts to Rome, where the *Codices Reginenses* are still among the glories of the Vatican library.

While still in Stockholm, Christina had commanded scholars to her court to be her tutors and librarians and to ornament her salons, including the philosopher René Descartes, who died in her service in 1650. After him, the best-known was Isaak Voss (1618–89, also called Vossius in Latin). He was a member of a high-profile Dutch intellectual family, a classicist and theologian, who had already travelled widely through the manuscript libraries of Europe. He knew James Ussher, the archbishop of Armagh who had first brought the Book of Kells to

attention, and indeed Hugo Grotius in Paris. Voss received the regal call from Christina in the summer of 1648. He arrived in Stockholm in March 1649: at their first audience, he addressed her in Latin, and she replied in Dutch. It was initially very cordial. Voss taught her Greek. He brought his own formidable reference collection to Sweden and placed it at the queen's disposal, where it became indistinguishable from her own books. Relationships with absolute monarchs, however, are always hazardous. Eventually, in the autumn of 1653, at least as reported by Voss, Queen Christina unilaterally terminated his contract and invited him to make a personal selection of books from her great library in lieu of unpaid wages and in compensation for the swallowing up of his own collection. No bibliophile should ever be faced with such temptation. (I feel I should pause at this point to allow any collectors to dream of what they might have chosen in similar circumstances.) Ten chests of books removed from the royal library were sent via Hamburg back to Amsterdam in March 1654, and a further shipment followed in June that year. There were understandable mutterings in Stockholm that Voss had plundered the queen's library, which he strenuously denied. His haul, however, included not only the *Aratea* but also the great sixth-century Codex Argenteus of the Gospels in the language of the Goths, which Voss promptly resold and is now in the university library of Uppsala. The *Aratea*, however, he retained. After his death it was sold in 1690 with the residue of his collection to the university of Leiden. At the foot of the first page of the manuscript is a label printed on a ribbon of paper, "Ex Bibliotheca Viri Illust. Isaaci Vossii", to which is added the number 296 in ink. On the spine of the box, in which I eventually returned the Leiden *Aratea* to the invigilator of the reading-room, is a red rectangle with a paper label, "IS. VOSSII Codex Latinus $Q^{to.}$ $N^{o.}$ 79".

The exact copying of manuscripts did not end with the Middle Ages, and it is not yet over even now. The edition of the *Aratea* by Grotius in 1600 was, so far as technology and taste allowed, a facsimile (or copy) of the manuscript. The engraved pictures are very close to those of the ninth-century exemplar. Some details are changed, such as the length of the horns of Taurus, and all backgrounds are transformed into skies

of billowing clouds, without borders. Grotius had no qualms about improving the sequence of the plates, according to his reading of Ptolemy's *Almagest*, and he invented pictures which were lacking from the manuscript, such as Libra and Virgo. As the frontispiece of Jupiter was already missing, he replaced it with the Leiden planetarium, printed upside down (at least in the one I looked at). Fundamentally, however, the scale and solemnity of the pictures is completely in keeping with the arcane Carolingian (and, further back, the late-Roman) exemplar. This cannot be said for the next reproduction of the planetarium, which was enlarged into a vast double-page map when it was re-copied from the Grotius engraving for the *Atlas Coelestis* in 1661, now embellished within a magnificent baroque border, with putti holding up the titles and exotic astronomers discussing and measuring celestial and terrestrial globes. That monumental atlas of the heavens was dedicated to Charles II, king of England 1660–85, and there is a certain pleasure in thinking of King Charles looking at a picture derived from the manuscript of the Carolingian *Aratea*.

The history of printed facsimiles of manuscripts takes the practice of manuscript copying right into the modern age. The fourth-century Vatican Virgil, which had escaped reproduction in ninth-century France, became one of the earliest type facsimiles, published in 1741, using engravings of the pictures copied from the original by Pietro Santi Bartoli in the seventeenth century. The invention of photography in the nineteenth century transformed the ability to reproduce medieval manuscripts, as digital scanning has again in our own time. The technique of chromo-photolithography was perfected in the 1860s. Quite rapidly, whole new opportunities opened up for the copying of illuminated manuscripts, as never since the Middle Ages. Notable facsimiles included the Grimani Breviary (1862, and again 1903–8); the Utrecht Psalter (1874); the thirteenth-century Apocalypse, Bodleian MS Auct. D. 4.17 (1876), first Roxburghe Club manuscript facsimile; the sixth-century

ABOVE: The planetarium of the *Aratea* manuscript copied in the engraving in Hugo Grotius, *Syntagma Arateorum*, published in Leiden in 1600

BELOW: The planetarium copied again with surrounding embellishments in Andreas Cellarius, *Atlas Coelestis seu Harmonica Macrocosmica*, published in Amsterdam in 1660

Syriac Old Testament in the Ambrosiana in Milan (1876); the *Codex Alexandrinus* of the Greek Bible in London (1879–83); the *Codex Egberti* in Trier (1884); the Laurentian manuscript of Sophocles (1885); Miélot's *Miracles de Nostre Dame* in the Bodleian (1885); the Munich *Nibelungenlied* (1886); the Book of Ballymote, in the Royal Irish Academy (1887); the Talhoffer *Fechtbuch* in Gotha (1887); the Manesse Codex (1887); the Leiden Rule of Chrodegang of Metz (1889); the fourth-century biblical *Codex Vaticanus* (1889); the Ottonian Gospels in Hildesheim (1891); the Elder *Edda* saga (1891); the Hours of Bona Sforza (1894); the Hennessy Hours (1895, and again 1909); the newly identified Gospels of Saint Margaret of Scotland (1896); the dispersed miniatures from the Hours of Étienne Chevalier (1897); the fifth-century Quedlinburg *Itala* fragments in Berlin (1898); the Sarajevo Haggadah (1898); the *Codex Bezae* in Cambridge (1899); the Coronation Book of Charles V (1899); the Metz Pontifical (1902); the Psalter of Saint Louis in Leiden (1902); the *Très Riches Heures* of the Duc de Berry (1904); the Stowe Missal (1906–15); the sketchbook of Villard de Honnecourt (1906); the *Térence des Ducs* in the Bibliothèque de l'Arsenal (1907); the Hours of Anne of Brittany (1909); the Breviary of Philippe le Bon (1909); the Trinity College Apocalypse (1909); the Benedictional of Saint Aethelwold (1910); the Goslar Gospels (1910); the Bible of Charles the Bald (1911); the *Codex Sinaiticus* (1911–12); the Freer Gospels (1912); the Queen Mary Psalter (1912); and many, many others. Like the copying of manuscripts in the Middle Ages, some of these productions were strictly academic and some were primarily for the aesthetic pleasure of their purchasers.

The production of expensive 'fine art facsimiles' of famous medieval manuscripts was popularized especially in the second half of the twentieth century and it is now a vast industry, especially for collectors in Germany, Switzerland and Spain. The firm of Faksimile Verlag, founded in Lucerne (Luzern) in 1974, issued a full-colour facsimile of the Leiden *Aratea* for the luxury market in 1989. The publication of that modern book is itself simply another stage in the history of copying the manuscript of the *Aratea*, which is a ninth-century copy of a fourth- or fifth-century codex, derived in all probability from an original in the court of imperial Rome, copying a manuscript from ancient

Greece. Most modern published reproductions of the *Aratea* are now no longer taken directly from the precious manuscript in Leiden, but instead from the Swiss facsimile or from the on-line digitized version. Therefore those, in their due turn, have become exemplars. The process is going on still. Owners of facsimiles often tell you that they possess a numbered 'original', but the definition of originality has always been complex when we are dealing with medieval manuscripts.

The Morgan Beatus

mid-tenth century
New York, Morgan Library and Museum,
M 644

The standard rules sent out several days in advance to people who apply to use manuscripts in the Pierpont Morgan Library include an instruction which I have not encountered elsewhere: "Please refrain from wearing colored fingernail polish, since it might leave marks on the rare material that you are handling." It is an intriguing if unusual rule. Frivolous glitter and cultural consciousness go hand-in-hand in the wonderful modern Babylon which is New York. I had written to the Library for permission to see their tenth-century illustrated manuscript about the end of the world as foretold in the Apocalypse. Morgan M 644 (as it is) is famous for its large and graphic scenes of tumult and ruin, and the expected judgement and destruction of civilization. As I walked up Madison Avenue, amid that relentless noise of the city, the fury of yellow taxis and the howls of police cars, the clangour of construction, the bursts of satanic steam from underground heating vents, and all the strident frenzy of commerce, I could call to mind so many apocalyptic disaster movies set among these soaring towers. It all seems imaginable here. Manhattan is surely the most urban metropolis in the Western world. Revelation 18:16 and 18 laments "the great city clothed in fine linen, in purple and scarlet, adorned with gold" – look up at the gilded Life Insurance Building as we pass 26th and 27th Streets – "with jewels, and with pearls ... the great city, where all who had ships at

sea grew rich by her wealth". The biblical text is not referring to New York, of course, but the description is applicable. This is a sophisticated and exhilarating place, with an edge of sin, and it is thrilling to visit. It is forever noisy and busy. It is the only city in America where there are pedestrians in large numbers along the sidewalks, rapidly surging and clustering on each corner as the lights change, although no one now looks where they are going, for most are clutching take-away coffee and staring down at their cell phones to read and send last-minute messages as they rush blindly onwards. Everything in New York appears to be a headlong race against time. As I strode up the avenue too, this seemed an appropriate opportunity to reflect on the end of the world.

Throughout history, people have often believed that they were living in the world's last days. This view still has its adherents today. A common belief of Christianity in the early Middle Ages was that the duration of the universe was to be divided into six equal ages, of which the sixth and last was then surely drawing to its imminent close. This was based on an interpretation of the six days of creation as a prefiguration of a divine plan. Since 2 Peter 3:8 explicitly equates one day in the eyes of God with a thousand years on earth (itself an echo of Psalm 90:4), creation was therefore expected to endure for 6,000 years from start to finish. After the conclusion of the final millennium, the Devil was predicted to be locked in a pit for a further thousand years during the reign of Christ (as described in some detail in Revelation chapter 20), before the Last Judgement. The time spans given in the genealogies of the Old Testament can be added up to place the date of Creation around 5500 BC and so there was a logical assumption that the sixth millennium might come to its end in or about AD 500. This, for example, was the expectation of Hilarianus, author of the *Chronologia, sive Libellus de mundi duratione*, written *c.* 397, estimating that there were then just over a hundred years remaining before the anticipated final cataclysm. Others, including his contemporary Saint Augustine of Hippo (354–430), suggested that the sixth age had surely already ended with the incarnation of Christ, and that the world was now into the count-down of the thousand years of the Devil's enchainment. However, Augustine also cautioned against a too-literal interpretation

of the numerical clues scattered through the Scriptures, and he cited the texts in which even Jesus himself apparently did not know precisely when the predicted end would occur (Mark 13:32 and Acts 1:7).

Nevertheless, the last book of the Bible, the Apocalypse or Book of Revelation, describes a very precise vision of the end of the world as revealed on the island of Patmos to Saint John the Divine. It tells of signs which will mark the fulfilment of its prophecies, including the advent of a persuasive Antichrist who will rise like a beast out of the earth and will deceive even the faithful (Revelation 13), and the arrival of the Whore of Babylon, adorned with gold and jewels (and doubtless coloured nail polish), drunk with the blood of the saints (Revelation 17). It has been very easy, in all ages, to identify portents such as these with actual people and places of one's own time, and to equate contemporary chaos with the unfolding in reality of apocalyptic events vividly predicted in the Scripture.

We are about to look at a collection of interpretations of the Apocalypse gathered in Spain by the monk Beatus of Liébana (perhaps c. 740–c. 800), apparently a member of the monastery of San Martín de Turieno, now called Santo Toribio de Liébana, about half-way between Léon and Santander in northern Spain. Although Beatus is a documented writer, his name does not actually occur in any of the manuscripts. However, his authorship was attested by the late Middle Ages and it has been universally accepted. Clues from other writings by Beatus suggest that his commentary on the Apocalypse was begun around 776 and that it was revised over the following decade. This was a period in history when the destruction foretold in the Apocalypse must have seemed terrifyingly current, especially in Spain. The old Roman Hispanic civilization was visibly in ruins. Muslim Berbers from North Africa had surged upwards across the Strait of Gibraltar in 711. The Islamic Umayyad emirate was established in Córdoba in 756. It was not difficult for Spanish Christian monks to identify Muhammad with the apocalyptic Antichrist. The counter-attacks by Charlemagne began in 778, and were seen in terms of biblical battles between good and evil. Other calculations of dates of the creation of the world placed the event around 5200 BC, allowing the end of the sixth millennium to

be adjusted to 800 AD, which must have appeared credible at least to Beatus of Liébana in Spain as the eighth century drew towards its close.

The popularity of particular manuscripts can often give a clear sense of the preoccupations of any culture. No copies of the commentary of Beatus survive from the compiler's lifetime. The fateful year 800 passed without catastrophe. For a hundred years the text was hardly read. One single decorated leaf is known from the late ninth century, a chance survival in the monastic library in Silos, in the province of Burgos in northern Spain. The earliest illustrated manuscripts of Beatus began in a trickle, turning into a moderate torrent, around the middle to second half of the tenth century, within sight of the millennial year 1000. The oldest datable manuscript of Beatus, made during the lead-up to this new apocalyptic deadline, is the copy which we are about to see in the Morgan Library.

The Morgan Library ('and Museum', now added to its name in an attempt to seem less intellectually elitist) fills the block along the frontage of Madison Avenue between 36th and 37th Streets. Its heart is the

The Sherman Fairchild Reading Room in the Morgan Library, opened in 2006 for the consultation of rare books and manuscripts

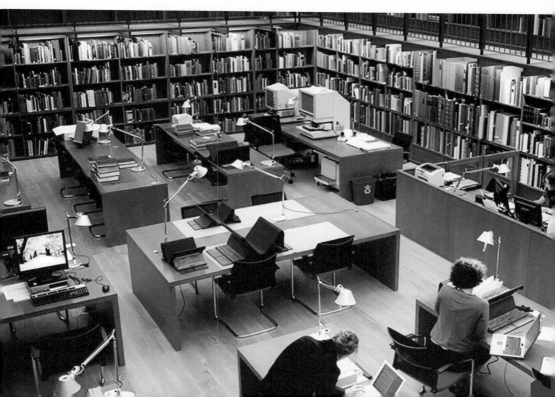

library built in an Italian Renaissance style in 1902–6 for the banker John Pierpont Morgan (1837–1913), supplemented and given to the public by his son, J. P. Morgan Jr, in 1924. Their joint collection is really of world class, as refined and wide-ranging as anything in Europe. The buildings have been expanded at different stages, most recently in a dramatic and inconceivably expensive remodelling by the architect Renzo Piano, completed in 2006. Because I was due to arrive before the Library's general opening hours, my instructions from Roger Wieck, curator of manuscripts, were to go to the staff entrance round the corner of the old brownstone building at 24 East 37th Street. I pushed the buzzer and, a voice having asked what I wanted, I was admitted into a lobby like a loading bay with a security desk behind sliding glass windows. I wrote my name in a book beside a number, in my case 'ID # 1214', which was also on the plastic clip-on visitor's pass I was given, the size of a credit card. They take no chances here. After a short wait, I was escorted by a man dressed like a railway conductor in a dark red uniform with the Library's logo on the pocket of his jacket, out into Piano's spacious open atrium, as high as the building itself. It has windows decorated with translucent squares of bright colour, like paper cut-outs, and huge sheets of plain glass suspended from the ceiling, reflecting the windows and forever turning in the air. There are two glass-walled elevators side by side and apparently no stairs. My guide steered me in, telling me confidentially that we needed the third floor. You glide upwards through space, high above the public exhibition areas and doubtless no pleasure for acrophobes, and emerge turning right into the Sherman Fairchild Reading Room. There is a double vestibule with locked doors at each end, like the keepers' entrance to the lion enclosure in the zoo, and another security desk with more books to sign with your arrival and departure times. On my second day (I am jumping ahead here) I was required by the assistant to state whether I had washed my hands. "Is that a requirement, or a health check?" I asked, pretending puzzlement. "It's policy," she snapped primly, ignoring the sarcasm, and I noticed that there is in fact a handy little sink for library users at the entrance, beside a bank of lockers for readers' bags. It is actually not a bad idea, preferable to wearing gloves, and I obediently obliged.

Finally, they unlock the second door and you are admitted into the end of the research room. It is oblong, without windows, with reference books lining the walls and around a glass-floored mezzanine gallery above. The whole ceiling is a veiled skylight. There are half a dozen long polished wooden tables, each with up to three chrome and black chairs with red seats. On the tables are natty bendable lamps. I chose a seat by an adjustable wooden book-rest, facing the issue desk, and I opened it widely in expectation of a very big manuscript. Ripples of disapproval ran across the faces of the invigilators. They silently passed me a laminated sheet of instructions, '*Rules for Handling Bound Manuscripts*' (the Morgan Library is altogether unlike the Biblioteca Laurenziana in Florence), including "Books are viewed on book-stands to prevent damage to bindings. Do not adjust the supports. If you wish to change a book's placement ask a staff member who will determine whether it can be done safely." A young man, perhaps a third of my age, reset the stand tightly upright, without asking me. I could see the Beatus manuscript waiting for me on the desk in a big grey cloth box. "Do you want volume I first?" asked a woman with exquisitely crafted fair hair and a stylish blue jacket. I said that I had not known it was now in two volumes. Another woman, equally expensively dressed (this is New York) and suspecting I knew nothing, inquired whether I would also like to see a copy of the Library's own typescript description of the book: I replied that I would be delighted. They also brought me a big magnifying glass, which I had not requested but was glad to have, and soft plastic rulers for taking measurements, since my own was inspected and was deemed a potential danger. There were also weights for holding manuscripts open, formed of metal chains encased in soft blue velvet. At last, I was judged ready to proceed, and the first volume was carried across.

The manuscript's odyssey from Spain to New York had involved adventures which would have appalled its current invigilators. Some of this I learned from the Library's three-page typed description which I read carefully first. From at least 1566, it had evidently belonged to the military order of Santiago of Uclés, in the province of Cuenca in central Spain. It is apparently listed in the order's eighteenth-century library

The note signed by Guglielmo Libri, previously enclosed in the manuscript of Beatus, claiming that it had once been exchanged for a silver watch

catalogue, item 39, as having been given to the order by Martín Pérez de Ayala (1504–66), bishop of Guadix 1548–60 and Segovia 1560–64, and archbishop of Valencia 1564–6. The house was suppressed in 1837. What happened next can be partly reconstructed from a folded note on pale-blue paper, once enclosed in the manuscript itself but now part of a package of letters and documents in the British Library in London, where I had already seen it. It is signed by Guglielmo Libri and is dated in London on 19 April 1848. It tells us that this Beatus manuscript was at one time owned by Roberto Frasinelli (1811–87). He was a natural scientist of German birth who had become a book dealer in Madrid. The note claims that he had obtained it, without any binding, from the abbey of Valcavado in the kingdom of Léon, in exchange for his silver watch, which had been valued at 30 francs. Part of this,

at least, was demonstrably untrue. Valcavado, where Beatus himself is reputed to have been a monk, did indeed once own a copy of this text, but it had left the monastery when the site was abandoned in the early eighteenth century and that manuscript is now in the university library in Valladolid. The claim was either mistakenly conflated with memories of the other, or was invented with the hope of plausibly linking this manuscript to the original author. The note reports that Frasinelli had offered his manuscript for resale at a huge price to several institutions, including the national libraries in Berlin and Paris, who declined to buy it without seeing it (a tactful response which may conceal a thousand uncertainties about legitimacy of title), and that Frasinelli then engaged advice from an intermediary, Professor Francisque Michel (1809–87), of Bordeaux, editor of the *Roman de la Rose* and the *Chanson de Roland*. Michel sold it on 6 May 1847 to the author of the pale-blue note, Count Guglielmo Bruto Icilio Timoleone Libri-Carrucci dalla Sommaia (1802–69), book collector, forger, and thief, who gladly agreed to Frasinelli's asking price, payable in Madrid, plus a commission of 500 francs to Michel.

Libri, as he is known to book historians, would be a marvellous subject for a swashbuckling novel, or even a musical. He was colourful, stout, balding with bushy sideburns, dishevelled, "as if he had never used soap and water or a brush" (as reported by Sir Frederic Madden from the British Museum), but dressed exotically with cloak and stiletto – he claimed fear of assassination – and he was evidently both infinitely charming and utterly amoral. Libri had been a professor of mathematics, on endless leave from the university of Pisa, and a failed revolutionary in Tuscany. From 1831 he lived as an exile in France, where he secured appointments at the Sorbonne and later at the Collège de France. He was elected a chevalier of the Légion d'honneur in 1837. In 1841 he became secretary of the French *Catalogue général des manuscrits des départments*, still the standard reference text listing manuscripts in the municipal libraries of France, many of which he visited in the course of his duties. Like a bull sold to a stud farm, Libri was in heaven. He was – I will defend him on this, for he has many vicious detractors, even now – an enlightened palaeographer and scholar of rare books, and a

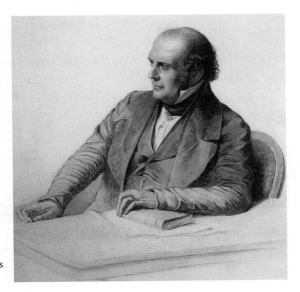

Guglielmo Libri (1802–69), collector and maverick, owner of the Beatus, coloured drawing *c.* 1850 attributed to Édouard-Louis Dubufe

committed collector with a wonderful eye for rarity. He was one of the first connoisseurs of the history of script and of early book bindings as artefacts in their own right. One must imagine the truly overwhelming quantities of unrecorded early manuscripts which were being tumbled unsorted onto the open market and into the reluctant custody of harassed and ill-prepared local municipalities during that half-century of revolutionary turmoil in Europe. Libri not only seized opportunities for interesting purchases, such as the Beatus, but he also helped public collections by joyfully relieving them of unwanted treasures. In some cases these transferences might have taken place with the unofficial consent of local custodians at their wits' end. Modern standards judge Libri very differently. He is the best-known thief in the history of manuscripts. It is now acknowledged that Libri stole from the town libraries of Dijon, Lyons, Grenoble, Carpentras, Montpellier, Poitiers, Tours, Orléans, Autun, and elsewhere, and even from the Bibliothèque royale in Paris. He mutilated manuscripts for their best bits. He obfuscated the provenances, disassembling books and reconstructing them unrecognizably, erasing ancient inscriptions and faking others, with the help of professional forgers in Paris. He doubtless enjoyed himself enormously. It was all a glorious and addictive game, conjuring for his own pleasure

multiple layers of deception and illusion. Libri may well have invented the connection between the Beatus and Valcavado simply for the sport of it. He also repaired the manuscript and patched its damaged margins, and he had it all bound in antique-looking purple velvet.

Book collecting, even supplemented with thefts, is an expensive pastime for a man with a lifestyle far ahead of his income. At the time of his purchase of the Beatus in 1847, Libri was already in advanced negotiation to sell his collection of manuscripts *en bloc* to the British Museum in London for a figure not significantly lower than his own valuation of £10,000. At the last moment, doubts were raised about the provenances, and, as discussions faltered, Lord Ashburnham stepped in and, through the agency of the bookseller William Boone, opportunistically bought the entire library from Libri for £8000. Either then or in the year or so which followed, Libri unloaded the now-improved manuscript of Beatus too into the custody of the earl, valued at 12,500 francs. It was listed as no. XV in the library of Ashburnham Place, near Battle in East Sussex, in 1853.

Bertram, 4th earl of Ashburnham (1797–1878), was anything but swashbuckling. He was aristocratic, proud, aloof, upright, a High Church Anglican, unbending and impeccably moral. Largely by the purchase of entire collections, he formed a noble cabinet of almost 4000 manuscripts, many of great antiquity and mostly illuminated. He may not be an endearing or collegial figure in the memory of posterity, but he did not deserve to be saddled with the increasingly embarrassing wares of a continental maverick whose reputation ended in disgrace. In 1850 the French courts sentenced Libri in his absence to ten years in prison and he was struck from the Légion d'honneur, but he had escaped to England, married there twice, and died in the sunshine at Fiesole outside Florence in 1869. In the meantime, Ashburnham and his heir, the more easy-going 5th earl (1840–1913), were subjected to insinuations and threatened law suits, culminating in the negotiated disposal of the manuscripts of Italian origin to the Biblioteca Laurenziana in Florence in 1884 and of the contested French manuscripts to the Bibliothèque nationale in Paris in 1888. The Spanish Beatus, being neither, was relegated to the so-called 'Appendix', a group of some 200

manuscripts of presumed innocent origin finally sold by the Ashburn-ham family in 1897 for £30,000 to Henry Yates Thompson (1838–1928).

Yates Thompson was virtually a professional manuscript collector. Even for a man with an inherited fortune and a wealthy wife, £30,000 was at that time a colossal sum. Yates Thompson conceived the idea of restricting his library to exactly 100 manuscripts, of the highest available quality, forever refining his collection as opportunities allowed, discarding lesser items when better examples appeared on the market, maintaining his total at precisely a hundred volumes. Rejected manuscripts from the Ashburnham Appendix were consigned to Sotheby's (1 May 1899); some others were weeded out later during their new owner's endless upgrades. The volume of Beatus on the Apocalypse retained its place in Yates Thompson's 'Hundred' through the many culls, and it was number 97 when it was described for him by M. R. James, Cambridge palaeographer and writer of ghost stories, in the collector's *Descriptive Catalogue of the Second Series of Fifty Manuscripts* published in 1902. For that, the manuscript would have been simply parcelled up and sent by post from the Yates Thompsons' house in Portman Square in west London up to King's College in Cambridge, where James charged him five guineas a description, regardless of length. The account of the Beatus ran to twenty-seven printed pages, the longest single entry he ever wrote.

To the shock of M. R. James and others, who assumed that the collection was destined for public ownership in Britain, Yates Thompson eventually resolved to sell his manuscripts at Sotheby's in a series of auctions beginning in 1919. The family tradition is that failing eyesight had robbed him of the enjoyment of ownership. This was just the moment when the younger J. P. Morgan (1867–1943) was supplementing and rounding out his father's great collection and planning its future. Yates Thompson wrote on 8 September 1918 to Belle da Costa Greene, Mr Morgan's librarian (also inherited from the father), informing her of the impending sale. Even before his letter had reached New York, this sensational news was pre-empted by a cable from Bernard Quaritch, the London booksellers: Greene wrote back to Yates Thompson that an "audible gasp went up in the library". The first sale was set for

J. P. Morgan (1867–1943), who inherited and expanded his father's great library and gave it to the public in 1924; Belle da Costa Greene (1883–1950), beguiling librarian to both Morgans and first director of the Pierpont Morgan Library

3 June 1919. The Beatus was lot XXI (the numbers were in Roman numerals). The catalogue description, written by Yates Thompson himself, aimed to engage all interests by comparing its illumination with Irish and Celtic manuscripts, as well as with Byzantine and 'Saracenic' art, as he called it. The elder Morgan had owned a thirteenth-century copy of Beatus (M 429), but Morgan's son and the librarian were both conscious that the family collection was weakest in very early manuscripts. This seemed their chance to make good that defect. From the Yates Thompson sale of 1919, therefore, J. P. Morgan, through Quaritch, secured seven early lots, including the Beatus, which was bought for £3000. Yates Thompson afterwards congratulated Belle da Costa Greene (the letter is in the Library's archive): "I could not wish for the seven items a more dignified and delightful home than they will find in the Morgan Library", adding that the combined sum they had spent on those manuscripts was "about the same money as was paid by some enthusiastic Frenchman, whose name I cannot discover, for the Jeanne de Navarre". This Book of Hours, and the identity of its purchaser in the Yates Thompson sale, will be the subject of Chapter Nine below.

Henry Yates Thompson (1838–1928), who sold the Beatus manuscript in 1919, photographed in 1906; Yates Thompson's bookplate, transferred from the previous binding of the Beatus, recording that he had purchased the manuscript in 1897 from the library of the Earl of Ashburnham

Thus it was that this tenth-century manuscript of Beatus of Liébana was now placed in front of me in the Morgan Library in New York. It is no longer covered in Libri's purple velvet, for it was rebound at the Library into two arbitrary volumes by Deborah Evetts in 1993, in fresh white tawed leather over wooden boards. This is the style which we too use now for new bindings in the Parker Library, but William Voelkle, now senior research curator, who came out to greet me at this point, chuckled disapprovingly that it now looks like a wedding album. The manuscript is big, about 15½ by 11¼ inches, which fact alone tells us that this is a public display book, for communal use in its monastery rather than for intimate and private study. When complete and in one volume, it comprised over 300 leaves, which must have been almost as unmanageable an armful to move as the Codex Amiatinus.

Inside the front cover is a grey bookplate lettered in white "The Pierpont Morgan Library". Below that, transferred from the previous binding (not easily, for the edges frayed as it was peeled off), is the upright Yates Thompson label in gold on black paper, "EX MUSÆO HENRICI YATES THOMPSON", with his number '97' and "bsee.e.e, The Earl

of Ashburnham May 1897". His private price code was "bryanstone", whereby 'b' = 1, 'r' = 2, 'y' = 3, and so on, and therefore he had costed its purchase in 1897 as £1600 0s. 0d.

To judge from earlier foliation in pencil, probably in Libri's hand, the first forty leaves were once bound in a different and haphazard order, and the volume at one time opened with what is now folio 10, with the start of the preface by Beatus. This leaf is very damaged from damp or decay on its lower and outer edges. These dark stains continue, gradually diminishing, onto what must have been subsequent leaves. Clearly the manuscript was unbound for some time and its beginning was exposed to the elements or rodents.* The gatherings were still very jumbled when the manuscript was first collated by M. R. James. Let us assume (I am sure rightly) that the leaves are now correctly assembled and bound into their proper tenth-century sequence. The volume actually begins with a cluster of thick modern parchment flyleaves, one unpleasantly rumpled, and then the original manuscript opens with a decorative lozenge shape within a floral frame, enclosing a chequerboard acrostic of repeated letters in red, blue and gold, spelling out in every direction "*s[an]c[t]i micaeli lib[er]*", 'Saint Michael's book', indicating ownership or patronage of a monastery dedicated to the Archangel Michael. Then follow a series of portraits of the four Evangelists, like those in early Gospel Books (see Chapters One and Three), or of pairs of angels holding Gospel Books between them. Following these is a sequence of genealogical tables of Old Testament figures from Adam

* The structure of those first leaves is still complicated, but the collation through both parts seems to be: i⁵ [of 6, lacking ii after folio 1], ii⁴ [probably of 6, lacking i and vi, after folios 5 and 9], iii⁶ [probably of 8, lacking iv–v after folio 12], iv⁸, v⁶ [of 8, lacking iv–v, after folio 26], vi² [of 8, lacking ii–vii, after folio 30], vii³ [of 8, lacking ii–vi, after folio 32], viii–xi⁸, xii⁶ [complete], xiii–xvi⁸, xvii⁷ [of 8, lacking ii, after folio 105], xviii–xxi⁸, xxii⁶ [of 8, lacking ii and v, after folios 144 and 146], xxiii⁸ [now bound out of order, but foliated correctly], xxiv⁷ [of 8, lacking v, after folio 161], xxv⁷ [of 8, lacking vii, after folio 170], xxvi–xxvii⁸, xxviii⁷ [of 8, lacking iv, after folio 190], xxix⁷ [of 8, lacking ii, after folio 195], xxx⁷ [of 8, lacking viii, after folio 208], xxxi–xxxiii⁸, xxxiv⁶ [apparently], xxxv–xl⁸, xli⁷ [apparently of 8, viii apparently lacking or cancelled after folio 293], xlii⁶; with contemporary quire numbers on the last leaves, from the third gathering (folio 15v) onwards, often followed by the letter 'q' or 'Q' (*quaternio*).

RIGHT: The first page of the manuscript, with an elaborate acrostic spelling out the name of the patron, "sancti micaeli liber", 'the book of Saint Michael'

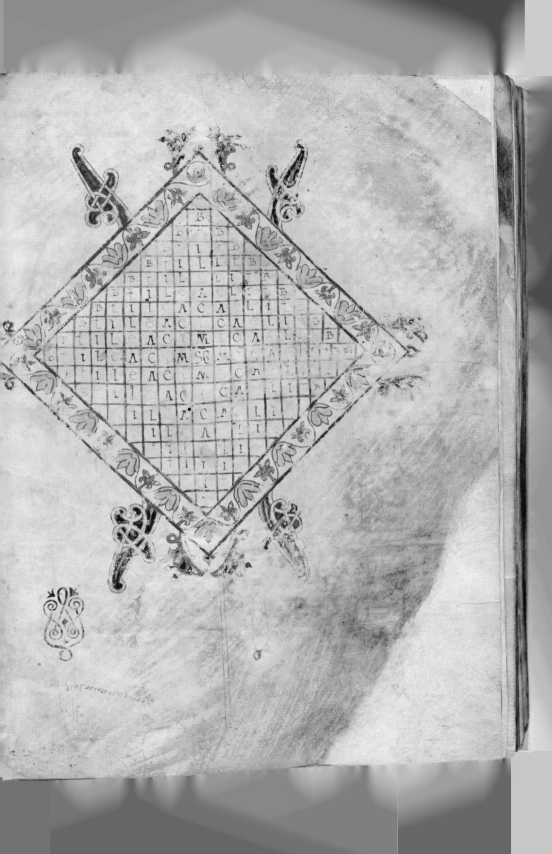

IURE SACERDOTII LUCAS TENET ORE IUBENCI

LEFT: Like an early Gospel Book, the Beatus opens with portraits of the evangelists: this is Saint Luke, conveying his gospel to a witness

RIGHT: The genealogies of the Old Testament, dividing the history of the world into five ages, begin with Adam and Eve

to Jesus, linked by chains of coloured circles and arches. Adam and Eve are shown naked and knobbly-kneed in the upper corner of the opening, brightly pink like newly arrived English holidaymakers on Spanish beaches. The tables reflect the first five ages of the world, Adam to Noah (although its second leaf is now missing), Noah to Abraham (*"Incipit secunda etas seculi*," it announces), Abraham to David, David to the Babylonian captivity, and the captivity to the Incarnation. The completion of these five previous ages of the world leads to the assumption that the present sixth and final age is already upon us, and is about to culminate in the Apocalypse and the end of time, which is the primary subject of the manuscript.

All that was preliminary, like those supplementary texts added before the openings of Gospel Books. The preface by Beatus on the Apocalypse begins on what is now the tenth leaf. There is a very tall letter 'I', filled with coloured flowers and interlace, doubling both for the invocation (*"In n[o]mine d[omi]ni ...*", 'In the name of the Lord') and the opening heading (*"Incipit liber revelationis ...*", '[Here] begins the book of the revelation ...'). The initial resembles the opening of Genesis in a Bible. The author explains that he has decided to set down the principal prophecies of Scripture, in order to confirm the divinity

of Christ, and to strengthen the faithful and to confound the infidel (an allusion, no doubt, to the Muslims in Spain). We saw in the last chapter how medieval authors always claim that their work is copied from previous writers. Beatus dutifully asserts that the interpretations are not his own, but – this is at the top of the second column – that he has taken them from Jerome, Augustine, Ambrose, Fulgentius, Gregory, Tyconius, Irenaeus, Apringius and Isidore. His sources are actually even wider than he states, and extend back to Quintilian, Sallust and Virgil. Beatus apologizes for his poor style, and he hopes that the dedicatee, the Holy Father Etherius, may forgive him. The name is in the defective stained lower corner, and I would not have found it at all without a copy of the printed edition of the text beside me.

Actually, Beatus is right. Most of his compilation is indeed quarried verbatim from previous writers, especially from Tyconius, a North African biblical commentator of the late fourth century. Even much of the preface is largely copied from sentences used elsewhere by Isidore of Seville (c. 560–636), with the name of Etherius, bishop of Osma in 785, substituted for that of Isidore's sister Florentina in the preface to his *Contra Iudaeos*. I am conscious, as I type this, that much of what I can say about manuscripts of Beatus is drawn, with similar respect, from numerous books and articles on the subject by Professor John Williams, who died in 2015 while this chapter was in draft, and so I too belong in a continuing tradition of deference to previous authority. Beatus arranged his text into twelve books, each with its own prologue. Within these books, the Apocalypse is divided into sixty-eight *storiae*, or sections of the biblical narrative of variable length, followed by long allegorical commentaries, each with a huge heading in red and blue capitals, sometimes also in green and purple, "*explanatio suprascripte historie*", 'interpretation of the above-written narrative'. The passages of each *storia* are usually partly written in red ink, sometimes also in blue.

Thus, for example, after the various prologues of Jerome, each with commentary, the first *storia* comprises Revelation 1:1–6. By now we are on folio 22v, for the author is in no hurry to get to the point. The

RIGHT: The preface to the commentary by Beatus, explaining the purpose of his commentary on the Apocalypse and listing his sources. For many years this was bound as the opening page, resulting in heavy damage

NNMEDNI
NSTRIIHV
XPI·
NCPT·LIBER·REUE
LATIONIS·DNI
NSTRI·IHV·XPI

Quidam quę diuerſiſ
tēporibuſ huiuſ
cerriſ ſcra mēmi

libriſ pſumunacq̄ quruna
lanuca nccaucdin ſ cellē
cior ntri ſ cm dcaca in
ad dcſ corpor apone elur

De paſſione quoſq̄ cam orier riue
dcarum cmone nrino crſ ſudicio
pronnibur rccinre ſ huinumcu
libilur liber cr ceorum uucrum
nobilir cmorum ſ cunili brebuaccſ
nccuca pauca prpginda puıſde
y aprofacucum uuecoruuıc
fida ccucqum ıſrina culpfide
llum ſrpciaca prpliſ·
Quequamuir omnibuſ nocuıcſ na
crpſ cmpliaudinem recuoaıcur·
per cuurca pcaliuſ cumıa

admonorum rccunce
dumbreb cmone lequmur·
Quequruucı non ame recluacor puoc
que cplunıcu repperıbı ſhoc
libello ſnduaruncı ca ſumuca
c hir uucaoribuſ· Iccca lbſroname
ugurcno ambrorio fulgenuo
grrgorio cconıo hıranco ubruno
ſ ſıdoro· uorqlnalur longi
non beellau cıa· In hoc queu cu
pleuelo cmone lnu lquibur
dnuacum cu nu planu fide
uuaſ de uoemone cxporuucum reeog
norcır· Omium cu mcı libriſ
cuu hunc librum crcdur crpe
cluucuum· cr cı alıcubı o
delınquuıa ſnduluucu
que cıcu ruperuer

bcruua pcruıcı c
bubılum uuconu
percqurre doce

Quorumq̄ eloqu
gurbur dam ſn ccu
cacuc cuo

Yarcmonıy

accompanying *explanatio* tells that the book is called 'Apocalypsis' (the opening word of the Latin) because matters are hidden, and 'Apocalypse' means the uncovering of secrets. God sent his angel – this is still from the first biblical verse – indicating that the book was not conceived by reflexion or from false texts, but directly from the messenger of truth, 'to his servant John', the holiest of the apostles, to whom was revealed the divinity of Christ (as in 1 John: 1:1–2), who writes to each of the seven churches of Asia, not just to one, citing Malachi 1:11 ('among all nations'), and there is mystery in the number seven, for six and seven are divine numbers and, as there were six days of creation and one of rest, so there are six ages of the world plus one beyond the end of the world, and thus the seven churches represent each age, and they are in Asia, because the word 'asia' means 'elevated', for the world is raised by God, from whom John sends grace, as in Exodus 3:14 and John 1:1–2, and who fills the earth (Jeremiah 23:24) and made all things (Ecclesiasticus 24:8), and so on, citing Wisdom 1:7, Acts 7:8, Isaiah 40:12, and much more. This is only a brief summary. It fills four huge pages. The second *storia* is the text for Revelation 1:7–11, in which he who comes with clouds declares himself to be the Alpha and the Omega, who was and who is and who is to come. Its *explanatio* by Beatus says that God comes in the form of a dove, like the Holy Dove descending at the baptism of Christ, and that the word 'dove' in Greek is '*peristera*', the letters of which have a traditional numerical value which can be added up to 800, which is also the value of the letter '*omega*', and that an 'alpha' in Greek script is written with three strokes of equal length, symbolizing the Trinity, but that an omega in Latin is drawn as an almost complete circle which contains and protects all things; and much, much more. It is exasperating but also, in fairness, a fascinating and characteristically monastic way of studying any biblical text from all directions, word by word, searching endlessly for layers of meaning in every stroke of the pen.

It all assumes close familiarity with the whole Bible. The myriads of scriptural quotations are mostly given without references. The reader would be expected to recognize their sources. There are also words in the Greek alphabet, which presupposes an audience with at least basic

reading knowledge of that language. Monasteries in eighth-century Spain, for all their fears that civilization was collapsing around them, were still schooled in classical learning. Some biblical quotations in the manuscript are written in red ink or are indicated by the use of the *diple*. This is a Greek word meaning 'double', pronounced in two syllables like 'dip-lay': they are rows of little curved symbols running vertically down the margin beside a quotation. Their first occurrence here is on folio 27v beside a long extract from Jeremiah 31:33–4. The interest of the ancient *diple* is that it was later revived by early typographers, for whom printing in colour was prohibitively expensive, and its descendants survive today as those elevated symbols we call quotation or speech marks. Another endearing but decorative feature of this particular scribe's work in the manuscript is his use of rows of little red hearts, like those in a love-sick teenage girl's exercise book, filling lines and enlivening his ornamental explicits.

The Morgan Beatus is written in the script known to palaeographers as Visigothic minuscule. To explain it, we need to go back to the origin of Latin writing in ancient Rome. There were two distinct classes of script common in Roman antiquity. The first of these were high-grade display capitals, such as the letters 'S.P.Q.R.' on classical monuments, easily legible to us, and rustic capitals in books, as imitated in the Leiden *Aratea*. At the other end of the scale were rapid cursive hands – 'joined-up writing' as children call it – used on papyrus for administrative documents. At the simplest level – it was a bit more complex in reality – Roman capitals evolved over the centuries into uncials, and eventually (through subtle and gradual mutations, as in genetics) descended into modern European letter forms, including those used in this book. The cursive, however, was exported outwards with imperial bureaucracy into the Roman provinces, where it bred independently into many local variants of handwriting, such as the strange-looking spidery Merovingian minuscules in France, Alemannic minuscule in western Germany, and so on. These were then swept away by Charlemagne in the early ninth century in a deliberate programme of standardization of script throughout his vast dominions, substituting the famous 'Carolingian' or 'Caroline' minuscule. Only on the

outer fringes of Europe, beyond the reach of Carolingian authority, the tenacious descendants of Roman cursive managed to live on, like prehistoric animals still surviving in some fictional valley isolated from the outside world. The best-known of these living fossils are Beneventan minuscule in southern Italy and up the extreme fringes of the eastern coast as far as Croatia, and Visigothic minuscule in much of Spain and Portugal. The fact that such scripts endured, against the trend, even into the eleventh and twelfth centuries, tells us a great deal about the cultural frontiers of contemporary politics.

Visigothic minuscule, which has nothing to do with the illiterate tribal Visigoths other than a shared association with pre-Muslim Iberia, is beautiful and calligraphic and exasperatingly difficult to read. It is filled with flowing ligatures inherited from Roman cursive, such as the joined 'e' and 'r' resembling a single letter. The lower case 'a' is open-topped like 'u', and 's' looks like 'r', and 't' rather like a modern 'a.' Reading Visigothic reminds me of being a child on the first days of the summer holidays. One would scamper painfully in bare feet across the road and over the pebbles on the beach, feigning ease and nonchalance; by the very end of the holiday, it was truthfully no hardship at all. Early next summer it was agony all over again. Stare at an impenetrable page of Visigothic minuscule in despair, struggle letter by letter, and by late afternoon, usually just as the library is about to close, it becomes at last surprisingly legible; next morning it is quite unreadable once more. This might explain partly why Beatus had such limited circulation outside early-medieval Spain.

M 644 is written in two columns in a rapidly flowing script, mostly 32–34 lines to the page. The ruling pattern is heavily scored, sometimes remaining starkly white where the surface of the parchment has become a dirty yellow. Vertical prickings, as in the Gospels of Saint Augustine, are in single rows between the columns, resembling stabholes made with the tip of a knife. It is not, however, the text or the script which make copies of Beatus so famous, but their stupendous illustrations. The New York manuscript has sixty-eight huge full-page

RIGHT: Visigothic script is the strange handwriting of early Iberian manuscripts; the twelve medallions symbolise the half-hour silence in heaven (Revelation 8:1)

ıgıllo ſcēm ſınān eā reıpıau
uıdıc̄ · nuncucō ınquoını
reparınum ſıgıllum

IXPLICITSEXTI
SIGILLIEXPLANA‍T‍IO

INCIPTIXPLA
NATIOSIGILLISEPTI

♥ ♥ ♥ ♥ ♥

aquumap̄ ſuıſſcō ſıgıllū
ſep̄rınum ſuccumōā
ſılarıchum ın cęlo

ſ ı l e
N c t ı
o ē ſ ſ

e aapuſrānſılarıchı ındıā · quıa eūdōn
uıſıonān ındıā hōc pluſ plānur
uſuruſſrıā · quodlnhōc ſeparmo
ſıgnononuıdıā aruncaumquunat
adhuc ſıarıuſ ōrıa uıdēr
eaua ēuperquıſ mulau oſārdē
rınaur · ınarruaumōrā ſılarıchū
quodſıſrē ē luenr loeuaıo · nonſēaē

ſınrurōbı · hıeuıdōādumōrā
nuırandıſ nōnſuccē · nuncuēō
reıpıaulaue uxpıpuſſıone euıdē
ulıaſ · dıeaıuuſ ·

IXPLECILIBQUARIS

♥ ♥ ♥

INCIPTLIBER
QUINTVS
♥ ♥ ♥

e ıudıᷓ ᷓp̄ āmuncıeloſ
quıraıbuna Inconſp̄ēcaıı
dēı quıuecēp̄ſuna ᷓp̄ᷓrınaıbuſ
ea ulıuſ angeluſ uēnıa · erᷓᷓa
ſupurrım · hubānſ auſ̄bulum
uurreum · eaduıſſrunaIllı
odoſumēnaumulau deoruᷓꝺⁱonıbⁱ
ſeorum omıum ſupurrım ueıᷓr
quēᷓa Inconſp̄ᷓcaudeı ·
eauſeēndıa ſunı odoſumēnaorſ
deoruᷓꝺⁱonı b̄ſeorum · eaꝺ̄nunu
ungelıInconſp̄ᷓcaudeı
eauecēpıa ungeluſ auſ̄bulū
eaᷓmpleına Illud ᷓlegnⁱaᷓᷓ
eamıſıa eaum Inaꝺᷓu
e auea ſuaruna uoeᷓ aonⁱa ᷓua
ea fulguru ea aꝺᷓ moau

EXPLICISTBRE

pictures, as big as panel paintings, and forty-eight smaller illustrations, as well as very numerous decorated diagrams and ornaments. My fellow researchers in the Morgan Library that day were all looking meekly at pale-brown archives and little printed books: I was turning huge thousand-year-old parchment pages crackling with bright colour and astonishing imagery. It was hard not to feel a certain swagger.

There is at least one picture for each *storia*, usually closely following the biblical text, both in subject matter and in position on the page, in that they are placed after the Scriptural passages they illustrate. That is curious, for in most books illustrations come first, followed by the text. Some pictures of this manuscript incorporate captions drawing attention to details of the scenes they represent, for unlike some medieval art these are not images for the illiterate. *Storia* 1 is Revelation 1:1–6. Its picture, which follows on folio 23r, is in two registers, with Christ above on his throne commissioning two angels, one of whom brings what is probably a wax tablet to John below. Beside the lower angel are words in capital letters, "UBI PRIMITUS IOHANNES CU[M] ANGELO LOCUTUS EST", 'Where John first speaks to the angel.' They sound rather like stage directions. The second *storia* is Revelation 1:7–8. There on folio 26r is Christ hovering in a breathtakingly fluid cloud, 'and every eye shall see him', shown as nine saints gazing upwards goggle-eyed. It is all very literal. The third is Revelation 1:10–20. Like John, watching from the lower left, we see in the accompanying picture the Son of Man on his throne, robed in olive-green with a golden sash, with the seven hanging candelabra above, helpfully but quite unnecessarily identified in white capitals as "SEPTEM CANDELABRA", and the seven stars beside his right hand, and John falling at his feet while Christ reassures him by holding the keys of death, and then John is taken to see seven round arches inscribed with the names of the churches of Asia – Ephesus, Smyrna, Pergamon (incidentally, the city that gave its name to parchment, *pergamenum* in Latin), Thyatira, Sardis, Philadelphia and Laodicea.

The prologue to book II is illustrated, rather unexpectedly, with a stunning double-page rectangular map of the world. This is on folios

RIGHT: Christ in the upper compartment commissioning two angels to bring the revelations to Saint John below

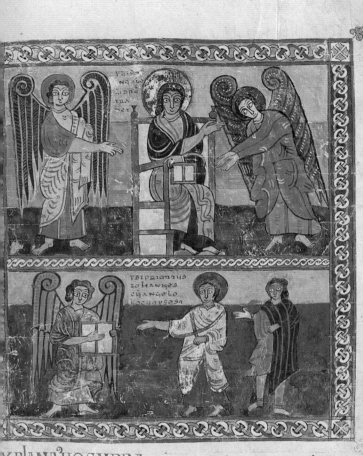

VBI
NGLO
VIDERI
TRA
ba

VBIPRIANTUS
IOHANNES
EVANGELO
LOCVTVSESA

XPLANATIOSVPRA
SCRIPESTORIE:

pecalipsis ihuxpi quae credidit
os illidi pulum suae cerum
quae operet es se cerao·

habet legitur quod apoculipsis
Idea revelacio dicitur se revelacion
lucere cerrum munifecava ubico
Quod nisi ipso revelanne quire·
Intelligere nonvalebia e
ula· Apocalipsis ihuxpi

33v–34r. Before discussing the messages to each of the seven churches, Beatus digresses on the regions to which each of the twelve apostles brought the Gospel. It was of especial interest to his countrymen that Saint James, disciple of Jesus himself, was credited with bringing Christianity to Spain. The world is shown surrounded by a broad frame of yellow sea with blue fish and the odd sea serpent south of Africa. In the band of sea to the left and below, classical ships are scratched into the surface of the pigment, hardly visible in reproductions. The world is oriented (note that word) with east at the top, site of the Garden of Eden, shown with Adam and Eve beside a prickly tree. Land masses are divided by the Mediterranean into Europe, Africa and Asia. On a rectangular cartouche in the ocean at the lower left, at the very edge, I can make out, with help of the Library's magnifying glass, the words "Britannia Insula" next to another island, here some distance further south, "Scotia Insula", actually Ireland. Spain is understandably prominent in the foreground, fringed by mountains topped with trees. Africa has two huge countries separated by the Nile – Libya and Ethiopia (where monsters and the phoenix live). Jerusalem is shown as a little castle gate, the only city depicted. Mediterranean islands are all squares. It is all extremely naive and based on echoes of Roman geography, but, as one stares, picking out place names – Narbonne, Germany, Rome, Macedonia, Constantinople – one finds a certain respect for the understanding of the shape of things over vast distances, from a time when the highest perspective on the world was obtainable by nothing better than climbing a hill or a tree.

Let us continue turning pages. The parchment is generally thick and of rather coarse quality, often creamy and yellow on the hair-side, undulating from exposure long ago to damp. It has many original flaws and large elliptical holes caused by careless skinning or preparation (some huge, like those in Emmental cheese), which the scribe has written around. Because the majority of lower outer corners were damaged

RIGHT: The Son of Man with the seven candelabra and the seven stars by his right hand (Revelation 1:12–16), and Saint John with the arches of the seven churches

OVERLEAF: Map of the world, set within a yellow sea: the east is at the top, Europe at the lower left, Africa on the right, and Spain in the foreground

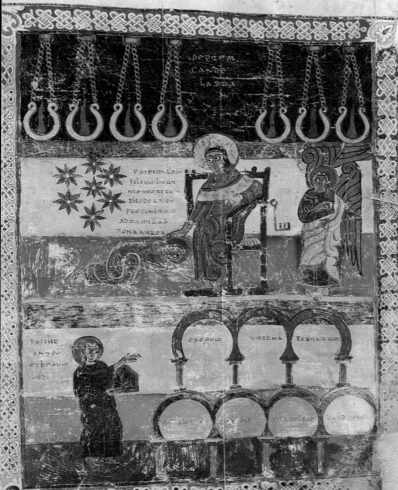

by decay and are now patched with new parchment, one is in reality mostly handling the manuscript by touching the replacement pieces rather than by thumbing original parts from the tenth century.

There, for example, are the pictures of churches of Asia, often as exotic and as multi-coloured as mosques; we come to a Noah's Ark, like a child's model with shelves, including a yellow elephant with spots and two giraffes, symbolizing the safety of the Church during cataclysm (giraffes really are rarities in medieval art); there is the Lamb of God standing holding a cross within a great polychrome wheel of creatures and elders, bordered with stars and turned by archangels; there are the seven angels blowing trumpets and fire being thrown down like arrows on the earth, against a sky turned yellow; mountains being hurled into the sea, in a torrent of fire, with naked bodies tossed in the deep among shipwrecks and darting fish; the sun and the moon and the stars turning partly to darkness, and a great eagle flying across the sky calling 'Woe, woe, to the inhabitants of the earth'; plagues of locusts, as vast as monsters; and, the last illustration in what is now volume I, the hooded witnesses of Revelation 11:3, clothed in sackcloth hoods and prophesying with fire from their mouths. This is on folio 149r, the final leaf as now divided, and we are still only half-way through the Apocalypse.

I unsuspectingly took the first volume back to the issue desk and asked now for the second. I was reprimanded for carrying the book myself. Apparently I should have asked for an invigilator to do this. Manuscripts in the Morgan Library are accompanied by loose slips of paper with a bar code and a 'Record ID', a six-figure number, which the assistant scans as the volume is checked back. I remarked conversationally that I had never seen such a thing before. She looked at me pityingly and told me that all major libraries do this now, to keep track of manuscripts and to maintain statistics.

The second volume opens on folio 150 with the *storia* from Revelation 11:7–10. The first picture shows the Antichrist – his face vindictively scratched by an outraged reader (long ago, I hope) – chopping the witnesses into nasty bloodied pieces, while Jerusalem above is being

RIGHT: Noah's Ark with all its animals and including the dove with an olive branch and the raven eating a dead body, all part of a digression inserted at the end of Book II

smashed up by the Antichrist's followers. It gets more horrific page by page, faster and faster. Saint Michael fights the seven-headed serpent in the battle in heaven, in a double-page opening, hurling dead bodies to the ground below; a hideous horned beast rises out of the earth; a striped angel sweeps across the firmament, and Babylon is destroyed and naked limbs fly about, severed from people; the seven plagues are poured upon the earth, including rivers turning to blood and lightning falling like a relentless hail of crimson spears; the Whore of Babylon shares a wine cup with the smiling kings of the earth who have fornicated with her (this is folio 194v, she too has had her face scratched, serves her right); Babylon burns, a complex mosaic of colour and fire; the Devil is chained and is thrown into the abyss; and in a huge Last Judgement, spread across two pages, the countless dead stand before the throne of God, and the damned are cast through an aperture in the tiled floor of Heaven, falling naked into a purple pit of fire. When the text of the Apocalypse commentary is finally over on folio 233v, it is as if the scribes of the manuscript are unable to stop in their headlong frenzy of biblical vision and prophecy. They continue writing. The volume goes into Jerome's commentary on the book of Daniel. This too is visionary and prophetical, but, in comparison, it is strikingly less crowded and gentler. Pictures include Nebuchadnezzar's dream; Balthazar's feast, with a scribe's hand emerging from a candlestick to write the prophecy of doom (in Visigothic minuscule) on the vault of the king's hall; and Daniel, not too distressed, in the lions' den.

The style of painting is what is commonly called Mozarabic, associated with the mingling of Christian, Jewish and Islamic traditions in Muslim-occupied Spain. In practice, Arabic and Hebrew manuscripts were not illustrated, and certainly not at this period, and illuminated Latin manuscripts from Iberia at this time are so rare that comparisons even there are difficult. The blaze of primary colours and exotic abstract patterns of the Beatus manuscript can certainly be paralleled in the tiles and mosaics of Islamic architecture, and in the carpets and metalwork from the Maghrebi coast of northern Africa. The stripes of

RIGHT: The opening of the second volume, as currently bound, with the killing of the witnesses and the Antichrist now scratched by a reader of the manuscript

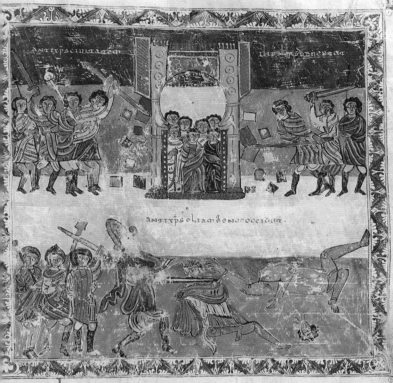

ANTIXPS CIVITATE DEI · IHS IN SUBURBANA DEI

ANTIXPS ELIAM DE ORO OCCIDIT ·

EXPLANATIOSVPRASCIPTISTE

E

umce et vos to occidit tos
vineas unerxps tos quosse
duxerra uocis et saluna ·

Occide et uusin eos qui confess du
suorna Spaluas uabmanelu

cta umcde qui uangelus
et legi nonestluna ' occidos
uasan tos qui xpo occidua
unmpton marum buua qua us
dus mauange le usa ' esquidos
uos mprassor to occidera uos

intense yellow and deep orange are very striking and unlike anything found north of the Pyrenees, and it is all brighter in the original manuscript than in any published reproductions. The unusual pale green is vibrant and lovely. Some blocks of colour display streaks of vigorous application, as if they were dabbed on and spread not with a soft brush but with a palette knife or a spatula.

Art historians point to distinctive oriental details in the Morgan Beatus such as the palm trees and the cushioned divan on which the Whore of Babylon reclines (that is the picture on folio 194v). However, the closest parallels, especially in the figures, are really with Coptic art and particularly with Ethiopian manuscripts and painted art, even today. I am not the first person to observe this. Sydney Cockerell, a collaborator with M. R. James in the Yates Thompson catalogues, noted privately in his own copy of the description, "They are very Ethiopian in character." (Cockerell will be one of the heroes of Chapter Nine and we will be introduced to him properly then.) Strikingly comparable faces, with similar big staring eyes, occur in those two Gospel Books recently rediscovered in the Abba Garima monastery in northern Ethiopia, apparently of the sixth century (see above, p. 44). Lest this seems inconceivably remote from tenth-century Spain, remember the manuscript's late-classical world map which depicts Ethiopia as the largest country on earth, shown closer to Spain than (say) Greece. Noah's Ark here includes a giraffe. Africa touched the cultural life of Europe in the tenth century to a greater degree than it does now.

Are the pictures good art? They are not remotely as sophisticated as even the worst of the wild-eyed compositions in the Book of Kells. M. R. James, happiest with the grace of fourteenth-century gothic painting, was not impressed with their quality. He wrote in his description in that same catalogue of 1902: "The drawing of them is exceedingly rude: the eyes of the figures abnormally large, their attitudes absurdly stiff." It is, however, a theatrical style which is somehow very effective for its purpose in illustrating this particular and startling text. Brilliant colours and uncomprehending fear are astonishingly powerful.

RIGHT: Christ appearing in a cloud in heaven, with every eye seeing him – a picture in a style curiously similar to Ethiopian art

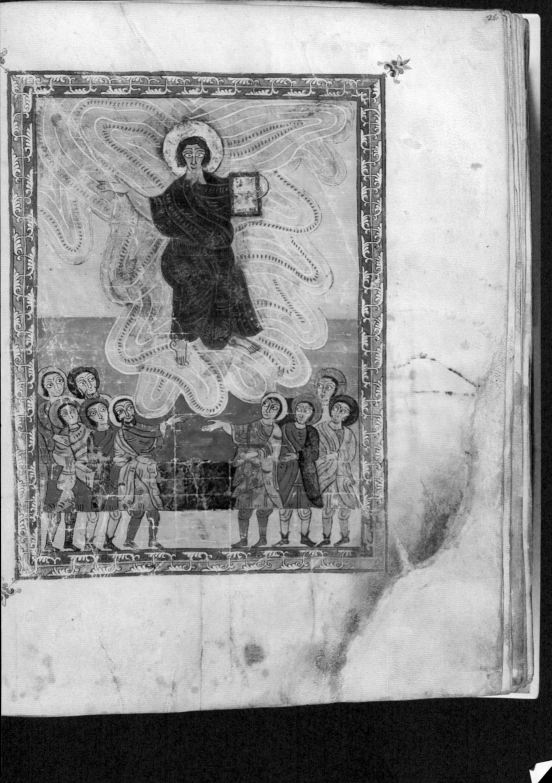

There is an urgency, bordering on panic. It is art ideally appropriate for terrifying and nightmarish visions of unimaginable horror, and for the whirling kaleidoscopic cacophony of cataclysmic disaster, as savage and as unforgettable as Picasso's *Guernica*.

The fireworks and downright strangeness of the pictures in Beatus manuscripts may actually have had a practical purpose. The monastic method of studying the Scriptures was to read a sentence or two aloud, and then to think about the text word by word, looking slowly for multiple layers of meaning. It was called '*lectio divina*'. That meditative rumination was itself an act of devotion. If the monk could gaze at the page and memorize it, then this slow pious reflexion could continue in his mind long after the original manuscript had been closed up and put away in its box in the cloisters. Passages of plain script, maybe especially in Visigothic minuscule with little word-division, are difficult to envisage afterwards, but pages with complex illustrations as dramatic and as unsettling as those here are impossible to erase from memory. Their naivety is a benefit. The brilliance of the colour and the startling narrative drama have a real value. They served as a mnemonic device to enable reflexion on Revelation to continue among many readers at once, at any time of day or night.

I have kept back until now one of the most remarkable features of this famous manuscript. We not only know who designed and painted it, but even why and possibly when. There is a long colophon in little capital letters along the upper half of folio 293r. It begins:

Resonet vox fidelis, resonet et concrepet. Maius quippe pusillus, exobtansq[ue] iubilet, et modulet, resonet, et clamitet. Mementote enim mihi, vernuli xp[ist]i, quorum quidem hic degetis cenobii summi dei nu[n]tii Micahelis arcangeli. Ad paboremq[ue] patroni arcisummi scribe[n]s ego, imperansq[ue] abba victoris equidem ud[u]s amoris ui[u]s libri visione Iohanni dilecti discipuli ...

'May the voice of the faithful ring forth, ring forth and echo! May Maius, although little and hopeful, rejoice and sing and sound forth and shout! Remember me, servants of Christ, you who live in the monastery of the Archangel Michael, the supreme messenger of God. I myself write this in honour of the arch-great patron, at the command of Abbot Victor [or 'of the abbot of the

The verse colophon of the Morgan Beatus, signed and dated by the scribe Maius for a monastery of Saint Michael, perhaps the abbey of San Miguel de Moreuela

victor', as we will see shortly], and also out of love of the book of the vision of John the beloved disciple …'

Thus we have the name of the scribe, Maius, 'major' (he makes a pun on his own name, modestly referring to himself as little), working for the monks in the monastery of Saint Michael the Archangel. The opening initials of every second line in the colophon, taken vertically from '*Memento*' downwards, also spell out 'M', 'A', 'I', 'U' and 'S'. The name appears too at the end of the text of Beatus on folio 233r, "Maius Memento", 'Remember Maius': these two words seem to me to be in a slightly different script, and they may have been added commemoratively in his honour, rather than by Maius himself. By happy chance, another manuscript of Beatus, now in the national archives in Madrid, was completed by his pupil and successor, the scribe Emeterius, who wrote a colophon acknowledging his late teacher and collaborator in that book as having been the 'archipictor' Maius, scribe of the monastery of San Salvador de Tábara, who died – Emeterius tells us – on

30 October 968. Such an absolute date for any scribe's life is a rarity. The title *Archipictor*, 'master painter', doubtless means that Maius had been both scribe and illuminator. On the reverse of that same leaf in Madrid, Emeterius also made a drawing of himself at work in their scriptorium in a tower of Tábara. The picture is rather damaged at its edges in the manuscript, which is fragmentary, but it was carefully copied 250 years later into yet another manuscript of Beatus, once owned by the church of Las Huelgas in Burgos. By a second pleasing coincidence, that very copy is the one which was bought by Pierpont Morgan senior in London in 1910 and so it too is in the Morgan Library in New York (M 429). Without moving from my chair in the Sherman Fairchild Reading Room, I could therefore contemplate an early thirteenth-century reproduction of a tenth-century picture of the making of a Beatus manuscript in Tábara by someone who knew and worked with the scribe Maius himself.

The picture shows a bell-tower, with bell-ringers on ladders. It may be wishful thinking, but it would be pleasant to imagine that Maius's references to ringing forth are allusions to these bells. Attached to the right of the tower is a two-storey tiled extension. Its ground floor is made of stone and has very small narrow windows and a door with a lock: it is perhaps the library or strong-room. Immediately above this is a studio where the scribes worked. One is seated in a chair, holding a pen and a knife, and is writing a book on a sloping stand. Beside him is another scribe pricking the parchment with a pair of dividers. On a little ledge outside, a small boy is cutting up parchment with a pair of scissors.

The collaboration depicted between principal scribe and two assistants is a feature of monastic manuscripts. Although Maius takes the credit for all of what is now M 644, the first five gatherings include the occasional work of a second and less skilful scribe. This too is consistent with production in an organized scriptorium, rather than work by an isolated genius.

Tábara is in north-west Spain, north of Zamora in the old kingdom of Léon. Its medieval church still has an ancient stone bell-tower, not very different from that depicted by Emeterius. Although our manu-

The early thirteenth-century Beatus of Las Huelgas in Burgos, with a copy of the earlier picture showing the scribe Emeterius working in the bell-tower at Tábara

script was doubtless made there, it was clearly destined for a monastery dedicated to Saint Michael the Archangel. It is generally asserted that this must have been the abbey of San Miguel de Escalada, nearly eighty miles to the north-north-east of Tábara, near the city of Léon. The manuscript is often called the Beatus of Escalada. This is based on little more than the fact that by the twelfth century Escalada had become one of the dependencies of the Augustinian canons of Saint-Rufe d'Avignon, and there is a later note of a death added on folio 293v of the manuscript, "obit petrus levita Cus Si Ri", which might (or might not) stand for 'canonicus sancti Rufi'. That is fairly thin evidence for what is not supported by other likelihood. I owe to William Voelkle the chance to read a typescript by John Williams, intended for use in the catalogue of a planned exhibition at the Morgan, citing Ferreo Gutiérrez, who has a far more tantalizing identification. He notes that San Salvador de Tábara was established by Saint Froilán of Léon, who also founded a second house, San Miguel de Moreuela, which is only four

miles south-east of Tábara. This is an infinitely more probable patron than an unconnected abbey several days' journey to the north over mountainous terrain. With the wind in the right direction, Moreuela would have been within the sound of the bells, which Maius may have been alluding to. Neither of these two houses dedicated to Saint Michael is known to have had an abbot called Victor, but the word probably simply refers in this context to an unnamed abbot of the archangel himself, who was the triumphant victor over Satan in the Apocalypse.

However, this is not all of the colophon by Maius. There is more to come. It continues:

… inter eius decus verba mirifica storiarumq[ue] depinxi per seriem, ut scientibus terreant iudicii futuri adventui peracturi s[e]c[u]li. Ut suppleti videlicet codix huius inducta reducta quoq[ue] duo gemina … ter terna centiese, [et] ter dena bina era. Sit gl[or]ia patri soli filioq[ue] sp[irit]u simul cum s[an]c[t]o trinitate, per cuncta sec[u]la sec[u]lis in finitis temporis

'… as part of its decoration, I have painted in a sequence the amazing words of the texts, so that wise people may fear the judgement to come at the end of the age. To supplement the completeness of this present manuscript two twins are also brought in … In the era of three times 300 [and] three times twice 10. Glory be to the Father and to his only Son and Spirit, with the Holy Trinity, throughout every age to age to the end of time.'

First of all, Maius tells us that he illustrated the manuscript himself. This is not so unexpected in a book of this date: the clear separation of the crafts of scribe and artist did not really become the norm until the eleventh or twelfth century. The fact that he mentions it at all is unusual. This is the oldest known manuscript of Beatus with any picture cycle. Is he telling us that he himself invented and devised the imagery? It sounds like it. He did, after all, have a posthumous reputation as the 'master artist' of this text. It might be that in this manuscript we have that rarest of moments in medieval art history, when a particular cycle of compositions is actually created for the first time, by a known artist, rather than being derived from some existing tradition. Furthermore, Maius tells us why he did so: to make people fear the end of the world.

The next sentence is difficult. He seems to be saying that he is supplementing the manuscript about the Last Judgement with two complementary or twin additions, presumably those which now follow the commentary of Beatus: the short text on the degrees of kinship, the *De affinitatibus et gradibus* of Isidore, and then the rather longer commentary on Daniel by Jerome. Others, however, including M. R. James, a far better Latinist than me, have taken this clause to be part of the date, in which Maius is rounding off the manuscript in the year twice two... and then the rest, which is three times 300 plus three times 20. That would be either 4 + 900 + 60 (= 964) or, if the two twins are texts, not years, more simply 900 + 60 (= 960). However, Maius uses the word "era", the uniquely Spanish dating system which ran thirty-eight years ahead of the traditional numbering. Therefore, making the subtraction, the date is 926, or, more probably, 922 AD.

This is just credible if Maius died in 968 (he could have been twenty-five when he wrote the Morgan manuscript and seventy-one when he died), but a career as a scribe for almost fifty years is unlikely, especially before the invention of reading glasses, necessary for most of us after a certain age. In the original manuscript there is a clear space about an inch wide before the words "ter terna", which I have transcribed above with a row of dots. Something has evidently been erased. I cannot tell whether this was a contemporary alteration by Maius himself (the scribe drawn by Emeterius uses both pen and scraping knife), or whether someone such as, say, the trickster Libri has removed a few words to make the manuscript seem even older than it is. Most manuscript historians now date the Morgan Beatus cautiously to some time between the 920s and 968, probably to around the late second quarter of the century.

Eight other extant manuscripts of the commentaries of Beatus can be assigned to the second half of the tenth century, up to the year 1000. They fall mainly into two related 'families' of text, usually referred to as 'IIa', which includes the Morgan manuscript, and 'IIb', which is a first cousin, although it is not entirely clear whether this branch all descends from the work of Maius in Morgan M 644, or whether both families derive from a single common grandfather which no longer

survives. That lost progenitor, if there was one, could also, of course, have been made by Maius at an earlier date (such as in 922), and so his claim to have invented the iconography is not necessarily invalidated even if M 644 is not the sole source of both families.

The manuscripts in family IIa include: Valladolid, Biblioteca de la Universidad, from Valcavado, written by the scribe Obecus, dated between 8 June and 8 September 970; Lérida, Museo Diocesá de La Seu d'Urgell, inv. 501, second half of the tenth century, at Urgell Cathedral by 1147; Escorial, Real Biblioteca del Monasterio, &.II.5, possibly from San Millán de la Cogolla, *c.* 1000; Madrid, Biblioteca Nacional de España, ms Vitr. 14-2, written and probably painted by the scribe Facundus, dated 1047, owned by Ferdinand I of Léon and Castile and his wife Sancha of Léon (both d. 1065), a marvellous book; and London, British Library, Add. MS 11695, written by the scribes Domenicus and his kinsman Nunnius, begun *c.* 1073 and completed 1109, from the abbey of Silos. Those in family IIb include: Madrid, Archivo Histórico Nacional, Cod. 1097B, written by the scribes Monnius and Senior, painted by the artists Magius and Emeterius, finished on 27 July 970, which is the manuscript from Tábara, with the portrait of Emeterius in his tower, described above; Gerona, Museu de la Catedral, inv. 7 (11), written by the scribe Senior and painted by the artists Emeterius and Ende, "*pintrix*" (a woman), finished on 6 July 975, at Gerona Cathedral by 1078; and several manuscripts of the twelfth and early thirteenth century, including New York, Morgan Library, M 429, dated 1220, the latest secure date of any Beatus manuscript, from the monastery of Las Huelgas in Burgos.

Note how many of these manuscripts are actually dated and are signed by those who made them, including one painted by a female illuminator, perhaps a nun. The recording of makers' names, not so common in manuscripts, may be because these are texts on the Last Judgement, an occasion when everyone is glad to be remembered favourably. The unusually high proportion of precise dates also suggests a text for which millennial calculations were never far from the patrons' minds. The Valladolid manuscript preserves the dates when it was begun and finished, showing that its 230 leaves took the scribe

ninety-three days; excluding Sundays, that is just under three leaves a day, a brisk rate.

In the event, the world did not end in the year 1000. Some eleventh-century chroniclers, such as Adam of Bremen, noted with apparent relief that it passed "feliciter", harmlessly. Byrhferth, monk of Ramsey Abbey in England, wrote around 1011 that 'the thousandth year has now been completed, according to the calculations of the human race, but remains to be determined in the presence of the Saviour': maybe the sums were somehow not precisely right. There was a modified conclusion that the final millennium ought perhaps to be predicted not from the incarnation of Christ but from the date of his Passion, which brought a certain anxious attention to the year 1033. That too slipped by without apocalyptic catastrophe. The later manuscripts of Beatus on the Apocalypse are wonderfully flamboyant and decorative, but they lack that intense and urgent terror which we can glimpse through the eyes of Maius in the tenth century.

Apocalyptic expectations did not cease with Beatus, and they are still current in our own time. Revelation 12:6 describes the woman with a man child, commonly identified as the Virgin and Jesus, fleeing into the wilderness for a period of one thousand, two hundred and sixty days, before the war in Heaven which is predicted to mark the end of time. On the principle that a day is a year in the eyes of God, the year 1260 coincided with a flurry of illustrated Apocalypses, especially in England, extending to around to 1260 years after the Crucifixion (1293), when these manuscripts too began to pass out of fashion. They returned as printed block-books in the Netherlands and the Rhineland in time for the feared half-millennium of 1500, and Albrecht Dürer, never one to miss a timely marketing opportunity, published his incomparable woodcut Apocalypse in 1498: it secured his fortune. We all recall the popular and escalating millenarianism as the year 2000 approached. That date too passed, without even the crashing of the world's computers, as was popularly predicted. One day, however, the world will end, not yet (as we may hope), and all the manuscripts of Beatus of Liébana will be destroyed.

Hugo Pictor

late eleventh century
Oxford, Bodleian Library,
MS Bodley 717

Riddles were a popular entertainment a thousand years ago. The earliest manuscript still remaining in the ancient cathedral library of Exeter, in Devon in the far south-west of England, is the so-called 'Exeter Book'. It is a tenth-century miscellany of different texts in the Old English (or Anglo-Saxon) language, given to the cathedral there by Leofric, bishop of Exeter 1046–72. It includes a section of ninety-five cryptic and poetical descriptions of everyday objects, which the audience has to guess. Like the riddles posed by Gollum for Bilbo Baggins in *The Hobbit*, their misleading obscurity is part of the pleasure in solving them. One begins, "Mec feonda sum / feore besnyþede / woruldstrenga binom / wætte siþþan, dyfde on wætre ..." – it seems scarcely credible that this is actually English – 'Some fiend took away my life and worldly strength too, wetted afterwards, dipped in water ...'; the subject is then placed in the sun, loses its hair, and is scraped and cut and folded. The right answer, as you will doubtless have guessed already, is a manuscript, for this is the process of making and folding parchment. Then, the riddle continues, a 'bird's delight' (a quill) races across the surface, leaving dark tracks and dyes from trees, and the whole is covered with boards and skin, and it becomes a help for great men and itself is holy. Another of the riddles in the Exeter Book begins "Ic seah wrætlice / wuhte feower ...", 'I saw four things in beautiful

qua uortæ flama pascetur. Siquis q̄ habet in conscientia sua zizania quæ in
micus homo dormiente patre familias sup seminauit: hec ignis exuret: æ
notabit incendiū. æ o mūa scō̗z oculis eo̗z supplicia mostrabuntur. qui pauro
æ argento æ lapide p̄cioso edificauer sup fundamtū dn̄i senū. ligna. stupula.
ignis pabulū sempiterni. Porro q̄ uolunt supplicia aliquando finiri. æ licet
post multa tp̄ora. tamen habe terminū cornita: bis utuntur testimoniis.
Cū intrauerit plenitudo gentiū. tunc ōis istl̄ saluus fiet. Et itum. Conclu[dit]
dl̄ o mūa sub peccato: ut omib; misereat. Et in alio loco sc̄r. Iā dn̄i sustinebo.
qm̄ peccaui ei. donec iudicet causam mea. æ auferat iudiciū meū. æ educat
in luce. Et rursū. Benedici te dn̄e qm̄ natus es m̄i. Auertisti faciē tuā a me. æ
miser tus es mei. Dn̄s quoq; loquitur ad peccatores. Cū ira furoris mei fuerit
rursum sanabo. Et hoc est qd̄ in alio loco dicitur. Quā magna multitudo boni
tis tue dn̄e. quā abscondisti timtib; te. Que omia replicant. affirmare cupient
post cruciatus atq; torm̄ta futura refrigeria. æ que nunc abscondita sunt ab
quib; timor utilis est. ut dū supplicia reformidant. peccaro
 desistant. Ad nos dī solius debemus scire: ne de tin
 quere. cui nonsolu miscdie; sed æ tormta
 imponere sunt. æ nouit quē q̄ modo.
 aut quamdiu debeat iudicare.
Soluq; dicamus. qd̄ humane conuenit fragilitati. Dn̄e ne in furore tuo
arguas me. neq; in ira tua corripias me. Et scit diaboli æ omniū negato
atq; impio̗z qui dixerunt in corde suo non est dē.
 credimus eterna tormenta. sic pec
 cato̗z atq; impio̗z æ tam
 xp̄iano̗z quo̗z opa
 igni pbanda
 sunt atq;
 purganda. moderata
 arbitramur. æ mixta clementie
 sententia iudicis.

EXPLICIT LIBER BEATI
IHERONIM SUP YSAIAM

fashion …', apparently describing a quill pen, journeying rapidly in the company of three fingers, leaving dark and vivid footsteps as they all travel across the parchment together.

The manuscript which we are to examine in this chapter was originally also part of that same medieval library in Exeter, probably acquired by the cathedral in the time of Leofric's successor there, Osbern, bishop from 1072 to 1103. It was assembled, written and bound, more or less as described in those Anglo-Saxon riddles. Its importance lies in the fact that we not only know the name of the man whose three fingers held the pen in the late eleventh century, but we even have a picture of him doing so, for it ends with what is generally considered to be the earliest signed self-portrait in English art. The manuscript is Oxford, Bodleian Library, MS Bodley 717. It is a copy of the commentary in Latin on the Old Testament book of Isaiah by Saint Jerome, translator of the Vulgate Bible. On its final page is a famous coloured drawing of a seated man, pausing as he prepares a manuscript. He is shown dipping his pen into an ink-horn, holding the quill daintily between the thumb and two fingers of his left hand. His name is beside his head, "*Hugo pictor*", 'Hugo the painter', and there is a second caption above, "*Imago pictoris & illuminatoris huius operis*", 'Picture of the painter and illuminator of this work', all seemingly clear and unambiguous. The figure is shown as tonsured monk; he appears to be left-handed; and he has green hair. At least one of those facts is wrong, and perhaps all three are. Like the riddles of the Exeter Book, Hugo has left us false trails and tantalizing clues, which this chapter will attempt to resolve.

Bodley 717 is part of the founder's bequest to the Bodleian, the now-immense university library of Oxford University. The book's accession number, like the leviathan institution itself, is named after Sir Thomas Bodley (1545–1613), the eldest son of a Puritanical printer and publisher originally from the same city of Exeter. Unusually for the time, Bodley wrote an autobiography in 1609, published in 1647. In it, he recounts how his family had moved abroad during the aggressively Catholic regime of Queen Mary (1553–8), settling in Geneva in 1557,

LEFT: The last page of the former Exeter Cathedral manuscript of Jerome's commentary on Isaiah, with a self-portrait of the scribe, signed 'Hugo Pictor' (enlargement on p.243)

when he was twelve. It is a small aside (but we are on the subject of English artists) that the Bodley children were accompanied in their exile by the then ten-year-old Nicholas Hilliard (c. 1547–1619), later the most famous portrait miniaturist of the northern Renaissance. In Geneva, Thomas Bodley recalled, he had attended lectures by Calvin and Beza. Back in England during the more enlightened and reforming reign of Elizabeth I (1558–1603), Bodley was admitted to Magdalen College, Oxford, became a fellow of Merton College, and briefly taught Greek there. Much of his career, however, was spent on royal embassies to Europe, especially in Germany and the Netherlands. In those days, diplomacy was a profitable profession. He added to his wealth by marriage in 1586 to the widow of a successful fish merchant from Devon. They had no children.

In 1598, Thomas Bodley first approached the Vice-Chancellor of Oxford about re-establishing and sponsoring a general reference library for the university. There had formerly been a library there endowed by Prince Humfrey (1390–1447), duke of Gloucester, but his donations and subsequent acquisitions had dribbled away through loans and negligence, as books do (especially during Reformations), leaving only "the rome it selfe remaining", as Bodley's letter to Oxford expressed it. He offered "to take the charge and cost upon me, to reduce it again to its former use: and to make it fit, and handsome with seates, and shelfes and Deskes". Today, such philanthropic initiatives would be made complicated by years of university sub-committees and planning applications. In 1598 the university accepted within three weeks. Bodley's builders began at once, restoring Duke Humfrey's fifteenth-century library building and later adding the adjoining Jacobean quadrangle, still one of the major sights for tourists in Oxford. Thomas Bodley wrote to his librarian-designate, Thomas James, in June 1599, describing the activity of "carpenters, ioiners, carvers, glasiers, and all that idle rabble"; within a year – clearly not so idle after all – they were already fitting rods to the new oak bookcases, with chains and locks for security, and Bodley and James set about finding enough books to fill the new shelves.

It is often said that Thomas Bodley, like Matthew Parker, sought texts which would become symbolic defenders of the Reformation.

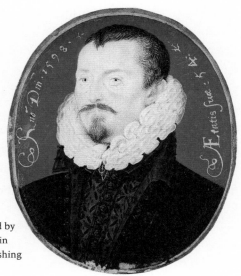

Sir Thomas Bodley (1545–1613), painted by his childhood friend Nicholas Hilliard in 1598, the year Bodley proposed establishing a library for Oxford

Although this is consistent with his Puritan background, there was in fact nothing narrowly Protestant or indeed necessarily Christian at all about his relentless acquisitions, which in his lifetime came to encompass books from all across the world, even from the Middle and Far East. Bodley, who had lived in the Netherlands, surely knew of the modern renaissance library at the university of Leiden, opened in 1594, which we visited in Chapter Four. The impression is one of urgency, to stock a universal library for Oxford as comprehensively and as promptly as possible. One of the earliest of the Bodleian's *coups* was the acquisition of nearly the entire medieval library of Exeter Cathedral, secured in 1602. Bodley himself was from Exeter and his younger brother, Laurence (*c.* 1547–1615), a clergyman, was a canon of the cathedral there. Between them, they persuaded the dean and chapter that their earliest books would be put to better use in Oxford. Eighty-one manuscripts were transferred across England to the Bodleian, including the celebrated Missal of Bishop Leofric and the Jerome with the portrait of Hugo Pictor. The Exeter Book, with its Old English riddles, was overlooked and remained behind in Devon, either because it was not with the main library or because it was regarded as too frivolous. Most of these acquisitions for Oxford are intellectual texts, not merely

antiquarian or pretty curiosities. The fact that they were books of the Catholic Middle Ages was irrelevant. The manuscript of Jerome was listed in the first printed catalogue of the Bodleian, published in 1605, when it was on the south side of the library, in bookcase H, shelf 2, shelved beside the nine volumes of Erasmus' edition of the works of Jerome, published in Basle in 1526.

As a graduate student, I wrote my thesis in that same library room, still known from its original construction as 'Duke Humfrey's Library' or simply 'Duke Humfrey', exactly as restored and furnished by Sir Thomas Bodley. It was then the normal reading-room for manuscripts and early printing. My supervisor was the Keeper of Manuscripts in the Bodleian, Richard Hunt (1908–79). The printed Jeromes were still on the shelves, although all manuscripts had by then been moved out of sight to the safety of the distant underground stacks, on what was called 'J Floor'. One would gain access to Duke Humfrey by the Jacobean oak stairs in the corner of the Schools Quadrangle up into Arts End and would push through a loosely hinged barrier, behind which visitors had to stand respectfully in awe. One collected wobbling piles of manuscripts from the issue desk on the right, each with a protruding green ticket bearing one's name and 'H' for Humfrey. I enjoyed sitting at those late-Elizabethan desks attached to Bodley's bookcases down the length of the medieval room, beside the tall gothic windows, surrounded by my nest of Romanesque manuscripts. I was there during the winter power shortages of late 1973, when it was so cold that we wrapped ourselves in overcoats and had to leave by about four o'clock when it became too dark to read. Although it was numbing to hold a pen without gloves (ink was still permitted in Duke Humfrey's Library then), we recaptured in those December days what must have been a common experience of all scribes of Northern Europe for a millennium or so before scholarship was all transformed by electricity and central heating.

Modern conservators care little about romance. Dragging precious manuscripts along a miniature railway track out from their underground lair and then up several floors in a rattling lift was deemed hazardous for them. Duke Humfrey's Library was closed to readers of rare books in 2011, to the dismay of medievalists across the world, who will

never again sit at those desks where the Oxford antiquary Gerard Lang-baine (1609–58) had eventually died of cold. For four years, anyone consulting manuscripts was banished to a dreary reading-room in a basement near the University Museum. £80,000,000 has been spent on refitting what used to be called the New Bodleian, the pale stone construction of municipal architecture of 1937–40, designed by Sir Giles Gilbert Scott (1880–1960), opposite the Clarendon Building at the foot of Broad Street, just across the road from the original Bodleian. It is now renamed the Weston Library, in recognition of a £25,000,000 donation in March 2008 from the Garfield Weston Foundation. Willard Garfield Weston himself (1898–1978) was a Canadian manufacturer of biscuits, a not unfitting adjunct to the fortune of Sir Thomas Bodley based on fish.

I went there sullenly for the first time, when it was nearing completion and had begun admitting readers, expecting to hate it and to resent the move to a modern building. In reality, it is a wonderful surprise. Readers still enter through what used to be the front door in Parks Road, opposite the King's Arms pub, up either low steps or a ramp. What was once the New Bodleian inquiry office on the left is now a lobby with coin-operated lockers for users' bags and coats. Two genial middle-aged men on the security desk inside directed me upstairs for rare books, only inquiring as an afterthought whether I had a reader's ticket. During that particular visit, the construction work was still in progress on the ground floor in what has since become the Blackwell Hall, and the building was filled with sounds of drilling and the smell of wet concrete, where I did not remember any open space at all. It was probably not so different from the carpenters, joiners, carvers and glaziers working busily nearby just over 400 years earlier. A few months later, when I was there again, it was all completed, and Hugo Pictor's manuscript was already in an exhibition titled *Marks of Genius* in a marvellous treasury of the Library's greatest books.

One floor up, along the front of the Weston building parallel with Parks Road, is a kind of open common-room area, now called the Samsung Room (sponsored ultimately from South Korea), with low green or yellow sofas and coffee tables, and banks of computers. The new

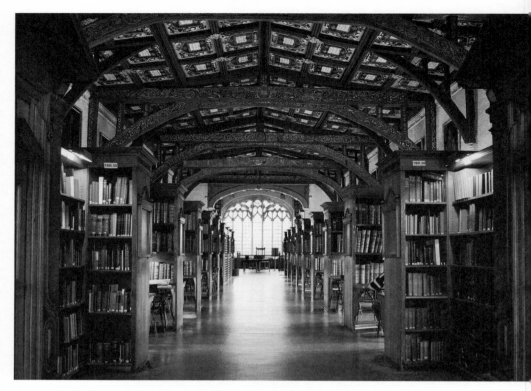

Duke Humfrey's Library in the Bodleian, the medieval library refurnished by Bodley and used as the reading-room for rare books until 2011

Mackerras Reading-Room runs off this space at right angles, behind glass doors. In its entrance lobby a boy with a foreign accent asked to see my reader's card and then copied out my name and arrival time slowly into a ledger. It is reassuringly old-fashioned. He was to do the same in reverse when I came to leave. The long room ahead, primarily intended for books and manuscripts on music, was named in honour of Sir Charles Mackerras (1925–2010), chief conductor of the Sydney Symphony Orchestra, Australia. The international reach of modern learning would surely have delighted Sir Thomas Bodley. I gave my name at the central desk and, against the security of lodging my card, a woman brought out from the shelves behind a large battered box of bright orange-vermilion cloth with the words "MS BODLEY 717" stamped in gold at the foot of the spine. It had been placed on reserve for me by Martin Kauffmann, of the Department of Western Manuscripts. I asked the woman if it mattered where I sat, and she replied good-naturedly,

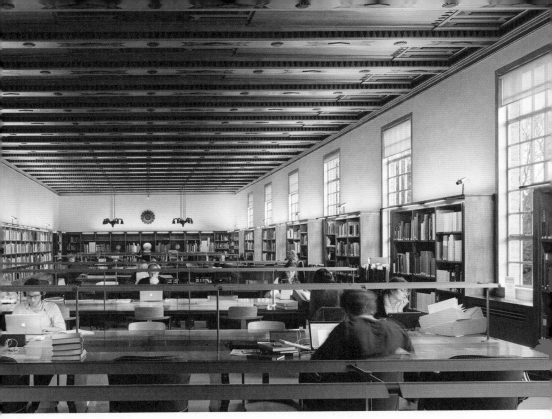

The Bodleian's new rare books reading-room in the Weston Library, originally designed in the 1930s by Sir Giles Gilbert Scott

"Not at all, but there may be more space in the next room." I carried the box away in my arms.

Parallel to the Mackerras Room is what used to be the old PPE Reading-Room of the New Bodleian. It is now refitted for the consultation of those rare books which one formerly studied over the road in Duke Humfrey's Library. It runs almost the full length of the building, with seven tall small-paned windows along the north wall, overlooking the gardens of Trinity College. The room, still undesignated ("a naming opportunity", Martin Kauffmann told me later, hoping I might mention the fact here), preserves many of the fittings and features designed for it in the late 1930s by Gilbert Scott, including magnificent wooden beams overhead inlaid with marquetry motifs looking like something painted by American Indians. These are not as spectacular as the gilded Tudor panels emblazoned across the high ceiling of Duke Humfrey with the repeated arms of Oxford University, but it is all still stately

and impressive. There are four huge art deco chandeliers, two at each end. Gilbert Scott's long tables, with chairs for five readers on each side, have been skilfully widened from the middle outwards to allow capacity for central electronic facilities, unimaginable to Sir Thomas Bodley. There are spacious dark wooden bookcases against the walls, four shelves high, not yet crammed, unlike those of the old Selden End at the far extremity of Duke Humfrey's Library, where uncontrolled overspill of new reference books used to tumble out organically along the deep windowsills and table ends. There are closed-circuit television cameras on top of the bookcases, but otherwise there is no intrusive invigilation. An unexpected benefit of a single open room, rather than the hidden crannies of Elizabethan alcoves, is that one can see and wave to other readers. I was pleased to espy down the far end Richard Gameson, of Durham, whose article on Hugo Pictor, published in 2001, is one of my principal sources for Bodley 717. I had a photocopy of it in my folder that morning.

I settled myself in and opened the box. The manuscript is very heavy. It is about 14½ inches by 10, by about 3¼ inches thick, inclusive of the binding. The number "717" is written in a seventeenth-century calligraphic hand across the outside top edge of the pages, so that the figures would be the right way up if one rolled the closed book onto its fore-edge, with the spine uppermost. Presumably this was how it was first shelved in Bodley's library, rather as if it were on hands and knees. The idea of placing a book upright on a shelf with the spine outwards, as we do now, was almost unknown before the late seventeenth century. Sir Thomas Bodley's funerary monument in the chapel of Merton College shows a bust of the great man in an architectural frame which is held up by pillars of books with their fore-edges outwards, as his library itself doubtless was. MS Bodley 717 is bound in muted seventeenth-century leather, discreetly blind-stamped with a roll-tool frame with little flowers in its corners. The volume has been unsympathetically re-backed by the Bodleian in modern shiny brown leather, apparently in March 1950, to judge from a date inside the lower cover. My guess is that this repair had something to do with the rescue of Hugo Pictor from obscurity by Otto Pächt (1902–88), refugee

to Oxford from occupied Vienna, who published the manuscript in *The Bodleian Library Record* in the autumn of 1950. The foot of the new spine is stamped in gilt with the number "MSS. BODL. / 717" (wrongly, strictly, since "MSS" is a plural): at least it shows that by then, at the very latest, the manuscript was being shelved upright.

I propped up the book and opened it. Of course, being human, I turned at once to the last page, which is folio 287v, to see the original of the iconic image of Hugo Pictor, hunched up under his arch in a compartment bounded by zig-zag lines in red and green to the right of the tapering end of the text. The picture is curiously small and delicate,

Hugo Pictor's self-portrait, showing him holding a knife and dipping a pen into an ink horn attached to his chair

tucked discreetly into a little inner corner of the page. This modest and private self-portrait of Hugo is now reproduced universally by methods and for purposes inconceivable in Hugo's time, including scans onto T-shirts, mouse mats, screen-savers and mobile-phone covers.

Then I came back, as I should have done initially, to the front of the book. The opening pages are spectacularly illustrated, unusually for a text as routine as a patristic scriptural commentary. I was not really expecting that. On the first verso is a huge full-page frontispiece, like those portraits of evangelists prefacing early Gospel Books. Its composition is not utterly unlike that of Saint Luke in the Gospels of Saint Augustine. Here the figure is the prophet Isaiah, shown full-face, seated on a bench below an arch supported by striped stone pillars, perhaps in a temple, with the rooftops of a great city above, probably imagined as ancient Jerusalem. In so far as the artist has thought about the architecture at all (which he might have done, since the First Crusade was preached in 1095 and Jerusalem was in people's minds), he shows the skyline of the holy city between suitably oriental domes, although these are surmounted by crosses hardly appropriate for the time of Isaiah, who lived there in the eighth century BC. The prophet has a halo, like Ezra in the Codex Amiatinus. Some Old Testament exoticism is conveyed by his bizarrely braided hairstyle, parted in the centre, which would do credit to any Rastafarian. His arms are outspread, like a meditating Buddhist, threaded with a long scroll, the ends of which identify him unambiguously, "ISAIAS P[RO]PHETA", and which reads in red capitals along its length, "ECCE VIRGO CONCIPIET ET PARIET FILIUM, ET VOCABITUR NOMEN EI[US] EMMANUEL", 'Behold, a virgin will conceive and bear a son, and his name will be called Emmanuel' (Isaiah 7:14), for Christianity the most important sentence of the book of Isaiah, cited in Matthew 1:23.

Facing it, for this is a double-page opening, is an ornamental heading, 'Here begins the ['first' added] book of Saint Jerome the priest on Isaiah the prophet ...' (but in Latin, of course), in three rows of decorated capitals in red and green, with a half-page picture set in two bays of a cloister, with a tiled roof. Below the first arch is a tall tonsured cleric, with a halo, named in red on either side of his head, "HIERONIM[US]", Jerome, biblical scholar and translator and now canonized as one of the

four great Doctors of the Church. Eusebius Hieronymus (*c.* 342–420) was born in Stridon, in the Roman province of Dalmatia – its exact location is disputed between modern Croatia, Slovenia and Bosnia – and he was one of the first truly international Christian scholars, spending time in Gaul, Antioch, Syria, Constantinople, Rome and Egypt, before finally settling in Bethlehem. He is shown here dressed as a priest in a blue cassock, rather than as a cardinal, as usually and anachronistically in Western art from the thirteenth century onwards. (There were no cardinals in the modern sense before the eighth century.) Jerome here is writing a long scroll inscribed with the opening words of the preface to his commentary on Isaiah. This flutters into the adjacent bay of the cloister, where it is received by the seated dedicatee, Eustochium, also with a halo and similarly identified with her name in red capitals. Saint Eustochium (d. *c.* 419), a woman and a nun, despite the neuter ending to her name, was the daughter of Jerome's special friend Saint Paula (d. 404); the scholar's two devoted female acolytes had left Rome together and eventually established themselves near their master's own house in Bethlehem, where in time they founded four monasteries. This is relevant when we turn the page. There on the second verso is that same opening of Jerome's preface, here in full, "Expletis vix longo tempore …", with a complex and half-page initial 'E', filled with figures amongst the foliage. Descriptions of Bodley 717 offer different suggestions as to who these might be. In the text of the preface addressed to Eustochium, Jerome tells her that, having not so long ago finished writing expositions on the twelve prophets and on the book of Daniel, he is now undertaking Isaiah, since that is what he promised to Paula before her death. In the lower part of the initial, two men are evidently burying Saint Paula, in the church of the Nativity in Bethlehem. Jerome continues that he was also under obligation to that learned man Pammachius, brother[-in-law] of Eustochium. At the left, a tonsured saint is writing: this is surely Jerome again, facing deferentially towards a young woman and a man at the centre and right, again with haloes, who must be Eustochium and Pammachius.

OVERLEAF: The frontispiece with Isaiah enthroned in Jerusalem, facing a half-page picture of Jerome writing to his disciple, the nun Eustochium

IEROR SUP
YSAYAM;

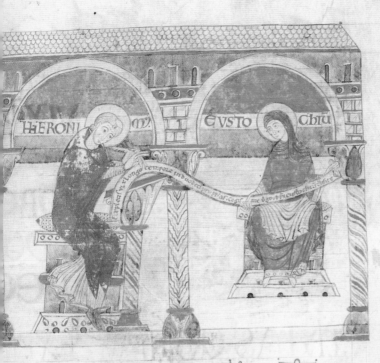

HERONI MꝈ EVSTO CHIꙄ

NCIPꞎ LIBER ISCI

HꝭꝭROMI PBRI SUPꝭR

ISAIA PPHM ADEUSTCIꝰ
VIRGINE XPI

Jerome's preface announces that he will explain the text of Isaiah primarily for what the prophet tells us about the coming of Christ, proclaimed here as Emmanuel, to be born of a virgin and to become the saviour of all people. Unlike Beatus on the Apocalypse, which borders on absurdity in its search for hidden and mystical layers of meaning, which its original author can never have imagined, Jerome is sensible and rational, seeking to know no more than what Isaiah really meant, word by word, and how his words apply to Christianity. Jerome takes advantage of – even shows off – his immense knowledge of languages, and his experience of translating the Bible into Latin. For example, look at his commentary on Isaiah 1:3, where the Lord speaks to the prophet, *'The ox knows its owner and the donkey its master's manger; but Israel does not know, my people do not understand.'* Jerome compares the wording in the Greek Septuagint ('Israel does not know *me*, and my people do not understand *me*') and the stretching of the metaphor in the Hebrew text ('Israel does not know its owner' and 'people have not understood their master's manger'). He notes that the Israelites are not compared with dogs, for example, which are clever and domesticated animals, but with beasts of dull understanding. The ox bearing the yoke of the Law represents the Jews and the donkey burdened by sin is a symbol of the Gentiles. Both are beasts of burden and the one rejected by his people is not so much God as Christ, who said, 'Come unto me, all you who labour and are burdened …' (Matthew 11:28), and so on. It might be a perfectly normal sermon in any Christian church today.

One of the most controversial words in all the biblical prophets is what is meant by the Saviour being predicted to be born of a 'virgin', as prophesied in the scroll shown in the manuscript's frontispiece. Jerome discusses this in book III, chapter 16. This is on folios 38v–39r of the manuscript, and a medieval reader has run a wobbly line down the margin beside this passage. Although the usual word in Hebrew for a virgin, Jerome tells us, is *'bethula'*, Isaiah uses *'alma'*, a term employed throughout the Septuagint to mean simply a young woman. The Jews, therefore, Jerome concedes, deny that Isaiah was prophesying a virgin birth in its literal sense. However, Jerome explains at length, citing not only multiple forms of the word in the Old Testament but also the Greek

version of Genesis by the second-century Jewish convert Aquila, the word has a secondary meaning in Hebrew, indicating something that is concealed, as a virgin is kept hidden by her parents and has therefore been unseen by any man, which is the meaning of '*alma*' in the Punic language, which ultimately derives from Hebrew, and so on, in which case actual virginal purity was indeed what Isaiah meant. The scribe of Bodley 717 transliterates Hebrew words into the Latin alphabet, but he then draws a horizontal line above them to show that they are exotic, as we might use italics. Jerome's multi-lingual learning is enormously impressive, even by today's standards, and it inspires credibility.

For a biblical commentary, usually among the most austere classes of medieval text, this is exceptionally luxurious. The opening of the main text is marked with a big initial showing Isaiah prophesying to the Israelites, who are recognizable by wearing the *Judenhut*, the distinctive pointed hat worn by medieval Jews in the Holy Roman Empire. Each of the eighteen books begins with an elaborate big initial of restless plant stems and flower heads, sometimes with dragons and lions, all against blocks of coloured infill. Every page has small capitals in red or green, some with decoration. It is a very ornamental and expensive-looking manuscript.

Interestingly, the margins of the pages appear never to have been cropped, and many lower edges (especially) preserve the natural curves and undulations of the edges of the animal skin used to make the parchment. Sometimes in the outer corner there is an unambiguous arc of the creature's neck or shoulder, and even parallel ripple lines where the edge of the skin has been stretched and suspended tightly in a frame during manufacture. The Exeter riddle alluded to the stages of making parchment, such as soaking in water, bleaching in the sun, removing hair, and scraping with a knife. The principle of making parchment is that the waterlogged skin is pared and thinned over and over again as it gradually dries while suspended under considerable tension from all sides. If the skin is from sheep or goat, the scraping is all done while the sheet is wet. If it is made from calfskin, the parchmenter

OVERLEAF: Jerome's commentary on Isaiah 7:14, prophesying that a virgin will bear a son, marked at the lower left with a marginal line and the note "contra iudeos", 'contrary to the Jews'

signum peterint & accepint· Quamquā iuxta hebrei sermonis an
titatem· in quo scriptū ÷ ut oenasse adonay & oīs similiter transit
non temptabo dñm possit legi non exaltabo dñm· Sciebat eni
pius quod si signum peteret accepturꝰ ēēt· & glorificaretur diīs·
quasi idolorū cultor· qui in oīnibꝛ· angulis platearū & in monti
cisqꝛ nemorosis aras constitueraт· & ꝑ leuitas habebat phanatı
uult signum petere quod ꝓceptum eſt· Et dīꝯ· Audite ꝗ domī
Numquid parum uobis ÷ molestos ēē hominibꝛ· quia molesti
deo meo· Quis ÷ iste qui dīꝯ· audite ꝗ domus dauid· Nequı
dſ qui sup ad achaz dixerat· pete tibi signum a dño dō tuo· ſ·
ut ex consequentibꝛ appbatur· Quia molesti· & dō meo· & eſt se
Quia non solum ꝓphas ꝓsequimini· & eorū dicta contennitis· ſ·
& iubentis dei sentencie contra itis· ita ut ei exhibeatis labore
alio loco aiт· laboraui sustinens· iccirco dñs faciet que secunta
Pro labore & molestia quod aquila & summachus transtulerꝰ sep
ta· & theodotion agonem interpretati sunt· id ÷ luctam atqꝛ·
quia contenciose non subiciant collum dei seruitati· ſ· illo uı
eorū uolente curare· respuant sanitatem· Et hoc notandū quo
rege impiissimo nolente signum petere· sermo ꝓpheticus ad do
dauid hoc ÷ ad tribum regiam conuertatur· de qua sup legı
& nunciauerunt hec domui dauid dicentes· Consensit siria cū
Propterea dabit dñs ipse uobis signū· Ecce uirgo concipiet & pa
filium· & uocabis nomen eius emmanuel· Nequaquā multipl
iuxta aplin paulum & multis modis loquetur dſ· nec iuxta al
ꝓphā in manibꝛ ꝓpharū assimilabitur· ſ· qui ante loquebatu
lios dicet ipse assum· De quo & sponsa rogabat in canticis cantı
Osculetur me osculo oris sui· Dñs enim uirtutum ipse ÷ rex glorı
descendet in uterum uirginalem· & ingredietur & egredietur o
talem portam que semp clausa ÷· de qua gabriel dicit ad uirgı
Ps̄ sc̄s superueniet in te· & uirtus alтissimi obumbrabit tibi· Ppter
quod nascetur in te sc̄m· uocabitur filius dei· & in puerbiis· S
entia edificauit sibi domum· Quando autem dicitur· dabit dñs
uobis signum· nouum debet ēē atqꝛ· mirabile· S in autē iuuencı
uel puella ut iudei uolunt & non uirgo pariat· quale signū eı
appellari· cum hoc nom̄ etatis sit non integritatis· & reuera uт
iudeis conferamus pedem· & nequaquā contencioso fune ꝓbeam
eis risum nrꝫ impietie· uirgo hebraice betula appellatur· que in
loco ñ scribitur· ſ· ꝑ hoc uerbo positum ÷· alma· quod ꝓ se pauı

non iudeos

adolescentulam transtulerunt. p̄o alma apud eos ūbū ambi
ū est. Dicitur enim & adolescentula &abscondita. id est apocrifos
...e & in titulo psalmi noni ubi in hebraico positū almanot. cecen̄
...tes transtuler̄ p adolescentia. quod septuaginta in̄precati sunt
...sconditas. & in genesi legimus ubi rebecca dr̄ alma. aquilam
... adolescentulam nec puellam. s; absconditam transtulisse. Su-
...nus quoq; mulier amisso filio cum helisei fuisset pedib; puo
...r xpibiberet eam giezi audit appha. Dimitte eam. quia in do
...e & dn̄s abscondit a me. In hebreo scriptū celimmenmenni
...na. non solum puella uel uirgo s; cum emphasi. uirgo abscondi
...r & secreta. que nunquam uirorū patuerit aspectib; s; mag
...parentū diligentia custodita sit. Lingua quoq; punica que de
...breoₓ fontib; ducitur. pprie uirgo alma appellatur. Et ut
...im pbeamus iudeis. nr̄o quoq; sermone alma sc̄a dr̄. Omn̄iq;
...e linguarū uerbis utuntur hebrei. ut est illud in cantico canticoₓ
...greco forion id est ferculum fecit sibi salomon. quod & in hebreo
legimus. Verbum quoq; nugas & mensuram hebrei eodem m̄
...sdem appellant sensib; & quantū cū mea pugno memoria. ñquā
... arbitror alma in muliere nupta legisse. s; in ea que uirgo est. ut
...n solum uirgo sit s; uirgo iunioris etatis. & in annis adolescentie
...st enim fieri. ut uirgo sit uetula. Ista autem uirgo erat in annis
...ellarib; uel certe uirgo ñ puella ista. & que adhuc uirū nosse
...osset. s; iam nubilis. Deniq; & in deuteronomio sub puelle
...adolescentule nomine. uirgo intelligitur. Si inuenerit inquit
...mo in campo puellam desponsatam. & ui oppmens dormierit
...n ea. inficietis uirū solū qui concubuit cum ea. & puelle nichil
...cietis mali. Non est adolescentule peccatū moras. quia quomodo
...quis insurgat contra pximū suum & inficiat animam eius. sic
...e negotiū accidit. In agro inuenit eam. clamauit puella des
...nsata. & non inuentus est qui auxiliaretur ei. & in regū uolu
...ne legimus. quod quesierint puellam uirgine nomine abisag
...ntroduxerint ad regem. que dormiret & foueret eum. & erat puella
...ulcra nimis. & ministrabat ei. & rex cognouit eam. Quodq; seq̄t
...uocabis nomen eius emmanuel. & septuaginta & tres reliq similit
...nstuler̄. Pro quo in matheo scriptū est uocabunt. quod in he
...raico non habetur. G iste puer qui nascetur ex uirgine o domus
...uid nunc a te appelletur emmanuel id est nobiscū deus. quia
...b; ipsis pbabis a duob; inimicis regib; liberata. deum te habere

p eo q̄d in latino dicat abscondit a me.

An early twelfth-century drawing of a parchmenter scraping skin tied tightly under tension; and a hole in Hugo Pictor's manuscript caused by the parchmenter having carelessly cut through the surface

continues to scrape it further after it has dried but while it is still stretched on the frame. An illustration of this final process occurs in the famous frontispiece to an early twelfth-century manuscript of Saint Ambrose in the Staatsbibliothek in Bamberg. It has a vignette of a sheet of skin which is tied tautly within a wooden frame, while a monk is rasping it with a special curved blade on a handle. That implement is called a 'lunellum'. It may happen, from time to time, that the blade accidentally cuts through the surface. Because the skin is being pulled tightly in every direction, even a small flaw or accidental gash can easily open up into a round or oval hole. We can see examples of this in Bodley 717 on folios 36 and 53 and elsewhere. However, if the parchmenter is able to untie and loosen the sheet from the frame quickly enough, he may be able to sew up the cut before it becomes stretched open. There are repairs of this kind on folio 42, delicately stitched in white thread, and on folio 188 in green thread. They are undoubtedly original, done in the parchment-maker's workshop long before the sheets were sent to the scribe. Such sewing is not rare in parchment of the Romanesque period, and yet the practice has never been systematically studied, which it merits, not least since this is embroiderers' stitching contemporary with the Bayeux Tapestry. Of all the fine arts of the Middle Ages, needlework is one of the least preserved, except (unsuspected and unrecorded) in pages of manuscripts like this.

nfulę quę falfif amarıfquę huı̶ felı tunduntur Hucub.
ıre æ̶ ora concludere: æ̶ illud nofse qd̶ ad ıfr̶l̶ dıctu̶
æ̶ tace. æ̶ mutare fortıtudıne̶. ne pımbecıllıtatem
ſint audıre fermone̶. ut accedant prıuſ ad dnm.
ı̶pı falute contente̶. qd̶ dıdıcerınt eetoſ doceant.
nt. utru̶ omıu̶ dſ ıufta feruuerıt. Sıc aute̶ ıntro

A cut in the edge of the parchment, made accidentally during its preparation, repaired by the parchmenter with stitching in green thread

After scraping, the parchment was cut and folded, as described in the riddle, and it was assembled into gatherings.* This volume is complete, one of few entirely intact medieval manuscripts we will encounter in this book. In the modern pencil foliation, '165' is accidentally repeated, and so the numbering (followed here) runs one behind the actual total thereafter. There are 38 lines to a page, ruled either with scoring or with plummet, with the prickings clearly preserved in the three outer margins. The text is written in a single column, typical of the eleventh century but unusual by the twelfth, when a volume of this size would usually have been rendered in two columns.

Inspection of the manuscript itself reveals that it apparently retains the core of its original binding. Margins are entirely untrimmed, as we have just seen, with none of the neat planing and speckling of edges common in seventeenth-century rebinding. The gatherings are sewn onto three thongs only, minimal for a book this large in the seventeenth

* The collation of Hugo Pictor's manuscript is: 2 medieval flyleaves + 4 single leaves (folios iii–vi) + i–xxxii⁶, xxxiii⁸, xxxiv–xxxv⁸, xxxvi¹⁰ + 2 medieval flyleaves. Most gatherings end with numbers in Roman numerals on their last leaves. We will return later to those four separate preliminary leaves (folios iii–vi), for they conceal an important part of the story.

century but standard for the eleventh, and the positions of these correspond with the faint offsets on the medieval flyleaves once pasted to the inside of the boards where the thongs would originally have emerged. There is a piece of string from a medieval bookmark currently lying loosely between quires 19 and 20 (this is after folio 152): it would have fallen out if the gatherings had ever been separated for rebinding. Where the binding has partly worked loose between folios 129 and 130, allowing a glimpse of the spine fold inside, there are no visible traces of re-sewing. What probably happened is that in 1602 the manuscript was still pegged into its thick contemporary wooden boards covered with leather, the final stage of bookbinding mentioned in the Exeter riddle. Perhaps to make it lighter to transport, the pegs were knocked out and the boards were discarded. Then, after arrival in Oxford, the original eleventh-century thongs were simply re-threaded into cheap new pasteboards and were re-covered. The unnoticed thousand-year-old structure underneath is still functioning soundly.

Although the transference of the manuscript to Oxford is documented, its earlier provenance in Exeter is not in any doubt either. In the upper margin of the recto of the page with the frontispiece is the inscription, apparently in the hand of John Grandison, bishop of Exeter 1327–69, "lib[er] Ecc[lesi]e Exon[iensis] de [commun]i[bus]", 'the book of the church of Exeter, from the communal collection', repeated as ": lib[er] Ecc[lesi]e Exon[iensis] :" above the opening initial two pages later. An inventory of the cathedral's possessions made for the use of the sub-treasurer in 1327, just before Grandison took office, includes two copies of Jerome on Isaiah, one described as being small, valued at 13s. 4d. (one mark in medieval currency), and one called large but assessed more modestly at 10 shillings. Possibly, since it is hard to imagine a finer manuscript, this was the more expensive of the two. Prices in medieval library catalogues usually represent the sum forfeited if a borrower should lose a book. Lending was stopped at Exeter by 1412–13 when a new library was built and instead the books were chained to bookcases. By then only one copy remained of Jerome on Isaiah. The other may well have been borrowed and never returned. The surviving manuscript is listed in the cathedral inventory of 1506, and it can be

identified absolutely from the late-medieval custom of citing the opening words of a manuscript's second leaf, since all copies of the same text begin identically but almost every transcript will reach its second leaf at a different point. The Exeter Jerome is described as "2 folio *eiusque sapiencia*", which are indeed the words which begin the manuscript's second leaf. The volume was the ninth book on the ninth of eleven desks on the south side of the library. There is a clear green offset from a chain hasp at the foot of the volume's last flyleaf, although this could also be from chaining in the Bodleian in the seventeenth century.

The text is independently attested too at Exeter in the early fourteenth century. At that time, the Franciscans in Oxford prepared what they called the '*Registrum Anglie de libris doctorum et auctorum veterum*', a kind of inter-library union catalogue of the major theological and patristic texts surveyed in almost a hundred religious houses of England, Scotland and Wales, arranged by authors. Jerome's commentary on Isaiah was recorded widely and was reported as present in as many as in twenty-four British libraries, a quarter of the census, including Exeter Cathedral.

In the late eleventh century, however, it had been a rare novelty. No manuscript of the text was known at all in late Anglo-Saxon England. Jerome actually mentions Britain, discussing the spread of the inhabitants of the earth in commenting on Isaiah 40 (it is oddly satisfying to know that Jerome, writing in Bethlehem, had heard of the country at all). Around 1090, the three first manuscripts of Jerome on Isaiah appeared in England at almost exactly the same time. They were acquired by the cathedrals of Exeter (our copy), Canterbury and Salisbury. The question is how – and indeed why – did Jerome's commentary on Isaiah suddenly enter England? The answer takes us to the heart of political and social history, for the later eleventh century was a time of unimaginable upheaval and change in England.

Ask anyone in Britain to name a date in history. Apart from a few people who have never quite recovered from the exhilaration of England's win in the World Cup in soccer in 1966, most will say '1066'. The Norman fleets landed in Pevensey on 28 September that year under the command of William, duke of Normandy, as depicted in the Bayeux

Tapestry. The invaders defeated the Anglo-Saxon armies and killed King Harold at the Battle of Hastings on 14 October. Duke William, subsequently styled William the Conqueror, was crowned king of England in Westminster Abbey on Christmas Day, 25 December 1066. The result was absolutely devastating for Anglo-Saxon life, but it also catapulted England into the greater history of Europe. The date has so seared itself into the English consciousness that it has never been forgotten. The Norman Conquest and subsequent occupation utterly transformed many aspects of government, land ownership, privilege, language and social identity, all of which still have enduring consequences in Britain today. The modern landscape too still preserves buildings defiantly built by the conquerors at that time – great stone castles dominating the medieval cities, and cathedrals and monasteries in the solid Romanesque style imported from Europe. Even the stone was sometimes brought across from Normandy. The structures were manned by Normans and new bishops and abbots were appointed almost exclusively from previous appointments in Normandy. It was not all bad. The monk William of Malmesbury (*c.* 1080–1143) famously described how the conquerors breathed new vigour and life into the declining monastic standards of Anglo-Saxon England. Many new monasteries were founded. Between the Conquest and the death in 1135 of Henry I, the Conqueror's youngest son, the number of religious houses in England increased from about sixty to more than 250, and they all needed books.

We see this renewed activity reflected dramatically in the numbers of surviving manuscripts. From the previous five centuries of Christianity and monastic endeavour in the British Isles, between the arrival of Saint Augustine and 1066, even fragments of manuscripts are rare. For the period of sixty-four years between the Conquest and 1130, however, almost a thousand extant books are recorded. From then to the end of the twelfth century, there are too many for anyone to have attempted to count. Their huge numbers are tangible evidence of really quite extraordinary industry in the making of manuscripts and the stocking of libraries in England in the aftermath of the Norman invasion.

The Anglo-Saxons had not been without books, but their repertoire and the opportunities for acquisition had been limited. The old days

of Mediterranean-style scholarship at Wearmouth and Jarrow were long gone, and monasteries had suffered from relentless incursions of Vikings. Bishop Leofric, donor of the Exeter Book, had presented an interesting group of manuscripts to his cathedral, but, apart from liturgy and a couple of volumes in Old English, they were mostly texts which he had doubtless picked up randomly during his studies in Lotharingia, and many canons of Exeter probably looked at them with bafflement and lack of interest. Without him, however, late Anglo-Saxon Exeter would have had almost no books at all.

Standardization was characteristic of the Normans. When they took command of ecclesiastical institutions in England or founded new ones, it is almost as if a directive was sent out with a list of obligatory and uniform texts of reference. The urgency is comparable to that of Thomas Bodley around 1600, but the shopping-list was more precise. Suddenly every monastic library was expected to possess similar sets of all the mainstream texts of traditional Christian theology. All literacy returned to Latin, the international language. Norman foundations were duly stocked with comprehensive runs of the same patristic works of the Church fathers, especially Ambrose, Jerome, Augustine, Cassiodorus and Gregory. These core requirements generally included the commentary on Luke by Ambrose (*c.* 339–97) and perhaps his *Hexamaeron* on the six days of creation; the letters and commentaries of Jerome (*c.* 342–420), the *De civitate dei* of Augustine (354–430) and his writings on Genesis, on the Psalms (often in three volumes) and on the Gospel of John; the Psalter commentary by Cassiodorus (*c.* 485–*c.* 580), and the long and discursive *Moralia* of Gregory (*c.* 540–604), which is a commentary on the book of Job incorporating much good sense about human life. Many of these traditional texts had previously been poorly represented in English libraries, if at all. Books were made in large numbers over a short period and, as Norman church buildings all resemble each other, so too do their new manuscripts. Just over half of the entire library sent from Exeter Cathedral to Oxford in 1602 comprised manuscripts which had been written in the short period from the late eleventh century to the early twelfth: they include four volumes of works by Ambrose, three by Jerome, fifteen by Augustine, and

nine by Gregory, all of which are now in the Bodleian Library. Many of them closely resemble the style of Hugo's Jerome. The Exeter Cathedral library catalogue of 1327 records even more patristic texts, including eleven by Jerome, twenty-two by Augustine and fifteen by Gregory. Most of these texts had been unavailable in Exeter before the late eleventh century and some – like Jerome on Isaiah – had no precedent in England at all. Exemplars for such books had to have been found somewhere. In every likelihood, the models all came from Normandy.

The textual tradition to which Bodley 717 belongs is the so-called 'Gallican' family of Jerome on Isaiah, widely represented in northern France, including late eighth-century copies from the abbeys of Corbie, near Amiens, and Saint-Amand, between Lille and Valenciennes. They are all thought to derive from a lost manuscript perhaps once in the palace library of Charlemagne. Within that general family, there are some oddities in the text of Bodley 717, and someone in medieval Exeter noticed them. For example, on folios 7r–7v there is a long passage inserted into the commentary on Isaiah 1:12. A late eleventh-century corrector adds a warning note in the margin, "Istud non est de Jeronimo", 'This is not from Jerome' (quite rightly, and I have been unable to find a source for the rejected passage). The same corrector

A reader of the manuscript, presumably from Exeter, has checked the text against another copy and notes that the passage he has marked is not from Jerome

suggests alternative readings in various places. Examples near the beginning include (a) on folio 3r, where the text interprets the word Isaiah to mean 'salvator domini', the corrector proposes 'salutare domini' instead; (b) on folio 6r, on Isaiah 1:8, the text says that Paul wrote more

on the topic, "scribensque dicit, '*Ergo numquid …*'", and the corrector rightly suggests that it ought to have said, "… scribensque, '*Dico ergo, numquid …*'" (it is Romans 11:1); and (c) on folio 9r, the text refers to '*ministeria vini*' and the corrector offers '*misteria vini*' as a more sensible alternative. On folio 227r the corrector left a note for himself, "huc usque emendatum est", 'corrected as far as this', and then he continued working, forgetting to erase his own note.

The proofreader checking the text has made a note to himself on folio 227r that the manuscript had been corrected as far as this

Although the manuscripts from Exeter are mostly in the Bodleian, there are other cathedrals in England which still preserve large parts of their medieval libraries *in situ*, almost untouched since the Middle Ages. To understand Bodley 717, we are going to take day trips to two of them. The first is to Salisbury, the beautiful gothic-spired cathedral in Wiltshire, about eighty-five miles south-west of London, half-way to Exeter. Construction began in the 1220s, following the move from a less satisfactory hilltop site at Old Sarum nearby. The present library was built above the eastern range of the cloister in 1445. You enter through an unmarked medieval oak door at the end of the south transept of Salisbury Cathedral itself, and up a narrow spiral stone staircase to another medieval door, studded with metal bosses and an iron ring handle. Here I was met by the librarian, Emily Naish. Mine was the first name in the visitors' book in almost a month. There is a little area for work at an octagonal wooden table, separated from the bookcases, which are gated off like the chancel in a church. Emily had already laid out for me MS 25, their contemporaneous copy of Jerome on Isaiah acquired

for the cathedral's previous location at Old Sarum in the time of Saint Osmund, chancellor of William the Conqueror and bishop of Salisbury 1078–99. Osmund, who is himself attested as a scribe and bookbinder, came from Séez in Normandy and he clearly personally directed the acquisition and copying of the books on the Norman list of set texts. When the new town of Salisbury was built in the early thirteenth century, the possessions of Osmund's old cathedral were moved down to their improved site two miles to the south, beside the river Avon. There is a pleasure in handling a manuscript which has not changed owners in almost a thousand years and has never travelled more than a couple of miles. The Salisbury manuscript looks utterly different from Bodley 717. It is a thoroughly utilitarian text crowded onto its pages, with negligible decoration. I sought and found the four passages which I have just cited from the Exeter manuscript. The interpolated passage is not there. All three of the improvements suggested by the Exeter corrector correspond to original readings in the Salisbury manuscript. In other words, the two manuscripts were copied from independent exemplars, but, at a very early date, a scribe from Exeter collated Hugo Pictor's manuscript against the copy at Old Sarum, or something very like it, and he added these changes into the margins of their own copy. This reveals for us a moment in Norman intellectual history. Salisbury and Exeter are both among the nine 'secular' cathedrals of medieval England – that is, not monastic – and it is very likely that they all knew each other well, in the south-west of England, comparing their acquisitions against one another's. There were undoubted links at the time of Bishop Osbern of Exeter, since his cathedral's copy of the Exeter Domesday Book was copied by a Salisbury scribe. It is characteristic of the Middle Ages that in comparing their respective manuscripts of Jerome, the corrector from Exeter did not alter the text: he noticed the discrepancies and simply added the word "*vel*", 'alternatively', without making a decision.

To find parallels for the production of Hugo's manuscript, our second excursion takes us as far to the north-east of England as Exeter is

RIGHT: The copy of the same text acquired in the late eleventh century for Salisbury Cathedral is a less luxurious manuscript, with minimal decoration and many original holes in the parchment

Durham Cathedral and castle, imposing symbols of the uniformity and authority of the Norman conquerors, photographed from near the station

to the south-west, to the cathedral in Durham. Today, this once remote outpost is barely three hours by rail from King's Cross. As the London train pulls into Durham station, you get a breathtaking view of one achievement of the Norman Conquest on the hillside opposite – the formidable castle, begun in 1072, and its adjacent cathedral in matching sandy-brown stone, refounded in 1093, both huge and impregnable on the edge of the crag above a great loop in the river Wear far below, on its journey out to Wearmouth and the North Sea. You walk down the hill from the station, past Richard Gameson's house, over the Milburngate Bridge, and up Saddler Street steeply into the medieval town. The library of Norman manuscripts is still largely intact in the former monastic quarters of the cathedral. You cross the nave of the church and go out again around to the far side of the cloisters, where the library is upstairs. The librarian is an Australian; the assistant is a New Zealander.

The medieval bishops of Durham were regarded as princes in their own right, rulers of secular dominions as well as Church properties. It was a very wealthy diocese. The Norman appointment to the bishopric was William of Saint-Calais (sometimes called Saint Carilef), bishop

The titles of the books given to Durham Cathedral by William of Saint-Calais, bishop there 1081–96, listed on the flyleaf of his Bible

1081–96. He was born in Bayeux, in the heartland of Normandy. Saint-Calais, from which he took his name, was a monastery in north-west France, east of Le Mans, where he had been prior and later abbot, before coming on to England following the Conquest, under the patronage of Odo of Bayeux, half-brother of the new king. The second volume of his Bible survives still in Durham Cathedral library, a late eleventh-century manuscript on a princely scale, notably similar in style to Hugo's Jerome in the Bodleian. On its first leaf is a list of forty-nine books given by Bishop William of Saint-Calais to his new cathedral, beginning with the Bible itself. This reads almost like a checklist of the texts with which the Normans set out to equip their foundations. There they all are: Augustine on the Psalms, in three volumes; Augustine's *De civitate dei*, and his commentary on John's Gospel; Jerome on the twelve minor prophets (but not on Isaiah, as it happens); Gregory's *Moralia*, in two volumes, and his commentary on Ezekiel; Rabanus Maurus on Matthew; and works by Origen, Bede, Ambrose, and so on. About twenty of these books are clearly identifiable still on the shelves in Durham Cathedral. It is a fortuitous survival. One of them, the third volume of his set of

Augustine of the Psalms, ends with a long colophon in verse recording that it was commissioned by Bishop William during the time when he had withdrawn from his own bishopric. The phrasing is "tempore quo proprio cessit episcopio". This is a precise statement and a precious one, for it dates the book to the narrow period between late 1088 and September 1091 when the bishop was forced into exile from Durham and withdrew home to Normandy. (He had been implicated in a rebellion led by his patron, Odo of Bayeux, against William Rufus.) He must then have sent the manuscript back to England or brought it with him when he returned. This is entirely consistent with the statement by the cathedral's historian, Symeon of Durham, writing between 1104 and 1107 (thus within memory), that William of Saint-Calais had sent books from Normandy before his return from exile in 1091.

The verses in the manuscript of Augustine continue. They say that the materials for writing the manuscript were provided at the bishop's expense but the labour by his command, by one sharing his name of William: "Materies sumptu sed labor imperio / Nominis eiusdem confers Willelmus." Thus we have the name of the scribe, at least for this volume. There is more information in the second volume of the same three-part set, also still in Durham. One of its initials, closely similar in style to that of Hugo Pictor, includes a coloured drawing of a standing bishop with his name above his head, "*vvillem[us] episcop[us]*", William of Saint-Calais himself, tall and stately in a green surplice, and a hunched-up figure kneeling below his feet, with his own name too, "*Rob[er]t[us] Beniamin*", Robert Benjamin. He resembles Hugo Pictor, with a clerical tonsure and a blue garment. He is pointing to the bishop with a long finger and he is holding a long scroll with words addressed to his patron, praying that the bishop will receive reward in the future life but more practically wishing that he himself, the painter, may receive his greatest rewards in payment, "*et pictor mercis maxima dona*".

From all this, we can say that Durham Cathedral's set of manuscripts of Augustine on the Psalms was commissioned in Normandy between 1088 and 1091, that the bishop supplied the materials at his own

RIGHT: William of Saint-Calais depicted in the initial of one of his manuscripts with the artist William Benjamin hunched up at his feet

N OMNIB;

SCIS SCRIPTIS

gra di que liberat nos comendat se
nobis. ut comendatos habeat nos
hoc in isto psalmo cantat. de q cu
ura caritate loq suscipim. Aderit
dns. ut sic eā corde concipiā. qm dig
nu ꞇ a sic eā pniam. qm expedit no
Multū eni moue di amor a amor.
Timor q iust ꞇ amor q misericors.
Qs eni ei diceret qd fecisti. si dānare
iustū. Quita q miscᵭā ei. ut iustifica
iniustū. ex hoc plectū nobis a aptī
audiuum. eandē grām maxime co
mdante. de cui comendatione ha
bebat iudeos inimicos uelut de legis liti
psumentes. a tanq iusticia suā dili
gentes. atq iactantes. De qb; dicit
Testimoniū phibeo ill q zelū di habe
s; n scdm scienciā. Et tanq ei diceret
qd eni habere zelū di non scdm scientiā subiec
c tanuo. Ignorantes eni di iusticiā. a suā uiolentes
constituere iusticie di non st subiecti. Gl ante
ꝭ no tanqm de omib; excludunt a se grām a tan

cost, that one of the scribes was also called William, and that the artists included a certain Robert Benjamin, who was expecting to be paid and was therefore evidently some kind of a professional rather than a dutiful monk working for nothing. The extreme rarity of any self-portraits of named illuminators at all makes this an appropriate pendant to that of Hugo Pictor, and it may challenge Hugo's claim to have created the earliest such picture in a manuscript in England.

As might be imagined, such detailed information has caught the attention of historians of English Romanesque book production, especially the palaeographers Michael Gullick, Richard Gameson and Rodney Thomson, all friends and colleagues to whom I am immensely indebted. On different occasions we have all sat for hours into the night, discussing these books from every angle. When detailed comparisons are made between the manuscripts in Durham with those from Exeter, we can see that the same scribes not only contributed to books destined for both of these English cathedrals but also to manuscripts which were clearly made for domestic use in Normandy, where William of Saint-Calais spent his exile, probably principally in Bayeux, where he had been born. For example (the discoveries are mostly Michael Gullick's), the principal scribe of William of Saint-Calais's Bible was certainly still living in Bayeux more than thirty years later, since he wrote an entry on behalf of Bayeux Cathedral in the mortuary roll of Abbot Vitalis of Savigny, conveying the cathedral's condolences on the death of Vitalis, who died in October 1122. The roll is preserved in the French national archives in Paris. The same scribe made contributions to the Durham set of Augustine on the Psalms (decorated in part by Robert Benjamin) and, more relevantly for our tale, he wrote a copy of Lanfranc which was at Exeter Cathedral, now in Oxford, and two volumes of Gregory, still in the town library of Bayeux. Furthermore, one of the scribes who corrected the Bible of William of Saint-Calais was involved too in proof-reading the manuscript of Origen which Bishop William also gave to Durham Cathedral. The main scribe of the Origen, in turn, wrote a Gregory for Durham, an Augustine for Exeter, and probably part of another Augustine, which is still in Normandy, where it was once owned by the abbey of Jumièges, near Rouen, about

eighty-five miles east of Bayeux. The teams of collaborating craftsmen included the artist Robert Benjamin, who had added his portrait to the Augustine in Durham. As far as we can judge from his style, Robert Benjamin also painted the opening initial of William of Saint-Calais's Bible and he contributed to that Augustine from Exeter and the copies of Gregory from Bayeux; he also decorated a manuscript of Augustine on John, now in Rouen, where it belonged to the local abbey of Saint-Ouen. There is clearly a bigger international operation here than some lone illuminator in Exeter, and it involves remarkable triangulation between Durham, Exeter and Normandy.

With all this in mind, let us go back to the Bodleian in Oxford, where MS Bodley 717, signed by Hugo Pictor, is still being held safely on reserve for us at the issue desk in the Mackerras Room. We can now see how uncannily it resembles the Durham and Norman manuscripts, both in its orderly prickly-footed continental script and its initials of complex and seething plant designs drawn mostly in red, infilled with deep blue, green and red. It must also have been made in Normandy. There is a detail on which I may be wrong (local antiquaries may correct me) but the roof shown above Hugo's alcove is clearly tiled: in Devon, traditional roofing was thatch, whereas in Normandy it was usually tiles or shingles. Michael Gullick tells me that the manuscript's parchment has an entirely European texture, unlike the soft English skins used for books clearly made in Exeter, and that the ruling pattern, with four vertical lines between each column, is characteristically French, where English scribes would usually have ruled three. These are small details but cumulatively important, confirming what we already know from Durham and Normandy. The so-called English self-portrait by Hugo Pictor is actually continental.

Bodley 717 is written by four scribes but it is all decorated by a single artist. The four scribes are: (1) folios 1r–8v, quire 1; (2) folios 9r–144v, quires 2–18; (3) folios 145r–185v, line 18; and (4) folios 185v, line 19, to the end of the manuscript, finishing with the portrait of Hugo Pictor on folio 287v. Notice, as so often on our journeys among manuscripts, how the scribes' stints often correspond to the division of quires. The

scribes ruled their parchment with different implements, which is evidence that they prepared their own sheets (scribes 1 and 4 scored lines deeply; scribes 2 and 3 drew their lines in plummet, or lead-point). The universal assumption among manuscript historians is that scribe 4 is Hugo Pictor himself, but is it?

We are right to ask the question. The experience of the Durham Augustine reminds us of the separation of labour in that manuscript between the activity of its scribe, William, and its artist, Robert Benjamin. More than that, the portrait of Hugo is identified explicitly as being that of the 'painter and illuminator', without mention of being a scribe at all. I think we can accept, on the face of it, that Hugo was the painter of this whole manuscript, since the decoration throughout is entirely consistent with that of the self-portrait. However, Hugo actually depicts himself as a scribe. There is little doubt about this. He is ruling out a manuscript with one hand, preparatory to writing (a task undertaken by scribes, as we have just seen), and with the other hand he is dipping his quill pen into ink, clearly not a brush into paint.

LEFT and RIGHT: Two initials in the Bodleian manuscript painted by Hugo Pictor: when Hugo himself also copied the text, as on the right, the script and initials fit snugly together, but when the text had already been written by an earlier scribe, as on the left, they match up awkwardly

Confirmation that he was indeed both scribe and artist is found in the shape of the spaces left for the insertion of initials. Both scribes 2 and 3 (let us exclude 1 for the moment) left simple rectangular blank spaces where large initials were to be painted later, without thought to their shape or composition, and they added guidewords in the margins to indicate what letters were to be supplied. When Hugo came to fill them in, his flamboyantly fluid and multi-tentacled initials fitted uncomfortably into these big draughty square apertures. However, during the stint written by the last scribe from folio 185v onwards, the edges of the script are moulded line by line to fit around the curves and limbs of the painted initials, nestling together snugly like a newly married couple in bed. Text and decoration must have been executed simultaneously by the same person. In short, scribe 4 must be Hugo.

As with the identifiable scribes from Durham, the hand of Hugo Pictor as either scribe or artist has now also been found or proposed in a number of different manuscripts. These include two others which came to the Bodleian from Exeter (Augustine's *De civitate dei* and Gregory's

De cura pastoralis); probably Jerome's commentary on the Minor Prophets given to Durham by William of Saint-Calais; pieces of homilies from Augustine which somehow reached Sweden, perhaps through England; and most telling of all, a manuscript of the minor works of Anselm, now in Rouen, which was owned by the abbey of Jumièges in Normandy. The Anselm is significant because its text describes its author as being the archbishop of Canterbury, thereby dating its execution to no earlier than Anselm's appointment to that office in 1093, itself comfortably after William of Saint-Calais had come back to Durham. Thus Hugo did not migrate to England in the entourage of the returning bishop, as some have suggested, but stayed home in Normandy. The hand of Hugo Pictor as artist, but not as scribe, almost certainly appears too in another manuscript from Jumièges, a volume of saints' lives, now in Rouen. It is possible that he painted a fragment of a late eleventh-century hymnal, ascribed to Jumièges on style alone, in the Bibliothèque nationale in Paris. This attribution is especially tantalizing as the hymnal includes a little figure of a cleric singing and blessing, with his name in red, *"Hugo levita"* (presumably meaning Hugo the Levite, or deacon). The painting is so close to the hand of Hugo in Bodley 717, and the name is similar, but is it the actually same man? I cannot convince myself entirely, but it may be.

On balance, the evidence of the Durham manuscripts seems to point more to Bayeux than to Jumièges as a likely place where these collaborating and close-knit scribes and decorators were supplying manuscripts for both English cathedrals. The scribe of Bishop William of Saint-Calais's Bible was still working for the cathedral chapter of Bayeux thirty years later. Exeter, like Salisbury, was not a Benedictine cathedral priory, but a secular foundation, staffed by canons, as was Bayeux. It is somehow easier to envisage the chapter of Exeter making arrangements with a sister cathedral in Normandy than with a Benedictine monastery. Bayeux was not so alien and inaccessible as it might seem. It is exactly the same distance from Exeter as London, and by ship is much easier to reach. If Hugo too was associated with an export workshop in Bayeux, then Jumièges Abbey on the far side of Normandy

RIGHT: A fragment from a hymnal decorated in Normandy by an artist very similar to Hugo Pictor, signing himself here "Hugo Levita", perhaps (or perhaps not) the same person

EXVLTET IAM ANGELICA

turba caelorum. exultent diuina mysteria.

et pro tanti regis uictoria tuba intonet salutaris.

Gaudeat se tellus tantis irradiata fulgoribus.

et aeterni regis splendore lustrata totius orbis

se sentiat amisisse caliginem. Laetetur et

mater aecclesia tanti luminis ornata fulgoribus. et magnis populorum

uocibus hec aula resultet. Qua propter astantibus uobis fratres karis

simi ad tam miram sancti huius luminis claritatem. una mecum queso

dei omnipotentis misericordiam inuocate. ut qui me non meis meritis

intra leuitarum numerum dignatus est aggregare. luminis sui gratia

infundente. cerei huius laudem implere perficiat. Per dominum nostrum

ihesum christum filium suum. cum quo uiuit et regnat in unitate spiritus sancti deus

per omnia secla seculorum. Dominus uobiscum. Et cum spiritu tuo. Sursum

corda. Habemus ad dominum. Gratias agamus domino deo nostro. Dignum

Uere dignum quia

et iustum est. inuisibilem deum patrem omnipotentem. filiumque

eius unigenitum dominum nostrum ihesum christum cum sancto

spiritu toto cordis ac mentis affectu. et uocis ministerio personare.

qui pro nobis eterno patri ade debitum soluit. et ueteris piaculi cautionem

pio cruore detersit. Haec sunt enim festa paschalia. in quibus uerus ille

agnus occiditur. eiusque sanguine postes consecrantur. Haec nox est in

qua primum patres nostros filios israel eductos de egypto. rubrum mare si

cco uestigio transire fecisti. Haec igitur nox est que peccatorum te

colum illuminatione purgauit. Haec nox est que hodie

could just as logically have been another external client, like Exeter and Durham. This is the period when we find the earliest hazy documentary references in France and England to monasteries hiring scribes and artists to help with unprecedentedly large commissions of manuscripts.

There is even a hint that the workshops perhaps had access to manuscripts partly prepared in advance, awaiting commissions, or (perhaps more likely) to some previous grand project, abandoned uncompleted. There is a suggestion that William of Saint-Calais took over the patronage of the Durham Augustine about half-way through its second volume, at the point where Robert Benjamin depicts himself with the bishop. Something similar occurred with Bodley 717. When Hugo Pictor first entered the enterprise, the text up to folio 185v was already written but not decorated. Hugo then finished writing the manuscript and then went back over the whole volume, inserting illumination where the previous scribes had left only spaces. A small detail in the book's structure tells us that the decoration was supplied subsequently, and that it was a conscious upgrade. You will recall the collation given above, with four leaves inserted at the beginning before folio I (they are designated as folios iii–vi by the hand of the Bodleian numerator). I said that they concealed an important part of the story. When Hugo assumed responsibility for the project, there had perhaps been a modest one-page opening intended before what is now folio I, which once began, "Unde orationum tuarum ..." (line 13 in the modern printed edition of 1993). Instead, Hugo now removed that leaf and inserted a whole new beginning of unprecedented elaboration, adding those four extra leaves with new full-page pictures, all painted by himself, emphasizing the role of Eustochium and her mother as the people who commissioned the commentary from Jerome. Towards the foot of folio vi *verso*, as it now is, Hugo Pictor began to realize that his alternate lines of red and blue were not going to fit exactly with "Unde orationum ...", which must have been already written. He began to cram his lines tighter and tighter. Eventually he gave up, added an extra line of text above "Unde orationum ..." on folio Ir, and even that did not match precisely and had to be erased and rewritten again. Now at last the opening runs on smoothly.

We do not actually know that Hugo was a monk at all. Neither he nor Robert Benjamin call themselves 'brother', which one would normally expect (the formula would have been "frater Hugo …"). The only reason for assuming them to have been monks is, quite simply, because no one has really imagined that any other people were making manuscripts in the eleventh century, and, more precisely, because both depict themselves with tonsures. So too does the next-earliest illuminator to leave a named self-portrait in an English manuscript, William de Brailes, documented among the book trade in Oxford, c. 1230–52, who painted himself in a Book of Hours and in the prefatory leaves from a Psalter; and we know for certain that de Brailes was not a monk, because he had a wife, called Celina, and a private house in Catte Street. A self-portrait with a tonsure is perhaps no more than a nod to clerkly status and to a calling as a maker of holy books. It is not necessarily any more autobiographically authentic than Hugo Pictor showing himself with green hair or Robert Benjamin with a halo, as indeed he does.

Come back to the self-portrait in Bodley 717. Hugo's apparent tautology, "*pictor & illuminator*", is curious, for the occupations seem synonymous. Strictly, an illuminator was one who decorated a manuscript with gold or silver, which sparkles in the light (hence the word), but there is no gold in any of this cluster of Exeter–Durham–Normandy books. It must simply mean here, as loosely elsewhere, a person who ornaments a manuscript. "*Pictor*", 'painter', is presumably something a little different. It cannot really mean a scribe. Where we know about the careers of medieval illuminators, they were often simultaneously makers of wall paintings or any other pictures or works of art required. Hugo may actually have been a professional craftsman in multiple areas beyond manuscript production. He was perhaps the overall designer of the project. In the Durham manuscript Robert Benjamin, *pictor*, is shown in discussion with the patron, not actually painting. Robert and Hugo were probably the professional directors and coordinators of their respective enterprises.

OVERLEAF: The manuscript originally began modestly; Hugo Pictor upgraded it by adding a luxurious opening, but struggled to make it join seamlessly with the right-hand page here, already written. In the initial, Jerome himself is shown on the left as a scribe

Vnde orationū tuarū fultus auxilio que diebus ac noctib; indei lege me-
litaris. & templum es spū scī· imitabor patrē familias quidethes' auro
suo pfert noua & uetera. & sponsam dicentem incantatio canticorū.
noua & uetera fratuelis nri seruauit m. sicq; exponā isaiā. ut illū non
olum pphiam. sed euangelistam & apostolū doceam. Ipse enī dese & de
ceteris euangelistis ait. Quam speciosi pedes euangelizantium bona.
euangelizantiū pacem. Et ad ipsum quasi ad apostolū loquitur dr.
Quem mittā. & quis ibit ad populum istum.? Et ille respondit. Ecce
ego. mitte me. Nulluscp; putet me uoluminis istius argumentū breui
cupere sermone comprehendere. cū uniuersa dñi sacranta presens
scriptura contineat. & tam natus de uirgine emmanuel quā illustri
um patrator opum atcp signor. mortuus ac sepultus & resurgens ab
inferis. & saluator uniuersarum gentiū predicatur. Quid loquar
de phisica. aethica. theologica.? Quicquid sanctarum. e. scripturarum.
quicquid potest humana lingua pferre. & mortaliū sensus accipere.
isto uolumine continetur. De cuius mysteriis. testat ipse qui scripsit.
Et erit uobis uisio omnī. sicut uerba libri signati. Quem cū dederint
scienti litteras. dicent. Lege istum. Et respondebit. Non possū signatus
est enim. Et dabitur liber nescienti litteras. diceturcp ei. Lege. Et res-
pondebit. Nescio litteras. Siue igit hunc librum dederis nescienti lit-
teras populo nationū. respondebit. non possum legere. quia fididuci
litteras scripturarū. siue dederis scribis & phariseis qui legis litteras
nosse se iactant. respondebunt. Non possum legere. quia signata. e. liber.
Quicircco eis signatus. e.? qm non receperunt eū quem signauit deus
pater. qui habet clauē dauid. qui aperit & nemo claudit. qui claudit
& nemo aperit. Neq; ut mortui cū insanis feminis somniant pro-
phete inertissimi sunt locuti. ut nescirent qd loquerent. & cū alios eru-
dirent ipsi ignorarent qd dicerent. de quib; aptr ait. nescientes que
loquantr & de quib; affirmant. si iuxta salomonē eloquitr inpuerbiis.
sapiens intelligit que pfert de ore suo. & in labiis suis portabit scientiā
etiam ipsi sciebant quid dicerent. Si eim sapientes erant pphete quod
negare ñ possum. & moises omnī eruditi sapientia loquebat ad diũ.
& dñs respondebat ei. & de d. anihele ad principem tyri dr. nūqd tu
sapientior es daniele. & dauid sapiens erat qgt labat inpsalmo. incerta
& occulta sapientie tue manifestasti m. qm sapientes pphe instar
brutor animantiū qd dicerent ignorabant.? Legim & in alio aptr loco.
Spc ppharū pphis sub iecti sunt. ut in sua habeant potestate quando
taceant. quando loquantr. Quod si eim uidet infirmū. illud aptr es dem

In reality, it is unlikely that Hugo was left-handed. His script has none of the backward slant so often detectable in the writing of left-handed people. It is just possible that he drew himself from a mirror, forgetting to adjust the image (or he knew it was in reverse, which is why he called it an "*Imago*", 'reflexion'). More probably, he shows himself holding the quill in his left hand in his self-portrait because the picture does not primarily depict him writing or painting, but designing the page. He is ruling its guidelines, using his right hand. The pen is in reserve, to be used when he is ready.

If Hugo Pictor was master craftsman in Bayeux, this might give a clue to the patronage of that remarkable set of books for Exeter Cathedral. Unlike Robert Benjamin, Hugo gives no name of his paymaster. A commission of this size and extent of decoration, more richly illustrated than anything acquired even by the prince-bishop William of Saint-Calais, would have been very expensive, especially as it was part of a set of at least nine matching volumes. It is reasonably supposed that these manuscripts came to Exeter during the latter end of the episcopacy of Osbern, bishop there 1072–1103. The limited contemporary assessments of Bishop Osbern do not suggest a man of extravagance or of notable personal generosity to his cathedral, unlike William of Saint-Calais, and in his last years Osbern suffered from infirmity and blindness. He was, however, a member of a noble Norman family, a second cousin of William the Conqueror on his mother's side, and he was the younger brother of William FitzOsbern (d. 1071), intimate companion of the Conqueror at the Battle of Hastings, later first earl of Hereford and soon one of the richest men in England. More importantly, the two brothers were cousins of Odo of Bayeux, son of Duke William's mother. Odo fought beside William FitzOsbern at Hastings, and he was bishop of Bayeux from 1049 to 1097. He was even wealthier than the FitzOsberns, second only to the Conqueror. He might have been the key figure in commissioning the manuscripts for Exeter and Durham. In 1088 he returned from England to Bayeux in the company of William of Saint-Calais, and the two are found witnessing charters together for Bayeux in 1089. Odo is most famous as the probable patron of the Bayeux Tapestry. You can probably guess what is coming. Hugo, *pictor*,

designer, craftsman, was quite possibly attached to Odo's household. The overall similarities between Hugo's narrative illustrations in Bodley 717 and the Bayeux Tapestry are intriguing: beady-eyed, long-nosed, small-mouthed figures in complex architectural settings identified by captions in large capital letters of alternating colours. Hugo was an illuminator – that is accepted – but '*pictor*'? It is conceivable that he and Robert Benjamin had been part of the bishop's team who designed the Bayeux Tapestry.

A small advantage of inquiring into the history of almost a thousand years ago is that one is permitted to speculate on possibilities without necessarily having evidence beyond reasonable plausibility. The Durham Augustine and the Exeter Jerome seem to have been taken over by Robert Benjamin and Hugo Pictor respectively when they were already half-prepared, probably around 1088. It might be that some of the books which went to Exeter and those that were given to Durham were fortuitous salvage from some interrupted campaign of book production in Bayeux. If so, maybe the manuscripts had been begun for Odo of Bayeux, perhaps for his own cathedral. The abandonment of the work could have been connected with Odo's fall from royal favour in 1087, with the loss of his fortune. At that moment, William of Saint-Calais was conveniently at hand with money, as was someone from Exeter. Possibly this was a member of the FitzOsbern family. The first earl's widow and most of his children died too soon to have been involved in commissioning Hugo Pictor, except for his daughter Emma, who was still in Normandy in 1095, where she died, having vowed to join the First Crusade with Odo of Bayeux. It is imaginable that someone like Emma FitzOsbern could have sponsored luxury manuscripts for her uncle's diocese, especially as the inserted and unique frontispieces of Bodley 717 emphasize the patronage of two women, and show scenes of the Holy Land.

Finally, let us come back to the self-portrait of Hugo Pictor, and ask whether it tells us anything (anything at all) about the practice of making manuscripts in the late eleventh century. Hugo is seated in a chair which has holes in the ends of each of its arms. Loosely inserted

in one of these is an ink-horn, sensibly furthest from the manuscript, for it looks perilously insecure. If both holes were used, a scribe could have been provided simultaneously with ink or pigments of different colours. The pen here is clearly a feather ("a bird's delight" in the Exeter riddle), very likely from a goose, and its barbs are still present, although most modern scribes insist that these are always pared away before writing with a quill. The ink would be iron gall ink, prepared by crushing up oak apples – the spherical growths like wooden marbles which result when a gall wasp has laid its eggs on the branch of an oak tree – mixed with copperas (ferrous sulphate). The riddle alluded also to dyes from a tree, which may be this black ink from an oak, or it could be red, which might come from brasilwood or madder, both of which are plants (other reds, such as vermilion, were from minerals). The manuscript Hugo is preparing is on a separate sloping lectern, draped in cloth to protect and perhaps to stabilize the book. The slope is so that the pen can strike the page at a 45-degree angle without discharging its ink too rapidly and messily, a mistake most of us made as children, trying for fun to write with feathers found on the beach. The knife is for ruling lines (Hugo himself scores his very heavily into the pages), for holding the page steady without the natural grease from using one's fingers, and for sharpening the pen several times a day. (It is, of course, a penknife.)

There are two other pictures of scribes at the beginning of the manuscript, both showing Jerome in the act of writing. The first is almost a twin of Hugo's self-portrait, a parallel which may represent conscious self-identification with the industrious saint, especially if the patrons in both cases were women. They are both wearing similar loose-sleeved hooded blue robes over white undergarments. Both have long arched noses, pink spots on their cheeks, they are clean-shaven and have tonsures in their green hair. The colour green may be intended to represent grey. This first picture of Jerome shows the author seated on a cushion on a bench. Remember that the manuscript is written in a single column of very long lines. A bench was often used by scribes in preference to a chair, for it is less tiring to slide oneself up and down along its length than it is to twist the whole body back and forth when writing

across the width of a broad page. The second Jerome, now swarthier and bearded, less like Hugo, is shown in a chair with dragon-headed finials at the ends of its arms. The dragons' open mouths are the apertures to hold the ink-horn and the movable book stand. Chairs with dragon-headed finials appear twice in the Bayeux Tapestry.

In all three pictures, notice how the pen is held. Most people today are taught to grasp a pen between the first and second fingers, secured by pressure from the thumb. Its movements are made by manipulating the thumb and forefinger. In the images here and in almost all others showing scribes in medieval manuscripts, the pen is held by the thumb against the underside of the first two fingers, more like a painter's brush inverted. The two smaller fingers are tightly curled up. To write, the whole hand has to move across the page, and the entire arm is involved. A common scribal exclamation in medieval manuscripts, including at least one from late eleventh-century England, is "Tres digiti scribunt totum corpusque laborat", 'Three fingers write but the whole body labours.' When the pen is held as shown by Hugo, however, it is undeniably simpler to rotate it while writing, creating the fashionable thick and thin or broad and narrow lines which are a delight of Romanesque calligraphy. As the Exeter riddles told us, three fingers and pen all journey in parallel, leaving dark footprints, so that the manuscript becomes a help for great men and itself is holy. Both Jerome and Hugo Pictor would have shared that experience, bridging the 700 years between their lives, one composing and the other importing this text with the conquerors into Norman England.

The Copenhagen Psalter

third quarter of the twelfth century
Copenhagen, Kongelige Bibliotek,
MS Thott 143 2°

Come in – really. Check at the supervisors' desk first, out of courtesy, but they probably won't mind, not here upstairs in the Royal Library in Copenhagen, for Danes are invariably easy-going and hospitable. Pull across one of the low yellow office-chairs on wheels, and come and look carefully at this. Keep our voices down, for there are other people consulting manuscripts here too. Opened on the desk right in front of us, supported by two foam wedges, is the finest and most famous illuminated manuscript in Denmark. Sit beside me and let's gaze in admiration for a moment. We won't touch it: just look. By any definition, this is an astounding work of art of the highest class, in almost flawless condition. The manuscript is a large Latin Psalter or book of psalms from the Old Testament, dating from the third quarter of the twelfth century. To my eye, this was the greatest period in Western European book production. Think of the term 'illuminated manuscript' and this is what most people expect. In its utter refinement and opulence it far outranks the earnest drawings of Hugo Pictor of seventy years earlier, or the primitive if heart-felt pictures of Maius of Tábara. If manuscripts were accompanied by music, the Copenhagen Psalter would have trumpets and a church organ. Every page of the manuscript shimmers with burnished gold and splendid ornament. The script is calligraphically magnificent. The volume opens with the twelve pages of an exquisite

calendar of saints' days written in multiple colours, and then, before the start of the first psalm, there is a sequence of sixteen full-page pictures which are truly breathtaking and are the glory of this manuscript. We will start there. These huge scenes follow one after another, page after page of illustrations, like a picture book. This part of the manuscript is not merely a decorated text but uninterrupted art. These pictures are the size of icons.

The first of them, on folio 8r, shows the Annunciation. Gabriel and Mary stand facing each other, eyeball to eyeball, between two arches of a cloister, raising their right hands to show that they are speaking. Dangling from their left hands are scrolls, Gabriel's saying, "AVE MARIA GR[ATI]A PLENA D[OMI]N[U]S T[ECUM]", and Mary's replying, "FIAT MICHI S[E]C[UN]D[U]M V[ER]BU[M] TUUM" (Luke 1:28 and 38). Gabriel has purple and brown wings, flecked in white, and he wears a pale-blue tunic covered with a gorgeously ornamented cloak of red and green which flutters behind him, as if he has begun talking while still moving. He has heavy eyebrows and a wrinkled forehead. His bare feet are on tip-toe. Even so, Mary is taller than him. She is not dressed in blue, as usually in later European art, but in a deep purplish brown cloak beautifully patterned like the finest woven damask, over a dress of several colours gathered at the neck. The Holy Dove flies down over her head. The background is covered in a sea of highly burnished gold, in which we can see our own reflections. Above the arches are the Romanesque tiled rooftops of Nazareth, in every colour.

Let me turn the page for you. On the other side of the same leaf is the Visitation. Within a frame as bright as strips of Mosan enamel, Mary and her cousin Elizabeth grasp each other tightly (Luke 1:40), standing between two swaying trees which are symbolically laden with red fruit, for both women are pregnant. Their clothes again are wondrously coloured and patterned and the background too is of mirror-finish gold. The pictures in the Copenhagen Psalter have no captions

RIGHT: The Annunciation, the archangel Gabriel greeting the Virgin Mary, who replies that she accepts according to God's word

OVERLEAF: The Visitation, with the Virgin and Saint Elizabeth embracing; and the Annunciation to the Shepherds, shown as semi-grotesque rustics

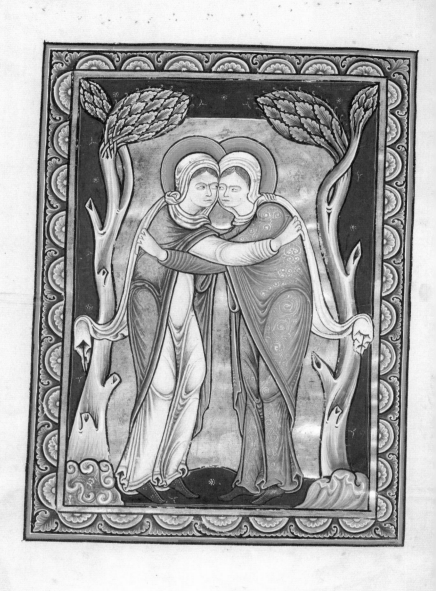

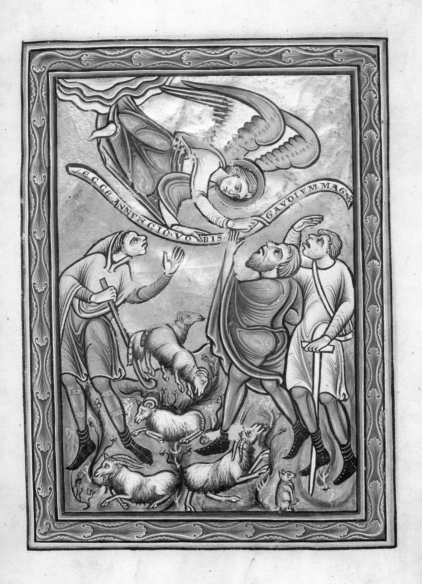

to identify the scenes, as many other manuscripts do. These subjects would have been recognizable to almost any medieval owner – or perhaps a book of this class could only have belonged to someone with a personal chaplain, who would retell the biblical story each time they opened the manuscript together. It would be recounted from this picture that Mary is about to declaim the *Magnificat*, the psalm of the New Testament which is included at the end of this Psalter.

Immediately opposite the Visitation, the scene shifts to nine months later. A huge and heavy-looking angel drops from a golden heaven above the heads of three grotesquely ugly peasant shepherds, who are watching over emaciated goats, not sheep, accompanied by what seems to be a grey cat (or maybe it is some misshapen little dog). It is rather shocking, to modern sensibilities, that rustics are often depicted in medieval art as almost sub-human. This is no pastoral idyll. The angel says to them, even them, common peasants, "ECCE ANNUNCIO VOBIS GAUDIUM MAGNU[M]" (Luke 2:10; notice that I am not translating this Latin, for the words would be familiar to almost everyone in twelfth-century Europe, even to the half-literate). Turn the page again and there is the reason for the great joy they are being told about: the birth of Christ. This scene has none of the primitive conditions of a rural stable. We are now back in an upper-class setting, perhaps a palace or at very least a great church. The Virgin Mary dominates the scene lying with one hand under her head on a vast diagonal bed, draped in precious blue cloth. She has no halo but instead a superbly ornate crimson damask pillow. On the right is Joseph, grey-bearded and in a red Jewish hat. Follow their eyes and they are both gazing at a blue box, like a sarcophagus floating in golden space, containing the Child tightly bound in purple, nuzzled by the heads of a blue donkey and a wet-nosed ox. The scene is revealed to us by the parting of two red and white curtains, one tucked into the frame behind Mary's bed, the other wound round the back of Joseph. Lamps hang from the ceiling. What seems to be a royal crown, set with coloured jewels, is suspended above the head of the Christ Child.

LEFT: The Nativity of Christ, set in luxurious surroundings with a crown hanging over the head of the Child in the manger

The next four images are all centred on kings, good and bad, in an exceptionally full sequence of the narrative of the Magi (Matthew 2:1–12). These are on folios 10r–11v. The three kings, all crowned, meet Herod in his royal palace and they ask where the prophesied king of the Jews has been born. Then they set off on horseback in a courtly but urgent cavalcade through a forest towards Bethlehem, following the star. There are postcards of this picture for sale in the library bookshop downstairs. (Many of these scenes would be suitable for reproduction as Christmas cards.) On the facing page, the kings reach their destination and they indicate and worship the Holy Child, who sits on his mother's lap holding a sceptre (already a king too), seated on a throne. Then Herod, the bad king in his palace, orders the massacre of all babies in Judea, vividly and gruesomely shown, with fruit trees in the background turning black and dying. There would be stories to tell here too and example to be followed or avoided.

The pictures go on. The Holy Family flees to Egypt, led by an angel. The young man behind them, according to medieval legend, grew up to become the Good Thief crucified beside Jesus. The child Jesus is presented in the Temple, again below hanging lamps and jewelled crowns. Now adult, Christ is baptized by John the Baptist, standing among fish in the green waters of the Jordan. On folio 13r he enters Jerusalem humbly on an ass, proclaimed as king by the townsmen. There is a strange feature in this picture. Above him an angel flies down holding an elaborately jewelled reliquary cross. This detail, unique in medieval art, as far as I know, probably alludes to the legend of the seventh-century Byzantine emperor Heraclius who was able to return the True Cross to Jerusalem only when he removed his crown and entered the sacred city as a barefooted penitent, as humble as Christ on the donkey. Then Christ is betrayed in Gethsemane, crucified (the sign above the Cross describes him as 'king of the Jews'), resurrected, and finally enthroned in majesty as king of Heaven. Kingship is a recurring theme. The incarnation and life of Christ were understood in the Middle Ages to have been foretold in the psalms, the work of David,

LEFT: The Magi, shown as three kings galloping through a forest as they follow the star which leads them to the Child in Bethlehem

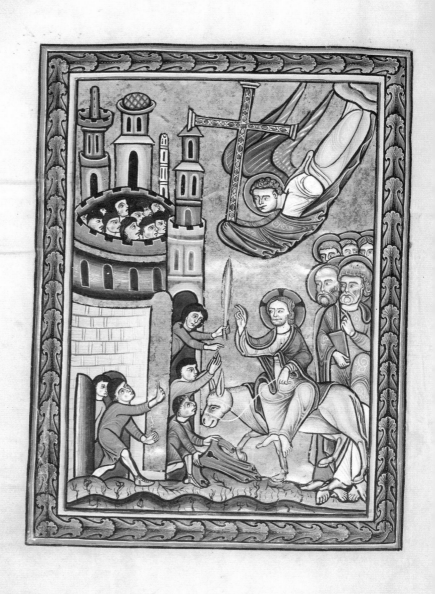

himself a king and dynastic ancestor. His Psalter follows, opening on folio 17r with an almost full-page initial 'B', a seething jungle of tangled branches sprouting from the mouth of an ogre, backlit by tooled and burnished gold. It includes a dog sniffing up between the legs of an unhappy naked man trying to step through the undergrowth. 'Blessed is the man,' the text begins, 'who walks not in the counsel of the ungodly …' There is a luxurious refinement in the Copenhagen Psalter which I have never seen elsewhere else. In the pink frame around the opening initial are seven large gold stars. In the centre of each is (or was) a real jewel, actually glued or pasted into the illumination of the manuscript. This is extraordinary. They are actual tiny gems, perhaps opals. If so, they may have come from Bohemia or Hungary or even Ethiopia. The temptation to pick at them with one's fingernail is almost irresistible, and some of the jewels have already fallen off.

In examining manuscripts and wondering about their patrons, I have a self-formulated rule that if you are not sure whether a book is royal, it isn't; for when manuscripts were commissioned for medieval kings or emperors, the luxury and gratuitous displays of wealth are overwhelming and unambiguous. There was a marvellous exhibition of royal manuscripts at the British Library in 2011, *The Genius of Illumination*, and one came away almost morally outraged at the wealth wantonly expended by medieval kings on their private books, when half of Europe starved. These are manuscripts in a class of their own. The sophistication and the use of seemingly limitless gold and even jewels in the Copenhagen Psalter, as well as recurrent imagery of kings throughout the pictures (and we have looked so far at little more than a dozen pages), all leave one in little doubt that this must be a manuscript made for a royal patron.

Today the modern Danish royal family is admired for living like ordinary people, riding bicycles and shopping in the supermarket. In the Middle Ages it must have been very different indeed. The distinctions of life style between the very rich and the poor, almost invisible now in contemporary Scandinavia, would have been extreme in medieval

LEFT: The Entry of Christ into Jerusalem, riding humbly on an ass, as an angel flies down carrying a wondrously jewelled reliquary cross

Europe. A commoner admitted into the royal presence was doubtless intended to be overwhelmed by displays of wealth and majesty. These were the defining characteristics of kingship. This was not mere personal greed. The maintenance of civil authority in any restless and hierarchical society depended on constant reiteration of superior status and resources. I have experienced something of that shock of wealth in turning the pages of five other great Romanesque private Psalters, all of which will recur throughout this chapter. Imagine them descending the staircase at an imperial ball, glittering with diamonds, and allow me to introduce them one by one. They are: (1) the Hunterian Psalter in Glasgow University Library, whose patron will be suggested below; (2) the Psalter of Queen Ingebourg, wife of Philippe Auguste, king of France 1179–1223, in the Musée Condé at Chantilly; (3) the 'Avranches' Psalter, possibly made for King Philippe himself, now in the J. Paul Getty Museum; (4) the Psalter of Queen Blanche of Castile, wife of Louis VIII, king of France 1223–6, in the Bibliothèque de l'Arsenal in Paris; and (5) the Leiden Psalter, probably made for Geoffrey Plantagenet, son of Henry II, king of England, and, like the *Aratea*, now owned by the university library in Leiden. All five are extraordinary books. Like the Copenhagen Psalter, every one of them is incomparably richer and more ostentatiously extravagant than any of the earlier monastic manuscripts we have so far looked at in this book, and all of them are fit for kings. They positively shout their royal status.

The manuscript which we are inspecting today still belongs to a royal library. In reality, however, Det Kongelige Bibliotek, as it is called in Danish, is the national collection. It grew out of what was once the private library of the kings of Denmark, founded by Frederik III in the seventeenth century. It has been public since 1793. A substantial brick building was constructed for the library in 1906 on the bridge-connected island of Slotsholmen, a mile or so south of the old city centre of Copenhagen. It was transformed in 1999 by a striking new extension, popularly known as 'the Black Diamond' (*den Sorte Diamant*), linked to the earlier building by walkways and extending the library

RIGHT: The opening initial of the Psalter itself, with semi-heraldic parrots and lions and a surround inset with actual jewels glued into the manuscript

BEAT'
VIR:
QVI
NA
BI
IT

in consilio impiorum: & in uia peccatorum
non stetit. & in cathedra pestilentie non
sedit.
Sed in lege domini uoluntas eius: & in lege
eius meditabitur die ac nocte.

across the road and down to the waterfront of the harbour basin. The new part resembles two huge not quite rectangular and leaning cubes of polished black granite and glass, designed by the architects Schmidt, Hammer & Lassen K/S. It is one of the great buildings of modern Scandinavia and it was staggeringly costly, a fact which everyone in Denmark remarks on when you say you have been there. On this particular morning, I myself had walked out from where we were staying in the centre of Copenhagen in about fifteen minutes along Niels Juels Gade and Christians Brygge (which means a brewery, for one was founded nearby by King Christian IV), dodging bicycles and gusts of wind off the canals, touched with spots of rain. The library's main door is not along the edge of the harbour, as you might expect, but round the corner on the far side of the Diamond. You enter, threading past the bookshop (which also sells raincoats – very practical, the Danish), into an atrium from which a very long and gently sloping escalator carries you unimaginably slowly up to the first floor. Here a motherly woman on the information desk directed me to the lifts behind me, up to the floor called 'F Vest'. You come out and turn left, along a glass-lined corridor to a door on the left marked 'Center for Manuskripter og Boghistorie', through which you find yourself in a kind of upstairs mezzanine gallery which is the rare-book reading-room, overlooking the huge open space of the library's atrium far down below. It is a bit like the top deck on a cruise ship, looking out over further decks (actually other reading-rooms), each projecting slightly beyond the next, on the various floors beneath. The hanging gardens of Babylon were probably something like this too. In the far distance below is the entrance hall, traversed by its slow-moving escalator, and across to the right is a huge wall of glass, the height of the whole building, looking across the bright and rippling waters of the harbour, illuminating the library.

As I came in there was a motley group of people clearly up from the country, descendants of the shepherds in the Copenhagen Psalter, clustered around the inquiry desk by the entrance and all chattering at once. I am not sure of their complicated question, probably to do with

RIGHT: The 'Black Diamond', the new extension to the Royal Library in Copenhagen, looking out from the atrium across the harbour; the manuscripts reading-room is behind the balcony at the upper right

family history, but the sole assistant was helping them with a care and a patience I could hardly imagine in any other national library. As I stood waiting, uncertain as to how long this would all take, Erik Petersen, the library's principal specialist in medieval manuscripts, hurried out and pulled me aside, greeting me courteously. He has thinning and shaggy fair hair and little glasses and, like many Danes, he is one of the nicest and least assuming people you could hope to meet. He wears an open-necked shirt, as they all do. He was already clutching under his other arm what proved to be the great Copenhagen Psalter itself in its dark green cloth box. Erik walked me over to the row of tables along the edge of the balcony, looking out across the void. Readers' spaces are separated by upright rectangles of glass, like bookends. The metallic tables are gun-metal grey – Scandinavian, modern Gustavian – inset with thick panels of transparent plastic, which give a softer and more forgiving writing support than the hardness of metal. Under some are information sheets, not prohibitions, as in most libraries, but things that might be helpful, such as that readers may take their own photographs of manuscripts, which I did. Erik turned on the little light on the desk and set me up with foam wedges for supporting the manuscript. He put down the box in front of me. I remarked that I did not yet know what I was going to decide about the manuscript's famously enigmatic origins. He sighed with sympathy. "I am not an art historian," he said, in that low and evenly paced monotone of Danes speaking English, as if delivering the punchline of a deadpan joke: "and art historians jump too quickly to conclusions." We will bear that advice in mind throughout this chapter.

The pursuit of which king (or queen) commissioned the Copenhagen Psalter is going to lead us around various royal families of the twelfth century. Most of Europe then still comprised monarchies and the choice is very wide. Let us therefore begin with established facts, some of which have been discovered by Erik Petersen himself. The earliest unambiguous description of this manuscript is in the seemingly unlikely context of Johann Heinrich von Seelen, *Meditationes Exegeticae*, Lübeck, 1737, which includes a digression about the Psalter (in Latin), noting that it had formerly been owned by Rudolphus Capellus (1635–84), professor of Greek and history in Hamburg in northern Ger-

many. His library descended to his son, Dietericus Matthias Capellus (1672–1720), after whose death the manuscript emerged as lot 566 in the *Bibliotheca Capelliana* sale in Hamburg in 1721, bought by Michael Richey (1678–1761), who had lent it to von Seelen for examination. It was seen by the well-known German bibliographer Johann Albert Fabricius (1668–1736), who transcribed the calendar. From Richey the manuscript was acquired by that voracious Danish collector, Count Otto Thott (1703–85), statesman and a member of the royal privy council (*Gehejmekonseillet*). His vast library, gathered throughout his life, came to comprise some 140,000 items, including 4,000 manuscripts. Thott's house on Kongens Nytorv in Copenhagen is now the French embassy. He bequeathed his early printed books and his manuscripts to the Danish royal library. The Psalter still preserves the donor's name in its distinctive pressmark "Thott 143, 2°", the latter referring to its size on the library shelves, among the volumes which were folio in format.

Out of its box, this is indeed a substantial book. The measurements, inclusive of binding, are about 12 by 8¼ inches, by some 2¾ inches thick. The binding is eighteenth-century dark red-brown morocco decorated with concentric frames in gold. The spine is in gilded compartments, without lettering. The quality of tooling is clumsy and the tinselly gold is over-rich. To judge from the book's history, it must have been bound in northern Germany or Denmark. (Since the binding is rather over-blown and tasteless, any Dane would mutter that it must be German.) The pastedowns and endleaves are of startling bright-red paper heavily gilt stamped with a floral pattern including the occasional putto and bird, all deeply impressed. Eighteenth-century printed gilt paper is now a subject of connoisseurship and collecting in its own right, but it always reminds me of Christmas crackers. On the last page of the manuscript itself are unexpectedly crisp offsets from the turn-ins used in an earlier binding, showing clearly that the book was previously covered in woven textile and that there were once two broad ribbon ties near the top and bottom of the fore-edges. One of the paper flyleaves has a circular stamp, "BIBLIOTHECA REGIA HAFNIENSIS", printed around a crown.

The text comprises a full Psalter, preceded by a calendar (as I said)

and followed by the standard biblical canticles with a litany invoking the names of saints, and various short prayers. Latin Psalters, like Gospel Books, go back to ancient Christian times, and indeed earlier (since the psalms in Hebrew are part of the Jewish Scriptures). Monks and clerics used the psalms in Latin in their daily devotions. Eventually, Psalters became more or less the first books commissioned and owned by private individuals, outside monastic communities. The beginnings of lay literacy are notoriously difficult to document. There are some Psalters associated with the Carolingian emperors and their courts, such as the famous late eighth-century Dagulf Psalter, commissioned by Charlemagne for presentation to Hadrian I, pope 772–95, now in Vienna, but most of these were probably intended as feudal gifts to religious houses or for use by chaplains in the palace. It is not really until the middle of the twelfth century that Psalters were first owned and retained privately by individual members of the laity. Many of the earliest examples seem to be of English origin, an oddity which has never been satisfactorily investigated or explained. Among other purposes, people used Psalters for learning to read. This was probably the custom in monasteries too, where Psalters were often reserved for use by the novices. The late twelfth-century royal Psalter in Leiden, cited above, which was made in England, has a medieval note below its first psalm asserting that it was used by Saint Louis of France as a child when he was learning to read, "*Cist Psaultiers fuit mon seigneur saint Looys qui fu Roys de France, Ou quel il aprist en s'enfance*". Louis was born in 1214 and so that was around 1220. It may be very significant that the Copenhagen Psalter has apparent evidence that it too was prepared from the outset in order to teach someone to read. Between the canticles and the litany it has a complete alphabet, written out clearly and spaciously by the book's main scribe, ending with a row of the basic and standard medieval marks of abbreviation and punctuation, which any medieval reader needed to learn. This is followed, as in virtually all children's primers and hand-held alphabet boards right up to the nineteenth century, by the Lord's Prayer and the Creed. Children and new readers were taught the letters and then they customarily began practising with the *Pater Noster* as their first reading text.

In so far as we can deduce anything from quality of decoration and a few unusual lines, it is likely, then, that the manuscript was intended for use by a royal child or young person of high status who might be learning to read. Even that does not narrow the field greatly. A quick survey of the kings in northern Europe around 1170 with children about the right age to be given first reading lessons would include Henry II, king of England 1154–89, with sons born in 1157, 1158 and 1166; Frederick Barbarossa, king of Germany 1152–90 (and emperor from 1155), with sons born in 1164 and 1165; Louis VII, king of France, 1137–80, with a son born in 1165; Valdemar, king of Denmark 1157–82, with a son born c. 1163; and even Magnus V, king of Norway 1161–84, who was himself born in 1156 and might still be receiving schooling.

The manuscript has three additions which suggest that it was already in royal ownership in Scandinavia at an early date. The first is an obit, or anniversary of a death, added into the calendar on 27 May, "Anno d[omi]ni. M°. cc°. lxxii°. Obijt illustris dux Jucie Eric[us] filius Abel regis". It is on folio 4r. This is the death in 1272 of Erik, duke of Jutland, younger son of Abel, king of Denmark, 1250–52. He had been made duke of Schleswig in southern Jutland in 1260. Such commemorations

An anniversary added in the calendar to commemorate the death of Duke Erik, son of King Abel, on 27 May 1272

of deaths in calendars of manuscripts were usually added at the time by members of the deceased's family. As the anniversaries came up each year, these would be reminders to reflect on the departed and to pray for their souls. Duke Erik's mother, queen of King Abel, was Mechtilde – or Mette, in Danish – of Holstein, who died in 1288. The manuscript is assumed to have belonged to her, or at the very least to someone in

Suscipe digneris sancta trinitas. hos psalmos consecratos. quos ego miserrima & peccatrix cupio decantare in honore nominis tui. et in honore sancte marie virginis. & omnium sanctorum tuorum. pro me misera peccatrice. & pro anima patris mei. & matris mee. & pro anima byrgeri ducis. & pro animabus fratrum meorum. & sororum mearum. et omnium consanguineorum meorum. & omnium fratrum & sororum & familiarium ordinis nostri. Suscipe clemens & misericors deus hanc oblationem psalmorum. quam ego peccatrix & humiliter offero. & quidquid aures tue pietatis digne pulsavero in misericorditer concede. Tu enim corda omnium nostri. tu scis quid in expediet. Concede ergo ut hec oblatio psalmorum ad salutem tam corporis quam anime proficiant. pro propinquisque meis. vivis profint adveniam. & de functis ad requiem sempiternam. Amen.

Marginal note:

Duorum Birgero-rum fit mentio in historia Svecica. Prior est Birgery Jerl prorex, rege Waldemaro, A. C. 1251. Posterior est Birgery Magni filig, A. C. 1291. De utroq. vide Joh. Locce-nium in historiis rerum Svecicarum, p. 88. 98. et in fine libri.

In Calendario huic libro præmisso, sub mensis Maji die 27. mors filii Regis A-belis Erici, Ducis Jutiæ, addito A.C. 1272 indicatur. Ex his annis C. 1251, 1291, 1272 collatis colligo hunc librum circa A. C. 1270, ante annos minimu 400 scriptum esse.

her immediate household. The reason for this likelihood occurs in a second addition. This is a long dedication prayer added on folio 16v of the manuscript. It was evidently written when the Psalter was entrusted to a community of nuns in the late thirteenth century, and, as the donor commends the use of the book, using female forms, she asks for prayers for the souls of her parents, for the soul of Duke Birger ("& p[ro] anima Byrgeri ducis"), and for the souls of her brothers and sisters and of all her other relations. The connection is that, after the death of King Abel, Mechtilde of Holstein married Birger Jarl (c. 1200–1266), regent of Sweden and reputed founder of Stockholm. ('Jarl' is a title of nobility, like 'earl' in English; Birger Jarlsgatan is now one of the principal streets of Stockholm.) The fact that Birger was already dead by the time the prayer was written and that Mechtilde is not included presumably dates the inscription to between 1266 and 1288, and it may even have been written by the widowed queen herself. When Mechtilde eventually died, she was buried with her second husband in the royal abbey of Varnhem, in southern Sweden, beneath a tomb slab showing herself, Birger Jarl, and her beloved son, Duke Erik, mentioned in this Psalter. When the grave was opened in 2002, three skeletons were indeed found there.

The third and most tantalizing inscription was added into the Copenhagen Psalter several generations earlier. It occurs at the top of the otherwise blank first leaf, folio 1r. It is named here "Reliquiarum enumeratio", an 'inventory of relics'. The inscription is slightly later than the manuscript itself, but it must date from fairly comfortably within the twelfth century. Medieval relic-lists are not especially rare, and they were usually entered onto blank pages of whichever book was regarded by its owners as especially precious. A similar list was inserted into the Gospel Book of Saint Augustine, describing relics stored in a box in the abbey in Canterbury where the manuscript itself was kept, as we saw in Chapter One (above, p. 30). If we could identify whose collection of relics this was, then we would probably know who owned the Copenhagen Psalter in the late twelfth century.

What is unusual is that it is clearly personal. The list opens, "Has

LEFT: A thirteenth-century consecration inscription, using female forms and asking for prayers for the souls of deceased members of the donor's family, including Duke Birger

Reliquiarum enumeratio.

Has reliquias possidet
num domini de cruce, sancte marie virginis, de sancto Iaco... ... apostolo, de sancto
Bartholomeo apostolo, de sancto mathe apostolo, de sancto laurentio, de sancto clemente
de sancto ypolito, de visceribus sancti remigii, de capillis marie magdalene, de sanc
to ambrosio episcopo, trium magorum, Quatuor coronatorum, Dente sancti bertini, ka
terine virginis, agathe virginis, Undecim milia virginum, Sancti nicholai e
piscopi, Sancti godardi, Sanctorum innocentium, Sancti mauricii sociorumque eius, Ite de
baculo sancti malachi, De sancto thoma archiepo.

A list of a privately owned collection of saints' relics, with the name of their original now carefully scraped away

reliquias possidet ..." and then, hugely frustratingly for us, nearly an entire line has been thoroughly scraped away. However, the first erased word "dns", '*dominus*', is still clearly legible. 'Lord' someone – name and title erased, evidently an individual – 'possesses these relics ...' Generally, major relics were expensive and belonged to churches, but occasionally monarchs and great noblemen had private collections. (In Chapter Nine below we will see relics owned by Louis IX and Philippe VI of France.) The sacred treasures of the mystery owner here are then listed: wood from the True Cross, strands of hair of the Virgin Mary, relics (doubtless bones) of Saints James the Apostle, Bartholomew, Matthew, Lawrence, Clement and Hippolytus, pieces of the entrails of Saint Remigius, strands of hair of Saint Mary Magdalene, relics of Saint Ambrose, the three Magi, the Four Crowned Saints, a tooth of Saint Bertin, and relics of Saints Katherine, Agatha, the 11,000 Virgins, Nicholas, Godard, Holy Innocents, and Maurice and his companions, a piece of the staff of Saint Malachy, and a relic of Saint Thomas the archbishop. The last of these, a piece from the body of Thomas Becket, provides an absolute date, at least for the final addition to the owner's relic collection, since it cannot have been listed earlier than the martyr's death in Canterbury in December 1170. Saint Thomas was canonized in 1173, and the trade in his relics was rapid and international.

In an article of exemplary historical detection published in 2012, Christopher Norton of York University identifies the likely source of almost every one of the relics listed in the Copenhagen Psalter. He notes that the only fragment of the True Cross otherwise known in Scandina-

via had been presented in 1110 by King Baldwin of Jerusalem to Sigurd, king of Norway 1103–30, and that by at least 1153 it was kept in the cathedral of Nidaros (now called Trondheim) in Norway. He records too that relics of the relatively obscure Saint Hippolytus, the eighth item on the list here, were probably brought to Scandinavia from Rome in 1161 and were also uniquely enshrined in Nidaros. He documents how almost every one of the relics listed could have been gathered along the logical stopping places on the journeys to Jerusalem by the crusading King Sigurd of Norway in 1107–10 and to Rome by any Norwegian pilgrim, especially Eystein, archbishop of Nidaros, who made the trip in 1160–61, and he proposes that this is a comprehensive inventory of the relics housed in the cathedral of Nidaros by Magnus V, king of Norway 1161–84, grandson of Sigurd the Crusader. Professor Norton's conclusion is that the Psalter probably belonged to King Magnus himself, and that Magnus is quite likely to have commissioned it. There is an appealing logic to this, and it places the patronage of the Psalter firmly in Scandinavia. He suggests that the first line of the relic-list on folio 1r was originally "Has reliquias possidet *dominus magnus rex norvegiae in ecclesia nidrosiensi*", or some similar variant of those words.

Of course, seated at my eyrie overlooking the lower floors of the library in Copenhagen, I stared and stared at that erased line, using a magnifying lens and tipping the manuscript backwards and forwards against the light. So much hinges on that missing name. My fellow students in the Center for Manuskripter og Boghistorie, if they could have seen what I was doing, would have regarded this as eccentric in the extreme, peering for more than an hour at an invisible word on the only unilluminated page in one of the most beautifully illustrated books in the world. I actually enjoy seemingly illegible inscriptions, rather like tackling cryptic crosswords, where one can sometimes reach a solution by piecing out options letter by letter before the word finally falls into place. In a manuscript, as in a crossword, there is (or was once) an answer, if only one can find it. Although the missing words at the opening of the Psalter are heavily scraped off, some of the upper extremities of the ascenders of the erased letters are still just visible. After "dominus" there is space for two or probably three letters without ascenders. Then

there was a tall letter which rose above the line and flicked over to the right, precisely like the tip of the 'l' in 'lignum' at the end of the first line, or that beginning 'lauurencio' in line 3. Immediately adjacent to it was another tall letter terminating, with a double flick, both backwards curving towards the possible 'l' and splitting off forwards too, like the top of the high 'd' of 'de crinibus' in line 2. Then there were several low letters. Whatever the name here was, it was certainly not 'magnus rex', which has no ascenders at all. The name appears to have opened blank-blank-blank-'ld'. Suddenly, I got it. Like finally solving a cross-word clue, one wonders afterwards why it took so long. The first of the missing words here must surely have been "uualdemarus", Waldemar, presumably Valdemar the Great, king of Denmark 1157–82 and duke of Jutland. He was the grandfather of King Abel, whose wife, Mechtilde of Holstein, owned the manuscript in the thirteenth century. The relics were surely his, and so therefore was the Copenhagen Psalter.

At this point – it was already nearly one o'clock – I had arranged to meet my wife downstairs in the library's very fine restaurant along the water-front, called Søren K, where we ordered what the waiter recommended as the quickest and most modestly priced option, for service in good Danish restaurants is often astonishingly slow (like the escalators) and eye-wateringly expensive. We had the white asparagus with nettle-butter and home-smoked salmon, *Hvide asparges, brændenældesmør & hjemmerøget laks*, with a glass of Carlsberg. Could any other rare-book library in the world serve up a meal like that? We sat outside in the sun afterwards, for the weather had cleared up, and it was an opportunity to gather up and reread my photocopies of the previous studies of the manuscript by my old friend Patricia Stirnemann, of Paris.

As Patricia Danz, which she was then, she wrote her original the-sis on the Copenhagen Psalter (Columbia University, 1976), when the manuscript was hardly known. She has returned to it again in articles published in 1998, 1999 and 2004. Her principal concern has always been with the various illuminators of the manuscript, but of course she has speculated on its origin, and it was she who drew attention to the significance of the child's alphabet. Her hypothesis, backed by dating

which we will come to later, is that the Psalter was made on the occasion of two simultaneous events which took place in Denmark in 1170. These were the translation of the relics of the newly canonized royal saint, Knud Lavard, father of King Valdemar, and the coronation on the same day of the boy-king, Valdemar's son, also called Knud (Canute as spelled in English), who was then in his seventh year, appropriately the age when a Christian prince might be expected to begin learning to read. His grandfather, the holy Knud Lavard, first duke of Schleswig, had been murdered in 1131 in the forest of Haraldsted Skov, near Ringsted, about forty miles south-west of what is now Copenhagen. Saint Knud was canonized in 1169 and his body was formally translated in Ringsted Priory Church on 25 June 1170, in a politically charged double ceremony in which King Valdemar asserted his dynastic claim to the throne by also crowning his own son and heir apparent, the younger Knud, inheritor of the new saint's name. Patricia believes that this was the event which occasioned the making of the Psalter. The intended recipient was the six-year-old Prince Knud, and the Psalter with its alphabet was to be his initiation into both kingship and literacy.

I looked back at the notes I had made before lunch about the erased line of the relic-list. Christopher Norton had suggested that the words might have concluded with the location where the relics were kept, such as, in his hypothetical reconstruction, "… *in ecclesia nidrosiensi*". I was fairly certain that I could make out that the scraped-away phrase once ended with the letters, "… *sta*", still faintly visible at a certain angle, perhaps with a mark of abbreviation. The letter before the apparent 's' seems to have had some descender below the line. At first I thought that it might have been something like "*in cista*", 'in a box', although there would have been no reason to erase such words. Reconsidering, I agreed that it should more logically have been a place name. About eight letters before the end is the ascender of a tall letter which could have been a '*d*', and '*apud*' is imaginable. The last words might therefore have been "*apud ringsta[dium]*", 'at Ringsted', which is the Latin name and is plausibly consistent with what is visible. The list does not include any relics of Saint Knud Lavard, since his separate shrine was in Ringsted anyway. This, then, would be the Psalter of the Crown Prince,

made for his coronation, used afterwards to record his father's relic collection in the royal priory of Ringsted, where King Valdemar was eventually buried in 1182. On his father's death, Knud inherited the throne in his sole name as Knud VI, ruling until his own death in 1202, when he too was buried at Ringsted. His armorial seal, the earliest known from Denmark, shows three running lions: very similar heraldic-looking lions (this may be coincidence) are racing up the right-hand side of the great Beatus initial at the opening of the Psalter. On the corresponding left-hand side are three parrots. We do not know the emblems of King Valdemar, but one could envisage a royal Psalter made jointly for the two Danish kings, the father and his now co-crowned young son.

This does not necessarily invalidate Professor Norton's thesis that some of the relics, at least, had belonged to King Magnus of Norway and the cathedral treasury in Nidaros. It is a wonder of relics that they are infinitely divisible, even the smallest of crumbs, and exchanges among the Scandinavian kings are easily imaginable. After 1180 Magnus himself was driven from Norway and he stayed for two years as a guest of King Valdemar in Denmark. Rewards and gifts were the life-blood of medieval diplomacy.

Back upstairs in the reading-room of *den Sorte Diamant*, we must open up the manuscript again. We have more to ask it. It begins with a calendar listing the saints' days in each month, from January to December. This is such a standard feature of late-medieval devotional texts, such as Missals and Books of Hours (and indeed many modern prayerbooks), that it is worth asking why a calendar should be a component of any Psalter at all. Reading of the psalms is not affected by the saint's day. The liturgical year, if that was relevant, runs from the first Sunday in Advent, not from January at all. Latin Psalters are known from the sixth century onwards: for the first 400 years of their survival, not one has a calendar. In Chapter Four we encountered the fourth-century 'Calendar of 354', an early Christian almanac acquired by the Carolingian court library. Many texts from there seem to have been disseminated out through England by the tenth century. Northern England, in particular, preserved an interest in computistical studies initiated by Bede. The earli-

est surviving Psalters with attached calendars are English, dating from around 1000. Calendars were perhaps especially useful for lay owners, since monks would know the festivals anyway from the daily Mass, but secular owners might benefit from guidance and from having a place to record family obits and anniversaries. By the eleventh century, especially in England, calendars had become normal components of Psalters.

The calendar of the Copenhagen Psalter reveals an unmistakeable flavour of its English ancestry. It is written in black ink, but significant feasts are singled out gaily in red, blue or green. Although not illustrated, it is certainly festive in every sense. These special days, in the order they occur, include Saints Cuthbert and Wilfrid in green; John of Beverley in blue; Dunstan in red; Augustine, apostle of the English, in blue (and on the same day, 26 May, Bede, in black); Botolph in red; Alban and Oswald in green; and Edmund, king and martyr, in blue. Saints Botolph of Lincolnshire and Edmund of Suffolk – ironically martyred by the Danes – both relate loosely to East Anglia, but Cuthbert, Wilfrid of York, John of Beverley (in Yorkshire), Bede and Oswald, king of Northumbria, all point fairly decisively towards the north of England or even especially to the north-east. Saints Cuthbert, Wilfrid and Oswald are invoked too in the litany which follows the text of the Psalter.

What is striking is what is not there. Not one of these English feasts has a vigil or an octave, the supplementary celebrations the day before and a week later, as principal festivals do in monasteries. In other words, these may be important days, but they are not accorded the highest ranking. The three likely centres for luxury book illumination in northern England in the twelfth century were Lincoln, York and Durham. There is nothing here that is uniquely peculiar to any of these or necessarily excludes anywhere else. The most obvious omission from the calendar is Saint Thomas Becket, martyred in 1170 and canonized in February 1173. His feast on 29 December was universally adopted across Europe almost immediately. His name does not appear in the litany either. Absence is not absolute proof of an earlier date, for medieval scribes, like all of us, might sometimes overlook the obvious through

OVERLEAF: The calendar of the Copenhagen Psalter, showing various English feasts such as Saint Oswald and the highest level of veneration accorded to Saint Augustine, patron of the Augustinian Order

Augu stū mensē leo ferūdus igne peruric.
Augu stū nepa prima fugat de fine secunda.

Augustus habet dies .xxxi. & lunā .xxix.

viii	c			Auguͦ. Sͥ Petri ad uincͣa. Machabͥ mͬ. Ā.
xvi	d	iiii	N̄	S̄ā Stephani pape & mͬ. Inαpīt .vi. embol.
v	E	iii	N̄	Inuentio S̄ā Stephani pͭhomͬ.
	f	ii	N̄	
xiii	G	ι · ͻ ·	N̄	S̄ā Oswaldi regis & mͬ.
ii	A	viii	ID	S̄cͦr Sixti felicissimi & Agapiti mͬ.
	B	vii	ID	Aruinus omͬ.
x	c	vi	ID	S̄ā Ciriaci socioꝛq̃ eius mͬ.
	d	v	ID	Vigilia.
xviii	E	iiii	ID	S̄ā Laurentii leuite & mͬ.
vii	f	iii	ID	S̄ā Tiburtii mͬ.
	G	ii	ID	
xv	A	IDᵫS		S̄ā Ypoliti socioꝛq̃ eius mͬ.
iiii	B	xix	kͬ	Septembͬ. S̄ā Eusebii prͤbi & conf. Vigilia.
	c	xviii	kͬ	Assumptio S̄c̄e Marie uirginis.
xii	d	xvii	kͬ	
i	E	xvi	kͬ	Octaue S̄ā Laurentii mͬ.
	f	xv	kͬ	S̄ā Agapiti mͬ. & S̄c̄e Helene. Sol in uirgine.
ix	G	xiiii	kͬ	S̄ā Magni mͬ.
	A	xiii	kͬ	
xvii	B	xii	kͬ	
vi	c	xi	kͬ	Oct̃ & S̄c̄e Marie. Sͥ Timothei & Simphoͬ mͬ.
	d	x	kͬ	Vigilia.
xiiii	E	ix	kͬ	S̄ā Bartholomei apͭli.
iii	f	viii	kͬ	
	G	vii	kͬ	
xi	A	vi	kͬ	S̄ā Rufi mͬ.
xix	B	v	kͬ	S̄ā Augustini doctoris. Sͥ hermetis mͬ.
	c	iiii	kͬ	Decoll̃ S̄ā Iohis Bapͭ. Sͥ Sabine uirͥ & mͬ.
vii	d	iii	kͬ	S̄cͦr felicis & Adaucti mͬ. Dies egiptiacus.
	E	ii	kͬ	Finit .vi. embol.

Hor habet horas .x. Dies .xiiii.

uirgo tuo bachū septēber opīat.
septēbris uulpis ferit a pede deniā.

Septēber habet dies .xxx. Lunā .xxx.

Scī Egidii abbis. Priscī mr̄.

Incipit .ii. embolism̄.

Dies egiptiacus.

Octaue Scī Augustini doctoris.

Hic finiunt dies caniculares.

Natiuitas Scē Marie uirginis.

Scī Gorgonii mr̄.

Scōr̄ Prothi & Iacincti mr̄.

Octob̄. Exaltatio Scē Crucis. Scōr̄ Cornelii & Cȳp.

Octaue Scē Marie. Scī Nichomedis mr̄.

Scōr̄ Eufemie Lucie & Geminiani mr̄.

Sol intrat libram.

Vigilia

Scī Mathi apli & eugeliste. Dies egiptiacus.

Scī Mauricii socioruq; eius mr̄.

Equinoctiū secūdm Romanos.

Scōr̄ Cosme & Damiani mr̄.

Scī Michaelis archangli

Scī Ieronimi prbī & conf.

Nox habet horas .xii. Dies .xii.

inattentiveness or even through wilful stubbornness. However, this dating of before 1173 would be entirely consistent with production in time for the royal celebrations in Ringsted Priory, six months before Becket's death.

The second distinctive layer of the calendar is Augustinian. This is even more unambiguous than its Englishness, for there is Saint Augustine of Hippo himself, 28 August, in red, with the octave, 4 September, in blue, and there is his translation, 11 October, in blue, the traditional date of the saint's reburial in Pavia in the eighth century. The order of Augustinian canons was founded long after Augustine's death in 430, but it conformed to a rule of life laid down by their patron saint and it became especially prominent in the twelfth century.

In Chapter Six we saw how difficult it can be to distinguish the arts of England and Normandy immediately after the Conquest. A hundred years later, the kings and nobles were still Norman and many owned estates in France, but the script and illumination of manuscripts had begun to diverge. The writing of the Copenhagen Psalter is almost certainly by an English scribe, with the characteristic trailing-topped 'a', 'g' not quite closed in its lower loop, and the striking ampersand, very like the slightly earlier script of the Bury and Lambeth Bibles. On style alone, the Copenhagen Psalter is almost universally attributed to England. It was awarded the accolade of being selected for the colour frontispiece in the standard corpus of twelfth-century English illumination, C. M. Kauffmann's *Romanesque Manuscripts, 1066–1190*, published in 1975. There are many reasons why a luxury Psalter destined for the Danish royal family might have been made in England. The practices of book illumination in the British Isles were highly sophisticated and long-standing, whereas those of Scandinavia were still largely untried. Northern England, especially the north-east, was within the cultural legacy of the Viking occupation, and there were probably even then still some resident speakers of the Danish language. An earlier Canute – King Knud II of Denmark – had been king of all England little more than a century previously. He had sent back English priests to organize the Scandinavian churches. The liturgy of Denmark was dependent on English customs. (The Swedish churches, by contrast, looked to

Germany.) There were many ongoing connections. The early twelfth-century life of Saint Knud IV was written in Denmark by an English monk, Ælnoth of Canterbury. The relic-list in the Copenhagen Psalter is also evidence of closeness, for it includes items which must have come from England. For example, the pieces from the entrails of Saint Remigius were probably from those of Remigius of Lincoln, whose relics were dispersed when his tomb was opened in the 1120s. Among the rarities of the relic-list are pieces of the Virgin's hair, of which reputed specimens were at Lincoln and Canterbury. The relics at St Augustine's Abbey, cited in Chapter One, included specimens from the True Cross, as here too. The bone of Becket, of course, came from Canterbury. It would not be unexpected for a Psalter to have been sent from England, perhaps accompanied by a donation of relics. It could even have been a royal gift from King Henry II or his family to their remoter cousins of Denmark. Henry II's daughter had married Henry the Lion, duke of Saxony; Henry the Lion's own daughter Gertrude was betrothed in childhood to Prince Knud of Denmark and they married in 1177. She became queen of Denmark in 1182 (a name possibly echoed in Shakespeare's *Hamlet*). These were all families who knew one another.

The five other very early privately owned luxury Psalters, listed above on p. 292, all also have some kind of kinship with each other and with their interrelated patrons in a way which is not yet clearly definable. By far the closest to the Copenhagen manuscript is the Hunterian Psalter in Glasgow. Its calendar too is Augustinian, omits Saint Thomas Becket, and seems to point towards the general area of York or possibly Lincolnshire. It has thirteen full-page miniatures of great splendour. One of its artists also worked in the Copenhagen Psalter, as we will see shortly, and both manuscripts may even have been copied by the same scribe. The two Psalters are not exact twins, for there are differences both in text and in iconography, but they are sometimes referred to as 'sister' manuscripts. If the Copenhagen Psalter is royal, then so is that in Glasgow. Its intended owner, however, is not known. It was clearly used in continental Europe, not in England, and it is first explicitly recorded (in 1769) in France.

The next is the Ingebourg Psalter at Chantilly. It was made in France

for Ingebourg of Denmark (1175–1236), daughter of King Valdemar and younger sister of Knud. She must have known the Copenhagen Psalter as a child. She was sent to marry Philippe Auguste, king of France, in 1195 (himself a great-nephew of King Stephen of England), a difficult and lonely marriage, ultimately doomed. The closely related 'Avranches' Psalter, named from its place of rediscovery in 1986 (now in the Getty Museum), is by the same artist as the Psalter of Queen Ingebourg and it may have been commissioned for her husband, who was therefore the brother-in-law of Knud of Denmark. The Leiden Psalter is also English and has a calendar with a seemingly northern emphasis and an added obit for the death of Henry II on 7 July 1189. It may have belonged to his illegitimate son, Geoffrey Plantagenet, archbishop of York, half-brother of Matilda, wife of Henry the Lion, father-in-law of Knud. It was afterwards owned by his niece, Blanche of Castile, wife of Louis VIII, son of Ingebourg's husband. Queen Blanche also owned and probably commissioned the great royal Psalter in the Bibliothèque de l'Arsenal in Paris. Blanche was a granddaughter of Henry II of England. The loose family links around an orbit involving the royal dynasties of England, Denmark and France, and the pairing of these half-dozen manuscripts for king and queen, make one wonder whether the Hunterian Psalter might have been intended for someone such as Sophia of Minsk (c. 1140–98), wife of Valdemar the Great and mother of Knud VI, or another close member of their family, and maybe it too was made for the same celebrations of 1170. It is really very tempting. I hear the cautious voice of Erik Petersen echoing in my mind: "art historians jump too quickly to conclusions."

In 1999, Erik Petersen edited a volume of essays on medieval book culture in Denmark, *Living Words & Luminous Pictures*, which included an article on the Copenhagen Psalter by Patricia Stirnemann, who is indeed an art historian and who weighs her conclusions thoughtfully. She begins with the one artist who worked in both the Copenhagen Psalter and in the manuscript now in Glasgow. As she recognized in her original thesis, the same illuminator executed the initials of psalms 1–54 and psalm 80 in the Copenhagen manuscript and those of psalms 1–101 in the Hunterian Psalter. Patricia has now found the hand

A manuscript of the life and miracles of Saint Augustine, illuminated at the abbey of St-Victor in Paris by one the principal artists of the Copenhagen Psalter

of the same artist in a number of other manuscripts of approximately the same date. These include two very early manuscripts of the *Sententiae* of Peter Lombard (*c.* 1100–1160), master in the cathedral schools in Paris, one dated 1158 (the oldest known), the other not later than 1169; a copy of the first recension of Peter Lombard's Great Gloss on the Epistles of Saint Paul, from the library of Notre-Dame in Paris, where the author himself was bishop 1158–60; and a manuscript of the life and miracles of Saint Augustine, made for and surely in the Augustinian abbey of Saint-Victor in Paris. In historical likelihood, it is almost inconceivable that any of these four manuscripts could have been made anywhere but locally in Paris.

Our attention then shifts to the abbey of Saint-Victor. This had been established just to the east of the city walls of Paris in 1110 by William of Champeaux (*c.* 1070–1121), the philosopher and teacher of Abelard. The Augustinians were canons, not monks. They interacted with the secular world, reaching out their learning to the laity. They undoubtedly supplied manuscripts. The *Liber Ordinis* of the abbey, a kind of in-house rule book, mentions paid scribes working in their scripto-

rium. From its foundation, the house of Saint-Victor in Paris had run academic schools which could be attended by students who were not necessarily themselves members of religious orders. Famous teachers there included Hugh of Saint-Victor (d. 1142), theologian and prolific author, Richard of Saint-Victor (d. 1173), who was apparently a native of Scotland, Andrew of Saint-Victor (d. 1175), born in England, and Adam of Saint-Victor (d. c. 1177/92), who may also have been British. The early history of the abbey shows that surprisingly many of its resident members and visiting scholars came from England. Ernerius, the abbot of Saint-Victor 1162–70, may himself have been English too. His sister was married to a Norwegian. (I am quarrying all this from Patricia Stirnemann.) In the year of his appointment, the Danish archbishop of Lund, Eskil, fell out with King Valdemar and took up exile in France, coming to Saint-Victor. He brought a deposit of 397 silver marks, which he left in the care of Abbot Ernerius. In 1168, he made up his quarrel with Valdemar, who then invited him to preside over the translation of the new Saint Knud Lavard and the coronation of the boy-king in Ringsted in 1170. It is Patricia's contention that the Copenhagen Psalter was commissioned by Archbishop Eskil while on (or as a result of) his visit to Saint-Victor in Paris, and she hints that the 397 silver marks may have had something to do with paying for the book.

That is remarkable. One of the greatest English manuscripts of the twelfth century could thus, in theory, actually have been written and illuminated in Paris, as indeed could the Hunterian Psalter now in Glasgow, perhaps also ordered by Eskil for the same event. English scribes and artists were doubtless working at Saint-Victor. We know the names of a number of scribes in twelfth-century France who were born and trained in England, including Manerius of Canterbury, who wrote a great Bible now in the Bibliothèque Sainte-Geneviève in Paris. The calendar and litany of the Copenhagen Psalter certainly look very English but they are no more precisely localizable within England beyond a general nod to 'The North', as the signposts say on English motorways, which, from the southerly perspective of Paris, might have seemed to include Scandinavia. The abbey of Saint-Victor was Augustinian, which explains the second layer of the calendar.

When I began cataloguing manuscripts for Sotheby's, I once left a question of localization open with multiple suggestions. My head of department and mentor for the rest of his long life, Anthony Hobson, read this through despairingly and pronounced in his languid voice, "You have to come to a *decision*." The truth is, in this instance, I don't know. I have worried over it unceasingly, and I cannot make up my mind. There are other options, or variants. Archbishop Eskil, if it was he, could have made the acquaintance of the illuminators in Paris but he could have employed them anywhere, including in England. That may well be what happened. The manuscript could have been begun in one place and finished in another, although the final result looks very unified. I wish I could decide. Erik Petersen may commend my reluctance to rush to any conclusion, but I would dearly love to know the answer. There is even a possibility – a very remote but persistent possibility – that the manuscript was made in Denmark itself. I keep finding myself coming back to this, unable to shake it off entirely. Archbishop Eskil returned home in 1168. The date of the ceremony was set for the summer of 1170. This is a book made for a king. Medieval kings did not shop by mail order. They commanded artists. For enough money, an entire workshop, with scribes and illuminators and all their equipment, could travel anywhere, even to the court of a king of Denmark. Four artists and a scribe, working simultaneously, as they clearly were, could easily make a Psalter like this within two years. I long for it to have been illuminated in Ringsted.

The collation of the manuscript appears very simple.* As far as I know, it has not been noticed before that there is probably an entire gathering of further full-page miniatures missing after folio 7, between what are now quires i and ii. The stub of the flyleaf protruding after folio 7 is rather roughly hacked off. The inner fold between those gatherings is battered and is torn vertically at the foot of folio 8, damage which occurs nowhere else in the book. The removal of an entire quire at this point would make sense. The cycles of full-page miniatures at the beginning of early luxury Psalters usually begin with scenes from the Old Testament, from the Garden of Eden through to the lifetime of David, author of the Psalms. The Hunterian Psalter begins like that

* It is: i^{1+6} [the flyleaf now foliated '1', with the relic-list, plus the calendar], ii–xxv^8.

(although it too lacks leaves). The purpose was to link the Fall of Man with the psalms, which were seen as prophecies of the coming of Christ. The pictures in the Copenhagen Psalter are only half the sequence, and probably the manuscript once had eight more leaves, with sixteen Old Testament pictures as well. They might have been removed as early as the thirteenth or fourteenth century, when the cult of the Virgin came to dominate private devotion, and it was perhaps thought that the Annunciation was a now more appropriate opening page for nuns than naked figures of Adam and Eve.

The division of labour corresponds absolutely to the collation. It is satisfying to see this so clearly. The first artist painted what remains of the cycle of full-page miniatures (quire ii) and then he picked up work again in quires x–xv, from folios 72 to 119. The manuscript was not yet bound when the different illuminators were working on it and the loose quires would have been distributed among the artists. If the first two painters began simultaneously, then maybe the length of time it took the first artist to execute up to thirty-two full-page miniatures was the same as it took his next colleague to paint the seventy-two text leaves assigned to him, before the first hand was able to take over again. This first artist has a magnificent monumental style, lavished with bright colours and untooled burnished gold, as smooth as glass. At the beginning, we saw how the full-page miniatures are brimming with royal symbolism. There might also be allusion to the patron in his initial for psalm 87 showing God admonishing a bearded fair-haired man, perhaps inspired by verse 8, 'Thy wrath is strong over me': textually this applies to David the psalmist, but the Nordic-looking figure might resemble King Valdemar. Other initials by this artist include Christ in the temple for psalm 81, an angel urging a man to listen to God as an illustration for psalm 85, and musicians celebrating God for psalm 91. Many are purely decorative and whimsical. Among them are a fearsome lion seizing a man from behind and biting his head; a man sitting backwards on a bear lancing a donkey which is playing a harp; an ape looking in a mirror; a naked animal, perhaps a dog, wearing an enormous orange

RIGHT: The artist of the full-page miniatures also executed initials within the Psalter, including this, showing God admonishing a fair-haired prince

eam altissimus.

Dominus narrauit in scripturis populo&:
& principum horu qui fuerunt in ea.

Sicut letantium omnium: habitatio in te.

Canticum psalmi filiis chore in fine
pro melech ad respondendum. In
tellectus eman isrlite.

OMINE
deus salutis mee:
in die clamaui &
nocte coram te.
Intret in conspectu

tuo oratio mea: inclina aurem tuam ad
precem meam.

Quia repleta est malis anima mea: & ui
ta mea inferno appropinquauit.

Estimatus sum cum descendentibus in la
cum: factus sum sicut homo sine adiu
torio. inter mortuos liber:

Sicut uulnerati dormientes in sepulchris

cap and seated on a blue goat as he leads a dog on a leash, followed by a man; a pair of winged twins in orange tunics seated on the backs of giant birds; and a truly wonderful dark-brown hairy monster, perhaps a bear, resembling a wild thing as illustrated by Maurice Sendak, standing on its hind legs gazing forwards with its paws under its chin. This is on folio 110r. If the manuscript was intended for a child, these are joyous images to engage attention and to aid memorization of the pages.

The second artist is the one we have already met, who worked on the Hunterian Psalter and on four manuscripts illuminated in Paris. In the Copenhagen Psalter, he painted quire i (the calendar) and quires iii–ix (folios 16–71). He may sometimes have collaborated elsewhere, as on folio 103r. The great Beatus initial is by him, with its real gemstones pasted on. He employs paler and softer colours, and his burnished gold is often beautifully tooled, like chased metalwork. Pictures by him include large historiated initials of Samuel crowning David for psalm 26; Nathan chastizing King David for psalm 50, including Bathsheba leaning affectionately on the king's shoulder – she has long plaited fair hair, very Scandinavian; and Saul commanding Doeg to slay Ahimelech and all his family for disloyalty, illustrating psalm 51. Although all these subjects are common in Psalters, they would have seemed relevant for royal use.

The third illuminator – at least as distinguished by Patricia Stirnemann (I am not quite sure that I can really tell him from the first) – painted quires xvi–xviii. These correspond to folios 120–43. His initials are mainly decorative, but they include a man fighting a white dog and a blue lion killing a green dog, and a standing bear.

The fourth and final artist of the Copenhagen Psalter is one of the most recognizable and famous of all twelfth-century illuminators. In England we call him 'the Simon Master'. In France he is sometimes known as 'the Master of the Capuchins' Bible'. His style is part of a group described by despairing art historians as 'Channel School' because frankly we do not know whether it is English or French. Here the Simon Master decorated quires xix–xxiv, corresponding to folios 144–91. His

RIGHT: The artist of the full-page miniatures sometimes painted strange animals and monsters, including this hairy creature standing on its hind legs

tio mea preueniet te.

V tquid domine repellis orationem meam?
auertis faciem tuam a me?

P auper sum ego & in laboribus a iuuentu
te mea: exaltatus autem humiliatus
sum & conturbatus .

I n me transierunt ire tue: & terrores tui con
turbauerunt me .

C ircundederunt me sicut aqua tota die:
circundederunt me simul .

E longasti a me amicum & proximum: &
notos meos a miseria . I ntellectus ethan
israhte .

IS e
ricordi
as domini:
in eternum cantabo.
I n genera tione & generatione:

ABOVE: The Hunterian Psalter in Glasgow is a close cousin of the Copenhagen manuscript, perhaps copied by the same scribe and certainly illuminated by one of the same artists

RIGHT: The same scene in the Copenhagen Psalter, the Anointing of David by Samuel, painted by the same artist, both illustrating psalm 26 (in the Vulgate numbering)

picture initials are a half-length king holding a scroll for psalm 137 and the figures of the prophets Isaiah and Habakkuk in the canticles. Others include characteristic 'Channel' features, such as distorted and sinewy pink lions; tiny white dogs clambering through foliage; naked blue giants; dragons biting each other to form themselves into the shape of initials; a lion on its hind legs fighting a man with a sword and shield; cats with musical instruments; a man with a wooden leg shaving a hare; a naked man wrestling with green lions; and many others.

"What do they mean, these ridiculous monstrosities?" asked Saint Bernard of Clairvaux rhetorically in his celebrated denunciation of art in the first half of the twelfth century; "why these immodest apes?

 IM
nus illu
minatio
mea. & sa
lus mea.
quem ti
mebo?
ominus

protector uite mee. a quo trepidabo?
um appropiant super me nocentes. ut
edant carnes meas.
Qui tribulant me inimici mei. ipsi in
firmati sunt & ceciderunt.
i consistant aduersum me castra. non
timebit cor meum.
i exurgat aduersum me prelium. in
hoc ego sperabo.
nam petii a domino. hanc requiram.
ut inhabitem in domo domini omni
bus diebus uite mee.

Detail of an initial illuminated by the Simon Master towards the end of the Copenhagen Psalter, showing a cat playing a stringed rebec

What use are lions? monstrous centaurs? half-humans? and mottled tigers? Why fighting knights and hunters blowing trumpets?" What do they mean? Nothing at all, would be my answer to Saint Bernard, but they add immensely to the joy of Romanesque manuscripts. Mouritz Mackeprang, in his account of the Copenhagen Psalter published in 1921 (although written earlier), struggled valiantly to relate the subjects of the pictorial initials to verses of the psalms they decorate. Psalm 16, for example, opens with a dancing lion resting its shoulder on a fish; Mackeprang suggested that it was an illustration of verse 12, 'They are like a lion hungry for prey.' Psalm 88 is introduced by that wonderful standing hairy wild thing, mentioned above: he related it to verse 8 of that psalm, 'He is more awesome than all who surround him.' Psalm 93 in the manuscript has a hybrid bear or lion devouring a lamb; Mackeprang pointed to verse 6, '[Evildoers] slay the foreigner and they murder the fatherless.' Look hard enough and you can find textual parallels for almost anything. In all probability most of the images are purely decorative, for these are pickings from repertoires in the artists' imaginations. It might be that an illuminator, wondering what to draw next, might happen to notice the word 'lion' (for example) somewhere on the page, which would be enough to trigger an idea; but these are not conscious psalm illustrations as such.

Some are stock designs, commonly found in other manuscripts. One picture by the Simon Master on folio 171v of the Copenhagen Psalter shows a cat playing a rebec, a stringed instrument used with a bow. It is a subject curiously widespread in Romanesque art, both in manuscript illumination and in sculpture. It must be what is referred to in the children's song beginning, 'Hey, diddle diddle, / The cat and the fiddle', part of ancient nursery lore of immense antiquity. I used to suspect it was perhaps to do with the string of a violin being supposedly made from cat gut, until one day a master of medieval music, Armando Lopez Valdivia, came to dinner at home bringing a rebec. As he began to play the instrument after supper, our cat rushed in at the sound, as if drawn by a magnet, rolling on the floor in ecstasy, eyes rolling, feet in the air, mouth open, as punch drunk as a dervish and hilarious to witness. Doubtless medieval cats responded the same way when musicians struck up rebecs in the twelfth century, and the comic association stuck.

On folio 173v is an initial formed of a man with a wooden leg holding a pair of shears over a hare or rabbit. It doubtless reflects the medieval expression that it was harder to do such-and-such than it was for a one-legged man to shave a hare. The point was that a hare was the fastest animal in the field and to catch one and then to hold it down while shaving it was impossible, but for a man with a wooden leg to do so, as shown here, was beyond impossible. It was a symbol of what simply could not be done. It also occurs on the opening illuminated page of the Bible of Bury St Edmunds Abbey, c. 1130, the earliest manuscript illuminated in England by an independently identifiable professional illuminator, Master Hugo (not to be confused with Hugo Pictor). That book is so incomparably vast and its design so complex that this picture there was probably a wry allusion by Hugo to a task which no one thought could ever be done. Look at the placing here. The same picture illustrates the final psalm of the Copenhagen Psalter. Perhaps here too no one thought the manuscript would ever be ready by the presumed deadline of 25 June 1170. It is as if the Simon Master is announcing that they have achieved the impossible.

The provenance, the text and the collaborating artists of the Copenhagen Psalter all bring us to that turning-point in the history of

dii ancipites in manibus eorum.

d faciendam uindictam in nationibz: increpationes in populis.

d alligandos reges eorum in compedibus: & nobiles eorum in manicis ferreis.

t faciant in eis iudicium conscriptu: gloria hec est omnibus sanctis eius. Alleluya.

AVOATE dominum in sanctis eius: laudate eum in firmamento uirtutis eius.

audate eum in uirtutibus eius: laudate eum secundum multitudinem magnitudinis eius.

audate eum in sono tube: laudate eum in psalterio & cithara.

audate eum in tympano & choro: laudate eum in cordis & organo.

audate eum in cimbalis bene sonantibus.

books when literacy was passing out of the monopoly of the monasteries, when itinerant secular artists were edging into the business but had not yet settled in permanent workshops, and when manuscripts crossed the great divide from inalienable possessions of the Church into luxurious and purchasable artefacts for the laity, with a definable cost and a commercial value. The Simon Master, like Hugo in the Bury Bible, was demonstrably a professional illuminator. He very possibly began his career at Saint-Victor in Paris. Many of the books he painted were the kind of textbooks which students at the schools of Paris might purchase and take home, which must be the explanation of manuscripts by him which belonged in the Middle Ages to monasteries as widespread as Bonport (in Normandy), Liesborn (in western Germany), Klosterneuberg (in Austria) and Esztergom (in Hungary). However, the Simon Master also travelled. There is no reason why he could not have been to Denmark, through his Victorine connections. He takes his modern sobriquet from Simon, abbot of the great monastery at St Albans in southern England from 1167 to 1183. Simon had been in touch with the abbey of Saint-Victor in Paris about importing new texts, and clearly at some stage in his abbacy – maybe in the 1170s – exemplars and illuminators were brought across to England, this artist among them. At least three books made by local scribes in St Albans during the time of Abbot Simon have decoration attributable to him. In all probability, the Simon Master later moved on to work for other patrons too as opportunity arose, possibly in England, or perhaps he returned to France. The twelfth century is the period from which we begin to have considerable amounts of information and yet sometimes we know absolutely nothing.

There is a feature of the Copenhagen Psalter which is not at all unique to that manuscript, but which has never been extensively discussed as a phenomenon in studies of medieval books. Above or beside every miniature and illuminated initial here are tiny sewing-holes. It is clear that all the illumination in the Psalter was once concealed behind little

LEFT: The initial for the final psalm, painted by the Simon Master, depicting a man with a wooden leg catching and shaving a hare, a medieval emblem for a task which was impossible

protective textile curtains which were stitched onto the pages. Such holes are very common in grandly illuminated manuscripts, especially of the twelfth century in England and in northern Europe. Every member of our intimate family of royal Psalters has them: there are sewing-holes adjacent to the illumination of the Hunterian Psalter, the Ingebourg Psalter, the Avranches Psalter, the Psalter of Blanche of Castile and the Leiden Psalter. Once you start to notice them, it is striking how widespread these sewing-holes are in luxury manuscripts of this date. We need not doubt that these are contemporary with the books themselves. The stitch holes are either at the tops of pages, for flaps which lifted up, or are down the left-hand sides of initials, occasionally even beneath them, so that curtains once unfolded sideways or upwards like little shutters. Very occasionally textile flaps actually survive in Romanesque manuscripts, still sewn in place. They often seem to have been roughly and even carelessly stitched. They were not merely to protect illumination from rubbing, like the modern paper interleaving currently loosely enclosed in the Copenhagen Psalter, for a manuscript which is simply closed up suffers no friction. If that were so, then one curtain would suffice for each double-sided illuminated opening. On the contrary, leaves here with the full-page miniatures all have two rows of sewing-holes at the top of each page, showing that the pictures on both sides of each leaf must have had their own separate curtains.

We are accustomed to medieval illuminated manuscripts presenting astounding and sparkling effects as the pages are turned or when the books are exhibited as double openings in glass display cases. When its first owners opened the Copenhagen Psalter, the appearance would have been very different. The illuminations would all have been out of sight, like icons in Greek churches, hidden behind curtains. The act of lifting the flaps, to reveal the sacred or decorative images, must itself have been part of the devotional experience. Revelation, like the parting of red and white curtains to show the Incarnation depicted in the miniature on folio 9v, is made literal. It is a reminder of what a different world we inhabit.

In other aspects, this medieval Psalter and its daily prayers still have resonance and relevance today. We, the laity in Europe, can now mostly

read, a development of education which goes back to this new fashion in the twelfth-century royal courts. The practice gradually trickled down the social scale to people like us. Countless men and women still use the psalms, and many of the festivals of the Psalter's calendar punctuate our modern year, even without religion, including Saint Valentine's Day, Easter and Christmas, all listed here. On 24 June the manuscript gives the Nativity of Saint John the Baptist and, on the same day, the word "*Solsticium*", both entries being singled out in blue ink. 23 June, the eve of the midsummer solstice, "Sankt Hans Aften", as they call it, is still a popular festival in Denmark and late-night bonfires are lit on the beaches. I have taken part in it on the shore in Gammel Skagen, in northern Jutland, Duke Erik's dominion, linking arms in that experience with a tradition in Scandinavia which seems far older than Christianity.

Declarations of personal faith are not my topic here. However, what I understand by the 'communion of saints', invoked as an article of belief at the end of the Creed (included in the Psalter here), is that it is a kind of spiritual kinship with fellow believers from across all ages, sharing aspirations and experiences in common. I felt a sudden moment of this, after a long day in the Royal Library, in reading the evening collect for peace on folios 193v–194r of the Copenhagen Psalter. It begins, "Deus a quo s[an]c[t]a desideria recta consilia & iusta sunt opera ...", words which were then already very ancient and which are still used every night in Evensong in the chapel of Corpus Christi College and elsewhere across Western Christendom, and which are as relevant today as they were to Valdemar the Great and Knud IV, who read them here too, as we do. In the translation of the English Prayer Book they are: "O God, from whom all holy desires, all good counsels, and all just works do proceed, give unto thy servants that peace which the world cannot give ... and also that by thee, we, being defended from the fear of our enemies, may pass our time in rest and quietness ..." That text has not changed, or the need for peace and freedom from fear, in 850 years. Our world and theirs touch hands for a moment, and the heart leaps in a shared prayer.

OVERLAF: The collects at the end of the Copenhagen Psalter, including prayers for the grace of God and for peace and freedom from fear of our enemies

DEVS cui propri or.
um est misereri semper &
parcere. suscipe deprecati
onem nram. & quos delicto
rum cathena constringit: miseratio tue
pietatis absoluat. Alia.

Omnipotens sempiterne deus
qui facis mirabilia magna
solus. pretende sup famulos
tuos & sup cunctas congrega
tiones illis comissas spiritu gratie salu
taris. & ut in ueritate tibi complaceant:
ppetuu eis rorem tue benedictionis in
funde. Alia.

Pretende dne fidelibus tuis
dexteram celestis auxilii. ut
& te toto corde perquirant:
& que digne postulant conse
qui mereantur. Alia.

Deus a quo sca desideria re
cta consilia & iusta sunt o

pera: da seruis tuis illam quã mundus da
re ñ potest pacem. ut & corda nra manda
tis tuis dedita: & hostium sublata formidi
ne tempora sint tua prestione tranquilla.

Domo tua Alia.
quesumus domine spirituales ne
quitie repellantur. & aeriarum di
scedat malignitas tempestatum.
Hinabus quesum' Alia.
dñe famulorum famulartúq; tua
rum oratio pficiat supplicantium.
ut eas & a peccatis omnibz eruas:
& tue redemptionis facias ee participes.

Evs qui es Alia..
sanctorum tuorũ splendor
mirabilis atq; lapsorum
sulleuator inenarrabilis: fac
nos famulos tuos sce dei genitricis semp
q; uirginis marie, & omnium scorum tuox
ubiq; tueri presidiis. necnon familiarita
te atq; consanguinitate nob iunctis, &

The *Carmina Burana*

first half of the thirteenth century
Munich, Bayerische Staatsbibliothek,
Clm 4660

I took the Latin option at school, not because I had any particular aptitude for it (I hadn't), but because I was generally worse at nearly everything else. It was a local state school for boys, King's High School, in Dunedin, New Zealand, where, with hindsight, the curriculum was even then very old-fashioned. We struggled through the usual grammar and translation exercises. One day in the sixth form, our Latin teacher – he was called Mr Dunwoodie – imaginatively brought in a portable gramophone from home and a recording of the medieval *Carmina Burana* set to music by Carl Orff (1895–1982). It was unforgettable. We were all captivated by the haunting music and the sensuous rhythmical Latin lyrics about girls and drinking and the manifest unfairness of fortune. To a classroom of hormone-humming teenage boys, here was Latin which touched the soul as Caesar's *Gallic Wars* had never done. We urged Mr Dunwoodie to play it over and over again, assuring him that it was educational. To his credit, he did. We soon knew many of the Latin verses by heart, and some I still do: *o! o! o! totus floreo, iam amore virginali, totus ardeo!* – 'Oh! Oh! Oh! I am all in bloom, now I am all burning with first love', and so on. We were just the right age. This music was to us a seductive evocation of anarchic and amorous medieval students vagabonding their way in verse and song across twelfth-century Europe, with a free-spirited ethos very like that of the

mid-1960s. It is quite likely that Latin masters in schools elsewhere in the world sometimes also played the same record to their own classes at that time and our generation all shared familiarity with these songs of lust and rebellion in Latin, which for that purpose was still – just – serving as an international language.

Some years later as a graduate student in Oxford in the early 1970s I spent my summers with a rucksack and a camera, the latter borrowed from the Bodleian Library, travelling many of those same routes as the wandering scholars of the *Carmina Burana* had done 800 years earlier to Paris and around the cathedral cities of France and Germany and the monasteries of Austria, looking at medieval manuscripts in local libraries. I mostly stayed in youth hostels, or in a tent. It was a lonely but fascinating experience, but I rather enjoyed the self-image of brushing the grass and insects from my hair and making first for the washrooms of municipal libraries, where I shaved and cleaned my teeth, before presenting myself brightly at the inquiry desks with lists of precious twelfth-century books to see. Sometimes I met the same people in the reading-rooms of many libraries, and we all felt part of a kind of international confraternity of itinerant students from different universities working on our various doctoral theses. Once, when my German failed in a monastery in Austria, I resorted in desperation to Latin as the only common language.

I remember my first visit at that time to the Bayerische Staatsbibliothek in Munich. After homely and sleepy libraries of rural France, where schoolchildren and old men frittered away their afternoons in chatter and newspapers, Munich was seriously daunting. The state library is in the Ludwigstrasse, the great avenue which runs from the Siegestor, the monumental arch in the north of the city, down to the Odeonsplatz in central Munich. The library is an enormous classical building in brick and that ubiquitous central European yellow paint. It was opened in 1843. There are four sculpted giants seated on pedestals outside, Thucydides (history), Homer (literature), Aristotle (philosophy) and Hippocrates (medicine). You go up the steps from the street

LEFT: The great staircase in the Bayerische Staatsbibliothek, which, it is said, only King Ludwig I of Bavaria was permitted to ascend during his lifetime

and push through one of three big doors which open into a vast and high lobby. It is like the biggest bank you have ever entered. Before you rises a huge white marble staircase between classical pillars. The metal banisters are attached by tiny bronze lions. It is said that Ludwig I, king of Bavaria 1825–48, planned this to be the grandest staircase in Europe and that during his lifetime he was the only person allowed to use it. As I negotiated nervously up it in the 1970s, I felt about two inches tall. At the top are enormous statues of Albrecht V, duke of Bavaria 1550–79, who founded the library in 1558, and King Ludwig I himself. The library building is arranged around two quadrangles on either side of the staircase. For the general reading-rooms for printed books you would proceed straight ahead. To reach the rare book and manuscript department you turn right and right again, doubling back towards the front of the building, through the pillared Fürstenhall above the entrance, and then left along the corridor parallel to the Ludwigstrasse, past the door to the exhibition room for library treasures, through a turnstile, left once more (now continuing away from the street into the far side of this quadrangle), passing two spectacular sixteenth-century globes and the travelling library of King Ludwig, and finally into the reading-room. It has natural light from either side, tempered by net curtains. There are long tables occupied by grey-headed professors who look as though they have academic titles in German running to several lines. The issue desk is at the far end of the room. There are stairs in the centre leading up to book stacks on the mezzanine floor, with probably the most comprehensive open-shelf collection of reference books on manuscripts in the world (it will reappear briefly in Chapter Twelve). The setting is professional and intellectual, and the only sound is the industrious scratch of pencils. There is nothing sleepy or provincial about the Staatsbibliothek in Munich.

The original thirteenth-century manuscript of the *Carmina Burana*, and the source for the cantata of Carl Orff, has been here since 1806. It is called 'Burana' from the Latin name for the monastery of Benediktbeuern in Upper Bavaria, founded in the eighth century about forty miles south of Munich. The manuscript was discovered uncatalogued among the books in the library there after the suppression of the monastery

The monastery of Benediktbeuern in Upper Bavaria, closed in 1803, where the manuscript of the *Carmina Burana* was found and from which it takes its name

in 1803 during the Napoleonic reforms. It contains about 350 poems and songs, many of them unique, of which only about twenty pieces or extracts were eventually set to modern music by Orff. Most are in Latin, but the volume has scraps in various European languages and important pieces in Middle High German, which are among the oldest surviving vernacular songs. The manuscript of the *Carmina Burana* is by far the finest and most extensive surviving anthology of medieval lyrical verse and song, and it is one of the national treasures of Germany.

I owe my permission to see the manuscript to Wolfgang-Valentine Ikas, head of reference in the rare-book department in Munich, whom I had the good fortune to encounter at a conference in Tennessee. As I began to explain my request, I could sense him dreading that I was about to ask for the Gospels of Otto III, one of the most valuable and most supremely fragile books in existence, and his relief when I named the *Carmina Burana* was palpable. Nonetheless, it is too precious to be normally available. Even Dr Ikas himself had never actually seen the original. First of all, he had to consult the conservators from the Institut für Buch- und Handschriftenrestaurierung as to whether the

manuscript was in a fit condition to be consulted by a mere reader at all. After a few anxious days, consent was granted.

This visit was very different from those first student forays with the rucksack. They waived my need for a reader's ticket and I was taken straight through. I recognized several people in there already, including Berthold Kress from the Warburg Institute, who was photocopying an article in Russian on images of the prophet Daniel and did not seem the slightest bit surprised to see me, and Günther Glück, who had come to study beautiful books, of which he himself owns a very refined private collection. Necessary pleasantries were exchanged and I proceeded to the issue desk.

Because the *Carmina Burana* is classified as a 'Tresorhandschrift', the highest grade of importance in Munich, I was required to wear gloves, which they sell to readers and you may keep them afterwards (to be fair, they gave me mine). They are white with ribbed backs, trimmed with scarlet around the wrists: very stylish, even though the lines of bright colour make it look slightly as though your hands have been cut off. I was directed to a special roped-off table to the left of the supervisors' desk. They brought out blocks of wedge-shaped foam, draped with green baize. The manuscript and its separate supplementary leaves are kept in weighty hessian-covered boxes.

The book's binding is about 10 by 7 inches and the volume is around 1¾ inches thick. The thin wooden boards are eighteenth century, bevelled on their inner edges in the German manner, covered with blind-stamped brown leather. The style of the binding is identical to that of other manuscripts once at Benediktbeuern, and is now the only absolute evidence remaining that the book was ever in that monastery at all. The single clasp and catch are late medieval, and were presumably transferred from a previous binding. A strap is attached to the edge of the lower cover (again characteristically German: in a French or English binding it would be suspended instead from the upper cover). The strap, which is repaired, is of leather tawed white, which might therefore have been the colour of the book's medieval binding. The clasp at the end of the strap and the catch on the upper cover onto which it hooks are both of brass, engraved with the words in gothic script "ave"

and "ma[r]ia" (the 'r' obscured by the nail attaching the catch to the cover). There is now an unsightly conservation packet, like a medical dressing, tied around the clasp to protect it from scratching anything else. Devotional words such as 'Ave Maria' are quite common on medieval German book bindings and are not necessarily any indication of provenance, but they are entirely consistent with a text which we must assume was once bound for a religious community.

Squeeze the manuscript slightly to release the clasp, and open it up on the library's green baize book-rest. There is a paper flyleaf with various additions including "B Buran 160" in pencil (early nineteenth century, crossed through), an approximate date "s.XII–XIII" in red ink (also crossed through), and the current shelfmark "Clm 4660" in a large hand in purple chalk. This number is also on a paper label on the spine. In the Staatsbibliothek the letters 'Clm' stand for *Codex latinus monacensis*, 'Munich Latin manuscript', and so strictly it is tautology to write, as people often do, 'Munich MS Clm' such-and-such, for all that is subsumed in the three initials. The *monacenses* were numbered in order of accession. Those brought from Benediktbeuern are Clm 4501–4663; 4660 was thus the 160th in sequence, which explains the pencil number.

On the first page of the manuscript is the famous signature image of the Wheel of Fortune, depicting a king presiding at the top and then tumbling down as his crown falls from his head and finally lying crushed at the foot of the wheel. There is irony therefore in the indelible nineteenth-century black stamp slapped to the right above the picture of the falling king, "BIBLIOTHECA REGIA MONACENSIS", 'Royal library of Munich', since, with the turning of fortune, the royal kingdom of Bavaria was abolished in 1918 after the First World War. At the foot of the page, added in six tiny lines crammed into the lower margin, not even part of the manuscript as originally written, are the words rendered iconic by Orff's staccato drumbeats and clashes of cymbals, "O fortuna, velud luna, statu variabilis, semp[er] crescis aut decrescis, vita detestabilis ...", and so on, 'O Fortune, like the moon, ever changing, eternally you wax and wane, dreadful life ...'

Actually, this is not the real opening of the *Carmina Burana* at all.

The manuscript is quite easy to collate (even wearing gloves), for the parchment is generally thick and the sewing is clearly visible.* However, the book is not at all in its original state. The two leaves now at the start are nothing more than pages cut from elsewhere in the manuscript and transferred to the beginning, presumably during the eighteenth-century rebinding, to provide a decorative opening. Such cosmetic adjustment is not unusual in manuscripts owned by bibliophiles who hate to see a text glaringly imperfect on its first page. That is not all, however, for the sequence is still lamentably jumbled and incomplete.† Some of the missing leaves, including six of those from a quire lost near the end, were discovered by Wilhelm Meyer (1845–1917), professor in Göttingen, among the vast residue of miscellaneous loose leaves then unsorted in the Staatsbibliothek. These are now Clm 4660a, known as the *Fragmenta Burana*, accompanying the main manuscript but still in nineteenth-century paper folders, with notes by Meyer dated 1870, all in a portfolio tied with black ribbon and kept in a separate matching hessian box. It is a question which must have come up from time to time, whether to disassemble the indifferent eighteenth-century binding to restore all leaves to their proper sequence, including the loose leaves found later, for it is not easy to form a mental picture of the original manuscript and its content while it is in its present order.

Sometimes the very first impression of any manuscript can be unexpectedly informative. All manuscripts do not look like each other. Across the reading-room in Munich I could see people consulting

* As bound now, it runs: i², ii–vi⁸, vii⁶ [of 8, lacking vii–viii (2 leaves after folio 48)], viii¹ [of unknown number, a single leaf remaining (folio 49)], ix⁷ [of 8, lacking vii (a leaf after folio 55)], x–xi⁸, xii⁸⁺² [a bifolium (folios 78–9) inserted after v], xiii–xiv⁸, then a whole quire missing, xv⁸, xvi⁶. The two leaves described as missing after folio 48 are those transferred to the beginning, now called quire 'i'.

† The original order of the gatherings, as numbered above, would once have been: vii+i, ii–vi, viii, xii, ix–xi, xiii–xvi, lacking at least a quire at the beginning and another quire between folios 98 and 99. In the numbering of the folios, this order would have been: [leaves lacking], 43–48, 1–42, 49, 73–82, 50–72, 83–98, [a quire lacking], 99–112.

RIGHT: The present opening page of the *Carmina Burana*, showing the Wheel of Fortune and the addition in the lower margin with the song 'O fortuna, velud luna'

BIBLIOTHECA
REGIA
MONACENSIS.

Regno.

gnabo

regnaui

sum sine regno.

FO. QT. Mesas ambulant passu fere pari. pro
digus non reditur uitium auari. uirtus temperantie
quadam singulari debet medium ad utrumq; uitiu
caute contemplari. Si legisse memoras ethicam ca
tonis. in qua scriptum legitur: ambula cum bonis.
cu ad dandi gloriam animum disponis. inter cete
ra hoc primum considera. quis sit dignus donis. Dare

O fortuna uelut luna statu uariabilis semp crescis aut decrescis uita de
testabilis nunc obdurat z tunc curat ludo mentis aciem et estatem potestate
dissoluit ut glatiem. Sces immanis z manis rota tu uolubilis statu malus
uana salus semp dissolubilis obumbratam z uelatam m quoq; nitens nunc p tuum
dorsu nudum fero tuuscelerts. Sces salutis z uirtutis m nuc gnaria e afficit et
defectus semp angaria hac i hora sine mora cordis pulsu tangiter q z sce sternit fortm.

Ottonian liturgy, Italian law, and French Books of Hours. These are recognitions made entirely by format, size, appearance of script (without reading a word of it), and the scale and colour of ornament. Many of us make these judgements without really thinking. M. R. James (1862–1936), who in his time had probably handled more medieval manuscripts than anyone then alive (and who had first catalogued the Morgan Beatus in 1902), conveys something of this instinctive process in his ghost story *Canon Alberic's Scrap-Book*: "Even before the wrapping had been removed, Dennistoun began to be interested by the size and shape of the volume. 'Too large for a missal,' he thought, 'and not the shape of an antiphoner' …"

If I had seen someone studying the *Carmina Burana* at some distance, I might have thought they were examining a Breviary. Without looking too closely, that is really what the manuscript looks like. A Breviary was (and for monks still is) the standard compilation of psalms and readings for the church year recited during the daily offices from Matins to Compline. It was used by the clergy and members of religious houses. A Breviary was an easily portable book, sometimes called a 'Portiforium' for that reason, compact and orderly, chunky and thick, often written in quite informal script (unlike a Missal). The earliest Breviaries in Germany date from around 1200, precisely the period of the genesis of the *Carmina Burana*. The resemblance is not merely in shape and size, but also in the page layout with nearly every sentence beginning with a red initial, like the verses of psalms, and the insertion here and there of specimen lines of musical notation above the script, as often in Breviaries. Some of the songs actually open with the same words as psalms familiar from Breviaries, such as "'Bonum est'" and "Lauda". It is commonly noted that the love poems of the *Carmina Burana* follow a sequence from spring to autumn: so does the summer volume of a Breviary, from Easter to the last Sunday before Advent. I do not know whether any modern scholar of medieval literature or secular music has observed the parallel before, but the visual pun would surely have been noticed by anyone in the early thirteenth century.

RIGHT: Much of the *Carmina Burana* appears at first sight to resemble a thirteenth-century breviary, with red initials, readings, apparent rubrics and short sections of musical neumes

comprehensam rea solo clarior non est sub polo uiribus in
uicta. Satis illi fuit gratie. michi gratum est suaue quod fe
cisti inquid praue ne ne tamen aue ne reuelet illi ca
uel. ut sim domi tuta. Si senserit meus pater uel mara
nus maior frater erit michi dies acer. uel si scieret mea
mater cum sit angue peior quater uirgis sum tributa.

EIA. Dulcis in tempe
florenti stat sub arbore Iuliana cum sorore dul
cis amor. Ref. Qui te caret hoc tempore fit ui
lice. Ecce florescunt arbores lasciue canunt uolucres in
de tepescunt uirgines. dulcis amor. Ecce florescunt lilia
e uirgines dant agmina summa deorum carmina dulcis amor
Si tenerem quam cupio in nemore sub folio oscularer cum
gaudio dulcis amor. Item a t. oooooooooo

Vror. Estas in . . . choatur ameno tempore phe
buisque dominatur a pulso frigore. Vinus maiore
puelle uulnere multimodo dolore p quem z arte
ror. Vt mei misereatur z me recipiat z declinetur ad me
z ita desinat.

FLOREBAT. Olim studium. nunc uertitur
in tedium. iam scire diu uiguit. s; ludere pualu
it. Iam pueris astucia contingit ante tempora. qui
p maliuolentiam excludunt sapientiam. Set retro
actis seculis uix licuit discipulis tandem nonagerium
quiescere post studium. At nunc decennes pueri de
cusso iugo liberi. se nunc magistros iactitant. ceci cecos
pcipitant. Inplumes aues uolitant. brunelli cordas in
citant. boues in aula salitant. sine precones militant.
In taberna gregorius iam disputat inglorius. seueritas
Jeronimi partem causatur obuli. Augustinus de sege
te. benedictus de uegete. sunt colloquentes clanculo.
et ad macellum seculo. Mariam grauat sessio. nec
Marthe placet actio. iam lye uenter sterilis. rachel lippe
scit oculis. Catonis iam rigiditas suertitur ad gane
as. et castitas lucretie turpi seruit lasciuie. Que pri
or etas respuit. iam nunc clarius claruit. iam calidu
in frigidum ⁊ humidum in aridum. Virtus migrat
in uicium. opus transit in ocium. nunc cuncte res de
bita, orbitant a semita. Vir prudens hoc consideret.
cor mundet ⁊ exoneret. ne frustra dicat dne in ulti

A few generations later, the Franciscan troubadour Matfre Ermengaud called his collection of secular verse the *Breviari d'amor*, the Breviary of Love, making the same pairing in its name.

Once the leaves of the manuscript are reconceived into their original order, there are four clear sequential clusters of text. They are usually classified as moral and satirical poems; love songs, opening with the heading "*Incipiunt iubili*", 'Songs begin' (that is, on folio 18v); drinking and gaming songs; and religious dramas. Let us take each in turn.

Many of the satirical poems are on the eternal themes (not unique to our own or any age) of the corruption of morality in modern times, such as "Ecce torpet probitas" ('See how decency is moribund'), and how the world is no longer governed by virtue but by money instead, now the greatest king on earth, "In terra nummus rex est hoc tempore summus". There are poems on the harshness of fortune, including "Fortune plango vulnera" ('I sing the wounds of fate') and the famous "O fortuna, velud luna" already mentioned, both of which are additions in blank margins. Some are on the decline of learning, such as that on folio 44v:

> Florebat olim studium
> nunc vertitur in tedium,
> iam scire diu viguit,
> s[e]d ludere p[re]valuit.
> Iam pueris astutia
> contingit ante temp[or]a,
> qui p[er] malivolentiam
> excludat sapientiam …

('Scholarship once flourished, now it is turned into boredom; for a long time knowledge was esteemed, but now playing is preferred. Now the cunning of a boy takes hold before its time, and through mischief it eliminates wisdom …')

There is a fascinating mock Gospel reading beginning on folio 11r, with a heading "*Ewangelium*" in red (the 'w' is a Germanic spelling),

LEFT: The poem 'Florebat olim studium' on the eternal theme of the decline of learning in our own time, in contrast to the esteemed scholarship of the past

intended to look at first glance like a normal Gospel lection from Saint Mark in a Breviary or Missal, until one realizes that it refers to the currency, silver marks, "*INITIUM s[an]c[t]i ev[an]g[e]lii se[cu]nd[u]m marcas argenti*, In illo t[em]p[or]e dixit papa ..." It is a scurrilous prose narrative about the pope and his cardinals refusing to admit anyone unless they pay hugely for the privilege. The text is made up almost entirely from thirty-one authentic quotations from the Latin Bible reassembled utterly out of context, snipped and pasted from words of the Epistles, Gospels, Job, Psalms, Zephaniah, Acts, Jeremiah, Deuteronomy, and so on. It reminds me of a joke sermon an ordinand at Knox College once taught to me late at night, which began, "Behold, there came two wise men, and their names were Adam and Eve, and they went out into a field to sow, and they fell upon a fertile woman, and their tribe numbered many ...", and much more (after several beers I think I can still do most of it), where the humour depends on knowing the Bible intimately. Although the satire here is harshly critical of the papal Curia, it is only comprehensible in a religious context.

The love songs form the longest and most famous section of the *Carmina Burana*. There are about 188 of them, depending rather on how they are divided. They are almost all copied out as if they were blocks of consecutive prose (unlike lines of verse in the Leiden *Aratea* or the Hengwrt Chaucer, which begin on a new line each time), and rhyme patterns here are hardly noticeable until you start to read the texts aloud. Some poems describe love affairs of history, such as that of Aeneas and Dido, but most pretend to recount personal experiences of romantic encounters or unrequited passion. Many begin with descriptions of springtime when young men's thoughts turn to love. That was a common convention in the first lines of medieval secular poetry. (The opening of the *Canterbury Tales* "Whan that Aprill ..." was humorous, for, instead of love, as the fourteenth-century reader would expect in April, Chaucer's motley heroes lust for pilgrimage instead.) In the *Carmina Burana* there are many pastoral maidens in sunny meadows and randy lads seizing opportunities, or pining in vain. A good

RIGHT: The mock Gospel, '*Ewangelium*', constructed from authentic biblical phrases reassembled to form a satire on the corruption of the papal court

languet mundus ope. Set cum sis plena uis cedat his
uisia premantur orbe leto tristi spireto iure freto pellan
tur. Aruit spes estuans diuturnitate. secula iam pere
unt diinbecillitate. ordo principatus mentis discrepata
uoluitur inserie. mundo non piata. falso quoque uerita
tis conuincitur augurio. nec altus est in istahel fidem
dans centurio. Ewangelium ꞏꞏꞏꞏꞏꞏꞏꞏꞏꞏ

INITIVM sci euglii. sedm marcas argenti. In illo
tpe dixit papa romanis. Cum uenerit filius homini
ad sedem maiestatis nre primum dicite. Amice ad
quid uenisti. At ille si pseuerauerit pulsans nil dans
uobis. eicite eum intenebras exteriores. factum est au
ut quidam paup clericus ueniret ad curia dñi pape.
et exclamauit dicens. Miseremini mei saltem uos hos
tiarii pape. quia manus pauptatis tetigit me. Ego nõ
egenus et paup sum. ideo peto ut subueniatis calami
tati et miserie meę. Illi aut audientes indignati sut
ualde. et dixerunt. Amice paupertas tua tecum sit in
pditione. Vade retro sathanas. quia non sapis ea que
sapiunt nummi. Am am dico tibi. non intrabis i gau
dium dñi tui. donec dederis nouissimum quadran
tem. Paup uero abiit ꞇ uendidit pallium et tunica.
et umusa que habuit. et dedit cardinalibz et hostia

LUCIS. Orto sydere exit virgo ꝑecie Itē.

tate vernali oues uisa regere baculo pastorali.

Sol effundens radium dat calorem nimium uirgo

speciosa solem uitat �ṅoium sub arbore frondosa. Dum ꝑ

ᶜᵗᵒ paululum lingue soluo uinaclum salue regie digna

audi queso seruulum esto michi benigna. Qur salutas

uirginem que non nouit hominem exquo fuit nata sa

at deus neminem inueni ꝑ hec prata. Forte lupus ade

rit quem fames expulerat gutturis auari oue rapta ꝑ

perit cupiens saturari. Dum puella cerneret quod sic o

uem ꝑderet pleno clamat ore siquis ouem redderet me

gaudeat uxore. Mox ut uicem auxilio denudato gladio

lupus immolatur ouis ab exicio redempta reportatur.

PARA Bula mediante Item at

non in malo paulo ante lucesolis radiante uirgo

uultu eleganter fronde stabat sub uernante canens

cum acuta. Illuc ueni fato aiante nimpha non est forme tante

equi pollens eius plante que me risto festinante grege fugit

cum balante metu dissoluta. Clamans redit ad ouile hanc

sequendo precor sile preces spuit ⁊ monile michi ⁊ meas

hostile quod ostendi tenet uile uirgo sic locuta. Munus uel /

trium uirginit uolo, et plena estis dolo rse sic ostendit colo.

example opens half-way down folio 63v and ends towards the top of the next page:

> Vere dulci mediante,
>
> non in maio, paulo ante,
>
> luce solis radiante,
>
> virgo vultu elegante
>
> fronde stabat sub vernante,
>
> canens cum cicuta.
>
> Illuc veni fato dante,
>
> nimpha non est forme tante,
>
> equi pollens eius plante,
>
> que me viso festinante
>
> grege fugit cum balante
>
> metu dissoluta …

('In the middle of sweet springtime, not in May but a little before [this is an accepted conjecture, for the manuscript actually says "non in malo", which makes less sense], as the bright sun shone, a maiden with a pretty face stood under the green foliage playing a pipe. I came there assigned by fate. No nymph has such beauty, or is worth the equal of her bare foot. When she saw me hurrying [another conjecture, for the scribe wrote "que me iusto festinante"], she fled with her bleating flock [she was evidently a shepherdess], overcome by fear …') During the course of the next verses he catches up with her, offers her a necklace, which she scorns, but he nevertheless pins her to the ground and kisses her, or more, and afterwards her only concern is that her father and brother should never know, and especially not her mother, who, as the girl says, is worse than a serpent ("angue peior"). As folk songs (and teenage experiences) go, it is fairly normal.

A much finer piece of literature is the great poem opening on folio 23r:

> Dum Diane vitrea
>
> sero lampas oritur,

LEFT: The opening of the song 'Vere dulci mediante', on the writer's romantic encounter with a pretty shepherdess in the sweet springtime

non equis legibus dampnandus animus ꝗ uineris rebus.

Sede si quis tam deuoto ludum inuitatur. huius rei testis octo
cholum cuius regit gloto. quod sepe nudatur. Causa lubi sepe
nudi sunt mei consortes. dum sic prestem sup uestem meam
mutant sortes. Heu p̄ludo sepe nudo dat uestem saccus. sed
dum penas mortis uenas. dat nescire bachus. Tunc faturant
peccatrum ꞇ laudant tabernarium. excluditur denarius pro
fertur sermo uarrus. o eusal misir belcher denn. tunc eum
osculantur uir enabren nihuf denrin ꝗ bacho fatulamur.

Tune rotant ciphi desup ꞇ canna pluit mustum ꞇ qui potaue
sic nup bibat pluf quam sic uestum. Tunc postulantur tef
ꝗ ipocaus iactantur nec de furore boree quicquam premeditat.

Ilraberna quando sumus. Item de Codem.
non curamus quid sit humus. sed ad ludum p̄eramus.
qui semp insudamus. quid agatur intaberna ubi num
mus est pincerna. hoc est opus ut queratur. sed quid loquar au
diatur. Quidam ludunt quidam bibunt. quidam indiscre
te uiuunt. sed inludo qui morantur. ex hiis quidam denudant̄.
quidam ibi uestuntur. quidam saccis induuntur. ibi nul
lus timet mortem. sed p bacho mittunt sortem. P rimo p̄num
mata uini. ex hac bibunt libertini. semel bibunt p̄captiuis.
post hec bibunt ter p uuuis. quater p̄xpanis cunctis. quinq̄

et a fratris rosea

luce dum succenditur,

dulcis aura Zephiri

spirans omnes etheri

nubes tollit, sic emollit

vi chordarum pectora

et immutat cor quod nutat

ad amoris pignora ...

This is the moon rising at dusk, lit by the setting sun: 'When the crystal lamp of Diana rises late and when it is ignited by the rose-coloured light of her brother, the sweet blowing breath of the west wind carries all clouds from the heavens, and so too it softens souls by the power of its musical strings and it transforms the heart faltering from the efforts of love ...' It is a poem about drifting gently into sleep, after the exertions of love. The poet's eyes close to the sound of nightingales and the wafting scent of rose petals under a tree. Say what you like about Carl Orff's music, but this is beautiful.

With the drinking songs we are shaken awake with the thump of beer mugs and the slapping of lederhosen. There are famous songs like "In taberna quando sumus / non curamus quid sit humus ...", 'When we are in the tavern we are not concerned with the nature of the earth ...', but rather with money for drinking: one drink for captives, three for the living, four for all Christians, five for the dead, six for sexy sisters, seven for sylvan soldiers, eight for naughty brothers, nine for scattered monks, ten for sailors, eleven for quarrellers, twelve for penitents, and thirteen for travellers; and much more, increasingly inebriated. This song is on folio 87v of the manuscript, which is quite badly damp-stained, and maybe the manuscript was used in the pub. Other songs are on gambling ("Tessera, blandita fueras michi ...", 'Dice, you were pleasing to me [once] ...'), and on chess ("Qui cupit egregium scachorum nosce ludum ...", 'Whoever wants to know the famous game of chess ...', actually a quite accurate explanation in verse of the moves of the pieces on the chessboard). One of the longer songs opens "Cum

LEFT: The drinking song 'In taberna quando sumus', the most damp-stained page of the manuscript, perhaps damaged during actual use in the tavern

in orbem universum …", the scriptural injunction to go out into the world (Mark 16:15), but it is turned here into a call for all the disaffected of Europe to defy the rules and to join the joyful and carefree life on the road, eating, drinking and gambling. Revellers are summoned from all points of the compass – Italians, Bavarians, Saxons, Austrians.

The fourth group of texts in the *Carmina Burana* comprises religious dramas. These appeal to scholars different from those interested in secular songs, for they are devotional. Such texts are the ultimate medieval predecessors of all modern theatre. Liturgical plays are known from the early tenth century onwards, based around the themes of the major festivals of the church year, including saints' days. The first drama here is a Christmas play, a tradition which still survives today, at least in nursery schools. The script in the *Ludus de nativitate domini* in the *Carmina Burana* manuscript opens on folio 99r with stage directions in red. It is very graphic and easy to envisage on a stage. It requires a large cast. Saint Augustine is to be seated in front of a church flanked by Isaiah, Daniel and other Old Testament prophets. The Archisynagogus (or high priest) enters from the left with further Jews. Isaiah sings, "Ecce virgo pariet sine viri semine / per quod mundum abluet a peccati crimine …" ('Behold a virgin will give birth without the seed of man, by which the world will be cleansed from the stain of sin', loosely from Isaiah 7:14). Daniel too chants a warning: "O iudea misera, tua cadit unctio …", about the Jews being seated in darkness. The Erithraean Sibyl points to a star and interprets it as a sign that the saviour of the world will be born through the conception of a virgin. Aaron enters and places his flowering rod on the altar, the only one which blossoms among the twelve rods of the tribes of Israel (cf. Numbers 17:8), and he too sings. Balaam comes in riding on an ass – the audience must have loved this bit – and reports that a star will arise from Jacob (cf. Numbers 24:17). The Archisynagogus stamps his foot and argues the logical implausibility of this, saying to the Jews that a man can no more descend from a virgin than a camel can from an ox. They all bring their dispute to Augustine, who rules that the prophecies cannot be wrong. The Archisynagogus

RIGHT: The *Ludus de nativitate domini*, the script of a play about Christmas, showing stage directions and the opening songs

Pritio ponatur sedes Augustino in fronte ecclesie. 7 Augustinus

habeat a dextera parte ysaiam 7 danielem. 7 alios pphas. a sinistra

aut archisynagogum 7 suos iudeos. Postea surgat ysaias cum pphe

tia sua sic. Ecce uirgo pariet sine uiri semine. per quod mun

dium abluet a peccati crimine. de uentur gaudeat iudea mu

mine. 7 nunc ceca fugiat ab erroris limine. Postea. Ecce uirgo

concipiet. 7e. Iterum cantet. Dabit illi dominus sedem dd. 7e.

Postea daniel procedat. pphetiam suam exprimens. O iudea

misera tua cadet unctio. cum rex regum ueniet ab excelso solio.

cum reuento florde castratis lilio. uirgo regem pariet. felix puer

perio. iudea misera sedens in tenebris. repelle maculam relicti tu

nebris. 7 leto gaudio partus tam celebris. erroris munimine cedat

illicei ris. Postea cantet. Aspiciebam in uisu noctis. 7e. Tercio lo

co sybilla gesticulose pcedat. que inspiciendo stellam. cum gestu

mobili cantet. Hec stelle nouitas fert nouum nuntium. quod

uirgo nesciens uiri comercium. 7 uirgo permanens post puer

perium. salutem populo pariet filium. Celo labitur ueste sub

altern. noua progenies matris ad ubera. beata faciens illius uiscera.

que nostra meruit purgare scelera. Intrare gremium flos no

uius ueniet. cum uirgo filium intacta pariet. qui hosti liuido

ruinas excitiet. 7 noua secula rex nouus faciet. Celo ueniet

mutters and shakes his head, unconvinced. Then the archangel Gabriel enters with Mary and announces the coming birth. A star appears, and the choir chants, "Hodie xpistus natus est" ('Today the Christ is born', the antiphon for Vespers on Christmas Day). The three kings arrive and discuss the meaning of the star with King Herod, who is then mischievously advised by the Archisynagogus (more humour here). The shepherds dispute with the Devil as to whether the news can be true. They all converge on the Child in the stable in Bethlehem. Herod orders the killing of the Holy Innocents. He is eventually eaten alive by worms and he topples from his throne and devils carry off his body (cheering from the audience). Joseph takes Mary and the Child to safety in Egypt. At times it is not so different from a modern Christmas pantomime.

Other plays here are about the King of Egypt during the Holy Family's sojourn there and about Pontius Pilate. What becomes a saucy German song of a call girl asking the merchant for rouge to paint her face, when it was set to music by Orff ("Chramer, gip die varwe mier ..."), is actually part of the Pilate play and is sung in the manuscript by Saint Mary Magdalene: it occurs on folio 107v.

A curious thing about being made to wear white gloves in the reading-room – you will think I am obsessed with this topic – is that by now they had become really dirty, having evidently picked up 800 years' worth of dust clinging to the pages, even though I was extremely careful to touch only the corners of the margins. Far from me soiling the manuscript with my hand, the transference of dirt was actually the other way round. In turn, blackened gloves surely themselves become a hazard if one then touches clean pages. There is a sad addendum to this. I carefully brought the gloves home as a precious souvenir, stained by the *Carmina Burana*, and my shocked wife found them and put them straight into the wash.

The manuscript has eight pictures, skilfully drawn but rather carelessly coloured. We will look at them in the order in which they appear, which is not quite their original sequence. On the present opening page is the famous Wheel of Fortune, relentlessly turning clockwise. On the left is a young man clinging to the rim of the wheel as he rises up, with the word "regnabo", 'I will rule.' At the top he has become a

king, "Regno", 'I am ruling'; on the right he falls from the wheel and loses his crown, "regnavi", 'I have ruled'; and at the foot he lies crushed, "sum sine regno", 'I am without kingship.' The six-spoked wheel is a perfect circle, nearly 3 inches across, but there is no trace of a compass hole in the centre, as in the orbits drawn in the Leiden *Aratea*, and the outline was perhaps traced around a disc or the edges of a glass or jug. The central figure seated on the wheel is interesting. This is always described as a representation of Fortuna herself, but notice two odd features. First, the figure is not actually turning the wheel from a position of independence but is actually seated within it, and so is presumably subject too to the revolution of fate. Stranger still, the figure looks like a man, with a pronounced shadow of a beard and growth on the upper lip. Fortuna, made famous in the *Consolatio Philosophiae* of Boethius (*c.* 480–*c.* 524), is invariably female. Staring at this picture, I suddenly realized that this is surely the regnant king himself in maturity, wearing the same crown as his little picture at the top and draped in the same green and white cloak as he wears when he comes tumbling down on

The great seal of Frederick II, Holy Roman Emperor 1220–50, which probably provided the model for the figure seated on the Wheel of Fortune in the *Carmina Burana*

the right. This, probably the most widely reproduced image of Fortuna in all of medieval art, does not show Fortuna at all, who is nowhere in the picture. We have all been misled by the poem 'O Fortuna' in the lower margin, which is a later addition anyway.

Furthermore, the source of the image is probably identifiable and it was certainly male. It must have been noticed by art historians (although I do not recall having seen this mentioned in anything I have read) that the crowned figure here is modelled on the common image

of an enthroned king on the obverse of a medieval royal seal or imperial bulla. Among all the great seals of Europe at the time, the closest in composition is that of Frederick II as Holy Roman Emperor, which he became in 1220. The drawing and the emperor's seal are almost exactly the same size. Both designs show the same forward-placed left knee, the arms raised, and dangling folds of garments hanging from the neck. The crown and hair are virtually identical. If the figure is indeed copied directly from a charter of Frederick II, this may localize the production of the manuscript to some institution prominent enough to have received or had access to an imperial charter, and, more importantly, it dates it to not earlier than 1220.

The second picture fills the whole page of folio 64v. It shows two scenes in a verdant woodland. This must be a prime candidate for the earliest pure landscape in all of medieval art. It is generally assumed to represent springtime, the setting of many of the love poems, but this too is perhaps wrong. One poem opposite begins, "Ab estatis floribus amor nos salutat …", 'From the flowers of summer, love greets us …'. The picture is in two registers. In the upper level, the forest is full of birds. In the lower compartment, the forest includes animals, a crouching hare, a deer, a prancing horse, a creature in the undergrowth (perhaps a hound) and a lion. The clear separation of birds from animals is reminiscent of the cycles of creation miniatures in Romanesque Psalters and Bestiaries, for, according to Genesis, trees were made on the third day, birds on the fifth day, and animals not until the sixth day. The inclusion here of a lion is much more appropriate for the Garden of Eden than for a familiar spring day in the German woods. There are actually two poems on folio 56r which list, in the first, all the birds in nature (sparrowhawk, capon, stork, woodpecker, magpie, bee-eater, mew, ibis, turtle-dove, owl, jackdaw, vulture, parrot, dove, wood pigeon, raven, crow, hoopoe, fig-pecker, partridge, robin, and very many others) and, in the second, the animals, opening with the lion, as Bestiaries do also, and including "leopardus" (glossed "liebart" in German), "elephantes" (glossed "elephant"), and "ursos" (glossed "ber"), and others.

LEFT: Forests and woodlands as created by God, with birds above and animals below, including the hare, deer, horse and lion

tympanum cum lyra. Do er zu der linden chom. dixi se/
deamus. diu minne twanch sere den man ludum faciam.
Er graif mir an den wizen lip. non absq̃ timore. er sprah
ich mache dich ein wip dulcis es cum ore. Er war mir
uf daz hemdelin. corpe detecta er rante mir in daz vur
gelin cuspide erecta. Er nam den chocher unde den bogen
bene uenabatur. der selbe yr̃e mich betrogen ludus copleat̃.
Sorexe flos florem quia flos designat amorem.

Illo de flore nimio sum captus amore.
Hunc florem flora dulcissima semper odora.
Nam uelud aurora fiet tua forma decora.
Florem flora uide quem dum uideas michi ride.
Flore . florerent tua nox cantus phylomene
O caila del flore rubeo flos conuenir ori.
Flos in pictura non est flos imo figura.
Qui pingit florem non pingit floris odorem.

The woodland scenes are representations of nature as it was created by God rather than simply pastoral springtime of the Middle Ages.

The next two illustrations are more explicitly on love. The one on folio 72v is long and narrow, and you need to turn the manuscript sideways to see a tall standing young man in red giving a flower to a girl in a long green dress, tied with a red and white waistband. The line of text immediately above opens, "Suscipe flos florem quia flos designat amorem ..." ('Flower, receive a flower, for a flower represents love ...'), a theme still promoted by florists on Valentine's day. The Virgin Mary holding a flower became a distinctively German theme in religious iconography in the thirteenth century. The picture on folio 77v is of doomed love and betrayal. It too is in two registers, although not quite in narrative sequence. Above, Dido meets Aeneas outside Carthage, she watches his departure from a high window, and then she stabs herself and falls off the battlements into a fire. Below, Aeneas and his companions gather on the shore, they are taken out in a little boat to their ship, and there Aeneas stands in the prow as he sails away.

The four remaining pictures illustrate drinking and gaming. On folio 89v is another long narrow miniature, showing three men drinking and a fourth making the sign of the cross over a cup, mimicking the Mass. It is above the song which starts, "Potatores exquisiti ..." ('Excellent drinkers ...'). Two gambling tables with men throwing dice are shown on folio 91r. This is above the poem "Tessera blandita fueras ...", cited above. On the next page two men are shown playing backgammon, as another brings in a drink. It is doubtless set in a tavern. The final picture shows a pastime which we might now regard as cerebral and commendable rather than as a frivolous vice: two people playing chess. It is above the poem on the rules of the game, also already mentioned. Very unusually in art, the chessboard in the illustration is laid out with an utterly credible disposition of the pieces. I have experimented with my own set. I can reach this exact position on a board in fifteen moves, if black begins. Whoever drew the picture knew how to play chess and has represented a moment in an actual game.

LEFT: A pair of lovers shown sideways, with a young man entreating the girl to accept a flower as a symbol of love

Contrahas hostes tu rumpis federa pacis

Et qui nulla scium: omnia scire facis.

O vultus clausa seris tibi pandam archa tenacis.

Tu das ut detur: nil dare posse facis

Vas ceco visum: das claudo crura solacis.

Credens esse deus: hec quia cuncta facis.

Ergo bibamus, ne siciamus: vasa repleamus

Quisquis suos, posteriors, sive prior,

Sic sine cura morte futura repetitur,

Pone merum et talos: pereat qui crastina curet,

Bachus erat captus: vinculisque tenacibus aptus.

Noluit ergo deus carceris esse reus.

Ast in conclavi disrupit uincula suavi

Et facus sompni pdiit clauibz

P OTAGORAS, Et quisquis licet

sitis sive siti. et bibatis expediti et cyphos inobliti cyphi
crebro repetiti non dormiant et sermones inauditi pro
litteant Qui potare non poterit ite pariter ab his festis, non est loc
hic modestis inter letos mos agrestis, modestie, et sue certus restat

BIBLIOTHECA
REGIA
MONACENSIS

Although the pictures are all finely drawn and are of the same general date as the script, it is fairly clear that they were afterthoughts in a manuscript not originally designed to be illustrated at all. They fall at odd places in the text, sometimes at the very end of the groups of poems on the theme depicted. That is not normal in a medieval manuscript. The strange shapes of the spaces cannot have been intended. The cruciform outline of the Wheel of Fortune miniature is compressed badly out of shape at its foot and it still overlaps the first line of neumes below. The subject of Fortune is suitable for the song "O Fortuna" on the same page, but that song is an addition in the margin and is not integral either; it is not obvious which suggested which, the picture or the song. The image of the lovers is so cramped that it had to be inserted sideways. The scenes of Dido and Aeneas, however, do not fill the space available. The illustration of men drinking overlaps not only the last line of text above but also part of the red initial 'P' below the picture. The frame of the drawing of the backgammon players is painted over the line of text beneath. The only explanation is that the pictures, like many of those songs added into blank spaces and lower margins, were ongoing refinements not originally intended when the copying was begun or present in the manuscript's exemplar. The significance of this is that the manuscript was not a routine duplicate of a similar and comprehensive illustrated exemplar, but was an evolving work-in-progress which the scribes were adapting and upgrading as they went along. This, in short, is the original anthology, and not a copy.

What, then, was the compilers' source of the poems and songs? This may be the unique collection gathered together for the first time, but the individual pieces were culled from earlier lives. Specialists in medieval music and literature have worked themselves into frenzies of speculation on the poems' origins and dates, arguing righteously with each other. These are dangerous waters of academia into which I am reluctant to dip as much as a toe. Scott Schwartz, a practising lutenist, calls these the 'Carmina Piranha' with good reason. Where the texts can be found elsewhere, as some can, almost all belong in the twelfth century, upwards of

LEFT: The opening of the drinking songs, '*Potatores*', with men drinking at a bar and mimicking the sacred blessing of a chalice in the Mass

a generation earlier than the manuscript here. A few pieces cite specific dates. One poem describes the Peace of Venice between Pope Alexander III and Frederick Barbarossa in the summer of 1177, opening "Anno xpisti incarnationis ..." Another refers to the defeat of the French in the Crusades in 1187 and bewails the fall of Jerusalem to Saladin in the following year: "Heu, voce flebili cogor enarrare / facinus quod accidit nup[er] ultra mare / quando Saladino concessum est vastare / terram quam dignatus est xp[istu]s sic amare ..." ('Alas, in tearful voice I am obliged to relate the crime which recently happened beyond the sea, when Saladin was allowed to devastate this land which Christ thought worthy of [his] love ...'). The verses report that the valiant Christian knights were outnumbered in battle 300 to one. It is easy to envisage a troubadour strumming this song around the courts of Europe, part news bulletin, part heroic romance. The latest absolute date seems to be the poem "Dum philippus moritur ..." on folio 52r, deploring the death of Philip of Swabia, youngest son of Barbarossa, murdered in Bamberg by the jealous count palatine of Bavaria. That took place on 21 June 1208.

Only one poem includes the name of its composer, "Versa est in luctum cythara walteri ...", 'The lute of Walter is turned to mourning ...' (an allusion to Job 30:31), on the widespread decline of religion and law. A pointing finger drawn in the inner margin of the manuscript approvingly commends this edifying verse, which is on folio 51v. The writer here is accepted as being Walter of Châtillon (1135–1204, he died of leprosy), French theologian and author of a popular epic on Alexander the Great. Others are attributed with greater or lesser certainty to Hugh of Orléans (c. 1093–c. 1160), of Paris and elsewhere, nicknamed 'Primas'; Peter of Blois (c. 1130–1212), clerical lawyer and civil servant, secretary to Henry II of England; Philip the Chancellor (c. 1160–1236), chancellor of the cathedral schools of Notre-Dame in Paris from 1217; the enigmatic 'Archpoet', as he called himself, member of the household of Rainald of Dassel, archbishop of Cologne 1159–67; and to others. A much disputed question is whether the *Carmina Burana* could include verses by Peter Abelard (1079–1142), charismatic

RIGHT: The poem commemorating the devastating defeat of the French in the Crusades in 1189, "Heu, voce flebili ...", naming Saladin as the victor

ti. ꝑ te crucem subui. quare non subiſti. hanc loco peniten
tie. uade iam periſti. Ergo ferens laȝarus ducatur in
exemplum. digne penitentibᵤ; ut ſit eis templum. inquo
uirtuſ habitat ſue paſſionis. hanc impleat et muniat
ipſe ſuis donis.

HEV. uoce flebili cogor enarrare. facinuſ quod acci
dit nup ultra mare. quando ſaladino conceſſum eſt uaſ
tare. terram quam dignatuſ eſt xp̄ſ ſic amare. Cū cun
te unio anno poſt milleno. centum et octoginta iunc
ti cum ſepteno. quo reſpexit dn̄s mundum ſorde ple
no. erigens de paupe paupem a ceno. Malus comes tri
poli mentem ferens ream. magna cum turmulde te
nens tyberiam. turco ſuiſ fraudibᵤ; ducit in iudeam.
atꝗ primū occupat totam galileam. Saladinus con
uocat barbaros ꝓ girum. habitantes phrigia. pontum
uſꝗ tyrum. agarenos populos araben et ſyrum. ab
egipti finibᵤ; uſꝗ in epirum. Gemuint hircomili.
turgo et edite. mauri atꝗ getuli barbari et ſcite. fi
lii moab amon et iſmahelite. atꝗ cum his omnibꝰ
ſunt amalechite. Turcos ac maſſagetas precipit ad
eſſe. katari atꝗ ſarmates nolunt hinc abeſſe. cur
runt quadruuandili. medi atꝗ perſe. undiꝗ conue
niunt gentes ſic diueꝛſe. Terram intrant inclitam

philosopher and first truly outstanding teacher in the schools of Paris. One candidate is the poem on folio 68r which begins:

Hebet sydus leti visus
cordis nubilo,
tepet oris mei risus,
carens iubilo …

('My happy face's star is dimmed by a cloud of my heart, the smile of my mouth grows cold, lacking joy …') It is a heart-rending lament of a lover who is cruelly banished from the company of his beloved, a position in which Abelard found himself in 1118, separated for ever from Héloïse, both by judicial ruling and by unspeakably cruel castration. The attribution hinges on a play on words in which the author describes his love as having a name like Phoebus, "cuius nomen est a phebea" (itself a correction in the manuscript), lighting up the world. Phoebus was the sun god, *helios* in Greek, which does sound a bit like Héloïse. It stretches plausibility but it is just possible, as a kind of intimate joke among lovers schooled in the classics.

The *Carmina Burana* were assumed by Carl Orff to be the informal songs of wandering minstrels and 'goliards' (the word derives from the name of Goliath and means those beyond the edges of society), but, where sources can be identified, they are often unexpectedly scholastic and even clerical. The manuscript is peppered with classical and biblical allusions. In the previous chapter we watched the breaking of the old monopoly of learning once held by the Benedictine monasteries, and the rise of new orders of clerics, such as the Augustinian canons (which included the Victorines), living in cities and interacting with the secular world, as the early monks tried not to do. There were huge changes to society and literacy in the twelfth century. The urban cathedrals, also staffed by canons rather than monks, increasingly too became centres of learning, reaching out to new audiences. Schools in French cathedrals such as Chartres, Orléans, Montpellier and Laon attracted students entirely on the reputation of those who were currently teaching

RIGHT: The poem "Hebet sydus leti visus", describing the cruel separation of a pair of lovers, possibly composed by Abelard on his loss of Héloïse

bilis uenus amoris, dea me tibi subicio auxilio egens
tuo, iam caleo et pereo in ea. Collaudate meam pudicam
delectabilem amabilem amo frequenter eam et quam
mestus uigeo et gaudeo. illam pre cunctis diligo et uene-
ror ut deam. Nu grůnet aber diu heide mit grůneme
lobe stat der walt der wider chalt twanch si sere beide diu
zit hat sich uerwandelot ein senediu not. mant mich an
der gůten von der ih urigerne scheide: Vnde supra.

Habet sydus leti uisus cordis nubilo repet-
ooris mei risus caretis iubilo, iure mereo, occultatu
nam ppinqua cordis uigor floret inqua toral hereo.
In amoris hec chorea cunctis preniter cuius nomen hec choreaphe
bea lucet teneret et ipspeculo seruit solo, illam colo eam uolo nu-
tu solo iniupe seculo. Tempus queror tam diurne solitudinis
quo furabar uinocturne aptitudinis, oris basia aquo stillat
cynamomum et rimatur cordis domum dulas cassia. Habet
illa tamen carest spes solaci, iuuenilis flos exaret tanti spacii.
intercisio annullatur ut secura ad iunctuis prester iura hec
diuisio. Roter munt wie du dich swachest. la din lachinisin.
scheme dich swennt du so lachest. nach deme schaden din
dest nih wolgetan owi so verlorner stunde sol von minne-
chlichen munde solich unminne ergan. Item At.

there. The Wheel of Fortune raised masters and scattered them too. The most enduring were those of Paris, capital of France and seat of the royal court. There Peter Abelard and Peter Lombard (d. 1160) taught in the schools of Notre-Dame, and Hugh of Saint-Victor (d. 1142) and his successors attracted students to the school on the left bank at the Augustinian abbey of Saint-Victor, where the Copenhagen Psalter might have been made, twenty minutes' walk south-east of the cathedral. These and other halls of study gradually coalesced over the course of a hundred years into what by the first half of the thirteenth century had become the university of Paris.

It was very international. Students converged from all across Europe. Relative peace and stable economies made this possible. Language was no problem, for all teaching and intellectual conversation was still in Latin. For much of the twelfth century, before the universities became corporate entities, many would-be students probably drifted opportunistically from one urban school to another. Sometimes they may have followed masters who were themselves itinerant. On returning home, a former student might set up his own school. In so far as wandering scholars were a reality, they belong to this period. They doubtless shared the romantic and high-spirited nature of all young people away from home for the first time, but they were not, by and large, rebels or anarchists. Many were clerics, or at least in minor orders, intent on one of the new careers in political or religious administration, and some were highly educated.

An example, among many, is Peter of Blois, who went first to the cathedral schools in Tours in the 1140s, studying literature and rhetoric under Bernard Silvestris, then on to Bologna in Italy, to learn Roman law with Umberto Crivelli and others, and finally in the 1160s to Paris, for the study of theology, where he subsidized his own attendance by taking pupils himself. He afterwards became successively tutor to the infant king of Sicily, secretary to the archbishop of Rouen, chancellor of the archbishop of Canterbury, archdeacon of Bath, letter-writer to Henry II, participant in the Third Crusade, and finally archdeacon of London. In his later life he received a letter from an old friend, now a monk of Aulnay abbey, asking him for memories of their rumbustious

youth together. Peter of Blois replied that he thought it appropriate to leave out the naughtier songs ("omissis ergo lascivioribus cantilenis") and instead he enclosed a couple written in what he calls his more mature style, to cheer his gloomy friend and to alleviate his boredom. By comparison with the style of those songs, up to about half a dozen of the *Carmina Burana* are now commonly attributed to Peter of Blois, including "Dum prius inculta / coleret virgulta / estas iam adulta..." on folio 36r ('When summer, now fully grown, occupies the bushes previously left bare ...'). It narrates how the singer espies under a green lime tree a pretty maiden named Phyllis, and he follows her across the meadows, led by hope. When in her youthful innocence she resists his advances, he forces himself fully into her ("me totum toti insero", frankly, this is rape) and afterwards he suffers the death pangs of an exhausted lover. That, by any definition, is a *lascivia cantilena*. It is not necessarily a record of an actual experience in the life of Peter of Blois, a supposedly celibate cleric, but it is a song of youthful bravado and imagination, no doubt originally sung to raucous cheers and applause. The name of Phyllis is a classical one, the daughter-in-law of Theseus, known in the twelfth century from the *Heriodes* of Ovid. It conveniently sets the scene in an acceptably fictional world.

Classical verse was very well-known to twelfth-century scholars. Virgil's *Aeneid* was the source for the songs about Dido and Aeneas. They did not need explaining as it was assumed that everyone would be familiar with such tales. Ovid is mentioned by name several times in the *Carmina Burana*. His *Ars Amatoria* and some epigrams of Martial were quite as explicit and raunchy as anything in the *Carmina Burana* and were common in medieval monastic libraries. (Catullus was not widely rediscovered until the fourteenth century.) There was one major difference. Classical verse is written in formal quantitative metre, with the words arranged into traditional and recurring patterns of long and short syllables, which have to be learned. The majority of the poems in the *Carmina Burana* are in simple rhythmical metres, like most modern verse, usually with rhymes at the end of each line or even within the lines. The pattern probably developed for writing hymns, a popular genre in the twelfth century. It is a form which lends itself to the beat of drums

est omnibus qui uolunt beari quedam excellente ppo
scolari ut amet ⁊ faciat amari. Sueze vrowe min la
mich del genießen du bist min ougen schin uenus wil mich
schiezen nu la mich chuniginne diner minne niezen.
ia nemag mich nimmer din uerdriezen. I ⁊ ᵒ.ij.

L ONGA Spes ⁊ dubia pmixta timore. soluit
in suspiria mentem cum dolore. que iam diutu
anxia mansit in amore nec tamen mestum pel
lo dolorem. Heu cur est plurital pauptrata parum ⁊ lo
a diuersital dixerunt iniurium. quam pre cunctis cari
tal cordil habet eap; omnil largiul odit auarum. In hoc
loco stringitur nodul absq; nocto nec ullul rectpitur mo
dul in hoc modo ⁊ qui numquam soluitur plul constrin
git nodo. ⁊o duxundeia loditraundeia. Hanc amo prece
teril quam non uincat rosa quam pferre poteril cunctul;
nec ipsa nec uoce nec litteril quam sit speciosa. flos in
amore spirat odore. Te rogo suppliciter dea pbitatil. lal
sum me uinculum fac anxietatil. ne mortil piatium
sit mercil pietatil. laul tibi soli laul tibi soli. Roseam
gerit faciem formosa precantil. cuiul amore cruciat ig
neisq; flammil grauem eiul sentio stimulum amore
plul amore plul amore. Ino puro saucul uesito stu

and the rhythms of marching or dancing, exploited dramatically in the settings by Orff, where the rhymes are so insistent that they sound like repetition. As much as anything, the catchy metre of the songs probably disseminated them along the trade routes and into the repertoires of crusaders, courtiers and students travelling across Europe in the twelfth century. Poems which perhaps began as private statements of passion or moral teaching, often quite local or earnest, became universal by endless recitation along the road and after dinner in hostelries. That widespread migration of oral literature tells us much about conditions and routes of travel at the time. It may also explain some of the jumbled wording of the manuscript, which many scholars dismiss as having been carelessly assembled by the scribe. Any text transmitted by memory will gather small variants as it travels, and the compiler of the *Carmina Burana* may in fact have been meticulously conscientious in recording the exact wording of lyrics as they reached his ears.

Since Latin was the language of international literacy, verses composed in France were just as understandable in London, Cologne, Rome or Salzburg, at least by educated men. When the poems had lost their context so far that they had been reduced to dance songs in which women participated, however, extra verses were sometimes added in the German language. Many of the earliest records of vernacular languages of Europe are associated with women, who were at that time generally less Latinate than men. About forty of the love poems of the *Carmina Burana* have refrains in German, in the same metre as the Latin. These were probably supplied when the songs were used as rounds, with the different languages to be sung simultaneously by male and female voices. About a dozen other poems in the manuscript are partly or entirely in German. This is extremely early in the survival of any vernacular literature. Some German verses in the *Carmina Burana* are addressed to women, doubtless in the guise of admirers supposing that their suits might be more successful if the lady understood what was being asked of her. Examples are "Süziu vrouw min …", 'My sweet woman …', imploring her to enjoy the darts of Venus, and "Selich wip,

LEFT: Verses in the German language at the top of the page, including "Süziu vrouw min", 'My sweet woman', enticing her into love

vil süziz wip …", 'Lovely lady, most sweet lady …', describing how the writer has sent her a love letter. Others are set in the voices of women themselves, addressed to men. There is a charming poem on folio 72r in which a woman is whispering to her lover who has secretly stayed all night, "Ich sich den morgen sterne brehen …" ('I see the morning star breaking …'), urging him to slip away without being seen. It is reminiscent of Shakespeare's Juliet to Romeo at dawn, "O, now be gone! More light and light it grows" (Act III, scene V). In one famous five-line verse in German in the *Carmina Burana* the protagonist gladly offers to sacrifice the wealth of the entire world to lie in bliss in the arms of the queen of England. In fact, in the manuscript itself the scribe originally wrote 'king of England' – "chunich van engellant" – which was crossed out and later altered to 'the queen' ("diu chunegin"). It seems to me in reality to make better sense as the wish of a woman, speaking German. The formidable Eleanor of Aquitaine (*c.* 1122–1204), queen of England 1154–89, was an unlikely object of male fantasy, but her son, the dashing Richard the Lionheart, was unmarried and nearby, a prisoner in Austria in 1192–4. This would furnish a plausible date and general locality for the composition of the German text.

It is generally accepted that the manuscript of the *Carmina Burana* was not compiled at Benediktbeuern itself, but probably somewhere further south in what is now Austria, then part of greater Bavaria. The script has pronounced Italianate features, as often in Austrian books, and the smooth pages have a southern feel to the touch, unlike the more suede-like texture of German parchment. (This is a judgement impossible to make from a photograph, or while wearing gloves.) If the figure on the Wheel of Fortune is indeed based on a seal of Frederick II, as suggested above, the manuscript is not earlier than 1220. However, the script begins 'above top line', as palaeographers call it. This needs explaining. Before writing a page of any manuscript, a medieval scribe generally ruled a precise grid of lines to keep the script straight and tidily circumscribed. Before about 1230, the scribe wrote his first line of text above the top horizontal line. After about 1230, scribes dropped

RIGHT: Verses in German, including (in line 2) the woman beseeching her lover to leave her bedroom, since she can see the morning star breaking

appulso pari tertio. Fit ludus ineffabilis, menbris deseruit
labiis. Ich sich den morgen sterne brehen, nu helt la dich niht
gerne sehen, nu liebe dest min rat, swer tougenlichen mut
net wie tougenlich daz ster, da frunschaft yute hat. I̅t̅

VIRGO. Quedam nobilis div gie geholge vmbe tis
do si die burde do gebant. Resp. Eya heia wie si
lanch, artha artha wie si smach, vincula vincula vin
cula rumpebat. Venit quidam iuvenis pulcher z ama
bilis der zerrant ir den bris. Er wieng si bi der wizen hant.
er furt si in daz uogel sanch. Venit sive aquilo der warf
si verre in einen loch er warf si verre in den walt. I̅t̅e̅.

ICH was ein chint so wolgetan, virgo dum flo
rebam, do brist mich div werlt al, omnib; place
bam. Resp. Hoy z oe maledicantur tilie
iuxta uiam posite. Ia wolde ih an die wisen gan, florel adu
nare, do wolde mich ein ungetan ibi deflorare. Er nam mich
bi der wizen hant, s; non indecenter, er wist mich div wise
lanch, valde fraudulenter. Er graif mir an daz wize ge
want, valde indecenter er furte mich bi der hant multum
uiolenter. Er sprach vrowe gewir val, nemus est remotu,
durre weth der habe, har planxi z hoc totum I z stat ein
linde wolgetan, non procul auia da hab ich mine herphel an

their script below that line. We do not know why the change took place, except as part of a general trend towards compressed neatness in gothic design, but it happened extraordinarily fast and consistently right across Europe. There must be fluctuations in local practices but, as a rule of thumb, it is a remarkably useful dating guide for manuscripts from the first half of the thirteenth century. On that basis, a date of around 1220 to 1230, perhaps with slight flexibility into the early 1230s, seems justifiable.

Local allusions in the texts are consistent with an origin in the county of Tyrol or in the duchy of Styria (Steiermark), to the east of the Tyrol. One song, cited above, names the neighbouring states as being the Italian marches, Bavaria and Austria (Vienna). Another extols the unequalled hospitality of the provost of Maria Saal, identifiable as Heinrich, appointed bishop of Seckau in Styria in 1232, and it is often argued that the manuscript may have been compiled in the episcopal court of Seckau, perhaps under the patronage of Heinrich's predecessor Karl, prince bishop of Seckau 1218–31. This was the tentative conclusion of the great Munich palaeographer Bernhard Bischoff in his essay for the facsimile edition of 1967. Since then, Georg Steer of the university of Göttingen has argued in a massively exhaustive article in 1983 that the precise dialect of the German verses points further west, to the region of the south-west Tyrol, across from Styria. By linguistic parallels which I can neither fault nor confirm, he suggests a likely provenance in the Augustinian house of Neustift, just north of Brixen, founded in the 1140s, between Innsbruck and Salzburg, approximately fifty-five miles south-east of Munich. Saint Augustine, patron of the order, was shown presiding over the play about the nativity of Christ.

It is sometimes suggested, especially from an indignant Protestant perspective, that the *Carmina Burana* are merely coarse songs to be giggled over irreligiously by smutty-minded monks. That was absolutely not their original purpose. An Augustinian community or episcopal household would expect engagement with the foibles of the secular world. They might interpret the cruder poems as allegorical or even pastoral, on the modest sins of the laity encountered daily in hearing confessions. More than that, however, we should see the *Carmina Bur-*

ana as product of that great twelfth-century shift from exclusively monastic learning to the migration of knowledge into the streets outside. Monks read books slowly from end to end, memorizing and ruminating meditatively; the laity and secular clerics, in contrast, consulted books and looked information up. This is strikingly represented in new kinds of manuscript. In the decades on either side of 1200 we find a mass of recent encyclopaedias, anthologies, florilegia, compendia and summaries, together with popular distillations of knowledge on traditional monastic subjects such as theology (Peter Lombard), biblical interpretation (the Glossa Ordinaria), biblical history (Peter Comestor), canon law (Gratian) and, not least, liturgy (Breviaries and Missals), all new forms of book. Even the texts of the Scriptures, hitherto known by lifetimes of study and memorization, were restructured and divided into numbered chapters for ease of consultation. It was as if the old knowledge was seen to be vanishing. The shallowness of the modern world is a recurring theme in the *Carmina Burana*. Remember that initial observation that the manuscript has the semblance of a Breviary, which is relevant here. They are tellingly similar books. The verses and songs were previously oral texts, as the daily psalms and prayers had been to monks, and these were all now being gathered into unified portable anthologies encompassing what was no longer known by heart. Many of the poems in the *Carmina Burana* had been transmitted aloud for up to a hundred years. The urge to commit them to writing emerged partly from a desire of people like the friend of Peter of Blois to recapture and record the joy of their distant youth (a common enough wish as generations pass), but especially from the new fashion for gathering up and documenting the world. The manuscript is an encyclopaedic handbook, an ordered anthology of secular and scholarly verse, entirely in keeping with the religious spirit of the early thirteenth century.

There is nothing visible in the manuscript to show how or when it eventually reached the Benedictine monastery at Benediktbeuern. If I had to guess, I might suppose it was not necessarily there before the eighteenth century, when the south German monastic libraries became universal repositories of books and served almost as public reference collections. When ecclesiastical property in Bavaria was secularized in

1803, the official responsible for inspecting Benediktbeuern was Johann Christoph, Freiherr von Aretin (1773–1824). He wrote that he found there a hidden cache of forbidden books, which, at least in the Protestant interpretation above, might have included songs considered to be inappropriate for monks. Von Aretin is said to have been so enchanted with the manuscript that he afterwards carried it about with him – like a priest with a Breviary, in fact – during the rest of his commission. In 1806 the library from Benediktbeuern was transferred to the state library in Munich, and von Aretin himself became its principal librarian.

In October 1843 the volume of the *Carmina Burana* was in an exhibition of treasures at the Staatsbibliothek when it was seen by chance by Jacob Grimm (1785–1863), one of the two anthologizing brothers now best known for collecting fairy stories. He returned to examine it and he persuaded the then librarian, Johann Andreas Schmeller (1785–1852), to publish an edition of the text in 1847, which they called *Carmina Burana, Lateinische und deutsche Lieder und Gedichte einer Handschrift des XIII. Jahrhunderts aus Benedictbeuern auf der K. Bibliothek zu München*, a title which conferred its modern name on the anthology. This edition, for all its faults, is still in print, although it is academically superseded now by the far greater multi-volume text edited by Alfons Hilka and Otto Schumann published from 1930 to 1970.

In 1934 a copy of the fourth edition of Schmeller's text, Breslau, 1904, was offered by a second-hand bookseller in Würzburg, Helmut Tenner, of Frank's Antiquariat, for the modest price of 3.50 Reichsmarks, and it was ordered by the relatively little-known composer Carl Orff, of Munich. It arrived on 29 March: "a truly memorable day for me," Orff afterwards recalled; "I opened it and on the very first page I found the famous depiction of 'Fortuna with her wheel' and underneath were the lines 'O Fortuna / velut luna / statu variabilis …'" The picture and the words enthralled me." You and I know, from looking at the manuscript, that this was not correctly the opening page at all, and that the 'O Fortuna' poem is in any case a scribal addition, but Orff neither knew nor cared. He was captivated. He began sketching music for the words immediately. He took the title of Schmeller's book to be that of the medieval text. A week later he wrote to his friend Michel Hofmann

(1903–68), archivist in Bamberg, asking what 'Burana' could mean, as he was unable to find the word in his Latin dictionary. Hofmann told him about the manuscript in the Staatsbibliothek, but there seems to be no evidence that Orff was interested in seeing it, or even in using the new and better edition of its text by Hilka and Schumann. Orff and Hofmann were soon in regular correspondence over the rapidly evolving cantata, one writing the music and the other advising on text. They took to signing themselves as 'Buranus' (Orff) and 'Carminus' (Hofmann). The composition was finally completed by Orff in August 1936 and the first performance took place in Frankfurt on 8 June 1937.

Munich in the mid-1930s cannot be considered now without reference to politics. Hitler came to power in 1933. How far Orff's setting of the *Carmina Burana* is or is not a piece of conscious Nazi propaganda is a hugely debated question. At one level, it is everything that the Nazis stood for – a great medieval Germanic text, unique in Europe, celebrating youth and masculine prowess, crusades and chivalry, transformed into a mighty massed spectacle with hypnotic drum beats and insistent rhythm. On the other hand, although Orff selected a disproportionately large number of the poems in German, Latin was regarded with suspicion and the originality of the music was seen by some among the Nazis as dangerously modern and foreign. One critic from the Reichsmusikkammer notoriously called it "bayerische Niggermusik". Orff's own political allegiances were deeply ambiguous. To his shame, he agreed in 1938 to rewrite the music for Shakespeare's *Midsummer Night's Dream*, to replace that of Felix Mendelssohn, then vilified as a Jew. The *Carmina Burana* were performed in Germany throughout the War, in Dresden, Essen, Cologne, Mainz, Stuttgart, Görlitz, Frankfurt, Göttingen, Hamburg, Aachen, Münster, Munich and doubtless elsewhere. The music and presentation rather than the words of the ancient manuscript certainly caught the spirit of the time. Joseph Goebbels wrote about Orff in his diary on 12 September 1944: "… 'Carmina Burana' exhibits exquisite beauty, and if we could get him to do something about his lyrics, his music would certainly be very promising. I shall send for him on the next possible occasion." As far as is known, that meeting never took place. After the War, Carl Orff – he

was by no means alone in this – reimagined himself as having been a secret opponent of Nazism, protesting innocence, probably untruthfully. When the *Carmina Burana* were first staged in Britain at the new Royal Festival Hall in June 1951, the music critic of *The Times* dismissed them as still politically sensitive, "simplicity itself – rum-tum rhythms, carolling in thirds, strophic tunes, German beer-garden and student song stuff … naively Teutonic". The association of the *Carmina Burana* with Hitler's Germany never occurred to us at King's High School when we heard the music played in our classroom fifteen years later, and we imagined it was all authentically medieval.

The settings of the *Carmina Burana* are now among the most widely performed pieces of all modern music. The opening four notes of 'O Fortuna' are perhaps as immediately recognizable as any since Beethoven's Fifth Symphony. Listening to it now, it is clear that the music

A production of Orff's *Carmina Burana* in the Württemberischer Staatstheater in Stuttgart in 1941, with a Wheel of Fortune at the back of the stage

Carl Orff (1895–1982), photographed in 1938, shortly after the completion of the score of his version of the *Carmina Burana*

of Orff has nothing whatsoever to do with actual medieval song. The samples of original musical notation in the manuscript itself bear no relation to the vast orchestral confections created around the words in the mid-twentieth century. The editing and reordering of the verses to suit the music has produced a text utterly unlike anything ever hummed in the 1100s by Walter of Châtillon or Peter of Blois. Nonetheless, the words of the *Carmina Burana*, a quaintly named compendium, now Munich, Clm 4660, inspectable by approved readers among the Tresorhandschriften in the reading-room of the Staatsbibliothek, have, thanks to Carl Orff, reached more people than medievalists could ever imagine. The figures will undoubtedly change utterly even before these words are in print, but, at time of writing, if you type 'Carmina Burana' into a general on-line search engine, you get approximately 2,600,000 hits; write 'Book of Kells' and up come 1,180,000; 'Très Riches Heures', 100,000; and 'Spinola Hours', under 6,000. Fortune's Wheel has its surprises yet.

The Hours of Jeanne de Navarre

second quarter of the fourteenth century
Paris, Bibliothèque nationale de France,
ms n.a. lat. 3145

Berchtesgaden is high in the Bavarian Alps, in a corner of south-east Germany which juts out into Austria near Salzburg, about thirty-five miles from the likely origin of the *Carmina Burana*. Above the town, in what is known as the Obersalzburg, Adolf Hitler bought land in the summer of 1933 and built a house which he called the Berghof, to be a secure mountain retreat and private command post, overlooking some of the most beautiful scenery in the world. Adjacent houses were acquired by Joseph Goebbels, Albert Speer, and other high-ranking Nazis. As the Second World War entered its final days in Europe in 1945, there was an expectation, both in Germany and among the Allies, that Hitler and his inner circle would retreat to the Obersalzburg, which would then become the site of the final Armageddon of the War. It was believed, wrongly as it turned out, to be massively fortified to withstand a sustained and violent siege. By mid-April 1945 the American Seventh Army and the First French Army, under the joint command of General Jacob Devers, were both advancing towards Berchtesgaden, one from the north and the other from the west. On 25 April the Obersalzburg was bombed by the Royal Air Force. From that moment all authority was lost, and local people raided the houses of the Nazis, scattering the luxurious private possessions they found there. Hitler committed suicide in his bunker in Berlin on 30 April. On 4 May the Allied armies

entered Berchtesgaden to scenes of chaos and devastation. The Seventh Army included detachments from the French Second Armoured Division, which had originated in central Africa in 1942 and had taken part in the liberation of Normandy and Paris. The First French Army had been formed in northern Africa and had participated in the invasion of southern France in August 1944. By the afternoon of 4 May the flag of Free France was fluttering above Hitler's Berghof. The French troops (especially) had no inclination to respect the property of Nazis, and American accounts accuse them of looting, a claim denied, of course, by the French, who point instead to artefacts taken from the Obersalzburg being shipped back illegally to the States. These were unprecedented days, of utter disorder and exhilaration, and doubtless jubilant soldiers of both armies pocketed souvenirs of greater or lesser value. There are several reports of a railway train of eight box cars parked in a siding by Berchtesgaden station, raided by the French, who fired shots randomly into it and forced it open. One French officer from the 11th company of the Régiment de Marche du Tchad recalled treading on what he thought was a brick: he picked it up and realized it was a medieval manuscript. He later wrapped it in brown paper and kept it. Another officer, an army medical doctor, stumbled on a second manuscript enclosed in a little oblong box. Both items were secreted into knapsacks. That railway train proved to have contained portions of the private hoard of stolen artworks gathered by Reichsmarschall Göring, which were being sent to the Obersalzburg for safety during the anticipated final days. When James Rorimer, member of the Monuments and Fine Art section of the Seventh Army, arrived in Berchtesgaden a week later, the remaining treasures from the train were safely secured by the Americans and were displayed under an improvised sign: "The Hermann Göring Art Collection – Through Courtesy of the 101st Airborne Division".

Back in France, the soldier who had found the first manuscript showed it to an old friend in the Bibliothèque municipale in Valenciennes, and between them they realized with astonishment that they were holding the original of the famous *Très Belles Heures* of the Duc de Berry, illuminated in Paris around 1383. It had been purchased in about 1884 by Baron Adolphe de Rothschild (1823–1900) and in March

The train found at Berchtesgaden in early May 1945, with portions of the stolen art collection of Reichsmarschall Hermann Göring

1941 had been stolen in Paris from the bank vault of his great-nephew, Baron Maurice de Rothschild (1878–1957), who had reported its theft after the War. The manuscript was duly returned to the baron, who, in turn, presented it to the Bibliothèque nationale in 1956. It is now ms n.a. lat. 3093 in the library there.

In 1951 the second manuscript picked up at Berchtesgaden was given by its finder to the monastery of Boquen in central Brittany, where the former officer had spent a period of retreat. This had been a medieval abbey, suppressed in 1790 but re-settled in 1936 by Cistercian monks under the direction of Dom Alexis Presse. Details of the donation are obscure, since the manuscript had been illicitly liberated in 1945. Dom Alexis, who died in November 1965, is said to have confided the story to his successor, Dom Bernard Besret, who transformed the community into a centre for radical Catholic revival. The account is taken up in the

Baron Edmond de Rothschild (1845–1934), of Paris, who formed a superb collection of illuminated manuscripts, many of which were afterwards looted during the Second World War

autobiography of Maurice Rheims (1910–2003), Parisian art auctioneer and a close friend of the Rothschild family. In the summer of 1967, Monsieur Rheims recalled, the chapel of Boquen was in need of a new roof following storm damage, and Besret took the manuscript to be valued by an antiquarian bookseller in Rouen, who had the sense to refer it to the Bibliothèque nationale in Paris. Three days later therefore it was deposited for examination with Marcel Thomas, curator of manuscripts, and the young François Avril, who had joined the department that year as a junior assistant. They recognized it immediately as the long-lost Hours of Queen Jeanne de Navarre.

This was the famous manuscript we encountered briefly in Chapter Five (page 200), which had made a world record price in the Yates Thompson sale at Sotheby's in London in 1919, to "some enthusiastic Frenchman" whom no one could identify. We now know that buyer to have been Baron Edmond de Rothschild (1845–1934), of Paris. It was MS 94 in his collection of 102 medieval and illuminated manuscripts. The baron's house at 41 faubourg Saint-Honoré is now the residence of the American ambassador to France, where the entwined monogram

'E.R.' is still on the front door. After the death of Edmond de Rothschild's widow, Adelheid, in 1935, his collection was valued for family division by the London bookseller Maurice Ettinghausen. A copy of the list is preserved in the archive at Waddesdon Manor, the Rothschild house in Buckinghamshire in England. On it the Hours of Jeanne de Navarre is assessed at £3000 and is assigned to Edmond's daughter, Alexandrine de Rothschild (1884–1965), also of Paris. She was an eccentric and recluse, living in a magnificent library. During the Nazi occupation of France, her art collections, like those of her elder brother, Maurice (mentioned above), were systematically looted in April 1940 and the Book of Hours simply vanished, unaccounted for. It was reported by Madame Alexandrine (as she is usually called) to the heart-rending *Répertoire des biens spoliés en France durant la guerre 1939–1945*, an extraordinary loose-leaf oblong grey cloth-bound album held together by

The *Répertoire des biens spoliés*, the vast list of artworks reported as stolen during the War, recording the Hours of Jeanne de Navarre as the fifth item on this page

MANUSCRITS ANTÉRIEURS A 1800	МАНУСКРИПТЫ ДО 1800 г.	MANUSCRIPTS PREVIOUS TO 1800	MANUSKRIPTE VOR 18..		
340	32.330		Bible hébraïque. 1. vol. épais sur vélin orné de nombreuses miniatures dans, un étui en maroquin janséniste brun portant le millésime de 1370	M. James, Armand de Rothschild	
341	35.664		Double feuille d'un manuscrit français avec très belles miniatures sans cadre, env. 45×30 cm.	M. Erwin Rosenthal	
342	33.041		Heures — Livre d'heures de Charles le Noble, ms. de la fin du XIVe s. rel. cuir à décor d'arabesques persan	Baron Maurice de Rothschild	
343	33.041		Heures — Livre d'heures du Duc de Berry, ms. sur vélin de la fin du XIVe s. richement décoré de miniatures en camaïeu	Idem	
344	32.141		Heures — Livre d'heures de Jeanne II Reine de Navarre, ms. du XIVe s. (271 feuillets 0,18/0,145/0,04), rel. maroq. citron avec ornements et tranches dorées, doublé de tabis rouge. 108 miniatures, lettres ornées et bordures à sujets humoristiques	Baronne Alexandrine de Rothschild	
345	28.244	Isaac Ben Joseph de Corbeille	Abrégé d'un grand livre de préceptes de Moïse de Coucy, avec deux commentaires. Sur le premier feuillet de garde une consignation de décès du 7 Tévet 5083 (1322), in-4 de 327 feuilles, vélin, écriture rabbinique allemande du XVe s.	Alliance Israélite Universelle	
346	28.244	Levi Ben Gerson	Commentaire sur Esther et les Proverbes, copie achevée le 3 yar, 5098 (23 Avril, 1338). En tête du premier feuillet cette mention d'un possesseur: « Moi, Jacob Ben Samuel, Morpurgo de Gradimont, l'an 426 » in- 4 de 118 feuilles, papier, écriture rabbinique espagnole	Idem	
347	28.244		Livre de Prières — Fin XIVe s., enluminé de vignettes, sur vélin, éd. italienne avec notice du censeur en espagnol	Idem	
348	32.069	Lyra (Nicolaus de)	Liber glossatarius super epistolas beati Pauli, 1396	M. Jean Furstenberg	
349	32.069	Lombard (Pierre)	Lombardi Petri sententiarum libri IV. XIVe ou XVe s.	Idem	
350	10.005 Strasb.		Das Recht der Gebuehrenschaft von Geringsheim, Suntheim und Kenie „Kehl" (Betrifft die Rheinfähre) ms. de 10 pages sur parchemin, 1380	M. Mutterer	
351	32.141		Roman de Giron le Courtois — ms. du XIVe s. (incomplet), 80 feuillets, 103 dessins à la plume dans les marges plus 4 dessins d'arbres. 0,495/0,33/0,03, reliure en velours rouge, écrin maroq. Lavallière	Baronne Alexandrine de Rothschild	
352	28.244	Salomon (Ezobi)	Les Homélies — ms. français composé par Salomon Ezobi, rabbin français du XIVe s.	Alliance Israélite Universelle	
353	33.041		Il Trionfo di Petrarca. Rel. cuir sombre avec dessin ; le dos brun a été rénové (0,22×0,15)	Baron Maurice de Rothschild	

XVe SIECLE

354	44.225	Bible en latin. Dédicace d'un abbé suisse en français	M. Siegbert Bernstein	

metal bolts issued immediately after the War by the Bureau central des Restitutions, part of the French command in occupied Germany. The *Répertoire*, which was roughly printed on fragile paper in French, Russian, English and German, was a field manual for locating and matching up artworks orphaned by the War. I own a copy of volume VII alone and it is nearly a thousand pages thick. There on p. 30, no. 344 among medieval manuscripts lost from France to the Nazi regime, reference 32.141, is "*Heures* – Livre d'heures de Jeanne II Reine de Navarre, ms du XIVe s. 271 feuillets … 108 miniatures, lettres ornées et bordures à sujets humoristiques", the property of the Baronne Alexandrine de Rothschild. It was never found in the huge stores of spoils stashed in caves, salt mines and castles in Germany and Central Europe. For a generation it was assumed to have been a casualty of the War. In publicly announcing its rediscovery during the 700th anniversary celebrations of the death of Saint Louis, held in Royaumont and Paris in May 1970, Marcel Thomas described its reappearance in France as little short of a miracle.

Monsieur Rheims continues his story. As he tells it, he arranged a meeting with the younger Baron Edmond de Rothschild (1926–97), nephew and heir of Alexandrine. The baron asked the abbot what the new roof would cost and was told about 40,000 francs; he at once wrote out a cheque for that sum. The Bibliothèque nationale had already informed him that morning how much they would like to acquire the manuscript. Rheims describes Edmond de Rothschild talking on the telephone to Mr Oppenheimer in Johannesburg, presumably the diamond industrialist Harry Oppenheimer (1908–2000), all the while caressing the Book of Hours, like the Bond villain Blofeld with his white cat, finally breaking off the conversation to declare, "I haven't even time to read the Bible, and so I might as well let them have it." The Hours of Jeanne de Navarre is now Paris, Bibliothèque nationale de France, ms n.a. lat. 3145, and we are going to see it.

The French national library traces descent from the collections of the medieval kings, especially Charles V and Louis XII, kings of France 1364–80 and 1498–1515 respectively, but as a public institution it is a product of the French Revolution. The royal library was renamed

the 'Bibliothèque nationale' in 1795, with a brief period in the mid-nineteenth century as the Bibliothèque impériale. In 1868 it moved into splendid new premises commissioned by Napoléon III on the east side of the rue de Richelieu, running up from near the Louvre, designed by the classical architect Henri Labrouste (1801–75). The library's rise to world status, especially in rare books and manuscripts, owes much to the genius and energy of Léopold Delisle (1826–1910), director of the library from 1874 until his retirement in 1905. In 1996, the principal collections of printed and modern books were moved out to the new and generally unpopular Bibliothèque François-Mitterrand, as it is commonly called, on a new site some distance upriver, but, I am glad to report, the medieval manuscripts still remain for use in their old building, where I have benefited from a reader's ticket for almost half a century.

In fact, on this visit to see the Hours of Jeanne de Navarre, there was major construction work still in progress, begun in 2010 and expected to last for seven or eight years. Access for readers was no longer, as it would usually have been, by the courtyard opening off the rue de Richelieu but temporarily through the little formal garden at the back of the building in the rue Vivienne. It was shortly after the *Charlie Hebdo* shootings of January 2015 and security was an unwelcome issue in Paris. I was made to walk through a metal detector at the edge of the street. It set off its alarms, but the officers looked tired and waved me through anyway. During the construction, the entrance into the building is through the library's back door, which brings you into the lobby at the bottom of the nineteenth-century staircase. The main entrance hall to the left was closed off at this time. The *Salle ovale* reading-room for general reference is in the far corner of the ground floor. For rarities you proceed up the grand stone stairway, flanked at the foot by pillars with heads of goddesses, up one floor for manuscripts, two for coins and medals. I sought the manuscript room where I expected it, a familiar and large upstairs room running the full length of the courtyard parallel to the rue de Richelieu, and it was not there, temporarily sealed off too during the building work. By the time this book is published, I very much hope that it will be open again. In the meantime, consultation

of manuscripts has been transferred across the landing into the Galerie Mazarine opposite, another long room overlooking the garden where we had entered in the rue Vivienne. I had previously been in there only for exhibitions. It is a remaining part of the adjacent seventeenth-century Hôtel Mazarin, built in 1644–5 by the great Cardinal Jules Mazarin (1602–61), to house his art collection. It is a remarkable high gilded salon, decorated with pastoral frescoes by Gian Francesco Romanelli (d. 1662), inspired by the *Metamorphoses* of Ovid. For the present use it has been transformed into a reduced replica of the *Salle des manuscrits*: the windows are covered with white blinds, the painted walls mostly boarded over in red and lined with temporary bookshelves in plain wood, long laminated tables have been brought in with unpadded wooden chairs, and the room is lit not by the six antique chandeliers suspended from the ceiling but by new banks of unlovely fluorescent strip lights.

The procedure is as it was in the old reading-room. At the entrance is a long desk staffed by several people, all men. Their duty is to take your reader's ticket and to give you instead a little square of red plastic (these used to be made of wood when I began using the library), with the number of the seat they are assigning to you. I said that I was coming to see a major illuminated manuscript and so I was given place 45 near the central corral of the reading-room invigilators. That, mostly occupied by women, is where you fill in by hand your application form for a manuscript, supplying your name and address. I also showed them the email I had received from Charlotte Denoël, *Chef du service des manuscrits médiévaux*, authorizing my access to the original itself (in Paris they are a bit inclined to fob you off with a microfilm, especially if they suspect that your French is not up to arguing). When the manuscript arrives, you then exchange it for your square plastic plaque. This all seems unnecessarily complex, but it is their way of doing things.

The Book of Hours of Jeanne de Navarre is more substantial than I remembered from the previous time I had seen it, about 7¼ by 5½ inches and about 2¼ inches thick, depending on how tightly you squeeze the covers. You can see how it might have been mistaken for a brick at Berchtesgaden. It was bound around 1780 in yellow-brown morocco

The Galerie Mazarine, temporarily adapted for use as the manuscript reading-room during building work at the Bibliothèque nationale in Paris

over pasteboards with elaborate gilt decoration. The pastedowns inside the covers are of crimson silk, with gilt borders. It looks precious. The manuscript shows no visible signs of damage in war-torn Germany, except that a bookplate at the front has been lifted off, doubtless that of Henry Yates Thompson (as described above, p. 201), leaving a rectangular shadow. That would have been the only explicit indication of any modern ownership. Faintly in the extreme upper left-hand corner of the paper flyleaf is a tiny pencil note, "MS 94", which is actually the Rothschild inventory number, although it is almost invisible. There are a few historical notes on the flyleaves but nothing that could easily have identified its wronged owner when it was found in Berchtesgaden in 1945.

The text principally comprises: (1) a calendar of the church year, listing saints' days and with allegorical illustrations at the top and bottom of each page; (2) the Hours of the Holy Trinity, with pictures for each of the eight hours from Matins to Compline; (3) the Hours of the Virgin Mary, also with pictures for each of the eight hours; (4) various short prayers, with two pictures; (5) the seven Penitential Psalms, with a litany

The upper outer corner of the flyleaf of the Hours of Jeanne de Navarre, with "MS 94" in pencil, the Rothschild inventory number

invoking the names of saints, both parts with pictures; (6) the Hours of Saint Louis, with pictures for each of the eight hours; (7) the Hours of the Cross, also with pictures for each of the eight hours; (8) miscellaneous prayers in honour of various saints, especially the Virgin Mary and the Trinity, in Latin and French, including the Seven Joys of the Virgin, prayers to one's guardian angel, prayers to Saint Apollonia against toothache, a prayer for use during the elevation of the Host at Mass, a life of Saint Margaret, patron saint of childbirth, and others, with twelve pictures; (9) Suffrages, or prayers invoking particular saints, in the names of Saints Anne, Nicaise, Martin, Giles, Josse of Ponthieu, and the relics of all martyrs, each with a picture; (10) other short prayers, including the seven Gradual Psalms; (11) the Office, or Vigils, of the Dead, with a picture of a funeral service; (12) further Suffrages, commemorating the Holy Cross, Saint Michael, all angels, and Saints John the Baptist, John the Evangelist, Peter, the Magi, Leonard, Louis of Marseilles (or Toulouse), Denis and Nicholas, all with pictures; (13) the special variants of the Hours of the Virgin for use in Advent, with one picture; (14) the special variants of the Hours of the Virgin for use between Christmas and the feast of the Purification, with one picture; (15) the Psalter of Saint Jerome and other prayers; and (16) miscellaneous additions, in later hands, including the Hours of the Holy Ghost.

This kind of composite text is what is known as a 'Book of Hours',

a term which goes back to the Middle Ages. The precise contents vary from one manuscript to another, but the defining features are the distinctive cycles of prayers and psalms to be recited at each of the eight 'hours' which divided up the medieval religious day – the hours of Matins, Lauds, Prime, Terce, Sext, None, Vespers and Compline. Seven of the components in this manuscript are examples of such Hours. We will see another Book of Hours in Chapter Twelve, and I will have more to say there about some of the texts. For the moment, suffice it to say that a Book of Hours was a lay person's prayerbook, for use in private, at home or anywhere during a normal day but not specifically in church. The idea of reading psalms and prayers at set times of day derives from the long-established practice of monasteries. It was not the total of what monks did, but this was undoubtedly the structure around which the daily rhythm of medieval conventual life was based. For centuries, the laity, living in the secular world outside, probably had little idea of what was going on within the walls of monasteries, except for an uneasy feeling that the monks or nuns were somehow participating in spiritual benefits denied to the uninitiated. A whole series of different social shifts took place in the twelfth century, including, as we have seen in earlier chapters, the ending of the monastic monopoly of literacy and book production, and the rise of a probably very deeply felt popular piety and desire for more active participation in religion without the necessity of joining a monastery. Psalters, as we encountered in Copenhagen, became the first books commonly owned by the laity in imitation of the religious orders.

However, entire Psalters are unwieldy and difficult for the inexperienced to use. By the late thirteenth century the fashion among the secular nobility was for a new type of portable devotional compendium in which selected psalms and prayers were already prearranged into an appropriate order for recitation by the laity at times of the day corresponding to each of the old monastic hours from Matins to Compline. These short cycles were dedicated to specific religious themes or saints, principally the Virgin Mary, whose cult was becoming increasingly prominent in the later Middle Ages. Books of Hours were eventually made in very large numbers. Very many thousands of them still exist –

there are well over 300 in the Bibliothèque nationale alone – and they are now probably the best-known of all illuminated manuscripts. The Book of Hours of Jeanne de Navarre is a very early example; the Spinola Hours, which we will meet in the last chapter, is one of the latest.

There are two very striking aspects of the early fourteenth-century devotional books made for the French royal family, both Psalters and Books of Hours. One is how consistently these manuscripts were owned by women. They were not really taken up for male use until the time of Charles V, king of France 1364–80, and his younger brother, the Duc de Berry (1340–1416), and even the supremely famous Books of Hours commissioned by those two great patrons may have been initially intended for distribution and use among the women of their households. The other notable aspect is how closely associated these royal manuscripts still are with the religious orders, especially the Dominicans and Franciscans. Private confessors and domestic chaplains in the court were very often members of one of these two orders of friars. Aristocratic laywomen, doubtless influenced by daily exposure to their spiritual advisors and confidants, imitated the friars' practices. Many of these women eventually retired into convents when they became widows, living out their old age in fashionable houses such as the Franciscans of Lourcines in the suburb of Saint-Marcel in Paris, established in the 1270s by Margaret of Provence, widow of Saint Louis, or the Dominicans at Poissy Abbey, on the Seine downstream from Paris, founded in 1298 by Philippe IV, son of Saint Louis.

The manuscript in front of us is strongly Franciscan. Its calendar accords the status of "*grand double*", the highest level, to the feasts of Saint Francis and the translation of his relics (4 October and 25 May), and the same to the feast of the Franciscan Saint Louis of Toulouse, here called Louis of Marseilles, "*de l'ordre des freres meneurs*" (19 August, 'Friars Minor' being Franciscans). It gives the ranking of "*feste double*" to Saints Anthony of Padua and Clare, both Franciscans (13 June and 12 August), and it includes the two festivals of departed benefactors to the Franciscan Order (29 January and 27 November). The grading of

RIGHT: The calendar for May in the Hours of Jeanne de Navarre, including "*grant double*" status accorded to the feast of the translation of Saint Francis (25 May)

May a .xxi. iours. et la lune .xxx.

xi.	b			Saint phelippe et saint iaques apostres. feste double.	ix. lc.
xix.	d	vi.	ꝃ	Linuenaꝛō de la sainte croiz. demidouble.	ix. lc.
viij.	c	iiij.	ꝃ		
	f	iij.	ꝃ		
xvi.	g	y.	ꝃ	Saint iehn deuant la porte latine. feste double.	ix. lc.
v.	A				
	b	viij.	Jd	Lapparicion saint michel larchange. demidouble.	ix. lc.
xiij.	d	vi.	Jd	Sains gordien et epimacle martyrs.	ix. lc.
y.	d	vi.	Jd		
x.	f	iiij.	Jd	Sains nere achile et pancrace martyrs.	ix. lc.
	g	iij.			
xviij.	A		Jd	Saint bonifaace martyr.	ix. lc.
vij.	b	JDES			
	c	xvij.	ꝃ		
xv.	d	xvi.	ꝃ		
iiij.	e	xv.	ꝃ		
	f	xiiij.	ꝃ	Sainte potencienne uierge.	ix. lc.
xij.	g	xiij.	ꝃ		
i.	A	xij.	ꝃ		
	b	xi.	ꝃ		
ix.	c	x.	ꝃ		
	d	ix.	ꝃ		
xvij.	e	viij.	ꝃ	La translacion saint francois. grantdouble. ix. lc.	S. urbain pape ix. lc
vi.	f	vij.	ꝃ	Saint cleuthere pape et martyr.	ix. lc.
	g	vij.	ꝃ	Saint iehn pape et martyr.	ix. lc.
xiiij.	A	iiij.	ꝃ		
	c	iij.		Saint felix pape et martyr.	ix. lc.
xi.	d	y.	ꝃ	Sainte pronelle uierge.	ix. lc.

Iacobus Philippus

unt illud. Et comence une tres especial oroi
E pur ce te o do son de nie dam
mina sanctissima maria.
mater domini nostri ihu xpi.
pietate plenissima. summi re
gis filia. mater gloriosissima. mater orpha
nonum. consolatio desolatonum. uia erran
cium. salus in te sperancium. uirgo ante par
tum. uirgo post partum. uirgo in partu. fons
misericordie. fons salutis et gratie. fons pie
tatis et leticie. fons consolacionis et indul
gencie. ut intercedas pro me ancilla tua. Jo
hanna nauarre regina. ante conspectum fi
lii tui. ut per sanctam suam misericordi
am. et tuam sanctam intercessionem mi
chi concedat ante tempus mortis mee pu
ram de peccatis meis confessionem. et ue
ram penitenciam. et post mortem cum
sanctis et electis suis uitam et requiem
sempiternam. Amen. Et sensuit leuan
gile de la circoncision ihucrist selonc S. luc.

feasts with the number of 'lections' used in church on particular days, as here, is something one would usually expect in a Breviary or Missal, not a lay person's Book of Hours.

The original owner, however, was not a friar or nun, and her identity is not in doubt. About twenty margins include little vignettes of a queen kneeling in prayer, wearing a gold crown and a cloak lined with ermine, sometimes with a manuscript open in front of her. Elsewhere she kneels in the illuminated initials. Sometimes she appears within miniatures themselves, witnessing first-hand the Scourging of Christ and venerating the Virgin and Child in their actual presence. Many of the prayers in the text are adapted for exclusive use by a woman, as we can tell from words which have gender-specific endings in Latin. Examples are "... ut michi indigne peccatrici ancille tue" ('to me your unworthy sinful servant', all feminine forms), "... concede michi famule tue" ('grant to me, your servant', where a male petitioner would have been "famulo tuo"), and the prayer on receiving Communion, "Domine non sum digna ..." ('Lord, I am not worthy ...', the female form of the adjective). By extreme good fortune, the woman is actually named. This is in a prayer to the Virgin Mary which happens to include a plea to 'intercede for me, your servant, Johanna, queen of Navarre', or, in the original, "ut intercedas pro me ancilla tua Johanna navarre regina". These precious words are on folio 151v, easy to overlook in the middle of a page of text.

Jeanne (1312–49) was the only surviving child of Louis X, king of Navarre 1305–16 and king of France 1314–16. She was only four years old when her father died. Through no fault of her own, Jeanne's legitimacy was disputed, as her mother, Margaret of Burgundy, was rumoured to have had extra-marital affairs, and the ancient Salic Law was speedily invoked to prevent Jeanne's succession to the throne of France. By this, as the archbishop of Canterbury explains in Shakespeare's *Henry V*, "'No woman shall succeed in Salique land' / Which Salique land the French unjustly gloze / To be the realm of France" (Act I, scene II). On this authority therefore her uncle, her father's younger brother, had

LEFT: The prayer to the Virgin Mary, naming the kneeling figure shown in the initial as 'me, your servant, Johanna queen of Navarre' (lines 12–13)

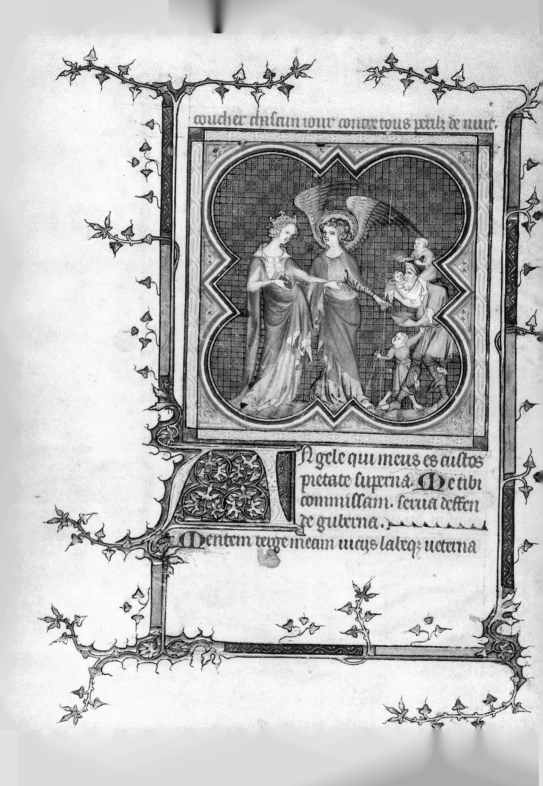

Ngele qui meus es custos
pietate superna. De tibi
commissam. serua deffen
de gubrina.

Mentem terge meam meus latrq; ueterna

himself crowned instead as Philippe V, king of France 1316–22. He was to become an apparent victim of a curse, said to have been placed on the line of Capetian kings for having burned the Grand Master of the Templars in 1307. They became known as the *Rois maudits*, the cursed kings. Philippe too died with no male heir, as did the next and final brother, Charles IV, king 1322–8, and Jeanne was once again poised to claim the throne. This time, Jeanne's father's cousin stepped in as Philippe VI, king 1328–50, the first of the Valois dynasty. It is a sad reality that medieval princesses did not always lead easy lives. I do not know whether Jeanne has yet been the subject of one of those passionate gilt-covered historical novels about spirited women caught up by destiny of their birth, read avidly by my wife and others, but she ought to have been. A deal was struck with Jeanne. She and her husband, Philippe d'Évreux, were jointly offered the throne of Navarre, the lilliput mountain kingdom in the Basque area of the Pyrenees, now long vanished and divided between Spain and France. Navarre was an old title of the kings of France, but it was outside the jurisdiction of the Salic Law, and Jeanne became a queen at last. She was crowned in Pamplona, capital of Navarre, on 5 March 1329.

The manuscript is showered with the arms of Navarre, defined in heraldic terms as '*gules*, a cross, saltire and double orle of chains, all linked together *or*'. The arms occur within more than eighty of the illuminated initials, and elsewhere, such as on shields held by the zodiac Gemini twins in the calendar and even by an ape in one of the margins. They are also found in some of the backgrounds of the pictures, such as the tessellated ground behind the Nativity. These, as well as the prayer naming Jeanne as queen of Navarre, date the manuscript to not earlier than her accession to that kingdom in 1328. Many other initials include the arms of Évreux, which Jeanne adopted on her marriage in 1318 ('France ancient with a bend compony *argent* and *gules*'). At the other extremity, the fact that Jeanne is clearly not shown as a widow indicates that the manuscript was made during the lifetime of her husband, who died in 1343, leaving her as queen alone.

LEFT: The arms and portraits of Jeanne de Navarre occur throughout the manuscript: here the queen is shown distributing alms to the poor, accompanied by an angel

An extremely unusual component of the manuscript is the fully il-
lustrated cycle of the Hours of Saint Louis of France on folios 85v–105v.
These are prayers and readings from Matins to Compline, like those of
any Book of Hours on more traditional themes, except that this text
is in honour of a family saint who had lived within what would still
(just) have been living memory, sixty years earlier. Louis IX was king
of France 1226–70, chivalric crusader and pious builder of the Sainte-
Chapelle. He was canonized by Boniface VIII in 1297. Jeanne de Navarre
was his great-great-granddaughter. Her husband, in fact, was, by a dif-
ferent line, the saint's great-grandson. The occurrence of the Hours
of Saint Louis in manuscripts is limited exclusively, as far as is known,
to books made in the first half of the fourteenth century for members
of the saint's own family. The earliest is in the Hours of Blanche of
Burgundy (c. 1295–1326), great-granddaughter of Saint Louis's broth-
er and the first wife of Charles IV, himself also a great-grandson of
Louis IX. That manuscript belongs to the New York Public Library.
Another is in the tiny Hours of Jeanne d'Évreux (1310–71), Charles IV's
third wife and sister-in-law of our Jeanne de Navarre, now not far away
at the Metropolitan Museum in New York. She too was a direct de-
scendant. A third is in the Book of Hours of Jeanne de Navarre's eldest
daughter, Marie de Navarre (1329–47), queen of Aragon, owned by the
Biblioteca Marciana in Venice. The text occurred also in the so-called
Savoy Hours, another manuscript made for Blanche of Burgundy but
destroyed in the terrible fire in the Biblioteca Nazionale in Turin in
1904. That volume had a heading explaining how the Hours of Saint
Louis were particularly to be recited by members of that most holy and
most royal dynasty of France, expressed as, "à personnes qui sont de si
sainte et de si très noble lignié comme est celle de France".

In Jeanne de Navarre's manuscript, here in front of us, the Hours
of Saint Louis are illustrated with charming and intimate scenes from
the saint's early life, like a family photograph album. We can turn the
pages, as Jeanne would surely have done with her children, Marie
(born 1329, just mentioned), Blanche (born 1330), Charles (born 1332),

RIGHT: Saint Louis as a child is driven in a carriage to his coronation in Rheims, a miniature
from the rare text of the Hours of Saint Louis

eus Cl prime
in adiutorium meum in
tende Domine ad adiuuan
dum me festina. Gloria pa
tri et filio et spiritui sancto. Sicut erat in
principio et nunc et semper et in secula secu

Agnes (born 1330s), Philippe (born 1336), and Louis, the saint's namesake (born 1341; there had been an earlier Louis who had died as a baby). Doubtless stories were told and morals were drawn. The first picture in this sequence shows Saint Louis as a child learning to read and write, under the direction of his mother Blanche of Castile and a schoolmaster with a whip (see frontispiece). The boy is holding a book. In Chapter Seven above we encountered the famous illuminated Romanesque Psalter in Leiden, with a fourteenth-century inscription asserting that it was the very book used by Louis as a child (p. 298). That manuscript in Leiden belonged to Jeanne de Navarre's grandmother, her aunt, and later to her daughter, and in all likelihood it was at one time owned by Jeanne herself. The picture in Jeanne's Book of Hours showing Saint Louis learning to read from that very manuscript is almost certainly a direct allusion to a specific family relic of the saint, as well as being a lesson to good children.

The other images in the hours here show Louis as a boy attending Mass (Lauds); Louis being taken in a horse-drawn carriage to Rheims for his coronation in 1226, accompanied by a queen, clearly his strong-willed mother, since Louis was only twelve and not yet married (Prime); his anointing as king (Terce); his coronation (Sext); Louis helping to carry the Crown of Thorns in 1239, a purchase which prompted the building of the Sainte-Chapelle to house it (None); Louis on his sick bed in 1244, fearing that he was about to die and promising to go on crusade (Vespers); and Odo de Châteauroux, papal legate, preaching the crusade itself in 1245 (Compline). These miniatures, like all others in the manuscript, are painted within quatrefoil frames in the *tricoleur*, the stripes of red, white and blue, then the colours of the French royal family and familiar now as the flag of the republic. The culmination of the cycle with the saint's launch of a crusade, unique to this manuscript, may be intended as a parallel to the announcement of a new crusade made by Philippe VI, great-great-grandson of Saint Louis, in 1333. If so, we can perhaps date the Book of Hours to that year or very soon after. The calendar includes Easter in red ink beside the date of 27 March. This is not necessarily to be taken at face value, since it may indicate no more than the range of Eastertide, but Easter Sunday did actually fall

on 27 March in 1334. That was exactly a hundred years since Louis had married and began to rule France in his own name. In 1334 Jeanne de Navarre's eldest child was five, a suitable age to begin learning to read.

It is really noticeable how personalized this Book of Hours is. All the other manuscripts we have encountered in previous chapters have comprised texts where intervention by the original patron was minimal. Here Jeanne de Navarre steps right into the book. She is named in a prayer. The manuscript includes the family's saint and perhaps others chosen by her, such as prayers to Saint Apollonia and a life of Saint Margaret in the French language. According to Sydney Cockerell, who wrote a long description of the manuscript for Yates Thompson in 1902, the former "perhaps indicates that Jeanne ... suffered from toothache", against which Apollonia was invoked; and the latter was patron saint of childbirth, appropriate for a young woman with many children. All the rubrics and headings are in French, the vernacular language of domestic households, especially used by women, as if Jeanne's confessor, a Franciscan we assume, is guiding her gently through her devotions. Some rubrics are quite confiding and direct. One begins, "*Vous devez savoir ...*": 'Your grace' – her chaplain might be addressing her aloud – 'You ought to know that according to the custom of the Court of Rome the *Te Deum laudamus* is not said daily before Lauds of Our Lady ...', and so on. Jeanne de Navarre is present in the illuminated borders, looking from the margins of the pages of her Book of Hours across the gulf from our world into that of the divine. When living people are first depicted in medieval devotional books, they are usually kept distant and distinct, in different universes, gazing in from the outside from behind the veil of a border or a historiated initial. In several remarkable scenes here, however, Jeanne de Navarre, owner of the manuscript, enters the sacred pictures themselves. One is on folio 118v. It illustrates a French prayer to the Virgin, "Douce debonnaire vierge ...", 'Sweet lovely Virgin ...'. The Virgin Mary is shown turning to the Christ Child and gesturing downwards with her right hand towards the initial 'D', where one might have expected Jeanne to be shown, gazing respectfully upwards. Instead, the initial is merely decorative, and Jeanne has crept up through the frame of the miniature and now kneels directly

Ouer. Oroison
debonnaire, uierge deuant le
saint conceuement. uierge
ou saint conceuement. uier
ge ou saint enfantement. humble uierge
mere dieu dame de toute mamere. et de tout

beside the Virgin. Here they are, two crowned queens together. This is an astonishingly innovative step and a daring one in the history of religious art. The Virgin, with eyes only for her son, has not actually noticed the medieval queen of Navarre interloping into her compartment at all. In another miniature an angel has entered our own world and is seen commending Jeanne de Navarre as she gives alms to the poor.

There is always an agreeably leisurely atmosphere in the Bibliothèque nationale. The tradition of gentle antiquarianism survives in France as nowhere else. Other readers of manuscripts here seem in no hurry, unless they are visiting Americans, of course, recognizable at once by frenzied industry and lack of time. I found myself sitting back in the chair and enjoying the manuscript for a while, before the next spurt of note-taking. Henry Yates Thompson had described this in 1902 as "one of the most charming of all Books of Hours", and it is indeed delightful.

Suddenly an hour has slipped past very pleasantly, as we sit gazing at tiny details from this microcosm of enchantment, like the globe held by God at Matins of the Trinity encapsulating a whole world in miniature, including a sailing-ship arriving at a harbour with trees and houses. At the Annunciation opening Matins of the Virgin, there are six uninvited angel musicians in the attic of Mary's house in Nazareth, performing so vigorously on a pipe, a drum, a lute, a psaltery and bagpipes that it is a wonder that the Virgin could concentrate on her prayers or hear a word of what Gabriel had to tell her. An even more impassioned angel is playing the kettledrums in an initial on folio 163r, so frenetically that he has crossed his arms to beat the drums opposite. The Flight into Egypt, for Vespers, includes two pagan statues falling off a frame like a gibbet as the Holy Family passes. What was thought to be one of these actual statues lying in the sands of Egypt was pointed out to medieval pilgrims: it is known to us now as the Sphinx. There are little *bas-de-page* vignettes in the borders of picture pages. Some seem to echo the central scenes. There are grotesques tending their own babies outside the sacred images of the Nativity at the hour of Prime. A boy is scolding the stabled

LEFT: Jeanne of Navarre entering the sacred space of the Virgin and Child and kneeling directly beside them, against a background emblazoned with the arms of Évreux and Navarre

cede. p dñm nŕm ihm xpm filium tui. qui te
cum uuiuc et regnac in unitate spiritus sancti
deus p omma secula seculox. Amen. Do
mine exaudi orationem meam. Et clamor
meus ad te ueniac. Benedicamus domino.
Deo gracias. Q̇unic omniū fidelium defūc
torum p misericordiam dei requiescant i pace amen

horses of the three magi at Epiphany, at Sext. There are naturalistic and pretty birds, unusual in European art as early as this, including owls, goldfinches, woodpeckers, swallows, ducks and even parrots. There are butterflies, a bat, children pulling off a boy's stockings, a hunter with a bow and arrow chasing hares into a hole, a striding man with a birdcage on his head (that one is on folio 153r and I cannot explain it), a couple playing chess (not remotely as convincingly drawn as in the *Carmina Burana*), boys fighting and a woman cutting her own throat, an ape dressed as a medical doctor, and a kneeling man proposing to a girl with a huge and frankly preposterous ring, and so on. The *Répertoire des biens spoliés* called them "sujets humoristiques" but there is also a dark side. There are borders with dragons and monsters and creatures of nightmares. Even the simplest pages introduce us to that quintessential feature of high gothic illuminated manuscripts, the so-called 'ivy-leaf' border, formed of stems with tendrils of burnished gold trefoils which sparkle as the pages turn. A botanist once pointed out to me that this foliage shown in French manuscripts is not actually ivy at all, as it is always described, but is bryony (*Bryonia dioica*), an even more poisonous plant. It is seriously dangerous, and in manuscripts it is often accompanied by dragons, lions and terrible monsters that can kill you. The world in the medieval margins is not a comfortable place, any more than the gilded life of Jeanne de Navarre was safe and secure.

Now let us focus again. It is hard to do, as the room is warm and soporific in the early afternoon. I collated the manuscript carefully and I give the result below.* There are two unexpected points. One is that the blank apparently missing after folio 10 is actually now the flyleaf, foliated as 'a' before folio 1, and it shares offsets with folio 1r from what were presumably once pilgrim badges sewn onto the manuscript's

* : i²⁺² [an added bifolium, folios 1–2, preceded by a blank flyleaf and followed by a miniature added *c.* 1420], ii⁷ [vii blank, of 8, viii cancelled, a blank leaf after folio 10], iii–v⁸, vi⁴, vii–xiv⁸, xv⁶, xvi⁸, xvii⁷ [of 8, lacking v, foliated '121'], xviii⁷ [of 8, lacking iii, a leaf after folio 126], xix⁸, xx–xxi⁷ [of 8, both lacking vii, leaves after folios 145 and 152], xxii–xxvi⁸, xxvii⁴ [apparently complete], xxviii–xxxiv⁸, xxxv⁴ [the original end of the manuscript], xxxvi⁵ [late fourteenth century, of 6, vi cancelled after folio 263], xxxvii⁸ [late fifteenth century], mostly with catchwords.

LEFT: The Adoration of the Magi, a suitably royal setting to invoke Queen Jeanne kneeling in prayer below, while a boy behind her scolds the magis' horses in their stable

opening leaf. That may be relevant when we look at the history of the book in the fourteenth century. More shocking is the loss of folio 121. This illustrated leaf was certainly still present when the manuscript was collated and foliated by Cockerell in 1902 and when it was sold in 1919, and it is unlikely to have been missing when Alexandrine de Rothschild reported the manuscript as stolen during the War. Did Hermann Göring cut it out? Many crimes are attributed to him but this is a new one. Its miniature was described by Cockerell as follows: "The Virgin crowned is seated on a throne. Over her head hangs a circular canopy. She holds a flower in her right hand and with her left hand supports the Child standing on her knee and leaning forward to Queen Jeanne who kneels to R. with hands clasped. Background, blue, pink and gold chequer." It sounds lovely, and it might still be framed on someone's wall, unsuspected by its current owner.

An enchanting feature of the Hours of Jeanne de Navarre is its calendar, illustrated with scenes which are complex and fascinating. We will examine the upper margins first. In each is shown a fantastical gothic gateway, apparently the entrance into Heaven, guarded by the Virgin Mary on the battlements, waving a banner. Each gateway supports an arch, like a rainbow, across the width of the page, enclosing a landscape. The sun travels along the line of the arch. From the gates step the signs of the zodiac – Aquarius in January, Pisces in February, Aries in March, and so on – pagan symbolism emerging from the Christian heaven into the temporal world. As each of the twelve constellations comes into the foreground, so its movement through the heavens affects the seasonal weather, an ancient astronomical belief articulated in the Leiden *Aratea*. The landscape for January looks like a sepia photograph of battle-scarred Flanders in the First World War, with stunted and leafless trees in a world of devastation. February is not much better, and it is raining too. By March the trees are in tiny bud. In April corn is growing and trees now have leaves. Meadows are full of wildflowers in May and it is warm enough for Gemini to disport themselves nakedly (although modestly behind a shield). Forests are

RIGHT: The Annunciation to the Shepherds, with a *bas-de-page* scene of peasants dancing to the music of bagpipes, and other grotesques and birds in the ivy-leaf border

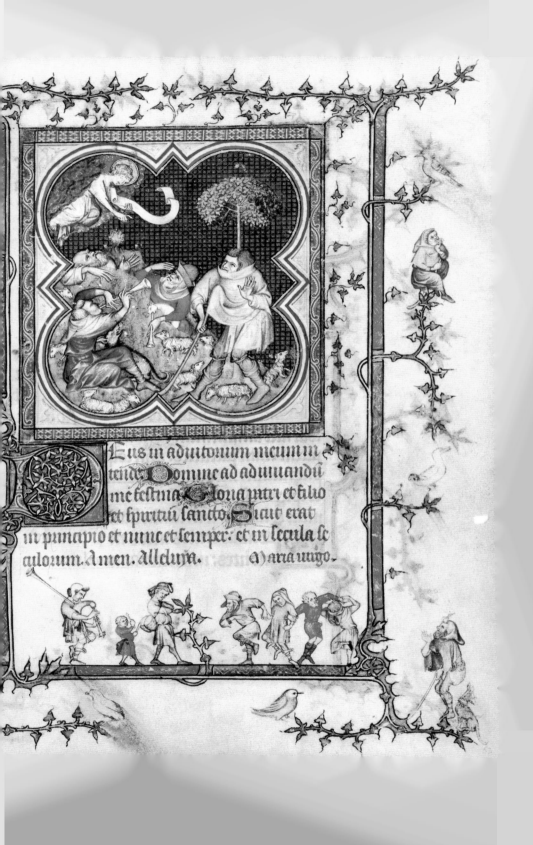

Eus in adiutorium meum in
tende. Domine ad adiuuandu
me festina. Gloria patri et filio
et spiritui sancto. Sicut erat
in principio et nunc et semper: et in secula se
culorum. Amen. Alleluya. Maria virgo.

in foliage in June. Grass has been cut and stacked in July, wheat harvested in August, vines are heavy with grapes in September (Libra, a girl with a pair of scales, might be ready to weigh them), pigs forage for acorns in October, and leaves are falling from the trees in November. In December is the only visible human participation in this eternal cycle, for here a peasant labourer is cutting firewood from trees already bare again, under the harsh sign of Capricorn. In each upper left-hand corner is a little figure of Saint Paul. He is presumably there because a liturgical calendar prescribes the church feasts of the year, with the number of lections to be used at each, and readings from the Epistles of Paul are an integral part of the Mass. However, Paul wrote letters to eleven recipients, not twelve, and so in January the number is made up by adding his own conversion to Christianity, falling off his horse and looking back as the hand of God appears from heaven (Acts 9:4). Thereafter for each month he is addressing a new audience, in biblical order, three diminutive Romans in February, several Corinthians in March, three Galatians in April, two Ephesians in May, and so on, through to Timothy alone in September, Titus with two friends in October (his companions may be Zenas and Apollos, mentioned in Titus 3:13), a solitary Philemon in November, and four Hebrews in December.

That is elaborate enough, and it has echoes which began in ancient astronomy and take us forward into the celebrated calendar of the *Très Riches Heures* of the Duc de Berry some eighty years later and eventually through to the Spinola Hours in the sixteenth century, as we will see in more detail in Chapter Twelve. However, it is nothing to the theological complexity of the scenes in the lower margins of the calendar pages of the Hours of Jeanne de Navarre.

In each lower border is an image of an elaborate gothic building. This is Synagogue, the temple of the Jewish Law. Beside each building stands an Old Testament prophet. Next to him is one of the twelve disciples of Jesus, an unlikely social encounter. They make polite if rather strained conversation to each other, the prophet using a suitable quotation from his book in the Bible and the disciple replying with a matching phrase from the Apostles' Creed. Thus Jeremiah in January says, "Patrem vocavit me", 'He called me Father' (Jeremiah 3:4, the

Bible text actually says '*vocavis*'), and Saint Peter replies tactfully, "Credo in patre[m] omnipotentem creatorem celi et terre", 'I believe in the Father almighty, maker of heaven and earth.' David cites his psalms in February, saying "Filius meus es tu", 'You are my son' (Psalm 2:7); Saint John the Evangelist reposts, "Et in ihesum xpistum filium eius unicum, Dominum nostrum", 'And in Jesus Christ his only son, our Lord.' In March, Isaiah offers his, "Virgo concepiet et pariet filiu[m]" (Isaiah 7:14), 'A virgin will conceive and bear a son', and Saint James counters, "Qui conceptus est de spiritu sancto natus ex m[ari]a virgine", 'Who was conceived by the Holy Ghost, born of the Virgin Mary', and so on, through to Zechariah in December, where the prophet cites himself in 9:13 of his book on the raising up of his sons and Saint Matthias answers with the last sentence of the Apostles' Creed on the resurrection of the flesh and life everlasting. That is not all. In each scene the prophet reaches back and pulls a brick out of the Synagogue and then passes it to the apostle. They resemble little books, like the manuscript found by the soldier at Berchtesgaden which he mistook for a brick. As he does so, the apostle seizes the hem of the cloak on the prophet. As each brick is removed, so the ancient Synagogue begins to crumble, month by month, one pillar already toppling by March, a whole tower detaching itself by April, an entire side in ruins by June, and so on, until nothing remains of the Jewish Law but a pile of rubble in December. The Christian Church, finally, could now be built up from the salvaged bricks of the demolished Synagogue.

The iconography of this distinctive calendar cycle, like the Hours of Saint Louis, is unique to a small group of interconnected manuscripts all made for the French court. The likely source is another royal manuscript, the so-called 'Belleville Breviary', illuminated around 1330 by the most famous and innovative of all Parisian court illuminators of the early fourteenth century, Jean Pucelle (d. 1334). Its calendar is more or less identical, in larger format. Indeed the entire Hours of Jeanne de Navarre is closely dependent on several manuscripts painted by Pucelle, including the Hours of Jeanne d'Évreux, already cited, now in the Metropolitan Museum in New York, securely attributed to Pucelle even in the fourteenth century. Jeanne d'Évreux was the younger sister

	f		Decembre a .vvi. iours. et la lune .vvr.
	g		... euesque et confesseur
xvij	A	iiij.	kl ... anne babiene vierge.
xv	b	ij.	... ope luce. vierge et niie.
	c	ij.	Sainct baste alte et confesseur
xviij	d	iiij.	kl Sainct nicolas euesque et confesseur
vi	e	vij.	kl Saint ambroise euesque et confesseur. feste double.
	f	vi.	kl La conception nostre dame. feste double.
xv	g	v.	kl Saint melchiade pape et martyr.
	A	iiij.	kl Saint damas pape et confesseur.
xi	e	iij.	kl ...
i.	d	ij.	kl Sainte luce vierge et niie. Demidouble.
	c	xix.	kl
ix.	f	xviij.	kl
xvij	A	xvi.	kl
vi.	b	xvi.	kl
	c	xiiij.	kl
xiiij.	d	iiij.	kl
iij.	e	iij.	kl Saint thomas apostre. demidouble.
	f	xi.	kl
xi.	A	ix.	kl
	b	viij.	kl La natiuite nostre seigneur ihesucrist. grant double.
viij	c	vij.	kl Saint estienne le premier martyr. feste double.
	d	vi.	kl Saint ichan apostre et euangeliste. feste double.
xvi	e	v.	kl Les sains innocens martyrs. demidouble.
v.	f	iiij.	kl Saint thomas arceuesque et martyr.
	g	iij.	kl Saint seuestre pape et confesseur.

The Calendar of the Hours of Jeanne de Navarre, with its very unusual iconography (LEFT), copied almost exactly from the slightly earlier Belleville Breviary, illuminated by the court artist Jean Pucelle (RIGHT)

of Jeanne de Navarre's husband, and members of the family certainly knew one another's manuscripts and they probably lent them to their favourite artists as models. The Book of Hours in front of us has details undoubtedly copied from the Hours of Jeanne d'Évreux, probably directly, including the Italianate composition of the Annunciation scene, with the same noisy angel musicians in the attic, and many tiny border details such as the same grey-bearded man in profile who ornaments the lower outer borders of the Annunciation to the shepherds in both manuscripts.

There are, in fact, several recognizable hands in the miniatures of the Hours of Jeanne de Navarre. These were separated and numbered

The Annunciation in Jeanne de Navarre's Book of Hours, with angel musicians in the attic (RIGHT), echoing the composition of Pucelle's miniature in the Hours of her sister-in-law, Jeanne d'Évreux (LEFT)

by Sydney Cockerell as long ago as 1902 and his judgements are generally still respected. His painters 1 and 2 are, to my eye, virtually indistinguishable. This artist or pair of artists painted the calendar (copied from the Belleville Breviary), the Hours of the Trinity, the Hours of Saint Louis, and many individual pictures scattered throughout the manuscript, including those of Saints Apollonia and Margaret which may be personal to Jeanne de Navarre. His work is known in a number of other manuscripts, including books dated 1336 and 1343. The artist was perhaps a pupil or former apprentice of Jean Pucelle, with access to his master's designs.

The most interesting artist, the third as Cockerell numbered them,

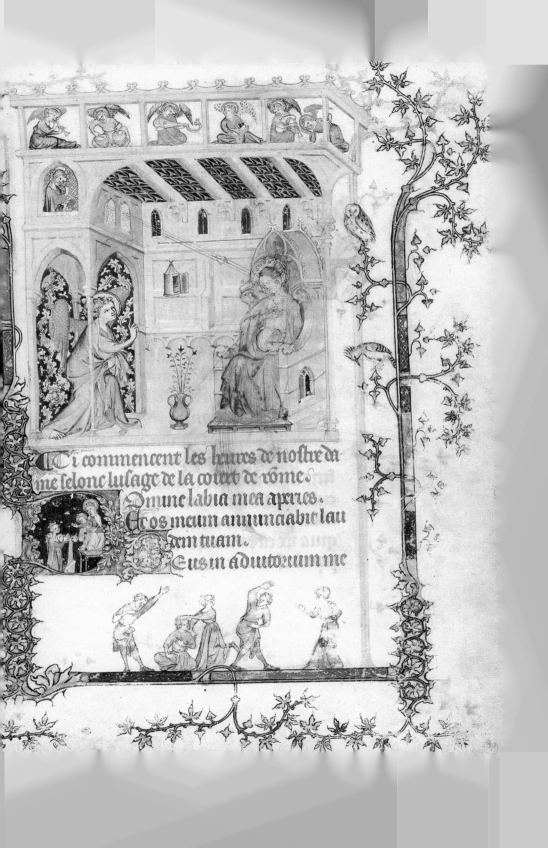

Ci commencent les heures de nostre da
me selonc lusage de la court de rôme.
Dmine labia mea aperies.
Et os meum annunciabit lau
dem tuam.
Eus in adiutorium me

is stylistically the most accomplished. He is really the leading illuminator there. He painted eighteen of the miniatures, including pictures for the manuscript's core text, the Hours of the Virgin (where we find both the Pucelle parallels just cited, the Annunciation composition and the grey-bearded rustic), the Hours of the Cross, and many individual pictures, including two showing Jeanne de Navarre herself. It is a very recognizable style. The hand of the same artist appears in a multitude of surviving royal manuscripts made in Paris in the middle third of the fourteenth century, including books made for Yolande of Flanders, Charles V and the Duc de Berry. Fortunately, there are quite good archival records of salaries paid by the French court. There is only one painter who is documented as working for all three of those patrons. He was called Jean le Noir. He was employed by Charles V by 1366, was "illumineur du roi" in 1371, and he was on the payroll of the Duc de Berry in 1372 and 1375. That must be who he was. Here, for the first time in our visits to manuscripts, we have work by a professional artist with a name and an independently verifiable historical reality.

We even know his address. Jean le Noir owned a house on the west side of the rue Erembourg de Brie, on the left bank in Paris, about ten minutes' walk directly south of the royal palace. Today it is called the rue Boutebrie. It still turns off the rue de la Parcheminerie, another name surviving from the medieval book trade, and it joins what is now the boulevard Saint-Germain by the Cluny-La Sorbonne métro station. What is interesting is that Jean Pucelle, his presumed teacher, had also lived on the same side of the same street until his death in 1334, and Jean le Noir might have inherited the house. The first reference to him is slightly earlier in 1332, when "Jehannin Lenoir, enlumineur de pincel" ('brush illuminator'), was arrested for the supposed theft of four pence which one Jean de Beauvais had left on two buckets, which had been stolen and found outside le Noir's lodgings on the right bank. Thereafter he can be traced consistently through various municipal records of Paris until his death in about 1380. His daughter, Bourgot, was also an illuminator.

Everything about the Hours of Jeanne de Navarre points to Paris. This was the richest and largest metropolis of Europe, with a population

of about 250,000. It was the seat of the royal court, the bishopric of Paris administered from Notre-Dame, and the greatest university of the Middle Ages. The wealth and needs of all three ensured that Paris attracted the finest artists and craftsmen. There were shops on the Île de la Cité, between royal palace and the cathedral, and on the covered bridges over the Seine. It was a period of exquisite manuscripts, precious metalwork, ivories, textiles and jewellery of infinite refinement and expense. At the same time, France was facing hazardous harvests and relentless plague, culminating in the Black Death of 1348–9. The country was being dragged into the horrendously expensive Hundred Years' War from 1337 with its disastrous defeats at Crécy (1346) and Poitiers (1356). To judge from the illuminated manuscripts, however, it is as if members of the royal family were loftily unaware of the hardships of the realm. They lived sugared lives in castles and palaces. Their manuscripts circulated and descended almost exclusively among themselves. The Hours of Jeanne d'Évreux and the Belleville Breviary, for example, were both inherited by Charles V and then by the Duc de Berry. Rather as the royal dynasties married only within very finite social circles, so their most precious possessions were kept within the family.

It was suggested as long ago as the nineteenth century that the Book of Hours of Jeanne de Navarre must have been presented to her originally by Philippe VI, the king who struck the deal whereby he would become king of France while she herself was assigned the throne of Navarre. The reason for this is the inclusion of a miniature on folio 150r showing a king and a queen with their family kneeling before the relics of the Sainte-Chapelle, unambiguously recognizable from tasselled heraldic banners as Philippe VI himself and his first wife, Jeanne of Burgundy, whom he married in 1313 and who died in 1348. In fact, it seems more logical to suppose that the donation happened the other way round. That the manuscript was made for Jeanne de Navarre is not in doubt, as she is named in the text, but there is no evidence that she took the book to Navarre or that it ever left the capital. The picture of Philippe VI and his family is by the manuscript's fourth artist, as numbered by Cockerell. This particular artist painted seventeen of the miniatures, clustered in two groups of Suffrages, all with pictures

One of the last additions to the Hours of Jeanne de Navarre showing Philippe VI, king of France, kneeling with his family before the relics in the Sainte-Chapelle

of saints. Their whole aspect is different from the work of the previous painters, both in style and in rougher finish. I am not the first person to wonder whether they represent a later phase in the decoration of the manuscript. Maybe they should be dated to the 1340s. Jeanne de Navarre might have passed on the book on the death of her husband in 1343. The picture of the king and queen kneeling in the Sainte-Chapelle includes other members of their family. They are accompanied by a young man with his arms raised in supplication. That is doubtless their son and heir, Prince Jean (1319–64), later Jean II, king of France. Immediately behind the prince are the faces of a woman and a small boy, who would be impossible to match precisely with other members of the family of Philippe VI in the mid-1330s. If we re-date this miniature to a decade later, however, then their identities fall into place, for the woman is therefore Bonne of Luxembourg (1315–49), daughter of the king of Bohemia, who married Jean in 1332, and the child is their son, the young Charles V, born in January 1338.

The Suffrages, all by this same fourth painter, include the very un-

usual picture of Saint Louis of Marseilles, bishop of Toulouse, a nephew of Saint Louis of France and so another family saint. He was canonized in 1317. He is reputed to have saved the life of that same Prince Jean, when the boy was so ill that he was beyond hope, and his grateful father afterwards made a pilgrimage to Louis's shrine in the company of Jeanne de Navarre's husband. We noted earlier the offsets at the beginning of medieval pilgrim badges once sewn into the book. Therefore this is a Book of Hours which has been taken to a shrine. It adds to the likelihood that the manuscript had already passed from Jeanne de Navarre into the custody of Philippe VI and his family. Since the tradition was that these books were used mainly by women, it would reasonably have been assigned to the care of the crown princess, Bonne of Luxembourg. The picture of her royal parents-in-law would be to emphasize her connections by marriage to the dynasty of Saint Louis, an inheritance which she in turn would teach to her young son.

Both Jeanne de Navarre and Bonne of Luxembourg died of the Black Death within a few weeks of each other in the autumn of 1349, the former aged thirty-seven, the latter only thirty-four. Jeanne's daughter Blanche afterwards married Philippe VI as his second wife and became queen. Bonne's children included Charles V, king of France from 1364, and the famous Duc de Berry. In the manuscript the arms of Évreux have in many cases been partially scraped away to leave the French royal semé of fleurs-de-lys of France. In one place the arms are overpainted with the new arms of three fleur-de-lys, adopted by Charles V in 1376. It is likely that the manuscript remained in the family.

Sometimes the provenance of a manuscript is so astoundingly obvious that no one sees it at all. Our attention moves to a detailed entry in the inventory of the library of the Duc de Berry in 1402. It records a Book of Hours which has never been identified with any surviving manuscript. The book is described as opening with the Hours of the Trinity and the Hours of the Virgin and as having an extensive series of prayers to the saints, "unes heures de la trinite et de n[os]tre dame, ou il a pluseurs Commemoracions de sains …". It is extremely unusual for any Book of Hours to begin with those of the Trinity, as our manuscript does, directly after the calendar, followed immediately by the

Hours of the Virgin, as listed, and the manuscript does indeed have an exceptional number of pictures of saints, upwards of thirty altogether. That alone makes the identification tantalizingly tempting. However, the inventory continues. 'These [Hours], beautifully illustrated and illuminated,' the description explains, 'did belong to the lady duchess of Normandy, mother of his lordship': "lesquelles furent de ma dame la duchesse de normandie mere de mons[eigneur], tres bien escriptes ystoriees et enluminees ...". She was none other than Bonne of Luxembourg, duchess of Normandy 1332–49, shown in the manuscript on folio 150r and the presumed recipient suggested above. Then the binding is described as having two enamelled clasps, with the arms of the queen of France and Bavaria. That refers to Isabeau of Bavaria (1370–1435), queen of Charles VI, who married her in 1385. The Book of Hours must therefore have been rebound for her, before it came to Jean de Berry. There is still more: we even know what the Duc de Berry did with the manuscript. There is a note in the margin of his inventory, 'Given to the queen of England ...' Since this donation by the duke cannot be

The inventory of the Duc de Berry in 1402 with a detailed description of a Book of Hours inherited from his family, almost certainly the Hours of Jeanne de Navarre

earlier than 1402, that queen must be Joan of Navarre (*c.* 1370–1437), dowager duchess of Brittany, who married Henry IV of England on 7 February 1403. It may even have been a wedding present and it was utterly appropriate. This new English queen was not only the Duc de Berry's niece (for her mother was Jeanne de France, his younger sister)

The Duc de Berry (1340–1416), whose sister married Jeanne de Navarre's son, welcoming dinner guests in the opening miniature of his *Très Riches Heures*

but she was also a granddaughter of Jeanne de Navarre, for whom the manuscript had originally been made. For a second time, therefore, the prayer "intercedas pro me ancilla tua Johanna navarre regina" was applicable to its owner, but this time she was a different Joan and was a queen of England instead.

If this is correctly identified, we can fill a major gap in the manuscript's history. The Book of Hours was made for Jeanne de Navarre. It apparently passed in her lifetime to her cousin's family, who may have employed the fourth artist, and to their daughter-in-law, Bonne of Luxembourg. It went then through Bonne's son Charles V to his own daughter-in-law, Isabeau of Bavaria, who had clasps made for the binding, and thence to the Duc de Berry, who tactfully gave it to his niece, a royal granddaughter of the original owner. That zig-zagging descent through the female line is utterly characteristic of Books of Hours. What is significant in this case is that every one of these royal women was a direct descendant – or married to a direct descendant – of Saint Louis. The manuscript was thus owned by three queens of different countries and a crown princess, as well as the king of France and the

Duc de Berry himself, the greatest royal book collector of the Middle Ages. Sydney Cockerell would have sold his soul to know that.

Virtual proof of the identification with the Duc de Berry's gift to the queen of England is provided by a frontispiece inserted at the beginning of the manuscript, otherwise inexplicable. This was painted by an English artist around 1420, almost certainly in London. It shows a woman in royal ermine, kneeling before the Trinity and the Virgin and Child, representing the two defining texts from the Duc de Berry's inventory. The woman has an oval gold arc above her hair – it cannot be a halo and must surely be some sort of tall headdress – and her dress is dimidiated in the heraldic colours of France and England. She has a scroll which reads, "[mer]cy and grace", in English. The same artist illuminated the Book of Hours for Catherine of Valois (1401–37, daughter of Charles VI and queen of Henry V from 1420) and it is possible that we need to add yet another queen of the French royal dynasty to the increasingly star-studded provenance of the Hours of Jeanne de Navarre.

The next step in the manuscript's history brought it back to Paris, although I do not know precisely how it came about. I would suppose that the custom of passing the book on to daughters or daughters-in-law of Saint Louis's line simply came to an end with Catherine of Valois, who had neither. Instead someone therefore decided to give it to the convent of the Cordelières, in the rue de Lourcines in the faubourg Saint-Marcel in Paris, the nunnery of Franciscan minoresses, co-founded by the widow of Saint Louis. It catered for upper-class women, and it honoured the memory of Saint Louis himself. In default of actual descendants of the saintly king, it would have been an appropriate home for the manuscript. The site is now in the modern rue Broca, in the 13th arrondissement. The leaves added at the very end of the manuscript include a litany of unambiguously Franciscan use, written in a French hand and datable to not before 1481, since it invokes the Franciscan saint, Berard of Carbio, canonized in that year, and the prayers are in the form appropriate to a female community. Below the last line of the manuscript is an erased inscription which Cockerell read

LEFT: An early fifteenth-century frontispiece by an English artist added to the Hours of Jeanne de Navarre, showing a kneeling woman in prayer, apparently a queen of England

as, "Ces heures sont a seur anne belline", which is possible, although I cannot make out much myself. That need not necessarily mean that Sister Anne owned it, but that it was assigned to her use in the convent.

By happy chance there is an unambiguous sighting of the manuscript in the seventeenth century, when it was demonstrably owned by the Franciscan nuns in the rue de Lourcines. The antiquary Nicolas-Claude Fabri de Peiresc (1580–1637), who made a walk-on appearance in Chapter Four above (p. 171), was interested in the iconography of Saint Louis. There were medieval wall-paintings of the life of the saint in the convent. When he was inspecting these, one of the sisters must have told him about their Book of Hours, with its rare illustrated Hours of Saint Louis. Peiresc was allowed to borrow it for several days in 1621. The brief notes in ink on the opening leaf are in his hand. Peiresc made an extensive account of the entire manuscript, with drawings of many of its miniatures, and he correctly identified the original owner as Jeanne de Navarre. These notes, now among his papers in the library in Carpentras, were published in Paris in 1882, but at that time the original Book of Hours described was not yet known to have survived.

I hope that Peiresc did actually return the manuscript to the library of the convent. He was a compulsive book collector and might have been tempted to retain it. The Book of Hours does seem to have left the possession of the nuns before the house was finally closed and demolished in 1796. Its excessively gilded morocco binding has all the distinctive features of the work of Richard Wier (d. 1792), a London bookbinder of Scottish descent who with his wife was working in Toulouse from 1774. I discreetly took careful pencil rubbings of the tools, expecting every moment that the invigilators would challenge me, threatening prosecution and the guillotine at dawn, but they smiled benignly. Characteristics of Wier's bindings include coloured silk paste-downs bordered by unusually wide turn-ins of gilt ornament, as here, and bands of Greek key designs across the top and bottom of the spine, the use of large gilt flowers in the spine compartments within lozenges of buds, and the titles on red and green labels stamped in sloping capitals, often with poor command of French. Here the labels read, "*HEURES SUR: VELIN*" and "*AVECMINITURES*" (*sic*, and in one

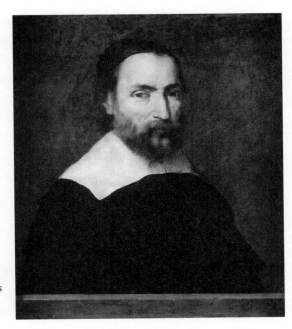

Nicolas-Claude Fabri de Peiresc (1580–1637), the first antiquary to study the Hours of Jeanne de Navarre and to identify its original owner

word like this). Wier became increasingly alcoholic. His only client in France was Count Justin MacCarthy-Reagh (1744–1811), an immensely wealthy landowner from Tipperary, partly brought up in France, and eventually one of the great book collectors of the eighteenth century. In 1761 MacCarthy sold his Irish estates and emigrated to Toulouse. In 1765 he married the daughter of the owner of vast West Indian sugar plantations. In 1776 he negotiated French citizenship for himself and the title of count. MacCarthy's grand library, rich in illuminated manuscripts and luxury editions of books printed on vellum, was catalogued by the de Bure brothers, Parisian booksellers, in 1815, and this publication later doubled as an auction catalogue for the sale of the library itself in 1817. The Hours of Jeanne de Navarre must be lot 392, which was bought by the firm of London booksellers Payne and Foss, of Pall Mall, for 350 francs, then about £13 10s. They may have been intending it for Francis Douce (1757–1834), for whom they bought six manuscripts that day, and, if they had succeeded, the Hours of Jeanne de Navarre would now be among Douce's incomparable collection in the Bodleian Library in Oxford.

It was not rare in the early nineteenth century for expensive manuscripts to remain in the trade for decades. Payne and Foss were in business until 1850. The Book of Hours was finally sold in 1847 for £73 10s. by another London bookseller, Henry George Bohn (1796–1884), of New Bond Street, to Bertram, 4th earl of Ashburnham. That was the year when Ashburnham also bought the tenth-century Beatus from Libri, as described in Chapter Five. The Hours of Jeanne de Navarre became H. 88 in the library of Ashburnham Place in Sussex. Like the Beatus, then, it was part of the sale by the 5th earl in 1897 of the entire remaining 'Ashburnham Appendix' to Henry Yates Thompson. Its notional valuation at that time was £300.

The ghost of Sydney Cockerell (1867–1962) has flitted in and out of this chapter. He had been secretary and executor to William Morris (1834–96), the great designer and protagonist of medieval art, and between Morris' death and his appointment as director of the Fitzwilliam Museum in Cambridge in 1908, Cockerell made a living as advisor and cataloguer of illuminated manuscripts to the very wealthy, including Yates Thompson. He became a tireless champion of the Hours of Jeanne de Navarre, whose name he discovered. It was Cockerell who transformed its reputation from being a pretty but unidentified £300 book into an icon of world stature. He borrowed the manuscript for three weeks in February 1899 and he took it across to Paris, where he showed it to Léopold Delisle at the Bibliothèque nationale. Several notes taken by Cockerell during that conversation are still visible in pencil on the second flyleaf, in his distinctive minuscule handwriting. It may well have been Delisle who pointed out that this was the untraced manuscript of Jeanne de Navarre described by Peiresc, as published in 1882. Later that year, doubtless furnished with material by Cockerell, Yates Thompson sponsored a luxury publication of the manuscript for presentation to the bibliophilic Roxburghe Club, to which he had been elected the previous year, *Thirty-Two Miniatures from the Book of Hours of Joan II, Queen of Navarre*, distributed to members in 1899. The second volume of Yates Thompson's catalogue of manuscripts (1902), in which the Beatus was described by M. R. James, has an exhaustive entry by Cockerell on the Hours of Jeanne de Navarre, which, especially dur-

Sydney Cockerell (1867–1962), manuscript advisor to collectors and later director of the Fitzwilliam Museum, Cambridge, tireless advocate of the Hours of Jeanne de Navarre

ing the manuscript's subsequent invisibility after 1919, has remained its principal description. The manuscript was exhibited in public for the first time at the Burlington Fine Arts Club in 1908.

In January 1919 Cockerell, now representing the Fitzwilliam Museum, was devastated by the news that Yates Thompson was intending to sell his collection (see above, p. 199). He borrowed the manuscript a second time and took it to a dinner at the Grosvenor House hotel in London on 30 January, where he convinced the Fitzwilliam's secret benefactor, T. H. Riches, to offer £4000 for it immediately, on the understanding that it would be bequeathed to Cambridge. Cockerell's diary, now in the British Library, gives the details. Next morning, Yates Thompson was inclined to accept. Mrs Thompson, however, said it was surely worth £5000 and the deal collapsed, to Cockerell's outrage and disappointment. On 14 April 1919, *The Times* announced the imminent auction at Sotheby's, mentioning the Hours of Jeanne de Navarre, saying of it that it had been "discovered in a Paris convent by the famous Peiresc", a seemingly superfluous observation which was to have a great effect on the result of the sale. The auction itself was on 3 June.

The Hours of Jeanne de Navarre was lot V (the numbers were in Roman numerals). The sale was taken by Sir Montague Barlow, a partner of Sotheby's. He opened the bidding at £2000. Edmund Dring of Quaritch was representing Baron Edmond de Rothschild, for whom the manuscript had special resonance, since he and his son between them already owned the Hours of Jeanne d'Évreux, the *Très Belles Heures* of the Duc de Berry, the *Belles Heures* of the Duc de Berry, and the Book of Hours of the duc's cousin, Charles the Noble. The Rothschilds, like the royal patrons of fourteenth-century France, liked to keep marriages and manuscripts within the family.

However, unexpected competition in the saleroom came from Charles Hagberg-Wright (1862–1940, knighted in 1934). Although he was a librarian by profession, he was a man of private means, a collector and a member of the Roxburghe Club, and he had earlier that same year married a prosperous widow. More relevantly, Hagberg-Wright was passionate about Nicolas Fabri de Peiresc. He published a biography of him in 1926, including a description of his hero's encounter with the Hours of Jeanne de Navarre in 1621. To the never-forgotten astonishment of the auction room in 1919, Hagberg-Wright was seen bidding tenaciously on the manuscript at Sotheby's to a level of madness, forcing the Baron de Rothschild to pay the utterly unprecedented price of £11,800, for many years a comfortable record for any manuscript sold at auction. In the same sale, the tenth-century Beatus, valued in 1897 at £1600 (compared with £300 for the Book of Hours), made only £1000. For the sixth and last time in its history, then, the Hours of Jeanne de Navarre again recrossed the Channel.

At this point we are about to examine some entirely unknown material. In response to my inquiry for more information, Charlotte Denoël in the manuscript department of the Bibliothèque nationale de France referred me to her colleague Aurélien Conraux in the library's own archives. Between them, they told me of an internal file of papers on their acquisition of the Book of Hours in 1967–73. I went back to Paris to see it at the new Bibliothèque François-Mitterrand, situated towards the end of line 14 on the métro, to the east of Paris. This is an

enormous modern building of wood, glass and silver metal, between four tower blocks resembling open books propped on their ends. You descend down multiple floors to reading-rooms arranged around the perimeter of a vast central underground light well, planted with trees and ferns. I was sent to Salle T – they are all alphabetical – dedicated to *Documentation sur le livre.*

The dossier is classified as E38/b221. It is a white archive box filled with folders of yellow paper, within a single purple wrapper. There are letters, memoranda, old-fashioned photocopies, drafts of replies, and so on, some clipped together, mostly in reverse order of date. The key figures are Étienne Dennery, *administrateur général* of the library, Marcel Thomas, keeper of manuscripts, Maître Georges Izard, the library's lawyer, Dom Bernard Besret, prior of Boquen Abbey in Brittany, where the manuscript was rediscovered, and Baron Edmond de Rothschild, heir of his aunt, the Baroness Alexandrine. The documents in the file allow us to fill in dates, hitherto lacking, and they tell a story rather different from that recounted by Maurice Rheims.

The manuscript was deposited by Besret for inspection at the Bibliothèque nationale in 1967, apparently in July. It was then thought to have been owned by the family of Anjou, but it was quickly recognized by the library staff as the lost Hours of Jeanne de Navarre and it was matched with the entry in the *Répertoire des biens spoliés.* There may be enough information to identify who had actually pocketed it at Berchtesgaden, for, in addition to being a medical officer, Besret described its unnamed finder as having been a former *député* of the Côtes d'Or. Edmond de Rothschild was duly informed of his apparent windfall, and there is a letter from Maurice Rheims in late 1967 reporting to Dennery that the baron was then inclined to sell the manuscript at auction, and to divide the proceeds between Boquen Abbey and a foundation which he was himself establishing in Jerusalem. On 28 December 1967 the baron came for a meeting at the Bibliothèque nationale to discuss terms under which they might buy it instead, again with a share of the proceeds for Boquen. There was a proposal for an independent valuation from the Parisian booksellers Giraud-Badin.

The bombshell came with a memorandum dated 14 February 1968

from Frau Böhm at the ministry of finance in Berlin. She supplied sensational and precise information about the manuscript during the War. She reported that it had been classified under the reference 'R 1550' at the Einsatzstab Reichsleiter Rosenberg (the ERR), the headquarters for sorting stolen art established in the Jeu de Paume museum in Paris, and that from there it had been sent personally (this word underlined) to Hermann Göring on 10 March 1942. Apart from the story of the manuscript having been found beside the train parked in Berchtesgaden, which derives solely from Besret (including his letter here dated 12 June 1968), this is the first independent evidence we have that the Hours of Jeanne de Navarre was requisitioned by Göring himself. Furthermore, Frau Böhm explained, Alexandrine de Rothschild had already received compensation from the German government. Documentation is attached. The baroness's lawyer, Hans Deutsch, had submitted a claim on 29 March 1958 for the loss of numerous works of art during the War, including the Hours of Jeanne de Navarre, which had been valued for the purpose by the dealer Heinrich Eisemann at 73,200,000 French francs, then just over £50,000 or a little under $150,000. For this and the many other missing items, the ministry in Berlin had agreed on 25 September 1958 to pay total reparations of 17,500,000 DM (about £1,500,000 or $4,200,000), which huge sum was transferred to the baroness in Switzerland on 3 March 1959. Therefore, as happens with any ordinary insurance claims where payment has been made, the unexpectedly recovered Hours of Jeanne de Navarre was now no longer the property of the Rothschild family at all, but belonged technically to the West German government, which had paid out its value.

One has to admire Dom Bernard Besret. He did not give up without a fight, and he maintained his claim to his abbey's share of the value throughout 1968, including requests to have the manuscript returned to him, which in June 1968 the Oberfinanzdirektion in Munich instructed the Bibliothèque nationale not to do while its title was in dispute. Finally in October 1969, after discussion with Maurice Rheims, Besret conceded defeat. On 7 November 1969, Baron Edmond, who had not known about his aunt's arrangement with Germany, also graciously withdrew. In theory, if the case held up, the German federal

Hermann Göring (1893–1946) with Adolf Hitler (1889–1945), inspecting a painting under consideration for Göring's private collection of art

government could now have had the manuscript sent to a library in West Berlin or Munich, for example. Perhaps with this in mind, Marcel Thomas managed in July 1971 to get it designated as an unexportable national monument of French culture.

In the meantime, the Bibliothèque nationale was in seemingly endless negotiation with the West German embassy. Marcel Thomas had enlisted the help of Florentine Mütherich, manuscript historian in Munich and everyone's friend, and together they had visited Hans Hauser, the cultural attaché in Paris, emphasizing the international goodwill which would result from a generous resolution. Calculations were made on the sum of 365,000 DM paid out to Madame Alexandrine, plus interest at 4 per cent since the date of the recovery of the manuscript, and, on 15 January 1973, Herr Hauser finally agreed in writing to the terms, on behalf of the federal ministry of finance, to reimbursement by the French government, payable in three annual instalments. The sum was paid, and title was transferred. Jeanne de Navarre herself never achieved the throne of France, but her adventurous Book of Hours is now safely gathered into the French national library, where it rightly belongs.

The Hengwrt Chaucer

c. 1400
Aberystwyth, National Library of Wales,
Peniarth MS 392 D

It is not often that medieval scribes hit the front pages of the national newspapers. "Chaucer's sloppy copyist unmasked after 600 years" ran the headline in the *Guardian* in England on Tuesday, 20 July 2004. The story, based on a press release put out the day before, recounted how Geoffrey Chaucer (*c.* 1343–1400), author of the *Canterbury Tales*, had once written a short verse apparently addressed to his private scribe called 'Adam', entreating him to be more careful in copying, and it told how the two oldest surviving manuscripts of the *Canterbury Tales* had been identified as being in the same hand as a document of the late fourteenth century signed by a scribe in London called Adam Pinkhurst, now revealed to be that mystery copyist himself. The discovery was quite rightly credited to Linne R. Mooney, an American originally from Maine who now teaches in the English department at the University of York. Professor Mooney, the article explained:

tracked Pinkhurst down by studying his signature to an oath in the earliest records of the Scriveners' company in the city of London, and comparing it with Chaucer manuscripts ... "Lots of people have looked at these records before, but they did not happen to be people who were working on scribes," Prof Mooney told the Guardian yesterday. They were not equipped to recognise that Pinkhurst's signature is also the handwriting of The Canterbury Tales

... Neither would they have had Prof Mooney's formidable immersion in the calligraphic side of the period.

We will discuss shortly why this sensational identification would transform what is known about the original circulation of the greatest work of Middle English literature, but, for the moment, consider the public reaction to the news in the summer of 2004. Instead of being delighted, as I expected, the British academic establishment was outraged. In part, no doubt, there was resentment that a relative outsider, an American indeed, was being feted as the expert on matters so quintessentially English. Without the courtesy of weighing her evidence, there were those who instantly prejudged any identifications by Linne Mooney to be inherently preposterous. Rather like men who write on feminist issues, Linne was simply dismissed as being unqualified to pronounce on the subject at all. This was dreadfully unjust and it was doubtless very upsetting for her. The gentle world of university common rooms can be very cruel. The on-going controversies over Adam Pinkhurst have come to resemble the pamphlet wars of the eighteenth century, driven as much by faith and jealousy as by reason and historical verification.

Since 2004, scholarship on the manuscripts of Geoffrey Chaucer has been utterly divided over the identification. There are those – certainly at what might be called the Wikipedia end of the spectrum – who accept the identification as proven fact, and who have taken it further, attributing more manuscripts and fleshing out the career of the scribe and his importance in the dissemination of Chaucer's greatest text. Adam Pinkhurst, unknown for most of history, now has his own substantial entry in the *Oxford Dictionary of National Biography*, written, not surprisingly, by Linne Mooney, titling him unequivocally as "scribe to Geoffrey Chaucer" and stating with certainty that his "handwriting is easily recognised". There are others who are still fiercely hostile to the whole suggestion. At best, many British palaeographers of conservative disposition have declined to commit themselves. I think that it was the late Malcolm Parkes who in discussions of this subject first used the tactful expression that 'the jury is still out' over the identification and this is still the response often muttered among many academics. Since law courts and their personnel appear recurrently both in the

records of Chaucer's life and in the text of his *Canterbury Tales*, let us convene that jury for the purposes of this chapter and cross-examine the witnesses.

Chaucer was the son of a London vintner, or wholesale wine merchant. He was well-educated and was fluent in several languages. He travelled abroad. He was part of the army of Edward III in the Hundred Years' War, and he was captured during the siege of Rheims in 1359 and was ransomed several months later. He married well, to an intimate of the royal household. He held various posts in the royal administration, principally Controller of Customs for the import and export of wool, skins and hides, in the port of London. Chaucer served as diplomat, justice of the peace and member of parliament. He lived in the generation when the English language was finally gaining respectability. Before the fourteenth century, the upper classes in medieval Britain had spoken French (or its dialect called Anglo-Norman) and most literacy was in Latin. For 300 years, English, descended from Anglo-Saxon, had been no more than the vernacular language of illiterate peasants, gradually absorbing French words on its way. Following the social turmoil of the Black Death in 1348–50, the new hybrid known as Middle English began to edge up the social scale. Chaucer's own circle was very respectably upper middle class. His early literary texts included the *Book of the Duchess*, commemorating the death in 1368 of the wife of John of Gaunt, duke of Lancaster. It was written in English. Chaucer wrote a translation into English of the Latin Boethius, called *Boece*, around 1380, and *Troilus and Criseyde*, a knightly romance in verse based on the Trojan War, in the mid-1380s. Chaucer's main fame today rests on the *Canterbury Tales*, a vast anthology of stories in verse and prose which he probably began writing around 1387. The *Tales* were presented as being recounted by twenty-nine ill-sorted pilgrims who had chanced to meet one another on a journey from London to the shrine of Saint Thomas Becket in Canterbury. According to the text's General Prologue, it was suggested by the host of the Tabard Inn in Southwark, the pilgrims' tour leader, that they should all amuse themselves on their travels together by recounting tales, two each on the way down to Canterbury and two each on the way home again. As originally

proposed, therefore, the whole collection would have involved 120 stories. Only about two dozen were more or less completed by the time of the author's death in his late fifties in October 1400.

No autograph manuscripts of Chaucer are known. The two oldest copies of the *Canterbury Tales*, usually ascribed to around or shortly after 1400, are the manuscript which is the subject of this chapter, the so-called Hengwrt Chaucer, which we are to visit in Aberystwyth, and a notably grander but slightly later copy, known as the Ellesmere Chaucer, once owned by the Bridgwater family, later Lords Ellesmere, whose descendants sold it in 1917 to Henry Huntington in California. It is now a stellar treasure of his patrician library and art gallery in San Marino near Los Angeles, opened to the public in 1928. It is the manuscript with the famous pictures in the margins showing the different pilgrims on horseback. Nearly everything that is reasonably knowable about the original text of the *Canterbury Tales* depends on the testimony of these two primary witnesses, Hengwrt and Ellesmere, and they are the

The Ellesmere manuscript of the *Canterbury Tales*, now in the Huntington Library, California, copied by the same scribe as the Hengwrt Chaucer

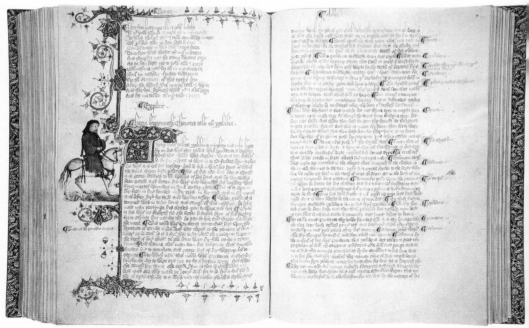

foundation of all modern editions. In so far as such judgements can be made, they seem to represent very pure and accurate texts.

It was suggested as long ago as 1935 that the Hengwrt and Ellesmere manuscripts appeared to have been copied by the same scribe. This was confirmed in 1978 in a ground-breaking article by Ian Doyle and Malcolm Parkes, the twin giants of mainstream Middle English palaeography, and they added two further examples of the same scribe's hand. These others are a fragment of Chaucer's *Troilus and Criseyde* in

A small fragment of a lost manuscript of Chaucer's *Troilus*, in the archives of Hatfield House, copied by the same scribe as the Hengwrt and Ellesmere manuscripts

the archives at Hatfield House in Hertfordshire, and a stint in writing a manuscript of John Gower's Middle English *Confessio Amantis*, copied by several different scribes and now in the library of Trinity College, Cambridge. From his place among the sequence of different copyists in the Gower, Doyle and Parkes accorded him the neutral and colourless epithet of 'Scribe B'. Whoever he was, he must have been some kind of professional scribe very close indeed to the lifetime of Chaucer, working in the region of London, which is consistent with his spelling. So far, this is uncontroversial and is more or less universally accepted.

Our first witness to be called in the trial of Adam Pinkhurst has to be the manuscript of the Hengwrt Chaucer itself. In a real law court, witnesses must begin by stating their names. Hengwrt, which means 'Old Hall' in Welsh, was once a large house, now demolished, near Dolgellau, Gwynedd, about twenty-five miles north of Aberystwyth in Wales. Scribbles and sometimes childish inscriptions in the manuscript show that in the sixteenth century it was owned in Chester, on the Welsh border. By the mid-seventeenth century the manuscript had been acquired by Robert Powell Vaughan (c. 1591–1667), a Welsh antiquary, who inherited the Hengwrt estates from his wife's family. His library included incomparable monuments of early Welsh literature, such as the thirteenth-century Black Book of Carmarthen and the fourteenth-century Book of Taliesin. The Chaucer was catalogued there in 1658 as *"Membrana 154 Chaucer's Works very fairly written on vellom. In fol. 4 inches thick."* It remained on the shelves at Hengwrt, largely neglected, until the death of the childless third baronet, Sir Robert Vaughan (1803–59), who bequeathed the house's manuscripts to his friend William Wynne (1801–80), of Peniarth, himself already a great collector. In 1904 the entire double library from Hengwrt and Peniarth was bought from Wynne's estate by Sir John Williams (1840–1926), medical doctor and philanthropist, founding benefactor of the National Library of Wales, and one of the least plausible of the many suggested candidates for the identity of Jack the Ripper. The new Library's location in Aberystwyth on the western coast, rather than in the Welsh capital in Cardiff, is principally because that was a condition of Williams' bequest, which was made in 1909.

The National Library of Wales (or Llyfrgell Genedlaethol Cymru) is really one of the most magnificently inaccessible outposts of learning in the British Isles. Aberystwyth is at least a five-hour car journey from London, depending on traffic. There are no airports closer than Birmingham or Manchester. By rail, which was how I travelled, even the quickest route takes three and a quarter hours from Birmingham, on a little stopping train initially so crowded that I had to stand, through Wolverhampton and Shrewsbury and then across the entire width of central Wales, calling at tiny stations with ancient-sounding names like Caersws, Machynlleth, Dovey Junction and Borth. It is a landscape of

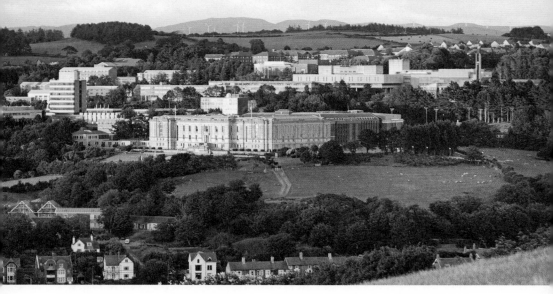

The National Library of Wales, established in 1907, built like a great palace on the hill overlooking the seaside town of Aberystwyth

neat green fields and solitary stone farmhouses, all like something from a model railway set of long ago. Eventually the train, by now almost entirely empty, totters slowly into Aberystwyth, a charming seaside town with tall nineteenth-century pastel-coloured and slated-roofed houses along the waterfront. I stayed at the Gwesty Cymru on Marine Terrace, with a view of the sea and the sunset. Aberystwyth has a wistful out-of-season feeling (this was mid-June, in fact), with almost no traffic and only gulls on the beach, with its crunchy grey sand and gentle waves. Because everyone can speak Welsh (and they do), impenetrable to the English, it all feels as foreign as Finland, and the occasional cars with their familiar British licence plates are a shock each time.

The next morning I took a taxi up the hill to the National Library, set on a spectacular site, high above the slate rooftops of the town below. It is a great classical building in granite, with a dedication stone at the foot of the front steps commemorating its opening by George VI in July 1937: I later learned that the building has many other dates, as it has been expanded and infilled in every architectural style from the early twentieth century onwards. You go in by an entrance on the ground level around to the right of the main steps, through a glass

turnstile into a low lobby with an inquiry desk and the library book-shop in front. I explained to a pleasant fair-haired receptionist on duty that I had come to see Maredudd ap Huw, curator of manuscripts. She replied in English, of course, but she telephoned him in Welsh. There followed a long conversation, with earnest glances in my direction. I have no idea what was being discussed, but I imagined her warning him of this very odd visitor with a dangerous look and messy hair and that she did not recommend him at all, and then she smiled sweetly and asked me to wait a moment.

Maredudd is a tall well-dressed young man with cropped dark hair and thin glasses. He could not have been more helpful or welcoming. In fact, it was all rather awkward. I had expected to be let anonymously into the reading-room, as on previous visits, but instead I was hurried upstairs to the President's Room, a kind of executive boardroom over-looking Aberystwyth, with a marble bust of Sir John Williams on a pillar in the corner. It seemed to be full of people. Here I was introduced to Sally McInnes, head of collection care, Nia Mai Daniel, in charge of ar-chives and manuscripts, Rhys Davies, archivist, and even to Aled Gruff-ydd Jones, national librarian and chief executive. They had apparently all come to witness my first formal meeting with their greatest Middle English manuscript. Like the Book of Kells, the Hengwrt Chaucer is in-cluded in the UNESCO Memory of the World Register, and it is not brought out often. A photographer was hovering in the background. I could tell that I was about to be a disappointment for everyone, espe-cially if they hoped for immediate judgements and startling revelations.

The room is long and narrow with a tall metal-framed window at the far end. Its Venetian blinds had been pulled up. I was placed at the long table, inset with dark green leather, in a matching padded leather chair. Opposite me was a 1930s yellow and white marble art deco fireplace. Already on the table was a brown cloth box, stamped on the spine, "PENIARTH / MS / 392D", about the most unmemorable reference for any world-class manuscript. Below the number was a spot of red leather, indicating (as Maredudd told me) the highest level of restricted access. I was given a pair of white gloves in a packet labelled "Made in China", which may explain their diminutive size. I wore them tactfully at first,

but gradually, as the day progressed, they were silently overlooked.

The reception committee held their breaths as I removed the book, but they soon got bored and slipped away. The Hengwrt Chaucer is bound in high-quality modern red morocco, ruled with black lines in a frame and lozenge pattern, with plaited straps from the lower cover ending in silver rings, which fit over catches on the edges of the upper cover. The boards are of wood, noticeably larger than the pages of text. The titling on the spine is superfluously extensive, lettered, "THE TALES OF CANTERBURY" and "GEOFFREY CHAUCER" and "HENGWRT MS. 154. PENIARTH MS. 392D", all in gold. The binding was made in the Library in 1956. The Gregynog Press, the private press of the sisters Gwendoline and Margaret Davies at Gregynog Hall in central Wales, had closed in 1940 and the stocks of unused leather and spare materials from its craft bindery were given to the National Library in Aberystwyth by Margaret Davies in 1954. The Library decided to use these for rebinding some of their great treasures, including the Chaucer. The result is much more traditional than, say, the austere oak of the Gospels of Saint Augustine or the Book of Kells, although their bindings are of similar date. The fragile sides of the previous late-medieval binding of the Hengwrt manuscript survive separately, and I was shown those too. The old covers are almost black; the new binding is red. The colours are an appropriate (although doubtless coincidental) echo of Chaucer's clerk of Oxenford, who had at his bed's head twenty manuscripts bound in black and red.

The manuscript measures 11½ by 8¼ inches. The opening page has an illuminated border surrounding the text, with bars of pink and blue sprouting at intervals into little clumps of foliage. This first leaf is undeniably worn and now rather shiny from exposure, and the pink pigment especially has faded, but the gold still sparkles over thickly laid white gesso. There is a great initial 'W', six lines high, for the famous opening line, "Whan that Averyll wt his shoures soote ..." Although this manuscript is not as luxurious as the Ellesmere Chaucer and is not remotely in the class of the contemporary illuminated literary texts being made in France for patrons such as the Duc de Berry, it is nevertheless not a cheap book. It uses gold. It is of some size, especially in comparison with many Middle English manuscripts of its time, such

as *Piers Plowman* or the Wycliffite scriptures, which are often small and unimposing. It is written on parchment, not paper, which was by then already being used in England for inexpensive books, and the skin here is of good quality, soft to the touch.

The most immediately striking aspect of the manuscript as it survives now is that every upper outer margin has been replaced, more obtrusively than is apparent in either of the facsimiles. Parchment is protein, edible to rodents. Probably when the book was neglected in the eighteenth century at Hengwrt, the upper corners of all pages were nibbled away. (I see the glimmerings of a children's story in there somewhere called *The Rat Who Ate the Hengwrt Chaucer*.) When the book was rebound in 1956, these defective margins were replaced throughout with patches of fresh white parchment, without any attempt to tone them in sympathetically with the adjacent mellowed old pages. The result is that the colour of every opening is as piebald as a spotted spaniel. At the same time – this would never happen today – the outside edges were stained red and then gilded along the top, even across the edges of the new insertions, and these can be assigned to the same campaign of binding since spots of red splattered onto the replacement parchment on folio 87.

Most of the book comprises script, in narrow columns if it is in rhyming verse or in upright rectangles in passages of text in prose, forty lines to the page, written in a quite large well-spaced English bookhand. Scribe B's writing here is curiously similar to the typeface of the 38-line second edition of the *Canterbury Tales* printed by William Caxton in Westminster in 1483. The manuscript has handsome decorated initials in blue with red penwork, and there are intense blue paragraph marks throughout. Many pages have the titles of the tales in the upper margins. With the help of these, it is easy to find your way around the text. The size of the script is large enough that it could have been used for public recitation. Reflexion on this reminded me of the full-page frontispiece in the copy of Chaucer's *Troilus* in the Parker Library, *c.* 1415–20, apparently showing the author reading or declaiming his poem to an aristocratic garden party. The Hengwrt Chaucer is

RIGHT: The opening page of the Hengwrt Chaucer, with the illuminated initial and border for the beginning of the General Prologue to the *Canterbury Tales*

Here bygynneth the book of the tales of Caunterbury

Whan that Aueryll wt his shoures soote
The droghte of march hath pced to the roote
And bathed euery veyne in swich lycour
Of which vtu engendred is the flour
Whan zephyrus eek wt his sweete breeth
Inspired hath in euery holt and heeth
The tendre croppes and the yonge sonne
Hath in the Ram his half cours yronne
And smale foweles maken melodye
That slepen al the nyght with open Iye
So pryketh hem nature in hir corages
Than longen folk to goon on pilgrimages
And palmeres for to seeken straunge strondes
To ferne halwes kowthe in sondry londes
And specially from euery shyres ende
Of Engelond to Caunterbury they wende
The holy blisful martir for to seke
That hem hath holpen whan that they weere seeke
Bifel that in that seson on a day
In Southwerk at the Tabard as I lay
Redy to wenden on my pilgrymage
To Caunterbury with ful deuout corage
At nyght was come in to that hostelrye
Wel xxix in a compaignye
Of sondry folk by auenture yfalle
In felaweshipe and pilgrymes weere they alle
That toward Caunterbury wolden ryde
The chambres and the stables weeren wyde
And wel we weeren esed at the beste
And shortly whan the sonne was to reste
So hadde I spoken with hem euerichoon
That I was of hir felaweshipe anon

ABOVE: The Prologue to the *Canterbury Tales*, description of the squire and the yeoman, in the second edition of the Canterbury Tales, printed in Westminster by William Caxton in 1483

RIGHT: The same passage of text in the Hengwrt Chaucer showing the description of the squire (from line 7 here) and the yeoman

either a book for a lectern or, at the very least, to be held in two hands. I myself consulted it on a huge soft grey cushion.

Because the binding is modern and the book opens well, it is easy to collate.* I have expressed this below rather unusually with pauses to indicate that the volume falls very clearly into five different units, almost like five separate manuscripts, (1) quires i to viii, (2) quires ix to xii, (3) quires xiii to xv, (4) quires xvi to xxix, and finally (5) quires xxx to xxxi. Each section seems to have been made as a separate entity. Folio 57v, the last page of the first unit, breaks off unfinished in the second page of the Cook's Tale, leaving a blank space as if the scribe were ex-

* The collation is: modern flyleaves (one of which is foliated as '1') + folios 2–57 (i–v⁸, vi², vii⁶, viii⁸), folios 58–87 (ix–xii⁸), folios 88–111 (xiii–xv⁸), folios 112–234 (xvi–xx⁸, xxi¹⁺⁸ [second leaf, folio 153, a single sheet], xxii¹⁶, xxiii–xxviii⁸, xxix¹⁰), and folios 235–50 (xxx–xxxi⁸), lacking at least one further gathering at the end.

OVERLEAF: The Cook's Tale in the Hengwrt Chaucer, breaking off imperfectly, with a note by the scribe that Chaucer wrote no more, followed by the opening of the Wife of Bath's Tale

But for to tellen yow of his array
His hors weere goode but he ne was nat gay
Of ffustian he wered a gypon
Al bismoteved with his habergeoun
ffor he was laate comen from his viage
And wente for to don his pilgrymage

With hym ther was his sone a yong Squyer
A lovere and a lusty Bachiler
With lokkes crulle as they weere leyd in presse
Of .xx. yeer he was of age I gesse
Of his stature he was of evene lengthe
And wonderly delyvere and of greet strengthe
And he hadde been somtyme in chivachie
In fflaundres in Artoys and Picardie
And born hym wel as in so litel space
In hope to stonden in his lady grace
Embrouded was he as it weere a meede
Al ful of ffresshe floures white and reede
Syngynge he was or floytynge al the day
he was as fressh as is the monthe of may
Short was his gowne with sleues longe and wyde
wel koude he sitte on hors and faire ryde
he koude songes wel make and endite
Juste and eek daunce and wel portreye and wryte
So hoote he loued that by nyghtertale
he slepte namoore than dooth a nyghtyngale
Curteys he was lowely and seruysable
And carf bifoorn his fader at the table

A yeman he hadde and seruantz namo
At that tyme for hym liste ryde so
And he was clad in cote and hood of greene
A sheef of peecok arwes bright and keene
Vnder his belt he bar ful thriftily
wel koude he dresse his takel yemanly
his arwes drodped noght with fetheres lowe
And in his hand he bar a myghty bowe
A not heed hadde he with a broun visage
Of woodecraft koude he wel al the vsage
Vpon his arm he bar a gay bracer
And by his syde a swerd and a bokeler

His maister shal it in his shoppe abye
Al haue he no part of the mynstralsye
ffor thefte and riot they been conuertible
Al konne he pleye on giterne or rubible
Reuel and trouthe as in a lowe degree
They been ful wrothe al day as men may see
This ioly prentys with his maister bood
Til he were neigh out of his prentishood
Al were he snybbed bothe erly and late
And somtyme lad with reuel to newgate
But atte laste his maister hym bithoghte
Vp on a day whan he his papir soghte
Of a prouerbe that seith this same word
Wel bet is roten appul out of hoord
Than þt it rotie al the remenaunt
So fareth it by a riotous seruaunt
It is ful lasse harm to lete hym pace
Than he shende alle the seruantz in the place
Ther fore his maister gaf hym acquitaunce
And bad hym go with sorwe and wo meschaunce
And thus this ioly prentys hadde his leeue
Now lat hym riote al the nyght or leeue
And for ther nys no theef with oute a lokke
That helpeth hym to wasten and to sowke
Of that he brybe kan or borwe may
Anon he sente his bed and his aray
Vn to a compeer of his owene sort
That loued dees and reuel and disport
And hadde a wyf that heeld for contenaunce
A shoppe and swyued for hir sustenaunce

Of this cokes tale
maketh chaucer na
moore

Here biginneth the prologe of the tale
of the Wyf of Bath ~ ~ ~ ~ ~ ~

Experience thogh noon Auctorites
Were in this World is right ynogh for me
To speke of Wo that is in mariage
For lordynges sith þt I twelf yeer was of age
Thonked be god that is eterne on lyue
Housbondes atte chirche dore I haue had fyue
If I so ofte myghte han Wedded be
And alle Were Worthy men in hir degree
But me Was told certeyn noght longe agon is
That sith þt Crist ne Wente neue but onys
To Weddyng in the Cane of Galilee
That by the same ensample taughte he me
That I ne sholde Wedded be but ones
Herke eek lo Which a sharp Word for the nones
Biside a Welle Ihus god and man
Spak in repreeue of the Samaritan
Thow haft yhad fyue housbondes quod he
And that ilke man Which that noW hath thee
Is nat thyn housbonde thus he seyde certeyn
What that he mente therby I kan nat seyn
But þt I axe Why þt the fifthe man
Was noon housbonde to the Samaritan
HoW manye myghte she han in mariage
yet herde I neuere tellen in myn age
Vp on this nombre diffynycioun
Men may dyuyne and glosen vp & doun
But Wel I Woot expres With outen lye
God bad vs for to Wexe and multiplye
That gentil text kan I Wel vnderstonde
Eek Wel I Woot he seyde þt myn housbonde
Sholde lete fader and moder and take to me
But of nombre mencion made he
Of Bigamye or of Octogamye
Why sholde men thanne speke of it vileynye
To seye the Wise kyng Dan Salomon
I troWe he hadde Wyues many oon

pecting the text to continue. In a slightly different ink, the same scribe, now learning that there was to be nothing further available to copy, notes in the margin "*Of this Cokes tale maked Chaucer na moore*". The next page, folio 58r really looks like the opening of a new manuscript, with its own heading, "*Here bigynneth the prologe of the tale of the Wyf of Bathe*" and a big initial "E". That unit concludes with the end of the Summoner's Tale towards the foot of folio 86v, and folio 87 is entirely blank, like a fly-leaf at the end of a manuscript. Folio 88r then begins once more like an opening page of a different text again, "*Here bigynneth the prologe of the Monkes [tale]*" (the last word is a bit the rat ate) with its own big initial "W". This section ends with the conclusion of the Manciple's Tale three quires later on folio IIIr, with no catchword. The first and last pages of this unit are noticeably dirtier than their adjacent folios 87v and 112r, as if they circulated independently before being bound up. Similarly, quire xxix concludes on folio 234v with what certainly resembles the end of a manuscript, with a calligraphic colophon with the author's name, "*Here is endid Chaucers tale of Melibe*." Folio 235r opposite, the opening of the final unit, "*The Prologe of the Persons tale*", is also darker and dustier, as if it too was for a time kept separately. Furthermore, these five different sections are not even assembled in the right order. The third unit (folios 88–111) should be bound between units four and five, between folios 234 and 235. We know this because folio 88r begins, "Whan ended was my tale of Melibee …" and the Tale of Melibeus actually ends on folio 234v; and folio 235r opens, "By that the Mau[n]ciple hadde his tale al ended …", and the Manciple's Tale does indeed end on folio IIIv.

All this is well-known to Chaucer scholars, but it is very noticeable how unambiguously visible these units are in the manuscript itself, as if this volume had been one of those medieval anthologies, known as *Sammelbände* in German, which original owners assembled by binding up multiple short texts gathered from various sources. The difference is that this whole composite of separate components is all written by the same scribe.

I can offer no sensible explanation as to why some sections of the

RIGHT: The opening of the Monk's Tale, the third distinct component of the Hengwrt manuscript, resembling the first leaf of a new manuscript

Whan ended was my tale of melibee,
And of prudence and hys benygnytee
Oure hoost seyde as I am feithful man
And by that precious corpus madian
I hadde leue than a barel ale
That goode lief my wyf hadde herd this tale
She nys no thyng of swich pacience
As was this melibeus wif prudence
By goddes bones whan I bete my knaues
She bryngeth me the grete clobbed staues
And cryeth slee the dogges euerichon
And breke hem bothe bak and euery bon
And if that any neigheboore of myne
Wol nat in chirche to my wyf enclyne
Or be so hardy to hir to trespace
Whan she cometh hoom she rampeth in my face
And cryeth false cowarde wrek thy wyf
By corpus bones I wol haue thy knyf
And thou shalt haue my distaf and go spynne
Fro day to nyght right thus she wol bigynne
Allas she seith that euere that I was shape
To wedden a milksop or a cowarde ape
That wol ben ouerlad of euery wight
Thou darst nat stonden by thy wiues right
This is my lif but if that I wol fighte
And out at dore anoon I moot me dighte
Or ellis I am but lost but if that I
Be lyk a wilde leoun fool hardy
I woot wel she wol do me slee som day
Som neigheboore and thanne go my way
For I am perilous with knyf in honde
Al be it that I dar nat hir withstonde
For she is big in armes by my feith
That shal he fynde that hir mys doth or seith
But lat vs passe awey fro this matere
My lord the monk quod he be myrie of cheere

manuscript are now bound so obviously out of order, especially since this faithfully preserves the sequence of the previous binding, which was itself late medieval. This was therefore not some relatively modern jumbling by a hasty bookbinder, as in the *Carmina Burana*. A possibility could be that the five different sections were actually made as exemplars, more useful if they could be lent out separately to multiple copyists at once, rather like the units called *peciae* which were hired out to scribes by booksellers in medieval Paris. Only when they had exhausted their purpose would they all be returned to Scribe B, and then perhaps after his death they were bound up for the first time in the random order of the components stacked up at that moment.

We must be careful not to read too much into tiny details, but it really is hard to escape the impression of a scribe receiving and making his text in instalments, wherever they came from, without knowing in advance what each part would comprise. Some gatherings are of odd lengths. The two leaves for quire vi, followed by another quire of six leaves, may represent what was once an eight-leaf gathering, redone with substituted text in two stages as the copying was in progress. The spaces left blank between some tales (such as folios 128v, 153r, 153v and 165r) may be because the scribe was still awaiting short bridging passages to link the stories together, never received. In the first of these (folio 128v) a prologue for the Squire's Tale did actually exist, for it appears in the Ellesmere manuscript, and so the scribe was right to wait. Two prologues in the Hengwrt manuscript probably arrived late and were fitted in. That for the Merchant's Tale is crammed onto folio 137v, which may have been left blank in expectation. The inserted leaf folio 153 is probably because of the last-minute receipt of the passage in which the host introduces the franklin. Above all, the clear expectation of more than a small fragment of the Cook's Tale, which breaks off with that subsequent – but, in fact, accurate – explanation, "*Of this Cokes tale maked Chaucer na moore*", mentioned above, suggests a disappointment not anticipated when the scribe started copying the tale on the page before. The explanation is clearly derived from something more informed than a defective exemplar. By the time those words were written, at least, the scribe knew that Chaucer had died.

It is generally possible to date most manuscripts fairly precisely by style alone. The constant evolution of script and fashions of book illumination, especially in a metropolitan centre like late-medieval London, allow us to assign likely dates to most manuscripts to within a decade or so, sometimes to even within a few years. There is general agreement that the style of the Hengwrt Chaucer points to some time between (say) the late 1390s and the early years of the 1400s. However, seldom has the dating of a manuscript been so crucial, for Chaucer died, with the *Canterbury Tales* unfinished and unpublished, probably on 25 October 1400. At that moment, there was clearly no particular sequence for many of the tales already completed, and some were probably not even yet assigned to the voices of particular pilgrims. The author's autograph drafts, which must surely have existed, were perhaps in little bundles or clusters about the size of some of the units of the Hengwrt manuscript. If the manuscript dates from before October 1400, it could, in theory, have been Chaucer's own copy, prepared professionally for him under his personal supervision, section by section as each autograph unit was completed and handed over for transcription; if it dates from after the author's death, then it could, equally theoretically, have been taken from original drafts acquired from Chaucer's executors as they came to light one by one among his effects. If Linne Mooney is right and the copyist was Adam who had worked with the poet during his lifetime, the authority of its text would be of even further importance. In the study of any work of literature fallibly transmitted by endless hand copying of hand-made copies, it is the dream of all scholars to reach back as nearly as possible to the primeval moment when the words left the pen of the author.

It seems to me that the manuscript was worked on by the scribe in two distinct stages, possibly even some years apart. The headings and maybe the corrections and linking passages were written after the completion of the text and illumination. That has not been precisely observed before. The first indication of this is the title heading on the opening page, *"Here bygynneth the Book' of the tales of Cant[er]bury"*,

OVERLEAF: A blank space left at the end of the Man of Law's Tale, in expectation of more text connecting it to the following Squire's Tale, now filled with birth dates of the Brereton family, 1605–12

age

...an ffu tender, hath most Jn ...
... eth alwas to keepe he ...
in
... ... :: wherfore, age who greatly longes
... rnt to mowe: Jn youth he must aplye
... self good seed to sowe : : :
E. Ellen: Baneslor the grandmother
of y͏ͤ vnder named chilldren

Ellen Brereton was borne the 24 of July
beinge on wensday. betwixt 4 & 5 of the clocke
Jn the after noown and in the year of
the Lords yeer 1605. And in the Raingē
of kinge James of Jnglande the threeed
Shee was borne at newington beyond london

John Brereton was borne the fifth day
of desember on a fryday. att tenn of
the clocke in the night in the yeare
of y͏ͤ Lord. 1606. Christend att
All Hollowes church in Chester

Frances Brereton Borne the 19 of
June on monday. 2 of the clocke
in the after noown. att Hanbor
now Tarnarben. 1609

Richard Brereton was born the 19 of June
on a monday att 3 of the clocke in the
after noown att Hanbor ——— 1611

Ann Brereton borne the 14 of marche on
a monday att sebon of the clocke in the
morninge in Hanbier ——— 1612

Here bigynneth the Squieres tale

At Sarray in the land of Tartarye
Ther dwelte a kyng that werreyed Russye
Thurgh which ther deyde many a doghty man
This noble kyng was cleped Cambyuskan
Which in his tyme was of so greet renoun
That ther nas nowher in no regioun
So excellent a lord in alle thyng
Hym lakked noght þt longed to a kyng
As of the secte of which þt he was born
He kepte his lay to which þt he was sworn
And therto he was hardy wys and riche
Pietous and Iust and euemoore yliche
Sooth of his word benigne and honurable
Of his corage as any centre stable Secundum circuli
Yong fressh and strong in armes desirous
As any bachiler of al his hous
A fair persone he was and fortunat
And kepte alwey so wel roial estat
That ther nas nowher swich another man
This noble kyng this Tartre Cambyuskan
Hadde two sones on Elfeta his wyf
Of whiche the eldeste highte Algarsyf
That oother sone was cleped Cambalo
A doghter hadde this worthy kyng also
That yongest was and highte Canacee
But for to telle yow al hir beautee
It lyth nat in my tonge nyn my konnyng
I dar nat vndertake so heigh a thyng
Myn englyssh eek is insufficient
It moste been a rethor excellent
That koude his colours longyng for that Art
If he sholde hir discryuen euery part
I am noon swich I moot speke as I kan
And so bifel that whan this Cambyuskan
Hath xx wynter born his dyademe
As he was wont fro yeer to yeer I deme

which is written above and outside the illuminated bar border. In English manuscripts of this time the heading would usually be contained within the boundaries of the illuminated frame: the title here is therefore subsequent to the illumination, by which time there was no enclosed space for it. This has a certain interest, since the title of the '*Canterbury Tales*' is not found at the opening of the Ellesmere manuscript. It does occur at the very end of Ellesmere, which concludes, "*Heere is ended the book of the tales of Caunterbury compiled by Geffrey Chaucer of whos soule Ih[es]u crist have mercy Amen.*" On that evidence, Chaucer was already dead. It is generally assumed that the last words composed by Chaucer are the strange retraction added at the very end of the text (missing in the Hengwrt manuscript), in which he renounces his frivolous literary efforts as worldly vanities, listing several works including the *Tales of Canterbury* "that sownen into synne", the earliest use of the title. If the Hengwrt manuscript was begun in Chaucer's lifetime, which it may have been, the title might not at that moment have even been thought of.

There is another related detail. The big blue initials are all painted in fulfilment of tiny guide-letters written in first by the scribe. The guide-letters were painted over when the initials were inserted. That is perfectly normal and they are what one would expect in any late-medieval professionally made manuscript. It does confirm (this is a minor point) that the Hengwrt Chaucer was not some home-made enterprise by a single amateur, but was a product of a production team where a scribe left instructions for an illuminator who was a different person, working without the exemplar before him. A much more telling point is that the little blue paragraph-marks throughout the text, symbols a bit like this ⁋, are also requested by the scribe with minute

The blue paragraph-marks in the text (LEFT) are requested by the scribe with tiny pen flourishes, but those in editorial headings (RIGHT) have no flourishes and must have been supplied in a separate campaign

zig-zags, which were subsequently painted over too. However – follow this closely – there are no zig-zag indications for those paragraph-marks which accompany headings and explicits. In other words, the headings were not part of the scribe's original design at the time he was copying the text and when he was marking it up for decoration. That is very significant. The manuscript was evidently made as a series of distinct booklets containing small groups of stories by Chaucer. The fact that the first and last leaves of some sections seem quite worn suggests that for some time the booklets were not bound together at all. The reworking of the manuscript to bring all of the different components into a single united sequence, now with headings to lead one into the next and under an omnibus title of the *Canterbury Tales*, took place in a quite separate and second campaign, after Chaucer's death, and (note this) the manuscript was still or once again in the possession of the scribe.

At this point, ladies and gentlemen of the jury, we need to call Geoffrey Chaucer himself to give evidence. I imagine Chaucer in the witness box as something like his portrait in the Corpus *Troilus*, a bearded man with pale-brown hair swept backwards, wearing a high-collared pink jacket and standing in a pulpit from which a red and gold cloth hangs down the front. He is shown there resting one hand on the edge of the pulpit and with the other he is addressing the audience.

Geoffrey Chaucer standing in a pulpit and addressing a courtly audience, a detail from the frontispiece of the Corpus *Troilus*, c. 1415–20

There is a short poem generally attributed to Chaucer which occurs in a single manuscript, a miscellany now in Trinity College in Cambridge, datable to *c.* 1430–32. In the original it is titled "*Chauciers wordes a Geffrey unto Adame his owen scryveyne*", 'Chaucer's *Words from Geoffrey to his own scribe Adam*'. It is the verse cited in the press release which opened this chapter. It reads:

> Adam scryveyne / if ever it thee byfalle
>
> Boece or Troylus / for to wryten nuwe
>
> Under thy long lokkes / thowe most have the scalle
>
> But affter my makyng thowe wryt more truwe
>
> So offt adaye I mot thy werk renuwe
>
> It to corect and eke to rubbe and scrape /
>
> And al is thorugh thy necglygence and rape

('Adam, scrivener [scribe], if ever it happens to you to copy *Boece* or *Troilus* again, may you have scabs under your long hair unless you write more accurately in accordance with my composition; I must redo your work so often in the day to correct it and also to erase and scrape, and all this is through your carelessness and haste.')

There are those who challenge whether this verse is actually by Chaucer at all, observing that the author's name is no more than a heading added to the manuscript by the miscellany's compiler, John Shirley (*c.* 1366–1456). However, under cross-questioning, Shirley proves to be a credible witness. He was a cultured London bookseller, translator and scribe, who was in his mid-thirties when Chaucer died. It is very easy to envisage that they might have met. Later Shirley too, like Chaucer, was a controller of customs in the port of London. He would certainly have worked with all the principal scribes during his lifetime. He often signed his name. He actually wrote on the endleaves of the Ellesmere Chaucer itself and in the Corpus manuscript of *Troilus*. If anyone in England knew every one of these people and the manuscripts personally, it was John Shirley. The poem for Adam has been printed among Chaucer's works since 1561, and there is no real reason to doubt its authenticity. If someone else wrote it, they are doing so in the name of Chaucer, since *Boece* and *Troilus* are his, and

they are speaking of a relationship which had to be believable to be understandable.

The only other possibility is that the poem is merely allegorical, in which the author, as the Creator, addresses Adam, the first and universal man, who through negligence has made confusion out of a once-perfect creation. In such an interpretation, the scabs threatened under Adam's long hair might be the neck swellings which were symptoms of the Black Death, thought by many in Chaucer's time to be divine punishment for mankind's misuse of what God had entrusted to his care.

However, let us take it at face value. Here is the poet Geoffrey Chaucer speaking to "his owen scryveyne", known to him by his first name. This scribe has already copied *Boece* and *Troilus and Criseyde*, texts composed by Chaucer in the early to mid-1380s. The fact that Chaucer had access to the transcripts again for correction after Adam had made them does imply that he was himself the client, commissioning fair copies, which would then be checked again perhaps before becoming approved exemplars for publication. If so, it dates the relationship to the 1380s. We cannot guess whether the criticism of Adam's work is a joke or whether it means that he really was an atrocious copyist. If he was truly bad, it is not likely that Chaucer would have imagined using him again (and unless it is humorous, it seems a rather

Chaucer's *Words to his own scribe Adam*, the unique copy of a short poem in which Chaucer appears to castigate one Adam for his careless copying of the author's *Boece* and *Troilus*

pointless poem). The Hengwrt scribe shows no evidence of carelessness and haste, but rather the opposite.

Whether Chaucer would have needed the services of a hired scrivener at all is entirely a matter of speculation. Quite apart from the scorn he heaps on Adam in the poem, he satirizes "scrivenish" handwriting in *Troilus*, and in the famous portrait of Chaucer on horseback in the Ellesmere Chaucer, the earliest picture of the author and in a volume copied by the same scribe as the Hengwrt manuscript, he is shown with a 'penner' or leather pencase suspended around his neck, the traditional attribute in art to indicate a professional scrivener. On this evidence, at the very least, Chaucer was thought by one contemporary to have been a capable scribe.

The activities of rubbing and scraping, mentioned in the poem, are common among almost all manuscripts in the Middle Ages, since even conscientious scribes need to correct and tidy their work. The Hengwrt manuscript contains erasures of the kind alluded to by Chaucer, where occasional words or phrases can be seen against the light to have been scraped away and rewritten. Scribes worked with knives as well as pens, and parchment can withstand a great deal of scraping, unlike paper. The fact of correction was not unusual, but the line in the verse probably does show that the Adam of the poem was copying manuscripts which were on parchment, and that he was therefore more than a mere archival secretary.

Adam was not an especially rare name in fourteenth-century England. Long before Linne Mooney, Chaucer scholars had searched among the archives of the London book trade for possible candidates for the scrivener addressed in the poem. The name of Adam Pinkhurst was first proposed, on no evidence yet beyond coincidence of name, as early as 1929. Another possibility, which also fits the date of *Troilus*, would be Adam Stedeman, recorded as a scrivener in London in 1384, and there is also an Adam Leycestre, a parchmenter, known in 1382, a member of a craft which often involved multiple activities in the book trade. Allusions to rubbing and scraping might be a further tease on the hasty preparation of Adam of Leycestre's parchment.

So far – and let us imagine the judge summing up at the end of

the first day's evidence in court – we have a manuscript which really seems to have been professionally copied by a scribe who had access to Chaucer's text, not previously known in public circulation, in five different sections at a time. If Chaucer had been alive when the Hengwrt manuscript was begun, this is what a scribal fair copy might have looked like. The corrections are not likely to be authorial. In a very clear second stage of manufacture, the scribe reworked the Hengwrt manuscript, still in his possession, inserting headings and the new title of *Canterbury Tales*, and he knew by then that Chaucer was dead and would be writing no more. The manuscript could have been prepared as an exemplar, to be used by other scribes to disseminate the text. Some fifteen years earlier, when Chaucer had needed an amanuensis to prepare for him similar fair copies of *Boece* and *Troilus*, he had apparently used a scribe known to him as Adam. At this stage we have no means to gauge whether or not they were the same man.

At last the ushers of our fictional court, convening again the next morning, are going to summon the defendant, Adam Pinkhurst himself, to give evidence. He does so under oath. Pinkhurst was an early member of the late fourteenth-century Company of Scriveners, a municipal trade guild for scribes and document writers which still flourishes as one of the ancient livery companies in the heart of the City of London. It is generally regarded as having been founded in 1373 and the register of its members began in 1392. The unique record of this is owned by the Company but is on long-term deposit at the Guildhall Library. Most of the Company's early archives were destroyed in the Great Fire of London in 1666 and this is one of the very few survivals from the Middle Ages. To see it, you go to the Guildhall, in Aldermanbury, off Gresham Street, in the London banking district, past the main entrance and along the outside of the building, following signposts. You enter where it says City Business Library but you then turn left up a few steps into the Guildhall Library itself. It is startlingly modern, with concrete walls, long white tables and red chairs, under bright strip-lights. Tables are occupied by rather seedy-looking middle-aged men, probably all pursuing genealogical or commercial history relating to London.

MS 5370, as it is, is kept in a brown padded box. It is bound in an early flexible cover of dark tanned hide, wrapped around with a big leather strap like a school satchel, secured by a large metal buckle. The text begins with the ordinances of the Company of Scriveners in the city of London. Pages 53–162 comprise the entries of new members from 1392 to 1600 writing and signing their oaths of allegiance in Latin, usually several to a page. The eighth subscription, which is on page 56, is that of Adam Pinkhurst, one of the longest and most elaborately calligraphed of all entries here. To judge from its flamboyance and lo- quaciousness, one can envisage Pinkhurst as the kind of extrovert who today could have worn a bow tie and bright blazer with a silk hand- kerchief in its pocket. The gist of the entry is that I, Adam Pinkhurst, citizen and court scrivener of the aforesaid city, aware of my unworthi- ness in the said art or science, knowing and memorizing the prescribed oath ordained by such worthy men, and so on (it is twenty-one lines long), freely and willingly subscribe to the ordinances and regulations established for the honour and use of my craft, and I have voluntarily written this page in my own hand as witness of my oath of allegiance and as a record in perpetuity. It is signed again in the left-hand margin in large ornamented letters within a border, "Adam Pynkhurst". It is undated but the mid-1390s would be a credible assumption.

It is beautifully written in a fine and large script. My immediate reaction, however, was that it does not look much like the Hengwrt Chaucer. I placed my copy of the facsimile beside Pinkhurst's oath and I looked back and forth between them for some time. There can be many explanations of an apparent discrepancy. For one, this is a documentary hand, writing in Latin, whereas the Chaucer manu- scripts are literary texts written in English in a standard book script. In palaeographical terminology, the former would be called a 'secre- tary hand' and the latter 'anglicana' (or 'anglicana formata' at its more refined level). The fact that the languages are different exacerbates the difficulty of comparison, for there are abbreviations and letters of the alphabet distinctive of each, including letters in Middle Eng- lish not used in Latin. A professional scrivener was expected to be a master of several scripts. Some medieval scribal pattern sheets sur-

The oath of allegiance written and signed by Adam Pinkhurst in the 1390s in the volume of ordinances and admissions to the Scriveners' Company in the city of London

vive, on which a single writer demonstrates his competence in very diverse hands, depending on whether he is undertaking (for example) a charter, a liturgical book, or a literary text. Within that, there will also be particular practices specific to the language being written. Signed manuscripts are not all written identically, and comparing hands is not quite like matching typefaces. Different-looking manuscripts can indeed be by the same scribe, and seemingly identical manuscripts may sometimes be by different scribes. In her detailed case for the identification of the 'Scribe B' of Hengwrt and Ellesmere with the Pinkhurst of the Scriveners' oath book, Linne Mooney isolates twelve particular letterforms which occur consistently in both scripts, together with two specific forms of decorative flourishing above the lines of writing, found sometimes in literary manuscripts by Scribe B and in abundance in Adam Pinkhurst's subscription to his oath. She

describes the flourishes as being "so distinctive to Pinkhurst as to be virtually a signature".

Whether or not the jury will decide Adam Pinkhurst to be Scribe B of the Hengwrt and Ellesmere Chaucers, his entry in the Scriveners' oath book is proof of his reality as a historical person, working in London as a scribe of administrative records. Unsigned documents which exhibit all of Linne Mooney's criteria of Pinkhurst's hand have been found by her and her research group from the mid-1380s through to 1415 and possibly even as late as 1427, especially among the official records of the City of London. Tentative identifications include a request, now in the National Archives in Kew, whereby Geoffrey Chaucer in his own name applied to the king in French to appoint a deputy as controller of the wool custom. Pinkhurst is plausibly proposed as the scribe of the petition from the Mercers' Company to the royal council in 1388 accusing the former mayor Nicholas Brembre of treason, which has the distinction of being the earliest datable petition written in the English language. Pinkhurst's style of hand is very clearly found in a number of entries in the wardens' accounts of the Mercers' Company in the 1390s and in the letter books of the London Guildhall in the early 1400s, showing that Pinkhurst the scrivener was an intimate member of the community of clerks working within the municipal and guild establishments of the City. With the possible exception of the Chaucer petition, which is almost too convenient to be true (and very slight), these identifications all seem uncontroversial and straightforward for the activity of Pinkhurst as a document writer. The entry in the Scriveners' oath book, like other medieval entries there, is endorsed in the right-hand margin in a slightly later hand, "*mortuus*", 'dead'; Adam Pinkhurst lived and eventually died.

There is independent evidence now too of a man called Adam Pinkhurst and his wife, Joanna, living in Surrey in 1355, and again in 1370 as one of the king's archers receiving a salary of sixpence a day for life (last paid out in 1400, which may be explained by his death, or simply by the sudden change of king). It is not yet clear whether we are dealing with one Adam Pinkhurst or two. The man from Surrey might have been an archer in youth who turned to scribal work in later

years, or maybe the archer and the scribe were father and son sharing the same name. A man already married in 1355 cannot have been born much later than 1335, older than Chaucer, which would make him at least 80 in 1415, which is possible but unlikely for a working scribe. The scrivener was probably his son or close relative.

In addition to the documents, other literary manuscripts have now been added to the corpus of books attributed to the hand of Adam Pinkhurst. One of these, a *Piers Plowman* at Trinity College, Cambridge,

A manuscript of *Piers Plowman*, credibly copied by Adam Pinkhurst in a hand very similar to that of his oath in the records of the Scriveners' Company

identified by Simon Horobin and Linne Mooney, does indeed look remarkably similar to the script of Pinkhurst's entry in the Scriveners' oath book, even to the flourishes. Two others bear closer resemblance to the Hand B as it appears in the Hengwrt Chaucer. One, first proposed by Estelle Stubbs, is an early copy of Chaucer's *Boece* also among the Peniarth manuscripts in Aberystwyth, which by coincidence shared a shelf in the nineteenth century with the Hengwrt *Canterbury Tales*. The second is a fragment of yet another *Canterbury Tales* manuscript in Cambridge University Library, tentatively suggested by Ian Doyle and subsequently added to the body of Pinkhurst's work by Horobin and Mooney.

Among the growing number of Middle English manuscripts assigned to Pinkhurst, note the high proportion of copies of Chaucer – one *Boece*, one *Troilus*, and evidence of at least three copies of the *Canterbury Tales*. If Adam Pinkhurst was indeed working as some kind of regular scribe to Geoffrey Chaucer, then this adds immense textual authority to these manuscripts, for they bring us to within a hair's breadth of the poet himself. If it is possible that the Peniarth manuscript of *Boece* dates from the 1380s, as Linne Mooney now suggests, then it becomes a candidate for the actual copy alluded to by Chaucer in his poem to Adam and we must suppose that it passed back through the author's hands for approval. That confers on the National Library of Wales not one but two manuscripts of quite extraordinary significance for English literature. Over lunch in the Library cafeteria that day, Maredudd ap Huw speculated whether this is almost too unlikely to be coincidence and whether both manuscripts had somehow descended together for much of their history. He suggested that, during the early-modern period of book collecting in England, manuscripts written in mere English were hardly regarded as serious, and so they ended up in more remote places, like Wales.

In a larger context, if Pinkhurst, document scribe and clerk to the guilds of London, was himself also preparing the *Canterbury Tales* for publication at the time of Chaucer's death, this would help fill one corner of our very scanty knowledge of the medieval English book trade. It is extraordinary what little is known about how literary texts were published and distributed in medieval England. In France and Italy, by contrast, there were elaborate networks of booksellers and agents who arranged the copying and sale of manuscripts. We will meet one of them, Jacopo di San Pietro, in the next chapter. By the late fourteenth century the French equivalent of an author at Chaucer's social standing would probably commission an elaborate copy of a new text, perhaps with many pictures, which would be presented to the king or some other well-connected patron usually belonging to the court or church. It would be designed to look eye-catching. The author would have had the manuscript made through one of the well-known city booksellers, and even before presentation it might have received a cer-

An early fifteenth-century presentation scene in Paris, with the author Christine de Pizan presenting her new book to Charles VI, in the hope that the king will recommend it to his friends

tain exposure in the workshop. If the recipient of the dedication copy admired it, he would recommend it to his friends. In turn, they too might aspire to commission their own manuscripts, and they could resort to the same bookseller, who might still have the exemplar, or they might borrow the dedication manuscript from its recipient for long enough to have it re-transcribed. The inventories of Charles VI and the Duc de Berry show evidence of this happening. Once the publishing process had begun, it took on a life of its own. By such means, literary output flourished in France and Italy around 1400.

Patronage in England was evidently different. Richard II and Henry IV owned some books, but almost none were recent texts. There were no English equivalents of the opulent and semi-public libraries of Charles VI, the Duc de Berry, the dukes of Burgundy, or those of the papacy and the rulers of the Italian states. The market for vernacular texts in Britain was middle class and unshowy. Only three of the eighty-five or so surviving manuscripts of the *Canterbury Tales* have medieval coats-of-arms, attesting to owners among the gentry or above;

a quarter of the manuscripts are on paper, at the inexpensive end of book production. No copies of the *Canterbury Tales* have narrative illustrations, beyond a couple with basic pictures of the individual pilgrims. This is so utterly different from the continent, where aristocratic manuscripts of the *Roman de la Rose* or Boccaccio, for example, are often emblazoned with dozens – if not hundreds – of illuminated miniatures. This is a shame, because the adventurous and amorous stories in the *Canterbury Tales* might have given us a marvellous repertoire of late-medieval pictures.

In France especially it was the bookseller or stationer –, *libraire* in French – who orchestrated the production of manuscripts. The *libraire*, who may sometimes have been a scribe, secured the exemplar, planned the design, copied or arranged the copying of the text, and subcontracted the illuminators. He was the person who gathered up and collated the pages and had them bound, and who delivered the finished manuscript to the client, with an invoice. There were almost no comparable stationers in England to whom an author or a customer might go. We know the names of only six people in London during the lifetime of Chaucer who are mentioned as being stationers in addition to other occupations (such as limner, parchmenter or bookbinder), and only one who was apparently full-time, Thomas Marleburgh, documented 1391–1429, with two shops in Paternoster Row on the north side of Saint Paul's Cathedral. In striking contrast, we know the names of 77 *libraires* in business in Paris alone in the thirty years between 1370 and 1400.

This is some reflexion on the insularity of England in the late fourteenth century, cut off by a strange language incomprehensible abroad, and devasted by the Black Death. The arts of England, at best embroidery and alabasters, could not compare with the sophisticated paintings and jewellery of Italy or France. England was clearly still a cultural backwater. Book historians have often speculated on how a text such as the *Canterbury Tales* could actually have been published at all. It used to be supposed that there might have been some kind of commercial scriptoria for literary texts in London, but there is absolutely no independent evidence of this. In 1978 Doyle and Parkes suggested that

the process was probably much more informal and was perhaps to be localized in Westminster, west of London. They showed how scribes involved in the English royal administration were moonlighting in the production of books for sale to members of the court and their visitors. One of these was the poet Thomas Hoccleve (*c.* 1368–1426), whose day job was as clerk of the Privy Seal in Westminster Palace. The lucrative locality was presumably the commercial logic of William Caxton, who set up his press within the precincts of Westminster Abbey in late 1476, and whose first book printed in England that winter was almost certainly the *Canterbury Tales*. Chaucer's own last known address was a house in Westminster, leased in December 1399, and he is buried in the Abbey. Caxton's tomb is in St Margaret's church, immediately adjacent. If Linne Mooney is right that Adam Pinkhurst is the key figure in disseminating the works of Chaucer, however, then the whole focus now moves eastwards right back into the City of London to the scribes around the Guildhall, a few minutes' walk north-east of Paternoster Row. If Pinkhurst was Chaucer's "own scryveyne", he might have done so out of loyalty to his late employer or even in fulfilment of the poet's last wishes. Without him, the *Canterbury Tales* might not have survived at all – if he was Pinkhurst.

In any historical inquiry there is always the risk that a brilliant and innovative idea begins as being possible, and then, by endless repetition, it imperceptibly mutates into probable, and then the appropriate caution seems to drop away, and what remains becomes accepted as true. There is no single part of the Pinkhurst identification which is unjustifiable individually, but it does require certain assumptions, each of which, once made, provides foundation for the next. If Chaucer was indeed employing an unsatisfactory scribe in the 1380s, which depends on accepting a literary composition as a report of fact, then we have to imagine the same man, now transformed into a masterly copyist and businessman, springing back into life as a busy publisher in the early decades of the fifteenth century. It is possible, it really is, but Adam Pinkhurst, the registered scrivener of the Guildhall, is not otherwise documented in the book trade, or at all after the 1390s. In many ways, given the professionalism of the Hengwrt and Ellesmere

manuscripts of Chaucer and the fact of their collaboration with illuminators, it would have been simpler to envisage the primary copies of the new *Canterbury Tales* being prepared and disseminated through the agency of a stationer such as Thomas Marleburgh or even John Shirley, who died in 1456 at the reputed age of ninety. Both had the right literary connections. Thomas Marleburgh commissioned verses from Thomas Hoccleve, who also collaborated as a copyist with Scribe B in the Gower manuscript in Trinity College, which formed the basis of the study of Doyle and Parkes. John Shirley was not Scribe B but he was certainly handling manuscripts of Chaucer, including the Ellesmere *Canterbury Tales*, and it was Shirley who uniquely preserved and identified Chaucer's verse to "his own scryveyne", which would have been the property of its recipient. These are men in Scribe B's circle. Unfortunately for us, neither Marleburgh nor Shirley was named 'Adam', unless that too is a fictional conceit, to protect the addressee and to suit the scansion.

The identification of Adam Pinkhurst would give a name and a comprehensible reality to one of the puzzles of medieval publishing. However, the entire edifice is constructed on one assumption – just one – which is that the hand of Adam Pinkhurst, an undoubted historical figure, is identical to that of Scribe B. The only signed example of Pinkhurst's hand is the single half-page entry in Latin in the oath book of the Scriveners' Company. That is all, and everything else depends on it. If the hand is not the same, or not certainly the same, then the entirety collapses, including the explanation of Chaucer's poem addressed to a scribe. This is an awesome responsibility. We palaeographers spend our careers matching hands and we often have no way of checking whether we are right, because, in the end, decisions are modern judgements made by people who were not there when the manuscripts were being written. Malachi Beit-Arié, the leading historian of medieval Hebrew script, once told me that he imagines getting to Heaven, where he will finally meet the scribes to whom he devoted his academic life on earth. "Was I right?" he will ask them; "was it you?" I am afraid that some will reply, "Do you know, it was all a long time ago and I really can't remember."

The first reasoned argument against identifying Pinkhurst with

Scribe B was published by Jane Roberts in *Medium Aevum* in 2011. We must not fall into the trap, too common in this particular controversy, of making judgements based entirely on the personalities of the protagonists, but it is worth noting that Jane Roberts too is a formidable palaeographer, especially of English manuscripts, and we must accord her the courtesy of listening. Perhaps we should even think of her in court too, taking the stand. She was, until her retirement, Professor of English Language and Medieval Literature at King's College, London. It was she who in 2004 first noted the similarities between the Mercers' petition of 1388 and the hand of Scribe B. However, she does not accept the identity with Adam Pinkhurst. She hints that the entries ascribed to Pinkhurst in the account books of the Mercers' Company may be in the hand of the scribe Martin Kelom, who was paid for working in that manuscript. She takes each of the letter forms which Linne Mooney isolates as distinctive of Pinkhurst's hand and she argues either that there is such inconsistency even among the attributed manuscripts that they cannot be relied on, or that all are simply common characteristics among similarly trained scribes of the same period. The distinctive upwards flourishing, which Linne Mooney described as being Pinkhurst's virtual signature, occurs in precisely the same form at this date in work signed by other scribes. This does not mean that Pinkhurst is not the copyist of all the items now attributed to him, but that those particular criteria are not exclusive to him.

Palaeographers often base initial judgements on what they call the 'aspect' or *ductus* of a hand. This is a bit like recognizing a person by knowing what they look like, rather than by ticking off measurements of nose, ears, eyes, mouth, and so on. The aspect of a script may include the angle of the hand against the page, the pressure, the flow, the sense of scale, the spacing between letters, and so on. Cumulatively these give an impression of the working style of a scribe. On this basis, in truth, it is difficult to see a single individual personality behind all the many manuscripts now ascribed on technical details to Pinkhurst.

I have twice had to do jury service in the Crown Court, once in Cambridge and once at Southwark in London, and both were fascinating and strangely reassuring experiences. Before retiring to consider

our verdict, the jury was carefully briefed by the judge. He told us that we must disregard any previous opinion we might have had on the likelihood of innocence or guilt, and should make our decision exclusively on the basis of the evidence as presented in court. He reminded us that in Britain the suspect remains innocent until actually proven otherwise. He emphasized that if a juror felt that the evidence left even the slightest margin of doubt as to the certainty of the case, then he or she had an absolute legal duty to acquit the defendant. He asked that all twelve members of the jury should reach a unanimous decision, but that, if this proved impossible, he might, in the end, accept a majority verdict.

We are now sitting around the long table in the jury room. Adam Pinkhurst is charged with being the scribe of the Hengwrt Chaucer, and of many other documents and literary manuscripts attributed to him. Since 2004 my secret prejudice has been that I desperately want Linne Mooney to be right, and I came to court hoping that this would be vindicated. We now weigh the evidence of the courtroom. We remind ourselves of the volume in Aberystwyth, assembled by someone who seems to have had piecemeal access to exemplars from a source very close to Chaucer or to Chaucer's estate (or both), and that the manuscript was written and completed in two stages. We remember that Chaucer is reputed to have used a scribe in the 1380s addressed as Adam. We have inspected a signed attestation by a municipal scrivener in London called Adam Pinkhurst. All this would together add up to a reasonable judgement, if the hands were unquestionably the same. As the judge has emphasized, there must be no room for ambiguity. We decide to take an initial poll around the table, and the first vote falls to me. Do I think that it is proven, beyond all reasonable doubt, that Scribe B was Adam Pinkhurst? All eyes are waiting for my reply. I take a deep breath. No, I do not. I really cannot see it. Perhaps the other eleven jurors will outvote me yet.

My unforgettable day in Aberystwyth ended with a tour of the National Library with Maredudd ap Huw. He showed me, at a suitable distance, the corridors of secure vaults at the back of the building, like cells below

the courthouse, where the Hengwrt Chaucer lives, in its brown cloth box, the most precious manuscript in the Middle English language. We walked back through the exhibition galleries. They telephoned for a taxi to take me down to the station. Maredudd disappeared for a moment and, as I was leaving, he presented me with a set of cards, a coffee mug, and a tea coaster, all illustrating the opening illuminated page of the manuscript. I may not after all know who wrote the Hengwrt Chaucer, but the coaster and the mug are in our kitchen.

The Visconti *Semideus*

c. 1438
St Petersburg, National Library,
Cod. Lat.Q.v.XVII.2

Here are some useful techniques if you are ever in a battle at sea. Put venomous adders into bottles and toss them over the railings of the enemy's ship where they smash onto the deck, and the snakes can rush out and bite your opponents. This device is recommended by the best authorities, as it was apparently originally proposed by Hannibal to Antiochus the Great. While the snakes are hissing and attacking, throw curved metal blades, which cut through the enemy's rigging, and fire-bombs too which then set the sails alight. Meanwhile, have divers strip down to their underwear and swim secretly under the ship with awls, so that they can quickly drill holes in the hull of the enemy's boat and it will sink. These suggestions and very many others are described and wonderfully illustrated in a practical treatise for princes on armaments and warfare, composed by the humanist and lawyer of Pavia, Catone Sacco (*c.* 1395–1463), who presented it probably in 1438 to Filippo Maria Visconti (1392–1447), count of Pavia since 1402 and duke of Milan from 1412. The book was called the *Semideus*, or half-god.

Most of Duke Filippo Maria's professional life was occupied by warfare, involving the endlessly shifting allegiances and territorial ambitions of the Italian states. In 1438 he was engaged in what is termed the fourth campaign of the Wars in Lombardy, principally against the republic of Venice and its allies. The credibility and the survival of any

Renaissance prince depended on his military skill. The reason for Sacco's treatise was to flatter the duke into taking up the larger defence of Christendom against Islam, for the Muslim fleets were then threatening the eastern Mediterranean. In 1430 the armies of the Ottoman Sultan Murad II had soundly defeated the Venetians who were attempting to defend Thessalonica, and they were now advancing relentlessly into the Balkans. The suggestion of using poisonous snakes may have had resonance with the Visconti family, since a blue viper consuming a child had been the dynasty's armorial charge ever since they had acquired control of Milan in the thirteenth century.

Filippo Maria died on 13 August 1447, without an heir. His only but illegitimate daughter, Bianca Maria, had married Francesco Sforza (1401–66), mercenary in the Visconti armies, who therefore assumed his father-in-law's dukedom and established a second great Milanese dynasty. Francesco took possession of his predecessor's estates and art collections. The dedication manuscript of the *Semideus* was recorded in the inventory of the ducal library in the castle of Pavia on 6 June 1459, item 599, "Semideus Catonis Sacchi ad Philippum Mariam

Filippo Maria Visconti, duke of Milan 1412–47, receiving the dedication copy of a book from its author, Galassio da Correggio

Louis XII, king of France, 1498–1515, kneeling in armour with his patron saints, shortly before his invasion of Lombardy in 1499

ducem Mediolani." Pavia is about twenty-five miles south of Milan, and it was the second capital of the duke's dominions. The manuscript was still there when the castle was inherited by Francesco's grandson, Gian Galeazzo Sforza, duke of Milan 1476–94. Another inventory of the library in Pavia in 1488 is more detailed. It opens now with rare treasures such as a unicorn's horn, a whale's tooth, a horned Viking helmet, a tortoise shell (broken), an astronomical clock, a *Mappa Mundi* mounted on wood, and so on, moving on to nearly a thousand books, among which the *Semideus* is item 31, when it was bound in crimson velvet with six silver clasps (two already broken), kept in a box of gilded leather. It was inventoried there again in 1490 when it was described once more, as item 22.

Gian Galeazzo was in turn succeeded as duke in 1494 by his uncle, Ludovico Maria Sforza (1452–1508), known as 'il Moro', and it all began to unravel. The new ruler of France, Louis XII, king 1498–1515, considered that he himself had a more legitimate claim to the dukedom of Milan than any of the Sforzas, since he was directly descended from Valentina Visconti (1371–1408), elder sister of the last Visconti duke,

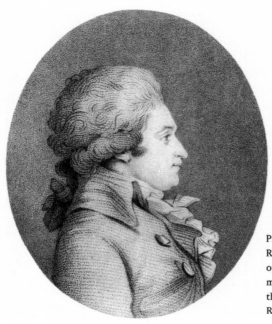

Piotr Dubrowsky (1754–1816),
Russian diplomat and
opportunistic collector of
medieval manuscripts during
the turmoil of the French
Revolution in Paris

Filippo Maria. Valentina had married Louis of Valois, duc d'Orléans (1372–1407, assassinated), brother of Charles VI. Their son, Charles d'Orléans (1394–1465), was Louis XII's father. Constant fighting and warfare were the principal duties expected of any king. Louis XII was already a very experienced soldier and he planned his Italian campaign with exemplary military care. He neutralized opposition from the Holy Roman Emperor and he brought the Venetians into alliance, old enemies of Milan. He appointed as his own commander Gian Giacomo Trivulzio, leader of the Milanese faction against Ludovico il Moro. In July 1499 a mainly French army of about 27,000 men, including 10,000 mounted knights, entered Lombardy. Each town they conquered was treated savagely, to discourage further opposition. By the end of August the French were preparing to lay siege to Pavia. On 2 September 1499, Ludovico fled from Milan and abdicated his dukedom three days later. Louis XII made his triumphant entry into the city as the new duke on 9 October. Ludovico rallied opposition from exile, fought back valiantly and retook Pavia in February 1500, but he was finally defeated and taken prisoner to France, where he died.

As was the custom, conquered cities were pillaged. As was also the fashion, Renaissance rulers were often book collectors. In 1499, or more probably 1500, while many jubilant French soldiers were doubtless in the city taverns or ravishing Italian maidens, the agents of Louis XII were upstairs in the library of the castle in Pavia, clearing the shelves and packing up the books. Large portions of the Visconti–Sforza library were brought back to France, including the manuscript of the *Semideus*, and most of these spoils duly entered the French royal collections at Blois, where they were inventoried in 1518. Leonardo da Vinci, a later trophy from Milan, died nearby in 1519. Well over 300 of those books looted from Pavia are now peacefully in the Bibliothèque nationale in Paris, including seventeen manuscripts which had once been owned by Petrarch.

The story now shifts to the next violent period of the history of France at the outbreak of the French Revolution in 1789. An opportunistic witness to those events was Piotr Dubrowsky (1754–1816), almost as passionate and possibly as unscrupulous a collector as Guglielmo Libri, whom we encountered in Chapter Five. Dubrowsky was born in Kiev and was educated at a time when French culture was regarded in Russia as the most sophisticated in Europe. In 1777 he was living in Paris. By 1780 he had joined the Russian embassy there, rising through various posts to that of secretary. A contemporary engraving of him shows a portly and genial-looking man in profile, with a long nose and the beginnings of a double chin, wearing a wide-collared large-buttoned coat and a silk cravat. By the time Dubrowsky was obliged to leave France at the height of the Revolution in August 1792, after the closure of the Russian legation, he was found to possess one of the most astonishingly valuable collections of French archives and illuminated manuscripts. It was almost entirely culled from the spoils of the Bastille, sacked by the mob on 14 July 1789, and especially from the vast library of the royal abbey of Saint-Germain-des-Prés in Paris, which was sequestered by the revolutionary committee in June 1791 and was closed in February 1792. When the abbey's ancient library was transferred to the French state in 1795–6, many of its most precious illuminated manuscripts were already in the possession of Dubrowsky and had been taken abroad. Whether

he had stolen them, as many believe, or had bought them unwittingly, or some ambiguous combination of the two, is not entirely clear. One of the manuscripts was a lovely Italian Renaissance Livy, perhaps once owned by Lorenzo de' Medici, which Dubrowsky claimed had been presented to him by the philosopher Jean-Jacques Rousseau (1712–78). This seems unlikely, since, like all the others, it too had previously been owned by Saint-Germain-des-Prés. One way or another, however, Dubrowsky's haul of some 700 manuscripts included such incomparable jewels as the eighth-century primary copy of Bede's *Historia Ecclesiastica*, from Wearmouth–Jarrow; a Carolingian illustrated purple Gospel Book; a twelfth-century English Bestiary; the fourteenth-century *Bible Historiale* of the kings of Navarre; the unmatched copy of Martin le Franc, *L'Estrif de Vertu et de Fortune*, illuminated for Philippe le Bon, duke of Burgundy; and the *Semideus* from Pavia.

Dubrowsky was back in Russia by 1800, and was short of money. He is reported to have negotiated to sell his library in England. Not for the first time in this saga, here was a might-have-been moment in the history of manuscript migration. However, through the intervention of Count Alexander Strogonov, president of the Russian academy of arts, the entire collection was bought in 1805 by the imperial public library then being formed in St Petersburg by Tsar Alexander I. The library was opened to the public in 1814. Following the Russian Revolution it became part of what was renamed in 1932 as the Saltykov-Shchedrin State Public Library in Leningrad, and which since 1992 has been more simply called the National Library of Russia, or the 'Rossiyskaya Natsional'naya Biblioteka', in St Petersburg, which we are going to visit.

The first hurdle is the immensely complex application for a Russian visa, for which one has to list, among many other things, every school and university attended and every job one has ever had, with dates and contact names and telephone numbers, and every country one has visited in the previous ten years, with dates. Any involvement with politics or armed conflict, at any period of one's life, has to be declared. There are clearly issues that are sensitive. For the stated purpose of my proposed visit to Russia, I toyed for a moment with writing 'gaining ac-

cess to government department to inspect manual on armaments and military strategy' but instead I put 'tourism'. I took all my forms and the appropriate fee round to the Russian consulate in central London.

It had been almost twenty-five years since my only previous trip to St Petersburg and that drab atmosphere of exhausted communism has entirely vanished. It is now a commercial and international city, like Prague or Beijing, with English being spoken as freely as Russian around the Hermitage museum or the souvenir shops of the Nevsky Prospect. Taxis are still cheap but meals are as expensive and as good as anywhere I have been. The strange alphabet is fascinating, and one compulsively pieces out the lettering of shop signs and advertisements, as slowly and proudly as a five-year-old, to find that one has read aloud words like 'Spaghetti House' or 'Coca-Cola'. It was high summer when I was there, during the so-called 'white nights' when it hardly gets dark, for St Petersburg is very far north. In the early morning, walking eastwards up the Nevsky Prospect away from the river Neva towards the Fontanka, I had the piercingly bright Baltic sun directly in my eyes and the same returning that evening.

The National Library is on the right, on the corner of Ostrovskogo Square, a small tree-lined park dominated by an enormous bronze statue of Catherine the Great, erected in 1873. At the far end is the Alexandrisky Theatre, a grand neo-classical confection in yellow and white. The library is the enormous nineteenth-century grey stone building along the western edge of the square. You push in through a series of heavy doors. All signs are in the Cyrillic alphabet. Behind a counter on the left was a woman resembling the late Mrs Khrushchev. I ventured, slowly and distinctly, "I have come to see a manuscript." She barked in Russian and disappeared. Soon afterwards a much younger assistant materialized, with excellent English, emerging from what looked like two wooden cupboards opposite. She ushered me into one: "Sit please a moment," she said, and "Passport please." By the time I had sat I could hardly see her over the counter, where she was copying my details. Lots of rubber stamps were in evidence. I offered her the letter I had been requested to bring from the Master of Corpus Christi College in Cambridge. She was impressed. "Are you professor?" she asked.

The façade of the National Library of Russia in Ostrovskogo Square in St Petersburg; the manuscripts reading-room is on the ground floor at the far right-hand end

She directed me to a computer screen on the right and I realized she was about to take my photograph. "You may smile, if you like," she said. "Not very Russian," I suggested; no response. I received my most exotic plastic library card yet, in green and white, and my full name printed as де амель кристофер фрэнсис риверс. She asked to inspect the books I had with me – my notebook and Paolo Rosso's printed edition of the *Semideus*, which I had intended to use with the manuscript. No, she informed me firmly: no printed books were allowed in the reading-rooms. I begged and pleaded to no avail. "I do not make the rules," she said; I refrained from muttering "very Russian" again and I let her take it from me, and we deposited it uselessly in the empty cloakroom. If Professor Rosso should happen to read this, he may be comforted to know that no harsh critic can ever again check the accuracy of his transcription against the manuscript.

She escorted me as far as the library's turnstiles, and she directed me off to the right on the ground floor, telling me to turn right again and then left down a passageway and through some doors and quite a bit more, most of which I immediately forgot. The long corridor has a

narrow red carpet and an old display of Soviet books. I seem to recall being told on my previous visit that Voltaire's library, bought by Catherine the Great, was shelved somewhere behind that display, but I may be wrong. I found myself up a few steps in a tiled lobby at the bottom of some stairs, entirely lost. A man looking like a librarian came past. "Manuscripts?" I pleaded. He pointed me through another door with steps down again, along a second corridor with partly walled-off book stacks on each side, into the reading-room, parallel with the square outside reaching to the corner of the Nevksy Prospect.

It is like a cosy schoolroom from the 1930s, with twelve little desks in two neat rows. Big white shutters exclude direct sunlight from the square outside. It must be different in midwinter, when it is mostly dark. The walls are pale green, with tall cupboards and bookshelves with wooden ladders. The reference books are in sombre sets and nothing looks remotely recent. There are banks of drawers with index cards, a retrieval system one seldom sees now. The parquet floor is very worn and is partly covered with strips of brown carpet. The vaulted ceiling is ringed with exposed pipes and wires. There are hard little wooden chairs with red cloth seats. Desks all face towards the invigilator's long table which is at the front end beside the entrance, like a teacher's desk, dominated that day by a huge vase of chrysanthemums festooned with pink ribbons. All it would need to complete the classroom image would be a blackboard behind the table. Like the good pupil, I chose a desk at the front.

My appointment was with Olga Bleskina, curator of West European manuscripts. She was kindly and helpful and knows her manuscripts intimately. There were more forms to fill in, all in Russian. Every paper receives an official stamp at each stage. We spoke mostly in German, which is better than her English. She has short dark straight hair, parted on the left, and she wore an elaborate glass necklace and a pale green jumper. I showed her the letter from the Master of Corpus again, which she kept. Finally she brought me the *Semideus*.

The manuscript is enclosed in a buff card folder, standard civil service Soviet issue (all I could read of the administrative imprint was the date of 1959), tied with white tapes, which I undid. It is very different from the

box of gilded leather in which it had been kept in 1488. There was a slip of paper clipped to the outside of the folder with my name in Russian, which I was starting to recognize. The volume inside is loosely wrapped in tissue paper. It is bound in rather handsome early nineteenth-century straight-grain green morocco, which could do with a polish, decorated in gilt on the sides and spine with wobbling lines and little sunbursts, emblems once used by the Visconti family. On both the upper and lower gilded edges of the pages, when the book is held tightly closed, there are pairs of dark shadowy bands across the thickness of the volume. Corresponding marks are not obviously visible on the fore-edge. They must be offsets from the six silver clasps described in 1488 of which two were said to be defective: evidently there were two at the top, two at the bottom, with the outer pair already broken and missing. The silver oxidized and left marks. The manuscript may have remained unchanged in that condition until it was rebound in the time of Dubrowsky, when evidently the shadowed medieval edges survived uncropped.

The endleaves are of mauve paper, and the front joints have broken away from the text block. There is a nineteenth-century bookplate in Russian, including the numbers 17, 5 and 2, which I take to be the bookcase and its place on the shelf. These are reflected in its formal pressmark, Lat.Q.v.XVII.2. 'Q' is 'quarto', the size being about 10½ by 7½ inches. As in many manuscripts in libraries of Central and Eastern Europe, there is a yellowing sheet of paper loosely enclosed at the front, signed by all those who have ever examined the original manuscript: there are fourteen names, none since 2006, all in Russian except, to my surprise and delight, for my old friend James Marrow, of Princeton, who inscribed the form on 28 August 1996. I might have guessed that he would already have been there.

On the manuscript's first page, originally blank, are sixteenth-century notes in French listing the births of various children of the Burgeneys family, ranging from baby Simon, born in 1518, to Jean, born in 1537. They are very faded and not easy to read. These are actually the earliest explicit evidence that the volume was in France soon after the pillaging of Pavia in 1499–1500, and it was clearly in private hands, not in the royal library. Rather as the most precious manuscripts in

churches and monasteries had in earlier times been used for inventories of relics (above, pp. 27 and 301–2), by the sixteenth century any French family's most valuable book was used as a repository for dates of births of their children, often recording the days of the week and the hour of the birth, information which might later be useful in horoscopes. Such records were sometimes known as '*livres de raison*'. The manuscripts brought from Pavia were mostly sent to the king's library at Blois, a destination usually marked in French at the very end of the text of each volume, "*De pavie ~ au Roy Loys XII*". No such inscription appears here. Instead, the word "*madame*" is written at the end in an early sixteenth-century hand. Possibly the manuscript was picked out as being exceptionally pretty and was given to a woman, conceivably Anne of Brittany, a notable bibliophile and Louis XII's queen, 1499–1514. There was a Louis de Burgeneys, seigneur de Moléans, who was the court physician in the later part of the reign of François I, king 1515–47, and it might have been a gift to him, or his wife. One of the godparents listed for the Burgeneys children is described here as being "de Bloys" and so perhaps the manuscript had not yet moved far from its former shelf-mates now in the royal library.

There are sixteenth- to seventeenth-century scribbles in French in the margins of the next two pages, including three verses. They are not masterpieces of literary art or handwriting. The first (of which I have attempted a translation in the notes) begins:

CHanter je veus en tous lieux
A mon plaisir que les dieux
Rois princes et grandz monarquez
Le monde avec les parquez
Et mesmes tout l'univers
Sans me declarer diverz
Mourount plus tost que de voir
A leur plaisir comme moy
Nefs chasteaux et le devoir
Issant de ceulx que je voy
En ce livre gracieux
Radore pas les haults dieux.

The opening 'Ch' is written calligraphically together to include a human profile. Run your eye vertically down the opening initials of each line and suddenly you notice that it spells out a name as an acrostic, 'Charles Manier', who presumably owned the manuscript, or at least cryptically inscribed it.

The second French verse describes the text as being superior to anything by Cicero. The third says that it teaches how to fight wars and to take castles and towns, and if anyone finds it they should willingly return it to the rightful owner or face the consequences:

> Il enseigne la maniere / a ceste race guerriere
> de prendre chasteau ou ville / Et cequi y est utille
> qui donque ci le trouvera / de bon coeur le rendra
> a Moy Seul qui le possede / Sil ne vault quon ly procede

The likely assumption is that the manuscript was gathered up by the library of Saint-Germain-des-Prés, perhaps during the monks' great period of book acquisition in the seventeenth century. The flourished inscription, "Ex Musæo Petri Dubrowsky", is boldly written in the collector's own hand in the margins on folios IV, 9r and 116r. There is a brief but perfectly accurate description by him on a slip of paper attached to the front flyleaf.

Finally, let us turn to the text itself. It is all in Latin. The collation is consistent with the manuscript being in three distinct parts.* The first component is Catone Sacco's dedication to Filippo Maria Visconti, the second is his speech in praise of the Virgin Mary, and the final and longest part is book III of the author's *Semideus*, his textbook on military strategy. Let us take each in turn.

The preface is addressed to the illustrious prince and most excellent lord, the lord duke of Milan, count of Pavia and Anghiera, and lord of Genoa. Catone Sacco praises the duke for his Christian piety, wisdom, consistency, magnanimity, trustworthiness, clemency, and so on (standard stuff), comparing him favourably with the heroes of the ancient world. He lists the sacred sites of Christianity, now in the hands of the

* It is: (a) folios 1r–8v, the dedication, opening on 2r (i⁸); (b) folios 9r–36v, the *De laudibus Virginis* (ii–iv⁸, v⁴), and (c) folios 37r–116r, the *Semideus* (vi–xv⁸).

Muslims – Jerusalem, which he can envisage the duke conquering, Bethlehem, where the kings came from the Orient to witness and worship with gifts, the parts of Egypt where Christ was first brought up, locations bitter to the Saracens but sweet to Christians, the Jordan, the Red Sea, Mount Sinai, and many others. He longs to see these free from the hands of infidels. He explains that he is attaching the third book of his *Semideus* on military strategy, drawn from ancient authorities including Aulus Gellius, Frontinus, Cato, Aristotle and Vegetius, with new additions by himself, through use of which, with the help of the Virgin Mary, the duke would easily vanquish any enemy. He is aware of his own ignorance, compared with a learned prince, who is a half-god himself, and he quotes the verse by Claudian on how Jupiter laughed at Archimedes' puny attempt to understand the universe. However, the author says, as the duke has fought to recover his rightful lands in Italy, how much better it would be to wrest the Holy Land from ruin, especially under the protection of the Virgin, whose name he bears. If a little city like Athens could prevail in warfare (he cites Plato's *Timaeus* here) or if the warriors of the Old Testament could win battles against all odds, how much more should the unconquered Filippo Maria (named here on folio 6v), greater than any king or prince, with the help of the Virgin, subjugate the barbarians and free the Holy Land, to become the knight of Almighty God himself? The author then makes an interesting calculation. He observes that the descent of the Virgin Mary from Adam, according to the biblical genealogies, was exactly sixty generations; and that the duke's own descent from Saturn is now precisely sixty generations too. The supernatural destiny of Filippo Maria Visconti is clearly preordained in this coincidence.

This explains the strange double frontispiece which precedes the dedication. At the top of the right-hand page is a roundel of the Holy Trinity. The page is filled with a design a bit like a letter 'U' with a central vertical column. The shape is entirely formed of lines of tiny round faces, resembling rows of beads strung together like a rosary, with microscopic names beside each. The manuscript is rather rubbed and it takes a moment or two to orient oneself. Adam is at the top centre, with subsequent generations working down the page, Seth, Enoch, and so on, down to Solomon at the foot of the page, where the line

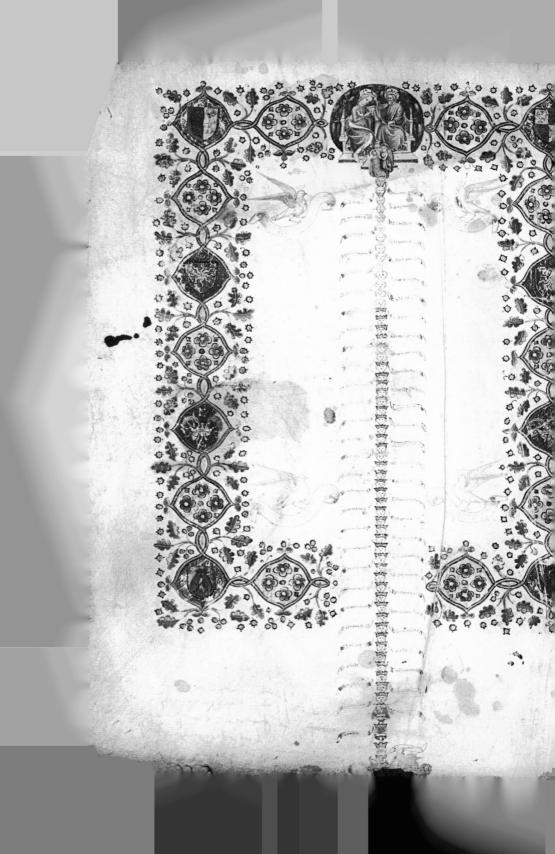

branches, the left-hand side working up again to Joseph at the top left, and the right-hand line up to his wife, the Virgin Mary. Count them up and the totals on each side of the family are indeed precisely sixty. Then compare the facing page, on the left. The beads here are even smaller, running from the bottom to the top. At the foot of the page is a green monster, evidently Saturn, from whom emerges a crowned face captioned as being Jupiter, king of the gods. His line of descendants runs up the page, first to Jupiter's daughter Venus, to her son Aeneas, to Ascanius, and so on, right through ancient Rome and continuing up without interruption to Matteo Visconti (1250–1322), Stefano (*c.* 1287–1327), Galeazzo (1354–78), Gian Galeazzo (1378–1402), and finally his son, at the summit, Filippo Maria Visconti, below the coronation of the Virgin, sixty generations from Saturn.

It really is striking to step into the Italian Renaissance and to witness it in action. At one moment, they are utterly committed Christians, discussing the need to recover the Holy Land for Christendom, based on biblical texts and under the assured protection of the Virgin Mary. At the same time, Filippo Maria was named after a warrior king of Macedon as well as the Virgin. Nearly every sentence of the preface is buttressed by classical references and allusions, Greek as well as Roman, and the duke is equated with Jupiter and is documented here as a quite literal descendant of the ancient deities, a half-god himself, like his semi-divine ancestor Aeneas, son of Venus. It is as if Christianity was never there. A bit like modern Russia, which has now reconnected with its Christian and Tsarist history as if Communism was a mere moment's inattention, the Visconti princes are presented in the first frontispiece as being in an unbroken line of descent from ancient pagan Rome with hardly a nod to any intervening lapse into another faith.

The illuminated borders of those pages are emblazoned with the repeated heraldic devices of Filippo Maria, including the Visconti arms with the viper and child (the *biscione*), said to have been originally used by a Saracen killed by Ottone Visconti in the First Crusade, dimidiated or quartered with the imperial eagle, the symbol of Milan, as well as the

LEFT: The ancestry of Filippo Maria Visconti shown in the *Semideus* manuscript rising from Saturn, Jupiter and Venus, at the foot of the page, up to Filippo Maria at the top below the Virgin Mary

duke's personal emblems of a radiant sunburst (or *raza*), a ducal crown threaded with sprigs of palm and laurel, and a crown trailing a knotted cloth, such as crusaders might wear from their helms (the *nodo*), together with his private motto, "*a bon droit*". They give a suitably martial and crusading flavour to the opening, like a herald's fanfare of trumpets, and they would have caught the dedicatee's attention.

Filippo Maria Visconti, who was born in 1392, was really among the first generation of the great Italian Renaissance princely book collectors, approximately contemporary with the elder Cosimo de' Medici (1389–1464), of Florence, and slightly older than Francesco Gonzaga (1395–1444), of Mantua, Alfonso of Aragon (1401–58), of Naples, Leonello d'Este (1407–50), of Ferrara, and others. They all gathered wonderful libraries. Bibliophily was becoming fashionable and literary knowledge was admired among enlightened heads of state. We have come far from the twelfth century, when the kings of Denmark were being taught their basic alphabet to enable them to read the psalms (Chapter Seven). The inventory of the Visconti library in Pavia in 1426, when the duke was only thirty-four, includes nearly a thousand manuscripts, only one of them a Psalter. The Latin classics are splendidly represented, often in multiple copies. All the ancient authors cited in the dedication to the *Semideus* are listed in that inventory, including four manuscripts of Frontinus on warfare, which makes it possible that Catone Sacco was actually using the ducal collection in Pavia as his reference library. There are also a very large number of chronicles, clearly a personal interest. One of the extant history books commissioned by Filippo Maria is an Italian translation of the lives of the Roman emperors by Suetonius, now in Paris, illuminated by a court artist whom he employed very extensively, known from this manuscript as the 'Master of the Vitae Imperatorum'.

The library catalogue also shows a great deal of traditional theology and works of vernacular piety. Again there is that double world, of pagan classicism and Christian devotion, sharing shelves and even single volumes. Not all the books owned by Filippo Maria were gathered by him personally, for many had been part of the ancestral collections of his family, and, where they survive, they were often decidedly secondhand. It was by chance rather than taste that he had inherited much

of the library of Petrarch. Other acquisitions, like the *Semideus*, were unsolicited gifts. In many ways, the broader range is closer to that of the royal library of France under Charles VI, king 1380–1422, than it is to the purist Renaissance humanism of the zealous Florentines. One of the most extensive and personal commissions initiated by Filippo Maria was the completion of a luxury Book of Hours known as the Visconti Hours, now in Florence, begun for his father, Gian Galeazzo. It too is charged throughout with the duke's arms and the same emblems and mottoes as the *Semideus*.

The Visconti Book of Hours, now in Florence, is filled with the arms and devices of Filippo Maria Visconti, including the viper swallowing a child and the duke's motto "a bon droit"

Although our manuscript in St Petersburg is a creation of the Italian Renaissance, its script shows no trace of the new humanistic *litera antiqua*, by then fashionable in Florence and Rome. The *Semideus* is still copied in the traditional rounded gothic handwriting, very similar indeed to the liturgical hands of the Visconti Hours and to that of a Breviary made for Duke Filippo Maria's wife, Marie of Savoy. Lombardy was strangely late in adopting the styles of humanistic manuscripts. While the rest of Italy was decorating classical texts with the popular 'white vine' illumination based on models from antiquity, the opening initials here in the *Semideus* are still formal and gothic, like those in the Visconti Book of Hours.

The second text of our manuscript brings us back to Christianity,

but in the diction of Cicero. It opens on folio 9r with a historiated initial of the Annunciation, in which the Virgin Mary sits on a kind of open-air terrace in mountainous landscape. There is a broad border of ivy leaves around the page infilled with burnished gold, enclosing repeated quatrefoils with the arms of Filippo Maria Visconti and the sunburst and knotted cloth. In the lower margin the Visconti arms are impaled with the three eagles of the county of Pavia, held up by two hovering angels in fluttering blue and pink robes. Between the border and the text is a vignette with a peaceful deer standing in a meadow between two dogs, possibly a retriever and a greyhound.

There is no title, but its colophon at the end names this text as *De laudibus virginis*, 'On the praises of the Virgin', by Catone [Sacco]. It opens, "Si unquam P.C. ad comendationem cuiusq[ua]m timidus accessi …", 'If I have ever come forward diffidently, *patres conscripti* [the formula for addressing members of the senate in ancient Rome], at the recommendation of a certain person …' It is a speech about the Virgin Mary, supported by the Scriptures and classical authors, including Aristotle, Pythagoras, Homer and Plato, in the language of a law court. 'Hear me patiently and kindly,' the author declaims at one point (one can envisage him pacing the room, his thumbs tucked under the lapels of his jacket), 'so that you may understand.' It contains two topical references. One is an allusion to the 1438 years since the confounding of the Jews (i.e., the Incarnation), which, since this is the presentation copy, is almost certainly the date of the manuscript. The other is a citation from a sermon by Bernardino of Siena (1380–1444), named here and evidently still alive, to the effect that the Son of God was conceived in Heaven without a mother and born on Earth without a father. Actually – for I have the benefit of an on-line word search facility, which Catone Sacco did not – the quotation is originally from Saint Augustine. The dating is probably confirmed by the inclusion of the same speech by Sacco in an anthology of humanistic texts now in the British Library, originally owned by Thomas Pirckheimer, humanist from Nuremberg, whose only visit to Pavia was in that same year, 1438.

RIGHT: The opening of the *De laudibus virginis* in the *Semideus* manuscript, an oration in praise of the Virgin Mary, patron saint of Filippo Maria Visconti; the signature at the foot is that of Dubrowsky

Finally, we come to the principal text of the manuscript. The *Semideus* itself is a dialogue, imagined as a conversation between 'A', who might be supposed to be the ideal prince, the half-god of the title, and 'B', his teacher, evidently in the person of Catone Sacco himself. In the manuscript the initials 'A' and 'B' are written alternately in gold, framed in blue penwork, and in blue, framed with red. The text begins here on folio 37r, "Preclaram ego esse rem militarem censeo ...". The dialogue is initially slow-moving, opening with the two interlocutors discussing the sources for the history of warfare. Translated approximately, it starts:

[A:] 'I myself consider the art of warfare to be noble, for I think it adds lustre to all actions.'

B: 'It is true, if it is naturally governed by prudence and skill. Look at all the Caesars, the Metelluses, the Fabios, the Scipios, and all the Catos, whom we honour for their undoubted fame, champions in those arts in which half-gods are to be measured.'

A: 'I am surprised that you include the Catos.'

B: 'Why not the Catos?'

A: 'Those writers are entirely known for peacetime.'

B: 'Peacetime?'

A: 'That is what informed people generally say.'

B: 'Perhaps you think that only peacefulness produces wisdom. Maybe you believe that they spent more time in idleness than action, but to other people that was itself activity. Cato and Scipio (the one first called Africanus) were never less inactive than when they seemed to be so, for both contributed equally to the art of warfare ...', and so on.

The decorative border includes the Virgin and Child surrounded by seraphim (coloured red) at the upper right, and Filippo Maria himself kneeling on the ground at the lower left. Below the text the duke's arms are held by two hovering angels, this time dressed for battle in armour, between the sunburst with a dove and the knotted cloth. Around these

RIGHT: The third part of the manuscript is the *Semideus* itself, constructed as a dialogue between 'A' and 'B' on the practice and skills of warfare

is the duke's motto or even war cry, written four times in burnished gold gothic letters, "*a bon droit*".

At this stage of my examination of the manuscript in the library in St Petersburg it was now early afternoon and I had been there since it had opened at nine. I stretched and looked round. The reading-room had filled up. There were no supports for cradling bindings (and most certainly no white gloves) and I noticed that all other readers of manuscripts were using pens. The invigilator, a kind-hearted middle-aged woman wearing outsized glasses, evidently realizing that I had missed lunch, started bringing me whisky-flavoured Russian chocolates to eat at my desk. I do not know her name and she spoke no English, but I declare her a saint among manuscript librarians. I sat unwrapping and eating them while turning the pages (carefully) of one of the most perfect and beautiful Italian Renaissance manuscripts in existence. Once readers could probably have smoked too if they had wanted to.

I cannot sensibly read you the whole text of the *Semideus*, for it is 140 pages of complex Latin. Let us follow the narrative by looking at the wonderful pictures, which are the greatest feature of this princely manuscript, and which I shall for ever associate with the smell and taste of slightly sticky Russian chocolate on a warm summer's afternoon. The first illustration is a couple of pages into the text. The accompanying dialogue is discussing how the great men of the past were all soldiers. The picture shows an armoured knight on a prancing white horse looking up at the Virgin and Child in the sky. The knight has the Visconti arms on his surcoat, and his features are unambiguously those of Gian Galeazzo Visconti, Filippo Maria's late father, with his distinctive pointed beard and receding grey hair, exactly as shown in profile in the Visconti Book of Hours. In the second picture, a leaf later, Catone Sacco defends his various classical namesakes called Cato, already introduced in the opening of the dialogue, whom he sees as his intellectual (and maybe literal) forebears. The illustration resembles a vast champagne fountain, with each level draining into the one below and each filled with the various generations of Catos, like bathers sitting in

RIGHT: Filippo Maria Visconti, with his arms on his armour and the surcoat of his horse, galloping to war under the watchful protection of the Virgin Mary, his patron saint

Icrum ducem milabus fuis uo
luptatis coherere. an bor pure?
HUtq; quidem. est enim un
ato placuois abstinuisse bonis.
Ecr ipsum studium uite. cui
a plerisq; sepe negligatur. z male
Catom semper plurimum cordi
fuit: dum non cessaret illos felici
te uirtutis fructum exptemini.
NGf libentes unam aliquod
preceptum eius ouce audierut.
Ecr quidem cum maxime in
oratione quam dixit ninnancie
apuo equites. accipe et etemim
me memori. agitur inquit cu

in locum infinuaūt fraudi et peri
nei obnoxium. Tribunus ad
consulem uenit oftendit exitui
de loci importunitate z hostium
circunstantia. matiuum censeo
inquit si rem seruare uis faciun
dum. ut quadringentos aliquos
milites ad ueticam illam sie eni
cato locum editum asperum qz
appellat ne ubeas: illamqz uti ce
cupent imperes hortensqz hostes
profecto ubi id uiderint fortissi
mus quisqz et promptissimus i
ad occurfandum pugnanduqz
in cos peruertentur: uneqz illo i

a tower of different spa pools. Two leaves later again, a Visconti prince, doubtless Filippo Maria himself, gallops to war with his sword raised, under the protection of the Virgin Mary. His horse is entirely covered with a green cloth emblazoned with the Visconti *biscione*.

On folio 45v we reach the first of the scenes of military campaigns. On the left we see an army dressed in red marching through a mountain pass, carrying the banners of a black scorpion on a white ground. They have set up their tents in the foreground. These are obviously the enemy, since the same scorpion device is borne by the evil army of Pharaoh shown in the Visconti Hours trying to cross the Red Sea. But they are about to meet their match. A herald blows a trumpet from the battlements of a hilltop tower at the upper right, and another detachment, bearing the Visconti standards, gallops shouting into the fray.

The Visconti army, in alliance with imperial troops under the banner of their eagle device, attacks the enemy's city on folio 59r. The town is dominated by an unmistakable minaret. The text describes how to advance on the city, with God's help, bearing shields and catapults and bringing constructions to be moved up against the walls, and what I take to mean bombards or cannons (literally 'roaring bronze'), with flame-throwers, slinging machines, and other instruments of war. Many terms for siege machinery are listed – "tormentis, fundibulis, scorpiis" and others: my little Latin dictionary simply defines each one as 'catapult' but there are evidently subtle differences known to military specialists. The picture shows a great ring of metallic-coloured mortars being rolled forwards. There is hand-to-hand fighting: those with scorpions on their shields are mostly killed, or are falling into the moat. The Christian army finally bursts over the drawbridge and gallops unopposed into the city.

Next the Visconti troops are crossing a river in a hot and treeless desert. Some of the soldiers have taken off their armour and have jumped in and are drinking the water. The Virgin watches from a blazing sun in the sky (the Virgin and Child also appear in the margins of a number of pages). Then there is a night scene, below a dark blue sky filled with stars. The enemy is camped on the right in the mountains. Campfires are

LEFT: The enemy, bearing the insignia of a black scorpion, has camped in a mountain valley, but they are about to be attacked by the Visconti army, charging down from a hilltop fortress

burning outside their tents, and spears are stuck in the ground around the encampment with their points facing outwards. The Christians in armour are creeping through the hills and they stealthily penetrate the ring of spears and massacre the enemy, caught unprepared in their nightclothes. A pitched battle takes place on folio 69r. Detachments of troops are riding in from all sides to join the fight. Many have coats-of-arms. The enemy's shields have scorpions or moors' heads; those of the Christians have a variety of heraldic devices, including Visconti and others with the Ghibelline eagle in chief (the 'capo dell'imperio'), allies of the Lombards. Without the shields and in full armour, as here, it would be impossible to know who was on which side (and much more so in the reality of medieval battle), and the value of heraldry is very evident. Afterwards, the Visconti troops have a welcome day off. They are shown camped in the woods by a river. Some horses are being stabled; others are being led to drink at the water's edge. Most of the soldiers have removed their armour. Some are wrestling and perform-ing acrobatics, while others play skittles, sit chatting in the sunshine, climb trees, or kneel in prayer outside their tent. The peacefulness does not last long. The army is savagely attacked in a valley on the next page. Severed heads and limbs are flung from the melee, dripping blood. But look! On the right two Visconti heralds on horseback point up to a narrow rocky road over a mountain at the upper left, where reinforce-ments are riding down to the rescue, just in time. Later we see the dif-ferent uses of horses, for carrying armaments, trotting, galloping, and so on; men are cutting down branches in a forest for the horses to eat.

These are all coloured drawings, executed with infinite charm and imagination. Colours are soft washes. The illustrations mostly spill around the little blocks of text, which seem to flutter down across the scenes like flags. Landscapes are utterly fanciful, with towering moun-tains and fairy tale castles, among clumps of green trees. The realities of conflict are presented as chivalric romance. The figures of the combat-ants are tiny, and all perfectly drawn, busy and earnest in their tasks. My new best friend the invigilator brought me a magnifying glass, and

RIGHT: The enemy troops camped under a night sky, as the Christian soldiers are creeping stealthily through the defensive ring of spears and ambushing them

aulam ducis aduersantiu intra
castra. qued ꝛ machabeo die ił
lucescente adiuuante eum diї
protectione factum in anthio
cum filium cupatoris pfuissct
legimus. Ceterum si longius
ducendus uideatur, hisce rebꝫ
opus esse ignorari nõ oportet.
primum ut uiator maniu cas
cuꝰspiciat. ideo diuerticula ꝛ
flumina. montes nemora ꝛ reli
qua picta habere nõ erit incon
gruens. tum etiam ꝛ ductores
instructos in itinere fides habeat.
aut datis custodibꝰ ne euadat

uel caufa id temptandi mifeat.
uel explorandi. tunc eftimo
uia et hofte profpecta non im
probabis fi eueftigio in ipfos
hoftes forte in ermes uel impro
uidos ueniero. Aut fi ut fcipio i
affricanus contra hannibalem:
qui iti per continuos dies ordi
natum ducit exercitum ut me
dia acies fortiffimis fundaret
et cum hoftes fic affidue ordi
nate precederent. eo die quo i
fuit decernendum legionafios
fcipio in cornibus collocauit et
mediam aciem retrahendo cor

another chocolate, and I was as utterly entranced as Filippo Maria Visconti must have been when he too first held this magical book in his hands.

The picture on folio 89r is entirely full-page, without text. We are clearly now in the desert of the Middle East, on an arid plateau above a mountain gorge. The fortification in the centre looks very like Saint Catherine's monastery on the slopes of Mount Sinai, except that it is unambiguously Muslim, with domes and minarets surmounted by crescents. The shield with the Moor's head is over the main gate and the portcullis is lowered. Soldiers bearing the imperial arms are throwing burning grenades over the battlements. A small wood to the right is on fire, sending up flames and smoke across the fort. Some enemy troops have come out and are being dreadfully massacred. It all looks fearsomely hot. One soldier is setting off a huge mortar aimed towards the citadel. Flames are already emerging from the barrel even though the cannon ball is not yet released. The logistics of manoeuvring that mighty European mortar into place in the desert would have been immense (one is reminded of the emperor Téwodros having his precious seven-ton cannon dragged across Ethiopia in 1867). A double-page picture soon shows something of how transport was done. Teams of soldiers, stripped to their jerkins, are carrying long beams on their shoulders, threaded with ropes and chains. The stars are shining and maybe this was cooler work at night. These elements are quickly assembled opposite to form a siege machine, which can be rotated to allow the attackers to swing out across the moat and to drop into the enemy's castle from above, at the level of the battlements. The mountain battle on folio 96r is certainly taking place at night. There is hand-to-hand fighting at the lower left between negroid men and the scorpion-bearing Muslims. Through a mountain pass come the Christian troops in armour, blowing trumpets and carrying blazing torches.

The final four pictures are concerned with river and sea warfare. The first is the scene described at the beginning here, where sailors in

LEFT: The Christian army taking a day off, refreshing their horses in the river, playing games and relaxing in the sunshine

OVERLEAF: An attack on a Saracen citadel in the desert, with the Christian armies firing a mortar and throwing grenades over the battlements, all watched by the Virgin and Child at the upper left

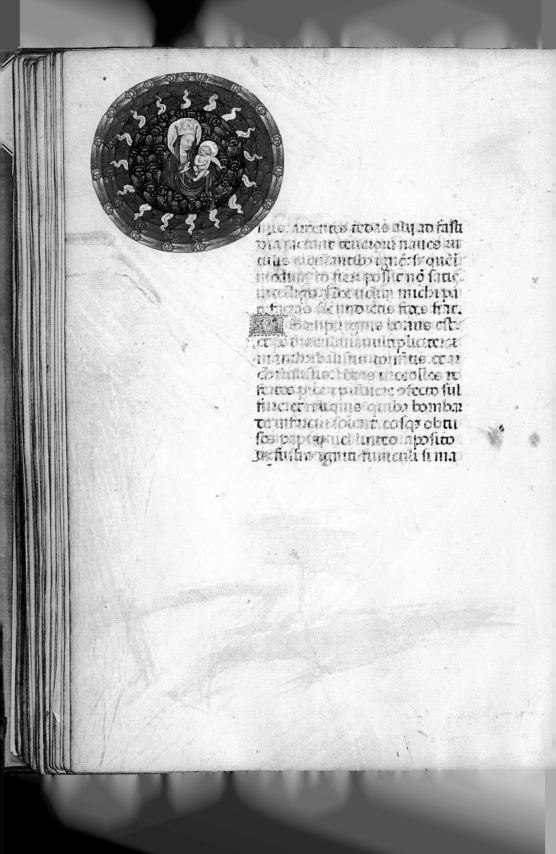

gie. Amentes itenus aliq ao tustu
uia piciant uenerous naues au
raug euoslautds ignem: qudi
modum ro fieri possit no satis
uitelligo. Sed uidm michi pa
ntigio sie uno itus fixe frit.
Semp igniu bonue est
p3 du uttuu in placitu
m aitib aliu uouuste. ecca
do itustuutec lettis uucoolsce ro
ferio piter psuiere ofecto sul
fuirer iuirigie qudo bomba
te iutuiatus solent. cosq3 obtu
los papirg uel luiteo. aposito
ofufho ignu fumvauti si ma

the Visconti ship bombard the enemy's vessel with snakes in jars and firebombs. Some are shooting with crossbows. The setting is a wide river, with the opposing fleet massed downstream. There is fighting on the shore and spectators are lining the river bank to watch the action. But remember W. H. Auden's poem, *Musée des Beaux Arts*, beginning, "About suffering they were never wrong, The Old Masters …", on how ordinary life goes on in Renaissance art even in the presence of the most extraordinary circumstances. The largest figure in this illustration is a civilian at the lower right who has tied up his horse and is cooking supper over a fire, oblivious to it all, with his back to the battle.

The next picture shows ships fighting at sea, using the same techniques of throwing snakes and of swimming under the enemy's ship to drill holes in the hull. A few pages later we see methods of setting fire to river forts. A man with a winch unrolls a rope to let a barge filled with explosives float downstream towards a bridge. On the left, men light fires under the walls of a fort but the defenders on the battlements throw down logs to crush them. On the right kindling and grenades are stacked under the walls. The final scene shows how to build a pontoon bridge over a river. You swim across and tie ropes to tree stumps on each bank, and then you lash on boards and bundles of branches. The army on the right is ready to ride across. The moon and stars are shining, for this is at night-time. The entire text ends on folio 116r, "… *Catonis sacci papiensis semideus explicit*", with that charming good wish, common in Italian humanistic manuscripts, "*lege feliciter*", 'enjoy reading it'.

The author, Catone Sacco, was one of those minor but industrious humanists and writers who made their livings on the fringes of the Italian renaissance courts. He was a classicist and civil lawyer, teaching in the university of Pavia from 1417–18 probably until his death in 1463. He wrote commentaries on the *Codex* and the *Digest*, two principal components of the Justinian corpus of ancient law, and letters and philosophical speeches addressed to statesmen. The *Semideus* is a rare text, and its transmission is unusual. In its entirety, it was conceived as three books, planned as a comprehensive treatise on statesmanship. Book I

RIGHT: Enemy ships in a river being attacked with firebombs and venomous snakes in bottles and by swimming below the water level to drill holes in the wooden hulls

The tombstone of Catone Sacco survives in
Pavia, in a courtyard off the Corso Strada Nuova,
showing the author teaching from a book to a
classroom of students

concerned the ideal prince, the 'half-god', based on the history of an-
cient Rome. Book II was on the duties of a prince in peacetime. Book
III, which is what we have here, concerns the techniques employed by
a military commander in action. Together, the *Semideus* forms a much
earlier version of the genre afterwards made famous by the *Cortegiano*
of Castiglione (*c.* 1507) and the *Principe* of Machiavelli (probably 1513).
However, there is no known manuscript or early printed edition of all
three books of Sacco's *Semideus* together. Transcripts of his Books I–II
occur on their own in a manuscript in the Hessische Landesbibliothek
in Fulda; a copy of Book I alone is found also in a manuscript in Basle.
Both these separated fragments are small components within mid- to
late-fifteenth-century anthologies of multiple texts, on paper. Book III,
however, is preserved uniquely in this luxurious dedication volume in
St Petersburg. In the preface, Sacco explicitly tells Filippo Maria Vis-

conti that he has 'attached' this third book of the *Semideus*, because it is relevant to his purpose here. This is at the very top of folio 5r: "attuli Semidei librum tertium". We will return to those words in a moment.

Back home in London I entered into an altogether fascinating series of exchanges with Anna Melograni, art historian of the Italian Ministero per i beni e le attività culturali, who has devoted her life to the study of fifteenth-century illumination in Lombardy. All of us who work on manuscripts rely hugely on the kindness of colleagues, and sharing ideas and possibilities is one of the joys of our trade. Puzzled by the variety and inconsistencies of the decoration here, I had sought her advice.

Her first reaction was that the military illustrations in the *Semideus* really cannot be as late as 1438. That has not been suspected before. Anna says that they are very close to – and perhaps even in the same hand as – the *bas-de-page* drawings in a manuscript of Boccaccio's *De mulieribus* and other texts in Copenhagen, which has a colophon recording its completion in Pavia on 10 February 1401, at eleven o'clock at night (it must have been very dark, in winter). The Copenhagen volume is illustrated by an unknown artist, in the circle of the late fourteenth-century illuminator Pietro da Pavia. I have compared reproductions of the two. I could believe that this is indeed the same hand, with its bare and wild organic hills, naturalistic forests, and tiny theatrical people. To judge from photographs alone, Anna Melograni tells me, she would assume that the artist's work in the manuscript of the *Semideus* is surely no later than (say) 1430 and that it could be considerably earlier. The opening initials and borders and the arms and devices of Filippo Maria Visconti, however, might all be consistent with 1438, the date which occurs in the preface.

What I think must have happened is this. Catone Sacco doubtless proudly commissioned an illuminated master-copy of all three books of his entire *Semideus*. I cannot assign it a date, except to say that the author was teaching in the university by 1418. Like the hypothetical texts of *Boece* and *Troilus*, which we envisaged in Chapter Ten, prepared on parchment by the scrivener Adam in the 1380s and supposedly returned afterwards to the young Chaucer for correction, this copy was

professionally made for the author's own use. The manuscript in St Petersburg contains numerous minor emendations which are almost certainly autograph, in a small semi-humanistic hand. At Sacco's instruction, the text was confined within extraordinarily small rectangles in the centre of each page, fifteen lines high, 3⅝ by 2¾ inches, hardly an eighth of the surface area of the page. One by one, the huge blank margins were slowly filled with illustrations by the artist of the Copenhagen Boccaccio of 1401 or someone very like him. The intention was possibly to have pictures surrounding every page throughout the text. It may have been conceived as an extravagant gift or perhaps simply for private vanity, comparable to some modern authors commissioning luxurious bindings for their own copies of their first books. One can envisage the illustrator's work continuing slowly in the 1420s. Perhaps well before 1430, the artist died or gave up, or Catone Sacco lost heart or available finance, and it was all laid aside, a task too big for completion. Every academic has projects like that. Then some years later, in 1438, the author suddenly glimpsed an opportunity to revamp the abandoned volume and to present it to Filippo Maria Visconti. He decided to restrict his theme to warfare and the timely need for a new crusade. He composed a new preface and the speech in honour of the Virgin Mary, the duke's name saint. He abstracted the final ten gatherings from the last part of his own unbound but illustrated master-copy of the *Semideus*, salvaging book III only, the only part now relevant, and he 'attached' that section, as he says, to the new volume. The same scribe was evidently still available, or it just might have been the author's own hand in formal mode. That is why quire iv is of only four leaves, since it had to match up with quire v (from folio 37), written a number of years earlier.

The composite manuscript was then decorated for presentation. The original artist was dead or long removed from the project. His hand appears nowhere in the additional components. Several different professional illuminators were now brought in, which may suggest a certain urgency to have the book ready for a particular occasion. The borders with the arms and devices of Filippo Maria Visconti were supplied at the beginning of each section, and the opening pages showing

the duke's descent from Saturn. The various small marginal vignettes of the Virgin and Child were inserted, sometimes slightly irrelevantly in a military treatise but useful here to engage the attention of a recipient whose middle name was Maria. These could be – I acknowledge Anna Melograni again – in the hand of Michelino da Besozzo, documented in Pavia 1388–1450, one of the great artists of his time. He was also a fresco and panel painter, in Pavia and Milan. The opening initial of the Annunciation in the *Semideus*, however, looks very like the early style of Giovanni Belbello da Pavia (fl. *c.* 1425–*c.* 1462). This marvellous illuminator eventually worked in many regions of northern Italy, but he began his career in his native city of Pavia, where early commissions included completion of the Visconti Hours for Duke Filippo Maria and contributions to the Breviary of Marie of Savoy. The streaky sky, the craggy hills, the swirling drapery and, above all, the colouring are all entirely characteristic of Belbello's work at this period of his life. That he contributed to this manuscript in 1438 adds a tiny new footnote to his biography.

When the assembled *Semideus* was ready and suitably bound in its crimson velvet with silver clasps, probably enclosed in its gilt leather box, it could be presented by its author to the duke. There is a good image of how this happened in the dedication copy of the *Historia Angliae* by Galassio da Coreggio (*c.* 1368–1442), among the manuscripts from Pavia now in Paris. Its frontispiece shows Filippo Maria Visconti in a big flat-topped hat and dark-brown velvet robes, seated on a throne, draped with a red floral cloth which extends down to below his feet. No hair is visible beneath the hat and the duke was either bald by then or he was shaved right up the back of his head. He looks a bit like Vladimir Putin. He has a long neck, straight nose, and piercing eyes, looking directly at the author who kneels before him, cap in his left hand, holding up a little manuscript bound in red with four gold clasps. The duke is leaning forward slightly and reaching out both hands.

If Filippo Maria was grateful for the *Semideus*, it had no effect. Catone Sacco must have been disappointed. No crusade took place and no other copies of the new book were made, either at the request of the duke or for the author himself. No manuscripts survive either of

the original *Semideus* complete in three books together, because Sacco had now given away what must have been his only copy of book III. He had presumably initially retained his own manuscript of the first parts, very probably also illustrated by the artist of the Copenhagen Boccaccio, an orphaned half-book, from which the known transcripts in Fulda and Basle must have crept into circulation. At some time after Sacco's death in 1463, the original was lost.

As we saw in the previous chapter, the preparation of complicated illuminated manuscripts in France and Italy was by this time usually coordinated by professional booksellers. Their tasks involved bringing together the various sub-contractors, scribes, illuminators and binders. An especially famous example in Italy was Vespasiano da Bisticci (1421–98), of Florence, who seems to have been personally acquainted with everyone who ever bought or commissioned humanistic manuscripts. In Pavia we know of one such figure, Jacopo de San Pietro, who is thought likely to have been responsible for assembling the *Semideus* for presentation. He is described as '*bedellus*', literally a 'beadle', a term sometimes used in medieval Paris for book agents with some loosely defined semi-official status within the university. When Catone Sacco later ordered a presentation copy of his own *Lectura super quibusdam titulis libri VI Codicis*, a commentary on civil law, to be given to Francesco Sforza, he again employed Jacopo de San Pietro. That manuscript also survives in Paris. It is inscribed on a flyleaf at the very end in a tiny hand, "1458 die XIIII° Iunii hoc Opus Aminiavit et ligavit Jacobus de S[an]cto Petri P[a]p[i]e", 'Jacopo de San Pietro of Pavia illuminated and bound this work, 14 June 1458'. The book is decorated modestly on its opening page with the Sforza arms and emblems. It is not by any of the artists of the *Semideus*. Jacopo de San Pietro clearly had some kind of ongoing role in the upkeep of the ducal library in Pavia. At least four extant Visconti books were rebound for the collection under his supervision, including an eleventh-century commentary by Boethius on Aristotle which had been owned by Petrarch and was inscribed in the fifteenth century as bound by "Jacobus de Sancto Petro bidelus". That book had already been in the library before rebinding, since it is de-

scribed in the inventory of 1426 as being in boards with white leather, and it is now in fifteenth-century blind-stamped calf, presumably the work of Jacopo or his sub-contractor. Intriguingly, in old age Jacopo de San Pietro became a printer.

The art of printing with movable type was perfected in Europe in the early 1450s by Johann Gutenberg, of Mainz (*c.* 1395–1468). There is every reason to accept the primacy of his claim. Cultural historians rightly emphasize the truly transformative importance of Gutenberg's discovery, comparing it with the invention of the wheel or the internet. For the first time, human thought and language became capable of limitless reproduction in apparently identical copies. Typesetting was slower than transcribing books by hand but, once set up, printing could mass-produce hundreds of copies involving a fraction of the time and cost it had previously taken to make a single one. Throughout

acute & cito reperięmus ; diſtincte & ornate diſponemus, grauiter & uenuſte pronuntiabimus ; firme & perpe ‑ tuo meminerimus ; ornate & ſuauiter eloquemur ; Er go amplius in arte rhetorica nihil eſt ; Hæc omnia adipi ſcemur : ſi rationes præceptionis diligentia conſequamur & exercitatione ; ;

FINIS ;

Opus Impreſſum Papie Per Iacobum De Sancto Petro; M.cccc°.Lxxvii; Die .xii.Menſis Nouembris ;

The colophon of the book printed in Pavia in 1477 by Jacopo de San Pietro, doubtless the same man who in his youth had worked for Filippo Maria Visconti and Catone Sacco

this history of manuscripts, we have encountered at every moment the problems of copyists' mistakes and their consequences: in typography, in theory at least, proof-reading eliminated error. The importance of printing cannot be overstated in the stabilization of languages, the advance of popular literacy, the rapid spread of enlightenment or evil, and the sharing and transformation of the human experience. The speed

with which printing was introduced across Europe is remarkable. By 1500, the end of the so-called 'incunable' period, 350 towns had printing presses, 30,000 titles had been issued, and some 9,000,000 books had been printed. Medieval manuscripts still have a certain glamour of exclusivity and uniqueness; mass-produced incunabula even now are very common.

Printing reached Italy very early. The received wisdom is that two Germans, Konrad Sweynheym and Arnold Pannartz, established the first Italian printing press in the monastery of Subiaco, near Rome, in 1465, before moving south two years later into Rome itself, specializing in the production of stately Latin editions for humanistic patrons, generally illuminated by hand. There is an arguable case that an itinerant printer, possibly Ulrich Han of Vienna, may already have been producing ephemeral Italian devotional texts perhaps in Bologna or Ferrara by 1462–3. Within a few years there were well-established printing shops in Venice (1469), Foligno (1470), Ferrara, Milan, Florence, Bologna and Naples (all 1471), Padua, Parma, Mantua and Verona (all 1472), and with increasing rapidity elsewhere. There may have been a printing press in Pavia by 1473. A rare edition of the Pseudo-Ciceronian *Rhetorica ad Herennium* was published in Pavia on 12 November 1477, naming its printer as Jacobus de Sancto Petro. This must be the same man. A book agent, illuminator and binder, already associated with the university and the Visconti library in 1438, might then have been (say) thirty; in 1477 he would in that case have been in his late sixties, not too old to have printed one book before retirement, as the medieval world passed away.

Of course, the industry of book production and publishing was eventually transformed by printing and many professional scribes were put out of business or needed to adapt, but in its basic principles the fifteenth-century book trade was initially not greatly altered. There were still suppliers of paper and parchment, sources of exemplars, authors, editors, designers, binders and booksellers, much as there had been for several centuries. Many of the same personnel, including Jacopo de San Pietro, simply continued doing what they had always done, with small mechanical modification. Although the technology is

now different, the love of beautiful books and a trade to supply them both still flourish today.

Another thing which has still not changed greatly since 1438, even in our own time, is the irrepressible human inclination for fighting and the need to justify warfare by ideological righteousness, on either side. Filippo Maria Visconti never did muster a crusade. Anxieties over possible threats to European culture from the massed forces of Islam are issues again today, but snakes in bottles are probably not the answer.

The Spinola Hours

c. 1515–20
Los Angeles, J. Paul Getty Museum,
MS Ludwig IX.18

My first visit to the site of the present Getty Center took place in October 1983, some fourteen years before it actually opened. The Getty Trust had then recently contracted for the purchase of a barren hilltop in the Santa Monica Mountains on the outskirts of Los Angeles. I had been driven up a rough dusty track by John Walsh, newly appointed director of the nascent museum, and we scrambled up among loose rocks and gorse bushes to admire the vast and hazy view of the Pacific Ocean to the west, Santa Monica far down below, and Hollywood and the skyscrapers of central Los Angeles off to the east. Rabbits scuttled through the bushes. I seem to remember hawks soaring overhead, but I may be inventing that detail. On this spot in the rough mountain wilderness, seemingly above and at the edge of the new world, John Walsh explained to me, waving his arms, they would build a very great treasure house of art, including, as they had recently decided, a collection of the finest European illuminated manuscripts.

More than thirty years later, I found myself again in Los Angeles standing on my hotel balcony at the foot of the same hill gazing up across the road at the gleaming modern acropolis high above me. It was a fine day, of course, as it always is in southern California. When I asked in the lobby whether I could walk up to the Getty, they regarded me with the sympathy reserved for the sub-normal and steered me

to the hotel shuttle bus. "We don't have a lot of sidewalk," said the driver, when I apologized for troubling him. I was his only passenger on the short ride up Sepulveda Boulevard to the first junction, where we circled off to the left, under the San Diego Freeway, and pulled into the area of museum security gates at the base of the hill, like the toll booths on a French motorway. In America anyone in uniform assumes you are a felon until proven otherwise. They leant in and demanded my 'parking reservation number', which of course, to their incredulity and extreme suspicion, I had not known to arrange in advance, having no car. This is a supposedly classless society and it is a free museum, created for all the people of Los Angeles, but anyone who cannot afford to arrive by car is deemed to be hardly the type of person the museum would want to admit.

There are ample multi-level car parks at the base of the hill, by the gates and also up at the top. Unless you are permitted to drive up, you go in through the first car park on the left, take an elevator up one floor (no one ever climbs stairs in Los Angeles), and you join a driverless white automatic three-carriage train, which every few minutes glides up the side of the hill, winding up and up through an artful landscape resembling the background of a Mantegna, arriving at a little station at the edge of the Museum itself. It has been worth coming for the free train ride alone. Step off and adjust your eyes to the brightness of the Californian sun. The buildings are very broad but not especially high, curling like a medieval city around the brow of that hill top where I had once scrambled among the rocks with John Walsh. The whole complex of museum, libraries and research centres was eventually opened in December 1997. The cost was phenomenal, stretching even the huge Getty endowment. Historically, perhaps only the Escorial or Versailles could have been comparable in vision and expenditure. From the train terminus you gaze out over several levels of courtyards which could be the stage set of a great opera, leading up to the portico of the Museum. There are artfully placed plants in giant saucers and sculptures by Maillol and Charles Ray. It is very obvious that this is indeed a museum, unlike the libraries of previous chapters. Step from the hot sun into the entrance lobby and you immediately notice the air conditioning. You

The Getty Center on a hilltop overlooking Los Angeles, comprising an art museum, a research institute and other facilities, opened in 1997

have a princely choice of riches to see on the left or the right, as bewilderingly infinite as an American menu, including paintings, sculpture, decorative arts, photographs, furniture, and (twinkling in the dark) illuminated manuscripts. It all looks reassuringly serious and unquestionably expensive. You are directed by strikingly pretty girls and clean-cut boys with blue eyes and white teeth. These must be the most sought-after internships in the world and they clearly enjoy their jobs.

I told one that I had an appointment with Elizabeth Morrison, curator of manuscripts. If American security personnel treat you as a probable criminal, all others in Los Angeles regard you as their best friend and address you by your first name. As if it were their greatest joy to assist me, they led me back out again down towards the little station, where I should have turned left down the ramp towards 'Central Security' (and by which time I had heard half their life stories and Hollywood ambitions). At the desk there I was asked for that constant American prerequisite, "Photo ID", as they call it, which in the States usually means driving licence, for I was still being subtly assessed, and I was assigned a clip-on day pass. Then I was escorted round the corner

to another elevator, down to floor L3 and along broad internal win-
dowless concrete corridors with pipes running along the ceilings, like
walkways in some penitentiary but enlivened with posters from previ-
ous Getty exhibitions, round several right-angles (by now I really had
no idea which way I was facing), and into the Manuscripts and Draw-
ings Department. They almost cheered as I was ushered in. The warmth
of the welcome one always receives here shames us all in our restrained
European libraries. Staff appear from everywhere. Introductions are
made all round. It seems a very happy place, which says a lot for the
good management.

The reading-room runs parallel to the outside wall of the Mus-
eum. There are tall lancet windows along the outer wall, as in a medi-
eval castle, looking out through rough stone blocks across a valley
to distant houses on the crumbling hillside opposite. There are white
blinds, doubtless lowered when the Californian light becomes too
strong. Bookcases at each end of the room have all the latest works
of reference. Parallel to each bookcase is a long table made of chunky
polished blocks of dark wood, with matching and substantial green
leather chairs. One table is for consulting manuscripts and the other
for drawings. It all looks costly. As on all previous visits to this room,
I was the only reader. The manuscript table is laid in advance as for a
solitary dinner, with grey foam wedges for supporting valuable bind-
ings, and weighted strips resembling purple velvet snakes for holding
manuscript pages open without having to touch the pages. There are
also heavy white strings with small weights at each end. I was issued
with a pair of rib-backed white gloves, alas, but I am subsequently as-
sured by Beth Morrison that the Museum is now considering relaxing
this requirement. Pencils are provided for note-taking.

The manuscript we have come to see is already waiting on a big
trolley, as alone as a millionaire in the back of his stretch limousine. It is
kept in a modern box of polished red morocco, lettered in gold on the
spine, "The Spinola Hours" and "Bruges c. 1510", made for maximum im-
pact when the manuscript was being groomed for sale by the masterly
New York bookseller H. P. Kraus in the late 1970s. We are immediately
in an atmosphere of luxury and temptation. A journalist once asked

H. P. Kraus (1907–88), master manuscript dealer, with the thirteenth-century Dyson Perrins Apocalypse, also sold to Peter and Irene Ludwig and also now in the Getty Museum

Mr Kraus if he could explain in a few sentences who buys illuminated manuscripts. Kraus grunted in his distinctive Austrian accent, "I can tell in two words: the rich." This is not merely 'a' Book of Hours, but '*the*' Spinola Hours, a title created by him to suggest fame and exclusivity, even though when the box was made the name did not exist and manuscript itself was almost entirely unknown.

We saw a very early royal Book of Hours in Chapter Nine. Within a hundred years, every educated or even half-literate person in Europe seems to have wanted to own one too. These were books for private people, who bought the most expensive copies they could afford. Books of Hours were used in domestic settings, carried about the house and opened up on little prayer-desks or cradled on the laps of their owners. By their nature they were always intimate and personal possessions. They must often have been kept on bedside tables, or in chests with household jewels and family treasures, and they were displayed to visitors. In fact, a museum is probably a far more appropriate setting now for a Book of Hours than a library. One theme of this chapter is luxury, and the manuscript in the Getty Museum will not disappoint.

The Spinola Hours was always a *de luxe* object of great costliness. We began our journey through the history of manuscripts with books

which effectively had no original commercial value, other than the expense of the materials required for making them. The early scribes and decorators had been members of religious orders who worked without payment. Manuscripts were made for communal use and they had no resale value. Once professional scribes became involved and private patrons began commissioning books (Chapters Six and Seven), then books acquired a cost and became saleable commodities. The finest illuminated manuscripts were soon very expensive indeed. The invention of printing dramatically reduced the price of basic book production. However, human nature being what it is, 'the rich', to use Mr Kraus's words, continued to compete for ever grander manuscripts still made and illuminated by hand. By the 1470s, the great commercial workshops of the southern Netherlands had more or less abandoned making books for institutional libraries and had instead begun to exploit a market in the production of manuscripts for a luxury trade to the princes and newly rich mercantile oligarchs all across Europe. Far from being put out of business, the Netherlandish illuminators entered a new period of commercial success. They now consciously refined their art into directions where printing could never go, and their creations became ever more spectacular and expensive. Seated in the Getty Museum, among the richest cultural institutions in the world, we are about to see one of the finest of them all.

Out of its box, the Spinola Hours is immediately recognizable as an item of value. It is bigger than many Books of Hours, about 9¼ by 6½ inches by about 2½ inches thick. The volume is bound in late eighteenth-century dark-red leather, probably Italian, to judge from the style. There is a gold floral border around the perimeter of each cover with a repeating pattern of scrolling leaves and flowers. In the centre of the covers, between swags of rococo ornament, is a coat-of-arms below a coronet, attesting to ongoing pride of ownership and exclusivity. These are the arms of the family of Spinola, of Genoa, which is where the manuscript's modern name comes from. We will return to the owners' identity later in this chapter. The spine of the book has seven raised horizontal bands covering the sewing-thongs, but there is no wording. This was unnecessary, for it would not have been bound

The bookplates of Peter Ludwig (1925–96) and his wife Irene (1927–2010), designed by the Swiss artist Hans Erni, on the flyleaf of the Spinola Hours

for a library where it needed to be recognized from its title. The edges of the pages are gilded and delicately incised with a hatched design of lozenges around what seem to be little flower heads. This manner of decoration is known as 'gauffering'. It may be original, since very similar designs appear on the gold edges of a book held by Saint Mary Magdalene in a picture towards the end of the manuscript. The corners of the binding are a bit bumped, but generally the Spinola Hours is in excellent condition. This is a manuscript which has been kept carefully.

At this point, not wishing to offend the companionable invigilator (Christine Sciacca that day), I reluctantly put on my white gloves and opened the book. The inside front cover is lined with bright-green silk. The facing flyleaf is of quite thick parchment, secured under the edge of the pastedown. It has two small modern printed bookplates

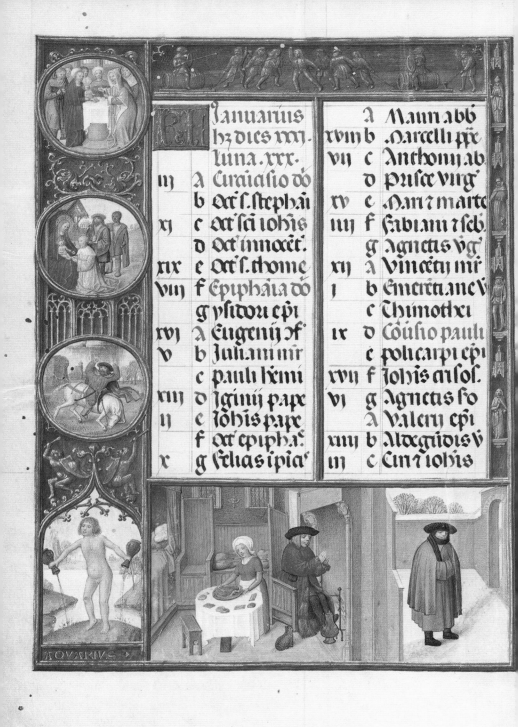

Januarius
h3 dies xxj.
luna. xxx.

				A	Mauri abb̄
iij	A	Curaiasio dō	xviij	b	Marcelli p̄e
	b	Oct s. stephā.	vij	c	Anthonij ab
xj	c	Oct sci iohis		d	Prisce virg'
	d	Oct innocēt.	xv	e	Mari 7 marte
xix	e	Oct s. thome	iiij	f	Sabiani 7 sebā
vij	f	Epiphaia dō		g	Agnetis vg'
	g	ysidori epi	xij	a	Vincēti m̄r
xvj	a	Eugenij of	j	b	Emerciane v
v	b	Juliani m̄r		c	Thimothei
	c	Pauli hemi	ix	d	Cōuersio pauli
xiij	d	Iginij pape		e	Policarpi epi
ij	e	Iohis pape	xvij	f	Iohis crisol.
	f	Oct epiphā.	vi	g	Agnetis sō
x	g	Felias ipiā'		a	Valerij epi
			xviij	b	Aldegidis v
			iij	c	Cani 7 iohis

incorporating a semi-abstract design of a profile sharing its eyes with what is apparently the face of an owl, etched by the Swiss artist Hans Erni (1909–2015, aged 106 at his death). One is inscribed "Irene & Peter Ludwig, Aachen" in capitals. These bookplates represent almost the only piece of the manuscript's previous history which is unambiguous, for those owners, although for only five years, were Dr Peter Ludwig (1925–96) and his wife Irene (1927–2010), of Aachen and Cologne, chocolate billionaires and art collectors, especially of twentieth-century painting. The Ludwigs bought the Spinola Hours from Kraus, then at the height of his career. Mr Kraus's daughter, Mary Ann Folter, kindly tells me that the sale went through in January 1978, and that the figure on the firm's sale slip was just over a million dollars. That was an extraordinary price for a book in the 1970s. Dr Ludwig was for a long time a very secret buyer of manuscripts, almost exclusively from Kraus. I met him only once, and I remember him as very tall and silent. The Ludwigs' collection was kept on deposit at the Schnütgen-Museum in Cologne, where I first saw the extent and richness of their illuminated manuscripts, like a dragon's hoard of gold, in the company of Dr Ludwig's elfin cataloguer, Joachim Plotzek. In his eventual publication of the collection, the Spinola Book of Hours was illustrated on the front cover of the second huge red volume. In 1983, in a deal which initially caused some ill-feeling in Germany, the whole Ludwig collection of nearly 140 illuminated manuscripts was uplifted and sold *en bloc* to the new Getty Museum as the foundation of a new department intended to bridge the gap between classical antiquities and the pictorial art of the Renaissance. It was as a direct result of the purchase that I had been brought by John Walsh out to Los Angeles that year.

The first page of the manuscript itself is blank. Turn it and we are plunged straight into the late Middle Ages. The Spinola Hours, like most Psalters and Books of Hours, opens with a calendar of the saints' days for the whole year. The script is in two columns in red and black.

LEFT: The opening page of the calendar of the Spinola Hours, showing a man warming himself by the fire in January and stepping cautiously into the wintry courtyard

OVERLEAF: March and April in the calendar, with the pruning of vines in the gardens of a castle and letting the farm animals out to pasture in April

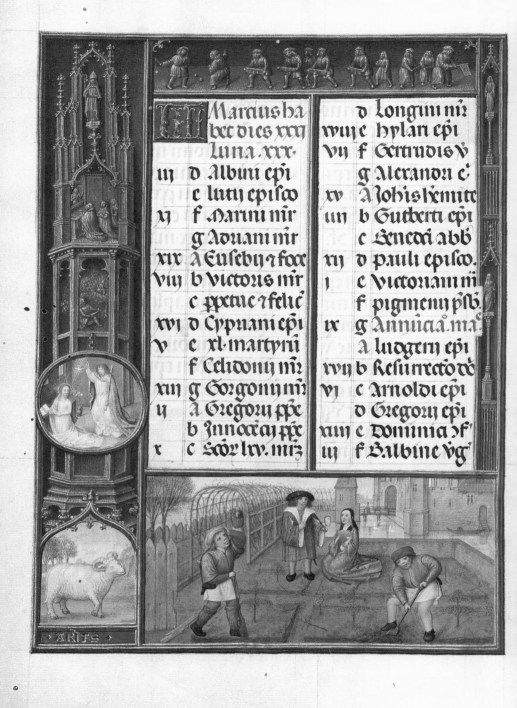

Marcius ha
bet dies xxxj
luna .xxx.

iij d Albini epi
 e luciij episco
xj f Marini mr
 g Adriani mr
xix a Euscbij ⁊ foce
viij b victoris mr
 c ppctue ⁊ felic
xvj d Cypriani epi
 v e xl. martyru
 f Celidonij mr
xiij g Gorgonij mr
ij a Gregorij ppe
 b Innocecij ppe
 x c sctor lxx. mr

 d longini mr
xviij e hylarij epi
vij f Gertrudis vg
 g Alexandri c
xv a Iohis hemite
 iiij b Gutberti epi
 c Benedci abb
xij d pauli episco
 j e victoriam ni
 f pigmenij psb
ix g Annuciaa. ma
 a ludgerij epi
xvij b Resurrecto do
vj c Arnoldi epi
 d Gregorij epi
xiiij e Dominia If̄
 iij f Balbine vg

ARIES

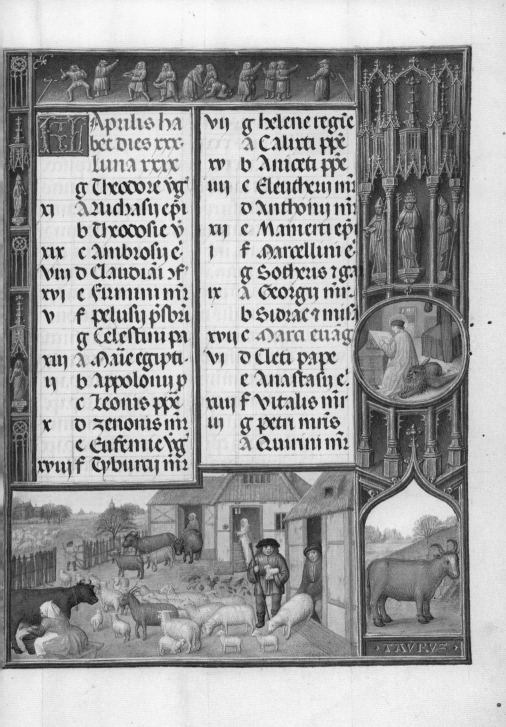

Apulis ha
bet dies xxx
luna xxix

	g	Theodore vg	vij	g	helene regie
xj	a	Richasij epi		a	Caluti ppe
	b	Theodosie v	xv	b	Aniceti ppe
xix	c	Ambrosij c	iiij	c	Eleutherij mr
vij	d	Claudiai of		d	Anthonij mr
xvj	e	Firmini mr	xij	e	Mamerti epi
v	f	pelusij psbri	j	f	Marcellini c
	g	Celestini pa		g	Sotheris 7 ga
xiij	a	Marie egipti	ix	a	Georgij mr
ij	b	Appolonij p		b	Sidrac 7 mis
	c	Leonis ppe	xvij	c	Marci euag
x	d	Zenonis mr	vj	d	Cleti pape
	e	Eufemie vg		e	Anastasij c
xviij	f	Tyburcij mr	xiiij	f	Vitalis mr
			iij	g	petri mris
				a	Quirini mr

TAVRVS

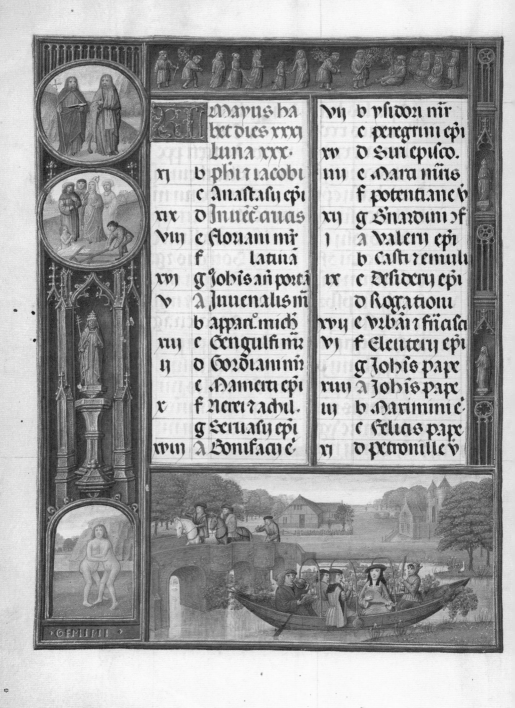

The decoration is exceptionally rich. In the lower margin of January is a picture of a domestic interior, with a man and a woman in winter. It is difficult to guess the social status of the setting. The man, at least, looks well-dressed and has a purse around his waist; the tall stone-mullioned windows are glazed; the huge stone fireplace has outlines of heraldic escutcheons; and yet this is what we would now call a bed-sitting room, with bedroom, dining area and living room all crammed together into one space. Surely no aristocrat lived like that. Maybe it is the servants' hall in a castle. The woman is laying a meal for one, to be as solitary as I was myself at the long table in the Getty Museum. The man, accompanied by his cat and a flagon of ale, is in the meantime warming his frozen hands and feet at the fire. At the far right, another man, or the same man slightly differently dressed, steps carefully outside into the January snow, with a grey scarf round his neck and his hands concealed in his cloak. The icy route he treads towards the courtyard gate has been trampled before and it is stained brown. By February, the snow has gone, and estate workers are already ploughing and staking up plants, presumably vines. In March a noble couple is venturing out of a castle into the garden with a white lapdog. The weather is scarcely any warmer. Gardeners lay out flowerbeds, but they are still dressed in hats, jackets and woollen leggings. Look closely and there is a moat behind, with swans gliding towards a woman on the drawbridge. She has perhaps come to feed them. Domestic animals are first led outside in April through the farmyard into the fields. There are cows with calves, sheep with spring lambs, and hens with their chickens scurrying around them. The cattle have bells round their necks. One woman milks a cow and another stirs a butter churn. At dawn on 1 May, the ancient celebration of the start of summer, noblemen ride out on horseback over a bridge and a boat with a party of young people floats lazily past on the river, with branches of the may tree (or hawthorn) and musicians. A youth in the back of the boat is drinking; another flask hangs over the side to keep it cool. Irises are growing on the banks. From the window of our flat in Cambridge in England one can see this scene almost unaltered

LEFT: May in the calendar of the Spinola Hours, showing a boating party, with music and drink, celebrating May Day and the start of summer

on the river Cam in the early summer today. There is shearing in June, and a man is resting on a bench outside a pub. Grass is cut and is loaded onto a haywain in July. Page by page, the medieval year is revealed. In August they reap the wheat, and they plough and sow for the new season in September. It continues in this way through to December, when the snows have returned and the moat is frozen over. Workers in the foreground are earnestly butchering pigs and catching the blood in a frying pan to make blood pudding in the kitchen at the far left. These are preparations for Christmas. It is all hugely familiar and yet rendered magical. There is an irresistible nostalgia in this unchanging rhythm of the year. It has the earthy reality of a painting by Brueghel. Borrow a magnifying glass from the invigilator, and the Getty Museum and the twenty-first century both vanish, and we are touching hands (except for those dreadful gloves) with the countryside of the southern Netherlands of the early 1500s. Down to the tiniest detail, it is there in our presence. No facsimile can re-create that enchantment of direct encounter.

Ultimately, calendars in medieval Books of Hours are all remote descendants of the lost fourth-century 'Calendar of 354.' We glimpsed reflexions of this mysterious late-classical manuscript in Chapter Four (p. 171). It was an almanac, made for an early Christian owner in a time of pagan antiquity, which was rediscovered in the ninth century, when it was admired and copied at the Carolingian court. It launched a textual dynasty of astonishing duration. The opening words of the Spinola Hours, "Januarius h[abe]t dies xxxi", 'January has 31 days', derive unchanged from that prototype of 1,150 years earlier. The same words began the calendars of the Copenhagen Psalter (Chapter Seven) and the Hours of Jeanne de Navarre (Chapter Nine). Similarly, the ancient signs of the zodiac, of no practical relevance whatsoever in a Christian prayerbook, are preserved here as pictures in the lower corners of each page, clinging still in the iconography of calendars through transmission from the Calendar of 354.

Along the upper margins of the Spinola calendar are children's games, not all recognizable (at least not to me). They are in brown and gold, like wood carving. In January the children are holding a mock tournament, dragging barrels across the ice. There seem to be dancing

Children playing in the upper margin of the calendar of the Spinola Hours, blowing musical instruments and catching butterflies in July

games, with children prancing in conga lines and carrying each other in piggyback. They are apparently playing marbles in April and catching summer butterflies under a hat in July. They are larking about, sparring on hobbyhorses, boating, snaring birds, playing with skittles and hoops, and tobogganing in December. People shown in medieval art often seem to us joyless and solemn, but these children are having fun.

Especially significant saints' days in most medieval calendars are written in red ink, what we now call 'red letter days', and here these special feasts are illustrated too in roundels in the outer margins, some hanging by little chains from the borders, like balls on a Christmas tree. In the Spinola Hours these red-letter festivals are all universal and disappointingly unlocalizable. The lesser names infilling the calendar here are perhaps drawn less consciously from the scribe's domestic repertoire. Here are Saints Aldegunda, Amand, Walburga, Gertrude, and many others, northern and local venerations, including Saints Nichasius, Gengulph, Boniface, Erasmus, Severinus, Lebuin, Willibald, Kylian, Donatus, Remacle, Lambert, the two Ewalds, the 11,000 Virgins, Hubert and Willibrord. From these alone, with the help of a dictionary of saints in the reading-room's reference collection, we can confidently assign the Spinola Hours to a context in the region of Flanders, the Netherlands and the Rhineland, although we could have guessed as much from the style of illumination.

Names of saints remind us that Books of Hours are, above all, texts of religious devotion. Turn the leaf following the end of the calendar and the manuscript's pious purpose is not in doubt. Here are pictures spread across a double page. There are exquisitely delicate images of the Virgin Mary and Saint Veronica, their eyes red and glistening with

OVERLEAF: The first large pictures in the Spinola Hours: Christ carrying the Cross through the Via Dolorosa, and resurrected in Heaven, blessing the world

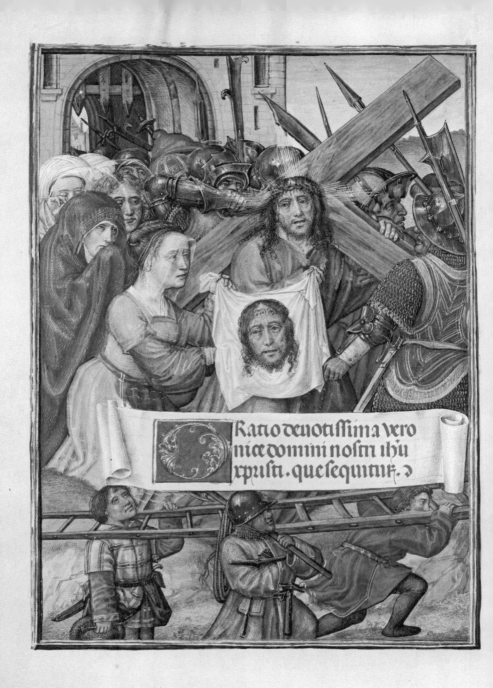

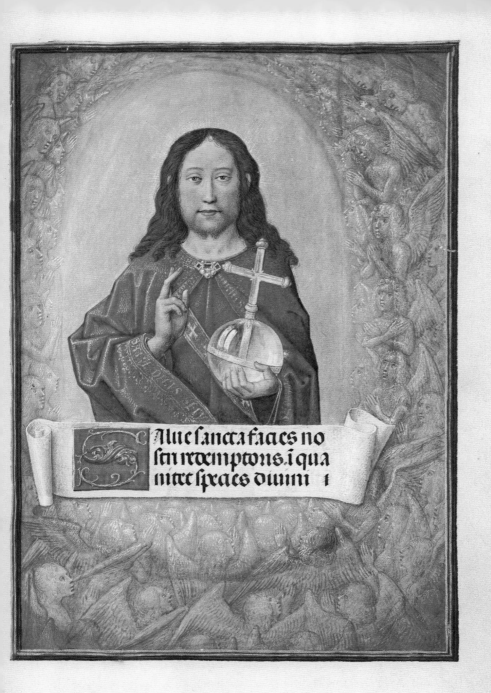

tears, as they watch Jesus as a prisoner dragged by soldiers through the
Via Dolorosa on his way to death; opposite is the full face of the risen
Christ in Heaven, holding a rock crystal orb, among hosts of archangels
in gold and palest red. He raises his right hand in stately benediction.
It is a composition known from other manuscripts, commonly believed
to derive from a lost painting by Jan van Eyck. It is startlingly natural-
istic. On both pages, Jesus is gazing straight out into the eyes of us,
the viewers. If we saw modern pictures like this in a religious context
today, we might dismiss them sniffily as being merely sentimental and
saccharine Roman Catholicism. It takes a moment to grasp that these
are 500 years old and painted by hand. Actually, there is a touch of
the spirit of the imminent northern Reformation even here. These are
evocations of religious emotion which reach out to interact between
the book and its reader. Already the very personal nature of Christian
devotion was a characteristic of the Netherlands. Figures such as Geert
de Groote (1340–84), founder of the Brethren of the Common Life, and
Thomas à Kempis (c. 1380–1471), presumed author of the *Imitatio Christi*,
emphasized the very direct relationship between the individual lay
person and salvation, unmediated by the organized Church. An ordi-
nary person could look straight into the eyes of Christ himself. Prayer
and private faith are difficult subjects for a social historian, but that
does not diminish their importance. A Book of Hours was an intimate
touchstone of piety, and the existence and demonstrable popularity of
such books in the southern Netherlands may tell us a good deal about
an elusive and little-documented aspect of daily experience.

Let us go straight to the manuscript's principal text, the Hours of
the Virgin Mary. It does not actually begin here until about a third of
the way through the book. As in most Books of Hours, one can find
any text most easily by looking for its distinctive opening illumination,
which here – as customarily for Matins – shows the Annunciation.
Pages were not originally numbered; we may call it folio 92v, which
it is, but the first owners would locate and define it by its picture.
In the Spinola Hours this is almost a title-page, and the picture sur-
rounds a framed panel of writing in red, "*Incipiu[n]t hore beate marie
virginis secundu[m] usu[m] Romanu[m]. Ad matutin[as]*", 'The Hours of the

Blessed Virgin Mary are beginning according to the usage of Rome – At Matins.' The scene shows a house with classical mauve marble pillars as a nod to the period of antiquity in which the Annunciation took place, but it is ultimately a contemporary Flemish renaissance palace with brick walls, set in a muddy courtyard and fenced garden with a medieval gatehouse and a town belfry beyond, like that of Bruges. We can see both the outside of the building and, within an inner frame, as if through X-ray spectacles, into the Virgin Mary's domestic chapel, which leads off her bedroom. There is Mary herself, kneeling in front of a devotional book, resembling a Book of Hours in a green cloth chemise cover, laid open on a prayer desk.

For a minute, try to put yourself into the state of mind of a devout woman in early sixteenth-century Europe. She would have been taught to regard the historical event of Gabriel appearing to Mary in her house in Nazareth as the most awe-inspiring and sacred event in the entire history of creation (Luke 1:28). At that holy instant, a mere human being – like you – found ultimate favour with God himself, blessed among women, and she conceived his Son. Implicitly, every pious Christian since then has aspired towards a state of such absolute acceptance by God. A female owner of a medieval Book of Hours might gaze at a picture of the Annunciation and try to imagine what it was actually like to have been that woman chosen above all others. The image focused her thought. She would try to concentrate on and replicate what Mary herself might have been thinking and experiencing. Similarly, a religious man of the late Middle Ages was encouraged to envisage participating personally in the horrors and pain of the Passion and Crucifixion of Christ. The Annunciation and the Crucifixion are by far the most common subjects in all of late-medieval art.

At the holy moment of the Annunciation, as the picture in this manuscript shows, the Virgin Mary was by convention kneeling at her prayerbook. We cannot see the words she has been reading. Everyone knew, however, that Nazareth was in the Roman Empire, for it is explicit at the beginning of Luke's Gospel, and that the Romans spoke Latin.

OVERLEAF: The Annunciation, in which the Virgin Mary is interrupted in her devotional reading by the archangel, paired here with Gideon, calling down divine dew on a virginal fleece, as an Old Testament prototype

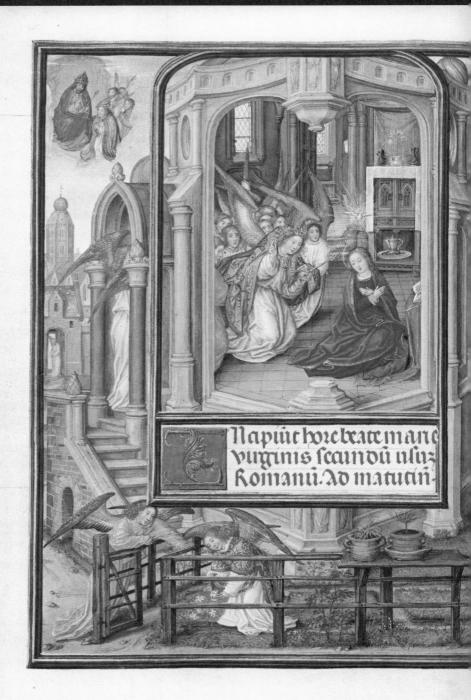

Napiūt hore beate marie
virginis secūdū usuz
Romanū. Ad matutiñ

omine labia mea ape
ries Et os meum annu
tiabit laudem tuam.

People would reason, quite logically, that any Scriptural texts that the Virgin could have known would have been from the Old Testament, most appropriately psalms and prophecies. Without studying the question too deeply, most people in the Middle Ages would doubtless have supposed that she did so in Latin. By reading and meditating on suitable Latin psalms and prophetical extracts in the Hours of the Virgin, therefore, an owner of a Book of Hours might be reading the same actual words which the Virgin herself had been reciting and thinking about. The user knelt at home with her Book of Hours laid open on a prayer desk, exactly as the Virgin is shown doing, re-creating for herself the historical conditions of that absolute pinnacle of all religious experiences. Across the picture in the Spinola Hours are the famous words of the angel, "*Ave*" (with no name of the person being greeted), "*gratia plena dominus tecum*", in golden gothic letters, 'Hail, full of grace, the Lord [is] with you.' That sentence might also be addressing the reader.

The words within the various 'hours' of the Virgin are mostly taken from Old Testament texts which the Virgin Mary herself could have known. It all opens with sentences from Psalm 50:17 and Psalm 69:1–2. Matins usually includes Psalm 94, "Venite exultemus …", ('O come, let us sing unto the Lord …'), Psalm 8, "Domine dominus noster …" ('O Lord our lord …'), Psalm 18, "Celi enarrant …" ('The heavens declare the glory of God …'), Psalm 23, "Domini est terra …" ('The earth is the Lord's …'), and so on, with three readings from Ecclesiasticus 24:11–20, where the writer describes the eternity of God and the exaltation of his holy people. These are interspersed with repeated phrases such as "Ave maria gratia plena" ('Hail, Mary, full of grace') and "Benedicta tu in mulieribus" ('Blessed are you among women'), words with which the Virgin's own reading of the psalms was famously interrupted by the archangel.

Matins was read from a Book of Hours before dawn at the same hour at which Gabriel had appeared to Mary in Nazareth; Lauds was used at first light, which was the time of day when she had set out to visit her cousin Elizabeth; Prime was read in the early morning, at about the hour at which Jesus had been born; Terce was used in mid-morning, at the time when the shepherds arrived breathlessly in Bethlehem, having left their flocks during the night; Sext was recited in the late morn-

ing, at the same rather more aristocratic hour at which the three kings presented themselves and their treasures to the Holy Child; None, the origin of our word 'noon', was the time of day when, some time later, the Child was brought to the priests in the Temple for circumcision; Vespers, the early evening office, was read at the hour of day when the Holy Family had set off at dusk to flee into Egypt, to escape the fury of King Herod; and Compline corresponded to the first hour of night when the Virgin, at the end of her earthly life, was lifted into the starry Heaven. Each of these Hours has a picture relating it to that hour – the Annunciation (as we have seen), the Visitation, the Nativity, the Shepherds, the Magi, the Circumcision, the Flight, and the Assumption. Such subjects are common to nearly all Books of Hours.

The Spinola Hours is one of a small group of exceptionally luxurious Books of Hours of similar date supplemented with further cycles from Matins to Compline which could be used additionally on different days of the week. The eighty or so leaves before the central Hours of the Virgin are taken up with Sunday Hours of the Trinity, Monday Hours of the Dead, Tuesday Hours of the Holy Ghost, Wednesday Hours of All Saints, Thursday Hours of the Holy Sacrament, Friday Hours of the Cross (the Crucifixion took place on a Friday) and Saturday Hours of the Virgin. Other components include three short votive Masses: the Mass of the Three Kings (a text one might associate with their relics in Cologne, or with royalty); a Mass against the plague, for dreaded recurrences of the Black Death were never far from people's minds; and a Mass for travellers.

Following the Hours of the Virgin are the Penitential Psalms, with their accompanying litany. They open in this manuscript on folio 165v. These seven psalms had been part of the liturgy since early Christian times. They were said to represent each one of the seven deadly sins, of which all had been committed at different times by the endearingly fallible author of the Psalter, King David himself. In the late Middle Ages the Penitential Psalms were recited in the liturgy on Fridays during Lent, but would be usable in private during any time of reflexion on

OVERLEAF: The Holy Trinity, for the Sunday Hours of the Trinity, paired with Abraham and the three angels, as an Old Testament prefiguration of the Trinity. The panels of text are painted to resemble strips of parchment pinned to the pages

Tos meum annutia
bit laudem tuam.
eus i adiutoriu3

the many mistakes and weaknesses of life. The accompanying litanies are always fascinating. These are very ancient invocations, calling on the names of saints, one after another, rhythmically like the tolling of a bell, repeating each time, "Ora pro nobis", 'Pray for us', followed by lists of primitive fears and dangers, such as thunder and lightning and sudden death, from which the Lord is beseeched to deliver us. Like calendars, litanies have textual ancestors from the dawn of Christianity. They lead logically into the Office of the Dead on folio 184v. Death was a preoccupation of medieval Europe. Warfare, unpredictable harvests, plague and negligible medicine all rendered life very fragile. People were constantly afraid of dying unexpectedly, without time for confession and the last rites. The Office of the Dead was a series of funeral obsequies, which readers tried to imagine as being their own. It was as if by participating in one's own funeral out of choice, one somehow forestalled any chance that the Grim Reaper might arrive without warning, and it was always sensible to be prepared.

The Spinola Hours ends with many short prayers and readings, the Psalter of Saint Jerome and the Verses of Saint Bernard, which are condensed abridgments of the Psalms for busy people in a hurry, a long series of Memorials or Suffrages, addressed to particular saints, and prayers for private use before and after attending Mass. Simply as a catalogue of the intimate hopes and daily fears of any private person five centuries ago, any Book of Hours is an extraordinarily vivid historical document.

Today most people appreciate Books of Hours principally for their pictures. This is an art museum. The Getty owns upwards of thirty manuscript Books of Hours and cuttings from many others. The miniatures in such manuscripts do not illustrate the text in any conventional sense. They are not depictions of narrative (and nor is there much resembling narrative in a Book of Hours anyway). The pictures, as we experienced when we were searching for Matins, are practical devices for locating and recognizing components of the text, and they are catalysts for spiritual contemplation. The great feature of the Spinola Hours is that many of the scenes are extraordinarily complex and innovative, quite apart from their technical virtuosity. When it was exhibited at the Royal Academy in London in 2003, it was described as

"the most pictorially ambitious and original sixteenth-century Flemish manuscript", no small accolade for a period very rich in illuminated manuscripts. Many illustrations are in pairs on facing pages, like diptychs. The scene on the right is sometimes typological, which means that it depicts an incident in the Old Testament which prefigured its later fulfilment in Christianity. Thus, for example, Abraham and the three angels are shown paired with the Holy Trinity to mark the Sunday Hours of the Trinity: Abraham's encounter with the three-person messengers of God, described in Genesis 18, was understood as foretelling the triple unity of Father, Son and Holy Ghost. The gathering of manna in the wilderness (Exodus 16) and Melchizedek giving bread and wine to the soldiers of Abraham (Genesis 14) are both twinned with a medieval procession of Corpus Christi in which the sacred Communion host illustrates the Thursday Hours of the Holy Sacrament, supernatural bread sustaining Christians. Moses and the brazen serpent, which was lifted up on a pole and saved the lives of the Israelites who saw it (Numbers 21), is set beside the Crucifixion at the opening of the Friday Hours of the Cross; and so on. The Annunciation itself at the opening of Matins of the Virgin is illustrated here as having been foreshadowed by the story of Gideon calling down divine dew on the fleece, from Judges 6:36–40, a typological parallel to the Virgin conceiving a son by the Holy Ghost. There are many like this, giving opportunity for a wide range of biblical illustrations from both the Old and New Testaments. They presuppose a reasonable knowledge of Scriptures, or familiarity with other works of art using typology, such as the *Biblia pauperum*, popular in the Netherlands. Similar iconography is sometimes found in Flemish stained glass windows. The Old Testament scenes in this Book of Hours reinforce the analogy that it represented, in part, at least, the kind of devotional world the Virgin Mary herself might have known. Other pictures in the Spinola Hours include a wonderful sequence of saints which seem to resemble real portraits of living people, a pair of scenes with a courtly death and an expensive funeral, for the Office of the Dead, and the inevitable Last Judgement in which Christ seems to float in a golden firmament with his feet on a crystal globe, as all humanity rises naked from the misty grey miasma of the ground below.

Die luna. hora pro de
Equiem functis. ad m.
eternam don a eis dñe.

Sitting at the long table in the Getty Museum, looking backwards and forwards through the pictures, is an utterly captivating experience. The illustrations may or may not touch a modern reader spiritually, but they certainly have the power to gladden the heart and to bring the distant past very vividly to life. The paintings are like a hand-held walk around an art gallery of tiny Flemish Old Masters, not even inferior in quality to the very best panel paintings. Little details add humanity and enchantment which are irresistible. You long to point them out to people, and to share observations. There is a parrot in a cage in the rich man's dining room. Next to it is a monkey on the window ledge: Professor William McGrew, primatologist, whom I consulted on this matter on my return to Cambridge, tells me that the animal is a Barbary macaque, probably from Gibraltar. Younger angels steal flowers from the Virgin Mary's garden. The flowers are lilies. A shepherd dances with his puzzled dog at the news of the Nativity. Mr Kraus reproduced this as his Christmas card when he owned the manuscript. Joseph fills a blue and white pottery jug in a waterfall, during a rest on the Flight into Egypt, and the jug is reflected in the clear water below. It is exactly the kind of pottery still made in Belgium. Children push in among the legs of the adults to watch the Crucifixion, as they would, fascinated by the spectacle. The boy David tries on a grown-up's helmet far too big for him, and rejects it before going out to fight Goliath. Damp stains run down the brick walls of the house of the dying man, where the flowerpots on the windowsill have been over-zealously watered. There is a beautiful night scene of Saint Julian in a rowing boat against the last glow of sunset on the horizon as the stars come out above and a woman holds up a lantern which illuminates the saint. Students of manuscripts tend to study them only from one great mountain top to another, ignoring the valleys and smaller hills (this was a metaphor which the codicologist L. M. J. Delaissé liked to use to his students in Oxford in the 1960s): it was not really until I began cataloguing routine Books of Hours for sales at Sotheby's that I became fully aware of the superior quality of those truly exceptional and innovative manuscripts,

LEFT: Dives and Lazarus, for the Monday Hours of the Dead, showing the rich man feasting, with a monkey on his windowsill, as the poor man begs in vain but dies and his soul goes to Heaven

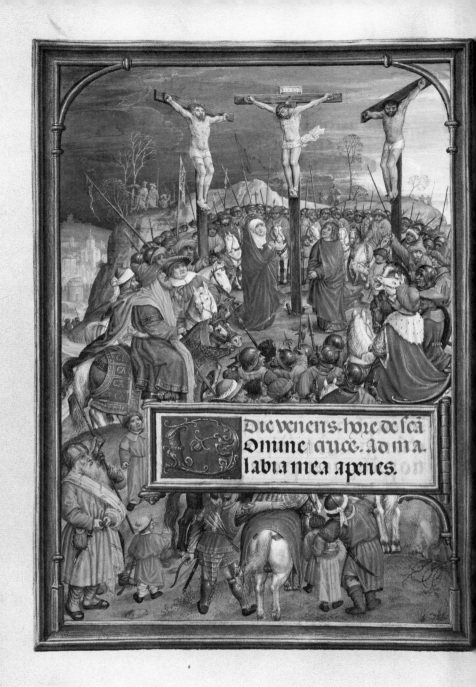

and the Spinola Hours is undoubtedly a mountain peak as towering as any I could hope to see.

Two other features of the artwork deserve mention briefly, before we move on (we have work to do yet). One is that a page of any book is essentially flat and two-dimensional, for that is the nature of script. The gradual evolution of perspective is one of the standard themes of art history. Manuscript illuminators in Europe were at this period beginning to struggle with integrating linear pages with illusions of three-dimensional space. This becomes a persistent preoccupation of the book arts in the late fifteenth century, especially in north-east Italy and in the southern Netherlands. The miniatures in the Spinola Hours are usually painted within *trompe-l'oeil* wooden frames, shadowed in black and gold, as if the pictures were three-dimensional panel paintings held up before us, or actual windows through which we look into a parallel universe beyond. The central rectangles of script, then, intrude on this illusion. Sometimes the artists transform the lines of writing into the appearance of real scrolls which seem to have fallen onto the page, creating shadows; sometimes the script is shown as if it is written on strips of actual parchment pinned to the pictures, so naturalistic that for a second the pins actually appear real; sometimes angels in the pictures themselves lean out into our world to hold the panels of script for us; sometimes the script is on oblong panels shown as hinged at the side, as if they could be folded back, like shutters, to reveal more of the paintings concealed behind. The artists are playing and experimenting with reality and illusion in entirely new ways. These are effects that could never have been achieved with printing.

The other aspect of the manuscript, easily neglected when we have such wonderful paintings, is that it has glorious 4–sided panel borders encircling the text on every written page. Such comprehensive and full borders throughout an entire manuscript are rare even in the most expensive commissions. The margins of the Spinola Hours are exceptionally wide, like those of the *Semideus*. The text area here takes up only about 4 by 3 inches: around this then are full borders, to dimensions of

LEFT: The Crucifixion, for the Friday Hours of the Cross, with the text painted in an illusion of a panel which could seemingly be hinged back

about 5¾ by 4 inches, all within a page size almost twice as large again, more than 9 inches high. If wide margins were thought to be a wanton luxury, these are taken to the extreme. Some of the borders framing the text imitate textiles or carved wood. Most are in what is loosely known as the 'Ghent–Bruges' style, which means that they are decorated with naturalistic flowers and berries, apparently plucked off and scattered across soft golden or coloured grounds, casting shadows to the right. There are carnations, thistles, cornflowers, roses, violets, pinks, straw-berries, forget-me-nots, and many others, perfectly observed to the smallest detail. Sometimes, equally real-looking snails and insects seem to have settled on them. This is a kind of double illusion. The flowers are so lifelike that a butterfly is mistaken into thinking them real and it settles on the page and, when we try to brush it off, we realize that it is we who have been deceived.

Today there are no butterflies in the hermetically-controlled reading-rooms of the Getty Museum. Conservators have dispropor-tionately great power in modern museums, like compliance officers in businesses. Staff here are not even allowed to bring vases of flowers to their offices, for fear that they might carry stowaway insects. The nature of the conceit in the Spinola Hours depends on the manuscript being used in an interior with open windows or even on the owner's lap in an outside garden, a realization which tells us something further about daily life in the Netherlands of the Renaissance.

The Spinola Hours is a prince among manuscripts from renaissance Flanders, but it belongs within a family of very famous royal cousins. To a greater or lesser extent, these include many of the grandest Books of Hours of the period, such as the First Prayerbook of Maximilian, Holy Roman emperor 1508–19 (in Vienna); the La Flora Hours, probably owned by Charles VIII, king of France 1483–98 (in Naples); the Hours of James IV, king of Scotland 1488–1513, and his wife Margaret Tudor, sister of Henry VIII (in Vienna too); the Hours of Isabella the Cath-olic, queen of Castile and Léon 1474–1504 (in Cleveland); the Roths-child Prayerbook, actually a Book of Hours (in Perth, Australia); and

RIGHT: The borders illustrating flowers so naturalistically that these appear to have attracted real insects to alight upon them, although the insects too are painted illusions

 certus dei. V. Stephanus ple
nus gratia et fortitudine facie
bat prodigia et signa magna in
populo. Oremus. Oio.

Mnipotens sempiterne
deus qui primatis martyrii in
beati leuite stephani sanguine
dedicasti. Tribue quesumus. ut
pro nobis intercessor existat qui
pro suis etiam persecutoribus ex
orauit. dominum nostrum ihm
xpristi filium tuum Qui tecum
viuit et regnat in vnitate spus
sancti deus per omnia secula se
culorum Amen.

the Hours of Albrecht of Brandenburg, archbishop of Mainz 1514–45 (privately owned); as well as royal Breviaries, such as the Breviary of Isabella of Castile (in London); the Breviary of Manuel I, king of Portugal 1495–1521 (in Antwerp); the Breviary of Eleanor of Portugal, queen dowager, d. 1525 (in New York); and the Grimani Breviary (in Venice). These are manuscripts owned by the rulers of Europe.

What is so peculiar about these and other manuscripts for the luxury market in the southern Netherlands is how many artists collaborated in each book. This is different from routine Books of Hours of the period, which were usually illuminated by single painters throughout. Furthermore, the same group of artists reappears practically every time. Four of five outstanding illuminators seem to have contributed pages to almost every one of the very costly productions, including the Spinola Hours. They all had a role, however minor, like the murderers on the Orient Express. It is almost as if the patrons consciously wanted manuscripts to include specimens of work by every one of the fashionable painters of the age.

The other oddity about the book production of this period is that we have almost no evidence of booksellers coordinating the work. Unlike France or Italy, or even England, we know almost nothing of commissioning-agents in Bruges, Ghent or Antwerp, for example. Initially, this was because of unusually strict guild regulations in the market towns of the southern Netherlands. In Bruges there were two municipal corporations involved, the powerful painters' and saddlemakers' guild of Saint Luke, which could include illuminators, and the much smaller manuscript-makers guild of Saint John the Evangelist based in the abbey of Eeckhout (on the site of what is now the Groeninge Museum). In a series of regulations enforced by the painters' guild time after time, a client was required by law to give commissions to artists in person rather than through an intermediary. The only general exemption was when the artists were in the service of the ducal households.

This exception is probably the clue to these expensive manuscripts. Royal and princely clients bypassed the book trade altogether. The project managers may have been their private scribes, who could have designed the layout and co-opted and co-ordinated the painters from

a limited but distinguished pool. Occasionally we know the scribes' names and their work from several manuscripts, such as F. Gratianus of Brussels, who signed a Book of Hours for Charles V in the Morgan Library, and Johannes de Bomalia, who signed several, including the Hours of James IV. The script of the Spinola Hours is a clear rounded upright well-spaced gothic hand. It looks to me to be by the same scribe as the Rothschild Prayerbook, which is largely illuminated by the same painters. There may be a tiny clue to his identity. Both the opening heading on folio 8v and the end of the text on folio 312r conclude with a lower case initial "d", which seems otherwise to have no meaning.

At this point, let us take a break for lunch in the Getty Museum. I was brought by Beth Morrison and Thomas Kren, present and former curators of manuscripts, to one of several restaurants in the museum complex. It is as far from renaissance Flanders as is possible to imagine. It is all wonderfully Californian, with stridently healthy food, pencil-thin diners, iced mineral water, and waiters assuming that we are all on first-name terms. The view in full daylight across Los Angeles is breathtaking. Thom Kren originally wrote his thesis on Ghent–Bruges illumination, and he is an acknowledged expert on the entire field of southern Netherlandish manuscripts. It was a chance to discuss the manuscript over yellowtail crudo and avocado.

The illumination of the Spinola Hours is generally ascribed now by Thom and his colleagues to the work of five distinct artists. Within this, some are assigned to the hand of a particular master and some to his 'workshop'. Personally, I cannot tell the difference in these sub-divisions within a workshop, except by assessments of quality, and, given what we know about collaboration in the Middle Ages and indeed about good and less good days in the output of all artists, I will assume here that 'hand' and 'workshop' are for practical purposes indistinguishable.

For convenience, we can number the five hands, dividing the eighty-four fully illustrated pages of the Spinola Hours as follows. (1) Forty-seven are by the 'Master of James IV'. This painter is named from his participation in that king of Scotland's Book of Hours in Vienna, cited above. There is very good cumulative but ultimately circumstantial

evidence for identifying him with the well-documented illuminator Gerard Horenbout (*c.* 1465–*c.* 1540), of Ghent, court painter to Margaret of Austria from 1515. (2) Twenty-four miniatures in the Spinola Hours are by the 'Master of the First Prayerbook of Maximilian'. This name derives from the manuscript made for Maximilian, also listed above. There is, here too, plausible but not absolute evidence for identifying the artist with Alexander Bening, illuminator of Ghent documented from 1469 until his death in 1519. His son was the even more famous illuminator, Simon Bening (*c.* 1483–1561). (3) Eight miniatures here are by the 'Master of the Lübeck Bible', which refers to the designer of the woodcuts in a Bible printed in Lübeck in 1494, but who was clearly primarily a manuscript painter, perhaps in Ghent. (4) Three are by the 'Master of the Dresden Prayerbook'. Strictly, the manuscript in Dresden from which he is named is a Book of Hours, rather than a prayerbook, and is one of his earliest works, from around 1470. His work in the Spinola Hours must be among his latest, and neither this nor the eponymous Dresden manuscript show him at his best. (5) Finally, two of the miniatures are by the 'Master of the Prayer Books of around 1500'. This is a clumsy epithet for a truly marvellous painter, whose works include a beautiful *Roman de la Rose* in the British Library and a Book of Hours in Vienna once owned by Margaret of Austria.

From this alone, we can see that these five artists of the Spinola Hours had all been employed in courtly circles at the highest level, and that the Master of James IV (probably Gerard Horenbout), was the principal painter of the manuscript. The Master of the First Prayerbook of Maximilian (perhaps Alexander Bening) was the second major contributor, and the other three painters had only small roles. These are all painters who worked mostly in Ghent or Bruges, in what is now Belgium, or on secondment to patrons in the broader region of the southern Netherlands.

In the afternoon we must collate the structure of the Spinola Hours. This is remarkably difficult to do. The manuscript is eccentrically constructed and is tightly bound. The task of collating is made harder by tissue paper interleaving attached to inner margins by some well-meaning but misguided earlier owner (if I ever became Director of the Getty my

first pleasure would be to order their removal), and by being made to wear those wretched gloves, which severely hamper the practised and very discreet little tugs sometimes necessary to reveal the sewing threads in the inner creases of bifolia. After huge effort, it is my belief that the collation of the Spinola Hours is as given below.* It reveals a number of observations. First of all (and there is no reason for this to have been noticed before), there are two hands in the floral borders around the text pages. One draws a gold ruled line around the inner frame of the lower and right-hand borders. This illuminator tends to paint masses of small flowers on a quite bright yellow ground. The second border artist rules a red line instead of a gold one, and his flowers are often larger with trailing stems on more muted grounds. The division of hands is absolutely by gatherings. The gold-line border artist painted gatherings ii–ix, xi–xiv, xvii, xxviii–xxxii and xl–xli. The red-line border artist painted gatherings x, xv–xvi, xviii–xxii, xxiv–xxvii and xxxvii–xxxix. Quire i (the calendar) has picture borders; quires xxiii and xxxiii both have architectural borders in quite different style; and quires xxxiv–xxxvi are in the Suffrages, where the borders are different anyway. Therefore, the manuscript was demonstrably being divided up and distributed among the artists when it was in the form of separate but distinct gatherings.

Now let us look at the two principal artists of the pictures. (For the moment, set aside the three who did occasional miniatures here and there: we will come back to them.) The Master of James IV (probably Horenbout) worked in quires i–ix, xiii, xvi, xix–xxi, xxv and xxxv. The Master of the first Prayerbook of Maximilian (perhaps Bening *père*) worked in quires xi–xii, xxxiii, xxx–xxxii, xxxiv, xxxvi–xxxvii and xxxix. They never collaborated within any single gathering. That is unexpected, and it suggests either that they could have been working in different locations or that they were not necessarily involved at precisely the same period of production.

* i⁷ [of 8, lacking i], ii–xi⁸, xii⁴, xiii², xiv⁶, xv–xvi⁸, xvii⁸⁺¹ [iii (folio 118) a single sheet], xviii–xxii⁸, xxiii⁶⁺² [i and viii (folios 165 and 172) are single sheets], xxiv–xxix⁸, xxx⁶⁺² [iii and vi (folios 223 and 226) are single sheets], xxxi⁸, xxxii²⁺¹ [ii (folio 238) a single sheet], xxxiii–xxxv⁸, xxxvi⁶⁺² [iii and iv (folios 266–7) are single sheets], xxxvii⁸⁺² [i and v (folios 272 and 276) are single sheets], xxxviii⁸, xxxix⁸⁺¹ [i (folio 290) a single sheet], xl⁸⁺¹ [viii (folio 306) a single sheet], xli⁵ [probably of 6, last blank cancelled, possibly of 8 and also lacking iv–v, 2 leaves after folio 310].

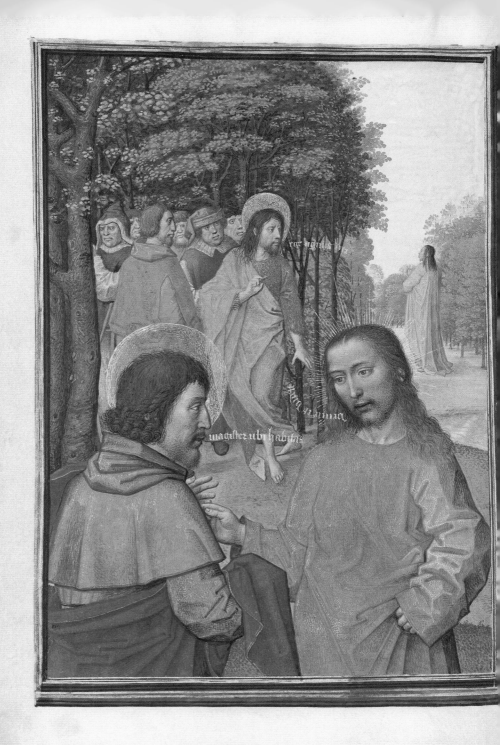

Using the division of principal hands by quire, I think that it is possible to propose a plausible sequence of work. Let us suppose that the Hours of the Virgin were made first, which is likely as it is the core text of any Book of Hours. It is a distinct entity (quires xiii–xxii). Its earliest miniatures to the end of Terce were painted by the already elderly Dresden Master and the Master of the Prayerbooks. These pictures are good but conventional. Then, quite early on in the project, there was a decision to upgrade the work. Perhaps there was even a change of patron. The presumed Horenbout was brought in. The opening of Matins was removed and redone by him. Its two first leaves are now a single bifolium, which forms a gathering on its own (quire xiii), which would only be easily explainable if it were a substitute. These leaves were painted by him with the extraordinary Annunciation and innovative scene of Gideon and the fleece. Horenbout completed the Hours of the Virgin from Sext onwards. He also added a calendar (quire i), the very unusual weekday Hours (quires ii–ix), the Penitential Psalms and the Office of the Dead (quires xxiii–xxix, running on together without a break between them), and a selection of Suffrages (quire xxxv). The manuscript was now, in effect, complete and had become very grand indeed. Soon afterwards, however, the Maximilian and Lübeck Masters were hired too. They added quires xi–xii, with the Gospel Sequences. Quire xii is only four leaves (its last page blank), as it had to fit in with quire xiii, already in place. They extended the Suffrages to include an exceptionally large number of female saints (quires xxxiv and xxxvi). Two of these are the single sheets added to quire xxxvi, with miniatures of Saints Barbara and Clare, which seems to suggest ongoing upgrading, even as the work progressed. Two other pictures of saints are on inserted leaves: Saint Jerome (folio 223v) and Saint John the Baptist preaching (folio 276v), the only true full-page picture in the book, without any text, both by the Maximilian Master. The oddest of all is folio 165, with the opening

LEFT: John the Baptist indicating Jesus, whom a disciple then speaks to (John 1:38), the only entirely full-page miniature in the manuscript, painted by the Maximilian Master

OVERLEAF: David in prayer, at the start of the Penitential Psalms, painted by the Lübeck Master, rather damaged, resulting in the replacement of the facing page in a different style by the Maximilian Master

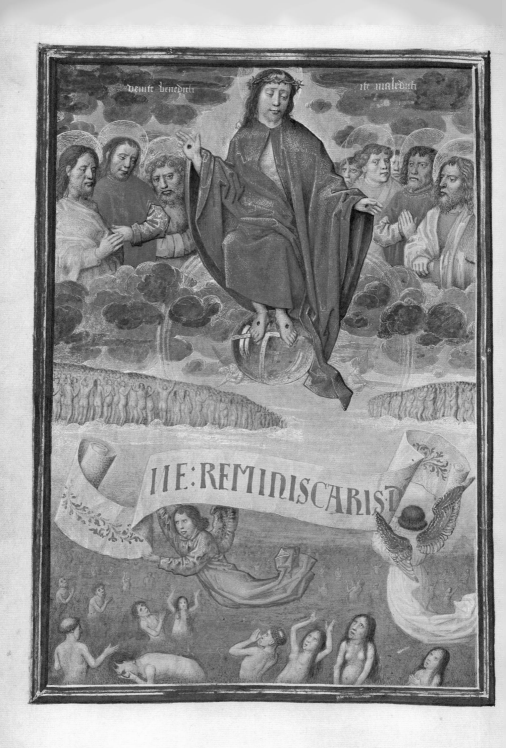

Omine ne in furore
tuo arguas me neqz i
ira tua corripias me

miniature for the Penitential Psalms. Collation reveals this too as a single leaf. It is not joined to its apparent other half, folio 172, and it can only be a replacement. Something strange happened here. Folio 166r shows scenes from the life of David, by the Lübeck Master. One would have expected it to face a picture of David's sins, such as Bathsheba. The top of folio 166r is rubbed and flaking. Something must have gone wrong with the facing image, which was cut out and replaced with the slightly less appropriate scene of the Last Judgement (folio 165v), now painted by the Maximilian Master. That alone suggests that the Maximilian Master was the final artist in the commission, filling gaps and correcting problems which had arisen. All this gives the impression of a patron taking an already very fine Book of Hours and then having it upgraded in stages to something quite different and complex, interfering, altering, changing, and watching the manuscript evolve.

There is no longer any explicit evidence in the Spinola Hours of the identity of the original patron. It must doubtless have been someone of exceptional wealth or opportunity. This was not some routine manuscript made on speculation for sale to a casual passer-by. Its scale, innovation and evident expense all comfortably eclipse the greatest Books of Hours illuminated at that time for the emperors and monarchs of Europe, listed above, for whom these same illuminators customarily worked. In Chapter Seven we encountered the de Hamel rule that if you are not sure whether a manuscript was a royal commission, it wasn't, for such books are usually head and shoulders above all others. If the Spinola Hours is the most luxurious of all, we should be seeking its patron at the highest level. Among the expensive Books of Hours from the southern Netherlands at this period, we can usually identify the original patron only by the presence of armorial frontispieces and sometimes portraits of the owners in prayer. Coats-of-arms usually occur at the very beginning and sometimes also at the end: examples include the Hours of Isabella the Catholic, the La Flora Hours, the Hours of James IV of Scotland, and the Brandenburg Hours, in all of which the first owner is known to us by that means only. The collation of the Spinola Hours reveals that single leaves have been excised from each end. This is precisely where a patron's arms would once have been. It is

strange too that the Spinola Hours concludes with a personal prayer to the Virgin, with an appropriately big initial and border (folio 311r) but with no facing illumination to balance the composition. That opening is at the middle of the final (six-leaf) gathering. It is entirely possible that a bifolium has been removed at this point, with a portrait of the owner praying before the Virgin Mary.

Now let us close up the Spinola Hours on the long table in the Department of Manuscripts and Drawings in the Getty Museum, and look again at its late eighteenth-century binding. This is where the tale begins to take an extraordinary turn from an unexpected direction. In every detail the binding of the Spinola Hours is identical to that on the *Très Riches Heures* of the Duc de Berry, the most famous Book of Hours in the world and the masterpiece of the Limbourg brothers from around 1415. I have actually examined the *Très Riches Heures* in the Musée Condé at Chantilly twice (which I am glad to have done, since it is notoriously inaccessible), and on the first occasion in March 1981, with the consent of the then curator, Raymond Cazelles, I took careful pencil rubbings of the binding, and I still have them. The gilt border uses precisely the same flower tools. The red leather matches exactly. The pastedowns inside are from the same distinctive green silk, facing plain flyleaves. Both the Spinola Hours in Los Angeles and the *Très Riches Heures* in Chantilly have the same central coat-of-arms on each cover, surmounted by a coronet and bordered with tumbling swags of ornament, and these are not struck from a single block, as sometimes on bindings where the armorials are mass-produced, but are built up individually from impressions of multiple little stamps. The arms, as we know, are those of the Spinola family, of Genoa.

Probably, however, there is a third manuscript to add to this astonishing pair. The Rothschild Prayerbook, one of the nearest stylistic twins to the Spinola Hours, is bound in nineteenth-century crimson velvet fitted with much earlier silver-gilt mounts which are generally suspected of having been added from elsewhere to embellish the book when it was in the possession of Baron Anselm von Rothschild (1803–74), another member of that prolific dynasty of collectors. It is

now the masterpiece of the Kerry Stokes Collection in Western Australia. Nothing, absolutely nothing, is known about its earlier history before it was recorded in Rothschild possession in the mid-nineteenth century. I had a happy opportunity to see the Prayerbook again when it was being prepared for exhibition in Melbourne in August 2015.

LEFT: The lower cover of the binding of the *Très Riches Heures* of the Duc de Berry, with the arms of Spinola, identical to the binding of the Spinola Hours

RIGHT: The upper cover of the Rothschild Prayerbook, with its binding wrapped in red velvet probably in the nineteenth century, and ornamented with silver-gilt fittings

I opened it up to a shock of recognition. The inside covers are an absolute match with those of the Spinola Hours and the *Très Riches Heures*. They are lined with precisely the same striking bright green silk facing flyleaves of thick plain parchment. The decorated gilt edges of the pages are gauffered identically with the same lozenges enclosing little flowers. It is uncanny. The crimson velvet covering of the Prayerbook is wrapped around an earlier binding, which had seven sewing bands up the spine, precisely as the Spinola Hours does. The thickness of the velvet now makes the overall binding slightly too big. I would be will-

ing to bet a goodly wager that if one stripped it off, there would be the same earlier Spinola dark red morocco hidden underneath. This is made even more likely by an observation which I can report only from memory. When I first saw the Spinola Hours in 1975, many of the miniatures had fanciful early to mid-nineteenth-century attributions of artists written in pencil in the lower margins. These ascribed individual pictures to the hands of Lucas van Leyden, Hans Memling, Albrecht Dürer and others. These preposterous ascriptions were erased, probably by Mr Kraus, although shadowy traces are occasionally still very faintly visible, as, for example, attributing the miniatures of the Crucifixion and Moses with the Brazen Serpent to Dürer. Identical attributions, in that same pencil hand, were once also in the lower margins of the Rothschild Prayerbook, and they now too have been erased. Those two books were evidently in the same collection, in the company of the *Très Riches Heures* itself, no less, and all three were once bound to match. If we could say where any one of these three manuscripts was, we could provide a provenance for all three.

We must go back. The early history of the *Très Riches Heures* is complicated. In 1485 it belonged to Charles I, duke of Savoy, and his wife, Blanche of Montferrat. Both were direct descendants of the Duc de Berry. Their daughter and eventual sole heiress was the first wife of Philibert II of Savoy, through whom the manuscript passed to his eventual widow, Margaret of Austria (1480–1530), regent of the Netherlands. The *Très Riches Heures* was then one of about twenty books from the ducal library of Savoy which Margaret subsequently brought back to the Netherlands. In the inventory of her possessions in 1523–4, the *Très Riches Heures* was still in loose gatherings. In 1524 it was bound, probably for the first time, by Margaret's court jeweller, Martin des Ableaux. On the blank flyleaves at the end of the *Très Riches Heures* one can just see oxidized offsets from the copper pins of two clasps once attached, which may be from that binding. On Margaret's death in December 1530, the *Très Riches Heures* was in the custody of Jean Raffault, seigneur de Neufville, her *trésorier général des finances*, and thereafter it vanished from history for several centuries.

To test the hypothesis, let us speculate that the Spinola Hours and

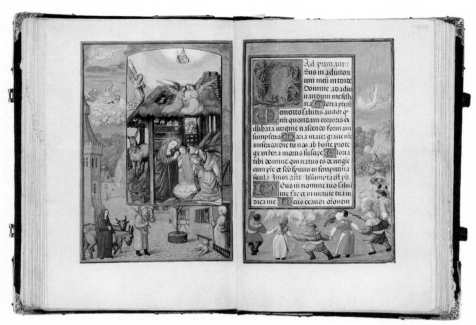

ABOVE: The Nativity of Christ in the Rothschild Prayerbook, including Joseph and Mary arriving in Bethlehem and shepherds dancing in the fields

LEFT: The Nativity of Christ in the Spinola Hours, including the shepherds dancing with one another and with a dog, painted by the 'Master of the Prayerbooks of around 1500'

the Rothschild Prayerbook might both have been owned by Margaret of Austria too, and that all three manuscripts could have remained together after her death. (The suggestion of associating the Spinola Hours with Margaret of Austria was first made by Joachim Plotzek in 1982.) There are multiple very small clues, including the emphasis on female saints in the Suffrages supplied at the final stages of the production, and the names of saints both from Germany and Spain, consistent with a daughter of a Holy Roman Emperor and widow of the heir of Spain. The litany, for example, invokes Saint Ildephonsus, of Toledo. Margaret was one of the richest and best-connected art patrons in Europe. Crucially, the Master of James IV, if we accept his identity with Gerard Horenbout, was from April 1515 appointed as her court painter and *valet de chambre*. He remained in Margaret's employ until at least 1522. Albrecht Dürer visited him in 1521 on his voyage to the Netherlands. Stylistically, those seven years from 1515 onwards

napuit vigilie mor
tuorum. Antipha. Pla
cebo domino. psalm?

correspond precisely to the period to which both this manuscript and the Rothschild Prayerbook can be assigned.

Margaret was the daughter of Mary of Burgundy (1457–82), sole heiress of the Burgundian empire, and Maximilian of Austria (1459–1519), king of the Germans and Holy Roman Emperor from 1508. (It is from him that the Master of the first Prayerbook of Maximilian takes his name.) Margaret was born in Brussels and was baptized in Ghent. She was betrothed as a child to the future Charles VIII of France, and was thus brought up as crown princess of France. This engagement was revoked in 1491. Instead, Margaret married the sickly and fragile Prince Juan of Spain, heir apparent of Ferdinand and Isabella (he was the elder brother, therefore, of Katherine of Aragon). He died aged nineteen within the year, in 1497. In 1501, Margaret then married Philibert II, duke of Savoy, who also died three years later, having collapsed while ill-advisedly hunting during a heatwave. The Office of the Dead in the Spinola Hours is illustrated by a vivid *bas-de-page* image of a man being speared by Death while out riding and then lying dying in bed, as his family gathers anxiously round. Duke Philibert too lingered for some days. Margaret, it is reported, desperately crushed her precious pearl necklaces to powder to make him a medicinal infusion, which failed to save his life. In 1506, following the death of her brother Philippe the Handsome, the 26-year-old Margaret finally returned home from Savoy to the Netherlands as regent and governor. There she established a splendid renaissance court at Mechelen (Malines), between Antwerp and Brussels, a little over thirty miles east of Ghent. She had no children and never married again.

Margaret of Austria gathered a marvellous art collection. Paintings in her possession included the incomparable Arnolfini marriage portrait by Jan van Eyck, now one of the great treasures of the National Gallery in London. She owned nearly 400 manuscripts, including the eleventh-century *Codex Aureus* from Echternach, made for the Emperor Henry III (preserved in the Spanish royal library of the Escorial), given to her by her father. Erasmus came to consult it in Mechelen in 1519

LEFT: The man speared by Death while hunting and then lying dying in bed, attended by his family, painted in the Spinola Hours by the Master of James IV

and he cites it in the preface to his Greek New Testament of 1522. Margaret's first Book of Hours had been presented to her at only three years old, when she was taken to France for her betrothal to the dauphin. That book may well be the famous manuscript known to us as the Berlin Hours of Mary of Burgundy, who was her mother and had recently died. Her brother Philippe the Handsome gave her a second Book of Hours when she left for Spain to marry Prince Juan, probably to be identified now with a manuscript in Vienna. Later, in addition to the *Très Riches Heures*, Margaret acquired the unfinished Hours of Bona of Savoy, widow of Galeazzo Sforza, duke of Milan (who had owned the *Semideus* described in Chapter Eleven), and she brought this back to Mechelen where she had it completed by her own court artist, Gerard Horenbout. She later gave it to her nephew, the Holy Roman emperor, Charles V. It survives today in the British Library.

If both the Rothschild Prayerbook and the Spinola Hours were commissioned by Margaret of Austria, the likely sequence is that the Prayerbook came first, maybe around 1515 when Horenbout first joined the payroll of the duchess. If the sequence of work proposed above is correct, then Margaret might have acquired the Spinola Hours half-finished, as she had with the Sforza Hours, and then she had Horenbout expand and upgrade it. If the Maximilian Master was indeed Alexander Bening, this happened no later than 1519, when he died. The manuscript was probably complete by about 1520.

The inventory of the household of Margaret of Austria in 1523–4, cited above, includes half a dozen Books of Hours. One by one, they can all be eliminated from any possible identification with the Spinola Hours or the Rothschild Prayerbook – too small, too old, or still extant elsewhere – except for two. One of these was listed as "*une assez grosses heures*", a Book of Hours of quite large size (but evidently not vast, like the *Très Riches Heures*, described here as "*une grande heure*"), bound in green velvet with clasps of silver-gilt. It was no. 53 in Margaret's inventory. Another, no. 367 there, is described in more detail: "*Premier, une riche heure en parchemin, bien historiee et enlumynee, couvertes de satin noir, clouant a deux fermilletz d'or, escriptes a la main.*" It is conceivable that the "*assez grosses heures*" was the Rothschild Prayerbook, for it is indeed of

Margaret of Austria (1480–1530), shown in a panel of a diptych by the 'Master of 1499', kneeling at a prayer book beside a fireplace in her palace, accompanied by a dog and a monkey

notable size, bigger than even the Spinola Hours. Might no. 367 have been the Spinola manuscript, in its original binding of black satin with two gold clasps? It is indeed exceptionally rich, well illustrated and illuminated, and is written by hand.

That particular manuscript was recorded in the palace in Mechelen as being kept 'in the little cupboard adjoining the room with the fireplace, overlooking the gallery of the chapel.' There survives a diptych in the Museum voor Schone Kunsten in Ghent showing Margaret of Austria praying before a Book of Hours apparently bound in black, kneeling in a room with a fireplace behind her, beside a carved wooden cupboard. At her feet are a dog and a monkey (both creatures also appear as the rich man's pets in the miniature of Dives and Lazarus

in the Spinola Hours). Opposite her, in a setting of a church and as if seen through a window, are the Virgin and Child. The fifteenth-century Gruuthuse house in Bruges still preserves one of those domestic upstairs galleries for private prayer, with an internal window looking down into the neighbouring church of the Virgin Mary, the Onze-Lieve-Vrouwekerk. The Book of Hours in Vienna, made for Mary of Burgundy, Margaret's mother, shows the patron reading her manuscript at just such a window, overlooking the choir of a church. All these set the scene for the original use of a manuscript like the Spinola Hours or the Rothschild Prayerbook in the palace of Mechelen.

Both manuscripts from the inventory described as the "*assez grosses heures*" and the "*riche heure*" passed at the death of Margaret of Austria to her niece, Mary of Hungary (1505–58), sister of Charles V, but, like the *Très Riches Heures*, they disappeared from sight in the sixteenth century, and none of the three manuscripts is among the books of Mary of Hungary when these were next listed in the Burgundian ducal library in *c.* 1569. As suggested above, the Spinola Hours lacks a frontispiece where a coat-of-arms would have been and it may well be missing a portrait of its owner kneeling before a prayer to the Virgin; so too does the Rothschild Prayerbook, which has no frontispiece and a leaf before the prayer to the Virgin has been removed before folio 145r. Both books were depersonalized in the same way.

The three companion manuscripts, if still together, may have reached Genoa through Ambrogio Spinola (1569–1630), commander-in-chief of the Spanish forces in the Netherlands, victor of the sieges of Ostend (1603) and Breda (1625), diplomat and courtier, who retired to his family house in Genoa in 1629, bringing with him the spoils of war and accompanied by the artist Diego Velázquez, to whom he had been introduced by his friend Peter Paul Rubens and whom he brought to see paintings in Italy. Viewers of manuscripts leave no trace, usually and thank goodness, but it is possible that Velázquez and even Rubens once turned the pages of the *Très Riches Heures*, the Spinola Hours, and the Rothschild Prayerbook.

The bindings were apparently made for Vincenzo Spinola di San Luca (1752–1826), of Genoa. We can deduce this because his own heir

and executor was his nephew – son of his mother's brother – Gio Battista Serra (1768–1855), and on the upper cover of the *Très Riches Heures* the Spinola arms have been overlaid with a leather patch bearing the arms of Serra (the Spinola arms are untouched on the lower cover), and immediately after his own death the manuscript was offered for sale. Gio Battista Serra had left it to Baron Félix de Margherita, who in 1855 lodged it where it could be inspected at a girls' boarding establishment in Genoa and at once invited offers. Baron Adolphe de Rothschild entered negotiations, but he was outbid in January 1856 by Henri d'Orléans, Duc d'Aumale (1822–97). The manuscript now called the Rothschild Prayerbook, however, was probably bought then by Adolphe's father-in-law, Anselm von Rothschild of Vienna. The *Très Riches Heures* was eventually bequeathed by the Duc d'Aumale to the Institut de France at the Musée Condé. If the Spinola Hours was sold in 1856 too, as is likely, it then disappeared utterly from sight.

As it happened, I myself was a witness to its rediscovery. I joined Sotheby's straight from university in the summer of 1975. In mid-October that year I was sent with Anthony Hobson to Munich, with a pre-sale exhibition of manuscripts from the collection of Sir Thomas Phillipps, which were scheduled for sale in London that November. Sotheby's had recently opened a small office in Galereistrasse 6a, beside the Hofgarten, off Ludwigstrasse. A retired butcher from Berlin had been told about the exhibition and he brought in a manuscript of his own to show us, accompanied by his daughter. I remember him unwrapping it from a blanket and placing it on the table, and it was passed across to me to open. This was, of course, the volume which we now know as the Spinola Hours. We were all astonished by what was before us. Anthony Hobson whispered to me in English that any manuscript of this quality must surely be known, and he told me that he would keep the owner talking while I ran up the Ludwigstrasse to the Staatsbibliothek to check Friedrich Winkler's *Die flämische Buchmalerei*, published in 1925 and then the standard list of southern Netherlandish manuscripts in public collections (it was Winkler who had invented those names such as the 'Master of the First Prayerbook of Maximilian', and so on). I still had my reader's ticket, for this was not so long after my visits as a graduate student,

as recounted in Chapter Eight. I was back within half an hour to report that the extraordinary Book of Hours was seemingly unrecorded.

The owner had various stories about its provenance, one of which was that it had been in his family for generations, and that Hermann Göring had tried to acquire it and that they had kept it during the War concealed inside a hollowed-out radio. We gave him a receipt and took it in for further inspection. Extensive inquiries at the time and in more than forty years since then have so far revealed nothing whatsoever, either reassuring or worrying, about the manuscript's twentieth-century past. In love and provenance it is sometimes chivalrous not to inquire too closely, although I regret not asking him more now. On balance, in the complete absence of any particular reason to suppose otherwise, we must assume the manuscript to have passed blamelessly through the horrors of the Second World War in private hands in Berlin. There is a modern green stamp on the flyleaf with hand-written initials which seem to be those of the man I met in Munich.

The manuscript was scheduled for sale in London in July 1976. I compiled the catalogue entry, 6 densely-printed pages, the longest I had ever written, and I made the first attempt to separate the hands of the artists. In those days, no pre-sale estimates were published. At that time too, the highest price ever achieved for any book at auction, although it had happened twice, was £90,000, both for the Caxton manuscript of Ovid (1966) and the Chatsworth Chaucer (1974); it was said that a six-figure ceiling was unreachable. The London press announced in April 1976, "Mystery manuscript could top £100,000 at Sotheby's", news indeed, and it reported, "… there is a ripple going through the manuscript world which should culminate in a veritable tidal wave of interest when this book … comes up for offer at Sotheby's on Monday, July 5". Many people came to see it in my tiny office overlooking St George Street in central London, including Hans Kraus, who had a reputation as an aggressive buyer. He describes the encounter in his autobiography: "I … decided to bid in person, to take no chances." On the morning of the sale itself, on an immensely hot summer's day, we all expected to see Mr Kraus in full battle cry. On the contrary, he sat glumly, raised his hand in a desultory way to about £60,000, and

The Sotheby's sale catalogue for 5 July 1976, written by Christopher de Hamel, which recorded and described the Spinola Hours for the first time

then very visibly he shook his head. Somehow, the bidding went on climbing up and up, with a partnership of puzzled English booksellers nodding their increments on one side against no obvious competition. It reached £250,000, and £300,000. It paused at £350,000. The booksellers, Frank Hammond and Charles Traylen, gave one more desperate bid in vain. At £370,000 the hammer fell. "H. P. Kraus," announced the auctioneer to an astounded room, no one more amazed than me. Mr Kraus had set up his strategy with Sotheby's beforehand. Aware that the whole room was looking to him to set a value and wishing to discourage competition, he had arranged with the auctioneer that, no matter what he said or did, such as shaking his head, he was nevertheless still bidding on the manuscript as long as he was wearing his glasses. He never removed them, and thus he bought the Book of Hours. He was quoted in *The Times* the next day: "'I had a conference with my wife and son before the sale', he said, 'and we decided to bid up to £700,000.'" From that moment the Spinola Hours, as it soon became, passed from obscurity back into history.

RIGHT: The lining of green silk inside the covers of the binding of the Spinola Hours, identical to that in the *Très Riches Heures* and the Rothschild Prayerbook

Epilogue

We are in the departure lounge at the airport. There is half an hour to wait before they are going to start boarding people with children or those who may need a little extra time. Our bags are checked through, but precious notes about the manuscripts we have seen are coming as hand luggage. This has been an exhilarating journey to a few of the great manuscript collections of the world. There are many other libraries we ought to have visited and will on other occasions. The British Library, the Vatican and possibly Vienna are the three supreme omissions, although we have encountered many references to manuscripts in all these places. There are wonderful treasures to see in the national collections in Brussels, The Hague and Stockholm, and in Milan and Venice, and in what began as ecclesiastical libraries in Bamberg, Sankt-Gallen and Verona. There are university libraries of great richness in Cambridge, Manchester (the John Rylands Library), Glasgow, Geneva, Leipzig, Cracow, Montpellier, Harvard, Yale and elsewhere. I confess to a fondness for the considerable municipal collections of provincial France in places like Troyes, Dijon and Rouen, transferred from former monasteries into the care of local towns after the French Revolution. Wherever you live, there are probably medieval manuscripts of some kind, as there are in Cape Town, Tokyo, Manila, Chicago, Lima (in the convent of San Francisco), Melbourne and Auckland. Some of my happiest expeditions have been to see outstanding manuscripts in small collections, like the great twelfth-century Bible still in Winchester Cathedral, the Boucicaut Hours in the Musée Jacquemart-André in Paris, the Missal of George of Topusko in the sacristy of the cathedral in Zagreb, guarded by a nun who stabs it with her forefinger to assure

you it is real gold, and the two manuscripts from the court of Matthias Corvinus in the Topkapi museum in Istanbul, left over from the Turkish occupation of Hungary in 1541. Those would all have made dramatic chapters for this book. I did manage to bring in references here to the sixth-century Greek Gospels in the diocesan museum in Rossano, the Albani Psalter in Hildesheim, the Ingebourg Psalter and the *Très Riches Heures* in Chantilly, and the astounding Breviary made for the Portuguese royal family kept upstairs in the Mayer van der Bergh Museum in Antwerp. Ask around; there are manuscripts to be seen. I should really have opened the journey with the modest but absolutely real medieval manuscripts in the Dunedin Public Library at the southern end of New Zealand, which so entranced me as a teenager. The staff allowed me to take them out of their cases and I used to spend whole Saturdays turning pages with wonder and enchantment.

One thread which has emerged through all these chapters is the element of pure chance which has brought the volumes to wherever in the world they are now. One may think of all great works of art as public and static, but this not at all true of illuminated manuscripts. Their restlessness has been an unexpected theme. Of the twelve items interviewed here, only one – the Hours of Jeanne de Navarre – is preserved today in the country where it was actually made, at least as defined by modern political boundaries, but there were several moments when even that manuscript could very easily have gone with the Douce bequest to Oxford or as the gift of T. H. Riches to Cambridge (but for Mrs Yates Thompson's irritation at Sydney Cockerell), quite apart from nearly disappearing under foot at Berchtesgaden. The Beatus was offered to Berlin and Paris but it later happened to appear at auction in London precisely when Pierpont Morgan felt he needed something (almost anything) early, and it migrated to America. The *Aratea* was in the library of Queen Christina in Stockholm and would naturally have joined the *Reginenses* in the Vatican, but for the opportunism of a suddenly frustrated employee from Leiden allowed to select his favourite books. If Ceolfrith had lived another two months, Amiatinus (certainly not called that) would have reached Rome and very likely would no longer exist. If Louis XII had been repulsed at Pavia in 1499, the *Semideus*

would never be in Russia. The movements involve the surges of political fortune quite as much as scholarly duty and philanthropy. More than half the manuscripts here have passed through commerce at some time. Two of them in their time held the world record price for any book sold at auction. Items were treasured or utterly disregarded, exchanged for a pocket watch in Spain worth 30 francs or abandoned 'among the shadows and under dust' in a deserted abbey in Tuscany. The Gospel Book of Saint Augustine was famous enough to be written about in the thirteenth century; the Spinola Hours was entirely unknown until I unwrapped its parcel in 1975.

These all began as silent and inanimate objects. There is a satisfaction in cataloguing unrecorded manuscripts and giving them lives. Any newly found medieval book has no precise definition at all until it has been examined from every angle, its texts identified, its structure collated, its script and decoration assigned to a credible place in the chronology of style, and its provenance teased out. By the end of that process the manuscript has a persona, an identity and very often a name which subsequently stays with it forever. It is curious how assigning names to a particular manuscripts gives them character, as with domestic animals. The epithet 'the Book of Kells' was first used in the 1620s, and undoubtedly added to the reputation and mystique of that manuscript. Visitors in Dublin would not queue up in such numbers today to see 'a late eighth-century Gospel Book', however pretty. '*Codex Amiatinus*' and '*Carmina Burana*' are nineteenth-century titles invented by German philologists trained in the classics, who assigned sub-classifications according to monastic provenance. Those manuscripts re-entered the world as newly definable entities in 1850 and 1847. Sydney Cockerell, famous in his lifetime for his taste for aristocracy, began using 'the Hours of Jeanne of Navarre' for a manuscript which had hitherto been regarded as an elegant but anonymous Book of Hours in private hands. That new royal title undoubtedly helped its passage at a high price into the collection of Baron Edmond de Rothschild and ultimately to the French national library. 'The Spinola Hours' was named by a bookseller with an eye to a million-dollar sale. For the purpose of this book, I myself invented the term 'the Visconti

Semideus' for a recorded but hitherto untitled manuscript in St Petersburg, and I hope that it sticks. There is still no real name for the former Exeter Cathedral copy of Jerome's commentary on Isaiah decorated by Hugo Pictor, and its lack of a recognized nomenclature somehow weakens its place in history. The Bodleian Library should use this as another fund-raising opportunity and put its naming out to tender.

A clearly defined medieval book has a unique personality, and part of what we have been doing in our visits to collections has been to engage with manuscripts as individuals and to discover what they can tell us, which can be learned from nowhere else. Sometimes it is simply a matter of reading them, for books can talk with words. No other artefacts do that. In the verses of the *Carmina Burana* we eavesdropped directly on the taverns and cloisters of the late twelfth century. In the fear of an imminent Armageddon in Beatus or the prayers in Books of Hours we moved closer into the private thoughts and hopes of their original owners. We have seen a little of the technique of textual criticism in action, whereby anomalies of wording and correction can unlock the origins of a text, opening up paths into the household of Gregory the Great or the publication of Chaucer, or even how eleventh-century canons of English cathedrals must have visited each other to compare their latest acquisitions from Normandy. These are small footnotes added to history. The manuscripts we have encountered have had things to tell us about the conversion of Europe to Christianity and Roman literacy, and about the migration of knowledge and the classicizing ambitions of the Carolingian emperors. These are not secondary sources: we were right there in the quarry, chipping directly at the raw material itself. The status of kings, the effects of warfare, the power of city guilds, the politics of Italy, and the winter in the farmyards of the Netherlands were played out in these dozen original books.

We have considered illuminated manuscripts as fields of study in their own right. We have peered at parchment, scripts as exotic as rustic capitals and Visigothic minuscule (I urge you to slip references to both those into dinner party conversations), illumination and bindings, and at evidence of how books were copied and assembled. There were huge implications for the origins of the business of professional artists and

commercial publishing. The value of determining and documenting the structure of the quires has returned over and over again. Quite often information we extracted from individual manuscripts could then be tied in with other independent records, such as the *Vita Ceolfridi* or the tax records of fourteenth-century Paris, to furnish actual names and places which bring reality to the lives of books. One might have supposed that makers of medieval illuminations were all anonymous. We have possible or certain candidates for the names of the painters of about half the manuscripts encountered here. The history of art and literature, even of monuments as important as the Bayeux Tapestry or the *Canterbury Tales*, has inched forwards fractionally by looking at these manuscripts.

What you will also have noticed is how often there are things we absolutely do not know, or cannot yet resolve. I have really no idea where the Copenhagen Psalter was made. I do not think that we can yet name the scribe of the Hengwrt Chaucer. I have made guesses, for example, at the patronage of Hugo Pictor's manuscript or the Spinola Hours and I may be entirely wrong. I will not be the slightest bit offended (in fact, I will be delighted) if anyone can find evidence of better or more likely explanations. There are still gaps in the lines of provenance of most of these manuscripts which will undoubtedly be filled one day. Lucky chance or sharp-eyed observation will add much more. In the Introduction I described this book as resembling a conversation in which we imagine all meeting together and discussing the manuscripts laid out on the table before us. I shall be very glad to hear from anyone with new ideas and information. Unlike many areas of historical inquiry, palaeography is a field with infinite opportunity for discovery or complete revision as further pieces of knowledge come to light, which they will, every time someone looks at these and other manuscripts.

It is therefore with unfeigned enthusiasm that I urge new recruits to the field. Manuscript historians are members of an agreeable confraternity of like-minded enthusiasts which transcends all nationalities and backgrounds, all sharing delight in the study of medieval books, and it is easy to belong. I hope that something of that international fellowship has been witnessed in action in this book, in references to

friends and colleagues acknowledged in the text and especially in the notes. No one whom I have consulted on some particular point has ever been unhelpful. There are enough medieval manuscripts out there – upwards of a million probably – that there is no shortage of material and we do not need to be too protective of our areas of speciality. Many important collections are thinly catalogued, some not at all, and there is much to be found. Any reasonably resourceful student in the field really is able to make new attributions and discoveries which will add to the sum of knowledge; there are not so many areas of conventional scholarship where this is still possible or as likely. There are good careers in manuscript studies in rare book libraries, universities and the antiquarian book trade, but there are opportunities too for perceptive enthusiasts, textual editors, private collectors, scribes, artists and readers, exactly as there have been for a thousand years.

Public collections vary greatly in their response to inquiries to see manuscripts. In fairness to custodians, manuscripts are fragile and are sometimes very precious. It is not always possible or advisable to allow handling of every supreme treasure. Libraries have their own rules of admission. Choose carefully and perhaps not too ambitiously. Take advantage of digitized surrogates for preliminary work. When you are ready, make a reasoned case for why you need actual access and most curators will at least listen, for we all know secretly that there is no substitute for actually encountering the originals face to face. Be aware that manuscripts exist outside public ownership too, something often neglected by historians. Our journey has had stories of the saleroom and acquisition, even in our own time, and it has touched on some manuscripts in private collections. They still change hands, and specimens of medieval manuscripts are not even necessarily particularly expensive (although they can be), and at least some original fragments are within the budgets of almost anyone. Purists may sniff, but gaze for long enough at a single page from a thirteenth-century Bible, which costs less than a good ticket to the theatre, and you will learn as much about medieval scribal activity as any textbook can teach you. Read a Book of Hours in bed and you are transported back 500 years.

Finally, I hope that these encounters have conveyed some sense of

the thrill of the pursuit and the simple pleasure of meeting an original manuscript, and asking it questions and listening to its replies. As the concluding words of the *Semideus* in St Petersburg say, "*lege feliciter*": 'enjoy reading'.

They have now announced the boarding of the flight and we are on the way home.

Bibliographies and notes

Introduction

I should say above all what a pleasure it has been to work with Stuart Proffitt and his colleagues at Allen Lane, including Ben Sinyor, Richard Duguid, Mark Handsley and Simon Rhodes, and we have had many long and exhilarating sessions together, often also with the picture editor Cecilia Mackay and the designer Andrew Barker. All have contributed immeasurably to this book. Occasionally we did not entirely agree. I, for example, would have preferred my original title of '*Interviews with Manuscripts*', since an interview seemed to me a closer approximation of what we are undertaking than a '*Meeting*', but I defer to the publishers' experience, and if that was the price for an enjoyable and fascinating collaboration, it was worth it.

CHAPTER ONE The Gospels of Saint Augustine

The Gospel Book of Saint Augustine is fully digitized and is available on-line in Parker-on-the-Web, a collaboration between Corpus Christi College and Stanford University, who are hosts to the website. The principal monograph on the manuscript is F. Wormald, *The Miniatures in the Gospels of Saint Augustine, Corpus Christi College MS 286*, Cambridge, 1954 (*Sandars Lectures*, 1948), reprinted in Wormald's *Collected Writings*, I, London and Oxford, 1984, pp. 13–35. There are concentrated distillations, all with bibliographies, in E. A. Lowe, *Codices Latini Antiquiores: A Palaeographical Guide to Latin Manuscripts prior to the Ninth Century*, II, *Great Britain and Ireland*, 2nd edn, Oxford, 1972, p. 4, no. 126; M. Budny, *Insular, Anglo-Saxon, and Early Anglo-Norman Manuscript Art at Corpus Christi College, Cambridge: An Illustrated Catalogue*, Kalamazoo, Mich., and Cambridge, 1997, pp. 1–50, no. 1; B. Barker-Benfield, *St Augustine's Abbey, Canterbury*, London, 2008 (*Corpus of British Medieval Library Catalogues*, 13), especially III, pp. 1732–3, dense with information; and N. Morgan, S. Panayotova and S. Reynolds, *A Catalogue of Western Book Illumination in the Fitzwilliam Museum and the Cambridge Colleges*, II, i, *Italy & the Iberian Peninsula*, London and Turnhout, 2011, pp. 18–22, no. 1.

There is still no serious intellectual biography of Matthew Parker, although a substantial bibliography is given in his entry by David J. Crankshaw and Alexandra Gillespie in the revised *Oxford Dictionary of National Biography*. In describing Parker as a collector, I have drawn on my own little guidebook in the Scala museums series, C. de Hamel, *The Parker Library*, London, 2010, which itself makes use of R. I. Page, *Matthew Parker and His Books: Sandars Lectures in Bibliography delivered on 14, 16 and 18 May 1990*, Kalamazoo, Mich., 1993. There is discussion of eventual publication of the proceedings of a symposium, 'Matthew Parker, Archbishop, Scholar,

Collector', held in Cambridge on 17–19 March 2016, convened by Anthony Grafton, Scott Mandelbrote and William Sherman. Gill Cannell and Steven Archer have been ideal colleagues in the Parker Library since I joined it. I have here slightly simplified the conditions of Parker's bequest, which specifies losses which would be deemed unacceptable, and that if Gonville and Caius in turn should subsequently lose a similar amount, the collection would pass to Trinity Hall. Some of Parker's books, although not so many, were given by him to Cambridge University Library. On p. 20 I refer to the derivation of 'uncial' from 'uncia', inch; an alternative is that the word first came out of a mistranscription of the opening minims of 'initial', subsequently imagined to be connected with inches. I am grateful to Professor Ralph Hanna for conversations on 'per cola et commata'. The reference from the Corpus Glossary, cited on p. 20, is Corpus Christi College, MS 144, folio 8v (W. M. Lindsay, ed., *The Corpus Glossary*, Cambridge, 1921, p. 14). For Tischendorf and the Codex Sinaiticus, now mainly in the British Library in London (Add. MS 43725), see the excellent summary in D. C. Parker, *Codex Sinaiticus: The Story of the World's Oldest Bible*, London and Peabody, Mass., 2010. For the exhibition at the Fitzwilliam Museum, mentioned on p. 24, see P. Binski and S. Panayotova, eds., *The Cambridge Illuminations: Ten Centuries of Book Illumination in the Medieval West*, London and Turnhout, 2005, in which the Gospel Book of Saint Augustine is no. 1, pp. 46–7, described by R. McKitterick. The book by the Bishop of Arizona is K. Smith, *Augustine's Relic: Lessons from the Oldest Book in England*, New York, 2016. Humfrey Wanley, introduced on p. 24, emerges from his writings as an engaging and likeable man; he visited the Parker Library at 'Bennet' College, as it was then called, in 1699 (P. L. Heyworth, ed., *The Letters of Humphrey Wanley, Palaeographer, Anglo-Saxonist, Librarian, 1672–1726*, Oxford, 1989, p. 138). He describes the Gospel Book in H. Wanley, *Antiquae Litteraturae Septentrionalis, Liber alter*, Oxford, 1705 (volume II of G. Hickes, *Linguarum Veterum Septentrionalium Thesaurus Grammatico-Criticus et Archaeologicus*), pp. 51 and 172–3. The second Gospel Book associated by Wanley with Saint Gregory is now Oxford, Bodleian Library, MS Auct. D.2.14. Other early antiquarian accounts of both manuscripts are T. Astle, *The Origin and Progress of Writing, As Well Hieroglyphic As Elementary, Illustrated by Engravings Taken from Marbles, Manuscripts and Charters, Ancient and Modern*, London, 1784, in which our volume is described on p. 83 and is illustrated as plate X; J. O. Westwood, *Palaeographia Sacra Pictoria: Being a Series of Illustrations of the Ancient Versions of the Bible, Copied from Illuminated Manuscripts, Executed between the Fourth and Sixteenth Centuries*, London, 1843–5, of which part 10, separately paginated 1–6, is 'The Gospels of Saints Augustine and Cuthbert'; and J. Goodwin, *Evangelia Augustini Gregoriana: An Historical and Illustrative Description of MSS nos. CCLXXXVI and CXCVII in the Parker Library of Corpus Christi College, Cambridge, being the Gospels sent by Pope Gregory the Great to Augustine, ad DCI*, Cambridge, 1847 (*Publications of the Cambridge Antiquarian Society, Quarto series*, 3). For the Bodleian manuscript, see Lowe, *Codices Latini Antiquiores*, as above, II, p. 31, no. 230; Barker-Benfield, as above, pp. 1734–5; and the complete manuscript in A. N. Doane, ed., *Anglo-Saxon Manuscripts in Microfiche Facsimile*, 7, Tempe, Az., 2002 (*Medieval & Renaissance Texts & Studies*, 187). I had an interesting conversation with Professor Doane in Madison, Wisconsin, on whether Auct. D.2.14 was made in Italy at all, or whether it was copied in England from an Italian exemplar, perhaps by an Italian scribe. The charters added to MS 286, cited on p. 27, are recorded in P. H. Sawyer, *Anglo-Saxon Charters: An Annotated List and Bibliography*, London, 1968 (Royal Historical Society, *Guides and Handbooks*, 8), pp. 351 and 408, nos. 1198 and 1455, and discussed in S. E. Kelly, ed., *Charters of St Augustine's Abbey, Canterbury, and Minster-in-Thanet*, Oxford, 1995 (*Anglo-Saxon Charters*, 4), pp. 95–7, no. 24 (and plate 3), and pp. 118–19, no. 31. Accounts of the earliest books in Canterbury include R. Emms, 'St Augustine's Abbey, Canterbury, and the "First Fruits of the Whole English Church"', pp. 32–45 in R. N. Swanson, ed., *The*

Church and the Book: Papers Read at the 2000 Summer Meeting and the 2001 Winter Meeting of the Ecclesiastical History Society, Woodbridge, 2004. Thomas Sprott's chronicle is still unpublished; it survives in two manuscripts. Thomas Elmham's *Speculum Augustinianum* is edited by C. Hardwick, London, 1858 (Rolls Series, 8); the original is Cambridge, Trinity Hall, MS 1. A Customary, such as that mentioned on p. 27, is an in-house rule-book of the duties and practices of members of a religious house: for this example, see E. M. Thompson, ed., *Customary of the Benedictine Monasteries of Saint Augustine, Canterbury, and Saint Peter, Westminster*, London, 1902 (Henry Bradshaw Society, XXIII), p. 101. Budny's suggestion of Saint Mildred is presented on pp. 6–7 and 11 of her *Illustrated Catalogue*, cited above. The Gospel Book divided between London and Cambridge is British Library Cotton MS Otho C.v and Corpus Christi College MS 197b (see Lowe, *Codices Latini Antiquiores*, as above, II, p. 3, no. 125, and Budny, pp. 55–73, no. 3). The term '*siglum* X' mentioned on p. 33 refers to readings provided by this particular manuscript's witness of the text in modern critical editions of the Vulgate, such as that prepared by H. J. White and J. Wordsworth, *Novum Testamentum Domini Nostri Iesu Christi latine, secundum editionem Sancti Hieronymi*, Oxford, 1899, and still used in the current text edited by Bonifatius Fischer and others (3rd edn, Stuttgart, 1985). The analysis of the text of MS 286 is in H. H. Glunz, *History of the Vulgate in England from Alcuin to Roger Bacon: Being an Inquiry into the Text of Some English Manuscripts of the Vulgate Gospels*, Cambridge, 1933, esp. pp. 294–304. I have avoided speculation on precisely where or by whom in Rome the manuscript might have been made: I owe to Father Robert McCulloch, SSC, the possibility that Gregory the Great would have commissioned books from the monastery of Sant'Andrea in Rome, where Augustine himself had been prior and which had been established by Gregory before becoming pope in a villa which belonged to his own family. It survives now as a Camaldolese abbey in the church of San Gregorio Magno al Celio. The letter of Gregory to Serenus about the value of religious art, cited here on p. 39, occurs in his *Registrum Epistolarum*, book IX, ep. 13 (Migne, *Patrologia Latina*, LXXVII: 1027); the reference was known to Matthew Parker, who cited it in a letter to Queen Elizabeth in 1559 (J. Bruce and T. T. Perowne, eds., *Correspondence of Matthew Parker, D.D.*, Cambridge, 1853, p. 89). Bede's account of Saint Augustine's meeting with King Ethelbert occurs in the *Historia Ecclesiastica Gentis Anglorum*, book I, cap. 35 (C. Plummer, ed., *Venerabilis Baedae: Opera Historica*, Oxford, 1896, pp. 45–6). The quotation from Sedulius in the tympanum of the picture of Saint Luke, mentioned on p. 40, reads, "Jura sacerdotii Lucas tenet ora iubenci", 'Luke holds the right of the priesthood in the mouth of an ox' (*Carmen Paschale*, book I, line 357). The open book held by Saint Luke is inscribed by a later hand "Fuit homo missus a deo", which is actually from the Gospel of John (1:6), but it refers to John the Baptist, whose birth begins Luke's Gospel. For the pictures in the Gospels of Saint Augustine, see F. Wormald especially (cited above), and J. Lowden, 'The Beginnings of Biblical Illustration', pp. 9–59 in J. Williams, ed., *Imaging the Early Medieval Bible*, University Park, Pa, 1999, including the other sixth-century manuscripts listed here on pp. 44–5. The first results of research by Professors Beeby and Gameson using Raman spectroscopy, mentioned on p. 42, are published as A. Beeby, A. R. Duckworth, R. G. Gameson and others, 'Pigments of the Earliest Northumbrian Manuscripts', *Scriptorium*, 59, 2015, pp. 33–59. The binding in the treasury at Monza is reproduced, among other places, in J. Richards, *Consul of God: The Life and Times of Gregory the Great*, London, 1980, pl. 13. The Abba Garima Gospel Books were announced by M. Bailey, 'Discovery of earliest illustrated manuscript', *The Art Newspaper*, June 2010, but they are still imperfectly published; I attended (and indeed partly chaired) the conference 'The Garima Gospels in Context' in Oxford in November 2013. The three great sixth-century Gospel Books listed on pp. 44–5 are the Rabbula Gospels (Florence, Biblioteca Laurenziana, cod. Plut. I. 56), the Rossano

Gospels (Rossano, Museo dell'Archivescovada), and the Codex Sinopensis (Paris, Biblio-thèque nationale de France, ms suppl. grec. 1286). The Rabbula and Sinopensis manuscripts were both exhibited at the Sackler Gallery in Washington in 2006 where I was able to see them: M. Brown, ed., *In the Beginning: Bibles before the Year 1000*, Washington, 2006, pp. 300 and 302, nos. 62 and 64. The story of the near acquisition of the Rossano Gospels is recounted in A. S. Lewis, *Life of the Rev. Samuel Savage Lewis, F.S.A., Fellow and Librarian of Corpus Christi College, Cambridge*, Cambridge, 1892, pp. 208–9, and is summarized in J. M. Soskice, *Sisters of Sinai: How Two Lady Adventurers Found the Hidden Gospels*, London, 2009, p. 94. There is a facsimile of the manuscript by G. Cavallo, J. Gribomont and W. C. Loerke, eds., *Codex Purpureus Rossanensis*, Rome and Graz, 1985–7 (*Codices Selecti*, 81). The Codex Aureus in Stockholm is reproduced in R. Gameson, ed., *The Codex Aureus: An Eighth-Century Gospel Book, Stockholm, Kungliga Bibliothek, A. 135*, Copenhagen, 2 vols., 2001–2 (*Early English Manuscripts in Facsimile*, 28–9). The British Library Gospel Book mentioned on p. 47 is Royal MS I.E.VI, made at St Augustine's Abbey, and was presumably, at least partly, copied from the now-lost Bible of Saint Augustine; cf. J. J. G. Alexander, *Insular Manuscripts: 6th to the 9th Century*, London, 1978 (*A Survey of Manuscripts Illu-minated in the British Isles*, I), pp. 58–9, no. 32, with pl. 161 illustrating the ox which is on folio 43r of the manuscript. The twelfth-century Eadwine Psalter, cited on pp. 47–8, is Cambridge, Trin-ity College, MS R.17.1; its prefatory miniatures are detached and are now London, Victoria and Albert Museum, 816–1894, British Library, Add. MS 37472, and New York, Morgan Library, M 521 and M 724 (see M. Gibson, T. A. Heslop and R. W. Pfaff, eds., *The Eadwine Psalter: Text, Im-age and Monastic Culture in Twelfth-Century Canterbury*, London, 1992, esp. p. 29). My younger son is named Edwin, in part after that incomparable manuscript. The Anglo-Catalan Psalter is Paris, Bibliothèque nationale de France, ms lat. 8846: see *Psalterium Glosatum (Salterio Anglo-Catalán)*, facsimile, Barcelona, 2004, with accompanying commentary by N. Morgan and oth-ers, 2006, discussing the Gospels of Saint Augustine on pp. 48–9. I am indebted to Cressida Williams, archivist at Canterbury Cathedral, for the sight of William Urry's typescript about the Gospel Book's trip to Canterbury in 1961. My account of the service in Westminster Abbey was written at the time and is reproduced here with small changes from the report I made in the College's annual yearbook, C. de Hamel, 'The Pope and the Gospel Book of Saint Augus-tine', *The Letter*, 89, Corpus Christi College, Cambridge, Michaelmas 2010, pp. 24–7. I gave a draft of this chapter to the novelist James Runcie, who incorporated some elements of it, in-cluding the fluttering of the pages during the singing of the hymn, into his tale involving a theft of the manuscript, set in the Parker Library and Canterbury, 'Ex Libris', to appear in *Sid-ney Chambers and the End of Days*, 2017 (*The Grantchester Mysteries*, 6).

CHAPTER TWO The Codex Amiatinus

A luxurious but reduced facsimile of the Codex Amiatinus, without commentary, was pub-lished by La Meta Editore, *La Bibbia Amiatina*, Florence, 2003. There is also a CD-ROM ver-sion, produced in 2000 by SISMEL (Società Internazionale per lo Studio del Medio Evo Latino). Principal descriptions of the manuscript with bibliographies are Lowe, *Codices Latini Antiquiores*, as above, III, 1938, p. 8, no. 299; and Alexander, *Insular Manuscripts*, 1978, as above, pp. 32–5, no. 7.

For the excavations at Wearmouth and Jarrow, see R. J. Cramp, 'Monastic Sites', pp. 201–52 in D. M. Wilson, ed., *The Archaeology of Anglo-Saxon England*, London, 1976, esp. pp. 229–41. Bede's accounts of the foundation of Wearmouth and the expeditions to Rome by Benedict

Biscop and Ceolfrith are in his *Historia Abbatum* (C. Plummer, ed., *Venerabilis Baedae: Opera Historica*, as above, 1896, pp. 367–8 and 373). The fragment of Maccabees which might be from one of the manuscripts brought back by them is bound at the end of Durham Cathedral Library, MS B.IV.6: it is most recently illustrated in R. Gameson, *Manuscript Treasures of Durham Cathedral*, London, 2010, pp. 22–3, no. 1. The tablet mentioning Ceolfrith is described in J. Higgitt, 'The Dedication Inscription at Jarrow and Its Context', *The Antiquaries Journal*, 59, 1979, pp. 343–74. The making of Bibles at Wearmouth–Jarrow is recounted in the *Vita Ceolfridi* included in Plummer's edition of Bede's *Opera Historica*, p. 395, and the same activity is described by Bede in the *Historia Abbatum* (Plummer, p. 379). For manuscript production at Wearmouth and Jarrow, see E. A. Lowe, *English Uncial*, Oxford, 1960, esp. pp. 6–13, reprinting the principal contemporary sources; and M. B. Parkes, *The Scriptorium of Wearmouth–Jarrow: Jarrow Lecture 1982*, Jarrow, 1982. The wording of the dedication inscription inserted into the Bible is recorded in the *Vita Ceolfridi* (Plummer, p. 402). A major source for this whole chapter has been R. Marsden, *The Text of the Old Testament in Anglo-Saxon England*, Cambridge, 2005 (*Cambridge Studies in Anglo-Saxon England*, 15), esp. pp. 91–8. There is a general survey of the early Vulgate, including the place of Amiatinus, in P.-M. Bogaert, 'The Latin Bible, c. 600 to c. 900', pp. 69–92 in R. Marsden and E. A. Matter, eds., *The New Cambridge History of the Bible*, II, *From 600 to 1450*, Cambridge, 2012. Tischendorf's observation of erasures in the dedication page occurs in his edition, *Novum Testamentum Latine interprete Hieronymo, ex Celeberrimo Codice Amiatino Omnium et Antiquissimo et Praestantissimo, nunc primum edidit*, Leipzig, 1850, p. ix. The decipherment of the original wording was published in G. B. de Rossi, 'De origine historia indicibus scrinii et bibliothecae Sedis Apostolicae commentatio', pp. lxxv–lxxviii in H. Stevenson and G. B. de Rossi, eds., *Codices Palatini Latini Bibliothecae Vaticanae*, I, Rome, 1886. The matching with the inscription in Ceolfrith's Bible is in F. J. A. Hort, *The Academy*, 31, 26 February 1887, pp. 148–9. The quotation from H. J. White on p. 62 is from p. 273 of his 'The Codex Amiatinus and Its Birthplace', *Studia Biblica et Ecclesiastica*, 2, 1890, pp. 273–308. My debt to Nicolas Barker is apparent throughout this chapter, but he also read an early draft and made some useful suggestions. I have used and reused R. L. S. Bruce-Mitford, *The Art of the Codex Amiatinus: Jarrow Lecture 1967*, Jarrow, 1978 (reprinted from *The Journal of the British Archaeological Association*, 3 ser., 32, 1969, pp. 1–25): the quotation on p. 65 beginning "Having put in one's slip …" is on pp. 1–2 there. My account of the Biblioteca Laurenziana, like those of several other libraries in this book, took inspiration from the elegant prose of A. R. A. Hobson, *Great Libraries*, London, 1970, in this instance pp. 84–91. Claire Breay checked the fruit in the courtyard for me, and gave other thoughtful advice. Scott Gwara kindly read the chapter too. I believe that my collation of the manuscript is accurate: previous versions, such as that by H. Quentin, *Mémoire sur l'établissement du texte de la Vulgate*, Rome, 1922, pp. 438–40, attempt to match reality with the original scribes' faulty numbering, which I have simply ignored. On the library of Cassiodorus and its source for the Codex Amiatinus, in addition to works already cited, see R. L. S. Bruce-Mitford, 'Decoration and Miniatures', pp. 109–260 in T. D. Kendrick, ed., *Evangeliorum Quattuor Codex Lindisfarniensis*, companion volume to the facsimile, Lausanne, 1960, esp. pp. 143–9 in Chapter Three, 'The Sources of the Evangelist Miniatures'; and P. Meyvaert, 'Bede, Cassiodorus and the Codex Amiatinus', *Speculum*, 71, 1996, pp. 827–83. The description by Cassiodorus of his '*Codex Grandior*', cited here on pp. 74–5, is found in his *Institutiones*, I, 14:2–3 (R. A. B. Mynors, ed., *Cassiodori Senatoris Institutiones*, Oxford, 1937, p. 40); he says it was made up of 95 quaternions, and 95 × 8 = 380 leaves. I owe to Gifford Combs my knowledge of the bookcase depicted in the Mausoleum of Galla Placidia in Ravenna. The portrait of Saint Matthew in the Lindisfarne Gospels occurs there on folio 25v (the manuscript is British Library, Cotton

MS Nero D. iv; the bibliography of that celebrated manuscript is too vast to attempt here). The proof that the scribes of the Codex Amiatinus were English (pp. 80–81 here) was made elegantly and definitively by Lowe, *English Uncial*, cited above, comparing other manuscripts all attributable to Wearmouth or Jarrow, such as fragments of two Gospel Books (Utrecht, Universiteitsbibliotheek, Cod. 32, folios 94–105, and Durham Cathedral Library, A.II.17, folios 103–111) and a leaf from a Psalter (Cambridge University Library, MS Ff.5.27, flyleaf). For the 'Stonyhurst' or 'St Cuthbert' Gospel, now British Library, Add. MS 89000, see T. J. Brown, ed., *The Stonyhurst Gospel of Saint John*, Oxford, 1969, and now C. Breay and B. Meehan, eds., *The St Cuthbert Gospel: Studies on the Insular Manuscript of the Gospel of Saint John*, London, 2015, which was published after I had completed this chapter: the authors incline to date both the Gospel manuscript and the Codex Amiatinus into the early eighth century (although the Bible, of course, to not after 716) and the argument now is that the Gospel was placed in Cuthbert's coffin later, perhaps much later, than the interment of his relics in 698. The scribes of Amiatinus were disentangled by D. H. Wright, 'Some Notes on English Uncial', *Traditio*, 17, 1961, pp. 441–56. On the provision of parchment for the manuscript, see R. Gameson, 'The Cost of the Codex Amiatinus', *Notes and Queries*, March 1992, pp. 2–9. I am assuming, as everyone does, that the Codex Amiatinus was written on calf-skin. Jiří Vnouček tells me that sheep can actually provide larger sheets than cattle, since a fully grown sheep is utilizable for parchment, whereas only very small calves produce skin soft enough to be of use. The Greenwell Leaf and its companion fragments, introduced here on p. 84, were the subject of the first of my Lyell Lectures, Oxford, 2009, not yet published. The Greenwell Leaf was first described by C. H. Turner, 'Iter Dunelmense: Durham Bible MSS, with the Text of a Leaf Lately in the Possession of Canon Greenwell of Durham, Now in the British Museum', *Journal of Theological Studies*, 10, 1909, pp. 529–44. I owe to Claire Breay the date of its acquisition by the British Museum: it is now British Library, Add. MS 37777. The first account of the Willoughby leaves was by W. H. Stevenson, *Report on the Manuscripts of Lord Middleton, Preserved at Wollaton Hall, Nottinghamshire*, London, 1911 (Historical Manuscripts Commission, report 69), pp. xi–xii, 196–7 and 611–12; they, in turn, are now British Library, Add. MS 45025. The Greenwell and Willoughby leaves are Lowe, *Codices Latini Antiquiores*, as above, II, p. 17, no. 177; the Bankes leaf was reported on pp. 351–2 of B. Bischoff and V. Brown, 'Addenda to *Codices Latini Antiquiores*', *Mediaeval Studies*, 47, 1985, pp. 317–66. M. T. Gibson, *The Bible in the Latin West*, Notre Dame, Ind., and London, 1993 (*The Medieval Book*, I), pp. 24–5, no. 3, wrongly postulates that the Bankes leaf may be from the third Ceolfrith Bible. In the quotations from the books of Kings, note that the Latin Vulgate text has I–IV Kings, renamed in modern translations as I–II Samuel followed by I–II Kings. My copy of the Latin Vulgate, referred to on p. 90, is A. Colunga and L. Turrado, eds., *Biblia Sacra iuxta Vulgatam Clementinam: Nova editio*, Madrid, 1965. The possible participation of Bede himself in the emendation of Genesis 8:7, discussed on pp. 92–3, was noted by Marsden, *Text of the Old Testament*, as above, p. 204; see also R. Marsden, '"Manus Bedae": Bede's Contribution to Ceolfrith's Bibles', *Anglo-Saxon England*, 27, 1998, pp. 65–85. On the reliquary, see M. Ryan, 'A House-Shaped Shrine of Probable Irish Origin at Abbadia San Salvatore, Province of Siena, Italy', pp. 141–50 in M. Ryan, ed., *Irish Antiquities: Essays in Memory of Joseph Raftery*, Bray, Co. Wicklow, 1998, reprinted in Ryan, *Studies in Medieval Irish Metalwork*, London, 2001, pp. 574–86. N. X. O'Donoghue suggests that these containers were chrismals for holding the sacred Host, rather than being reliquaries as such, which would make them even more appropriate for use by itinerant monks: see O'Donoghue, 'Insular Chrismals and House-Shaped Shrines in the Early Middle Ages', pp. 79–91 in C. Hourihane, ed., *Insular & Anglo-Saxon Art and Thought in the Early Medieval Period*, Princeton and University Park, Pa, 2011 (*The Index of*

Christian Art, Occasional Papers, 13). The *Vita Ceolfridi* (Plummer, p. 402) simply says that some of the party resolved to continue the journey after Ceolfith's death, "iter peregere", but not whether they arrived or that they ever returned home.

<p style="text-align:center">Chapter Three The Book of Kells</p>

This chapter is indebted in multiple ways to Bernard Meehan, keeper of manuscripts and head of research collections at Trinity College, Dublin. His captivating illustrated commentary, *The Book of Kells*, published by Thames & Hudson, London, 2012, is based on decades of living with the manuscript and it was my summer reading that year, in a deckchair dragged out into the sand dunes in northern Denmark, before my visit to Dublin. There is a magnificent luxury facsimile of the Book of Kells published by Faksimile Verlag, *The Book of Kells, MS 58, Trinity College Library, Dublin*, Lucerne, 1990. The *Commentary* volume, edited by Peter Fox, includes essays by Umberto Eco, Peter Fox, Patrick McGurk (on the text), Gearóid Mac Niocaill (on the additions in Irish), Bernard Meehan himself and Anthony Cairns (especially on the binding and pigments). These two books have been major sources throughout this chapter. An earlier facsimile was published by Urs Graf, Berne, 1951. Since 2012, an exemplary digitization of the Book of Kells has been freely accessible on-line through the *Digital Collections* site of Trinity College, Dublin. There are catalogue descriptions of the Book of Kells in Lowe, *Codices Latini Antiquiores*, as above, II, p. 43, no. 274; J. J. G. Alexander, *Insular Manuscripts*, 1978, as above, pp. 71–6, no. 52; and M. L. Colker, *Trinity College, Dublin: Descriptive Catalogue of the Mediaeval and Renaissance Latin Manuscripts*, Aldershot, Hants., and Brookfield, Vt, 1991, pp. 106–8. An exhaustive bibliography on the Book of Kells would be unimaginably long. Accessible accounts of its illumination include F. Henry, *The Book of Kells: Reproductions from the Manuscript in Trinity College, Dublin*, London, 1974; P. Brown, *The Book of Kells: Forty-Eight Pages and Details in Colour from the Manuscript in Trinity College, Dublin*, London and New York, 1980; R. G. Calkins, *Illuminated Books of the Middle Ages*, London, 1983, esp. pp. 78–92; G. Henderson, *From Durrow to Kells: The Insular Gospel Books, 650–800*, London, 1985, pp. 131–98; and B. Meehan, *The Book of Kells: An Illustrated Introduction to the Manuscript in Trinity College, Dublin*, London, 1994. A current regulation of Trinity College prohibits the use in any new publication of more than six illustrations of the Book of Kells in colour and six in black and white. We toyed with defying this by using unauthorised images from picture libraries, but decided instead to supplement the allowance with nineteenth- and early twentieth-century reproductions, long free of copyright, for they too are part of the story.

My quotations from the *Birmingham Daily Post* on p. 96 and from other British and Irish newspapers throughout this chapter, including many further unattributed details on the history of the manuscript in the modern era, were found by searching for the word 'Kells' in the *Nineteenth-Century British Newspapers* database, Gale Digital Collections. For the sale of the Perkins copy of the Gutenberg Bible in 1873 for the then highest price paid for any book in more than sixty years, see p. 302 in R. Folter, 'The Gutenberg Bible in the Antiquarian Book Trade', pp. 271–351 in M. Davies, ed., *Incunabula: Studies in Fifteenth-Century Books presented to Lotte Hellinga*, London, 1999. The manuscript of the *Annals of Ulster* is Trinity College, Dublin, MS 1282, and the entry quoted here is on folio 54r; it is published in S. Mac Airt and G. Mac Niocaill, eds., *Annals of Ulster to AD 1131: Text and Translation*, Dublin, 1983, p. 439. For medieval thefts of manuscripts for the value of their bindings, see C. de Hamel, 'Book Thefts in the Middle Ages', pp. 1–14 in R. Myers, M. Harris and G. Mandelbrote, eds., *Against the Law: Crime,*

Sharp Practice and the Control of Print, London, 2004. For the library, see P. Fox, *Trinity College Library, Dublin*, Cambridge, 2014. The account of repairing and rebinding the Book of Kells derives from an article lent to me by Edward Cheese: it is A. G. Cairns, 'Roger Powell's Innovation in Book Conservation: The Early Irish Manuscripts Repaired and Bound, 1953–1981', pp. 68–87 in J. L. Sharpe, ed., *Roger Powell: The Compleat Binder*, Turnhout, 1996 (*Bibliologia*, 14). I owe the translation of the Irish documents to G. Mac Niocaill, 'The Irish "charters"', pp. 154–65 in the facsimile commentary volume, 1990. The observation on p. 113 that the image of the Virgin and Child on folio 7v is the earliest in Europe derives from F. E. Warren, *The Liturgy and Ritual of the Celtic Church*, 2nd edn by J. Stevenson (the first was 1881), Woodbridge, 1987 (*Studies in Celtic History*, IX), p. lxxxv, n. 468, cited by Colker, p. 106. My description of 'insular majuscule' script on p. 121 is too short as a proper definition (I needed to keep the paragraph moving): for all these hands, see M. P. Brown, *A Guide to Western Historical Scripts from Antiquity to 1600*, London, 1990, including insular majuscule on pp. 50–51, no. 16. The poem cited on p. 122 by Hugh MacDiarmid, which opens "When a person is greatly interested in a problem …", is printed in his *Complete Poems*, ed. M. Grieve and W. R. Aitken, II, Manchester, 1994, pp. 1389–93. A practising scribe's account of how the script of the Book of Kells was achieved is M. Drogin, *Medieval Calligraphy: Its History and Technique*, Montclair, NJ, and London, 1980, pp. 109–12. The description by Gerald of Wales, quoted on p. 123, is found in J. F. Dimock, ed., *Giraldi Cambrensis Opera*, V, London, 1867 (Rolls Series, 21), pp. 123–4; it is translated by J. J. O'Meara, ed., Gerald of Wales, *The History and Topography of Ireland*, Harmondsworth, 1982, p. 84. The suggestion that the Book of Kells was not necessarily unique was thrown into focus by a news story in November 2015 of the discovery in a binding in a library in Berlin of a tiny fragment of Luke 13:16, very closely resembling it in script and decoration. It may have been from a manuscript which found its way to Germany with the early insular missionaries. The other great insular Gospel Books in Dublin are: the Codex Usserianus Primus (conceivably actually written in Italy), Trinity College, MS 55, formerly A.4.15 (Lowe, *Codices Latini Antiquiores*, as above, II, p. 42, no. 271, and Alexander, *Insular Manuscripts*, 1978, p. 27, no. 1); the Codex Usserianus Secundus (Garland of Howth), Trinity College, MS 56, formerly A.4.6 (Lowe, II, p. 43, no. 272); the Book of Durrow, Trinity College, MS 57, formerly A.4.5 (Lowe, II, p. 43, no. 273, which is the source of Lowe's comment, cited here, and Alexander, pp. 30–32, no. 6); the Book of Mulling, Trinity College, MS 60, formerly A.1.15 (Lowe, II, p. 44, no. 276); and the Book of Dimma, Trinity College, MS 59, formerly A.4.23 (Lowe, II, p. 44, no. 275). I have given the old numbers to emphasize the awe-inspiring fact that they were once all kept on two shelves of a single bookcase, 'A' in the Manuscripts Room of the library, with the Book of Kells as A.1.6: those shelves alone once held greater value than the gold reserves of most national banks. The four famous insular books outside Ireland mentioned here are the Lindisfarne Gospels, London, British Library, Cotton MS Nero D. iv (Lowe, II, p. 20, no. 187, and Alexander, pp. 35–40, no. 9, and now a facsimile with commentary by Michelle Brown, *Das Buch von Lindisfarne: The Lindisfarne Gospels*, Lucerne, 2002); the Echternach Gospels, Paris, Bibliothèque nationale de France, ms lat. 9389 (Lowe, V, 1950, p. 18, no. 578); the Barberini or Wigbold Gospels, Città del Vaticano, Biblioteca Apostolica Vaticana, Cod. Barb. lat. 570 (Lowe, I, 1934, p. 20, no. 63, and Alexander, pp. 61–2, no. 36); and the Cutbercht Gospels, Vienna, Österreichische Nationalbibliothek, Cod. 1224 (Lowe, X, 1963, p. 18, no. 1500, and Alexander, pp. 62–3, no. 37). For pigments in the Book of Kells, see S. Bioletti, R. Leahy and others, 'The Examination of the Book of Kells Using Micro-Raman Spectroscopy', *Journal of Raman Spectroscopy*, 40, 2009, pp. 1043–9; some scientists assert that lapis blue has been found in the Book of Kells, which presupposes access to a trade route from the Himalayas, but the identification is not universally

accepted. Westwood's *Palaeographia Sacra Pictoria* was cited in the bibliography to Chapter One: the quotation on p. 126 here is from part 17, p. 5. The suggestion on p. 129, which I do not think has been made before, that the full-page pictures could have been transferred from another manuscript is given possible support by the observation by Roger Powell that their parchment was differently prepared (cf. p. 4 of R. Powell, 'The Book of Kells, The Book of Durrow: Comments on the Vellum, the Make-up, and Other Aspects', *Scriptorium*, 10, 1956, pp. 3–21); perhaps one day DNA analysis will tell us whether these leaves are from a different stock of animal skin. The labour of the four scribes of the Book of Kells is largely divided according to the gatherings: the stints of Scribe 1, for example, include the entirety of quire xvi (folios 130–40) and of quires xxxiv–xxxviii (folios 292–339); Scribe 3 ends one session at the end of quire x (folio 87) and he begins the next at the start of quire xvii (folio 141); and Scribe 4 writes quires xi–xiv (folios 88–125) and he finishes his second stint at the end of quire xxi (folio 187). Single leaves with text are missing from the manuscript after folio 26, with part of the list of Hebrew names for Luke's Gospel; after folio 177, with Mark 14:32 to 14:42; and after folio 239, with Luke 12:6 to 12:18; and three text leaves lacking after folio 330, with John 12:28 to 13:19. Parings from the margins of the Domesday Book, kept as souvenirs by the binder (mentioned on p. 130), are described in Bernard Quaritch Ltd, Catalogue 1348, 2007 (*Bookhands of the Middle Ages*, VIII), p. 41, no. 47. Ussher's transcript of the manuscript's charters, mentioned on p. 131, is Trinity College, MS 580; the words 'book of Kelles' appear on folio 59v. Ussher's description is in his *Britannicarum ecclesiarum antiquitates*, Dublin, 1639, p. 691. My account of the arrival of the Book of Kells in Dublin was enhanced by the timely publication of Fox, *Trinity College Library*, as above, esp. pp. 23–4 and 39. The quotation from Queen Victoria on pp. 133–4 is from her *Leaves from the Journal of Our Life in the Highlands, from 1848 to 1861, to Which are Prefixed and Added Extracts from the Same Journal Giving an Account of Earlier Visits to Scotland, and Tours in England and Ireland*, ed. A. Helps, London, 1868, pp. 257–8. The royal signatures, which were on a flyleaf and not on the ancient pages, are now bound separately. On nineteenth-century pattern-books for illumination, see R. Watson, 'Publishing for the Leisure Industry: Illuminating Manuals and the Reception of a Medieval Art in Victorian Britain', pp. 78–107 in T. Coomans and J. De Maeyer, eds., *The Revival of Medieval Illumination*, Louvain, 2007, illustrating samples from the Book of Kells in W. J. Loftie's *Lessons in the Art of Illuminating*, 1885, on p. 97. Helen Campbell D'Olier's watercolour copies from the Book of Kells are Trinity College, MS 4729. Two of those made by C. L. Ricketts, now in the Lilly Library, University of Indiana, in Bloomington, are illustrated in S. Hindman and N. Rowe, eds., *Manuscript Illumination in the Modern Age: Recovery and Reconstruction*, Evanston, Ill., 2001, pp. 270–71 and pl. 37. Like Bernard Meehan's, Sir Edward Sullivan's book is tersely called *The Book of Kells*, London, Paris and New York, 1914 (the reference to the mischievous bookbinder, mentioned above on p. 130, is from p. 6). The letter from Joyce to Power is cited in R. Ellmann, *James Joyce*, Oxford and New York, 1982, II, p. 545. The quotation from *Finnegans Wake* on p. 138 here is taken from pp. 122–3 of the London edition, 1939. The '*Tunc*' page, as Joyce calls it, is from the Gospel narrative of the Crucifixion, "Tunc crucifixerant xp[ist]i cum eo duos latrones", 'Then they crucified two thieves with him' (Matthew 27:38); the page is indeed strangely tenebrous both in layout, for most of the words here are crammed scarcely legibly into an X-shaped cruciform pattern, and in grammar, for "xpi" (Christi) has no meaning here, and the standard Vulgate reading should be, "Tunc crucifixi sunt cum eo duo latrones." On the origin of the manuscript on Iona, in addition to works already cited, see P. Meyvaert, 'The Book of Kells and Iona', *The Art Bulletin*, 71, 1989, pp. 6–19.

There is a fine-art facsimile, *Aratea, Faksimileband*, Lucerne, 1978, and accompanying it, *Aratea, Kommentar zum Aratus des Germanicus, MS. Voss. Lat. Q. 79, Bibliotheek der Rijksuniversiteit Leiden*, Lucerne, 1989, with essays by B. Bischoff, B. Eastwood, T. A.-P. Klein, F. Mütherich and P. F. J. Obbema; the essay there by Mütherich, 'Die Bilder', pp. 31–68, is reprinted in her collected *Studies in Carolingian Manuscript Illumination*, London, 2004, pp. 147–265. The entire manuscript is available in high-resolution images from the Digital Special Collections website of the university of Leiden. It is illustrated too in W. Köhler and F. Mütherich, *Die karolingischen Miniaturen, IV, Die Hofschule Kaiser Lothars: Einzelhandschriften aus Lotharingien*, Berlin, 1971, plates 75–96. There is a bibliography on the manuscript in C. L. Verkerk, '*Aratea*: A Review of the Literature Concerning Ms Vossianus lat. q. 79 in Leiden University Library', *Journal of Medieval History*, 6, 1980, pp. 245–87. There is still value in G. Thiele, *Antike Himmelsbilder, mit Forschungen zu Hipparchos, Aratos und seinen Fortsetzern und Beiträgen zur Kunstgeschichte des Sternhimmels*, Berlin, 1898, esp. pp. 77–142. I was particularly indebted to R. Katzenstein and E. Savage-Smith, *The Leiden Aratea: Ancient Constellations in a Medieval Manuscript*, Malibu, Calif., 1988, published for the manuscript's exhibition in America; A. von Euw, *Der Leidener Aratus: Antike Sternbilder in einer Karolingischen Handschrift*, Munich, 1989; F. Mütherich, 'Book Illumination in the Court of Louis the Pious', pp. 593–604 in P. Godman and R. Collins, eds., *Charlemagne's Heir: New Perspectives on the Reign of Louis the Pious (814–840)*, Oxford, 1990, reprinted in Mütherich, *Studies in Carolingian Manuscript Illumination*, cited above, pp. 98–117; M. Dolan, 'The Role of Illustrated Aratea Manuscripts in the Transmission of Astronomical Knowledge in the Middle Ages', doctoral thesis, University of Pittsburgh, 2007, available on-line and remarkably good; and E. Dekker, 'The Provenance of the Stars in the Leiden *Aratea* Picture Book', *Journal of the Warburg and Courtauld Institutes*, 73, 2011, pp. 1–37 (she has also written *Illustrating the Phaenomena: Celestial Cartography in Antiquity and the Middle Ages*, Oxford, 2012). I am glad to have had the benefit of D. B. Gain, *The Aratus Ascribed to Germanicus Caesar: Edited with an Introduction, Translation & Commentary*, London, 1976 (*University of London Classical Studies*, 8), conjured up for me by Peter Jones, Librarian of King's College, Cambridge.

The principal text on the court library of Charlemagne is B. Bischoff, 'Die Hofbibliothek Karls des Grossen', pp. 149–69 in his *Mittelalterliche Studien*, III, Stuttgart, 1981, translated as 'The Court Library of Charlemagne', chapter 3 in M. Gorman, transl. and ed., *Manuscripts and Libraries in the Age of Charlemagne*, Cambridge, 2007 (*Cambridge Studies in Palaeography and Codicology*, 1), pp. 56–75; whether the contemporary list of texts cited here on p. 143 actually comprises those owned by the palace library itself is still controversial. For the intellectual culture of the whole period there are multiple books by Rosamond McKitterick. The two fourth-century Virgils cited on pp. 143–4 here are Città del Vaticano, Biblioteca Apostolica Vaticana, cod. Vat. lat. 3225 and Vat. lat. 3867. They are very well-known: good summaries by D. H. Wright are in M. Buonocore, ed., *Vedere i Classici: L'illustrazione libraria dei testi antichi dall'età romana al tardo Medioevo*, Vatican City, 1996, pp. 141–5, nos. 1–2 (and also D. H. Wright, *The Roman Vergil and the Origins of Medieval Book Design*, London, 2002). For the 'Calendar of 354', I used M. R. Salzman, *On Roman Time: The Codex-Calendar of 354 and the Rhythms of Urban Life in Late Antiquity*, Berkeley, 1990 (*The Transformation of the Classical Heritage*, 17). The ninth-century Terence made by Hrodgarius and the *Agrimensores* are both also in the Vatican (cod. Pal. lat. 3868 and Pal. lat. 1564). The famous remark by Scaliger cited on p. 145 was made to students in Leiden in 1606: see K. van Ommen, 'The Legacy of Joseph Justus Scaliger in Leiden University Library Catalogues, 1609–1716', pp. 51–82 in M. Walsby and N. Constantinidou, eds.,

Documenting the Early Modern Book World, Leiden and Boston, 2013, p. 53, with further references. Erik Kwakkel and Peter Gumbert were my hosts for the lecture in Leiden, and we spoke about the bindings by Sister Lucie Gimbrère. I am also grateful for conversations with David Ganz. On writing rustic capitals, see Drogin, *Medieval Calligraphy*, as above, pp. 89–92. For the Utrecht Psalter, the second supreme Carolingian book in the Netherlands, cited here on p. 150, see the exhibition catalogue, K. van der Horst, W. Noel and W. C. M. Wüstefeld, eds., *The Utrecht Psalter in Medieval Art: Picturing the Psalms of David*, Tuurdijk, 1996 (in which the *Aratea* is also described, p. 200, no. 13). On p. 150 I mention skies shown almost black (examples are folios 48v and 78v) ranging to turquoise (such as folios 60v and 62v). In describing miniatures on pp. 150–65 I have generally avoided using folio numbers for the sake of the flow of the paragraph, but for the record they are: (1) folio 3v, *Draco* the snake, with the bears *Ursus Minor* and *Ursus Major*; (2) folio 6v, Hercules; (3) folio 8v, the garland, *Corona borealis*; (4) folio 10v, Ophiunchus the snake-bearer standing on a scorpion and holding a serpent; (5) folio 12v, presumably Boötes; (6) folio 16v, Gemini standing together; (7) folio 18r, Cancer the crab; (8) folio 20v, Leo, a prancing lion; (9) folio 22v, Auriga the charioteer holding three goat kids; (10) folio 24v, Taurus shown as half a bull; (11) folio 26v, Cepheus reaching out his arms; (12) folio 28v, Cassiopeia enthroned; (13) folio 30v, Andromeda tied between rocks; (14) folio 32v, Pegasus, half a winged horse; (15) folio 34v, Aries leaping through a hoop; (16) folio 36v, Triangula; (17) folio 38v, Pisces, two fish; (18) folio 40v, Perseus holding the head of Medusa; (19) folio 42v, the Pleiades, seven women's heads; (20) folio 44r, Lyra; (21) folio 46v, Cygnus, a hissing swan; (22) folio 48v, Aquarius emptying a vase; (23) folio 50v, Capricorn; (24) folio 52v, Sagittarius; (25) folio 54v, Aquila the eagle; (26) folio 56v, Delphinus, a dolphin; (27) folio 58v, Orion, with Lepus between his legs; (28) folio 60v, Canis Maior; (29) folio 62v, Lepus the hare again; (30) folio 64v, Argo, half a ship; (31) folio 66v, Cetus the sea monster; (32) folio 68v, Eridanus the river god; (33) folio 70v, Piscis Austrinus; (34) folio 72v, Ara, an altar; (35) folio 76v, Hydra, Corvus and Crater; and (36) folio 78v, Canis Minor. The ninth-century copy of Cicero's translation of Aratus, mentioned on p. 166, is bound up in London, British Library, Harley MS 647, folios 12v–17v. Images from it are available in the British Library's on-line Catalogue of Illuminated Manuscripts, with bibliography. It is an aside, but curious in demonstrating its faithfulness to its classical exemplar, that the antiquary W. Y. Ottley believed that it was an actual manuscript of the second or third century (*Archaeologia: Miscellaneous Tracts Relating to Antiquity*, 26, 1836, pp. 47–214). A remarkably engaging and perceptive study of the evolution of the codex in the first centuries AD is H. Y. Gamble, *Books and Readers in the Early Church: A History of Early Christian Texts*, New Haven and London, 1995. On p. 169 I describe finding myself giving an unofficial tutorial to Leiden graduate students: one of them, Jenneka Janzen, wrote about the experience afterwards on the university's website. The parallel between the face of Cepheus on folio 26v and that of David in the Lothair Psalter (London, British Library, Add. MS 37768, folio 4r) is made by Mütherich, 'Court of Louis the Pious', as above, p. 105. The best surviving record of the Calendar of 354 is Peiresc's seventeenth-century copy of the lost Carolingian copy (Biblioteca Apostolica Vaticana, cod. Barberini lat. 2154). For Alcuin drawing the attention of Charlemagne to the *Historia naturalis* of Pliny, mentioned on p. 171, see Bischoff, 'The Court Library of Charlemagne', as above, p. 57. The two articles on the probable astronomical accuracy of the planetarium on folio 93v are R. Mostert and M. Mostert, 'Using astronomy as an aid to dating manuscripts: The example of the Leiden Aratea', *Quaerendo*, 20, 1999, pp. 248–61; and E. Dekker, 'Planetary Observations: The Case of the Leiden Planetary Configuration', *Journal for the History of Astronomy*, 39, 2007, pp. 77–90. The suggestion that the date of 18 March was the anniversary of the Creation derives from the thesis of Dolan, 'The Role

of Illustrated Aratea Manuscripts', cited above, p. 220. I read the English translation of the *Vita Hludowici* by A. Cabaniss, *Son of Charlemagne: A Contemporary Life of Louis the Pious*, Syracuse, NY, 1961. The practice of 'back drawing' on the reverse of illuminated pages in insular manuscripts is described in M. P. Brown, *The Lindisfarne Gospels: Society, Spirituality & the Scribe*, London, 2003, pp. 217–20, with plates 9a–b. The two copies taken from the *Aratea* around 1000 are Boulogne, Bibliothèque municipale, ms 188, and Berne, Burgerbibliothek, MS 88. For the patronage of Odbert, including Boulogne ms 188, see M. Holcomb, ed., *Pen and Parchment: Drawing in the Middle Ages*, Metropolitan Museum of Art, New York, 2009, p.74–6, no. 16. I wish I could think of a candidate for an artist in Ghent whose estate was being sold off in 1573: it is probably too late for Simon Bening, the book illustrator mentioned in Chapter Twelve, who had died there in 1561. The term 'bis capta' was a common classical reference to Troy. The book by Susius promising to edit the *Aratea* is his *Carmina tam sacra quam prophana*, Leiden, 1590; the reference is in the dedication. The *Syntagma Arateorum* of Grotius, Louvain, 1600, refers specifically to the Leiden manuscript on p. 30. To be fair, it is just possible that the indented outlines, which I noticed against the raking light, were made by Grotius for this edition, rather than in the Middle Ages at all. The *Atlas Coelestis seu Harmonia Macrocosmica* of Cellarius, Amsterdam, 1660, illustrates the planetarium in the double-page plate following p. 54. The library of Grotius is discussed in A. Nelson, 'Deux notes concernant la bibliographie de Hugo Grotius', *Nordisk tidskrift för bok- och biblioteksväsen*, 39, 1952, pp. 18–25. For Queen Christina and Vossius, I consulted C. Callmer, *Königin Christina, ihre Bibliothekare und ihre Handschriften: Beiträge zur europäischen Bibliotheksgeschichte*, Stockholm, 1977 (*Acta Bibliothecae Regiae Stockholmiensis*, 30), which mentions the *Aratea* on p. 150, and F. F. Blok, *Contributions to the History of Isaac Vossius's Library*, Amsterdam, 1974, esp. pp. 34–42. Michael Reeve tells me that both Oxford and Cambridge attempted to acquire the Voss library after his death in 1689, but lost it to Leiden. On the tangled history of the first facsimile of the Vatican Virgil, mentioned on p. 184, see D. H. Wright, 'From Copy to Facsimile: A Millennium of Studying the Vatican Vergil', *British Library Journal*, 17, 1991, pp. 12–35. There is a list of 637 manuscript facsimiles in H. Zotter, *Bibliographie faksimilierter Handschriften*, Graz, 1976, already long out of date, and I used too N. Barker, *The Roxburghe Club: A Bicentennial History*, n.p., 2012, Chapter 10, 'The Development of the Facsimile', pp. 119–37.

CHAPTER FIVE **The Morgan Beatus**

There is a complete facsimile of the Morgan Beatus, *Apocalipsis de San Juan, Beato de Liébana, San Miguel de Escalada*, Valencia, 2000, with an accompanying *Estudio del Manuscrito*, with contributions in Spanish and English by U. Eco, W. M. Voelkle, J. W. Williams, B. A. Shailor, L. G. Freeman, A. Del Campo Hernández, and J. González Echegaray. It is a problem with all commentaries accompanying expensive modern facsimiles that their scholarship is necessarily placed beyond the financial reach of most research libraries. Instead, I bought a copy of the profusely illustrated book by Williams and Shailor, *A Spanish Apocalypse: The Morgan Beatus Manuscript: Introduction and Commentaries*, New York, 1991. I should say at the outset how much I owe to William Voelkle and I am grateful for chance conversations with Barbara Shailor; to my great regret, I never knowingly met John Williams. The principal text on all manuscripts of Beatus is Professor Williams's *The Illustrated Beatus: A Corpus of the Illustrations of the Commentary on the Apocalypse*, 5 volumes, London, 1994–2003; since then, one more Beatus manuscript has come to light, a southern Italian manuscript now in Geneva, where I was shown it by Barbara

Roth. Two typescripts by John Williams connected with a planned but abandoned exhibition at the Morgan Library were generously shown to me by William Voelkle (they are mentioned on p. 227); they included 'Visions of the End in Medieval Spain: The Beatus Tradition', which was especially useful, now finally announced for publication by Amsterdam University Press in 2016, to be edited by Therese Martin, *Visions of the End in Medieval Spain: Catalogue of Illustrated Beatus Commentaries on the Apocalypse and Study of the Geneva Beatus*. At the time of writing, it has not yet appeared.

I refer on p. 191 to the author of Revelation as 'Saint John the Divine', the titular saint of the vast Episcopalian cathedral in New York and the appellation commonly given to the John named in the Apocalypse as its author (Revelation 1:9); whether he was or was not the same person as Saint John the Evangelist is a question where medieval tradition and modern biblical scholarship often differ. For the background to eschatology in the time of Beatus, I looked initially at P. Fredriksen, 'Tyconius and Augustine on the Apocalypse', pp. 20–37 in R. K. Emmerson and B. McGinn, *The Apocalypse in the Middle Ages*, Ithaca, NY, 1992, and E. A. Matter, 'The Apocalypse in Early Medieval Exegesis', pp. 38–50 in the same volume; R. Landes, 'Lest the Millennium be Fulfilled: Apocalyptic Expectations and the Pattern of Western Chronography, 100–800 C.E.', pp. 205–8 in W. Verbeke, D. Verhelst and A. Welkenhuysen, eds., *The Use and Abuse of Eschatology in the Middle Ages*, Louvain, 1988 (*Mediaevalia Lovaniensia*, ser. 1, *Studia*, 15); and K. R. Poole, 'Beatus of Liébana: Medieval Spain and the Othering of Islam', pp. 47–66 in K. Kinane and M. A. Ryan, eds., *End of Days: Essays on the Apocalypse from Antiquity to Modernity*, Jefferson, NC, 2009. I did not use but I have read since and greatly recommend J. T. Palmer, *The Apocalypse in the Early Middle Ages*, Cambridge, 2014. The principal text by Saint Augustine against over-literal interpretation of the biblical clues to the end of time, cited on pp. 190–91, is his Epistle 199, addressed to Heysichius (Migne, *Patrologia Latina*, XXXIII: 801–925). The unique ninth-century decorated fragment of Beatus, mentioned on p. 192, is Silos, Biblioteca del Monasterio de Santo Domingo, frag. 4 (despite its name, it is a Benedictine abbey, named not after the mendicant friar Saint Dominic but the saintly abbot who died there in 1073). The identification of the Morgan Library manuscript with that owned by the order of Santiago of Uclès was made by G. de Andrés, 'Nuevas aportaciones documentales sobre los códices "Beatos"', *Revista de archivos, bibliotecas y museos*, 81, 1978, pp. 543–5. Libri's account of the manuscript's acquisition by Frasinelli is now British Library, Yates Thompson MS 54, formerly Add. MS 46200, folio 102 (part of a collection of notes once enclosed in Yates Thompson manuscripts, many of which are now in the British Library); the account is also cited by Voelkle in the commentary volume to the facsimile. The true Valcavado Beatus is the volume now in Valladolid, Biblioteca de la Universidad, ms 433. Sir Frederic Madden (1801–73), whose diary account of Libri in 1846 is quoted here on p. 196, was Keeper of Manuscripts at the British Museum; the quotation is from pp. 178–9 of A. N. L. Munby, 'The Earl and the Thief' in N. Barker, ed., A. N. L. Munby, *Essays and Papers*, London, 1978, pp. 175–91. Other accounts of Accounts of Libri and Ashburnham include the ever-useful S. De Ricci, *English Collectors of Books & Manuscripts (1530–1930) and Their Marks of Ownership*, Cambridge, 1930, Chapter XI, pp. 131–8; A. N. L. Munby, *Connoisseurs and Medieval Miniatures, 1750–1850*, Oxford, 1972, chapter VII, pp. 120–38; Munby, 'The Triumph of Delisle: A Sequel to 'The Earl and the Thief'', in *Essays and Papers*, as above, pp. 193–205; and J. M. Norman, *Scientist, Scholar & Scoundrel: A Bibliographical Investigation of the Life and Exploits of Count Guglielmo Libri*, New York, 2013. Lord Ashburnham will reappear in Chapter Nine. For Yates Thompson, I am still rather proud of my little piece, 'Was Henry Yates Thompson a Gentleman?', pp. 77–89 in R. Myers and M. Harris, eds., *Property of a Gentleman: The Formation, Organisation and Dispersal of the Private Library, 1620–1920*,

Winchester, 1991. For the cataloguing of this manuscript by M. R. James (1862–1936), later Provost of King's and Eton, see R. W. Pfaff, *Montague Rhodes James*, London, 1980, p. 193, "really an essay of the subject of Beatus commentaries in general"; it is pp. 304–30, no. 97, in *A Descriptive Catalogue of the Second Series of Fifty Manuscripts (Nos. 51 to 100) in the Collection of Henry Yates Thompson*, Cambridge, 1902. Nearly the whole of the paragraph on pp. 199–200 is taken from Voelkle's essay accompanying the facsimile of 2000 and from conversations with William Voelkle himself, a long-standing and unfailing friend who has helped me on countless occasions in matters involving the Morgan Library. He has served under every director of the Morgan except for Belle da Costa Greene herself. There is a biography of her, disappointing in that the author knows nothing about rare books, H. Ardizzone, *An Illuminated Life*, New York and London, 2007, alluding to this episode on pp. 367–8. For collectors' and dealers' price codes, like the 'bryanstole' used by Yates Thompson, see I. Jackson, *The Price-Codes of the Book-Trade: A Preliminary Guide*, Berkeley, 2010. The printed edition of the text of Beatus on the Apocalypse, which I brought with me to New York, mentioned briefly on p. 206, is J. G. Echegaray, A. del Campo Hernández and L. G. Freeman, eds., *Beato de Liébana: Obras completes y complementarias*, I, Madrid, 2004 (*Biblioteca de autores cristianos Maior*, 76). It is superseded now by R. Gryson, ed., *Beati Liebanensis Tractatus de Apocalipsin*, Turnhout, 2012 (*Corpus Christianorum, Series Latina*, 107). The use of numerical values traditionally assigned to Greek letters of the alphabet, mentioned on p. 208, is known as 'isopsephy', whereby the letter *alpha* = 1, *beta* = 2, *gamma* = 3, and so on, through to *rho* = 100, *sigma* = 200, etc., to *omega* = 800. Peter Krakenberger kindly read the chapter in draft and he made several corrections to my knowledge of Spain, and he generously gave me a copy of his translation of S. Sáenz-López Peréz, *The Beatus Maps: The Revelation of the World in the Middle Ages*, Burgos, 2014, which was extremely useful at the eleventh hour. Cockerell's copy of the Yates Thompson catalogue of 1902 belongs to the library of the Grolier Club in New York, where I saw it (his observation quoted on p. 222 here is added by him in the margin of p. 315); for Cockerell himself, then intimate with the Yates Thompson collection, see above, p. 420. I have an experience to recount relating to the art of Beatus on the Apocaypse. I went in 2015 with the Association Internationale de Bibliophilie to a congress in Madrid. They had laid out for us on a big table in the Biblioteca Nacional some of the library's greatest treasures, including their two manuscripts of Beatus on the Apocalypse. Our group was drawn at once to these, as by the Pied Piper's music, gasping and exclaiming at the hypnotic and brilliant pictures, entirely overlooking the fact that the immediately adjacent manuscripts open on the same table were two illustrated notebooks by Leonardo da Vinci, unnoticeable in comparison. Beatus has the power to divert attention from the greatest artist of them all. The copy of Beatus signed by Emeterius, pupil of Maius, described on pp. 225–6, is Madrid, Archivo Histórico Nacional, Cod. 1097b; the scribe's inscription is on folio 167r. It has sometimes been suggested that the leaf with the picture was at some time transferred from another manuscript, which seems unnecessarily complicated. The scriptorium at Tábara from Morgan M 429 is reproduced in J. J. G. Alexander, *Medieval Illuminators and Their Methods of Work*, New Haven and London, 1992, p. 9, fig. 9. The 'twin additions' by Isidore and Jerome are those on folios 234r–237r and 238v–292v of the manuscript. The quotation from Adam of Bremen on p. 231 is from p. 121 in R. Landes, 'The Fear of the Apocalyptic Year 1000: Augustinian Historiography, Medieval and Modern', *Speculum*, 75, 2000, pp. 97–145, and that from Byrhferth is taken from pp. 31–2 of C. Cubitt, 'Apocalyptic and Eschatological Thought in England around the Year 1000', *Transactions of the Royal Historical Society*, 6 ser., 25, 2015, pp. 27–52.

Despite its fame, there is no facsimile or even an individual monograph on Hugo Pictor's man-uscript. It is catalogued in O. Pächt and J. J. G. Alexander, *Illuminated Manuscripts in the Bodleian Library, Oxford*, I, *German, Dutch, Flemish, French and Spanish Schools*, Oxford, 1966, pp. 34–5, no. 441. The classic text on book production at this period is N. R. Ker, *English Manuscripts in the Century after the Norman Conquest*, Oxford, 1960 (The Lyell Lectures, 1952–3). Any study of English cathedral and monastic books depends utterly on the same author's compulsive field guide, N. R. Ker, *Medieval Libraries of Great Britain: A List of Surviving Books*, 2nd edn, London, 1964 – I have been known to describe it as the most interesting reference book ever written – with N. R. Ker and A. G. Watson, *Supplement to the Second Edition*, London, 1987.

For the Exeter Book, introduced at the opening of this chapter, see N. R. Ker, *Catalogue of Manuscripts Containing Anglo-Saxon*, Oxford, 1957, p. 153, no. 116; there is a digital 'virtual fac-simile', B. J. Muir, ed., with N. Kennedy, *The Exeter Anthology of Old English Poetry*, Exeter, 2006. There is valuable background to that manuscript and its library companions in P. W. Conner, *Anglo-Saxon Exeter: A Tenth-Century Cultural History*, Woodbridge, 1993 (*Studies in Anglo-Saxon History*, IV). On the early history of the Bodleian, see I. Philip, *The Bodleian Library in the Seven-teenth and Eighteenth Centuries*, Oxford, 1983, and M. Clapinson, *A Brief History of the Bodleian Library*, Oxford, 2015. Bodley's autobiography, one of the earliest in English literature, has been reprinted, edited by W. Clennell, *The Autobiography of Sir Thomas Bodley*, Oxford, 2006. Nicholas Hilliard, his childhood companion, painted Bodley's portrait in 1598 (K. Garlick, *Catalogue of Portraits in the Bodleian Library, by Mrs Reginald Lane Poole; Completely Revised and Expanded*, Ox-ford, 2004, p. 35; it was given to Oxford University in 1897). The wording of Bodley's offer to the University has been printed many times, probably first by J. Gutch, ed., Anthony à Wood, *The History and Antiquities of the University of Oxford*, II, Oxford, 1796, p. 266. Opinions today may differ as to whether the decision of the Dean and Chapter of Exeter to send their manuscripts to Oxford was enlightened foresight or "a conspicuous breach of trust ... ignoring their suc-cessors' interest in the patrimony of their Church" (A. Clark, *A Bodleian Guide for Visitors*, Ox-ford, 1906, pp. 107–08). Although the Exeter Book was left behind, it cannot have been entirely out of sight, since it was known to Matthew Parker (Cambridge, Corpus Christi Col-lege, MS 101, p. 449, marginal note). Hugo's Jerome having been delivered to Oxford is listed on p. 70 of the *Catalogus Librorum Bibliothecæ Publicæ quam vir ornatissimus Thomas Bodleius eques auratus in Academia Oxoniensi nuper instituit*, Oxford, 1605, reproduced in facsimile as *The First Printed Catalogue of the Bodleian Library*, Oxford, 1986. I apologize for using local abbreviations of any kind: the "PPE" Reading-Room mentioned on p. 241 refers to the uniquely Oxford de-gree of Philosophy, Politics and Ecomomics, studied in this former space by Harold Wilson, Edward Heath, David Cameron, Bill Clinton, Benazir Bhutto, and many others. The article by Richard Gameson, mentioned on p. 242, is 'Hugo Pictor, enlumineur normand', *Cahiers de civi-lisation médiévale*, 44, 2001, pp. 121–38; and that by Otto Pächt, whom I knew in his old age, is his 'Hugo Pictor', *Bodleian Library Record*, 3, 1950, pp. 96–103. The edition of the text I used for Je-rome on Isaiah is M. Adriaen, ed., *S. Hieronymi presbysteri: Commentarium in Esaiam*, Turnhout, 1963 (*Corpus Christianorum, Series Latina*, 73); there is now a new English translation, T. P. Scheck, *St Jerome: Commentary on Isaiah, Including St Jerome's Translation of Origen's Homilies 1–9 on Isaiah*, New York and Mahwah, NJ, 2015 (*Ancient Christian Writers: The Works of the Fathers in Translation*, 68). The illustration on the verso of folio vi, which I describe as being Jerome with Eustochium and Pammachius, is published by P. d'Ancona, *The Art of Illumination: An Anthology of Manuscripts from the Sixth to the Sixteenth Century*, transl. A. M. Brown, London and New York, 1969, plate 37,

as depicting the Virgin Mary enthroned between Jerome and Isaiah, which is surely wrong. The early twelfth-century image of a parchmenter mentioned on p. 252 is Bamberg, Staatsbibliothek, cod. Msc. Patr. 5; it has been reproduced countless times, including in my own *Scribes and Illuminators*, London, 1992, p. 12, fig. 7 (Hugo Pictor, incidentally, is p. 64, fig. 55 there). Graham Pollard first noted the ease with which pegs could be knocked out of Romanesque bindings so that the thongs could be reattached into later boards: see p. 19 of his 'The Construction of English Twelfth-Century Bindings', *The Library*, 5 ser., 17, 1962, pp. 1–22. The two copies of Jerome in the Exeter inventory of 1327 are listed in G. Oliver, *Lives of the Bishops of Exeter and a History of the Cathedral*, Exeter, 1861, p. 302. For the history of the medieval library, I used A. M. Erskine, 'The Growth of Exeter Cathedral Library after Bishop Leofric's Time', *Leofric of Exeter, Essays in Commemoration of the Foundation of Exeter Cathedral Library in A.D. 1072*, Exeter, 1972, pp. 43–55. The custom of identifying a manuscript in a medieval book catalogue by citing the first words of the second leaf probably began in the library of the Sorbonne in the later thirteenth century: see J. Willoughby, 'The *Secundo Folio* and Its Uses, Medieval and Modern', *The Library*, 7 ser., 12, 2011, pp. 237–58. The Franciscan union catalogue, known from Bodleian Library, MS Tanner 165, is published by R. H. Rouse and M. A. Rouse, eds., with R. A. B. Mynors, *Registrum Anglie de Libris Doctorum et Auctorum Veterum*, London, 1991 (*Corpus of British Medieval Library Catalogues*, 2), citing the Exeter copy on pp. 88–9, no. 6.72. For Jerome's reference to Britain in his commentary on Isaiah, mentioned on p. 255, see the edition by Adriaen, 1963, p. 463; in Bodley 717 it occurs on folio 186v. The copy of Jerome on Isaiah from Christ Church Cathedral Priory in Canterbury is now Cambridge, Trinity College, MS B.5.24; that from Salisbury in Wiltshire is still in the cathedral there, MS 25, discussed on p. 260. The remark of William of Malmesbury on the revival of religion in England under the Normans occurs in his *Gesta Regum Anglorum*, III: 246: see W. Stubbs, ed., *Willelmi Malmesbiriensis monachi de gestis regum Anglorum libri quinque*, II, London, 1889 (Rolls Series, 90), p. 306. The list of surviving manuscripts known in or associated with Anglo-Saxon England, extended to 1100, which includes the period of Hugo Pictor, is H. Gneuss, *Handlist of Anglo-Saxon Manuscripts: A List of Manuscripts and Manuscript Fragments Written or Owned in England up to 1100*, Tempe, Ariz., 2001, with supplements in *Anglo-Saxon England*, 32, 2003, pp. 293–305, and 40, 2012, pp. 293–306; for the next generation, incomparably richer, see the catalogue by R. Gameson, *The Manuscripts of Early Norman England (c. 1066–1130)*, Oxford, 1999. On the systematic building up of patristic libraries by the Normans, see Ker, *English Manuscripts*, cited above, p. 4, and R. M. Thomson, 'The Norman Conquest and English Libraries', pp. 27–40 in P. Ganz, ed., *The Book in Medieval Culture*, 2, Turnhout, 1986 (reprinted in Thomson, *England and the Twelfth-Century Renaissance*, Aldershot and Brookfield, Vt, 1998, no. XVIII)), and Thomson, *Books and Learning in Twelfth-Century England: The Ending of the 'Alter Orbis': The Lyell Lectures 2000–2001*, Walkern, Herts., 2006, esp. pp. 48–60 and 101–4. Manuscripts now in Oxford acquired by the Normans for Exeter contemporaneously with Jerome on Isaiah include Ambrose, Jerome and Augustine (Bodley MS 137), Pseudo-Athanasius (Bodley MS 147), Augustine (Bodley MSS 301, 691 and 813), Gregory (Bodley MSS 707 and 783), and Ambrose (Bodley MS 739). For these and other manuscripts, see R. Gameson, 'Manuscrits normands à Exeter aux XIe et XIIe siècles', pp. 107-27 in P. Bouet and M. Dosdat, eds., *Manuscrits et Enluminures dans le monde normand (Xe-XVe siècles)*, Caen, 1999, and M. Gullick, 'Manuscrits et copistes normands en Angleterre (XIe-XIIe siècles)', pp. 83-93 in the same volume. On the textual tradition of Jerome on Isaiah, see R. Gryson and others, eds., *Commentaires de Jérôme sur le prophète Isaïe*, I–V, Freiburg, 1993–9 (*Vetus Latina: Aus der Geschichte der lateinischen Bibel*, 23, 27, 30 and 35–6), which updates and corrects B. Lambert, *Bibliotheca Hieronymiana Manuscripta: La tradition manuscrite des oeuvres de Saint Jérôme*, Steen-

brugge, 1969 (*Instrumenta Patristica et Mediaevalia*, 4). The two primary manuscripts of the Gallican family of the text, mentioned on p. 258, are Paris, Bibliothèque nationale de France, ms lat. 11627 (from Corbie), and Salzburg, Stiftsbibliothek Sankt Peter, a.X.22 (from Saint-Amand). For book production in Salisbury, see T. Webber, *Scribes and Scholars at Salisbury Cathedral, c. 1075–c. 1125*, Oxford, 1992, and Webber, 'Salisbury and the Exon Domesday: Some Observations Concerning the Origin of Exeter Cathedral MS 3500', *English Manuscript Studies*, 1, 1989, pp. 1–18. The four readings in Salisbury MS 25 are on folios 4v, 2r, 3v and 5v. I also checked them in Cambridge, Trinity College MS B.5.24, the Canterbury copy. It is slightly different from both. Like Salisbury, it does not include the interpolated passage; "salutare" on folio 4v, the Salisbury reading, is written over an erasure; it has "scribens" on folio 7v, as at Salisbury; but reads "ministeria" on folio 10r, like the Exeter text. The conclusion has to be that the texts of Jerome on Isaiah at Exeter, Salisbury and Canterbury all reached England independently, and that they are not copied one from the other. A further fragment of Jerome on Isaiah came to light in 2016, still privately owned: it was copied around 1100 by the scribe Robertus, who evidently worked at Préaux Abbey in Normandy but supplied books for Canterbury (including Cambridge, Trinity College MS B.4.5, and Oxford, Bodleian Library, MS Bodley 317); the new fragment, however, is subtly different again from Trinity B.5.24 and was not its exemplar. The books of William of Saint-Calais, bishop of Durham, introduced on pp. 262–3, are described in R. A. B. Mynors, *Durham Cathedral Manuscripts to the End of the Twelfth Century*, Durham, 1939, pp. 32–45; M. Gullick, 'The Scribe of the Carilef Bible: A New Look at some Late Eleventh-Century Durham Cathedral Manuscripts', pp. 61–83 in L. Brownrigg, ed., *Medieval Book Production: Assessing the Evidence*, Los Altos Hills, Calif., 1990; A. Lawrence-Mathers, *Manuscripts in Northumbria in the Eleventh and Twelfth Centuries*, Woodbridge, 2003, esp. pp. 27–48; and R. Gameson, *Manuscript Treasures of Durham Cathedral*, London, 2010, esp. pp. 50–61, nos. 10–12. William of Saint-Calais's Bible is Durham Cathedral A.II.4; the list of donations is on folio 1r. Volume III of Augustine on the Psalms is Durham Cathedral B.II.14; the verse about being commissioned by Bishop William is on the last leaf. The statement by Symeon of Durham that William sent books back from his exile, referred to here on p. 264, is in T. Arnold, ed., *Symeonis monachi opera omnia*, I, 1882 (Rolls Series, 75), p. 128. Volume II of Augustine on the Psalms is Durham B.II.13; the initial with the portrait of Robert Benjamin is on folio 102r. Michael Gullick kindly read this chapter in an early draft and made wise suggestions. Nearly all the identifications of scribes on pp. 266–7 here are by him and derive from his article 'The Scribe of the Carilef Bible', published in 1990. Manuscripts by the Bible scribe cited here are the additions to Durham B.II.13, e.g., folio 23r (Augustine), Paris, Musée des Archives nationales, 138 (the Bayeux entry in the mortuary roll of Abbot Vitalis), Bodleian Library, MS Bodley 810 (Lanfranc, from Exeter) and Bayeux, Bibliothèque municipale, mss 57–8 (the two-volume Gregory). The Origen also corrected by the scribe who corrected the Bible is Durham B.III.1. Its principal scribe worked on Durham B.III.10 (Gregory), Bodleian Library, MS Bodley 301 (Augustine, from Exeter) and probably Rouen, Bibliothèque municipale, ms A 103 (460) (Augustine, from Jumièges). Robert Benjamin worked on Bodley 301, Bayeux 57-58, already cited, and on Rouen, Bibliothèque municipale, ms A 85 (467) (Augustine, from Saint-Ouen). I claim no originality in the conclusion that Hugo Pictor too worked somewhere in Normandy: in addition to the articles already mentioned, see the deceptively unassuming paper-wrapped catalogue of an exhibition mounted jointly by the Bibliothèque municipale and the Musée des Beaux-Arts in Rouen in 1975, *Manuscrits normands, XI–XII^{ème} siècles*, compiled by François Avril, esp. pp. 49–51, nos. 42–4; and observations by C. R. Dodwell, *The Canterbury School of Illumination, 1066–1200*, Cambridge, 1954, pp. 115–18, and J. J. G. Alexander, *Medieval Illuminators and*

Their Methods of Work, 1992, cited above too, esp. pp. 10–11. On pp. 268–9 I describe initials in the first part of Bodley 717 as not fitting the spaces allotted to them: examples are folios 16r, 31v, 61r, 87r, 104r and others; those by Hugo Pictor which fit snugly are on folios 201v, 216v, 230v, 256v and 270v. The attributions of other manuscripts to the hand of Hugo Pictor, listed here on pp. 269–70, derive entirely from Gullick, Gameson and Thomson on script and from Pächt and Avril on decoration. The manuscripts listed here are Bodley MS 691 (Augustine, from Exeter), Bodley 783 (Gregory, also from Exeter), Durham B.II.9 (Jerome, given by William of Saint-Calais to Durham), Stockholm, Riksarchivet, Frag. 194–5 (homilies), Rouen ms A 366 (539) (Anselm, named as archbishop on folios 1r and 111r, from Jumièges), Rouen ms Y 109 (1408) (lives of the saints, also from Jumièges), and Paris, Bibliothèque nationale de France, ms lat. 13765, folio B (hymnal fragment). The fragments in Stockholm are described in M. Gullick on pp. 57–8 of 'Preliminary observations on Romanesque manuscript fragments of English, Norman and Swedish origin in the Riksarkivet (Stockholm)', in J. Brunius, ed., *Medieval Book Fragments in Sweden: An International Seminar in Stockholm, 13–16 November 2003*, Stockholm, 2005 (*KVHAA Konferenser*, 58), pp. 31–82. They comprise parts of two homilies; the list of texts given to Durham by William of Saint-Calais includes "II. libri sermonum & omeliaru[m]", not otherwise known to survive, and one of them might have reached Scandinavia among manuscripts supplied from northern England, a route which will recur in Chapter Seven. The suggestion that William of Saint-Calais took over the patronage of Durham B.II.13–14 half-way through, alluded to here on p. 272, was made by Gameson, *Manuscript Treasures*, p. 59. For the formula 'frater' used by a monastic illuminator, compare "fr. Rufillus" who inscribed a self-portrait of himself decorating a twelfth-century Lectionary from Weissenau Abbey (Geneva, Bibliotheca Bodmeriana, Cod. 127, folio 244r); cf. Alexander, *Medieval Illuminators*, cited above, pp. 10–20, including a discussion of Hugo Pictor's occupation on p. 10 and examples of other professional illuminators describing themselves as 'pictor'. On the earliest hired scribes and artists, see M. Gullick, 'Professional Scribes in Eleventh- and Twelfth-Century England', *English Manuscript Studies, 1100–1700*, 7, 1998, pp. 1–24. For William de Brailes, introduced on p. 273, see especially C. Donovan, *The de Brailes Hours: Shaping the Book of Hours in Thirteenth-Century Oxford*, London, 1991; his two signed self-portraits are British Library, Add. MS 49999, folio 43r, and Cambridge, Fitzwilliam Museum, MS 330, folio 3r. The presence of William of Saint-Calais as witness in charters for Bayeux in 1089 is recorded in V. Bourrienne, ed., *Antiquus cartularius ecclesiae Baiocencis (Livre Noir)*, I, Rouen, 1902, pp. 8 and 12. The classic account of quill-cutting and holding a pen is E. Johnston, *Writing & Illuminating, & Lettering*, London, 1906, pp. 51–60 and 64–70, reprinted countless times since; I owe other observations, including the benefit of sitting on a bench rather than in a chair, to conversations with the modern scribe Donald Jackson. For chairs with dragon heads at the ends of arms, however, see D. M. Wilson, *The Bayeux Tapestry*, London, 1985, pls. 10 and 13. The colophon "Tres digiti scribunt ..." occurs, for example, in British Library, Royal MS 6.A.VI, folio 109r, a late eleventh-century manuscript of Aldhelm.

CHAPTER SEVEN The Copenhagen Psalter

High-quality digital images of the Copenhagen Psalter currently only as far as folio 18r are available on the Royal Library's *e-manuskripter* website. All the principal illumination is described and illustrated in a huge volume, M. Mackeprang, V. Madesen and C. D. Petersen, *Greek and Latin Illuminated Manuscripts X–XIII Centuries in Danish Collections*, Copenhagen, London and Oxford, 1921, pp. 32–42 and pls. 48–60. The manuscript is catalogued in C. M. Kauffmann,

Romanesque Manuscripts, 1066–1190, London and New York, 1975 (*A Survey of Manuscripts Illuminated in the British Isles*, 3), pp. 118–20, no. 96, and plates including colour frontispiece.

The return of the True Cross, which is probably also intended in the scene of the Entry into Jerusalem, as described on p. 289, has partial parallel in an eleventh-century Sacramentary from Mont Saint-Michel (New York, Morgan Library, M 641, folio 155v); cf. J. J. G. Alexander, *Norman Illumination at Mont St. Michel, 966–1100*, Oxford, 1970, p. 159, n.1. The British Library exhibition mentioned on p. 291 was S. McKendrick, J. Lowden, K. Doyle and others, *Royal Manuscripts: The Genius of Illumination*, London, 2011. Basic references for the other five great Psalters, first listed on p. 292 and mentioned again throughout the chapter, are (1) the Hunterian Psalter (Glasgow, University Library, MS Hunter 229): T. S. R. Boase, *The York Psalter*, London, 1962; Kauffmann, *Romanesque Manuscripts*, as above, pp. 117–18, no. 9; and N. Thorp, *The Glory of the Page: Medieval & Renaissance Illuminated Manuscripts from Glasgow University Library*, London, 1987, pp. 62–5, no. 14; (2) the Ingeborg Psalter (Chantilly, Musée Condé, ms 9): facsimile, F. Deuchler, ed., *Ingeborg-Psalter, Le Psautier d'Ingeburge de Danemark, Ms. 9 olim 1695, Musée Condé, Chantilly*, Graz, 1985 (*Codices Selecti*, 80); (3) the Psalter of Blanche of Castile (Paris, Bibliothèque de l'Arsenal, ms 9): H. Martin, ed., *Psautier de Saint Louis et de Blanche de Castile*, Paris, 1909; V. Leroquais, *Les psautiers manuscrits des bibliothèques publiques de France*, Macon, 1940, I, pp. xcvii–xcviii, and II, pp. 13–17, and, like other manuscripts here, it is in I. F. Walther and N. Wolf, *Codices Illustres: The World's Most Famous Illuminated Manuscripts, 400 to 1600*, Cologne, 2001 (a wasted opportunity for what might have been a wonderful book), pp. 162–3; (4) the 'Avranches' Psalter (Los Angeles, J. Paul Getty Museum, MS 66): [apparently F. Avril], *Un très précieux Psautier du temps de Philippe Auguste*, Paris, 1986 (a dealer's catalogue forRatton and Ladrière, but so far much the most detailed description in print), and brief publication in T. Kren, *French Illuminated Manuscripts in the J. Paul Getty Museum*, Los Angeles, 2007, pp. x–xi and 12–14; and (5) the Leiden Psalter (Leiden, Universiteitsbibliotheek, Cod. BPL 76A): N. Morgan, *Early Gothic Manuscripts*, I, *1190–1250*, London and New York, 1982 (*A Survey of Manuscripts Illuminated in the British Isles*, 4), pp. 61–2, no. 14, and now, like the *Aratea*, available in good images from the Digital Special Collections website of the university of Leiden. On different occasions, I have personally inspected all five manuscripts. The full reference to the first description of the Copenhagen Psalter, mentioned on pp. 296–7, is Johann Heinrich von Seelen, *Meditationes Exegeticae, quibus Varia Utriusque Testamenti, Loca Expenduntur et Illustrantur*, Lübeck, 1737, part V, pp. 185–95, *De Psalterio manuscripto Capelliano ob singularem elegantiam commemorabili observatio*; I was proud of having stumbled on this reference independently but I learned afterwards that it is cited, with other facts I would never have found, in E. Petersen, 'Suscipere Digneris: Et fund og nogle hypoteser om Københavnerpsalteret Thott 143 2° og dets historie', *Fund og Forskning i Det Kongelige Biblioteks Samlinger*, 50, 2011, available on-line. The Psalter is listed in the *Catalogi Bibliothecae Thottianae*, VII, Copenhagen, 1795, pp. 287–8. For eighteenth-century printed gilt paper, often loosely called 'Dutch' (actually usually German), see E. W. Mick, *Altes Buntpapier*, Dortmund, 1979. The Dagulf Psalter, cited here on p. 298, is Vienna, Österreichische Nationalbibliothek, Cod. 1861. The other very great twelfth-century Psalter, this manuscript's only serious rival, is the Albani or St Albans Psalter, now in Hildesheim, Dombibliothek (cf. K. Collins, *The St Albans Psalter: Painting and Prayer in Medieval England*, Los Angeles, 2013). The alphabet and Pater Noster in the Copenhagen Psalter, described on p. 298 too, are on folio 189v. A similar but much later example is in the Primer of Claude de France, Cambridge, Fitzwilliam Museum, MS 159, p. 2 (*The Cambridge Illuminations*, 2005, pl. on p. 230); for children's printed boards with the alphabet and the Lord's Prayer, see L. Shepard, *The History of the Horn Book: A Bibliographical Essay*, London, 1977. Professor Norton's article,

summarized on pp. 302–3, is C. Norton, 'Archbishop Eystein, King Magnus and the Copenhagen Psalter: A New Hypothesis', pp. 184–215 in K. Bjørlykke, Ø. Ekroll, B. Syrstad Gran and M. Herman, eds., *Eystein Erlendsson – Erkebiskop, Politiker og Kirkebygger*, Trondheim, 2013. In pacing this chapter, I kept back the references to Patricia Stirnemann's publications to a point where they could be brought out with a drumroll for maximum effect, which means that they seem to appear further down this bibliography than their importance merits. They are P. Stirnemann, 'The Copenhagen Psalter', dissertation, Columbia University, 1976, photocopy, Ann Arbor, 1979 (I had a copy with me in Denmark); P. Stirnemann, 'Histoire tripartite: Un inventaire des livres de Pierre Lombard, un exemplaire de ses *Sentences* et le destinataire du Psautier de Copenhague', pp. 301–18 in D. Nebbiai-Dalla Guarda and J.-F. Genest, eds., *Du copiste au collectionneur: Mélanges d'histoire des textes et des bibliothèques en l'honneur d'André Vernet*, Turnhout, 1998; P. Stirnemann, 'The Copenhagen Psalter', pp. 67–76 in E. Petersen, ed., *Living Words & Luminous Pictures: Medieval Book Culture in Denmark*, Copenhagen, 1999; and P. Stirnemann, 'The Copenhagen Psalter (Kongel. Bibl. ms Thott 143 2°) Reconsidered as a Coronation Present for Canute VI', pp. 323–8 in F. O. Büttner, ed., *The Illuminated Psalter: Studies in the Content, Purpose and Placement of Its Images*, Turnhout, 2004. The association of the Psalter with the iconography of the stone font of *c.* 1170 in Ringsted church, identifying the Entry into Jerusalem as a symbol of royal coronation, is discussed on pp. 131–3 of K. Markus, 'Baptism and the King's Coronation: Visual Rhetoric of the Valdemar Dynasty and Some Scanian and Danish Baptismal Fonts', pp. 122–42 in K. Krodres and A. Mänd, eds., *Images and Objects in Ritual Practices in Medieval and Early Modern Northern and Central Europe*, Newcastle upon Tyne, 2013. On the addition of calendars to psalters, a digression on pp. 306–7, see R. W. Pfaff, 'Why do Psalters have Calendars?' in his collected essays – it was actually a lecture – *Liturgical Calendars, Saints, and Services in Medieval England*, Aldershot and Brookfield, Vt, 1998, item VI, pp. 1–15; the two earliest examples are the Bosworth Psalter (British Library, Add. MS 37517, late tenth century) and the Salisbury Psalter (Salisbury Cathedral, MS 150, *c.* 969–89). On northern English Augustinian calendars, not much like the one in Copenhagen, see R. W. Pfaff, *The Liturgy in Medieval England: A History*, Cambridge, 2009, pp. 290–93. Carl Nordenfalk, aware of the northern flavour of the calendar, nonetheless ascribed the Copenhagen Psalter to southern England (*Gyllene böcker: Illuminerade medeltida handskrifter i Dansk och Svensk ägo*, Stockholm, 1952, pp. 30–31, no. 24). On p. 310 I compare the script with that of the Bury and Lambeth Bibles, which I think were both written by a single scribe (Cambridge, Corpus Christi College, MS 2, and London, Lambeth Palace Library, MS 3; cf. R. M. Thomson, *The Bury Bible*, Woodbridge and Tokyo, 2001, and D. M. Shepard, *Introducing the Lambeth Bible*, Turnhout, 2007). The identification of the relics of Remigius as coming from the saintly bishop of Lincoln (d. 1092) rather than from the much earlier Remigius of Rheims (d. 533) is because these were body tissue and not bones, as noted by both Stirnemann and Norton. On p. 313 I list several manuscripts in which Patricia Stirnemann has recognized the hand of the artist of psalms 1–54 of the Copenhagen Psalter and psalms 1–101 of the Hunterian Psalter: they are Troyes, Médiathèque, ms 900 (Peter Lombard, *Sentences*, credibly dated 1158); Oxford, St John's College, MS 49 (Peter Lombard, *Sentences*, owned by Hilary, bishop of Chichester, who was in France in 1163 and 1164 and who died in 1169); Paris, Bibliothèque nationale de France, ms lat. 17246 (Peter Lombard's Great Gloss on the Pauline Epistles); and Paris, Bibliothèque de l'Arsenal, ms 939 (miracles of Saint Augustine). The rules on the scriptorium at Saint-Victor, mentioned on pp. 313–14, are published in L. Milis, ed., *Liber ordinis Sancti Victoris Parisiensis*, Turnhout, 1984 (*Corpus Christianorum, Continuatio Medievalis*, 61), pp. 78–9. Some account of the abbey and the importance of Victorine studies is found in E. A. Matter and L. Smith, eds., *From Knowledge to Beatitude: St Victor, Twelfth-*

Century Scholars, and Beyond: Essays in Honor of Grover A. Zinn, Jr., Notre Dame, Ind., 2013. The three-volume Manerius Bible, mentioned on p. 314, is Paris, Bibliothèque Sainte-Geneviève, mss 8–10; its scribe was from Canterbury and his family is documented; cf. Dodwell, *The Canterbury School of Illumination*, cited in the notes to Chapter Six, p. 588, and W. Cahn, *Romanesque Manuscripts: The Twelfth Century*, London, 1996 (*A Survey of Manuscripts Illuminated in France*, 3), II, pp. 99–102, no. 81. Note that in referring to individual Latin psalms here and elsewhere in this book I am using the medieval Vulgate numbering: most modern Bibles are based on the Hebrew text but the Latin Vulgate, taken from the Greek Septuagint, combines the modern Psalms 9–10 into one and thereafter its numbering runs one behind until Psalm 147, which it divides into two, thus coming back to the total of 150 by the end. Saint Bernard's denunciation of monstrosities in art – and it goes on much longer than this (pp. 320–22) – is translated from his *Apologia* addressed to William, abbot of Saint-Thierry, in 1125 (J. Leclerq and H. M. Rochais, eds., *Sancti Bernardi opera*, III, Rome, 1963, p. 106). The man shaving a hare in the Bury Bible, mentioned on p. 323, is Cambridge, Corpus Christi, MS 2, folio 1v, interpreted as a proverb by M. Camille, *Image on the Edge: The Margins of Medieval Art*, London, 1992, pp. 18–20. For the Simon Master, see W. Cahn, 'St Albans and the Channel Style in England', pp. 187–211 in J. Hoffeld, ed., *The Year 1200: A Symposium*, New York, 1970 (including the Copenhagen Psalter on p. 189); R. M. Thomson, *Manuscripts from St Albans Abbey, 1066–1235*, Woodbridge, 1982, pp. 54–62 and 126–8; and D. Jackson, N. Morgan and S. Panayotova, *A Catalogue of Western Book Illumination in the Fitzwilliam Museum and the Cambridge Colleges*, III, i, *France, c. 1000–c. 1250*, London and Turnhout, 2015, pp. 141–5. The monasteries listed on p. 325 as owning scholastic books by the Simon Master are Bonport (Numbers glossed, Paris, Bibliothèque nationale de France, ms lat. 74), Liesborn (Genesis glossed, Münster-in-Westfalen, Universitätsbibliothek, Hs 222), Klosterneuburg (works of Aristotle and Boethius, Klosterneuburg, Stiftsbibliothek, Cod. 1089) and Esztergom (Esztergomi Főszékesegyházi Könyvtár [Cathedral library], I.21). The manuscripts attributed to the Simon Master at St Albans are Cambridge, Corpus Christi College, MS 48 (Bible), Cambridge, Trinity College, O.5.8 (Ralph of Flaix); and Stonyhurst College, Lancashire, MS 10 (Gregory). In France, he is known as the Master of the Capucins Bible from his work in Paris, Bibliothèque nationale de France, ms lat. 16743, possibly from Troyes; cf. W. Cahn, *Romanesque Manuscripts: The Twelfth Century*, London, 1996 (*A Survey of Manuscripts Illuminated in France*, 3), II, pp. 96–9, no. 79. Allow me a digression for a moment. We do not know where the Simon Master went after the death of Abbot Simon in 1183; maybe he went back to France. His hand also occurs, however, in the illumination of Corpus Christi College, Cambridge, MS 380, the only known manuscript of the *Speculum Fidei* of Robert of Cricklade, datable by its script to between about 1170 and 1190, and in what is probably the same author's own copy of his *Abbreviatio Plinii* (Windsor, Eton College, MS 134). Robert of Cricklade was prior of St Frideswide's Abbey, another Augustinian house, in Oxford, where he died after 1188, and it is almost inconceivable that the primary manuscripts of his textbooks could have been made anywhere but in Oxford itself. One of the earliest documents suggesting the presence of any academic activity around the site of what later became Oxford University is a charter recording a lease of land in Catte Street beside St Mary's Church there, dated *c.* 1190, witnessed by Roger the illuminator (H. E. Satter, ed. *A Cantulary of the Hospital of St. John the Evangelist*, I, Oxford (Oxford Historical Society, 66), p. 414). Could he have been the Simon Master, temporarily or permanently in Oxford, and is it conceivable that we have stumbled on a candidate for his name? For sewing-holes, discussed on pp. 325–6, see the brief account in C. Sciacca, 'Raising the Curtain on the Use of Textiles in Manuscripts', pp. 161–90 in K. M. Rudy and B. Baert, eds., *Weaving, Veiling and Dressing: Textiles and Their Metaphors in the*

Late Middle Ages, Turnhout, 2007 (a reference I owe to Michael Gullick). Any reader of this, in need of a good topic for a doctorate, requiring first-hand access to multiple manuscripts without the necessity of knowing Latin, could undertake systematic documentation of textile flaps, for the practice was undoubtedly very widespread.

CHAPTER EIGHT The *Carmina Burana*

There is a rather dreary-looking facsimile, *Carmina Burana, Faksimile-Ausgabe der Carmina Burana und der Fragmenta Burana, Handschrift Clm 4660 und 4660a der Bayerischen Staatsbibliothek in München*, Munich, 1967, with an excellent commentary by B. Bischoff, *Einführung zur Faksimile-Ausgabe*, in German and English. A detailed analysis of the manuscript by Otto Schumann is in A. Hilke and O. Schumann, eds., *Carmina Burana, mit Benutzung der Vorarbeiten Wilhelm Meyers, Kritisch Herausgegeben*, II, *Kommentar*, Heidelberg, 1930, pp. 3*–95*. Both have been crucial texts for this chapter. For background before my visit, I began with an old copy of Helen Waddell, *The Wandering Scholars*, London, 1927, and the Penguin Classic edition, D. Parlett, *Selections from the Carmina Burana: A Verse Translation*, Harmondsworth and New York, 1986. Especially useful to me were P. G. Walsh, *Love Lyrics from the Carmina Burana: Edited and Translated*, Chapel Hill, NC, 1993; T. M. S. Lehtonen, *Fortuna, Money, and the Sublunar World: Twelfth-Century Ethical Poetics and the Satirical Poetry of the Carmina Burana*, Helsinki, 1995; and T. Marshall, *The Carmina Burana: Songs from Benediktbeuern*, Los Angeles, 2011. All translations from the songs cited here are my own. I am grateful too for a conversation during a long car journey with Anne Azéma, of the Boston Camerata, who has sung many of the *Carmina Burana*.

On the acquisition of the books from Benediktbeuern, see G. Glauche, *Katalog der lateinischen Handschriften der Bayerischen Staatsbibliothek München: Die Pergamenthandschriften aus Benediktbeuern, Clm 4501–4663*, Wiesbaden, 1994 (*Catalogus Codicum Manu Scriptorum Bibliothecae Monacensis*, n.s., III, i), pp. vii–viii. Surviving manuscripts from Benediktbeuern are listed in S. Krämer, *Handschriftenerbe des deutschen Mittelalters*, Munich, 1989 (*Mittelalterliche Bibliothekskataloge Deutschlands und der Schweiz, Engänzungsband*, 1), pp. 78–9. If nothing else, the confected sequence of leaves described on p. 338 shows that the manuscript was probably a disassembled ruin in the eighteenth century but was reconstructed to look attractive while still in the possession of Benediktbeuern Abbey. The loose leaves never bound in must have been swept up when the library storerooms were vacated in 1803. The reference to Canon Alberic on p. 340 is from M. R. James, *Ghost Stories of an Antiquary*, London, 1906, p. 13. On the evolution of Breviaries, the classic text is V. Leroquais, *Les bréviaires manuscrits des bibliothèques publiques de France*, Paris, 1934. The examples of songs opening with the same words as psalms, mentioned on p. 340, are "Bonum est" (folio 3r) and "Lauda" (folio 3v), the same as Psalms 91 and 146–7; the psalm '*Bonum est*' was the last at Matins in a Breviary, and two successive psalms in Lauds open "Laudate". On p. 343 I mention the *Breviari d'Amor* of Matfre Ermengaud (1246–1322): curiously, manuscripts of that text do not especially resemble Breviaries, and the pun was merely in the name (cf. P. T. Ricketts, *Le Breviari d'amor de Matfre Ermengaud*, Leiden and London, 1976). With their folio numbers reassembled into the original order, the four clusters of texts, introduced on p. 343, would have been (1) moral and satirical poems, folios 43r–48v and 1r–18v; (2) love songs, folios 18v–42v, 49r–v, 73r–82v and 50r–72v; (3) drinking and gaming songs, folios 83r–98v; and (4) religious dramas, folios 99r–112v. On p. 353 is the observation that the figure in the Wheel of Fortune is also suffering the turning of fate: Fortuna is very occasionally found on the wheel herself, an idea mentioned by Honorius of Autun in the early

twelfth century (H. R. Patch, *The Goddess Fortuna in Medieval Literature*, London, 1967, reprinting the edition of 1927, p. 152). The imperial seal of Frederick II made in 1220 is described in R. Haussherr, ed., *Die Zeit der Staufer, Geschichte – Kunst – Kultur*, Stuttgart, 1977, I, p. 34, no. 50, and III, pl. 20. Naturalistic landscape is not really found in European art before the fourteenth century: cf. O. Pächt, 'Early Italian Nature Studies and the Early Calendar Landscape', *Journal of the Warburg and Courtauld Institutes*, 13, 1950, pp. 22–32. An example of a cycle of Creation miniatures, like those alluded to on p. 355, is the late twelfth-century Bestiary, Oxford, Bodleian Library, MS Ashmole 1511, folios 5r (creation of plants and trees), 6r (creation of birds and fish) and 6v (creation of animals). I owe to Nigel Morgan the observation on p. 357 that the Virgin Mary holding a flower seems to appear first in thirteenth-century German art. The letter of Peter of Blois, cited here on pp. 364–5, is Ep. LVII (Migne, *Patrologia Latina*, CCVII: 171–2). For the author, see R. W. Southern, 'The Necessity for two Peters of Blois', pp. 103–17 in L. M. Smith and B. Ward, eds., *Intellectual Life in the Middle Ages: Essays Presented to Margaret Gibson*, London, 1992. The classic demonstration of the 'above/below top line' rule, quoted on pp. 368/70, is N. R. Ker, 'From "Above Top Line" to "Below Top Line": A Change in Scribal Practice', *Celtica*, 5, 1960, pp. 13–16, reprinted in A. G. Watson, ed., *N. R. Ker, Books, Collectors and Libraries: Studies in the Medieval Heritage*, London, 1985, pp. 71–4. For Bernhard Bischoff (1906–91), regarded as the giant among all modern palaeographers, see S. Krämer, *Bibliographie Bernhard Bischoff und Verzeichnis aller von ihm herangezogenen Handschriften*, Frankfurt, 1998 (*Fuldaer Hochschulschriften*, 27). His judgements still command huge respect. The article by Georg Steer, mentioned on p. 370, is '"Carmina Burana" in Südtirol, Zur Herkunft des Clm 4660', *Zeitschrift für deutsches Altertum und deutsche Literatur*, 112, 1983, pp. 1–37. On the reordering of knowledge in the late twelfth century as reflected in the design of manuscripts, see M. B. Parkes, 'The Influence of the Concepts of *Ordinatio* and *Compilatio* on the Development of the Book', pp. 35–70 in *Medieval Learning and Literature: Essays Presented to Richard William Hunt*, Oxford, 1976, and M. A. Rouse and R. H. Rouse, '*Statim invenire*: Schools, Preachers and New Attitudes to the Page', pp. 201–25 in R. L. Benson and G. Constable, eds., *The Renaissance of the Twelfth Century*, Cambridge, Mass., 1982, reprinted in the Rouses' *Authentic Witnesses: Approaches to Medieval Texts and Manuscripts*, Notre Dame, Ind., pp. 191–219. For the life of Orff, I looked at A. Liess, *Carl Orff*, transl. A. and H. Parkin, London, 1966, and, not altogether comprehendingly, at W. Thomas, *Das Rad der Fortuna: Ausgewählte Aufsätze zu Werk und Wirkung Carl Orffs*, Mainz, 1990. Most of the tale as told here is derived from H. Schaefer and W. Thomas, eds., C. Orff, *Carmina Burana, Cantiones profanae cantoribus et choris cantandae comitantibus instrumentis atque imaginibus magicis, Faksimile der autographen Partitur in der Bayerischen Staatsbibliothek München*, Mainz and London, 1997, including W. Thomas, '"Fortune smiled on me …" The Genesis and Influence of the Carmina Burana', pp. xvii–xxi, translated by D. Abbott; and from F. Dangel-Hofmann, ed., *Briefe zur Entstehung der Carmina Burana, Carl Orff und Michel Hofmann, Herausgegeben und Kommentiert*, Tutzing, 1990. The review from the Royal Festival Hall published on 12 June 1951, p. 8, was found by searching for 'Burana' in the *The Times Digital Archive*.

CHAPTER NINE The Hours of Jeanne de Navarre

For an enterprising publisher, a facsimile of the Hours of Jeanne de Navarre would be a wonderful undertaking. There are some digital images, with the expectation of many more, on the *Mandragore* website for illuminated manuscripts in the Bibliothèque nationale de France. The most comprehensive published sequence is still the Roxburghe Club book of H. Yates

Thompson, *Thirty-Two Miniatures from the Book of Hours of Joan II, Queen of Navarre: A Manuscript of the Fourteenth Century*, London, 1899, and the standard description is still S. C. Cockerell, pp. 151–83, no. 75, in Yates Thompson's *A Descriptive Catalogue of the Second Series of Fifty Manuscripts*, 1902, cited above in the bibliography for Chapter Five.

For Berchtesgaden in 1945, I consulted A. H. Mitchell, *Hitler's Mountain: The Führer, Obersalzburg and the American Occupation of Berchtesgaden*, Jefferson, NC, and London, 2007 (the story of the brick is on p. 131). The recovery of the *Très Belles Heures* is recounted by its finder, Francis Rogé, 'Tribulations d'un manuscrit à peintures du XVe siècle', pp. 337–40 in *Valenciennes et les anciens Pays-Bas: Mélanges offerts à Paul Lefrancq*, Valenciennes, 1976 (*Publication du Cercle Archéologique et Historique de Valenciennes*, IX). I should make it quite clear, for one early reader of this chapter was unsure, that the Duc de Berry owned a number of Books of Hours, popularly known now from the words used in descriptions in his inventory as the *Très Belles Heures* (in Paris), the *Petites Heures* (also in Paris), the *Très Riches Heures* (at Chantilly), the *Belles Heures* (in New York), and so on: these are all different manuscripts. The recollections by Maurice Rheims were published in English as *The Glorious Obsession*, transl. P. Evans, London, 1980, pp. 224–7. I am indebted to conversations long ago with both Marcel Thomas and François Avril (and indeed briefly with Maurice Rheims) on the acquisition of the Hours of Jeanne de Navarre, in preparation for my Delisle Lectures at the Bibliothèque nationale, 1998, published in English as C. de Hamel, *The Rothschilds and Their Collections of Illuminated Manuscripts*, London, 2005 (Berchtesgaden is mentioned on p. 41); an updated list of Baron Edmond's manuscripts is F. Avril, 'The Bibliophile and the Scholar: Count Paul Durrieu's List of Manuscripts Belonging to Baron Edmond de Rothschild', pp. 366–76 in J. H. Marrow, R. A. Linenthal and W. Noel, eds., *The Medieval Book, Glosses from Friends & Colleagues of Christopher de Hamel*, 't Goy-Houten, 2010. The full title of the *Répertoire* is Commandement en chef français en Allemagne, Groupe français du conseil de controle, *Répertoire des biens spoliés en France durant la guerre 1939–1945*, VII, *Archives, manuscrits et livres rares*, n.p., n.d. The Hours of Jeanne de Navarre was cited as 'whereabouts unknown' in numerous references to it in M. Meiss, *French Painting in the Time of Jean de Berry: The Late XIV Century and the Patronage of the Duke*, London and New York, 1967; it was even described as untraced in F. Avril, 'Trois manuscrits de l'entourage de Jean Pucelle', *Revue de l'Art*, 9, 1970, pp. 37–48 (although by the time the article appeared he would have seen the manuscript). Numerous other publications by Monsieur Avril since then have discussed it, including *Manuscript Painting in the Court of France: The Fourteenth Century (1310–1380)*, transl. U. Molinaro, London, 1978, esp. pp. 68–73, pls. 15–17; the exhibition entry in *Les Fastes du Gothique: Le siècle de Charles V, Galeries nationales du Grand Palais, 9e octobre 1981–1er février 1982*, Paris, 1981, pp. 312–14, no. 265; and his commentary to the facsimile, *Les Petites Heures du Duc de Berry*, Lucerne, 1988–9, esp. pp. 115–23. This chapter is immeasurably indebted to all of these. Folio numbers for the components of the text, summarized on pp. 385–6, are: (1) the calendar, folios 4r–9v; (2) the Hours of the Holy Trinity, folios 11r–38r; (3) the Hours of the Virgin Mary, folios 39r–72r; (4) various short prayers, folios 72v–74v; (5) the Penitential Psalms and litany, folios 75r–85r; (6) the Hours of Saint Louis, folios 85v–105v; (7) the Hours of the Cross, folios 109r–116r; (8) miscellaneous prayers in honour of various saints, especially the Virgin Mary and the Trinity, in Latin and French, folios 116v–145r; (9) Suffrages, or prayers addressed to particular saints, folios 145v–150r; (10) other short prayers, folios 150v–158v; (11) the Office, or Vigils, of the Dead, folios 158v–182v; (12) further Suffrages, folios 183r–193v; (13) the special variants of the Hours of the Virgin for use in Advent, folios 194r–219v; (14) the special variants of the Hours of the Virgin for use between Christmas and the feast of the Purification, folios 220r–246r; (15) the Psalter of Saint Jerome and other prayers, folios 247r–257r; and (16) miscellaneous ad-

The tree diagram content:

Saint Louis
1215–1270
king of France 1226–70

Philippe III
1245–1285
king of France 1270–85

Philippe IV, le bel
1268–1314
king of France 1285–1314

Louis d'Évreux
1276–1319

Charles de Valois
1270–1325

Louis X
1289–1316
king of France 1314–16

Philippe VI
1293–1350
king of Navarre 1328–50

Jeanne de Navarre
1312–1349
queen of Navarre 1328–49

Philippe d'Évreux
1306–1343
king of Navarre 1328–43

Jeanne d'Évreux
1310–1371

Jean II, le Bon
1319–1364
king of France 1350–64

Bonne of Luxembourg
1315–1349

Charles II of Navarre
1332–1387
king of Navarre 1349–87

Jeanne de France
1343–1373

Charles V
1338–1380
king of France 1364–80

Jean, duc de Berry
1340–1416

Henry IV
1367–1413
king of England 1399–1413

Joan of Navarre
c. 1370–1437
queen of England

Isabeau of Bavaria
1370–1435

Charles VI
1368–1422
king of France 1380–1422

Henry V
1386–1422
king of England 1413–1422

Catherine of Valois
1401–1437
queen of England

The principal descendants of Saint Louis mentioned in Chapter 9, with the certain or hypothetical owners of the Hours of Jeanne de Navarre indicated in bold type

ditions, in later hands, folios 257v–271v. The best account of the manuscript's text is M. M. Manion, 'Women, Art and Devotion: Three French Fourteenth-Century Royal Prayer Books', pp. 21–66 in M. M. Manion and B. J. Muir, eds., *The Art of the Book: Its Place in Medieval Worship*, Exeter, 1998, esp. pp. 24–5 and 45–50 (the Hours of Jeanne de Navarre is illustrated on the front cover). For the history of Books of Hours in general, the classic text is the introduction to V. Leroquais, *Les livres d'heures manuscrits de la Bibliothèque nationale*, Paris, 1927, pp. i–lxxxv. There are two fine exhibition catalogues by R. S. Wieck, *Time Sanctified: The Book of Hours in Medieval Art and Life*, New York, 1988 (for the Walters Art Gallery in Baltimore), and *Painted Prayers: The Book of Hours in Medieval and Renaissance Art*, New York, 1997 (for the Morgan Library). We now also have S. Hindman and J. H. Marrow, eds., *Books of Hours Reconsidered*, London, 2013, including A. Bennett, 'Some Perspectives on the Origins of Books of Hours in France in the Thirteenth Century', pp. 19–40, and N. Morgan, 'English Books of Hours, *c.* 1240–*c.* 1480', pp. 65–95 (citing the Hours of Jeanne de Navarre on pp. 68–9). On p. 391 I describe how often the illumination of the manuscript includes kneeling figures of a queen: she is in initials on folios 68r, 122v, 131v, 152r, and others), and within miniatures on folios 125v and 137v. The examples I give of prayers in the female form are on folios 255v, 149v, 150v, and 151v. The mention of Jeanne by name on folio 151v of the manuscript occurs in the prayer beginning "Deprecor te o domina sanctissima maria …". It is a reminder that it is always worth skimming prayers in Books of Hours in the hope of coming upon personal names of owners. The first Book of Hours I ever worked on was MS 5 in the Dunedin Public Library: one prayer then unnoticed happens to ask for help for "me margeriam fitzherbert" (folio 87r); another, more famous, is Lambeth Palace MS 474, a modest enough Book of Hours with an inconspicuous prayer invoking Christ's help for "me famulum tuum regem Ricardum" (folio 182r), identifying the owner as Richard III, king of England 1483–5 (A. F. Sutton and L. Visser-Fuchs, *The Hours of Richard III*, Stroud, Gloucs., and Wolfeboro Falls, NH, 1990). For the Hours of Saint Louis, see M. Thomas, 'L'iconographie de Saint Louis dans les Heures de Jeanne de Navarre', pp. 209–31 in *Septième centenaire de la mort de Saint Louis: Actes des colloques de Royaumont et de Paris (21–27 mai 1970)*, Paris, 1976; and M. C. Gaposchkin, *The Making of Saint Louis: Kingship, Sanctity and Crusade in the Later Middle Ages*, Ithaca, NY, and London, 2008, and her *Blessed Louis: The Most Glorious of Kings: Texts Relating to the Cult of Saint Louis*, Notre Dame, Ind., 2012. The three other manuscripts which include the Hours of Saint Louis, listed on p. 394, are (1) New York, Public Library, Spencer MS 56 (the Hours of Blanche of Burgundy; cf. the entry by Lucy Sandler in J. J. G. Alexander, J. H. Marrow and L. F. Sandler, *The Splendor of the Word, Medieval and Renaissance Illuminated Manuscripts at the New York Public Library*, New York, London and Turnhout, 2005, pp. 223–6, no. 46); (2) the Hours of Jeanne d'Évreux (New York, Metropolitan Museum of Art, Acc. 54.1.2; facsimile, *The Hours of Jeanne d'Évreux, Acc. No. 54.1.2, The Metropolitan Museum of Art, The Cloisters Collection, New York*, commentary by B. Drake Boehm, A. Quandt, and W. D. Wixom, Lucerne, 2000); and (3) the Hours of Marie de Navarre (Venice, Biblioteca nazionale Marciana, cod. lat. I.104 (12640); facsimile, *Libro de Horas de la reina María de Navarra*, commentary by M. Zorzi, S. Marcon, and others, Barcelona, 1996). The heading to the Hours of Saint Louis in the now-destroyed Savoy Hours in Turin, quoted on p. 394, was printed by P. Durrieu, 'Notice d'un des plus importants livres des prières du roi Charles V, Les Heures de Savoie', pp. 500–555 in *Bibliothèque de l'École des Chartes*, 72, 1911, p. 510. The miniature of Saint Louis learning to read, mentioned on p. 396, is on folio 85v of the Hours of Jeanne de Navarre; the actual Psalter being used in the picture is Leiden Universiteitsbibliotheek, Cod. BPL 76A, and the inscription identifying it as having been used by Saint Louis is of about the same date as the Hours of Jeanne de Navarre. The prayers to Saint Apollonia and the life of Saint Margaret in the Hours of Jeanne de

Navarre, cited on p. 397, are respectively on folios 131r and 133r–134v of the manuscript. The rubric beginning *"Vous devez savoir ..."* is on folio 43v and is printed in Manion, 'Women, Art and Devotion', as above, pp. 35–6. The miniature of Jeanne giving alms to the poor is on folio 123v. For marginal drolleries, of the kind described on pp. 399–401, the classic texts are L. M. C. Randall, *Images in the Margins of Gothic Manuscripts*, Berkeley and Los Angeles, 1966, with provocative interpretation by M. Camille, *Image on the Edge: The Margins of Medieval Art*, London, 1992. The two-volume Belleville Breviary is introduced on p. 405. It is Paris, Bibliothèque nationale de France, ms lat. 10484; there is no facsimile – there should be – but it is illustrated in Avril, *Court of France*, pp. 60–63, Walther and Wolf, *Codices Illustres*, pp. 206–7, and elsewhere. It belonged to Charles V but its original patron is unsure, possibly Jeanne de Belleville, wife of Olivier de Clisson, whose possessions were forfeited to the king in 1343. Charles V gave it to Richard II of England, whose successor, Henry IV, presented it back to the Duc de Berry, when its calendar became the model for another generation of copies, including the *Grandes Heures* of the Duc de Berry (Bibliothèque nationale de France, ms lat. 919). The Hours of Jeanne de Navarre was at one time actually attributed to Jean Pucelle, artist of the Hours of Jeanne d'Évreux (cf. K. Morand, *Jean Pucelle*, Oxford, 1962, pp. 20–21 and 48–9); for the relationship between those two manuscripts, see especially Avril, *Court of France*, p. 68, "Pucelle's ghost still haunts the manuscript in a number of places", and Boehm, 'The Cloisters Hours and Jean Pucelle', pp. 89–116. The first artist of the Hours of Jeanne de Navarre, described on p. 408, was principally identified by François Avril in *Les Fastes du Gothiques*, citing an illuminated legal claim to the county of Artois, dated 1336 (Paris, Bibliothèque nationale de France, ms fr. 18437), and two copies of Thomas Aquinas, both now in Italy (Florence, Biblioteca Laurenziana, cod. Fiesole 89, and Vatican, Biblioteca Apostolica, cod. Vat. lat. 744, dated 1343). Other works by the third artist, identified by Avril as Jean le Noir, include the Breviary of Charles V and the *Petites Heures* of the Duc de Berry (Paris, Bibliothèque nationale de France, mss lat. 1052 and 18014). For Jean le Noir as a historical personality, see the altogether fascinating volumes by R. H. Rouse and M. A. Rouse, *Manuscripts and Their Makers: Commercial Book Producers in Medieval Paris, 1200–1500*, Turnhout, 2000, I, pp. 265–7, and II, p. 79. The fourth artist, as numbered by Cockerell, painted folios 145v–150v and 183r–193v. The suggestion that this hand, who may be the artist Mahiet, represents a later phase in the decoration of the manuscript has been made by M. Keane, 'Collaboration in the Hours of Jeanne de Navarre', pp. 131–48 in A. Russakoff and K. Pyun, eds., *Jean Pucelle: Innovation and Collaboration in Manuscript Painting*, Turnhout, 2013, esp. pp. 131–46 and p. 146, n. 1. The miniature of Saint Louis of Marseilles, mentioned on p. 413, is on folio 191r. The page where the arms of Philippe d'Évreux have been overpainted with those of Charles V is folio 52r. The first tentative identification of this manuscript with the entry in the inventory of the Duc de Berry was made by F. Avril and P. D. Stirnemann, *Manuscrits enluminés d'origine insulaire VIIe–XXe siècle*, Paris, 1987, pp. 177–8, no. 219. The inventory is L. Delisle, *Recherches sur la librairie de Charles V, roi de France, 1337–1380*, II, Paris, 1907, p. 238*, no. 97. The English artist of the frontispiece is discussed in K. L. Scott, *Later Gothic Manuscripts, 1390–1490*, London, 1990 (*A Survey of Manuscripts Illuminated in the British Isles*, VI), II, p. 214. The Hours of Catherine of Valois, mentioned here on p. 417, is London, British Library, Add. MS 65100; it was previously Upholland College, Lancashire, MS 42 (Christie's, 2 December 1987, lot 34). The account of the manuscript in the convent in the rue de Lourcines, described on p. 418, is A. Longnon, *Documents Parisiens sur l'iconographie de S. Louis publiés par Auguste Longnon d'après un manuscrit de Peiresc conservé à la Bibliothèque de Carpentras*, Paris, 1882, pp. 7–11, 21–66 and plates VII–XII engraved from Peiresc's drawings. As noted on p. 418, the manuscript was clearly no longer in the possession of the nuns by the French Revolution: in 1790 the last abbess

declared that they owned only 200 books, all of a religious nature, and the commissioners who inspected the library reported nothing of value (A. Franklin, *Les anciennes bibliothèques de Paris: églises, monastères, colléges, etc.*, III, Paris, 1873, pp. 401–2). On MacCarthy, see C. Ramsden, 'Richard Wier and Count MacCarthy', *The Book Collector*, 2, 1953, pp. 247–57; the suggestion that the Hours of Jeanne de Navarre was a MacCarthy manuscript was first made by S. De Ricci, *Les manuscrits de la collection Henry Yates Thompson*, Paris, 1926, p. 60, no. 75. The library was described in *Catalogue des livres rares et précieux de la bibliothèque de feu M. le comte de Mac-Carthy Reagh*, I, i, Paris, 1815. The identification with lot 392 on p. 64 is more or less absolute: it is described as a richly illuminated prayerbook with miniatures and borders of great beauty, small quarto in size, bound in citron morocco gilt, with 542 pages, which is 271 leaves, absolutely right, too exact for coincidence; the only discrepancy is that it adds that many miniatures are "en camaïeu gris", which they are not. The interleaved copy of the catalogue now in the Grolier Club in New York reveals that the estimate was 150 francs, but that it sold for 350 (for comparison, the previous lot, a Book of Hours with thirty-three miniatures, made thirty francs, and the following lot, another with fifty-four miniatures, made only 20 francs; but note that lot 61, MacCarthy's incomparable Gutenberg Bible on vellum, sold for 6260 francs, and is now the Grenville copy in the British Library). For Douce as a buyer at the MacCarthy sale that day, referred to on p. 419, see Munby, *Connoisseurs*, cited above, p. 52. Much has been written on Sydney Cockerell, including a biography, W. Blunt, *Cockerell*, London, 1964, and my own three Sandars Lectures, published in *The Book Collector*, 55, 2006, pp. 49–72, 201–23 and 339–66. He was the brother of Douglas Cockerell, mentioned on p. 18. The Burlington Fine Arts Club catalogue is *Exhibition of Illuminated Manuscripts*, London, 1908: the Hours of Jeanne de Navarre is on pp. 59–60, no. 130. The volume of Cockerell's diary quoted on p. 421 is British Library, Add. MS 52656. On Cockerell's special relationship with Thomas Henry Riches (1865–1935), see S. Panayotova, 'Cockerell and Riches', *The Medieval Book* (the de Hamel festschrift cited above), pp. 377–86. I owe my account of the auction to notes added in the Sotheby's copy of the sale catalogue, *Twenty-Eight Manuscripts and Two Printed Books, the Property of Henry Yates Thompson*, Sotheby's, 3 June 1919, shown to me by Mara Hofmann, and to the report in *The Times*, 4 June 1919. There is an entry by Alan Bell on Sir Charles Hagberg Wright in the *Oxford Dictionary of National Biography*; Wright's Roxburghe Club book, *Nicholas Fabri de Peiresc*, 1926, p. 7, recalls the Book of Hours as "an example of his appreciation of rare and beautiful manuscripts". Appropriately, marble busts of both Peiresc and Delisle are on pillars at the foot of the stairs leading up to the manuscript department in the Bibliothèque nationale de France. I express again my gratitude to Charlotte Denoël for making the last part of this chapter possible. For looted artworks requisitioned by Göring, we now have the astonishing photographic inventory from Les Archives Diplomatiques and J.-M. Dreyfus, *Le catalogue Goering*, Paris, 2015, covering paintings only and therefore not including the Hours of Jeanne de Navarre or its missing miniature, but recording other items looted from Alexandrine de Rothschild, p. 48.

CHAPTER TEN The Hengwrt Chaucer

The Hengwrt Chaucer is digitized in full and freely available on the website of the National Library of Wales. It was preceded by E. Stubbs, ed., *The Hengwrt Chaucer Digital Facsimile*, a CD-ROM produced by the National Library of Wales in collaboration with the Canterbury Tales Project at De Montfort University, Leicester, published by Scholarly Digital Editions, 2001; and by a printed facsimile in black-and-white, slightly reduced in size, which I have used

principally: P. G. Ruggiers, ed., *The Canterbury Tales, Geoffrey Chaucer: A Facsimile and Transcription of the Hengwrt Manuscript, with Variants from the Ellesmere Manuscript*, Norman, Okla., and Folkestone, 1979, with essential accompanying essays by D. C. Baker, A. I. Doyle and M. B. Parkes. The standard descriptions of the manuscript are J. M. Manly and E. Rickert, *The Text of the Canterbury Tales*, Chicago, 1940, I, pp. 266–83, and II, pp. 477–9, and M. C. Seymour, *A Catalogue of Chaucer Manuscripts*, II, *The Canterbury Tales*, Aldershot, 1997, pp. 31–4.

The *Guardian* for 20 July 2004 is available on-line. The first scholarly statement by Linne Mooney of her identification was 'Chaucer's Scribe', *Speculum*, 81, 2006, pp. 97–138, and she placed it in a larger context in L. R. Mooney and E. Stubbs, *Scribes and the City, London Guildhall Clerks and the Dissemination of Middle English Literature, 1375–1425*, York, 2013, esp. chapter 4, 'Adam Pinkhurst, Scrivener and Clerk of the Guildhall, *c.* 1378–1410', pp. 67–85. The phrase about the jury being out, which becomes the leitmotif of this chapter, is used in a review of that latter book by A. S. G. Edwards in *The Library*, 7 ser., 15, 2014, pp. 79–81. The Ellesmere Chaucer, introduced on p. 430, is now San Marino, Huntington Library, MS El. 26. C. 9 there. It is, I think, to the credit of Henry Huntington (1850–1927), railroad oligarch, that he did not rechristen it the 'Huntington Chaucer'. It is available in a colour facsimile, D. Woodward and M. Stevens, eds., *The New Ellesmere Chaucer Facsimile*, San Marino, Calif., and Tokyo, 1995, and in a cheaper monochrome version published the following year; for its decoration, see K. Scott, *Later Gothic Manuscripts*, cited above, pp. 140–43, no. 42, with reference to the Hengwrt manuscript. I first set eyes on it in its glass case in 1966, beside the Gutenberg Bible on vellum, but I have never actually handled it. The first suggestion from 1935 that Hengwrt and Ellesmere were copied by the same scribe, mentioned here on p. 431, is from p. 128 in J. S. P. Tatlock, 'The Canterbury Tales in 1400', *Proceedings of the Modern Languages Association*, 50, 1935, pp. 100–139. The seminal article by Doyle and Parkes, cited on p. 431, naming the copyist as 'Scribe B', is A. I. Doyle and M. B. Parkes, 'The Production of Copies of the *Canterbury Tales* and the *Confessio Amantis* in the Early Fifteenth Century', pp. 163–210 in M. B. Parkes and A. G. Watson, eds., *Medieval Scribes, Manuscripts and Libraries: Essays Presented to N. R. Ker*, London, 1978; supplemented by A. I. Doyle, 'The Copyist of the Ellesmere *Canterbury Tales*', pp. 49–67 in M. Stevens and D. Woodward, eds., *The Ellesmere Chaucer: Essays in Interpretation*, San Marino, Calif., and Tokyo, 1995, the volume of commentaries accompanying the facsimile. The two other manuscripts initially discussed by Doyle and Parkes as the work of the same scribe are Hatfield House, library of Lord Salisbury, Cecil Papers, Box S/1 (*Troilus*) and Cambridge, Trinity College, MS R.3.2 (Gower). Just for the record, the scribe cannot have been Chaucer himself, since the Gower manuscript is almost certainly datable to after that poet died in 1408, eight years after Chaucer's own death. Malcolm Parkes never accepted the identification of Scribe B with Pinkhurst, as his executor Pamela Robinson tells me, sending me photocopies of his final notes on the subject; Ian Doyle, as far as I know, has declined to commit himself in public but is perhaps inclined to be sympathetic. The preposterous case for Sir John Williams having been Jack the Ripper, alluded to here on p. 432, is presented by T. Williams with H. Price, *Uncle Jack*, London, 2005, hardly worth mentioning except to maintain the atmosphere of an impartial law court. I am indebted to Maredudd ap Huw for reading a draft of this chapter, and for correcting my spelling of various words in Welsh, including, I am embarrassed to report, his own first name, which is extremely rare and ancient. I owe to him the information on p. 435 that the manuscript was rebound in Aberystwyth using material from the Gregynog Press bindery. On p. 436 I observe that Scribe B's writing is oddly similar to the typeface of Caxton's second edition of Chaucer of 1483. It is just conceivable that this is not coincidence. Pinkhurst, if it was he, was scrivener to the Mercers' Company, of which Caxton was a member. Caxton writes in

the preface that an acquaintance brought him a manuscript (now lost) "that was very trewe and accordyng unto hys [Chaucer's] owen first book by hym made", which he then used for his new edition, and it might have been connected through the Mercers. The *Troilus* manuscript in the Parker Library at Corpus Christi College, Cambridge, first mentioned on p. 436, is MS 61; there is a facsimile edited by M. B. Parkes and E. Salter, *Troilus and Criseyde*, Cambridge, 1978. A perceptive guide to the codicology and collation of the Hengwrt Chaucer, before the scribal issue became contentious, is R. Hanna, 'The Hengwrt Manuscript and the Canon of the Canterbury Tales', *English Manuscript Studies, 1100–1700*, 1, 1989, pp. 64–84. For copying from units called *peciae* in medieval Paris, mentioned on p. 444, see especially J. Destrez, *La pecia dans les manuscrits universitaires du XIIIe et du XIVe siècle*, Paris, 1935, and for surviving examples of former *peciae* being subsequently bound up only when their usefulness had expired, see J. Destrez and M. D. Chenu, '*Exemplaria* universitaires des XIIIe et XIVe siècles', *Scriptorium*, 7, 1953, pp. 68–80. Chaucer's poem addressed to Adam, quoted on p. 450, occurs in Cambridge, Trinity College, MS R.3.20, p. 367. Recent debate over whether or not the words are to be taken literally, or even whether it is by Chaucer at all, is played out in B. Mize, 'Adam, and Chaucer's Words unto Him', *The Chaucer Review*, 35, 2001, pp. 351–77; A. Gillespie, 'Reading Chaucer's Words to Adam', *The Chaucer Review*, 42, 2008, pp. 269–83; J. Sánchez-Marti, 'Adam Pinkhurst's "Necglygence and Rape" Reconsidered', *English Studies*, 92, 2011, pp. 360–74; and A. S. G. Edwards, 'Chaucer and "Adam Scriveyn"', *Medium Aevum*, 81, 2012, pp. 135–8. On Shirley, who compiled the volume where the verse is found, see A. I. Doyle, 'More Light on John Shirley', *Medium Aevum*, 30, 1961, pp. 93–101, and, adding little to that light, M. Connolly, *John Shirley: Book Production and the Noble Household in Fifteenth-Century England*, Aldershot, 1998. Chaucer's satire of "scrivenish" handwriting is *Troilus*, book II, line 1026. The portrait of Chaucer wearing a penner is on folio 153v of the Ellesmere manuscript. The same attribute is even more unambiguous in the late-medieval portrait of Chaucer in the National Portrait Gallery, where the poet is shown fingering his penner, identified by F. W. Steer as evidence that Chaucer was seen as a scrivener (*A History of the Worshipful Company of Scriveners of London*, London, 1973, p. 68 and pl. 1). Examples of words in the Hengwrt manuscript written over erasures, as mentioned on p. 452, include "fader at the table" (folio 3r) and "ypolita the queene" (folio 14r), attributable to nothing more than mistaken copying conscientiously corrected. In the fourteenth century the name Adam was the twelfth most popular first name in England, ahead of Peter, Ralph, Geoffrey, Philip and others; see p. 106 of V. Davis, 'The Popularity of Late Medieval Personal Names as Reflected in English Ordination Lists, 1350–1540', pp. 103–114 in D. Postles and J. T. Rosenthal, eds., *Studies on the Personal Name in Later Medieval England and Wales*, Kalamazoo, 2006 (*Medieval Institute Publications, Studies in Medieval Culture*, 44). Earlier attempts to identify the Adam of the poem as a real person in the book trade include B. M. Wagner in *The Times Literary Supplement*, 13 June 1929, p. 474, and C. P. Christianson, *A Directory of London Stationers and Book Artisans, 1300–1500*, New York, 1990, p. 149. David Pearson facilitated my visit to the Guildhall Library. For the oaths taken by members of the Company, see Steer, *Scriveners*, as above, pp. 4–5. Pinkhurst's entry in the register is conveniently reproduced in Mooney and Stubbs, *Scribes and the City*, as above, p. 66, fig. 4.1. The standard textbook on the forms of '*anglicana*' script, mentioned on p. 454, is M. B. Parkes, *English Cursive Book Hands, 1250–1500*, Oxford, 1969, so dense as to be teetering on unreadable; it mentions the Ellesmere Chaucer on p. xxiii, n. 1. The twelve letterforms isolated by Mooney occur as an appendix in her 'Chaucer's Scribe' article of 2006, pp. 123–5; the quotation about the flourishing being "virtually a signature" is the last line on p. 125. Chaucer's application to the king for a deputy is Kew, National Archives, C 81/1394/87, but it is barely two lines long, on which any judgement

is almost impossible. Discussion for and against the identity of Pinkhurst as Scribe B occurs in A. J. Fletcher, 'The Criteria for Scribal Attribution: Dublin, Trinity College, MS 244, Some Early Copies of the Works of Geoffrey Chaucer, and the Canon of Adam Pynkhurst Manuscripts', *Review of English Studies*, 58, 2007, pp. 597–632, and its response, S. Horobin, 'The Criteria for Scribal Attribution: Dublin, Trinity College MS 244 Reconsidered', *Review of English Studies*, 60, 2009, pp. 371–81; D. W. Mosser, '"Chaucer's Scribe"Adam and the Hengwrt Project', pp. 11–40 in M. Connolly and L. R. Mooney, eds., *Design and Distribution of Late Medieval Manuscripts in England*, York, 2008; S. Horobin, 'Adam Pinkhurst and the Copying of British Library Additional 35287 of the B Text of *Piers Plowman*', *Yearbook of Langland Studies*, 23, 2009, pp. 61–83; S. Horobin, 'Adam Pinkhurst, Geoffrey Chaucer, and the Hengwrt Manuscript of the *Canterbury Tales*', *The Chaucer Review*, 44, 2010, pp. 351–67; A. J. Fletcher, 'What Did Adam Pynkhurst (Not) Write? A Reply to Dr Horobin', *Review of English Studies*, 61, 2010, pp. 690–710; L. R. Mooney, 'Vernacular Literary Manuscripts and Their Scribes', pp. 192–211 in A. Gillespie and D. L. Wakelin, eds., *The Production of Books in England, 1350–1500*, Cambridge, 2011; and R. F. Green, 'The Early History of the Scriveners' Company Common Paper and Its so-called Oaths', pp. 1–20 in S. Horobin and L. R. Mooney, eds., *Middle English Texts in Transition: A Festschrift dedicated to Toshiyuki Takamiya on His 70th Birthday*, Woodbridge, 2014. The three manuscripts listed on p. 457 as attributed now to Pinkhurst are Cambridge, Trinity College, MS B.15.17 (*Piers Plowman*), Aberystwyth, National Library of Wales, Peniarth MS 393B (Chaucer's *Boece*), and a fragment bound into Cambridge University Library, MS Kk.1.3 (*Canterbury Tales*). Where the dedicated Pinkhurst hunters have not yet seriously sought his hand is in contemporaneous books copied in Latin, for one would expect a professional scribe to have worked in both languages (and Pinkhurst uses Latin in the Oath Book); in that sense, the apparently high proportion of Chaucer manuscripts in the attributed group may not reflect his output as a whole. On the modest libraries of Richard II and Henry IV, compared on p. 459 with their equivalents in France, see S. H. Cavanaugh, 'Royal Books, King John to Richard II', *The Library*, 6 ser., 10, 1988, pp. 304–16, and J. Stratford, 'The Early Royal Collections and the Royal Library to 1461', pp. 255–66 in L. Hellinga and J. B. Trapp, eds., *The Cambridge History of the Book*, III, *1400–1557*, Cambridge, 1999. My counting of seventy-seven *libraires* in Paris on p. 460 was extracted from Rouse and Rouse, *Manuscripts and Their Makers*, cited in the bibliography to Chapter Nine; the contrasting statistics for England are from Christianson, *London Stationers and Book Artisans*, as above. For Caxton's choice of Westminster rather than London and the evidence that Caxton's Chaucer was the first book printed in England, now datable to late 1476 or early 1477, as on p. 461, see L. Hellinga, *Caxton in Focus: The Beginning of Printing in England*, London, 1982, pp. 67–8 and 80–81; and G. D. Painter and L. Hellinga, *Catalogue of Books Printed in the XVth Century Now in the British Library*, 11, *England*, 't Goy-Houten, 2007, pp. 8 and 104. The principal argument against Pinkhurst being Scribe B is J. Roberts, 'On Giving Scribe B a Name, and a Clutch of London Manuscripts from *c.* 1400', *Medium Aevum*, 80, 2011, pp. 247–70. A reasoned middle ground is L. Warner, 'Scribes, Misattributed: Hoccleve and Pinkhurst', *Studies in the Age of Chaucer*, 37, 2015, pp. 55–100, a very fine article for which I am grateful to Kari Ann Rand and Lawrence Warner himself. The author accepts that Pinkhurst copied Trinity College B.15.17, but not that he was Scribe B of Hengwrt and Ellesmere, which I find very persuasive. Finally I have an announcement. I felt that I ought to send an early draft of my chapter to Linne Mooney herself. She read it with exemplary speed and care, made several useful suggestions, most of which I have incorporated, and, although she regretted my conclusion, she gave it her generous *imprimatur*. That shows nobility and magnanimity, and I salute her unreservedly.

There are no comprehensive reproductions of the *Semideus*. There are good photographs of selected pages in A. de Laborde, *Les principaux manuscrits à peintures conservés dans l'ancienne Bibliothèque impériale publique de Saint-Pétersbourg*, I, Paris, 1936, pp. 83–4, no. 81; T. Voronova and A. Sterligov, *Western European Illuminated Manuscripts of the 8th to the 16th Centuries in the National Library of Russia, St Petersburg*, transl. M. Faure, Bournemouth and St Petersburg, 1996, pp. 258–63, plates 334–47; and in *The Art of XV–XVI Century European Manuscripts*, exhibition catalogue, State Hermitage Museum, St Petersburg, 2005, pp. 260–65, no. 60, text in Russian. The manuscript is described in W. Lublinsky, 'Le *Semideus* de Caton Sacco', pp. 95–118 in O. Dobiaš-Roždestvenskaja, ed., *Srednevekov'e v rukopisjach publicnoi biblioteki*, II, Leningrad, 1927 (*Analecta Medii Aevi*), in Russian with a summary in French; and in O. Bleskina, *Catalogus Codicum Manuscriptorum qui in Bibliotheca Publica Petropolitana asservantur*, St Petersburg, 2011, p. 280, no. 713. I owe several of these references to Olga Bleskina herself, who kindly furnished me with photocopies. By far the most extensive account of the manuscript, however, is the edition of the text, P. Rosso, *Il Semideus di Catone Sacco*, Milan, 2001 (*Quaderni di studi senesi*, 95), esp. pp. ccxxxvii–ccxlix.

For the Visconti library and its inventories, I used the standard classic, E. Pellegrin, *La Bibliothèque des Visconti et des Sforza, ducs de Milan, au XV^e siècle*, Paris, 1955 (*Publications de l'Institut de Recherche et d'Histoire des Textes*, V), supplemented by M. G. Ottolenghi, 'La biblioteca dei Visconti e degli Sforza: gli inventari del 1488 e del 1490', *Studi Petrarcheschi*, n.s., 8, 1991, pp. 1–238, describing the *Semideus* on pp. 19–21 and pl. V. The Visconti viper eating a child, mentioned on p. 468, survives as an emblem of Alfa Romeo motor cars, founded in Milan. The description of the manuscript in 1488 is "Item Semideus Catonis Saci papiensis cum cantonis sex argenteis et claviculis duabus incompletis in carta cum coperta veluto cremesili et cum capsa una ex coreo deaurato" (Ottolenghi, p. 32). For background on the conquest of Lombardy, I consulted F. J. Baumgartner, *Louis XII*, Stroud, 1994, and M. Mallett and C. Shaw, *The Italian Wars, 1494–1559: War, State and Society in Early Modern Europe*, Harlow, 2012. For the transference of the Visconti–Sforza library to France, see L. Delisle, *Le Cabinet des Manuscrits de la Bibliothèque impériale*, I, Paris, 1868 (*Histoire générale de Paris*), pp. 125–40; the *Semideus* is noted on p. 133, n. 3. I am unable to resist reporting that I used most of my advance from Allen Lane for writing this book to buy a fragment of a Dante manuscript also given in 1438 to Filippo Maria Visconti and similarly looted from Pavia during the French occupation, most of it now being Bibliothèque nationale de France, ms ital. 2017: even now, the disperals occasioned by that war have not quite all come to roost. The remarkable acquisitions of Dubrowsky in Paris are recounted in P. Z. Thompson, 'Biography of a Library: The Western European Manuscript Collection of Peter P. Dubrovskii in Leningrad', *The Journal of Library History*, 19, 1984, pp. 477–503; the engraving of him mentioned on p. 471, is on p. 13 of *The Art of XV–XVI Century European Manuscripts*, cited above. The Livy with the apparent arms of the Medici, acquired by Dubrowsky, is now Cod. Cl. Lat. F.v.2 in St Petersburg (Voronova and Sterligov, pp. 264–5); the other treasures listed here are Lat.Q.v.I.18 (Bede), Lat.Q.v.I.26 (purple Gospel Book), Lat.Q.v.V.1 (Bestiary), Fr.F.v.I.I/1–2 (*Bible Historiale*) and Fr.F.v.XV.6 (Martin le Franc). An account of my only previous visit to St Petersburg is C. de Hamel, 'The Colloquium of the International Association of Bibliophiles in Saint Petersburg, 12th–18th September 1994', *Bulletin du Bibliophile*, 1995, pp. 11–15. For surveys of the medieval manuscripts in St Petersburg, in addition to the catalogues listed above, see T. P. Voronova, 'Western Manuscripts in the Saltykov-Shchedrin Library', *The Book Collector*, 5, 1956, pp. 12–18 (citing the *Semideus* on p. 14), and

O. Kristeller, *Iter Italicum, Accedunt Alia Itinera: A Finding List of Uncatalogued or Incompletely Catalogued Humanistic Manuscripts in Italian and Other Libraries*, V, London and Leiden, 1990, pp. 177–96 (listing the *Semideus* on p. 191). I cannot give any precise reference to Louis de Burgeneys, seigneur de Moléans, suggested on p. 477: it was simply an unverifiable and chance hit on an internet trawl. I do not entirely understand the first of the French poems in the margins of what are now folios 2v–3r, printed on pp. 477–8 and which I may have transcribed too hastily from its atrocious handwriting, but the gist is something like this: '*Chanter!* I want to sing in all places, / However I want to, that the gods / Royal kings, princes and great monarchs / In all the world and its gardens, / So different I need not say how, / To death will come too soon to see, / On their own terms, as will I: / Power from ships and castles / How I see it all / Emerging in this lovely book / Regardless of the gods above' (I hope you noticed immediately that the opening letters of the lines of my version now spell out 'Christopher'). The poems share pages with the heading of the preface on folio 2r and the opening of the dedication on folio 2v, which begins, "Virginis laude esse omnem tuum …". Kristeller, *Iter Italicum*, V, p. 191, prints the first word, admittedly smudged, as 'Legis' and Rosso prints the second as 'laudem'. The verse by Claudian, mentioned on p. 479, also appears on the last page of the manuscript (it opens, "Iupiter in parvo cum cerneret ethera vitro …", Claudian, *Carmina minora*, LI, lines 1–6). Filippo Maria Visconti's famous manuscript of Suetonius, referred to on p. 482, followed the same route through Louis XII to Paris and it is now Bibliothèque nationale de France, ms ital. 131. Its prolific artist is known from this book as the Master of the Vitae Imperatorum; cf. A. Melograni, 'Appunti di miniatura lombarda: ricerche sul "Maestro delle Vitae Imperatorum"', *Storia dell'Arte*, 70, 1990, pp. 273–314, and the entry by F. Lollini in M. Bollati, ed., *Dizionario biografico dei miniatori italiani, Secoli IX–XVI*, Milan, 2004, pp. 587–9. The Visconti Hours, cited on p. 483, is divided into two volumes both by different ways now in the Biblioteca nazionale in Florence, I, Banco rari cod. 397, and II, cod. Landau-Finaly 22; for convenience I used M. Meiss and E. W. Kirsch, *The Visconti Hours*, London, 1972, but there is now a facsimile, *Il libro d'ore Visconti*, Modena, 2003, with accompanying commentary by A. Di Domenico and M. Bollati. The Breviary of Marie of Savoy is Chambéry, Bibliothèque municipale, ms 4 (C. Heid-Guillaume and A. Ritz, *Manuscrits médiévaux de Chambéry, Textes et enluminures*, Paris and Turnhout, 1998, pp. 30–43, with plates). The *De laudibus virginis*, described on p. 484, opens on folio 9r and it ends on folio 36v; the quotation 'Hear me patiently …' is from folio 18r; the allusion to 1438 years since the Incarnation occurs on folio 13v. The anthology in the British Library in London is Arundel MS 138 with this same text on folios 220r–225v. The illustrations described here in part III, the *Semideus*, occur on folios 39r (the knight looking at the Virgin and Child), 40r (the fountain of the Catos), 42r (Filippo Maria Visconti), 45v (the army in a mountain pass), 59r (attack on a city), 64r (crossing a river), 66r (an encampment at night), 69r (a pitched battle), 74v (a rest day), 79v (attack in a valley), 84r (horses), 89r (attack on a desert citadel), 91v–92r (carrying and assembling siege machinery), 96r (a battle at night), 99r (bombarding ships), 100r (a naval battle), 103v (burning river forts) and 106v (building a pontoon). The comparisons made with the Visconti Hours on pp. 488 and 491 are found in volume I of that manuscript, folio 40r (portrait of Gian Galeazzo Visconti), and volume II, folio 101v (Pharaoh's army). I owe my knowledge of Sacco's tombstone, reproduced on p. 500, entirely to Cecilia Mackay, indefatigable picture researcher for this book, who referred me also to A. Cavagna Sanguiliani, 'Arte retrospettiva: Antichi ricordi marmorei di professori dall'ateneo pavese', pp. 379-92 in *Emporium, Parole e Figure*, 22, 1905, esp. pp. 381-82. Books I and II of Sacco's *Semideus*, mentioned on p. 500, ocur without Book III in Fulda, Hessische Landesbibliothek, MS C. 10, folios 168r–185v; book I alone is found also in Basle, Öffentliche

Universitätsbibliothek, MS F. IV. 2, folios 160r–183r. I feel that I must add a note to my debt to Anna Melograni, cited and acknowleged on p. 501. She knew that I was likely to quote her, which I do with immense gratitude, but I must also emphasize that she has not yet personally seen the volume in St Petersburg and she is dependent only on random scans of the published photographs. Any of us making provisional observations about manuscripts which we have not examined do so with extreme diffidence. If what I have concluded proves in time to be entirely mistaken, you must blame me but not her. In addition to Anna Melograni, I am grateful for advice from Kay Sutton on the Lombard artists of this period. The manuscript in Copenhagen is Kongelige Bibliotek, MS Gl. Kgl. S 2092 4°. It is illustrated in G. Algeri, 'Un *Boccaccio pavese del 1401 e qualche nota per Michelino da Besozzo', Arte Lombarda,* n.s., 116, 1996, pp. 42–50. Although the Copenhagen manuscript is dated in February 1401, it might be that, according to the medieval calendar, which often ended in March, that year was actually what we would call 1402. The illuminators named here on p. 503 all appear in Bollati, *Dizionario biografico dei miniatori italiani,* cited above, with bibliographies. Paintings by Michelino da Besozzo include the panel *Marriage of the Virgin* in the Metropolitan Museum in New York, Maitland F. Griggs Bequest, acc. 43.98.7. The picture of the presentation of the Galassio da Coreggio's *Historia Angliae,* described on p. 503, is Paris, Bibliothèque nationale de France, ms lat. 6041 D, folio 8 *ter*: see M. Natale and S. Romano, eds., *Arte lombarda dai Visconti agli Sforza,* Milan, 2015, p. 230, no. III.19 and plate on p. 203, kindly given to me by Francesco Radaeli. The possible involvement of Jacopo de San Pietro in the *Semideus,* introduced here on p. 504, was first proposed by Maria Grazia Ottolenghi ('Biblioteca dei Visconti', 1991) and it was assumed without question by Paolo Rosso in his edition of the text. Sacco's *Lectura* illuminated and assembled by Jacopo in 1458 is Paris, Bibliothèque nationale de France, ms lat. 4589; his inscription is on folio 366r (Alexandre Tur of the Bibliothèque nationale supplied me with pictures at a moment's notice). The eleventh-century Boethius bound by him is Bibliothèque nationale de France, ms lat. 6400 A, inscribed on folio 107v, "Jacobus de Sancto Petro bidelus ligavit." A persuasive argument for the introduction of printing into Italy by 1462–3, mentioned on p. 506, is presented in Christie's, 23 November 1998, lot 18, describing an item now in the Scheide Library, Princeton. For the work of Jacopo de San Pietro as a printer, see R. Proctor, *An Index to the Early Printed Books in the British Museum, from the Invention of Printing to MD,* London, 1898, pp. 482–3, and A. Coates, K. Jensen, C. Dondi, B. Wagner and H. Dixon, *A Catalogue of Books Printed in the Fifteenth Century, Now in the Bodleian Library,* II, Oxford, 2005, p. 796, no. C-216.

CHAPTER TWELVE The Spinola Hours

The Spinola Hours, like the Hours of Jeanne de Navarre, is a prime candidate for a fine-art facsimile; it has not yet even been the subject of a monograph. Excellent images are available on the website of the J. Paul Getty Museum (go to 'Getty guide' and then 'Art object, details'). The most detailed catalogue description is still J. M. Plotzek, *Die Handschriften der Sammlung Ludwig,* II, Cologne, 1982, pp. 256–85. The manuscript was exhibited as no. 124 in T. Kren and S. McKendrick, *Illuminating the Renaissance: The Triumph of Flemish Manuscript Painting in Europe,* Los Angeles, 2003, pp. 414–17, with extensive bibliography on p. 529.

Numerous visits to the Getty Museum over the years have been made enjoyable by the hospitality of Thom Kren. His successor as Curator of Manuscripts, Beth Morrison, has generously read this chapter in draft and made helpful suggestions. The Spinola Hours never ap-

peared in a published Kraus catalogue but its passage through the firm was commemorated by his *In Retrospect: A Catalogue of 100 Outstanding Manuscripts Sold in the Last Four Decades by H. P. Kraus*, New York, 1978, pp. 224–7, no. 91. That volume was the first revelation of Dr Ludwig as a collector. The Spinola arms were first identified by Hertha Bauer, the reference librarian at H. P. Kraus, as I am told by Roland Folter, formerly the firm's managing director. His wife, Mary-Ann Folter, daughter of Mr Kraus, has kindly read an early version of this chapter too and told me about the sale price to Dr Ludwig. She added that he was in the habit of arriving without warning, of looking at many manuscripts, and then of making single offers on whole groups of items at once, and so individual figures were often notional and for accounting purposes only. On the history of private prayer as reflected in Books of Hours, alluded to on p. 526, see E. Duffy, *Marking the Hours: English People & Their Prayers, 1240–1570*, New Haven and London, 2006. On the use of Books of Hours as catalysts for imagining actual participation in the Virgin Mary's own devotions, see C. de Hamel, 'Books of Hours: Imaging the Word', pp. 137–43 in J. Sharpe and K. Van Kampen, eds., *The Bible as Book: The Manuscript Tradition*, London, 1998. The seven Penitential Psalms, mentioned on p. 531 and listed earlier too among the components of the Hours of Jeanne de Navarre, are, in the numbering of the Latin Vulgate and with their association with each of the deadly sins, psalms 6 (pride), 31 (greed), 37 (anger), 50 (lust), 101 (gluttony), 129 (envy) and 142 (sloth). The quotation on p. 535 from the Royal Academy exhibition catalogue is *Illuminating the Renaissance*, as above, p. 414. L. M. J. Delaissé's metaphor about the mounds and the mountain tops, recalled on p. 537, is used on p. 209 of his review of the first volume of M. Meiss, *French Painting in the Time of Jean de Berry* (cited in the bibliography to Chapter Nine above), *The Art Bulletin*, 52, 1970, pp. 206–12, a reference I owe to Sandra Hindman. The problem of integrating the two-dimensional nature of a manuscript page with the new three-dimensional realism, mentioned on p. 539, was first articulated by Otto Pächt (his *The Master of Mary of Burgundy*, London, 1948, and *Buchmalerei des Mittelalters, Eine Einführung*, Munich, 1984, pp. 198–202) and by his greatest pupil, Jonathan Alexander (in, for instance, his *The Book of Hours of Engelbert of Nassau*, New York, 1970, pages unnumbered). The extraordinary layers of illusion in Ghent–Bruges manuscripts are discussed in J. H. Marrow, *Pictorial Invention in Netherlandish Manuscript Illumination of the Late Middle Ages: The Play of Illusion and Meaning*, Louvain, 2005 (*Corpus of Illuminated Manuscripts, Low Countries series*, II), including many references to the Spinola Hours. On p. 539 I mention panels of text in the Spinola Hours being turned into three-dimensional illusions: specimen page references are folios 8v–9r (scrolls fallen on the page), folios 10v–11r (text pinned to the page), folios 40r and 165v (angels holding text) and folios 56v–57r (text hinged like a shutter). For Ghent–Bruges borders, see C. Fisher, *Flowers in Medieval Manuscripts*, London, 2004, and A. M. W. As-Vijvers, *Re-Making the Margin: The Master of the David Scenes and Flemish Manuscript Painting around 1500*, transl. D. Webb, Turnhout, 2013, which is not quite as directly relevant here as its title suggests. The shadows of flowers falling to the right are because artists worked with a window on the left, to give maximum light to a right-handed person, as shown in the two self-portraits of the Bruges illuminator Simon Bening (cf. S. Hindman, *The Robert Lehman Collection*, IV, *Illuminations*, New York and Princeton, 1997, pp. 112–19, no. 14). I once wondered whether one could date the execution of floral borders of Ghent–Bruges manuscripts to particular months when specific flowers were in bloom, but all seasons are mixed up, showing that the artists were not copying directly from living specimens in the workshop, however naturalistic, but from pre-prepared sketches. The famous Books of Hours which are first cousins of the Spinola Hours, listed on pp. 540–42, are: Vienna, Österreichische Nationalbibliothek, Cod. 1907 (the First Prayerbook of the Emperor Maximilian, *c.* 1486): facsimile, W. Hilger, ed., *Das ältere Gebetbuch*

Kaiser Maximilians I, Cod. Vind. 1907, Graz, 1973 (*Codices Selecti*, 39); Naples, Biblioteca Nazionale di Napoli, Ms I.B. 51 (the La Flora Hours, not later than 1498): facsimile, *Horae Beatae Mariae Virginis, La Flora, Napoli, Biblioteca Nazionale Vittorio Emanuel III, Ms I.B.51*, Turin, 2008; Österreichische Nationalbibliothek, Cod. 1897 (the Hours of James IV, *c.* 1502–3): facsimile, F. Unterkircher, ed., *Das Gebetbuch Jakobs IV von Schottland*, Graz, 1987 (*Codices Selecti*, 85); Cleveland, Ohio, Museum of Art, Leonard C. Hanna Jr. Fund, 1963.256 (the Hours of Isabella the Catholic, not later than 1504): facsimile, *The Hours of Queen Isabella the Catholic, The Cleveland Museum of Art, Cleveland/Ohio, Leonard C. Hanna Jr. Fund 1963-256, Commentary Volume*, Gütersloh and Munich, 2013, with accompanying commentary volume by L. De Kesel, 2013 (I am indebted to Lieve De Kesel for not only giving me a copy of her book, which has many references to the Spinola Hours, but also for reading a very early draft of this chapter and for helpful suggestions, especially on the attributions of artists); Perth, Australia, Kerry Stokes Collection, LIB.2014.017, formerly Vienna, Cod. Ser. Nov. 2844 (the Rothschild Prayerbook, *c.* 1515): facsimile, E. Trenkler, ed., *Rothschild-Gebetbuch, Cod. Vind. S.N. 2844*, Graz, 1979 (*Codices Selecti*, 67), F. Unterkircher, *Das Rothschild-Gebetbuch: Die schönsten Miniaturen eines flämischen Stundenbuches*, Graz, 1984; and private collection, formerly Lord Astor (the Hours of Albrecht of Brandenburg, *c.* 1522–3), last sold at Sotheby's 19 June 2001, lot 36, catalogued by me. The second cousins, as it were, are the royal Breviaries. Those listed here are: London, British Library, Add. MS 18851 (the Breviary of Isabella of Castile, not later than 1497): facsimile, *The Isabella Breviary, The British Library, London, Add. Ms. 18851*, Barcelona, 2012, with accompanying commentaries by S. McKendrick, E. R. García and N. Morgan; Antwerp, Museum Mayer van der Bergh, inv. no. 946 (Breviary probably for Manuel I of Portugal, *c.* 1500): cf. B. Dekeyzer, *Layers of Illusion: The Mayer van den Bergh Breviary*, transl. L. Preedy, Ghent and Amsterdam, 2004; New York, Morgan Library, M 52 (the Breviary of Eleanor of Portugal, early sixteenth century); and Venice, Biblioteca Marciana, cod. lat. I. 99 (the Grimani Breviary, *c.* 1515–20); cf. A. Mazzucchi, ed., *Breviario Grimani, Ms Lat. I 99 = 2138, Biblioteca Nazionale Marciana, Venezia*, Rome, 2009. For the guild regulations requiring clients to negotiate with artists directly, p. 542 here, see M. Smeyers, *Naer natueren ghelike: Vlaamse Miniaturen voor Van Eyck (ca. 1350–ca. 1420)*, Louvain, 1993, p. 93 (a reference I owe to Evelien Hauwaerts). For the exemption made for artists employed by the court, see p. 191 in L. Campbell, 'The Art Market in the Southern Netherlands in the Fifteenth Century', *Burlington Magazine*, 118, pp. 188–98. For known scribes of southern Netherlandish Books of Hours, including the two mentioned on p. 543, see R. Gay, 'Scribe Biographies', pp. 182–8 in E. Morrison and T. Kren, eds., *Flemish Manuscript Painting in Context: Recent Research*, Los Angeles, 2006. The Hours of Charles V is New York, Morgan Library, M 491. On the subject of lunch at the Getty (p. 543), I am reminded of a throw-away remark I made in my book *A History of Illuminated Manuscripts*, Oxford, 1986, pp. 168–9, referring to the collapse of the manuscript trade in Paris during military occupation, "Hungry people do not buy books": on an early visit to the Department of Manuscripts at the Getty I was charmed to see this sentence photocopied and enlarged into a poster on the back of a door. The division of the work by the five principal artists of the Spinola Hours, listed on pp. 543–4, is as follows: (1) the Master of James IV painted folios 1v–65r, 92v–109v, 130v–149r, 184v–185r, 256v–257v and 259v–260v; (2) the Master of the First Prayerbook of Maximilian painted folios 85v–89v, 165v, 223v–245v, 248v–255v, 264v–270v and 276v–290v; (3) the Master of the Lübeck Bible painted folios 83v–84r, 153v, 166r, 247v, 258v, 261v and 272v; (4) the 'Master of the Dresden Prayerbook painted folios 110r–120r; and (5) Master of the Prayer Books of around 1500 painted folios 125v–126r. The Dresden 'Prayerbook' itself is Dresden, Sächsische Landesbibliothek Ms A 311, a disappointing manuscript rather damaged by damp. It would have been better to have named him

after the much finer Carpentin Hours, little known until recently and still privately owned, and for which see A. Bovey, *Jean de Carpentin's Book of Hours: The Genius of the Master of the Dresden Prayer Book*, London, 2011; see also B. Brinkmann, *Die flämische Buchmalerei am Ende des Burgunderreichs: Der Meister des Dresdener Gebetbuchs und die Miniaturisten seiner Zeit*, Turnhout, 1997, discussing the Spinola Hours especially on pp. 325–9. The two other fine manuscripts by the Master of the Prayer Books of around 1500, mentioned on p. 544, are London, British Library, Harley MS 4425 (*Roman de la Rose*) and Vienna, Österreichische Nationalbibliothek, Cod. 1862 (the Hours of Margaret of Austria). The incomparable *Très Riches Heures* of the Duc de Berry has flitted in and out of several chapters of this book. It returns from p. 551 here. It is now Chantilly, Musée Condé, ms 65. There are countless reproductions and studies of it, including the facsimile, R. Cazelles and J. Rathofer, eds., *Les Très Riches Heures du Duc de Berry*, Lucerne, 1984, which reproduces the binding too. The Rothschild Prayerbook, mentioned above, was Christie's, New York, 29 January 2014, lot 157, and is now described in K. Sutton and M. M. Manion, *Revealing the Rothschild Prayer Book, c. 1505–1510*, Canberra, 2015, and K. Challis in M. M. Manion, ed., *An Illumination: The Rothschild Prayerbook and Other Works from the Kerry Stokes Collection, c. 1280–1685*, Perth, 2015, pp. 14–35, no. 1. I am greatly indebted to Kate Challis herself and especially to Kerry and Christine Stokes and their curator, Erica Persak, for enabling me to examine the manuscript when it was in Melbourne. The inventories of Margaret of Austria are published in M. Debae, *La bibliothèque de Marguérite d'Autriche: Essai de reconstitution d'après l'inventaire de 1523–1524*, Louvain and Paris, 1995; the items which might be the Rothschild Prayerbook and the Spinola Hours are p. 88, no. 53, and p. 494, no. 367. For the life of Margaret, I looked at J. de Iongh, *Margaret of Austria, Regent of the Netherlands*, transl. M. D. H. Norton, London, 1954. For her patronage of manuscripts, see D. Eichberger, 'Devotional Objects in Book Format: Diptychs in the Collection of Margaret of Austria and Her Family', pp. 291–323 in Manion and Muir, eds., *Art of the Book*, cited above for Chapter Nine; D. Eichberger, *Leben mit Kunst – Wirken durch Kunst: Sammelwesen und Hofkunst unter Margarete von Österreich, Regentin der Niederlande*, Turnhout, 2002; and H. W. Wijsman, *Luxury Bound: Illustrated Manuscript Production and Noble and Princely Book Ownership in the Burgundian Netherlands (1400–1550)*, Turnhout, 2010, esp. pp. 201–7. The presence of the *Très Riches Heures* in the possession of Margaret of Austria explains how its famous Calendar pictures were copied into the Grimani Breviary around 1515–20, quite possibly for Margaret herself before it passed into the possession of Cardinal Domenico Grimani (1461–1523). The Echternach *Codex Aureus* or Golden Gospels of Henry III, mentioned on p. 557, is now El Escorial, Biblioteca de San Lorenzo, Cod. Vitr. 17; it is one of the most spectacular manuscripts I have ever seen, and it could easily have merited a chapter in this book, except that two other Gospel Books had already featured. The Berlin Hours of Mary of Burgundy is Berlin, Staatliche Museen und Preussischer Kulturbesitz, Kupferstichkabinett, 78.B.12. It contains a unique image for its Office of the Dead on folio 290v, showing an aristocratic woman on a galloping horse pursued by skeletons with spears: Mary of Burgundy was killed in a riding accident on 27 March 1482, when her daughter was two years old. The manuscript which may have been given to Margaret of Austria later by Philippe the Handsome is Österreichische Nationalbibliothek, Cod. 1862, mentioned a moment ago. I owe both these suggested identifications of Margaret's first Books of Hours to Wijsman, as above, pp. 202 and 206. The Hours of Bona of Savoy completed for Margaret of Austria is London, British Library, Add. MS 34294, for which see M. L. Evans, *The Sforza Hours*, London, 1992, and the facsimile *Das Stundenbuch der Sforza*, with commentary volume by M. L. Evans and B. Brinkmann, Lucerne, 1994. In July 2015 the portrait of Margaret of Austria from the Museum voor Schone Kunsten in Ghent, described on p. 559, was placed on long-term loan at the Kunsthistorisches Museum in

Vienna. The Vienna Hours of Mary of Burgundy is Vienna, Österreichische Nationalbibliothek, Cod. 1857; its famous miniature of the duchess seated at a window overlooking a church is on folio 14v. For the identification of the specific member of the Spinola family who owned the *Très Riches Heures* and for the circumstances of the sale in Genoa, I am immensely grateful to the advice of Emmanuelle Toulet and for a preview of her projected article 'Du "manuscrit de Gênes" aux "Très Riches Heures du duc de Berry"' for inclusion in P. Stirnemann and I. Villela-Petit, eds., *Les Très Riches Heures de Jean de Berry*, for publication by Editions Panini in Rome; for the Rothschild involvement, see R. Cazelles, *Le duc d'Aumale: Prince aux dix visages*, Paris, 1984, p. 197. We encountered other Rothschild collectors in Chapter Nine. For Baron Adolphe, see my *Rothschilds and Their Collections*, pp. 5–7, and for Baron Anselm, pp. 7–12. I have to say that my idea that the three great manuscripts here might have travelled together from the sixteenth century until 1856 is ultimately unproven, but if any readers of this can add any confirmation or a better explanation, I shall be very glad to hear from them. The book I consulted in the Staatsbibliothek in Munich in 1975, as reported on p. 561, was F. Winkler, *Die flämische Buchmalerei des XV und XVI Jahrhunderts*, Leipzig, 1925; the updated edition, G. Dogaer, *Flemish Miniature Painting in the 15th and 16th Centuries*, Amsterdam, 1987, does indeed include and illustrate the Spinola Hours, pp.165–6. The article with the headline 'Mystery manuscript could top £100,000' was in *Antiques and Art Weekly*, 26 April 1976, p. 21. The account by H. P. Kraus is Chapter 43, 'One Manuscript for $750,000', pp. 319–23 in his autobiography, *A Rare Book Saga*, London, 1979 (the quotation about bidding in person is from p. 320). The manuscript was Sotheby's, 5 July 1976, lot 68, pp. 36–41 of the sale catalogue.

List of illustrations